Picturing Kingship

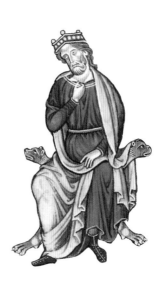

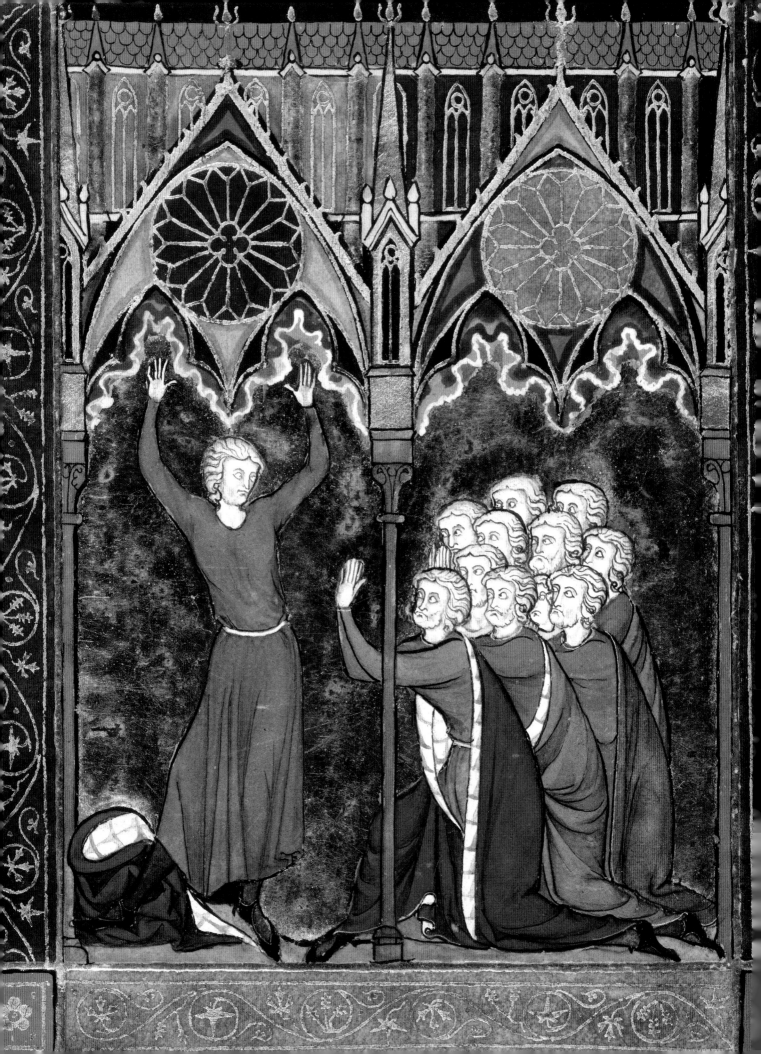

Picturing Kingship

History and Painting *in the* Psalter of Saint Louis

Harvey Stahl

The Pennsylvania State University Press
University Park, Pennsylvania

MM Publication of this book has been aided by a grant from the
Millard Meiss Publication fund of the College Art Association.

This publication has been supported by a grant from the
Samuel H. Kress Foundation.

Library of Congress Cataloging-in-Publication Data
Stahl, Harvey.
 Picturing kingship : history and painting in the Psalter of
Saint Louis / Harvey Stahl.
 p. cm.
Includes bibliographical references and index.
ISBN 978-0-271-02863-7 (cloth : alk. paper)
1. Psalters—Illustrations.
2. Catholic Church—Liturgy–Texts—Illustrations.
3. Illumination of books and manuscripts, French.
4. Illumination of books and manuscripts, Gothic—France.
5. Psautier de Saint Louis.
6. Louis IX, King of France, 1214–1270.
7. Bibliothèque nationale (France).
I. Title.

ND3357.S3S83 2007
745.6'70944361—dc22
2007017253

Frontispiece: Detail of folio 25v, Psalter of Saint Louis

Contents

Illustrations

Foreword

Harvey Stahl a travaillé depuis longtemps sur l'un des plus importants man-
uscrits à miniatures du Moyen Âge. Il s'agit du Psautier de Saint Louis,
ouvrage que l'illustre roi a eu quotidiennement entre les mains. C'est de
l'avis de tous les connaisseurs qui l'ont vu un des chefs d'oeuvre de la pein-
ture médiévale. Harvey Stahl, avec qui je me suis longuement entretenu du
manuscrit, en soulignait l'importance pour des raisons aussi thématiques et
proprement historiques. L'histoire sainte y apparaît étroitement liée aux
croisades de Saint Louis et à l'évolution de la dévotion et de l'art vers la nar-
ration de récits d'histoire. La Bible y devient une véritable histoire confir-
mant l'intérêt émergeant pour les discours articulés de la vison historique.
Ce livre est un grand livre sur un grand sujet.

<div align="right">JACQUES LE GOFF</div>

. . .

*[Harvey Stahl worked for a long time on one of the most important illuminated
manuscripts of the Middles Ages. The Psalter of Saint Louis was a work that the
illustrious king held daily in his own hands. All connoisseurs who have seen it
agree that it is one of the masterpieces of medieval painting. Harvey Stahl, with
whom I have long discussed this manuscript, underlined its importance for other
reasons as well, both thematic and historical. The sacred history therein appears to
be closely tied to Saint Louis's crusades and to the evolution of devotion and the
visual arts through the telling of historical stories. The Bible thus became true
history, confirming the emerging interest in subtle discussions of historical perspec-
tives. This book is a grand book on a grand subject.]*

Editor's Note

Harvey Stahl researched, wrote, and rewrote this book for the better part of two decades. When he was diagnosed with ALS, or Lou Gehrig's disease, late in 2001, he refused to admit his growing weakness and pushed to finish the work, but the disease was quicker than he was, and on June 22, 2002, Harvey died. I lived with the book for the entire time we were married, talked with Harvey often about the issues he was exploring, and read various early drafts. Still, it was a daunting task to do justice to this monumental work. I sifted through massive files of notes, trying to incorporate Harvey's latest thinking into the finished book, filling in footnotes when possible, and turning for help to many generous and kind colleagues. I may not have chosen the people Harvey would have, and if I have hurt anyone's feelings by not including them in the process, I ask them to forgive me. I want to thank the many people who answered my questions, helped with footnotes, read the manuscript, and gave invaluable advice: John Lowden, Richard Rouse, Jeffrey Hamburger, Alyce Jordan, Cecelia Gaposchkin, Anne Hedeman, Patricia Stirnemann, Abby Poust, Laura Hollengreen, Alexa Sand, and Chris Hughes. In editing the manuscript, I tried to insert as seamlessly as possible pages of notes Harvey had clearly meant to include in his next revision. I take responsibility for any errors in these passages and in the footnotes. The introduction and first three chapters were almost completely finished at the time of Harvey's death. I have made minor changes to the fourth chapter, more extensive ones to the fifth, incorporating newer writing into the old. The conclusion is based on a talk Harvey gave at the medievalist meeting in Kalamazoo, Michigan, and serves as a summary for the book, with more recent passages included, along with material from detailed outlines. The bibliography is as complete as I can make it, based on binders full of Harvey's handwritten notes, but omissions and misspellings are inevitable. All such errors are mine alone and not reflective of Harvey's scholarship.

Harvey, among his many files, also left a list of people to thank: For general information, Jacques Le Goff, François Avril, Marie-Pierre Laffitte, Willibald Sauerländer, Patricia Stirnemann, and Michael Baxandall. For

research on the textile covering of the Psalter, Brigitte Tietzel from the Deutsches Textilmuseum in Krefeld, Elizabeth Monnas of London, Anne E. Wardwell from the Cleveland Museum of Art, Karel Otavsky from the Abegg-Stiftung in Riggisberg, Linda Woolley from the Victoria and Albert Museum, Sophie Desrosiers from the École des hautes études en sciences sociales in Paris, and Gabriel Vial from the Centre international d'étude des textiles anciens in Lyons. For the binding, Marie-Pierre Laffitte and Jean Vezin. For the Isabella Psalter, Michael Camille, W. R. Woudhouysen, and James Marrow. For the legends, Howard Bloch, Sylvia Huot, Suzanne Fleischman, Sophie Richardson, Brian Stock, Gabrielle Spiegel, and Joseph Duggan. For the heraldry, Michel Pastoreau and Hervé Pinoteau. For the ivories, Charles Little and Danielle Gaborit-Chopin. For questions of style, Pamela Blum, Eleanor Greenhill, and Alison Stones. For iconography, Herbert Kessler, Gabrielle Spiegel, Philippe Buc, Elizabeth Brown, Nancy Regalado, and Robert Schneider. For Louis X, Loreen DePontee Boornazian. For the script and additions, Richard Rouse. For technical information, Adelaide Bennett, Carl Nordenfalk, Elisabeth Klemm, and Léon Gilissen. For historical research, Quentin Griffiths, Gabrielle Spiegel, Elizabeth Brown, William C. Jordan, Sarah Lipton, and Lester Little. For the history of the book, John Plummer, Anne van Buren, Caroline Bruzelius, and George Greenia. For musicological questions, Anna Maria Busse Berger, Rebecca Baltzer, Tilman Seebass, and Edward Roesner. For architecture, Jean Bony, Caroline Bruzelius, and Stephen Murray. For the Sainte-Chapelle, Alyce Jordan. Research assistants were Victoria Morse, William C. North, Amanda Hingst, and Kathleen Stewart.

For myself, I also want to thank Harvey's family, Helen Rosenberg, Sid and Susan Stahl, and Don and Elaine Stahl, for helping with photography orders and permissions and for their devoted support for completing the book. For clarifying many issues and helping me bring this book to a publishable state, I am deeply grateful as well to Keith Monley, manuscript editor extraordinaire, without whom this book would lack the academic integrity his careful eye and meticulous research provided. To any I may have missed whom Harvey meant to thank, my apologies for the oversight.

Melissa Moss
Berkeley, California
2007

Picturing Kingship

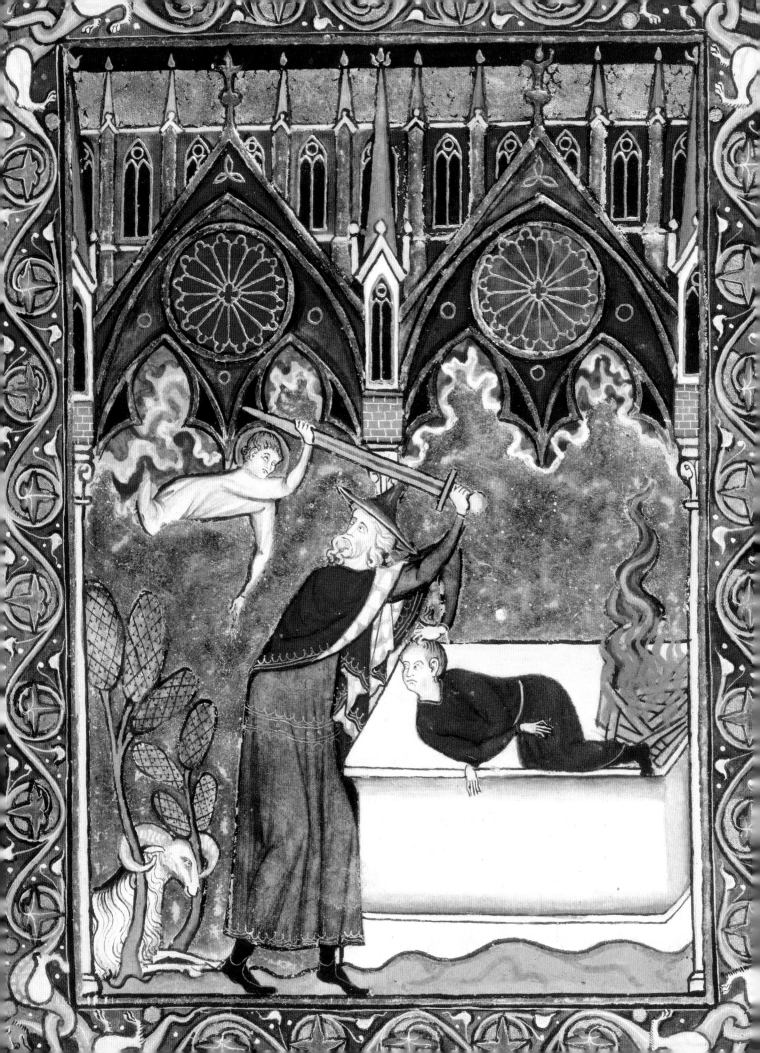

Introduction:
The Manuscript and Its History

In the mid-1260s an extensively illuminated psalter was made for Louis IX of France (Paris, Bibl. Nat., MS lat. 10525). Illuminated psalters, like books of hours, are often highly revealing documents, for few other works similarly bring historical and artistic issues to bear within the devotional experience of a single layperson. Private in use and frequently intimate in character, their content and decoration often reflect the religious and aesthetic preferences and, in some cases, the circumstances and self-image of the owner. This would have been the case especially for a wealthy person, whose prayer book may have been a specially commissioned work and who could therefore influence, directly or through advisors, the textual and visual content of the product. Among such works, a royal psalter is of particular interest, for if the king were devout, the manuscript might well have been an object of daily use, part of the physical culture surrounding the monarch and, in the case of an extensively illustrated work, a source of the imagery that informed his world.

A royal psalter is also exceptional because David was understood to be both the author of the Psalms and the prototype of all Christian kings, and so the words and imagery of the psalter might well seem to address the reader directly. Moreover, the visual imagery and ideological content of such a manuscript were not necessarily those of the monarch's more public works or, for that matter, those of the Church. Although usually traditional and flattering, its message to the regent could also be moralizing or instructional, tempered with private meaning, its content privileged, and not

Detail of folio 10r, Psalter of Saint Louis

always welcome.[1] What kings read and contemplated is always of interest but never more so than when the message concerns the relation not only between God and man but between the man and his office.

Those relations are built into the form and content of the Psalter of Saint Louis. The manuscript is his most personal possession to survive and the first prayer book of a French king to be preserved since the Carolingian era. Often reproduced, it is a work frequently used to exemplify the character and quality of royal patronage at a time when Paris first became the political, intellectual, and cultural leader of Europe. It is also well known because of the almost mythical stature that Louis IX acquired in the Middle Ages and retained for several centuries. He superintended one of the most expansive periods of the French monarchy and was the first and only French king to be canonized. Several later generations took him to embody the sacral nature of French kingship and the personal virtues requisite for success in office and treated his Psalter as a kind of relic and unofficial symbol of state.[2]

The historical king and his manuscript are not easily interpreted.[3] The king's profound piety and high ethical standards were no doubt a source of his strength and authority, informing his policies and judgment and his very real success as a reformer, mediator, and international leader. But his overarching sense of religious mission at home and abroad could also lead to decisions that were impractical, intolerant, and shortsighted, to misunderstandings about his duties and preferences, and to doubts about the priorities driving policy and strategy. He was a man who was self-conscious of his historical role and sometimes uncertain of his own performance and anxious about his legacy. In its own way, his prayer book is as complex as the man himself. It is not just a luxury manuscript that epitomizes the excellence that only the Crown could afford but an unpredictable and inconstant work, searching, often intemperate, and experimental in its vision. Its unusual pictorial program is politically charged but oddly openended, personalized for this singular reader and delivering a message that might have been difficult to present to the king in some other way. It is a work that provides the modern reader a privileged access to subjects of study that intersect nowhere else: the role the visual played in the private life of a king in whose reign the visual arts flourished; the shaping of devotion in the experience of a man whose piety was legendary; and the fictions of history, duty, and kingship created for a ruler who transformed the French monarchy and was idealized as its most Christian king.

The Psalter of Saint Louis is a small manuscript in octavo preserved in the Bibliothèque nationale in Paris (lat. 10525). It begins with seventy-eight full-page miniatures depicting episodes from the Old Testament.[4] Following the pictorial cycle is a liturgical calendar, and this in turn introduces the 150 psalms of David, the principal text of the book, which is followed by a short series of concluding canticles and hymns. Eight large historiated initials mark the major divisions of the psalms, and initials and line-endings, mainly in blue and gold, decorate the entire Psalter text.

The connection of this manuscript with Louis IX is circumstantial but has never been doubted. The calendar includes obits commemorating the deaths of the king's father, Louis VIII; his grandfather Philip II Augustus; his mother, Blanche of Castile; and his brother Robert of Artois. The backgrounds of four of the eight major psalm initials are decorated with heraldic emblems: the fleurs-de-lis of the king, the castles of Castile of his mother, and the pales of Provence of his wife, Margaret of Provence. The same arms occur in line-endings throughout the manuscript. Its liturgical calendar is Parisian and for use in the royal chapels; feasts related to the Sainte-Chapelle are particularly prominent. The same calendar and heraldry are found in a contemporary manuscript in the Fitzwilliam Museum in Cambridge, to be discussed below, but the feminine endings of some of its prayers indicate it was intended for a woman, probably either the king's sister or daughter, who were each named Isabella.[5] The Bibliothèque nationale manuscript, however, could not have made for any of the king's siblings, who were unable to carry the arms of Provence, and its obit for Robert of Artois makes it quite unlikely the manuscript was made for any of the king's children, such as the future Philip III, who was only four years old when his uncle died.[6] The only real possibility is Louis IX himself, an attribution that the program and details of the Psalter amply sustain.

No documents pertaining to the commission of the Psalter survive, and so the date and circumstances of its creation can be inferred only from internal evidence.

Because the calendar includes the feast of Peter of Verona, the manuscript must postdate his canonization in 1253 and the king's return from his first Crusade, in 1254.[7] A date after 1258 is also likely, for several line-endings include the arms of Champagne and of Navarre, in all likelihood a reference to Thibaut V of Champagne-Navarre, whom the king's daughter Isabella married in that year.[8] However, the manuscript was probably created almost ten years later, for its most advanced decoration reflects some of the most precocious currents in Parisian art of the 1260s. Other psalters were no doubt available to the king, and it is unclear why he needed a new one. Whatever occasioned its creation, the Psalter was made in a period marked by the king's deepening piety and concern about the public representation of the kingdom and his own legacy. It was probably planned in the first years of the 1260s, along with the manuscript in Cambridge. In this study I argue that in the end it responds to concepts of kingship and anxieties about legacy that are characteristic of the final years of the king's reign and that were especially in play as he departed for his second and ultimately fatal Crusade. This response, timely though unexpected in this context, may well explain why the book took on the final and unusual form it has today.

. . .

The Psalter is a small manuscript, measuring only about eight by six inches. Now bound in dark blue velvet, it originally had wooden covers and was probably held closed by leather straps with clasps.[9] It is a substantial object, almost three inches deep and weighing nearly three pounds, a book small enough to hold in one hand yet too heavy to handle casually or to open without support. Let us imaginatively take this book in hand and try to understand how it presents itself for viewing.

The modern cover and flyleaves are turned to reveal a page of thin vellum almost pure ivory in color. It is blank except for one sentence written near the top (fol. 1r), which begins *En ceste page est comment* . . . ("On this page is how . . .") and goes on to describe the Sacrifices of Cain and Abel,[10] the subject of the painting on the other side of the page. It is an odd way to begin a book: a page that identifies an image on its reverse, a label for an unseen painting, a backside.

Turning the page reveals two facing pages, each with illuminations that are so generous in their use of gold

they seem almost gilded (fols. 1v–2r). The illuminations are small, only about 5 by 3½ inches, and rather than centered on the page, they are placed toward the upper and inner part of the page, so that they face each other like the panels of a diptych. Each has a broad frame edged in gold and decorated with undulant vines; bounded by the frame is an elaborate architectural structure above and a narrative subject below. The left page depicts the event the legend describes: Abel kneels at the left of a hillock and lifts up a yearling, as the hand of God descends to bless his offering. Cain stands tall on the other side of the hillock and holds out a sheaf of wheat but turns away, as the flames from his kindling turn downward. The pictorial program thus begins with two acts of devotion, with figures of piety and irreverence, and with the acceptance and rejection of their offerings.

The architectural setting is a multilevel structure. Thin colonnettes rest on the lower frame and rise at the center and sides of the narrative scene, continuing up to support pinnacles with towers that just touch the upper frame. Between and behind these pinnacles rise two high broad gables, each with a large rose window over two pointed arches. Behind and above the gables is the flank of a contemporary Gothic building, with its high buttresses, clerestory windows, and roof. This structure is reiterated on the facing page (fol. 2r), where the narrative continues with the Murder of Abel. The legend for this page is on its reverse (fol. 2v), which in turn faces a folio (fol. 3r) with only the legend to the next painting. This arrangement of facing pages of illuminations alternating with facing pages of legends continues for another seventy-five folios. The system is clear: pictures face each other and form a unit, their legends are on their reverses, and the architectural and narrative elements that link each pair of facing pages are taken up again in the next pair. Viewing is a matter not just of turning pages but of opening and closing, one by one, the units of pictures.

The pictorial world within the illuminations is carefully organized. Cloud banks in the arcade separate it from the architectural structure above, and a central colonnette usually divides the narrative zone in two, the narrow fields on each side having the same proportion as the figures themselves. Although small in real height, the figures are large and distinct in relation to the densely patterned forms of the architecture and frame.

Some figures and forms push out to the foreground, while others lie in a shallow but discrete space implied by the layering of architectural planes above, the overlapping of figures, the geometric shapes that project forward and back, and the repoussoir effect of the outer frame. The frame overlaps everything within it, cutting off the architectural forms, the narrative objects, the figures and actions, which seem to continue behind it.

The scenes are usually crowded with figures, often arranged in facing groups with repetitive movements. Yet the compositions are anything but rigid. The gables and arcades compose and accent the figures and the space beneath them. Figures tend to glide, swing, and turn; groupings vary and play off against each other; and silhouettes and contours often repeat or build into encompassing shapes or rhythmic movements. In the end it is a space of fluid forms, undulant lines, and varying cadence, one that quickens the narrative, swells and concentrates space, and mobilizes the eye.

The frame and architecture form a casement and portal through which one is drawn into a diminutive world and absorbed into its scale and into its stories and situations. Although many figures have dancelike or exaggerated movements, other figures have intense gestures and hands and heads that determinedly touch, listen, and see. The compositions may be quick and their elements hypercharged and overrefined, but at the scale in which the narrative operates, details suggest intentional action, social exchange, nuanced behavior, and differentiated responses of the senses to the physical world.

These stories are unusually lit. The palette is built around a vibrant play of warm blue and light salmon, the latter applied as a thin wash over the white vellum surface, which lightens the color from beneath. Many figures are strongly modeled, with contrasting shadows and white reflections. And still others are so thinly painted that forms seem to exist within the ambient tones of colored wash. Gold, one of the most striking features of these paintings, is applied as leaf or as a liquid emulsion to the background of the biblical scenes, to the architectural elements, especially the gables, tracery, and buttresses, and to the decorative motifs of the frames. The metallic and reflective qualities of gold are normally at odds with painting, but in many of these paintings the tone of the gold varies as the luminous qualities of the two other colors are brought up, so that

all three work together. Technique and palette, usually organized around distinctions that maximize legibility, here reach for the most precarious balance of tone, reflection, and light. Biblical history seems built up of momentary effects.

These histories are viewed frontally, from a stationary point looking into the frame, but the histories are by nature fragmented, both internally, by the architectural forms and scenic divisions, and externally, by the divisions across the gutter of the page and the stops and starts from one double-page opening to the next. Against this fragmentation are the measured, stable, and constantly reiterated forms of the Gothic building, the scale and detail of which suggests a religious structure. It becomes a continuous housing, a form that extends laterally in both directions, with no beginning or end. The viewer follows alongside as pages are turned, the forms cut off by the frame of one picture seeming to reappear in that of the next one.

The first dozen or so paintings present a highly abridged account of the stories of Abel, Noah, and the patriarchs. The illuminations devoted to Joseph, Moses, Joshua, Gideon, Samson, and Saul are more expansive, their lives forming a series of brief histories. Some well-known events, such as the Plagues of Egypt, are summarized in only one picture; unusual histories, such as that of the Benjaminites, receive several; and numerous chapters, especially those concerning genealogy and law, are omitted altogether. Scenes of election, victory, and worship are frequent and thematically link the several narratives together into a larger history of the Hebrews: their becoming a people, their devotion, their leaders, and, finally, their kings.

The series of illuminations ends on folio 78r with Saul, who, having just been crowned and made the first king of Israel, strides forward, just as Samuel offers a sacrifice of thanksgiving. After this image of kingship and devotion and after the French legend accompanying it, the Latin texts begin, first the liturgical calendar and then the Psalms. Psalm 1 is introduced with a full-page illuminated initial *B* representing David, first in his castle, watching as Bathsheba is washed beside a stream, and then, below, at the edge of a rock and against a field of fleurs-de-lis, kneeling in prayer before Christ in a mandorla. The Psalms thus begin with acts of devotion and prayer, just as the introductory miniatures begin and end.

The transition from the miniatures to the text on the following pages is effortless, for the architectural layout of the paintings is in many ways continued in the design of the text pages: in the lining of the text column, the blocking of the margins, and the proportion and spacing of the script. The balance of tone and color that characterizes the full-page paintings finds its counterpart in the relation between the black script, white vellum, and blue and gold initials. That is, the pictorial values built into this book neither begin nor end with its pictures, just as the devotional themes neither begin nor end with its texts of the Psalms.

. . .

After Louis IX's death, his Psalter remained in the royal collections for six generations. The manuscript is not cited in his will, but the king left such personal possessions to his son Philip III, in contrast to his theological books, which he gave to Dominican and Franciscan foundations.[11] The subsequent history of the manuscript can be reconstructed from a text still found on the verso of the Psalter's flyleaf. Written in red ink in a good fifteenth-century book hand, it still faces the page with the legend to the Cain and Abel miniature and is placed in approximately the same position on the page (fig. 1): "Cest psautier fu saint Loys. Et le don[n]a la royne Jehanne d'Évreux au roy Charles filz du roy Jehan, l'an de n[ost]re S[eigneur] mil troys cens soissante et nuef. Et le roy Charles p[rese]nt filz dudit roy Charles le donna a Madame Marie de Fra[n]ce sa fille religieuse a Poyssi. Le jour saint Michel, l'an mil iiiic. . . ." The text explains that Jeanne d'Évreux, the wife of Charles IV, Louis IX's great-grandson, gave the Psalter in 1369 to his son Charles V, and that the latter's son, Charles VI, gave it to his daughter, Marie de France, who was then a religious at the priory of Poissy. It is thus likely that the Psalter remained in the royal family, passed down from one regent to another until it reached Charles IV, the last of the Capetian line. He would have given it to Jeanne d'Évreux sometime between their marriage, in 1325, and his death, in 1328. She then kept the manuscript during the entire reigns of Philippe le Valois and Jean le Bon, leaving it to Charles V only in 1369, two years before her death. It is unclear when Charles VI gave the Psalter to Marie or when this folio was added to the book. The date at the end of the text is largely rubbed away, but because it refers to Charles as the pres-

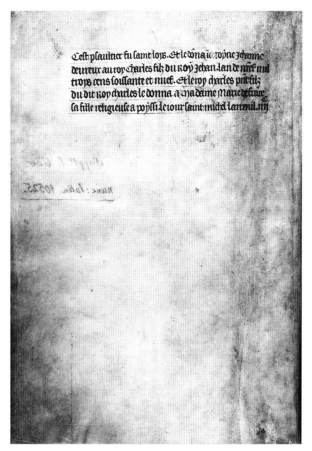

FIG. 1 *Paris, Bibliothèque nationale de France, MS lat. 10525, Psalter of Saint Louis, fol. Av: explanation of provenance.*

ent king and to Marie as a religious at Poissy, it must have been written between 1408, when Marie took the veil there, and Charles VI's death, in 1422. However, Marie could have obtained the manuscript much earlier, for her father began to loan and give away manuscripts from the royal library almost immediately after he came to the throne.[12]

The details of the inscription are supported by two documents. The first, the inventory made in 1380 at the death of Charles V, describes the manuscript in precise terms and lists it in the study of the king at Vincennes, that is, in his personal library.[13] It is described as having clasps decorated with enamels bearing the arms of France and Évreux, suggesting that Jeanne d'Évreux not only owned the Psalter but altered its binding. The second is the inventory made in 1484 at the death of Charlotte of Savoy. It cites the manuscript as that of Saint

Louis and explains that the deceased borrowed it from a woman at Poissy and that it must be returned.[14]

The manuscript is in nearly pristine condition. The feasts and obits in the calendar were never updated or the prayers changed, although Louis's own feast was added to the calendar, probably during the reign of Philippe le Bel, who actively promoted his grandfather's canonization.[15] For its later owners the manuscript evidently took on a new function as an object of the cult of Saint Louis, which was particularly strong within the royal family before and after his canonization, in 1297. In fact, the manuscript's history in these years closely parallels the way other objects associated with Saint Louis were collected, preserved, and handed down within royal collections. The first owner of record—Jeanne d'Évreux—was especially devoted to Saint Louis. She possessed at least three other objects connected with him and, as noted above, kept his Psalter for over forty years.[16] Toward the end of her life she gave both the king's Psalter and some of his relics to Charles V, who seems to have owned other reliquaries and objects connected with Saint Louis,[17] works he presumably passed on to his son, the unpredictable Charles VI. The latter was apparently just as willing to part with saint's relics as he was with the books in his own father's library.[18] Fortunately, his daughter Marie was interested in both.[19]

The status of the manuscript as a cult object is also suggested by the details of the text on the flyleaf. Most inscriptions of ownership simply record a name and sometimes a date and identify the text. This one is concerned to name the manuscript as Saint Louis's and to identify certain critical stages of its provenance. By beginning with Jeanne d'Évreux's gift to Charles V, it effectively describes how the book came into Valois hands, and by ending with the gift of the manuscript to Marie, it explains how the book left the royal library and was transferred to Poissy.[20] This change in location was probably the reason for the insertion of the leaf; it suggests that the Psalter, like a relic, had to be authenticated on the occasion of its *translatio*. Poissy was the place of Louis IX's birth, and at the time of its transfer, the Dominican priory there was the center of his cult. To contemporaries at Poissy, the inscription may well have implied the history by which the Psalter was returned to the king.

The transfer of the Psalter to Poissy was timely, for the Valois kings soon left Paris and the royal library was dispersed. The Psalter remained there more or less continuously until the dissolution of the convent in 1793, when many of its books were acquired by collectors and dealers.[21] The history of the Psalter is next discussed in print by the English bibliophile Thomas Dibdin, who was in Paris in 1818 and later published an account of his travels.[22] He saw the manuscript at the Bibliothèque impériale and described its wooden covers wrapped in red velvet and the "original, pure tint" of its parchment, a feature of the manuscript that is still striking. In an important aside Dibdin relates that a Paris bookman named Chardin had bought the book after the dissolution of Poissy and had sold it to a "Russian gentleman" about twenty-five years earlier. It is very likely that Chardin himself was the source of this information, for he was an important dealer whom Dibdin knew personally and who figures prominently in Dibdin's chapter on the Paris book trade.[23]

The Russian gentleman was Count Alexis Golovkin, for the manuscript next appears in the catalogue of his Moscow collection published in 1798.[24] The catalogue shows that Golovkin had purchased fine illuminated manuscripts and incunabula in the Paris market, especially during the previous twenty years.[25] The Psalter is not listed with his other books but with eighteen items in a supplement appended to the catalogue. The most recently published book in the main section of the catalogue appeared only in 1797, the previous year, while those in the supplement are primarily works that were rebound and probably recently acquired.[26] The entry for the Psalter of Saint Louis paraphrases the fourteenth-century inscription on the flyleaf and then adds that the manuscript remained at Poissy and was sold because of the "circumstances" of the Revolution. This latter explanation was probably intended to show why it had not figured in the main catalogue, and it suggests that Golovkin was one of the first, if the not *the* first, owner of the Psalter after the Revolution.[27]

Golovkin sold the Psalter by 1811, for it does not figure in a second catalogue of his collection, published in that year.[28] It is likely that it passed directly to Mikhail Petrovich Golitzyn, a bibliophile with the rank of equerry to Alexander I, emperor of Russia.[29] The Psalter next appears in Golitzyn's catalogue of 1816, along with other fine books described in Golovkin's earlier catalogue.[30] Sometime in the next two years the French

ambassador to Saint Petersburg, the count of Noailles, obtained the manuscript from Golitzyn and on August 20, 1818, just a few days before the feast of Saint Louis, presented it to Louis XVIII.[31]

The timing of the Psalter's repatriation could hardly have been more fortuitous. Louis IX was one of the four kings most frequently employed in the Restoration's public representations of royalty, the king who represented sanctity.[32] An image of Saint Louis had been placed over Louis XVIII's dais in the choir of Notre-Dame during the ceremonies marking his triumphal entry into Paris.[33] And in 1818 the feast of the saint—the king's namesake—was a major public celebration, with parades, speeches, balls, fireworks, and, as the main event, the unveiling of the new equestrian statue of Henri IV. The symbolic meaning of the day was carefully prepared and explicated in the official press. The schedule of festivities had been announced on August 20. A notice published on August 21 reported that the count of Noailles presented the Psalter to the king on the previous day, even though there is evidence that the manuscript had been in the Bibliothèque impériale at least since the previous June.[34] The king received the Psalter in a private audience not listed in the calendar of the king's activities for the previous day but in the report of domestic and Parisian news. It described how the count had the honor "de remettre au Roi" the Psalter and placed it "dans les mains des augustes descendants de Saint Louis." Immediately following was a note on how, before an immense crowd, the equestrian statue of Henri IV was successfully set upon its pedestal. To erase any doubt about the symbolism of these two works, an article appeared the next day entitled "Saint Louis–Henri IV–Louis XVIII."[35] Here the official press made explicit the links between the two Louis and the renewal of continuity between past and present that the festivities on the next day were to celebrate. There is no evidence that the Psalter was used in any official context during the elaborate celebration on the next day. It is nevertheless clear that these official announcements were well orchestrated. The highly charged language of the August 21 notice of the repatriation of the Psalter, coming as it did when the planning of festivities was in full swing, makes it seem as though the saint signaled his approval, returning his prayer book to his native land and to his rightful successor in time for his own feast day. Even if it figured only as an announcement in the daily press, the manuscript

functioned, as it did in the thirteenth century, to suggest the sacral origins of French kingship and the operation of providence in history.

Soon after these ceremonies, the Psalter was deposited in the Bibliothèque nationale and accessioned under the number Supplement Latin 636. It remained at the library until 1852, when it was removed for extended loan to the Musée des souverains, a museum created within the Louvre by Louis-Napoléon in order to reunite objects having belonged to the rulers of France.[36] There the Psalter figured within the overarching presentation of regalia, manuscripts, documents, seals, jewelry, armor, and textiles organized dynastically and extending from the Merovingian era to that of Napoléon I. In the exhibition the king's sanctity was no longer an issue, for all of the objects were "consecrated by royal usage."[37] Thus the penultimate home of a manuscript in which the historical construction of French kingship figures so importantly was a museum that reinterpreted that construction for a modern audience. Effectively, the Psalter had become an extension of its own narrative. It was not an inappropriate role, for that narrative, as I will show, is also about the reclamation of the past and its claims for the future. In this case, however, the future was particularly short-lived, for the Musée des souverains hardly outlasted the Second Empire. In 1872, two years after Louis-Napoléon was deposed, the manuscript was definitively returned to the Bibliothèque nationale, where it had been reserved and assigned its present number: *manuscrit latin 10525*.[38]

After Dibdin, no published account of the Psalter appears for sixty years, but the manuscript twice served as a model for artists decorating works associated with Saint Louis. In 1840 parts of three miniatures, selected primarily for their variety of dress, were combined to form the frontispiece to the volume of the *Recueil des historiens des Gaules et de la France* devoted to Saint Louis.[39] In contrast to this documentary function, the Psalter was used as a model book by the painters restoring the Sainte-Chapelle, first, from 1843, as a source of decorative motifs, then, by 1850, for figure studies and possibly costumes.[40] In 1862 Louis Steinheil used the Psalter to provide the six subjects for his frescoes in the two tympana of the inner west wall of the Sainte-Chapelle. In the two upper registers he juxtaposed scenes with liturgical connections—the Brazen Serpent and Abraham

and Melchizedek—and in the lower registers he copied four scenes of sacrifice, those of Cain and Abel, Abraham, Moses, and Samuel.[41] While all of these subjects are types for Christ's sacrifice, Steinheil seems to have gone out of his way to select miniatures from the major narratives as well as the first and last miniatures of the manuscript, effectively citing the king's Psalter in the redecoration of his chapel. And in his stress on the liturgical and sacrificial rather than scenes of anointment, rule, or victory, he responded to one of the basic themes in the introductory cycle as well as to a fundamental aspect of its narrative structure. In these terms, Steinheil's paintings represent the first real interpretative study of the Psalter.

· · ·

Several of the Psalter's miniatures were published as early as 1865, and the first modern description of its contents appeared the following year in Henri Barbet de Jouy's catalogue of the Musée des souverains.[42] Since then, the illuminations of the Psalter have been reproduced twice in their entirety and discussed in literally hundreds of publications.[43] The early literature is rich in critical observations and often precocious in its formulation of interpretative issues. For example, in 1884 Albert Lecoy de la Marche distinguished the symbolic content of the imagery of earlier manuscripts from the larger perspective of history and chronicles found in the Psalter cycle; and in 1893 Léopold Delisle discussed the vogue of picture cycles in such thirteenth-century manuscripts as the Psalter in terms of the expanded role of pictures in lay devotion.[44] But what is of particular interest is how this literature shaped many of the questions that are still central to the interpretation of the manuscript: how is one to understand the complex formal language of these paintings, their often problematic legibility, their technical achievement, their apparent isolation from contemporary works, and the social and cultural values they embody; and what are the implications of the Psalter for our understanding of royal patronage, Capetian ideology, and the circumstances of the king?

The critical study of the Psalter has largely occurred in two periods, the first in the decade around 1900 and the second from the late 1960s on. Study began at the turn of the last century with the discovery of what is still the single most important piece of external evidence to come to light: a sister manuscript, the so-called Isabella

Psalter in the Fitzwilliam Museum in Cambridge.[45] Two studies set the terms of discussion. The first was Arthur Haseloff's article of 1899, when the Isabella Psalter was in the collection of John Ruskin at Brantwood, and the second was Sydney C. Cockerell's book of 1905, after the manuscript had been acquired by Henry Yates Thompson.[46] Comparing the two works, Haseloff described the similarities in size, page layout, and decoration as well as in the text of the calendars and in the iconography of the psalm initials. He also called attention to the resemblance between the style of the Isabella miniatures and folios 25v–28r in the Saint Louis Psalter. This similarity also struck Cockerell, who found additional parallels in the script and in the motifs decorating the frames of the two manuscripts. In spite of these relationships, both writers were careful to distinguish the two works: Haseloff emphasized the softer, more supple, and better proportioned figures in the Isabella Psalter, and Cockerell found the Saint Louis Psalter to be less carefully copied but its figures thinner yet stylistically more advanced and its decoration more elaborate. Where Haseloff thought the two works might reflect different artists or different schools, Cockerell called the two manuscripts "twins" and argued that they were written and decorated in the same shop at approximately the same time, the king's manuscript slightly later. Both writers cited contemporary French manuscripts, particularly the Sainte-Chapelle evangeliaries, but neither could point to other manuscripts produced by the same artists or shop.[47] For later writers too, the context of production and the relation of the two manuscripts to each other and to other works remain at issue.[48]

Haseloff's study was followed by several publications and exhibitions that made the Psalter accessible to scholars and the public.[49] Although these uncovered no new evidence, their definition of the visual character of the work laid down the principal lines of discussion for the next sixty years. Of these, no study was more influential than Haseloff's own essay on French manuscript painting that appeared in 1906 in André Michel's *Histoire de l'art*.[50] Haseloff believed that in contrast to manuscript painting in the first half of the thirteenth century, when stained glass strongly influenced painting, the works of the last twenty years of Louis IX's reign showed the influence of architecture and sculpture, especially in ornament and framing devices and in a new realism and richness of

detail. He stressed the development of a finer and more precise drawing and a fundamental change in palette to more transparent and luminous tones and nuanced accents. But what struck him the most were the movements of the Old Testament figures, in whose manners he saw the realization of an ideal of beauty. No later writer took up his insights into the importance of transparency and movement, but many accepted and reasserted a number of his other ideas: the influence of contemporary architecture and sculpture upon painting; a fundamental change in drawing and palette; and a new social and aesthetic ideal evidenced in the Psalter's interest in realistic detail, in elegance and facility, and in actions that, for Haseloff, expressed a lighthearted optimism characteristic of the epoch.

An insightful and in some ways more problematic vision of this painting emerged only one year later in Georg Vitzthum's book on early Gothic manuscript painting.[51] The principal parallels to the Psalter he cited were in monumental sculpture, especially in the south transept portal at Notre-Dame in Paris and the west façade sculpture at Auxerre, where he saw not only the similar framing devices and decorative motifs Haseloff had cited but a similar conception of figures. Like Haseloff, he stressed the essentially small scale and pictorial nature of the work but described the overall effect in more dynamic terms, stressing its delicacy and lightness but also the unifying authority and materiality of its color, its sometimes sharp and incessantly changing motifs, and its seemingly endless richness of form. In contrast to the idealized language and social meaning that Haseloff saw in these miniatures, Vitzthum emphasized the expressive and sometimes contradictory aspects of its paintings.

Although the Psalter figured in important catalogues and surveys of Gothic painting during the next fifty years, interests began to shift after World War II from the Psalter itself to the manuscript as evidence of the king's patronage.[52] This had already been a factor for Vitzthum, who stressed the symbolic importance of Louis IX and of Paris as a great artistic center. In 1946 Paul Deschamps raised the question of the extent to which Louis IX personally influenced the evolution of French art.[53] In the end he pointed only to the prestige and ardor of the king, but Jacques Dupont, writing in the Skira survey of Gothic painting, emphasized Louis's

personal role, and Jean Porcher, both in the catalogue of the important 1955 exhibition of French Gothic manuscripts and in his general survey published a few years later, asserted that French Gothic painting found its origins in the king's patronage.[54] Porcher also believed that the structure of the upper part of the full-page miniatures reproduced the Sainte-Chapelle and probably reflected the personal influence of Pierre de Montreuil, whom many then believed to be the king's architect.[55] Although Porcher did not make detailed comparisons to architectural elements, his remarks were typical of the desire to see Parisian art of the mid–thirteenth century as an interrelated phenomenon centering on the patronage of the king.

The concept of royal patronage stimulating and promoting a distinct style in Parisian art found its most far-reaching statement in 1965 in Robert Branner's *St. Louis and the Court Style in Gothic Architecture*, a book that influenced the study of French thirteenth-century art in every medium. Branner used documentary sources to describe an extensive program of construction undertaken by the Crown and presumably directed by royal architects. Although many of these works are lost, he used preserved buildings, such as Royaumont, the Sainte-Chapelle, and the Virgin Chapel at Saint-Germer-de-Fly, to describe a set of formal characteristics evolving in royal foundations. Many of these characteristics—especially those pertaining to movement, surface effect, and dissolution of mass—are equally applicable to paintings.[56] Branner recognized the influence of nonroyal works but nonetheless argued that the court was the major force in the development of a distinctive style. He characterized this style as having found its early inspiration in buildings in the nearby provinces, taking root in the capital in the 1240s, especially with the construction of the Sainte-Chapelle, and developing into a genuine "court style" after Louis IX's return from his first Crusade, in 1254. The phenomenon was clear even at the time, he explained, for contemporary accounts and imitations of these buildings testify to the prestige of the capital, the saintly king, and his distinctive architecture. Branner's introduction of the term "court style" seemed to account for the consistency, quality, and influence of much of French art from the 1250s. But it also anchored the phenomenon in the king, and by emphasizing the contemporary perception of

French art, the king remained a factor even when patronage was not royal.[57]

In the years following the publication of Branner's book, the concept of a "court style" was extended well beyond the king and the innovations in his buildings. Louis IX and the people around him were presumed to be at the center of a new Parisian art characterized by luxury materials, fine craftsmanship, and elegantly proportioned figures with gracious movements and refined manners. With Parisian art so widely imitated, it was not long before almost any work of high quality could be described as made in the "court style."[58] At the same time, the term gradually became a social explanation for the aristocratic character of the works. However, the "court" was never really analyzed in terms of the individuals around the king, who were mostly churchmen, high-level administrators, and barons whose power and influence usually centered in the provinces.[59] Nor was the "court" defined in terms of a code of behavior, a culture of competing allegiances, a system of social and aesthetic values, forms of patronage, or an economics of production and exchange.[60] In the end, the patronage of the "court" substituted for that of the king, who supposedly stood at its center. This explanation of the Psalter's style never seemed farther from the personality of Louis, a man whom contemporaries described as dressing and behaving more like a friar than the king of France.[61]

It is not surprising that the king's own Psalter, a manuscript *de grand luxe,* seems to stand for the "court style" better than any other work and connects the interpretation of style more closely to the taste of the monarch himself. In the Psalter, however, that style would seem to be pushed to its limit.[62] The resulting contradictions have not gone unnoticed, for alongside the fine drawing and selective realism cited by earlier writers are features that strike recent authors as overstudied, artificial, and idiosyncratic. The problematic character of the painting, already noted by Vitzthum, reappears in François Avril's characterization of the art as tiny and fragile, its figures graceful but affected.[63] Using stronger language, Branner described the figures as elongated and thin, with awkward and uncomfortable postures, with snakelike and rubbery arms and piercing eyes. Elsewhere he characterized the style as one of "irrational, elegant mannerism."[64] If the manuscript embodies a "court style," then social self-referentiality is hardly surprising, and the luxury of the book would seem appropriate for an object that is in part a religious offering. But if these mannerisms do indeed result in aberrant figures, abstruse narrative, and hypertrophic settings, then they threaten to undermine the legibility of the miniatures and to imply that the content of the paintings is secondary to their refinement and that their meaning is less important than the self-reflexive delight the viewer takes in their overstated richness and "beauty."

Could the formal language of the paintings in the king's prayer book undermine their content? This seems inherently unlikely, given the king's profound piety, his familiarity with theology, his attachment to moral lessons, and the clarity and rationality that mark the sermons he heard and the treatises written for him and the ones that he himself wrote.[65] Charles Sterling seems to have sensed this problem in his survey of medieval painting in Paris, for his discussion of the Psalter includes a cautionary note warning that such terms as "mannerism" veil the real vitality, moral strength, and behavioral ideals of the art at this time.[66] More than any writer since Haseloff, Sterling tries to show how the style of the paintings match their content and high purpose.

In the last ten years of his life Branner turned to manuscript painting and wrote a series of groundbreaking articles that culminated in 1977 in his posthumously published monograph, *Manuscript Painting in Paris During the Reign of Saint Louis.* In these works he very differently characterized royal patronage and the conditions of production.[67] If he had previously argued for the court's having stimulated a distinct style that evolved in a series of royal buildings of high quality, he now saw the court as one of several factors affecting a market that produced illuminated manuscripts of variable quality for a range of clients and purposes. As in architecture, he noted the trend toward increasing elegance and refinement and the formulation of a more consistent approach after Louis IX's return from his first Crusade. But he tied the development in manuscript painting to royal patronage only in the most general terms, concluding instead that a complex milieu of nobility, churchmen, and academics was responsible for the change in style.

He had several reasons for taking this different approach. First, in contrast to Delisle, he found no evidence, aside from theological and didactic works, that Louis IX had a particular interest in books or that he col-

lected or owned more than any member of the nobility would have at that time.[68] Second, only two surviving and extensively illustrated manuscripts—the Isabella Psalter and the Psalter of Saint Louis—could be discussed with certainty as works produced expressly for the royal family. Third, he found no equivalent in manuscript production to the royal architect or master of the king's works, nor did he find evidence of royal ateliers. When the Crown wanted a manuscript, he believed, it used agents who patronized any of several paint shops, so that painting, even when found in works probably made for the nobility, is unusually diverse in style and quality.[69] Finally, in a study that identified nearly twenty styles or shops of illuminators working in Paris, Branner, like earlier writers, was able to cite no other manuscripts in which any of the Psalter or Cambridge artists painted. In the end, the two royal books appeared to stand apart from the Parisian painting they are usually said to epitomize.

Branner made numerous important observations about the arrangement of quires in the book, the painters of the miniatures, and the shops where they were worked, all of which is reviewed in the following chapters. But perhaps nothing has more far-reaching implications for our understanding of the Psalter than the way he viewed it in terms of the professionalization of manuscript production in thirteenth-century Paris. Like others, Branner described illuminators, scribes, parchmenters, and other professionals as playing separate roles in a collaborative enterprise coordinated either by a bookseller, or *librarius,* or by the scribe or illuminator. They effectively acted as a manuscript's producer, farming out responsibilities as necessary to different shops and generally orchestrating their work.[70]

Branner took this structure of production as the starting point for studying all Parisian manuscripts, including the Psalter. His analysis revealed six different artists working on the full-page miniatures, five on the borders, and four laying down gold and silver. He considered the border painters as specialists and believed one of them came from a different shop.[71] He noted the irregularities in collation and the frequent changes in hand and in decoration, interpreting them as indications of how the various artists had to learn to adapt to the style of the head of the atelier. These methods and conclusions fundamentally reshape earlier views of the book, its artists, its program, and its connection with its

patron. With several people and at least two paint shops collaborating on some single miniatures, the paintings become a corporate effort in which individual viewpoints are submerged or suppressed. Given the irregularities of gathering structure in the first half of the prefatory cycle, Branner believed that a plan was not in place from the outset and that the iconographic program developed only as work progressed. Even though the book is a royal commission and the king could presumably obtain anything he wanted, Branner presented the Psalter as being produced in the same way other books were: in a commercial book market keyed to collaboration, one that relied upon the entrepreneurial competence of middlemen and that brought together specialists who understood professional standards and who could follow an iconographic plan and adopt the generic language of the enterprise at hand. In this versatile and efficient system, what is inconstant or conventional is often offset by the quality of materials, the expert craftsmanship, and the elaborateness and spectacle of the finished work.[72]

If the notion of a court style effectively diffused the issue of patronage and seemed to sidestep the need to interpret form, then the structural irregularities in the manuscript and the mode of production raised questions about interpretation, about the intentionality of the program, and about the level or levels at which the paintings were given meaning. Oddly, the matter of the program had really never arisen, in part because of the assumption that miniatures were lost from both the beginning and the end of the introductory cycle.[73] It was not until 1988 that William Chester Jordan, in one of the most significant articles published on the Psalter, questioned these assumptions and made a case for the unity of the program and the relation of the whole project to the circumstances of the king.[74] Jordan's assessment of the Psalter is strongly informed by his earlier book, *Louis IX and the Challenge of the Crusade.* Although that book is not directly concerned with the king's patronage, it sets the stage for Jordan's later study by calling attention to the king's piety, to his many acts of public devotion, and to the expansive imagery of Christian kingship that, along with administrative reforms, characterized Louis IX's response to the failure of his first Crusade to the Holy Land.[75] The king's personalization of Christ's life, his idealization of his kingdom in terms of Christ's

imperium, and his undertaking a second Crusade underscore not only his willingness to employ a symbolic language in his own actions and in the imagery of state but the degree to which he understood himself and his reign in terms of biblical figures and metaphors. Jordan shows that Louis's policies, actions, and imagery went beyond usual medieval practices: they were penitentially motivated, profoundly internalized, and politically central to the last fifteen years of his reign.

In his article on the Psalter, Jordan calls attention to the lack of evidence that any paintings had been lost and proposes that the cycle be interpreted in terms of the internal coherence of the extant cycle. Nor does Jordan accept Branner's view that the work on the Psalter proceeded without plan. Pointing to details of color and architecture as well as to the structure of gatherings and the allocation of narrative histories, he describes the Psalter as having a clear program, one that develops a parallel between Louis IX and Old Testament figures, especially Joseph and Saul. Finding the Joseph story to be unusually lengthy and structurally central to the series of introductory miniatures, he argues that Joseph is the central figure of the cycle, possessing an importance he related to the frequent allusions to Joseph in later descriptions of Louis IX's failed Crusade and Egyptian captivity. Similarly, he notes that Saul, who is made king in the final miniature, was a figure of Christ and of the universal Church in Petrus Riga's *Aurora,* so that the depiction of Saul, however unusual as the culmination of a pictorial cycle, presents a normative view of the fulfillment of Christian history. He concludes that the Joseph story had a strong emotional relevance to Louis IX and that the overall cycle has "an affirmational quality that points irresistibly to a new Crusade."[76]

In a 1981 article the present author took a somewhat different approach to interpreting these miniatures.[77] The article called attention to the extensive cycles of Old Testament illustration that appeared during the reign of Louis IX, not only in the Psalter but also in the stained glass of the Sainte-Chapelle and in the Morgan Old Testament Picture Book, a manuscript illuminated about 1240–50.[78] Looking at the rare biblical subjects in these works and the early and sometimes exotic pictorial sources for them, I argued that they were used to create a vividly dramatic and enriched Old Testament narrative emphasizing the heroic deeds of leaders and kings. In

contrast to recent works in which Old Testament subjects function typologically, to show forerunners of Christ and models of kingship, these works reconstituted their subjects as a kind of chronicle that creates an implicit parallel between the Hebrew's conquest of the Holy Land and contemporary French attempts at its reconquest. The biblical cycles thus represent a new and essentially historiographical enterprise demonstrating both the continuity between biblical and French kingship and the proscriptive force of earlier events in the Holy Land on contemporary French expectations in the East.

These explanations assume that during the reign of Louis IX, like those of other kings and emperors, art was one medium for expressing an ideology of state and the ambitions of its leaders. There is much to suggest that this was the case. First, recent studies show that a coherent ideology of kingship emerged in the reign of Philip Augustus and was realized in that of Louis IX.[79] The ideas were those familiar from earlier medieval history, but they were restated and given a contemporary turn in laudatory texts, chronicles, didactic mirrors of kings, and official rituals, such as coronation or burial. They centered on the personal sanctity of the king, on dynastic continuity and legitimacy, and on the special role of France, guided by the providential mission of its king, as protector of the Church and leader among Christian nations. Much suggests that works of art engaged the same concerns. Indeed, recent years have seen a large-scale reevaluation of a number of works from this point of view, including certain portals and stained-glass windows at Chartres, the stained-glass program in the Sainte-Chapelle, a French Bible possibly made for the king in the Holy Land, the program of the inner west-wall sculpture at the cathedral of Reims, and the thirteenth-century tomb program at Saint-Denis.[80] The circumstances and contexts of these works vary greatly, since some were presumably made for the king's own use, while others were public works either donated by the Crown or addressed to it. However, all can be read as embodying this ideology, as affirming and glorifying French kingship, and as instructing the king.

But is every work to be taken at face value as a manifesto of state or lesson for the king? In a far-reaching study, certainly the most comprehensive treatment of Louis IX to date, Jacques Le Goff has questioned the role of the Crusades in the evolution of Louis's actions

and has reconsidered the elements constituting our understanding of his reign.[81] Le Goff sees Louis IX as a complex man whom we know not only through the varied interests of the extant documents concerning him but also through the ways religious idealism and fictions of kingship were built into his education, informed his behavior, and were ultimately fulfilled in his actions and self-presentation. His success lay in reconciling religious and political duties, in practicing both an ideal of kingship and a kind of *imitatio Christi,* and in ultimately realizing the kind of fiction of himself that he set out to create.[82] This politics of personal and national redemption results in a particularly complex construction of kingship and gives new urgency to the analysis of religious works of art that articulate a vision of state. One naturally wants to know if the programs and ideologies of these works are indeed as affirmational as they seem or if they might not mask a more complex situation, for the visual medium, with its special tropes and patterns of association, might well have provided a privileged field for addressing not only fictions of state but the tensions between duty and ambition that Le Goff describes. It makes it all the more urgent to know whether the Psalter merely presents a familiar biblical ideal or was one of the instruments by which Louis saw himself, and whether it speaks to the king in the language of contemporary accounts or in a distinctly different voice.

. . .

In order to get this study of the king's prayer book and its pictures under way, several preliminary subjects relating to psalters generally require some introduction. These have to do with the devotional practices of the king, the currency of psalters in the royal family, the place of illuminated manuscripts within royal patronage, and the evidence that the king was a knowledgeable viewer of pictures.

The psalter is a prayer book used in the Divine Office, the continual round of daily devotions that, unlike the communal ritual of the Mass, is private and centers upon the recitation of psalms rather than the performance of a sacrament.[83] The Psalter of Saint Louis is typical of the genre, at least in its contents. The psalms are arranged in biblical order but divided according to the liturgy into eight groups, each beginning with the first psalm read at Matins every day and at Vespers on Sunday. They are preceded by a calendar of feasts and

commemorations and followed by concluding prayers, mostly a standard group of canticles and creeds.[84] Calendar observances and closing prayers are often tailored to the circumstances and interests of the owner, as evidenced by the obits in the king's manuscript. There are, however, no antiphons, versicles, responses, or lessons, and the calendar provides the ranking of feasts but gives few other directions for liturgical use. The psalter is thus a minimal book, one providing the essential text of daily prayers and only a guide to the *temporale* of the Church year. It is, however, an extremely functional and familiar book, a constant companion to the devout reader, who would have used it daily and read through it weekly. For many, including probably Louis IX, it was also a first book, the text by which one learned to read.[85]

If the king used his Psalter at all, he used it often. Although his later biographers differ in their report of certain details, the pattern and regularity as well as the intensity of his devotion are indisputable.[86] He recited the canonical offices and low masses every day, rising at midnight for Matins and the Hours of the Virgin and again at about six in the morning for Prime and the Office of the Dead, saying his first mass at daybreak and reciting compline in his room before retiring. All of the hours were said with his chaplain or confessor, usually in his chapel, sometimes aloud and at other times in a low voice as clerks sang. Time was set aside for private reading in bed. His chaplain is likely to have used a breviary or missal to lead the king in the offices or low mass, but Louis could have gotten along well with only a psalter or, better, a psalter-hours like that in the Fitzwilliam, which also contains the Hours of the Virgin and the Mass of the Dead, both of which the king said daily.[87] For the most part, though, the king listened to and recited the Psalms. William of Saint-Pathus reports that at the end of Louis's life, when the king was ill and too weak to speak during the office, "a cleric said the psalms for him," and two Cistercian monks testified in his canonization hearings that he often heard the psalter explained and, sitting among the brothers, listened with the greatest attention.[88]

The Bibliothèque nationale manuscript is almost certainly not the first or only psalter the king used. Fourteenth-century documents and inscriptions refer to six psalters "of Saint Louis," manuscripts that, rightly or wrongly, were associated with the king after his canonization in 1297. Of these, it is likely that the king knew

three. The earliest is a manuscript now in Leiden that was made in northern England about 1200.[89] It was probably acquired by the king's father during the Barons' Revolt of 1216 and then given to Blanche of Castile. It has two fourteenth-century inscriptions explaining that the psalter was Saint Louis's and that he was taught from it as a child, a statement that may well be true if his mother acquired it when Louis was only two or three years old. Of approximately the same date is the sumptuous psalter made around 1200 for Ingeborg, the second wife of Philip Augustus.[90] It is called the "psalter of Saint Louis" in a fourteenth-century inscription in the manuscript and in the 1380 inventory of the library of Charles V. As in the case of the psalter in Leiden, the association with Saint Louis may be based in fact, for about the time of Ingeborg's death, in 1236, her manuscript was altered to give its closing prayers masculine endings.[91] The third psalter is the Bibliothèque nationale manuscript here under study. Its earliest connection to Louis IX is the 1380 inventory of the library of Charles V, where it is listed beside the Ingeborg Psalter and distinguished from it by its smaller size and its great quantity of stories at the beginning.[92]

Of the three other psalters associated with the king in fourteenth-century documents, one is an unidentified manuscript referred to as the psalter of Saint Louis in the 1380 inventory of the library of Charles V.[93] Another "psalter of Saint Louis" appears in the 1326 will of Mary of Hungary. Also unidentified, it is likely to have been a thirteenth-century manuscript that the king's brother Charles brought to Naples.[94] The third, a work now in the Bibliothèque de l'Arsenal, has a fourteenth-century inscription describing it as Louis's psalter "lequel fu à sa mère."[95] It was made in Paris about 1220 and was intended for a woman, almost certainly Blanche of Castile, who is probably the kneeling figure represented in one of the psalm initials.[96] The manuscript appears in Sainte-Chapelle inventories from 1335 with no mention of the king; his name occurs only in later inventories and in the inscription.[97] These later inventories and inscriptions are indicative of the way any fine older psalter made for a member of the royal family might have come to be considered the king's. As private prayer books, they could both signify his piety and serve as relics of his person, just as the Bibliothèque nationale manuscript did until the nineteenth century.

One other surviving manuscript, latin 10434 in the Bibliothèque nationale, although it is never referred to as a "psalter of Saint Louis" in later inventories, is likely to have been made for Louis IX or for the use of the royal family.[98] The connection with Louis IX is based upon the way the parchment sides of the closed book are decorated with fleurs-de-lis and castles of Castile, a practice that appears in two other manuscripts donated about this time to other royal institutions.[99] Those motifs are cited in the general description of a psalter inventoried in the library of Charles V at Saint-Germain-en-Laye, the royal chateau just to the west of Paris founded by Louis VI and used by later kings for hunting and fishing.[100] That Louis IX built a new chapel there in 1234–38 and donated relics of John the Baptist is likely to explain the emphasis on Saint Germain in its calendar and the exceptional place of John the Baptist in the prefatory cycle of pictures.[101] The style of these pictures corresponds to the 1239 date on which the king had other liturgical furnishings made for the chapel, and several features of the book's decoration anticipate those of the Psalter of Saint Louis.[102] Although the calendar includes none of the observances characteristic of royal chapels and the content of the miniatures is hardly official, the same could be said of the Psalter of Blanche of Castile. For whatever reason the manuscript was not associated with Saint Louis in the inventory of 1380, the case for its being a work acquired for the chapel at Saint-Germain-en-Laye is nonetheless compelling.

Psalters were particularly in favor among the royal family. Of the seven here associated with Saint Louis, one—the Arsenal manuscript—was probably made for Blanche of Castile, at least two others are likely to have passed through her hands, and two of the seven probably belonged to Louis's siblings or children.[103] Apart from the Arsenal Psalter, accounts show that Blanche commissioned one other psalter in 1241 and three others in 1242.[104] It is impossible to know if the illuminated psalter ascribed to her in a Maubuisson inventory was one of the manuscripts she commissioned in 1241–42 or was some other psalter she owned.[105] A Parisian psalter of ca. 1220 now in the Bibliothèque Sainte-Geneviève may also have been made for a member of the royal family, for it subsequently came into the collection of Marguerite de Bourgogne, probably through Louis's brother Charles, whom she married in 1268.[106] We have

seen that the Fitzwilliam manuscript, a combined Psalter and Hours, was probably made for the king's sister or daughter.[107] And in 1253 Margaret, the king's wife, gave a "most beautiful psalter" with "golden pictures" to William of Rubruck when he was sent that year on a mission to the Tartars.[108] It thus appears that Louis, his mother, and his wife provided themselves and their children with psalters, whether new commissions or older books adapted for their use, and sometimes gave them as gifts, even diplomatic ones.

Psalters were not the only manuscripts created for the royal family. Detailed accounts are not preserved, but we can obtain a reasonable, if partial, view of royal patronage from three sources: preserved manuscripts, royal accounts, and biographies of the king.[109] From the category of books that members of the royal family required for their personal use, very little, other than psalters, is preserved: only two small Bibles that Blanche and Louis IX may have owned and possibly a breviary made for the king's son Robert Clermont.[110] Another important category of royal patronage comprises gifts to institutions. The king provided the various royal chapels with service books, the foremost examples being the several Sainte-Chapelle evangeliaries and the Bari Gradual and Sequentiary.[111] Religious institutions that the Crown supported with new buildings were also supplied with books and liturgical objects. At Blanche's request, the king's *hôtel* paid Herbert the Parchmenter 40 s. to illuminate and bind an ordo for Maubuisson, and Guillaume de Saint-Pathus explains that the king provided books for services as well as for study to many of the churches he founded.[112] He may also have been responsible for creating a central reference collection. Geoffroy de Beaulieu, his Dominican confessor, reports that after the king returned from the first Crusade, he had manuscripts of scripture and theology copied from sources sought throughout the kingdom and put them at the disposal of scholars and other readers in the treasury of the Sainte-Chapelle.[113] So far, three of these have been identified.[114] Finally, there is evidence that texts thought suitable for the education of the king's children were copied and commissioned.[115] It is noteworthy that of the manuscripts preserved in all of these categories, only the psalters and the Sainte-Chapelle evangeliaries are extensively illuminated. One thus has the impression of patronage concerned almost exclusively with texts for

religious study and devotion, of a generous king but not a bibliophile, and of a patron who wished to have his books embellished in a way appropriate to the liturgy rather than someone particularly interested in looking at pictures.[116]

This view of royal patronage, however, needs modification. First, estimates of losses both of manuscripts and of the historical sources pertaining to them make it almost certain that the preserved manuscripts represent only a fraction of what was commissioned. The losses are likely to be at least as great as they were for the library of Charles V, where over 90 percent of the fourteenth-century collection remains to be identified and is presumed lost.[117] Nor can the reports of the king's expenditures on books be counted upon for a balanced view. They are not found in chronicles but in biographies that cite them to show his piety and charity, usually in order to promote his canonization. We thus know far more about his generosity toward religious institutions and his public works than we do about the books he commissioned for his own use.[118] Most important, the preserved accounts report expenditures during a very limited period. Those for Blanche record, in all, less than half of her calendar of personal expenses during the years 1241–42, or less than 3 percent of the period in which her *hôtel* is likely to have commissioned manuscripts.[119] Seen in that context, the four psalters she had made in these two years represent an impressive level of patronage. The situation is very similar for the records preserved from the king's *hôtel*. Although the range of preserved records is considerable, from 1234 to 1267, the periods involved are sometimes as brief as one day and represent in total less than three years, or 7 percent of his reign. Moreover, the records that would have included manuscripts fall almost entirely in two years, 1234 and 1239.[120] Yet we know that in 1234 a breviary for Hugh of Athies was purchased for the high sum of 14 £; in 1239 Herbert the Parchmenter was paid 40 s. to illuminate and bind an ordo for Maubuisson, as noted above; in the same year, 40 s. was paid to illuminate a book for the king, in all likelihood one of the Sainte-Chapelle evangeliaries; and the lavish sum of 21 £, or ten times the cost of the evangeliary, was paid for a breviary for the Sainte-Chapelle.[121] If the expenditures during these brief periods are typical, they suggest that the Crown was an important patron of illuminated books and that

the king was no less a patron than his mother. They also suggest that the number of psalters preserved or documented is not exceptional—we just know more about this kind of book. Rather than the splendid but atypical works occasionally produced for the king, they are likely to be representative of a class of religious works that were commissioned for the personal use of the royal family, to be given as charitable or diplomatic gifts, or to be used in a context that effectively represented the regency, such as the Sainte-Chapelle.[122]

The psalters lead us to modify our view of the king's patronage in a second and qualitative way, for their illumination sets them apart from the other manuscripts cited above. The latter are usually fine exemplars decorated with a few small initials and decorative penwork. The most elaborate—the Sainte-Chapelle evangeliaries—have a series of historiated initials with scenes illustrating the gospel readings they introduce. In contrast, virtually all of the preserved psalters have numerous full-page miniatures and at least one cycle of illumination. Chapter 4 demonstrates how their illumination is shaped into coherent historical and Christological programs that are coordinated with the text and initials and that have liturgical and sometimes personal and political implications for the king or queen.

These illuminated psalters are hardly the only royal works with such ambitious and complex programs of illustration. Two others are especially relevant to this study. The first is the Sainte-Chapelle, the palace chapel Louis IX built to house the Crown of Thorns. Its decorative program, which consists of stained glass, sculpture, and wall painting, is one of the most extensive and also one of the most integral in all of medieval art. As a narrative and metaphorical construction mediating between sacred and local history, it is one of the most important precedents for the Psalter's prefatory cycle. The second is the *Bible moralisée,* a kind of manuscript not recorded in contemporary accounts but almost certainly a royal commission. While it is an illustrated Bible with numerous ideas and recurrent themes rather than an integral program, it is of particular interest to this study not only because of the interpretations the king might have read but because of the strategies of reading to which he would have been introduced. Those strategies can serve to inform a picture of him as a viewer of other works.

· · ·

The *Bible moralisée* is the kind of book invented in Paris in the early thirteenth century, probably during the reign of Philip Augustus or Louis VIII.[123] It is a pictorial interpretation of the Bible shown through a series of paired roundels, one illustrating a biblical event and the other its spiritual meaning. After a full-page frontispiece showing God as Creator, the pages are typically organized in two columns, each with four pairs of roundels and with textual explanations alongside.[124] Next to each roundel with a biblical event is a paraphrase or excerpt of the relevant passage of scripture, and beside each interpretative roundel is a summary of its meaning. Four thirteenth-century exemplars are Parisian. The two earliest are a manuscript in Latin and an incomplete version in French, both in the Austrian National Library in Vienna and usually dated to ca. 1220–30 (Vienna, ÖNB, MS 1179, and Vienna, ÖNB, MS 2554).[125] The two remaining exemplars are three-volume works made in the following decade: one is in the treasury of the cathedral of Toledo, except for the last quire, which is in the Pierpont Morgan Library; the other is divided between the Bodleian Library in Oxford, the Bibliothèque nationale in Paris, and the British Library in London.[126] The three-volume edition has more than six hundred folios with almost five thousand images, illustrating and interpreting almost the entire Bible, from Genesis through the Apocalypse, including numerous subjects of which there is no trace of earlier illustration.

It is astonishing that so vast a hermeneutic enterprise would have been undertaken in a visual medium. The research and invention, planning and production, required to create these manuscripts are extraordinary by any standard, and the manuscripts should be counted among the most ambitious pictorial enterprises undertaken in any medium during the Middle Ages. Artistically, they represent a quantum enlargement of the pictorial repertory and an unprecedented expansion of both the range of visual interpretations and the strategies used to communicate them. Most interpretations are based upon traditional glosses found in Parisian exegesis and sermons from the twelfth century; however, the interpretations also include commentary on contemporary issues, many of them politically topical and socially charged and presented with unabashed *parti pris.*

The most direct evidence that the *Bibles moralisées* were created for a royal audience is found in the images

that conclude two of the manuscripts.[127] The final folio of the Toledo/Morgan *Bible moralisée* is a full-page illumination with a queen and young king enthroned and, in the register below, an ecclesiastic who sits with a book open beside him and gestures to an artist who works on a manuscript decorated with the double row of roundels distinctive of these manuscripts (fig. 2).[128] Most recent writers identify the king and queen as Louis IX and his mother, Blanche of Castile, and date the manuscript to the period between her son's coronation and majority (1226–34), a period in which she acted as regent.[129] A similar arrangement is found in the last two roundels of the Latin *Bible moralisée* in Vienna, where a bearded king holds up an open book in the roundel above and a man works on a page of an open book below (fig. 3). The books of the king and the man below are turned outward, one above the other, and again have the series of roundels characteristic of these manuscripts, so it is clear that the *Bible moralisée* is the manuscript being produced and that it is for the king. However, the identity of the king in the Vienna roundel is less certain. On stylistic and historical grounds, the most likely candidate is Louis VIII, who was thirty-six in 1223, when he began his short, three-year reign.[130] An association with Louis VIII is also suggested by four words in the line of the contemporary inscription in the margin just alongside his roundel. As Sarah Lipton has shown, the phrase *rex attavis natus regibus*, or "king born to royal ancestors," is from Horace and closely resembles the wording used by Rigord when he rededicated his chronicle of the reign of Philip Augustus to the young Louis VIII.[131]

For our purposes, the identity of the king is less important than the way the inscription refers to him in the miniature. Words and phrases in several other lines also refer directly to the pictures alongside.[132] Although extensive losses render the inscription as a whole unintelligible, the words *de manu* just alongside the man working in the lower roundel no doubt refer to the making of the book. The use of *lect . . .* in the penultimate line is likely to indicate reading, and *cerni figur* in the final one suggests something to be perceived, undoubtedly in the image. Thus, making the book is distinguished from reading the text and discerning the image, so that it is likely the inscription praised the maker of the book and the king and implied that the reader should attend to both text and picture.[133]

FIG. 2 *New York, Pierpont Morgan Library,* MS M.240, Bible moralisée, *fol. 8r, final page of the Toledo/Morgan exemplar.*

The pictures in the Vienna manuscript suggest a similar relation. The king sits alone with his book, open and held from below, its binding straps dangling at the side. The book in the roundel below is similarly opened. Lowden correctly suggests that the two images should be seen in the context of the whole page and points out that the king looks off to the left, probably at the third roundel in the left column of the page, where Christ has similar facial features (fig. 3).[134] However, the reason for the directed glance may not be the quasi-divine status of the king but the text connected with this specific roundel, where Jesus says, "I am the root and descendant of David," a claim that all anointed kings make, at least in a figurative sense.[135] More important, books are displayed not only by the king and the craftsman but in

FIG. 3 *Vienna, Österreichische Nationalbibliothek, MS 1179, Bible moralisée, fol. 246r.*

five of the six other roundels on the page, most promi-
nently in the two roundels immediately above the king.
In the upper roundel Christ holds the open book before
a group of clerics, warning them not to change a word
of it, and in the moralization below, a priest holds a
book before a group of Jews, heretics, and false decretal-
ists, excommunicating them for having denied, falsified,
and misused Holy Scripture.[136] It is clear that the book
referred to here is not just the Apocalypse but all of
Scripture—the entire manuscript—and that these les-
sons are reiterated as one looks down the column of
roundels from Christ at the top to the priest, king, and
the craftsman below. But to whom does the king display
this book? It can only be to the viewer, presumably him-
self or some other royal reader who, at this moment, is
holding and looking into the book in a similar way and
also being admonished to respect it.

The obligation to attend to the book is put differ-
ently in the Morgan page, where the queen's gesture of
speech is analogous to that of the ecclesiastic who
directs the artist below and, like his, is a gesture of
instruction.[137] That the queen would instruct her son is
consistent with reports from Louis IX's earliest biogra-
phers that she was responsible for his education.[138] Given
the compositional and narrative analogies between the
upper and lower registers, one assumes that she instructs
the youthful king in the content of the manuscript.

This is also suggested by the unusual character of
the Morgan page and final Vienna roundels, for these
are not donation or dedication images in the traditional
sense. The manuscript is not being presented to the
monarch, and its creator is not an author or donor but
an anonymous lay professional. Moreover, the regent or
regents are enthroned with regalia, but no courtiers,
personifications, or heavenly figures bless or praise
them. Also unusual is the placement of these miniatures
at the end of the book rather than at the beginning. This
practice, which occurs in a few Carolingian and Otton-
ian manuscripts, has the effect of implicating the content
of the manuscript in the interpretation of the image of
the monarch.[139] It suggests that the preceding pages are
intended for and fitting to him, that he is or will be the
beneficiary of its content and program, that he is its
audience and its issue. Rather than a dedicatory image
flattering its royal patron, it stresses the book's utility,
which would have been self-evident, given the long tra-

dition that held the Bible to be the source of all wisdom
and thus the ideal didactic text for kings.[140]

These final images indicate a royal audience, but
nothing clearly states who paid for the books and who
worked out the program and what motive they had. The
answers may well differ from one exemplar to another.[141]
Most of the illustrations involve normative spiritual
interpretations, suggesting those involved were advisors
learned in exegesis whose goal was to educate the king
or members of the royal family.[142] Recent studies have
pointed out how some moralizations appear to formu-
late models of royal behavior and others present warn-
ings about Jews, heretics, prostitutes, philosophical
trends at the university, and the wayward behavior of
clerics, schoolmen, and corrupt ecclesiastics.[143] This
polemical content may well reflect the concerns of a
specific group of people who were close to the court and
anxious about recent developments they understood to
be threatening to the Church. Whoever was responsible
for these books, the royal reader was presented with
spiritual commentary on almost all of scripture, with
numerous political and social lessons, and with a vision
of the role of the Church extending from Creation to
contemporary Paris.

That the instrument for doing so is essentially picto-
rial remains the most striking aspect of these books.[144]
Although they were created at a moment when book
production had evolved to a point that such elaborate
works were feasible, no earlier Parisian manuscripts
aspire to this scale, and no earlier royal work is compara-
ble in extent or sophistication. Moreover, earlier manu-
scripts with many illuminations, such as psalters, tend to
construct meaning differently: prefatory miniatures are
usually read sequentially and have an overarching Chris-
tological or eschatological content, and although psalm
initials are frequently moralizing, they do not have the
extended comparative and typological constructions
found in these manuscripts, something far more com-
mon in other media, such as metalwork and stained
glass.[145] However, the constructions in the *Bibles morali-
sées* are still more complex, for many images exploit set-
tings and actions, turn on associative values, invent signs
and manipulate field relations, and reiterate figures and
forms in ways that turn them into metaphorical construc-
tions. Describing these visual relations as "exegetical" or
"typological," with their suggestions of learned commen-

tary and spiritual analogue, is accurate but does not do justice to the varied relationships between the paired roundels, to their often polemical and poetic implications, or to their visual power. Since both the subject matter and the rhetoric used to express it were so uncommon, one may well ask how the king would have learned to read the book, what he might have understood, and, given the number of pictures and the sophistication of their visual operations, what their impact would have been, apart from the moral lessons presented.

To answer these questions, let us suppose the young Louis IX were studying the manuscript, alone or with his confessor, a page at a time. I shall try to respond to these questions by looking closely at a single ordinary page of Vienna 1179, a manuscript Louis IX might well have inherited from his father and have read at an early and impressionable age, say between twelve, when his father died, and twenty, after which the expanded and revised version in Toledo probably became available.

Folio 64r concerns events from Joshua 4–6, from the Israelites setting up stones to commemorate their crossing the Jordan to their offerings after the fall at Jericho (fig. 4). The first roundel shows several Israelites— bearded men wearing short skirts and pointed Jews' hats—who stand on a river bank; all drop stones into the river except for one at the right who bends down to place his on the bank. The lower, or moralizing, roundel depicts a group of Jews walking off to the left, their heads lowered, as Christ urges them away; to the right stand a group of apostles, who look on as the Jews depart. The roundels create similar distinctions between left and right groups, and dropping the stones and pushing away the Jews are narratively analogous actions, so it is clear that the subject involves Christ's rejection of the Jews. However, the meaning of the stones is not evident, and so the curious reader would have to turn to the adjacent text. It explains that there were two sets of twelve stones, one precious and the other deformed and set aside, and that the former were the precious apostles whom Christ received after he sent the Jews away.[146] Cued to differences between the stones, one might look back at the top roundel and notice again the single Israelite, above the apostles, who carefully lowers a stone to the shore as the others turn to the left and drop their stones into the rushing waters. But even without referring to the text, one can see how distinctions in

value are enacted: the carefully preserved, singular stone versus the many, common, and discarded ones; the stone secured on the shore at the right, like the apostles beside Christ, as against those to be carried away with the rushing waters, like the Jews whom Christ rejects. In the end, the operative distinctions are not a function of deformation, as the text alongside describes, for the Jews and their stones are shown normally; rather, they are a function of actions—holding and dropping, preserving and disposing—and of how the designer uses the different associations of land and water in the setting of this episode on the banks of the Jordan.

The upper roundel of the next pair, those on the lower left, shows the fall of Jericho. At the left the Israelites sound their trumpets as the nearby city walls fall, and at the right men carry the Ark of the Law on their shoulders.[147] The lower roundel also has two groups. At the left Peter and the apostles lift up an image of a crowned woman holding a chalice and seated within an intact niche. She is Ecclesia, as the reader would know from her representation on other pages.[148] At the right the Jews see her and move away, and the small idols beside them—nude and diabolical figures— fall off their pedestals. Thus the trumpets and Ark bring down the walls of Jericho; and Ecclesia, the Jews and idols. Like the first pair of roundels, the message is clear even if one does not read the accompanying text. Doing so, however, shows an interesting difference. The text compares the blast of the trumpets to the "voice" of the Gospels; that is, the Church triumphs through the word.[149] In the roundels, even though one figure holds an open book, the Church triumphs through the power of an image.

Another reading of these roundels is equally possible, for the idols of the lower roundel fall, just as the walls of Jericho do on the opposite side of the roundel above, and the apostles lift up Ecclesia, just as the Israelites at the upper right bear the Ark with the Old Law. Although each roundel still reads from left to right, this diagonal, or crisscrossing, reference makes an essential connection between the Ark and Ecclesia, the trumpets now also seem to bring down the idols, and the pictorial reversal underscores the difference between the Old and New Dispensations.[150]

The next two roundels present a striking juxtaposition and a more challenging problem of interpretation.

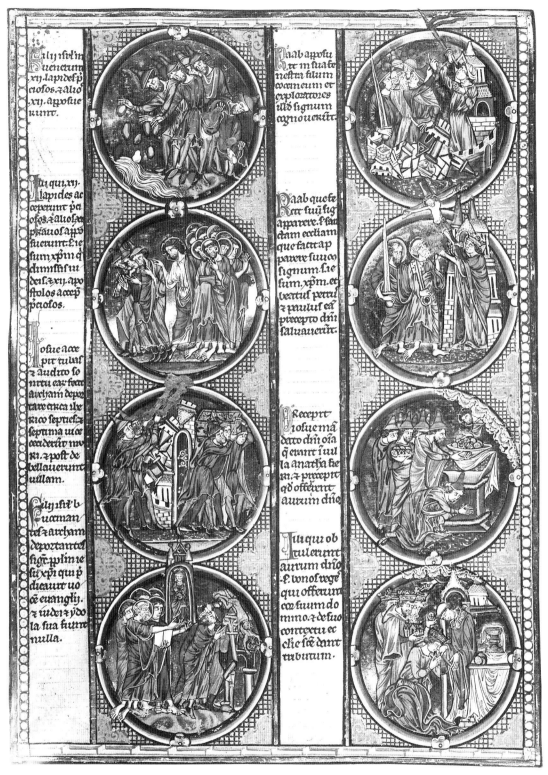

FIG. 4 *Vienna, Österreichische Nationalbibliothek, MS 1179, Bible moralisée, fol. 64r, page from the Book of Joshua.*

A glance at the two roundels shows a woman, similarly placed in each composition, waving a long staff over the heads of the men before her. In the upper roundel the staff is a pole carrying a scarlet cloth; in the lower, a crucifix. In the upper roundel the men before her are presumably the Israelites who stand among the fallen walls of Jericho; in the lower the crowned woman is the Church, who holds a chalice up to Peter as he and Paul look up to the crucifix and to Christ upon it. Paul holds a sword, his attribute, as does the young man in the roundel just above him. Thus the men are warriors, and the banner and crucifix, which extend above the edge of the roundels, are displayed like military pennants or insignia. One would naturally assume that the juxtaposition shows how some victory of the Israelites anticipates that of the Church, and this is in fact confirmed in the text alongside.[151] It identifies the woman in the upper roundel as Rahab, who, in the biblical account, displayed a scarlet cloth as a signal to the Israelites, who promised to protect her house, for she had protected the Israelite spies in an earlier episode.[152] Her house remains intact behind her, just as the church behind Ecclesia is, but the rest of the city is in ruins at the feet of the Israelites. The moralization explains that Rahab signifies the Holy Church, which makes its sign, Christ, appear, and that Peter and Paul have saved it at the Lord's command.

Signs, however, are susceptible to multiple readings, and a medieval viewer, especially a devout one, is likely to have understood the second roundel in other ways. The Crucifixion signifies both victory and the promise of salvation, the crucifix is a devotional object, and Ecclesia not only holds up the body of Christ but offers a chalice to Peter, a clear reference to the holy sacrament. What is interesting is that this almost self-evident interpretation of the second roundel does not follow the text in creating a parallel to the first roundel but instead presents a narrative inversion of it: Rahab the saved becomes Ecclesia the saving, and the sign the Israelites recognize in Rahab's banner becomes the empowering promise that the Church gives to Peter and Paul in these devotional and sacramental objects.

The lesson of the last pair is more straightforward. In the upper roundel the victorious Israelites present the booty of Jericho over an altar.[153] As one man kneels in prayer, the Lord descends to receive the offering. In the lower roundel the hand of the Lord blesses contempo-

rary kings who bring golden coins and reliquaries to a priest; the latter stands beside a modern altar and offers his hand for a kneeling king to kiss. The compositions and actions are so similar that the differences are striking. In the lower roundel worship is modernized, reliquaries displace jewelry as offerings, a priest receives expressions of piety, and the Israelites have become not just Christians but kings. In contrast to the upper roundel, where the Israelites offer the spoils of war, the good kings of the lower roundel, according to the text of the moralization, give "their hearts to the Lord and tribute from their own being to the holy Church."[154] The picture, however, shows that kings who receive the Lord's blessing are those who provide for the Church and submit to its authority.

Looking back over the page, it is surprising how progressively the four pairs of roundels work together, for the page begins with the Church's sending away the Jews, continues with its spreading its message, then empowering its leaders, and finally receiving the fealty of kings. Also linking the series are certain visual elements, such as the sacramental themes of the third and fourth moralizations, the elevated images of Ecclesia and Christ in the second and third, and the contrast between the placement of stones and the donation of offerings in the first and last roundels.[155] Also striking is the way the powerful protagonists in these roundels appear in varied guises. The full-length Christ, who rejects the Jews in the first pair of roundels, reappears on a crucifix in the third pair; and the Church, which is an image Peter holds up in the second pair of roundels, becomes a full-length figure who wields an image above him in the next. As a personification we see her operating not just as a character in the narrative but as an allegory that extends over many of these pages. The same is even true of the crucified Christ, who, on the previous page, appears in only a loincloth as he holds up a cross with himself upon it.[156]

The rhetorical strategies seen in these roundels—with their reversals, inversions, and substitutions, their reiteration of signs and themes, and their unexpected transformations of field, identity, and action—suggest the ways traditional subjects are transformed and new ones created. Of these, some of the most striking involve a *translatio* of meaning. In his treatise on rhetoric, written about the same time as the Vienna *Bible moralisée*,

John of Garland gave this example of metaphor: "The hand of the Albigensians is cut off by Canon Law."[157] The figures of speech here naturally involve substitutions, primarily of part for whole. The image of Peter taking the chalice and looking up at the cross also involves substitutions: of a crucifix for the sign of the Cross, and of the body of Christ for the host. The result, however, is an image with manifold meanings, for it is possible to see Peter as simultaneously looking at Christ on the Cross, taking the sacrament, and receiving a mandate. What results is a powerful image in which devotion and investiture coincide, much as they do in Early Christian scenes of the *traditio legis* or Communion of the Apostles or in scenes of Saint Francis that were created in the next decades.

Although images of similar invention and force occur in earlier works, such as the Saint Paul window at Saint-Denis, the *Bibles moralisées* mark an enormous expansion of such images and a broadening of the range of rhetorical strategy.[158] Part of the reason for this might be the manuscript's capacity to position its viewer as the discoverer of meaning. In these terms, these manuscripts are indeed works of court art, not in having elegant or mannered forms or in the social implications of the figure but in the pleasure the viewer takes in elaborate analogies, in the telling effect of detail, in novelty, and in the element of surprise. The two Vienna manuscripts, especially, delight in invention, in the process of discovery, in the challenge of puzzling out relations. They are manuscripts that would have held Louis IX's attention, at least to judge from the repartee and the puzzling queries Jean de Joinville tells us the king so enjoyed.[159]

This page of the *Bible moralisée* demonstrates how the manuscript's structure of comparison and explanation effectively trains its own readership. A person unfamiliar with visual images or with this manuscript might have required a few folios to settle into its formal and narrative conventions; to grow familiar with its cast of priests, clerics, kings, Jews, and others; and to understand how certain objects, such as crowns or chalices, moneybags or books, are freely transferable signs. Some texts would have to be read, but what are really operative are the moralizing roundels, which refer the reader back to the biblical scene and insist that a comparison be made, that similitudes and distinctions be observed. This results in an increasingly close analysis of physical features, behavior, motivation, and effect. One soon learns to follow the juxtapositions through their various transformations and, eventually, to become accustomed to the fluidity of identity and reference, to transformations of representational status, and to the reading of signs. As in any play of visual signs, the image has to be queried, its parts fit together and considered and, in this manuscript, reconciled with a Christian order and its moral teaching. Whatever the message, the manuscript puts into place an apparatus that demands thought, that makes possible a highly sophisticated level of visual communication, and that serves to guide and educate its reader in its own use. The viewer who is naturalized to the form and content of the manuscript, who has learned to understand it, has acquired an exceptional visual culture and a fluency in a privileged medium of discourse.

We have no eyewitness account of Louis IX studying a *Bible moralisée,* but if he did, the didactic apparatus built into the plan of the manuscript helped assure that he would get its message. And if he discerned the message in a *Bible moralisée,* he could do so in such later works as the stained glass of the Sainte-Chapelle and the Psalter of Saint Louis, works that also involve ideas about history, the Church, France, and its kings. The *Bible moralisée* tells us nothing of the responses of the king, but it enables us to suppose that contemporary painting was accessible to him and that he had the competence to understand its meaning. Indeed, reading the *Bible moralisée* could well have made him one of the most visually literate kings of the Middle Ages.

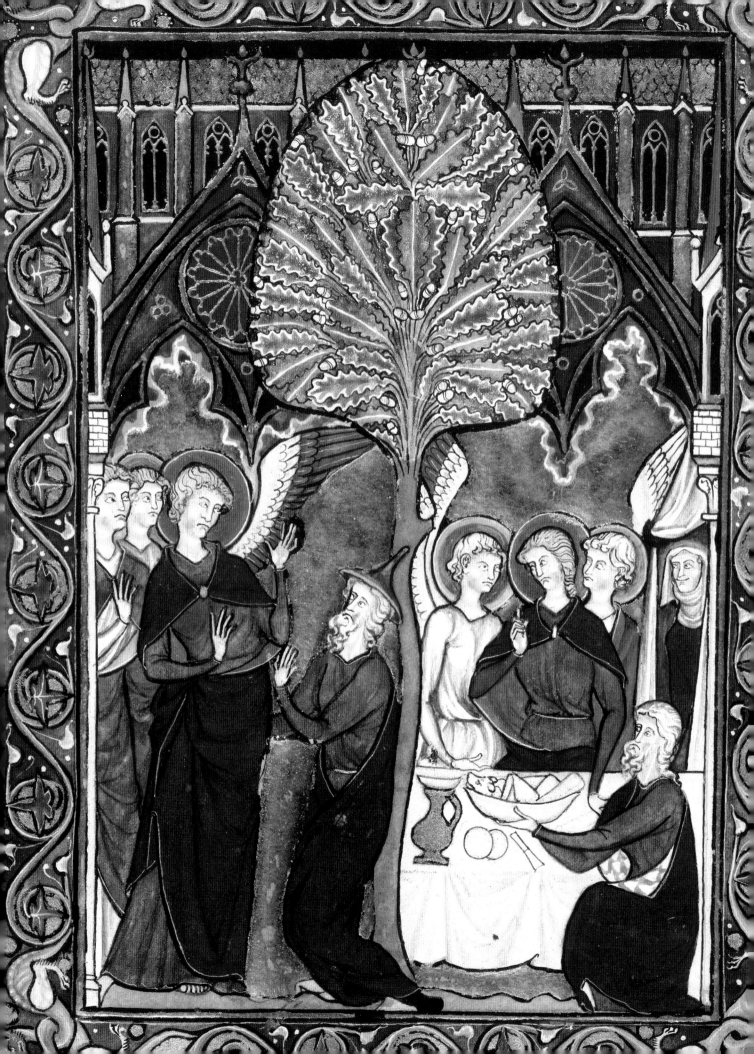

The Physical Manuscript

By the mid–thirteenth century, French psalters had evolved more or less consistent characteristics. A psalter was likely to be a quarto manuscript of about three hundred folios written in Latin and consisting principally of the 150 Psalms of David in the Gallican version, subdivided into eight, nine, or ten groups according to liturgical usage and local custom.[1] The Psalms were preceded by a liturgical calendar and followed by canticles, a litany of saints, and concluding prayers. Decoration varied considerably in quality and extent but generally was of two kinds. Between the calendar and Psalms were full-page miniatures illustrating episodes from the life of Christ; these were sometimes preceded by a few Old Testament subjects, usually events from Genesis and Exodus. The remaining decoration was to be found in the text. Psalm divisions were marked by large initials illustrated with subjects primarily from the life of David, while the other psalm initials, as well as all verse initials and line-endings, were decorated with painted and penwork forms, usually floral and animal motifs extending, often exuberantly, into the margins.

The Psalter of Saint Louis differs from this norm significantly. The book is smaller, and the pictorial and decorative elements are scaled down, concentrated, and particularly rich, especially in the lavish use of gold. The full-page miniatures are unusually numerous. They illustrate only Old Testament subjects, begin and end with exceptional episodes, precede, rather than follow, the calendar, and are more elaborately enframed than in any earlier psalter preserved. Some subjects are very rare in medieval art,

Detail of folio 7v, Psalter of Saint Louis

even in the history of painting, and a number of commonplace subjects are not found at all. As already noted, explanatory legends are not placed beside their corresponding miniatures but on their reverses, so image and legend cannot be read together. The decoration of the Psalter text is no less unusual: several psalm initials are illustrated with exceptional subjects, and the broad empty margins, bar line-endings, and lack of filigree all point to a design conception without parallel in manuscripts at this time.

This design conception is one of the hallmarks of the Psalter. It involves not only the extensive use of gold and a highly architectonic approach to page layout but pictorial effects based upon an unusually subtle and technically refined approach to color and modeling. Oddly, none of these aspects of the prefatory miniatures appears consistently. In fact, the miniatures undergo conspicuous and sometimes abrupt changes in palette, technique, figural style, and decorative motif, so much so that it would appear, at least superficially, that the artists either made little attempt to coordinate their efforts or changed their plans unpredictably. Neither was the case. Instead, these changes, as indicators of the manner in which work on the manuscript proceeded, suggest a group of talented artists of diverse backgrounds who were brought together with no clear protocol of design but who quickly developed one, solving problems as work progressed and enjoying the freedom to experiment with new ideas. The visual problems and expressive goals that engaged these artists and the terms in which they formulated solutions are especially characteristic of Parisian art at the end of the reign of Louis IX.

Interpreting their work must naturally begin with the physical evidence the Psalter provides about how it was made, as seen against a background of contemporary practices of painting and bookmaking. In the Psalter the evidence is fortunately present and notably clear. The manuscript has undergone few major changes, so that many details lost in the usual trimmings and rebindings are preserved. The thin parchment has left abundant traces, irregularities, and *pentimenti* showing how errors were corrected and designs changed. And the often transparent paint makes it possible to see the underdrawing and preparation of the miniatures. A no less important kind of evidence is provided by the architectural frames, prickings, palette, and bole, each of

which varies but in surprisingly parallel ways that reflect the organization of work on the manuscript. The quality of this physical evidence enables us to study the structure of the book, the alterations made to it, the techniques employed, and many aspects of the progression of work. It suggests a great deal about the conception and production of the book and about the values driving its design.

This chapter is devoted to a close consideration of the physical manuscript. It first introduces the fundamentals of the book's organization—its gatherings, parchment, and page design—and then goes on to an extended consideration of the design and technique of the prefatory miniatures, first in the narrative scenes and then in the architectural settings and the frames. It continues with tentative conclusions about the structure and sequence of production, topics that are taken up again in the following chapter. Thereafter, the chapter addresses the legends, calendar, and heraldry and briefly discusses the evidence of losses, additions, and alterations. Here it takes up a number of interpretative issues, such as sources for the French legends and the status of heraldry in the manuscript. The results of these several analyses are summarized at the end of the chapter.

Such close scrutiny of physical evidence can be tedious, and so I have tried to unburden the text by placing much of the technical data in appendixes and by providing the summary at the end of the chapter. It is rare, however, that so important a work of medieval art reveals so much about how it was made, and this is one instance when the study of physical particularities is worthwhile. It will show how a distinctive viewpoint is built into various levels of design; how beneath the luxury materials and high finish is a sometimes profound search for a satisfactory visual language; and how this viewpoint and language help determine the reader's relation to the book and its contents.

General Organization

Gatherings. The gatherings, or quires, of the Psalter of Saint Louis are the basic units in which the manuscript was created as well as bound. They correspond to the allocation of materials and labor and, in general, to the sequence of work on the manuscript. A change in the quality of parchment, the preparation of the page, its

technique and decoration, or the contribution of a scribe or artist is almost always accompanied by a change in gathering. The gatherings are therefore key to any consideration of collaboration and, within the introductory cycle, to the evolution of the decorative conception and pictorial style.

The original portion of the manuscript consists of 260 numbered folios that may be divided into three sections: prefatory miniatures, calendar, and psalms and concluding prayers.[2]

The seventy-eight prefatory miniatures are arranged in thirteen gatherings, of which ten consist of only four leaves, the rest being considerably longer and occurring only at the beginning of the series.[3] Each of these four-folio gatherings is composed of two bifolios—a binion—constructed in quarto, that is, from a single large sheet of parchment that has been folded twice. For a manuscript of this format, the binion is the smallest unit that can constitute an entire gathering. Although four-folio gatherings are exceptional at this time, especially in prefatory cycles of illuminations, they have the advantage of enabling an artist to work alone, on a single sheet, on miniatures that will be bound consecutively.[4]

The three longer gatherings are problematic: gatherings I and IV each have fourteen folios in a highly irregular arrangement, and gathering II is a regular arrangement of ten leaves. There is no evidence that any of these three has been altered.[5] The bifolios in gatherings I and IV fall into two groups, one forming a normal quaternion or quinion and the other a series of bifolios placed at irregular intervals within them. In diagram 1, bifolios 8/9, 11/12, 31/32, and 38/39 clearly fall into the latter category, and it is possible that 5/6 and 35/36 and others do also. It thus appears that regular gatherings were augmented with irregularly placed bifolios.

In contrast, gathering III is a binion like the rest of the prefatory gatherings. It was painted by a visiting artist and was one of the last gatherings to be completed. All the irregular gatherings thus come at the beginning of the manuscript and contrast markedly with the simplified, minimalist structure that characterizes the remainder of the prefatory cycle.

The full-page miniatures are followed by one gathering for the calendar (XIV) and fifteen for the text of the Psalms and concluding prayers (XV–XXIX). The calendar has the usual six leaves, one month to each side, and the

Gathering I:

Gathering IV:

DIAGRAM 1: *Structure of Irregular Gatherings* I *and* IV

text section consists of regular gatherings of twelve leaves.[6] The few exceptions to these numbers are noteworthy, for they invariably indicate a loss, addition, or special circumstance in the making of the book.[7]

· · ·

Parchment. The folios of the Psalter are an unblemished vellum, thin enough to diffuse light from behind when the pages are turned but, unlike the extremely thin vellum of many later manuscripts, still thick enough for the reader to feel their pliancy. Largely without fat, it is smooth but not slick to the touch, its surface having been prepared to a consistently delicate grain and even texture. Its ivory color imparts a warm tone to the large undecorated surfaces of the page. This relationship between the physical and the coloristic properties of the parchment has important implications for the layout of the page and the composition of the miniatures, as explained below.

The parchment has been only slightly trimmed—probably less than five millimeters at the bottom and side, a little more at the top—so that the proportions of the page are very close to the original. The color, finish, and weight of the parchment is consistent enough within each section of the Psalter that significant differences, especially in weight, are often noteworthy and can be linked to some other feature, such as a change in technique or style of painting, or to special circumstances of production.[8]

· · ·

Ruling and Page Design. The introductory miniatures are laid out on the flesh side of the parchment with a series of rulings, or guidelines, that are used to situate the

DIAGRAM 2

over center and shifted almost 40 percent toward the gutter, or median, of the book (see, e.g., fols. 1v–2r). The effect is to create particularly broad outer and lower margins and to cause facing miniatures to approach each other at the center of the double-page opening.

The standard for the ruling of the legends on the reverse of the miniatures is four lines, regardless of the line requirements of the legends (see, e.g., fols. 2v–3r).[11] These lines are not part of a regular system and do not have prickings of their own. Rather, they conform to the placement and dimensions of the miniature on the other side, the first line falling just underneath the upper edge of the miniature as it shows through from the reverse.[12] This convenient way to set the lining of the legends creates a physical match between the text of the legend and the miniature it describes, a connection that continually insists on the two-sidedness to which each legend refers when it begins "En ceste page."[13]

The lining of the text pages is consistent with and no less unusual than the lining of the miniatures. On either side of the text column is a pair of vertical lines extending from the top to the bottom of the page (diagram 3, fol. 127r). The horizontal rulings for the text are traced only between the innermost of each pair of vertical lines, so that the narrow vertical corridor between these latter is uninterrupted. This space—about 7 mm—is used to center the verse initials. This means that no two rulings cross anywhere on the page and that the block of text is bound on the left and right by a shaft of space rising from the base of the page to its upper edge. In laying out a page and providing a guide for scribes and others, designers at this time normally took account of proportions, sometimes using the golden section.[14] To judge from the way these shafts serve to link the top and bottom of the page and frame and bracket the text, the designers also took static relations into account. In these terms, the ruling of the text pages has more in common with architectural drawing than with graphic design.[15]

These rulings delimit a number of other elements, underscoring how they function not just as guidelines but as framing devices. They define the text block, with all bar line-endings lying within them and with blue or gold verse initials lying just outside, in the margin to the left.[16] The framed historiated initials also lie within these limits, the width of their frames keyed to the interval between the double rulings (fol. 126v). An interesting

boundaries of the outer frame. In most manuscripts this would involve four lines, one on each side of the miniature's frame. In the Psalter, however, it involves sixteen lines because the frames are bound by both inner and outer gold edges and because each of these gold edges is laid between two closely set parallel rulings (diagram 2).[9] Apart from the precision these double lines allow in laying in the gold, the overall arrangement, which required a total of sixteen rulings per miniature, suggests that the frames are themselves enframed. Indeed, the subtle and varied motifs, patterns, and palette used in these frames turn them into a secondary visual field, one that deserves attention in any consideration of the design and conception of the page.

Although the double rulings sometimes extend into the surrounding margins, they generally end at the frame and are not visible as one looks at the painting. In most other manuscripts at this time, rulings extend across the page, setting the miniature into a grid that links it to the edges of the page.[10] These miniatures, however, are unattached and seem to float on the parchment, independent islands of color on the whiteness of the page.

If each of these paintings connects up with anything, it is the image on the facing page. This results from the miniatures' off-center placement on the page; like the text columns, they are elevated about 45 percent

DIAGRAM 3

exception is the full-page Beatus initial (fol. 85v) where the double rulings actually determine the limits of the left and right side of the frame. This means that at this critical point in the manuscript, where reading pictures segues into reading text, the field in the frame corresponds precisely to the field of text on the facing page (fols. 85v–86r).

Similar design considerations may be seen in the formal black letter script. Each page has eighteen lines of text, written in regular, evenly spaced strokes and using few abbreviations. The proportion of a typical letter, such as *n* or *e*, is similar to that of the text column itself.[17] The spacing between lines is particularly generous. Above the first text line and midway between each of the others is a secondary guideline used to situate the heads of the lowercase letters and the upper edge of the bar line-endings.[18] With the faint midline shouldering the diamond-shaped heads of vertical strokes and most letters free of the baseline, the script line seems to float. Many of these forms and proportions are found in other works, but their combination here gives the impression of double-spacing, of measured graphic richness, and of open courses of script with decorative accents at each end rather than a solid block of text.

The page design described above arose at a particular moment in the evolution of psalters produced in northern France and the Paris region.[19] It had long been

customary for the column of text to be placed toward the upper left section of the recto page (and correspondingly to the upper right of the verso), so that full-page miniatures or single columns of text on facing pages would appear to be physically proximate, like the open leaves of a diptych.[20] Since the lower and outer margins were disproportionately wider than the upper and inner ones, efforts were made to integrate them into the overall design of the page by using such elements as penwork and eventually descenders and marginal illustration. In psalters, however, a distinct problem arose about 1220, when larger manuscripts, about 30 x 20 centimeters, gave way to smaller books, approximately 20 x 15.[21] The number of lines per page (normally between nineteen and twenty-one) generally remained unchanged, so that the difference in scale resulted in a text column (or miniature) that was too tall relative to the height of the page. Compensatory adjustments began to be made, especially in the size of the margins and the proportion of the column relative to that of the page.[22] More important, a certain process of clarification ensued, and many of the characteristics found in the Psalter of Saint Louis appeared: "double"-spacing between the text lines and the use of a median guideline; the strict adherence to left and right margins and the displacement of verse initials outside the text column; the limiting of most, if not all, horizontal elements between dominant vertical ones; and the regularization of horizontal units, especially through line-endings that shape the script into regular courses.[23] These features do not develop consistently in any one shop but may be found separately in several. Aside from the Cambridge Psalter, the manuscript that combines many of these features and uses proportions most similar to those in the Psalter of Saint Louis is a Parisian psalter made about 1240, probably for the royal chapel at Saint-Germain-en-Laye (fig. 5).[24]

A new situation developed after midcentury with the tendency to reduce the width of the outer margin and to shift the miniature or text toward the center of the page.[25] This change threatened a loss of connection between facing pages and a loss of tension between the miniature or text column and the surrounding margins. The Psalter of Saint Louis adopts only a modified version of these ideas and for the most part goes back to earlier forms. The proportions of the Psalter's text column or miniature are comparable to that of the page as a whole, about 2:3, and

ture zone (the usual narrative unit); the width of the narrow inner margin becomes approximately the same as the frame beside it; and the lower margin is about half the height of the miniature, which is itself equally divided between the narrative space and the architectural structure above it. Thus, the page and miniature do not just take account of each other but are constructed to be read in the same proportional terms. Page design becomes the means of relating one page to another, to its parts, to its miniature, and to the miniature's parts. It ties the viewing of the miniature to the turning of the page and to the handling of the book.

All of these changes focus on the margins, and here one finds another innovative aspect of the Psalter's page design: no pen flourishes, filigree, antennae, descenders, or marginalia; and the finish of the initials and line-endings indicates they were not anticipated (see fol. 87v, fig. 6). The entire script column, along with the initials, is altogether free of secondary decoration. The page is thus reduced to a few primary elements that appear with a new clarity, and space is reserved in large uninterrupted corridors and blocks that function structurally in relation to the composition of the miniatures.

The result of all these changes is a new concept of the page. Pared to its essential units, it is leaner, clearer, and more restrained and harmonious than its predecessors. Most important, the broad open surfaces play a decisive role, at once structural and relieving. Given the qualities of the vellum, the open surfaces become areas of sustained tone and luminance that enter into the balance of formal values within and around the text and miniatures. These clear and unencumbered surfaces are one of the most luxurious aspects of the Psalter. They give the page an openness and lightness, and make the delicate color and texture of the vellum integral to one's apprehension of the page and handling of the book. In no other Gothic manuscript I know is the blank parchment at once so architectural and pictorial.

In these terms the Psalter's most significant Gothic precedent may be the Ingeborg Psalter (Chantilly, Musée Condé, MS 1695; see figs. 67–72).[28] However, one cannot rule out the possible influence of earlier Carolingian or Ottonian books, both of which have comparably rich materials and a similar generosity of space, clarity and precision in layout, and restraint in decoration.[29] In many ways the Psalter of Saint Louis represents the reformula-

FIG. 5 *Paris, Bibliothèque nationale de France, MS lat. 10434, psalter for the royal chapel at Saint-Germain-en-Laye, fol. 63r.*

the height of the lower margin is again approximately half that of the text, both like those of works from the first quarter of the century.[26] Like contemporary manuscripts, though, the width of the outer margin is reduced, but only to about 40 percent of that of the text or miniature, a change that maintains the relation between facing pages while bringing the lateral proportions into the 2:3 ratio of the text/miniature and page.[27] Most surprising, these changes seem to take account of the Psalter miniature's subdivision into equal parts left and right, above and below. The width of the outer margin is now approximately the distance between two colonnettes in the pic-

tion of these values in a small-scale book. Here, as in certain Gothic buildings after midcentury, reduction in size does not lead to concentration of detail and density of effect but to a different kind of balance between surface and decoration, one depending upon geometry and emphasizing spareness, relief, and continuity.[30]

The Prefatory Cycle

In medieval art, variations in decoration or finish do not always call for comment. They may be indicative, for example, of nothing more than a desire for variety. In the Psalter of Saint Louis, however, variations are especially diverse: they extend from the structure of gatherings to the preparation and design of the page, the technique of painting, and the finishing of its various

parts. They pertain to all the parts of the miniatures and to all of the phases of painting.

The Psalter's variants can be divided into two groups. Variations in the pricking of the page or the proportions of the architectural framework pertain to the preliminary stages of work on the manuscript. They reflect differences in the preparation and distribution of materials and thus in the organization of work. In contrast, variations in technique, palette, and design of the frames and of the architectural settings pertain to execution and finish and are an aspect of decoration. If these elements continually change in the course of production, it reflects either changes in personnel—in Gothic illumination of this period, formal variants are often taken as a sign of collaboration[31]—or the development of practices over the course of production and, possibly, the changing ideas or goals of the group and of individual artists. In what follows I look first at the structural elements and then turn to those related to design and painting.

In doing so, I have made a number of assumptions. The first is that several people were involved in painting the seventy-eight prefatory miniatures and that they are likely to have had some kind of contact with each other or with whoever coordinated production. At the very least, materials of consistent quality had to be acquired and shared, and standards and procedures had to be set. Furthermore, all those working on the miniatures registered the most fundamental changes, however differently they may have interpreted them.

A second assumption is that the miniatures were created in approximately the same sequence in which they are bound. I have noted that the most complex and untraditional gathering structures are found at the beginning of the cycle and that a certain normalization occurs after the fourth gathering. At the same time, the last miniatures are the most advanced in both style and technique, as numerous writers have suggested.[32] Thus the artists operated in the same way scribes usually did, working in tandem on a group of gatherings at a time, taking them consecutively and sometimes leapfrogging one another, and then beginning another group.[33] With one significant exception, they did not go back and paint an earlier gathering.

A third assumption has to do with the sequence of work on specific miniatures. In general, the artists operated in three independent fields: the narrative scenes, the

architectural structures above them, and the frames. The frames were laid out when the page was ruled, but they were the last to be finished, since their painting and decorative motifs cut off or overlap the biblical scenes and the architectural settings above them. The latter were also laid out in advance; however, the palette is always that of the frame, suggesting these parts were done in tandem, whereas the palette of the biblical scenes is usually a separate matter. In general, then, the paintings were probably finished in a sequence moving from the center outward, from the biblical scenes to the architectural settings and finally to the frame.

Although variations in technique and palette are usually studied to illuminate the working methods of individual painters, it is useful in this context to begin by studying these variations in relation to the codicology. It is preferable to base initial findings on the material and visual evidence, to see first if formal variations correlate with structural ones, and to begin by focusing on the large changes that developed over the course of production. The next chapter will reveal whether those changes match up with the conceptual and expressive particularities of the paintings.

. . .

The Stages of Illumination. In medieval illumination at this time, the stages of painting are fairly consistent from one manuscript to another.[34] The process begins with ruling the page, that is, drawing lines between pins that hold the parchment to a standard frame. These lines define the format and framing of the miniature; they situate the miniature and compose the page. Next comes the underdrawing, at this time usually with plummet, often a stick of lead or graphite, but sometimes also with pen and ink. Whatever pictorial models or preliminary drawings are used, they can range from the barest outline, a way of just locating the principal elements and noting shapes, to a sketch laying out the general forms of figures, objects, and even details of gestures and drapery. Pattern sheets are sometimes used for drawing standardized or repeating elements. Forms are then either outlined or wholly redrawn in ink, and gold is applied where required, the leaf laid down on a prepared mordant or bole. The painting begins with a general body coat, or laying-in color, sometimes over a thin underlayer of lead white. Forms are then modeled in another color, usually a darker tone of the same hue, and fine details and high-

lights are finished with a fine brush and pen. This is not the case with all forms but is usually so with figures. In the mid–thirteenth century the figure can also be modeled with a lighter tone of the laying-in color and by reflections added with white paint or suggested by leaving the parchment or white underlayer exposed.

A contemporary and highly revealing example of how work actually progressed is found in the Douce Apocalypse, an English manuscript painted about 1270, probably for the future Edward I.[35] Like the Psalter of Saint Louis, it is a manuscript with a series of relatively large paintings that are technically sophisticated and pictorially innovative. The major miniatures are found in seven gatherings, of which only the first four are finished.[36] The remaining three are in various states of completion, suggesting that the painter or painters worked on the book in phases, completing one section—about half the book—before starting on the next, and that they began at the beginning of the book. Within the unfinished section of the book, however, the middle gathering is less advanced than the final one, so that the gatherings within a section may not have been painted in sequence. Although a single gathering may exhibit different stages of incompletion, the miniatures of the same bifolio are always finished to the same degree, which suggests that the entire bifolio underwent the same stage of painting at the same time. These conditions also apply in the Psalter.

The Apocalypse has two notable exceptions to the standard technique of painting described above. First, the sepia pen drawings that set out the final forms of the miniature do not always follow the preliminary underdrawing; adjustments were often made that strengthened or clarified the composition.[37] Second, some parts of the composition receive no underdrawing at all and are left blank, even though those parts with an underdrawing have been finished.[38] The parts left unfinished are often landscapes or areas that are less critical iconographically. Apparently they were not subject to the sequence of steps described above but were left to be begun and finished in a separate, final stage. There is nothing to suggest that these sections followed any model. They seem to have been painted freely onto the page, and so it is especially noteworthy that some of these landscapes are among the most spatially advanced of any thirteenth-century paintings north of the Alps. In general, the Apocalypse shows

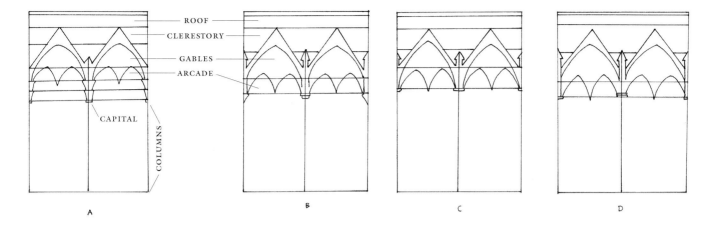

DIAGRAM 4

that the system of illumination was efficient but not rigid and that opportunities for refinement and invention were built into the procedures followed. In principle, the art historian should allow for similar flexibility in the making of the Psalter of Saint Louis.

. . .

Prickings. Taking into account slight stretching and minor variations, the prickings and the measurements between them are so internally consistent that variations are easily detectable. An examination of the prickings in the prefatory section reveals two standard patterns and confirms the use of frames with regular settings for pinning down the parchment.[39]

The two patterns differ mainly in the number of pricking holes. Both occur in the irregular first and fourth gatherings, but otherwise they alternate, first in single gatherings and then in runs of two or three.[40] A revealing error occurs on folios 59–62, or gathering IX, where each of the holes in the four corners of the miniature is repeated 4.2 cm below, the result being that the distance between the lower edge of the page and the lowest unused holes is the same as that between the upper edge of the page and the actual border. It is clear that one mistakenly began to lay out the miniature on the hair side of the parchment (the lines can still be seen on folio 62v) and then, recognizing the error, turned the two bifolios upside down and started again, repricking

the parchment on the flesh side in the usual way. The identical measurements of the two sets of holes confirm the use of a standard frame.[41]

. . .

Architectural Patterns. The measurements of the architectural structure in the upper half of miniatures are also consistent and, like the pricking patterns, indicate a standard design that was transferred to the parchment, possibly from a pattern sheet, or maquette.[42] An analysis of the positions of only the principal lines of the structure—the inner arches, gables, capital bases and pinnacles, moldings, and roof line—indicates that four patterns were employed (diagram 4). In comparison to the initial pattern (A), the second (B) is lower and slightly broader; the third (C) is scaled like the first, but the clerestory zone of the building above is proportionally larger, and the arcade is slightly more pointed; and the fourth (D) is similar to the second but with a taller arcade.[43] These variations may amount to only a few millimeters, but the differences are significant even apart from their aesthetic implications, for changes in pattern are consistent with changes in the prickings, and each corresponds to changes in gathering and to the irregularities of the first and fourth gatherings. The architectural part of the underdrawing is thus part of the preparation of the page and was similarly affected by the allocation of work.[44]

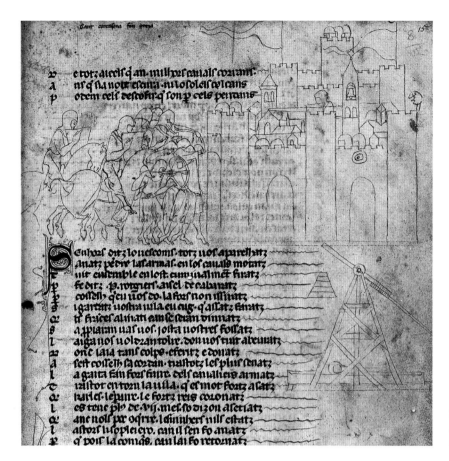

After the principal architectural forms were laid down according to the patterns, details were added freehand, especially the gold clerestory windows and roses. The windows are essentially of the same design throughout the cycle and, with the exception of the first gathering, the same is true of the roses.[45] Slight variations typical of freehand drawing are also found in the borders.

· · ·

Drawing. Several stages of drawing appear in the Psalter. The first and most basic is the underdrawing, which is in lead point and is visible where lines have not been inked over in pen. It can be seen most readily through the lighter and more transparent light colors but can often be studied from the back of the miniatures when the folio is raised to the light. Although the underdrawing lays out the basic forms of the composition, the degree of detail varies considerably. In some drawings the forms, surfaces, and drapery motifs within the contours of figures are hardly indicated, left to be defined and articulated in the subsequent stages of painting. Other

drawings set out the figures, their gestures, and many details of drapery, armor, and facial forms as well as buildings and other objects. This latter kind of underdrawing corresponds to the drawings often seen in unfinished miniatures, such as those of the *Chanson de la croisade albigeoise* of about 1290 (fig. 7).[46]

A second stage of drawing occurs after the painting. While normally this consists of strengthening the outer contours and adding facial and other fine details, in some folios it also involves what I refer to as the *overdrawing.* In contrast to the heavier lines of a figure's outer contour, these are fine, usually short lines added most often in areas with transparent colors. In many cases they selectively ink over and reinforce the underdrawing; in others, they further describe or articulate a surface or shape.

The relation between the underdrawing, painting, and overdrawing and the varied approaches to each are taken up later in this chapter and in the next. In general, however, sparse underdrawing is usually accompanied by

thin, transparent colors, minimum contrasts, and little overdrawing; that is, description centers in the painting itself. Conversely, those miniatures with the most detailed underdrawing tend to be those which depend upon line or contrast to shape or model the figure. Whatever the approach, it is consistent within a single gathering.

· · ·

Bole and Gold. In the Psalter, unlike any other medieval manuscript of which I am aware, the thickness of the bole varies considerably, and its color changes from one gathering to another, ranging from black to green to white to transparent.[47] These differences are subtle but very important in the original manuscript, for the thicker boles make the gold surface more convex and reflective, and the darker boles deepen the gold toward orange, just as the lighter ones make it pale toward yellow. It can hardly be a coincidence that the changes in the color and thickness of bole often go hand in hand with changes in pricking and architectural patterns and, more important, with changes in palette and in the coloring and design of the architecture and borders.

Changes in the application of bole are visible either directly where gold has flaked or indirectly from the reverse of the folio. Both ways of viewing the bole are cause for caution, the former because the color of a small area of bole revealed by flaking will be modified by the reflections coming from the gold surrounding it, and the latter because the light passing through the leaf gives a yellow cast to the color of the bole as seen from the reverse. In the latter case, the thickness of the leaf and the nature of the fixative must also be taken into consideration. Until these elements can be analyzed scientifically, it is not possible to ascertain which factor or factors account for the color of bole one perceives. In the following I refer to the color of the bole wherever what can be seen from one side of the page matches what can be seen from the other. Where there is no confirming match, I refer to the color seen from the reverse as the "foundation color." Although that color is the result of several possible factors, it is nonetheless a useful indicator of the technical changes that account for the differences in general effect of the gold leaf as seen from the front.

Gold is used in several ways in these miniatures other than to color the backgrounds. In the first folios the edges of the frames are in gold leaf, and all other details of the architecture and borders are painted with an emulsion of gold powder burnished to resemble leaf. As early as folio 5v and from gathering II onward, more details are finished in highly burnished leaf, such as the buttresses and the outlines of the gables and arches, and only the roof and very fine details, such as the forms of the rose and vine motifs in the borders, are painted in gold.[48] Gold is also used without a bole on objects that are gold in the biblical text, such as the golden calf.[49] In these places the gold is flat, slightly wrinkled, and distinctly different in surface from the burnished gold of the background.[50]

· · ·

Technique and Palette: The Histories. The parchment is readied for painting with a thin white coat that appears in all parts of the miniature.[51] The palette in most Parisian manuscripts of the second and third quarters of the thirteenth century is built around a principal dark and a principal light color, usually blue and orange-red, which are the "body," or laying-in, colors for figures. In the Psalter these laying-in colors are so thinly applied that the light colors are transparent and the dark ones, while usually opaque, can be transparent too.[52] Because these colors have different implications for modeling, I discuss them separately.

In the Psalter the principal color is a warm deep blue. In the first four folios it is especially clear; shapes are outlined in pen rather than modeled at the edges, and internal forms are shadowed with a slightly darker blue of similar hue. The use of this modeling tone is minimal, even reticent, and the natural depth of the blue is left undisturbed. At the same time, the subtle difference in value clearly signals a kind of painting that depends upon the perception of highly nuanced distinctions. In other parts of gatherings I, II, and IV, blue is handled with less delicacy.[53] However, the shadowing is always with a darker tone of blue, not black or gray, and shadows adhere closely to the low, usually curvilinear form of drapery rather than fall in large swaths or into broad folds or recesses.[54] Other dark or opaque colors, such as gray and orange, are less frequent and are usually flat and unmodeled.[55]

There are two notable exceptions to these practices in this first part of the prefatory cycle. The first involves gathering III (fols. 25v–28r). The parchment of this gathering is prepared with a denser base coat, one whiter

than the vellum, and the colors, including blue, are opaque and lie in an intermediate range of a steel gray, pale green, and russet. The internal forms of the figures are mostly drawn with pen rather than with a darker color, so that they tend to be flatter, even though their outer contours are delicately modeled in light brown or gray. These features occur nowhere else in the Psalter of Saint Louis but are typical of the Psalter-Hours in Cambridge.[56] The four folios, with their precise drawing and opaque surfaces, conspicuously differ from the other Psalter miniatures, which are largely keyed to the transparency of the medium.

The second exception is found in gatherings I, II, and IV and, curiously enough, affects only single figures. Several are painted in light blue and modeled with deep blue shadows and white highlights, such as Reuben in folio 17v, while others, notably the angels, are essentially the reverse, for they are painted in white but modeled with striking effect in delicate shades of blue (fol. 8r).[57] Most striking of all are the figures of Rebecca (fol. 11v) and Eleazer (fol. 12r). Their white robes are continuously modeled; shadows are especially deep and in several places envelop the outer contours; and white is applied not only in lines for reflections along protruding edges and folds but also in broader areas, such as the chest or shoulder, so as to suggest the way a discrete section of drapery is illuminated. What is new here is the tightness of the modeling and the clarity and richness of contrast, the effect of shadow upon silhouette, and how these manipulations encompass almost the entire figure, suggesting its illumination and the mobility of light upon it. Oddly, an almost antithetical approach to modeling is found in this same part of the manuscript: a few figures in gray-blue robes are painted so thinly that in some sections of the body, such as the knees and chest, the whiteness beneath the figure shows through and suggests its roundness (fols. 38r, 39v).[58]

All of these techniques, which tend to be highly localized in particular figures in the first gatherings, are taken up in the last two gatherings, where they become more pervasive, affecting all the figures. The blue and gray-blue body colors broaden in range (fol. 72r). In some cases contrasts are heightened and exaggerated by white reflections; in others, the dark hues are balanced and the rounded forms of the body are described within a narrow range of values (fol. 73v). Even the darkest colors, including black, are sometimes thinned to suggest the way the body is lit (fol. 74r), while blue is so darkened at the outer contours of some figures that they seem to emerge from shadows into light (fol. 76r). Most remarkable is the way these variations are found in figures that occur side by side, as though they were each a separate study, the eye moving from bold contrasts and powerful figures to exercises in nuance and figures that are almost apparitions of color (fol. 75v).

The principal light color of the Psalter palette is especially distinctive. As noted above, blue is normally paired with some variation of its complement, usually an orange brown or a red-orange. In the Psalter its complement is in many ways intermediate between both colors and thinner than either, and can have so little body color that it appears to be almost a wash. It is a color of unusual subtlety, in many ways the operative one in the miniatures.[59] It may vary with the addition of yellow to a pale golden tan or, with the addition of red, to a pale soft pink, but in most cases it lies in between, in the yellowish pink range. I refer to this color as "salmon," a term that also suggests something of its tonal delicacy.[60]

Because of the thinness of the medium, the salmon and other lighter colors involve techniques different from those for blue and the opaque and dark colors. The lighter colors are applied in a first coat that is so dilute as to be transparent, and subsequent details, while slightly darker, are never opaque. The result is a technique similar to watercolor, one in which the transparent color is brightened by the lightness of the ground and modeled by an overlay of wash of the same hue.[61] This technique appears in a highly developed form early on in the manuscript. Beginning in the irregularly occurring bifolios of gathering I (fols. 5v–6r, 8r–9v, and especially 11v–12r), salmon is used as barely more than a delicate ambient tone, modeled with traces of pink, alongside the deep blue. By gatherings II and IV a secondary, warmer application of salmon, a modeling tone, is used to suggest the forms of the drapery, but the nuance in hue is such that the darker tone appears to diffuse into the lighter one. The hue begins to move toward tan tonality and continues to do so in gathering V and later. Here the paint is still thin but is almost unmodulated, probably laid down in a single layer, so that the underdrawing, which sometimes shows through the light color of earlier miniatures, is overdrawn in pen. In the absence of

details modeled in a darker color, these short thin lines become increasingly operative, flattening the figures, which in any case diminish in scale. This dependence upon line drawing continues for most of the next six gatherings, especially the Samson scenes of VIII and IX, where the sparse lines of the underdrawing are complemented by details added in soft lead and in black ink.

As in the case of the opaque colors, the greatest change in technique takes place in the last two gatherings. If the lighter and darker colors were made to work together by heightening the contrast in values, here the darker colors are thinned and tightly modeled around a medium tone, and the lighter colors are varied and deepened through additional layers of wash. The result is gray-blue drapery surfaces having an exceptional thinness and luminosity, and greens, yellows, and oranges of striking vibrancy and freshness. Highlighting with white becomes extremely restrained and largely unnecessary, for the lightest areas are those where the vellum ground shows through.[62] When white is used, it functions like a final wash, adding a slight glow to an already delicate pink color.[63] The painted light and reflected light thus begin to merge, as do color and surface tone, so that some of the last figures have a luminous and ephemeral existence, yet one closely tied to the white vellum surface.

The final component of palette and technique is the gold leaf of the background. Although leaf was normally applied after the underdrawing but before the painting, in the Psalter, where the underdrawing is sparse, the application of gold and the painting probably followed each other closely, and much suggests that they were understood in the same terms and perhaps even applied by the same hand. Aside from its material and theological implications, a gold background poses far-reaching artistic problems. As a metal it can surround and imprison forms, and as a reflective surface it denies depth, atmospheric or coloristic, and tends to move all forms forward. In the Psalter miniatures, with their layering of space and emphasis on movement and luminous effects, the traditional use of gold might have had a devastating effect, immobilizing the figures, overwhelming nuances of color and value, and freezing the page into a highly burnished but ultimately decorative pattern.

Considerable evidence suggests that the Psalter artists became aware of these problems and responded by experimenting, probably by trial and error, with the preparation of the gold backgrounds. The foundation is dark gray and thin in the first four folios and a darker yellow in the remainder of the first gathering, the irregularly placed folios being a warm yellow of slightly green cast. In the entire second gathering the foundation is yellow; from the front the gold has a particularly yellow coloration, which works well with the large transparent surfaces of salmon in these miniatures. In the exceptional third gathering, the bole is black and thicker and the gold more strongly reflective and deeply colored than anywhere else in the manuscript.[64] The irregular fourth gathering, like the first, has folios prepared in two different ways, both considerably thicker than the preparation for gatherings I and II. Some folios have a dark gray foundation that continues into the next gathering (V), while others—including all the irregularly placed folios—have a green bole.[65] In the sixth gathering a yellow foundation suddenly returns, just at the point where other aspects of the miniature lighten, where the borders become gold filigree and the flank of the building becomes entirely salmon. Here, however, the foundation is thicker, and it remains so in the two subsequent gatherings (VII, VIII), where the bole darkens slightly to a warmer yellow-green. A similar darkening occurs in gatherings IX and X, where the bole appears to be brown, perhaps in part because the application is so thin that the leaf seems to be fixed directly to the parchment.[66] A last adjustment, to an even lighter brown and thinner bole, occurs in the eleventh gathering, just when the final experiments with color and tone take place.

This final change parallels the introduction of thin washes and is particularly appropriate to the palette in the three final gatherings. Warm but less dark, the gold here retains a cast that gives depth to the background but reduces the yellow that would otherwise sap the yellow, orange, and green of the paintings; and being thinner, the gold is flatter and thus reduces surface reflections that would otherwise interfere with the luminosity of the figures and the painted reflections. These changes in gilding thus parallel changes in palette and are consistent with the other concurrent changes in technique. I believe they represent an attempt to adjust the tonal and reflective aspects of gold to those of the palette, to create a more consistent visual field, and to explore the pictorial values of gold while retaining its economic and symbolic implications.[67]

FIG. 8 *New York, Metropolitan Museum of Art, Cloisters Collection, 1954, Hours of Jeanne d'Évreux (54.1.2), fols. 34v–35r.*

Thus, in these last gatherings several technical approaches appear, sometimes beside each other. Some forms are more thickly painted with bold contrasts and rhythmic line, and others are thinly painted with nuanced modeling in color or with gradations in value. These approaches are ultimately irreconcilable, at least in this form, for strengthening the color of the light tones results in a loss of transparency, and thinning the dark ones tends to wash them out. Subsequent artists, such as those working on manuscripts associated with Master Honoré, primarily pursued the former approach, which results in a more sculptural effect. It was only in later manuscripts, like the hours that Jean Pucelle painted for Jeanne d'Évreux, that the basic artistic problem was revisited.[68] By using the parchment ground for his white, as the Psalter artist did in the last gatherings, Pucelle retained the luminosity of surface without hav-

ing to paint on reflections; and by working in grisaille, he could model around the middle tones and develop a curvilinear play along a contrasted edge, as the Psalter artist did, but without having to paint in an increasingly thin medium. If the Psalter artists worked to some extent like watercolorists, thinning darks and grading color, Pucelle worked more like a graphic artist, grading darks and thinning color, the former trying to use the luminosity of the page to light their figures from beneath, the latter modeling his figures down from the whiteness of the vellum, so that its unworked passages function as both light and reflections and the figures seem to lie beneath the surface, sculpted out of the luminosity of the page (fig. 8). Despite their differing aims, they shared a concern with modeling a figure without loss of transparency, with integrating reflected light with the radiance of the ground. We do not know how

Pucelle arrived at his use of grisaille.[69] But since the Psalter may have been in the collection of Jeanne d'Évreux when Pucelle created the Cloisters Hours, one may only wonder if he ever saw the thinly painted and tightly modeled figure of Saul in the left half of folio 73v, which, in the original, is almost a study in tones of blue and gray and is as delicately lit by highlights from above as it is by the parchment from beneath.[70]

. . .

Technique and Palette: Architectural Settings and Frames. It is characteristic of the Psalter that its artists apparently pursued several lines of experimentation with regard to opaque or transparent paint, to drawing, and to the surface of the parchment. In some cases, such as modeling, irreconcilable approaches appear, even in the same miniatures. Another, equally revealing kind of experimentation occurs in the coloring of the architectural details and the design of the frames. The architectural structure remains essentially the same throughout the prefatory miniatures, but the choice of color for the side of the building, its roses and clerestory windows, spandrels and gables, spires and filets, continues to change, sometimes only slightly, from one gathering to another. The fundamental problem is the allocation of blue and salmon in relation to orange and gold. At issue is the extent to which the program of color is decorative and depends upon a complex system of small zones of alternating color or is structural and functions to clarify the architectural relationships and the linkage between facing pages. The situation is similar for the frames, in which the choices are between painted or golden, continuous or segmented, vine forms, but the fundamental problem is one of pattern and movement. Once again the issue is between a decorative concept in which forms and movements are independent of and sometimes conflict with those in the picture and one in which their delicacy and rhythm are consistent with the forms within.

For architecture, as for painting technique, the most forward-looking work occurs in the irregularly placed bifolios of the first gathering, folios 5v–6r, 8r–9v, 11v–12r. These introduce the basic blue-salmon contrast and experiment with extending the gilding to the upper parts of the building. The arrangement of folios 11v–12r, with the exception of the dark clerestory windows, becomes standard in gathering II: the color of the building flank and spandrels alternates with that of the clerestory windows, gables, and roses, the choices on one page reversed on the next. The intermediate third gathering is exceptional, since most of its details are taken up only in the last one. It does, however, introduce a slightly higher, thinner structure that reappears in the fourth gathering and in about half of the miniatures from the second phase of production. It also introduces an alternation of colors between the two bays of the same miniature, a practice that also continues in IV and V, and to a lesser extent in VI and VII, where the alternation between bays is confined to the roses, spandrels, and gables but the color of the building flank and clerestory windows remains the same not only from one bay to the next but also from one page to the next. The following gatherings extend this simplifying trend, with VIII eliminating all alternation between bays and pages, as well as the gold penwork in the spandrels and gables, a decidedly plainer and flatter approach that also informs the narrative scenes of these gatherings. This arrangement and its color scheme remain the rule until gathering X, when a pale pink appears in all the gables, and then XI–XII, where the pink, now moved to the spandrels, is balanced by a light blue in the gables, both elements outlined in black and redecorated with small black trefoils. This sharper relief and more delicate coloring go hand in hand with the palette and modeling found in the biblical scenes, the result being that the large gabled arches seem to relate to and sometimes overhang the scenes and to be detached from the building behind. There are other changes too in these miniatures, but those just described are sufficient to demonstrate that after the first gatherings, changes in the proportion, coloring, and motifs of architectural forms involve large runs of miniatures and parallel formal changes in the narrative scenes. These changes, while not always progressive, tend toward a clarified, stabilized, and more unified design.

The fundamental changes in the frames generally occur in the same places as in the architecture. The "irregular" bifolios of the first gathering involve essays with more broadly spaced motifs or with colors used consistently along the inner or outer sides of the vines instead of alternating on both sides. As in the pricking and architectural patterns, the arrangement found in the irregular folios of the first gathering continue into the second, and both patterns found in the first gathering

recur in the fourth. The intermediate third gathering has frames of entirely different design, exceptional in this location but identical to those of the last gathering. A basic change takes place with the fifth gathering, which introduces frames with sides subdivided into two and three units and an alternation of both painted and penned motifs and blue and salmon backgrounds. The tripartite units and the alternation of techniques are immediately dropped, for the next two gatherings (VI and VII) have only motifs penned in gold, which better correspond to the gilded architectural forms, and only two-unit frames, which better correspond to the two-part division of the miniature, though the sequence of colors on folios 47v–48r is reversed in the remaining six miniatures of these gatherings.[71] From the eighth gathering the frame edges become single units, reflecting the simplification in the decoration of the architectural forms. Later changes are subtle but significant, especially in the eleventh gathering, where the vine motifs begin to cross and become a series of linked and reversing spirals. In these last gatherings the uninterrupted borders of salmon and blue correspond to the full dimensions and coloring of the architectural structure, and the stylized vine motifs, to the preference for curvilinear and reversing forms in the figures. The result is a simplification of color and structure, a more unified approach to the density and complexity of motifs, and a clearer and more integral relation of the frame to the forms within it.

· · ·

The Structure of Production. These developments in the decoration of the architectural settings and of the frames are strikingly parallel. The irregularly placed bifolios of the first gathering anticipate the second and fourth, a decisive turn occurs in the fifth, and a more integrated architectural vision emerges in the eleventh and is realized in the two subsequent gatherings. The third gathering is part of this final development and, at least in the case of the architecture and frames, is all but identical to the last gathering. The reader will also recognize that these groupings also correspond to developments described for the palette, bole, and technique of painting in the biblical narratives. Such coincidences cannot be fortuitous. Since they follow differences in gathering structure, involve the decoration of all parts of the page, and correspond to the larger pictorial changes in the series, they are likely to be indicative of the organization

of work on the prefatory miniatures and the larger changes in production it underwent. I take the latter to consist of three phases: first, gatherings I, II, and IV; second, gatherings V–X; and third, gatherings XI–XIII. Gathering III, though related to this last group, is exceptional and constitutes a special case to be discussed in the next chapter.

It will also be recalled that these gatherings exhibit two different systems of pricking the parchment for ruling and four different architectural patterns. These physical variables, in addition to the differently tinted boles, all precede the painting of the miniatures. All of them involve runs of consecutive gatherings and reflect the allocation of regular and irregular bifolios in gatherings I and IV. In fact, the pattern of variables that are preparatory has much in common with the pattern of those that involve the finishing of the painting. Since we know the order of each phase of work, it is possible to see if any of these variables align in a meaningful way.

One naturally begins with the two patterns of pricking, which suggest the parchment was fairly evenly distributed, at least until the final phase of production.[72] The architectural settings were drawn next, but they are distributed progressively, the first being used in gathering I only, the second and third in gatherings I–VIII and XIII, and the final one only in IX–XII. Until the fourth, or the last stage of production, architectural settings are used consistently with the same pricking pattern. Because the fourth setting is used with both pricking patterns, there are five different combinations, so at this stage of production, before the bole was applied, the ruled parchment with architectural patterns might have been divided among five different groups.

It is more likely, however, that they were divided among two, because of the binary relation between the variables. The "regular" and "irregular" bifolios of gatherings I and IV not only have two different pricking and architectural patterns but also distinctly different boles, either dark (black/gray) or light (yellow/green). A particular pricking pattern and a light or dark bole are consistently associated in all the other gatherings too, usually in runs of two or three consecutive gatherings, and this association remains unchanged within a single phase of production. The same relation holds for the architectural patterns and bole; that is, within each phase of production no architectural pattern that appears with a dark

color of bole will also appear with a lighter one. The variables in one phase combine differently in the next, and new architectural patterns and new tints of bole are introduced. However, these pairings strongly suggest that two production groups worked in tandem and had access to the same materials and patterns.[73]

Appendix VII illustrates one way in which this working arrangement may have been organized. All the gatherings are divided into phases, with the regularly and irregularly placed folios in gatherings I and IV divided in subunits. The three physical variables related to the preparation are allocated to each gathering. When these units are then separated into a first or second group according to one of these variables, their relation to each other and from one phase of production to another becomes clear.[74] Appendix VII uses bole to distinguish the two groups from each other because the bole immediately preceded the painting and because the other variants depend on frames or patterns, which could presumably be transferred from one group to another.

The appendix occasions several observations. Two groups of artists collaborated on two of the three large gatherings during the first phase of production. After the first phase of production, each group worked independently on small, four-folio units, the final stage being completed by one group only. In the first phase of production, characteristics in each gathering remained unchanged within each working group; they were reallocated in the second and third stages, but the same features are never used by both groups in the same phase. The single group that completed the cycle seems to have assimilated characteristics of the other, particularly the lighter bole and the recently introduced architectural pattern.

The variables in Appendix VII enable us to study with greater precision the irregularly placed bifolios of gatherings I and IV and thus how work on the miniatures got under way. Diagram 5 illustrates how the allocation of responsibilities between the two groups of artists (x = first group, y = second group) is related to the structure of the gatherings.

Appendix VII and diagram 5 together suggest some of the problems encountered in these gatherings. For example, throughout the prefatory cycle conjoint miniatures, that is, miniatures painted on the same bifolio, are prepared and painted in the same way and have the same palette and decorative detailing. However, the conjoint

DIAGRAM 5: *Structure of Gatherings* I *and* IV *Showing Working Groups*

miniatures of bifolios 1/14, 2/13, 3/10, and 4/7 differ from each other in the tint of their bole and in the motifs and coloring of the architectural zone.[75] In spite of these differences, each scene still corresponds to the one in the facing miniature; that is, although the figural styles in the miniatures of folios 1v and 14r differ from each other, they correspond to those in the miniatures of folios 2r and 13v, respectively. Designing each of the conjoint miniatures to correspond to its facing miniature is a particularly inefficient and labor-intensive way of working, especially with decorative motifs and palette changing from one pair of facing miniatures to the next, as they do in this first gathering. In gathering II procedures are simplified because a standard decorative scheme is instituted, suggesting that the situation in the first gathering was not the result of a desire for variety but of uncertainty about how to proceed.

The allocation of responsibilities in these two groups reveals another problem. As noted above, facing miniatures are read together and for the most part correspond to each other in style, palette, decorative scheme, and so forth. However, the facing miniatures of folios 7v–8r and of folios 9v–10r do not correspond, but those of folios 7v and 10r and bifolio 8r–9v do. It is likely that these latter pairs were intended to face each other, an arrangement disrupted when the bifolio 8/9 was inserted into the gathering.[76] But this insertion carries with it certain problems of its own, for bifolio 8r–9v comes at a point in the gathering where, in order to maintain the arrangement of facing illuminations, the sheet has to be folded outward rather than inward, as it was with

inserted bifolios 5v–6r and 11v–12r. Since folding out-ward reverses the order of miniatures but the final order is still correct, the insertion of this bifolio must have been anticipated by whoever planned the miniatures. Thus, even though the painters took pains to paint the conjoint miniatures of a bifolio so that each would match the painting it faced, they could not coordinate miniatures coming from two different groups. A notably different situation arises at the only other place in the manuscript in which a bifolio is folded outward, folios 38r–39v. In this gathering differences in palette and dec-orative motif are not an issue, because the decorative forms and palette are roughly the same throughout the gathering. Here, however, the reversal in the order of the miniatures was not anticipated, and so this is the only instance in the cycle in which the illustrations do not correspond to the biblical order of events.[77] If there was a plan for this section, it was overlooked.[78]

Nothing suggests that any of the irregularly placed bifolios in gatherings I and IV are afterthoughts or rep-resent an attempt to expand a smaller cycle: many of their subjects—the Destruction of Sodom, the Plagues of Egypt, Moses Receiving the Law—illustrate Old Tes-tament subjects found in contemporary psalters and are essential to the program of the cycle.[79] Rather, the irreg-ular bifolios once again underscore the uncertainty about procedures and about how work done separately is to be integrated. This exceptional and short-lived arrangement suggests that these artists were not used to working together, that they may not have come from a traditional atelier of manuscript painters, or that they were not organized along traditional lines. If these initial gatherings demonstrate that the artists began without a definitive decorative scheme or manner of working, they also provide telling insights into the rapidity with which certain problems were brought under control while oth-ers continued to be the subject of experimentation.[80] The problems of collaboration were no doubt easier to solve than were those of artistic vision.

Appendix VII accounts for most of the variations in physical evidence presented earlier. Nevertheless, it must be regarded as tentative, for its organization into work-ing groups according to differences in bole, or founda-tion (as opposed to pricking patterns, for example), is based upon a model that assumes that choice of bole or palette was fundamental to the working methods of an artist. It is only in the next chapter, where individual hands are distinguished, that this hypothesis between artist and palette can be tested and the differences between these groups and phases can be translated into the personal and evolving vision of individual painters.

Legends

The prefatory miniatures are identified and explained in lines of text written on the reverse of each miniature (fig. 9).[81] These texts, the only French texts in the Psalter, average about twenty-five words, although some are three times longer. Each begins with the formula *En ceste page est comment . . . ,* that is, with a phrase that refers to the miniature on the reverse and introduces the explana-tion.[82] The latter does not quote or paraphrase the rele-vant biblical text, nor does it attempt to entitle or otherwise encapsulate the subject or to provide, at least not directly, a moral lesson or interpretation. It is instead descriptive and reconstructive; it identifies the principal actions of the miniature and guides the viewer through a selective reading of the depicted event or events. In this study I refer to these texts as *legends,* a term that, given the location and character of these texts, is more apt than *tituli* or *commentaries.*

The practice of accompanying medieval paintings with descriptive, explanatory, or moralizing texts goes back to late antiquity.[83] In illuminated manuscripts they appear as captions or scrolls within the paintings, in phrases or *tituli* beside them, or in longer texts nearby. They are increasingly common after the mid–twelfth century, occurring most often in manuscripts with an extensive and continuous series of miniatures, such as those found in lives of saints or in psalters.[84] They are frequently written in vernacular languages, even if the principal text is in Latin.[85] And if there are several scenes on a page, the legends may be placed around or between the miniatures, so that the reference to a particular scene is physically proximate and unambiguous.[86] By the late twelfth century legends tend to become longer and nar-ratively more descriptive, reconstructive, and linguisti-cally complex.[87] This is especially so for the legends in the Psalter of Saint Louis. Some of its legends are long and detailed because of the number of episodes illus-trated in a single miniature. But others become parallel narratives, as the author of the legends sometimes sup-

plies background or interim events, reorders actions that are simultaneous or causally related, and uses tense or syntax to suggest the role of a single episode within the larger series of miniatures.[88]

It will be recalled that the rulings for the legends depend upon the framing of the miniature on the reverse. They must have been made before the miniatures were painted and gilded, because they made no impression on the painting or the gold on the opposite side of the folio, even though some are deeply engraved into the parchment.[89] They may have been ruled when the miniatures themselves were ruled or after sketches for the miniatures were drawn on the parchment. In any case, the legends were anticipated very early, probably from the outset of production. They were allocated a standard length of four lines, even though some turned out to be shorter or longer.

The legends are the work of two scribes.[90] In the longer gatherings where they both worked, the allocation of folios among them bears no relation to the structure of those gatherings; each scribe simply worked on a run of folios. Similarly, the short, four-folio gatherings were each the responsibility of a single scribe, although the allocation of gatherings among them bears no relation to that among the two working groups proposed in Appendix VII. Thus even if the legends were planned from the outset, they were written during one of the last stages in production, probably after the folios had been ordered and were waiting to be bound.

The script is contemporary with that of the rest of the manuscript, and the way the texts are written suggests they were dictated.[91] Although there are no corrections, there are six interlinear additions, of which five identify the protagonist or add some essential detail.[92] These additions suggest omissions because of familiar names or shared assumptions rather than errors characteristic of copying, such as skipped lines and omitted phrases. Even if they were not dictated, changes in inking and pen, even in the same sentence, suggest the kind of frequent hesitations or interruptions one would not expect if the scribe were copying another text.[93]

The content of the legends points to a dependence on a pictorial model, in all probability the miniatures themselves, because several include details resulting from ambiguities or details in specific pictures or in relations between facing pages. For example, folio 71v

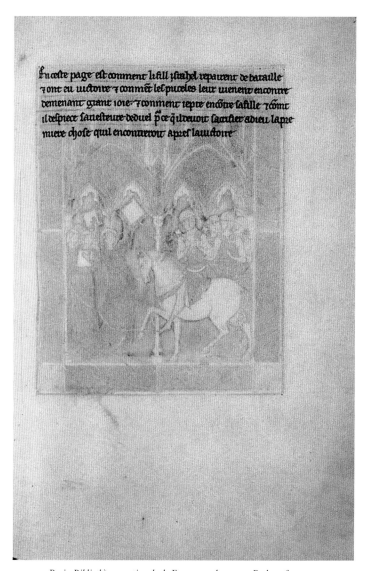

FIG. 9 *Paris, Bibliothèque nationale de France, MS lat. 10525, Psalter of Saint Louis, fol. 53r: legend for fol. 53v, Jepthah Is Met by His Daughter.*

should illustrate the episode of the Philistines suffering plagues after they had stolen the Ark of the Covenant. However, the painter gave one of the Philistines a Jew's hat, a detail that is not found in the underdrawing.[94] Since the legend identifies the whole group of men as Hebrews, its author probably took his cue from the finished miniature or from the painter or person responsible for this reinterpretation. The facing miniatures of folios 15v–16r lead to a similar conclusion. Joseph appears at the far right of folio 15v, carrying provisions

to his brothers in the fields; the brothers, however, are illustrated only on the facing page, where one points back to Joseph approaching from folio 15v. Because the legend to the miniature on folio 16r refers to Joseph even though he is not illustrated in it, the author is likely to have seen both miniatures or a sketch or plan that included both parts of the scene.

Thus legends were probably intended from the outset. The author might have consulted sketches or a person familiar with the iconographic program, but it is more likely that he based the legends on the miniatures themselves and composed and then dictated them shortly after the miniatures were painted.[95] In any case, the author responded to the pictorial cycle, and this makes his legends particularly important as a medieval reading of it. Although that reading is usually literal and descriptive, the author's response to the miniatures is revealed in the pattern of his errors, omissions, and additions, in what he selected as meaningful, and in the way he wrote, especially his syntax and tense structure. In Chapter 3 I analyze these texts and discuss this thirteenth-century reading of the miniatures in relation to modern ones, including our own.

The Calendar

The liturgical calendar follows the standard Parisian model of the mid–thirteenth century, such as that in Paris missals of about 1250.[96] In comparison to the latter, however, the Psalter makes several characteristic changes or additions. All occur in the Cambridge manuscript, and many are found in a contemporary breviary in the Library of Congress probably made for a member of the royal family.[97]

The significant changes or additions may be divided into three groups. The first and most exceptional are the four obits referring to members of the royal family: that for Robert of Artois, Saint Louis's brother (d. 1249; February 28); Philip II Augustus, his grandfather (d. 1223; July 14); Louis VIII, his father (d. 1226; November 8); and Blanche of Castile, his mother and, before his majority and while he was on the first Crusade, regent (d. 1253; November 27).

The second group consists of observances related to the Sainte-Chapelle: the feast commemorating the dedication of the building in 1248 (April 26) and its octave

(May 2); the reception of the Crown of Thorns in 1239 (August 11) and its octave (August 18); and the arrival of the True Cross and other relics in 1249 (September 30) and its octave (October 7). In addition, the calendar includes the octave of the feast of the Holy Cross (September 19), which is not usually found in Parisian calendars other than that of the Sainte-Chapelle, and the feast of the relics of Notre-Dame (December 4) in an ungraded entry. Branner found the latter feast to be typical of books that were made for the royal chapels and that presumably traveled with the king or royal family, as opposed to those made specifically for the Sainte-Chapelle and permanently housed there.[98]

The third and smallest group consists of two observances in which a connection to Paris or Louis IX is likely but not specifiable. One is the February 27 feast of the second translation of Saint Honorine, a Norman saint whose cult in France centered on Conflans-Saint-Honorine near the present-day Pontoise. Her feast is common in northern French calendars, especially those of the Rouen diocese, and becomes so in Paris in the fourteenth century.[99] It first appears in Parisian calendars about 1260, and although it occurs occasionally in missals and other books, it is a feature of royal manuscripts, including two psalters and the Washington Breviary.[100] That the observance of this feast was still limited is suggested by the Breviary of Philippe le Bel, of about 1296, for a note following the entry for Saint Honorine affirms that she is not officially in the Paris calendar.[101] This interest in Saint Honorine may have been stimulated by a hitherto unrecognized third translation of her relics in 1250.[102] Saint Louis was on the Crusade, but the bishops of Rouen and of Paris attended, the latter since Conflans-Saint-Honorine was the fief of the church of Paris.[103]

The second notable entry in this third group is the feast of Saint Dominic, on August 5. Although canonized in 1234, he is generally omitted in Parisian calendars of this time except those with specifically Dominican connections, in contrast to the feast of Saint Francis (October 3), which is almost always included. The Psalter's entry for Saint Dominic may reflect the king's close ties to the Dominican order, a connection also suggested by the importance given to Dominicans in the psalm initials.[104]

Two names were added to the calendar at a later date. "Ludovici" was entered on August 25, the day of

Saint Louis's death, in 1270, in a hand of the late thirteenth or early fourteenth century, perhaps just after his canonization, in 1296, and a fourteenth-century hand added the name of "Karolus Magnus" on January 28. Because the Psalter was in the royal collection throughout this period, it is likely that the earlier addition was made under Philip the Fair, who strongly promoted the canonization of his grandfather, and the later one, under Charles V, who had a special interest in Charlemagne.[105]

All of the original entries in the Psalter of Saint Louis calendar are found in the Cambridge manuscript, but the latter includes several saints lacking in the Louis Psalter. The two manuscripts also have many of the same spelling errors, but a few misspellings are unique to each one, making it clear that the Psalter of Saint Louis was not copied from the Cambridge manuscript but probably from a common source.[106] In general, however, the Saint Louis Psalter calendar is less conscientious. A number of indications of *memoriae* and lessons are omitted, especially from the first months, and the entry for the apostle Barnabas is overlooked entirely. The indication of nine lessons for the feast of Pope Gregory is entered twice, the feast of Saint Agatha is incorrectly written opposite February 4 and erased and reentered on February 5, and Saint Crispini (October 25), whose name usually precedes that of Saint Crispiniani, instead follows it.

The organization of the Saint Louis Psalter calendar differs from that of the Cambridge manuscript even though the texts are similar. In the Cambridge Psalter the lines of the calendar are written alternately in blue and in gold, an arrangement going back to a group of luxury Parisian psalters of the 1220s and 1230s.[107] The Psalter of Saint Louis follows a different scheme, also found in the same decades, in which different colors of ink are used to distinguish feasts from each other as well as from secondary information on the same line.[108] This arrangement normally means the scribe will write all the entries that call for one color of ink before going on to the next color, making oversights more likely. This may explain why the lessons and *memoriae* are often overlooked in January even though space is provided for them.

The lack of consistency in the color of ink apparently posed problems from the outset, and there are indications that the scribes began to experiment after the first few pages. On the January page blue is used for the first line of the introductory couplet and the *kalends* column, for some secondary feasts, and especially for indicating *memoriae,* lessons, and astrological notes. The coloring is inconsistent: the saint's name is in one color, other information on the same line is in another, and some major feasts are written in black. Beginning with March, most of what was previously in blue is written in red and black; with April, blue is used only for the first line and the *kalends* column; with June, only major observances are written in red, and the others are in black; and with November, one color is used for an entire line even if other observances on the same line are of lesser importance. Similar changes take place on the February page when the indications of *memoriae* and lessons are detached from the feasts to which they refer and are aligned at the right. This evident attempt to create a right margin makes the calendar difficult to read, and the practice is abandoned after June.[109] Most telling of all is the willingness to omit additional feasts if space on the line is insufficient for them. This practice occurs especially in the later months of the year.[110] These relationships recapitulate the values in evidence elsewhere in the manuscript: a new decorative system is tried out and proceeds by trial and error, and form often takes precedence over content, especially when consistency is at stake.

Heraldry

The heraldry is one of the most striking aspects of the Psalter, especially in the text section, where the arms of France, the golden fleurs-de-lis on blue, appear in the background of four of the eight large historiated initials and in line-endings on literally every folio. In many contexts at this time, such as seals, heraldry refers to specific familial or corporate entities. However, the meaning of these motifs in the Psalter is not easily circumscribed, for heraldry is not used consistently and heraldic signs often occur alongside motifs with no explicit heraldic reference. Because heraldry centers on signs of identity and the recognition of relationships, the matter is of no small moment in a private prayer book.

The problem presents itself most clearly in the Psalter initials. There the fleurs-de-lis occur not only alone (fols. 85v, 192r) but in combination with the castles of Castile (fol. 156v) or in combination with the castles in one part and with the pales of Provence in the

other part of an initial (fol. 110v). In several initials, the arms of France appear behind the figure of David, shown crowned and in contemporary dress as he kneels in prayer before Christ enthroned in a mandorla (fols. 85v, 110v). While their combination with the arms of the king's mother and wife is unexceptional, the king had no right to bear the arms of Provence, and although the king's arms are understandable in relation to David, the prototype for Christian kingship, the royal charges are also found behind nonroyal figures (fols. 110v, 192r).[111] Moreover, David is usually shown kneeling before generic cross forms or ordinary decorative patterns. At the same time, the conspicuous presence of royal arms behind David cannot be entirely without meaning, for it is David's words the king utters and makes his own as he prays, whether he kneels in devotion or is shown beseeching the Lord from the waters (fol. 156v). Thus, even though the manuscript's heraldry is often employed appropriately, it is not always so, and its use in relation to the king, his family, and other contemporary figures (fols. 110v, 192r) is likely to involve allusions that operate at a personal level.[112] This is also the case in the line-endings of two text gatherings and in at least one miniature.

Each line-ending, which fills the space between the end of a psalm verse and the right margin, consists of either a row of blue or salmon lozenges on a bar of burnished gold or a blue or salmon panel edged in gold or, in some of the longer instances, a split field of lozenges or panels with blue on the one half and salmon on the other. The lozenges or the open panel contain animal, floral, heraldic, or other decorative motifs, usually in gold. The motifs and lozenges are aligned with the long axis of the bar and are usually oriented inward, as though to punctuate or at least to slow or halt the direction of reading at the close of a verse. In technique and palette, they resemble the frames of the historiated initials and, like them, are framing devices, line fillers that abut and hold the text and accent it with regular courses of gold and color.

The line-endings are decorated with twelve different motifs or devices. They are listed below in order of frequency:

1. *d'azur à la fleur de lis d'or,* in lozenges
2. *de gueules au château d'or,* in lozenges
3. *de gueules palé d'or,* in lozenges

4. dragons, with tails turning into vines, in gold on panels of either blue or red[113] (fig. 6)
5. eagles, in gold in lozenges of either blue or red, on fourteen folios (fig. 6)[114]
6. opposing birds, their beaks touching over a plant, another plant between their tails, in gold on panels of either blue or red, on fifteen folios (fig. 6)[115]
7. five-petaled flowers, or cinquefoils, in gold on lozenges of either blue or red, on twelve folios (fig. 6)[116]
8. *d'azur à la bande d'argent coticée d'or,* in lozenges, on eleven folios[117]
9. a checkered rectangle, both alternating with two facing birds, in gold on panels, on five folios, and alone (*échiqueté d'or*) in lozenges of either blue or red, on two folios[118]
10. a cross in gold with divided or split ends (*ancrée* or *recercelée d'or*) in lozenges of either blue or red, on five folios (fig. 10)[119]
11. *de gueules au rais d'escarboucle d'or,* in lozenges on three folios[120]
12. intersecting lines, connecting the points of a lozenge and dividing it into quadrants (*esquartelé*), on either red or blue, on two folios (fig. 11)[121]
13. birds (martlets?), in gold in panels of blue or red, on one folio[122]

The first three motifs listed above, which are used also in the backgrounds of the historiated initials, occur only in lozenges and are frequently shown in combination with each other, all three sometimes appearing in the same line-ending.[123] The fourth motif, like the first three, appears in line-endings throughout the text, but it is found only in panels, is heraldic neither in motif nor in presentation, and belongs to a decorative vocabulary not unlike that in the borders of the full-page miniatures.[124]

The seven remaining motifs are found only in gatherings XV and XVIII and may be subdivided into two groups, again according to whether they appear in an open field or panel or in lozenges.[125] As before, the former group is entirely decorative, and the birds that are its most frequent motif (numbers 6, 9, 13) belong to the same decorative repertory as the dragons cited above. Of the six motifs in lozenges, the most important are numbers 8 and 11, which are clearly recognizable as the arms of Champagne and Navarre, respectively.[126] The Champagne arms are the only instance in which white is used

FIG. 10 *Paris, Bibliothèque nationale de France, MS lat. 10525, Psalter of Saint Louis, fol. 97r.*

FIG. 11 *Paris, Bibliothèque nationale de France, MS lat. 10525, Psalter of Saint Louis, fol. 90r.*

(for silver), and the Navarre arms occur only on the same line-ending as those of Champagne.[127] Although Champagne bands are sometimes on the wrong diagonal and the Navarre arms are neither *fermé* nor *pommeté*, their identity is nonetheless clear, and there can be no doubt that the motifs are used intentionally. Branner correctly connected these arms to Thibaut V of Champagne and Navarre, who married Louis's daughter Isabella in 1255.[128] Joinville reports that Louis considered Thibaut a son, and the latter frequently participated with the king and the future Phillip III in translations and other ceremonies.[129] The Champagne and Navarre

arms suggest that the other motifs in this group may have similarly specific references even though they also may not be drawn in heraldically precise terms. They also underscore how the lozenge is a potentially heraldic field, the open panel not, and indicate that the manner in which motifs are combined in the same line-ending may be meaningful.

Of the other motifs in lozenges in gatherings xv and xviii, the most frequent is the eagle. It is also the only one to be found in combination with the fleurs-de-lis, castles, and pales.[130] The eagle appears in the arms of a number of families or individuals at this time, but in

the circle of Louis IX in northern France it is most likely to have referred to the Brienne family. The equestrian seal of Jean de Brienne, also called Jean d'Acre, shows the eagle as its sole motif—the Brienne arms appear only on the counterseal—and the eagle is also his device in the Wijnbergen Armorial.[131] Because his mother was Bérengère de Léon et Castile, the daughter of Blanche's sister of the same name, the castles of Castile appear in his Brienne arms, together with a fleur-de-lis and eagle, and in those of his brother Alphonse.[132] The eagle may have been associated with their father, Jean de Brienne, and then more generally with the Brienne family, for in the thirteenth and fourteenth centuries it is the principal device on the shields and arms of the counts of Joigny, to whom they were related by marriage.[133] In any case, the eagle figures in the arms of no other branch of the royal family at this time; if its combination with the royal arms in these line-endings has any meaning at all, it is in relation to the Brienne.

The Briennes had a small territory near Troyes; they were nonetheless intimately connected with Louis IX and his court and were a family of international standing. Although their local activities were effectively restricted by the counts of Champagne, through a series of important marriages they had become influential in Athens and Constantinople as well as in the Holy Land. Jean de Brienne accompanied Louis IX on military expeditions, led the Fifth Crusade to Egypt, and was relied upon by Blanche, whom he had supported when claims to Champagne were at issue.[134] He was titular emperor of Constantinople from 1231, governing for Baldwin II, his son-in-law. In 1236, the year before his death, faced with a threatening alliance of Byzantine and Bulgarian forces, he sent his sons to Paris, confiding their care to the king and Queen Mother.[135] The two children were raised at court, and their long relationship with the king no doubt lies behind his appointing them to high positions some twenty years later: about 1255 Jean d'Acre was made the king's butler, or *bouteiller*, and Alphonse d'Eu, his younger brother, was named *chambrier*.[136] By the time the Psalter was made, the two brothers had been close to the king for almost twenty-five years.[137] They both accompanied him on the second Crusade, Alphonse dying on the same day as the king. Jean survived and in 1282 was one of those who participated in the proceedings for Louis's canonization. He testified after the

king's own son Pierre d'Alençon and was referred to as the king's cousin.[138]

During the reign of Louis IX the *chambrier* was the first officer of the court, and he and the second officer, the *chambellan*, were among the authorities ordinarily responsible for the clothing, jewelry, or special objects obtained for the king, including possibly his personal prayer books. No records apparently survive that actually show Alphonse functioning in this way.[139] There is more information on his brother. Although *bouteiller* was previously a honorific position, Jean d'Acre turned it into a profitable and important post by identifying and insisting upon former privileges of the office and by keeping a close watch on the accounts due him.[140] After Louis IX's death, he continued to play an important role at court, being entrusted with a diplomatic mission to the Pope in 1272 and with negotiations, in 1275 and again in 1290, concerning the Spanish rights of Blanche of France, Blanche of Castile's granddaughter. He was named executor of the 1285 will of Philippe le Hardi and sometimes played a role in *parlement* as well as in the court ceremonials connected with his office.[141] Thus both brothers were highly placed and close to the king, and there is a remote possibility they were involved with the commissioning of the Psalter. But even if this were true, it would tell us very little, for nothing is known of either brother's personal taste or interest in the visual arts or views of the king, the monarchy, or current religious or political issues. If these line-endings are indeed Brienne arms and refer to one or both brothers, they probably function to enlarge the circle of heraldic reference to include those who, like Thibaut of Champagne, are to be considered part of the king's extended family.

The remaining motifs in this section are less clear. One example may stand for the interpretative problems of the group. Like the eagle, number 7, the cinquefoil (*quintefeuille, marguerite*), appears in heraldic contexts but is not a device attributed exclusively to one family or individual. In north French seals of the mid–thirteenth century it is widely used on the equestrian arms of knights and, less frequently, on the seals of aristocratic women.[142] The most relevant parallel for its connection with the royal arms in the Psalter is the tile pavement from the destroyed chapter house of Saint-Germain-des-Prés, a work probably dating to 1273 and partly preserved in the Musée Carnavalet.[143] The pavement shows a fleur-de-lis as

the center of three successively enclosed squares composed, moving outward, of cinquefoils, castles of Castile, and pales of Provence. Although the four motifs are often found on decorated pavements, the Parisian work is notable because of the possibility of royal patronage and the cinquefoil's appearance within a hierarchical arrangement of clearly heraldic motifs. The situation is thus similar to what we find in these line-endings, but the motif itself may point to no individual, and none may be indicated.[144] Rather, the flower is likely to be a more general allusion. In a sermon on the Nativity preached before the royal family in the Sainte-Chapelle, Bonaventure, citing Christ's descent from the root of David, turns to floral imagery and specifically to the *margarite,* which, like the Solomonic lily of the valley, is precious and comforting.[145] The *margarite* is mentioned in the same terms in the epitaph of Louis's daughter Isabella.[146] Thus the allusions are royal but also Marian, as they are in the case of the fleur-de-lis itself.[147] Similar doubts surround the checkered rectangle, the cross, and the remaining devices. All are difficult to interpret because they are commonplace or because their decorative context makes it uncertain that a specific reference is intended.[148]

The use of these charges and motifs in the line-endings underscores the unusual role of heraldry in the Psalter. Some motifs identify individuals, but all may not, and those that do refer to individuals are not rendered in the systematic and precise way arms appear, for example, on contemporary seals or rolls.[149] The arms of Champagne and Navarre vary even within these line-endings, other devices appear on either red or blue fields, and Jean de Brienne or his sons are identified not by their family arms but by a fictive eagle. Indeed, heraldry was frequently used in this way, for such motifs as the eagle, the cross, and the cinquefoil were increasingly depicted as the arms of biblical or literary figures in contemporary illuminations.[150] On the one hand, line-endings are not a traditional context for heraldry, and it is by no means certain that the usual rules should apply. On the other hand, the arms of Champagne-Navarre refer to the king's closest family, and it is logical that the Brienne would use those titles and devices that allude to their real source of power, which did not lie in their small ancestral lands but in alliances by marriage to the royal families of France and Jerusalem. Indeed, the suggestiveness of the eagle might have contributed to,

rather than deterred, the Brienne's use of it; after all, Jean's repeated references to himself in relation to Acre or to Jerusalem were a fiction he actively maintained.[151] One must then allow for a heraldry that lies between the decorative and the systematic, one that is meaningful without being altogether precise, that recognizes how a motif signifies heraldically but then allows how its "charge" can function as an allusion.[152]

This is its use in at least one of the full-page miniatures. Beside Abraham battling the Canaanite kings (fol. 5v) is a shield blazoned *d'azur semé de fleurs de lys d'argent;* another shield decorated *d'argent au dragon de sable* is beside the king he conquers. It is not surprising to find the fleurs-de-lis and dragon motifs used to identify good and evil soldiers, but here the painter exceptionally uses silver, rather than gold, for the fleurs-de-lis.[153] Given the quality of the miniature, the familiarity of the arms of France at this time, and the frequent recurrence of the fleur-de-lis in this royal manuscript, the use of silver is almost certainly purposeful. By changing the tincture of the motif, the miniature avoids the erroneous identification of Abraham as a member of the royal house, but by retaining the charge, it reiterates the traditional linkage between the leaders of Israel and the rulers of Capetian France, an association found elsewhere in the Psalter, as seen in later chapters. The painter thus uses the forms and syntax but not the grammar of heraldry in order to cite a specific family and posit a relation that is prototypical, paradigmatic, and historically apt.[154] Such arms have a metaphorical function, suggesting the inherent relations rather than identifying individuals.

Given this fictive usage of heraldic charges, even the meanings of the fleurs-de-lis, castles, and pales in the Psalter may not be as straightforward as they appear to be. Although the fleurs-de-lis refer to the Crown, the king had no right to bear the castles of Castile alone, and he never bore the fleurs-de-lis with the pales of Provence, motifs that appear together in the initial of folio 110v and in many line-endings.[155] The castles figured on Blanche's own seal, but Eleanor's rights to Provence were a point of contention, and she may not have borne the pales until after Louis IX's death.[156] A few line-endings even combine the castles and pales, which never would have been found in contemporary arms.[157] Nonetheless, these arms do appear together in the king's Psalter as well as in some works made for his children.[158]

If these three arms, which are so conspicuous and insistent in their collective use, project an image of Capetian kingship, it is tempting to interpret their use politically, that is, to see the arms of Castile as representing Louis's claims on Castile, or Capetian political ambitions, at a time when a marriage between the two kingdoms was under negotiation, or to see the arms of Provence as declaring a proprietary relation in opposition to the designs that Louis IX's brother Charles had upon those lands.[159] But one might also interpret them like the arms of Abraham, that is, as a signal to the king that this book and the history in it were profoundly his own. As such, the combination and reiteration of these motifs, as well as the allusions to the houses of Champagne, Champagne-Navarre, and possibly Brienne, can be understood as a cumulative reference, one that manifests what Branner called "la présence de l'intime famille du roi."[160] Rather than a site for competing political claims, they create an extended reference to the individuals and also to the fabric of relationships surrounding the owner of the book. Like the obits for his ancestors in the calendar, and like the religious figures in the lower portions of the initials to Psalms 26 and 38 (fols. 110v, 126v), they were part of the mental world in which the king prayed.[161] They suggest the familiar and familial relationships that would have conditioned his relationship to the book. Along with other signs, like the alternating blue and gold verse initials of the text, they continually connected him to these pages where history, memory, and identity all come into play.

Losses, Additions, and Corrections

Because the subjects of the first and last miniatures are unprecedented as ways of beginning and ending a prefatory cycle of psalter miniatures, several scholars have assumed that paintings were lost from the beginning and end of the series.[162] However, there is no physical evidence of losses within the series of full-page miniatures or, for that matter, of additions to the miniatures or alterations to the gatherings, and despite the lack of physical evidence to affirm the originality of the present arrangement, Jordan has argued for its thematic coherence.[163] Two details strongly suggest that folios 1v and 78r were always the first and last miniatures. The scribe who wrote the first legend added an unnecessary "est" ("En ceste *est*

page est conment caym . . ." [fol. 1r, italics mine]). Although the legends contain scribal errors of other kinds, this is the only one in which an error appears in the standard formula introducing all the legends, an error most likely to have been made the first time the formula was used.[164] The evidence is even stronger that folio 78r always ended the cycle. In the early fourteenth century, when Charlemagne's name was added to the January page of the calendar, the wet ink transferred to the facing page, folio 78v.[165] It is unlikely that pages were lost before then, since the manuscript had presumably been in the royal collection since its creation. While such evidence is hardly conclusive, in the absence of indications to contrary, it supports the assumption of the originality of the present arrangement.

The Psalms are complete and are written without *tituli*, numbers, prefaces, or other secondary or supporting matter. The script is a Gothic *textualis formata*, a liturgical book hand written with exceptional clarity and elegance, probably by two scribes.[166] In comparison to the Isabella Psalter (Cambridge, Fitzwilliam Museum, MS 300), the script is more compact, and the text has more frequent abbreviations. And like the Cambridge manuscript, the text continues without break to the standard canticles and creed, ending with the last verse of the prayer beginning *Quicumque*. Both manuscripts omit the prayers beginning *Pater noster, Gloria in excelsis, Credo in deum patrem omnipotentum*, and *Credo in unum deum*, prayers that frequently but not consistently precede the *Quicumque*.[167]

The *Quicumque* is usually followed by the litany and closing prayers, and their absence in the Psalter has led several scholars to assume that several pages were lost from the end of the manuscript.[168] The last gathering, which has only three leaves, has a signature and so is complete.[169] However, ending with the *Quicumque* makes no sense liturgically, strongly suggesting some loss at the end of the present codex. There are two likely possibilities: either a gathering or two with the *Kyrie eleison* and litany followed, as they do in other Parisian psalters, or the prayers continued, as they do in the Cambridge manuscript, with such texts as the Hours of the Virgin, litany, collects, Hours of the Dead, and lessons for the feasts of the Virgin.[170] Considering how the Paris and Cambridge manuscripts resemble each other up to this point, the latter possibility cannot be ruled

out, but it is the less probable alternative, for if it were so, the Psalter would have been almost 50 percent longer, and by the fifteenth century the binding of the manuscript was already so tight that there was room for only a few additional folios.[171]

The text of the Psalter of Saint Louis has an unusually large number of corrections. They are expertly made. The original text has been scraped away, but the parchment is never excessively abraded, and the ink and script of the corrected text is usually indistinguishable from that of the rest of the page.[172] As in the calendars of the Paris and Cambridge manuscripts, some variations or corrections in the Psalm text occur in both manuscripts, but each has examples not found in the other, suggesting that one manuscript was not copied from the other but that both followed a common model.[173] The most revealing corrections are those which resulted in the replacement of folios in both manuscripts. The text of Paris folios 149–51 corresponds to a lacuna of two leaves between folios 64 and 65 in the Cambridge manuscript, and the text of Paris folio 157v (fig. 12) appears on Cambridge fol. 71v, a leaf that is clearly a replacement (fig. 13).[174] Three other leaves of the Cambridge manuscript are replacements of a similar kind, but, in these instances, the corresponding text of the Psalter has undergone only minor corrections; conversely, the passages that require several lines of corrections in the Psalter appear in the Cambridge manuscript in the original, uncorrected hand.[175] Thus, some corrections result from scribal errors and appear in only one manuscript, but others follow from errors in a common source and had to be corrected in both, a situation similar to that found in the calendar.

The four replacement leaves of the Cambridge manuscript are written in a hand different from those of the rest of the manuscript but very similar to that of the original folios of the Saint Louis Psalter.[176] The similarities are not only in script but extend to the decorative and technical aspects of the Cambridge replacement leaves. The conspicuous absence of penwork or any other secondary decoration is the same as that in the Psalter; the forms of the psalm and verse initials are identical in type, as are the motifs that decorate most of the line-endings (fig. 14). Even the technique of laying the gold is the same, as are the colors of the ink and paint, including the Psalter's distinctive salmon color,

which is otherwise not found in the Cambridge manuscript.[177] These replacement folios of the Cambridge manuscript were clearly created by the scribes responsible for the Psalter's text pages. The need to correct the Cambridge text must have been recognized early, when the scribes responsible for writing and decorating the Louis Psalter were still active and still working with the materials and system of page layout distinctive of the Paris manuscript.

In contrast, the four replacement folios in the Psalter of Saint Louis (e.g., fig. 12) differ from the original folios of both books and from the replacement folios of the Cambridge manuscript. The corrections on the replacement folios of the Psalter correspond to those made elsewhere in the manuscript, and these corrections were extensive and numerous enough to have required rewriting all the signatures of the text folios.[178] The script used for the corrections is difficult to date, because liturgical book hands changed very little in the decades after 1260 and because scribes could successfully imitate an earlier hand, just as artists imitated the original initials and line-endings.[179] The replacement folios, however, use a thinner parchment; their verse initials use a lighter blue; and a number of other production characteristics all suggest that the corrections were made at a time when the original materials and scribes were no longer available, as they were for the corrections to the Cambridge manuscript. One wonders whether the two manuscripts were not corrected at the same time—presumably in the late 1260s—because the king had already left on the Crusade with his manuscript, and, if so, how much later and in what circumstances the corrections were made. The additions to the calendar suggest interventions during the later thirteenth and early fourteenth centuries, so that one cannot rule out the possibility that a later member of the royal family had the manuscript corrected, presumably for his or her own use.

The high number of corrections to the psalm text—in the Psalter there are over eighty-five instances—is unusual in a prayer book produced in Paris at this time and especially unexpected in a manuscript in which such care was given to every aspect of execution, including the script itself. Many are the result of common scribal errors, such as the addition, omission, or repetition of words or entire lines.[180] But others suggest that the problem was in the model the scribes used. Because

FIG. 12 *Paris, Bibliothèque nationale de France,* MS lat. 10525, *Psalter of Saint Louis, fol. 157v.*

FIG. 13 *Cambridge, Fitzwilliam Museum,* MS 300, *Isabella Psalter, fol. 7v.*

ti ⁊ lucerne ardentes in manib; uestris ⁊ uos similes
hominib; expectantib; dominum suum quando re
uertatur a nuptijs. ℣. Justi autem inperpetuum
uiuent ⁊ apud dominum est merces eor.

eus qui nos
sanctorum cō
fessorum tu
orum confes
sionib; glori
osis circumdas
⁊ protegis da
nobis. ⁊ eor
imitatione

proficere ⁊ intercessione gaudere. Per
xpm dominum nostrum. Amen. Me
moria marie magdalene. ℣. Jn dieb; illis
mulier que erat in ciuitate peccatrix. ut cognouit
quod ihc accubuisset in domo symonis leprosi at

FIG. 14 *Cambridge, Fitzwilliam Museum, MS 300, Isabella Psalter, fol. 205v, with Confessors initial.*

most of the "wrong" passages have been removed or scraped away, the evidence that might lead to firm conclusions about the nature of the model or its perceived deficiency is absent. Preliminary findings suggest that the model was a particularly early text of the Psalms, such as the Vetus Latina or Mozarabic, and that the corrections served to make them consistent with contemporary Parisian usage.[181] If this proves to be the case, it is particularly interesting for the pictorial cycle, which includes subjects of rare iconography and compositional detail, elements that also suggest the influence of an early model. Whatever the reasons for the corrections, it is certain that they were done early and expertly and that only the text of the Psalms and prayers was affected, not the major psalm initials or full-page paintings.

Summary

In the prefatory cycle several important variants appear in the preparation of parchment, architectural patterns, choice of bole, and the design and coloring of the architectural structure and borders. The number, forms, and combinations of these variants clearly relate to the internal structure of the gatherings and their sequence. These relations tentatively indicate that the cycle was executed by two painters or groups of painters, who worked on it in three phases. Normally, each worked on a single gathering, but in the first phase two gatherings made by one group were completed with miniatures from the other. The odd organization of work first on single bifolios, the errors and frequent adjustments in technique and design, and irregularities in gathering structure all indicate uncertain plans and working procedures and suggest that the Psalter artists were not used to working together or were not accustomed to working in this medium. Similar irregularities and adjustments characterize the decoration of the calendar, the structure and layout of the first text gathering, and the use of heraldry in some line-endings. But such uncertainties were resolved very quickly, as the decorative system was clarified and structures of production were streamlined.

The manuscript provides no physical evidence of the loss of miniatures anywhere in the introductory cycle, although losses at the beginning cannot be excluded. Although legends probably were anticipated, they were based on the miniatures or on the sketches for

them and were most likely written after the leaves were collated but before they were bound. The text, like that used for the Cambridge manuscript, was based on a model that was incomplete or otherwise faulty by standards of the time, possibly an early version of the Psalms. Errors in copying also occur in the calendar, but the text required extensive corrections. Numerous passages were scraped away and rewritten, several pages had to be replaced, one gathering was restructured, and the entire text section of the manuscript was recollated. At least one final gathering is lost at the end of the book.

The calendar of the Psalter is Parisian, of use in the Sainte-Chapelle and other royal chapels. It commemorates the king's ancestors and closest relatives and may give special emphasis to saints of interest to him. Familial and ancestral connections also play a role in the historiated initials and line-endings, which are decorated partly with the arms of France, Castile, and Provence and probably refer to the king, his mother, wife, and children. A broader range of heraldic charges appear in the line-endings of two of the first text gatherings, and although all motifs cannot be connected with individuals, reference is made to some who were particularly close to the king, such as Thibaut V of Champagne and Navarre, who married Louis IX's daughter, and possibly Jean d'Acre and his brother Alphonse d'Eu, who were raised at court and appointed the king's butler and *chambrier*. But these motifs play a small part in the manuscript's heraldry, which is less a system of identification than a system of allusion, a way of recalling the extended family of the king and thus of personalizing the Psalter for its reader.

The analysis of the physical manuscript reveals an exceptional range of innovation, especially as initial uncertainties give way to a systemization and then to an energetic spirit of experimentation. The most striking of these innovations are seen in the preparation and technique of painting, in the relation between modeling with opaque paint and transparent washes, in the description of light, and in the use of reflections from figures and background. Experimentation by trial and error seems to account for the often subtle adjustments in motif, coloring, and proportion in the borders and architectural forms of the prefatory miniatures and, in different ways, in the historiated initials. Changes are most often reductive and aimed at achieving an essential

clarity, balance, and logic of arrangement, values especially evident in the design of the text pages, in their layout, the proportions of the script line, and the line-endings. If some experiments ultimately fail, as do those in the calendar gathering, and others are short-lived, such as the expanded use of heraldry in gatherings XV and XVIII, others achieve an integration of the planar and spatial and imply a design conceptualized in terms that are as architectonic as they are pictorial.

If the parallels that this achievement finds in contemporary building underscore the exceptional place of the Psalter in the history of the medieval book, its relation to earlier and later manuscripts suggests its exceptional place in the history of painting. By the end of the cycle, color and luminosity are essential components of the pictorial composition and a function of gold and parchment as well as paint. Modeling is sometimes from light to dark. And the relation between the pictorial and the architectural illusions, which is the object of attention in almost all miniatures, extends beyond the limits of the page to become the setting for the double-page openings, comprehending, as one turns these pages, all levels of visual experience, from the surface of the page to the handling of the book. Whoever the designers and painters were, their concern with the visual experience of the book—its form, illusion, legibility, and experience—was unprecedented. Their innovations of form and content are the subjects of the next two chapters.

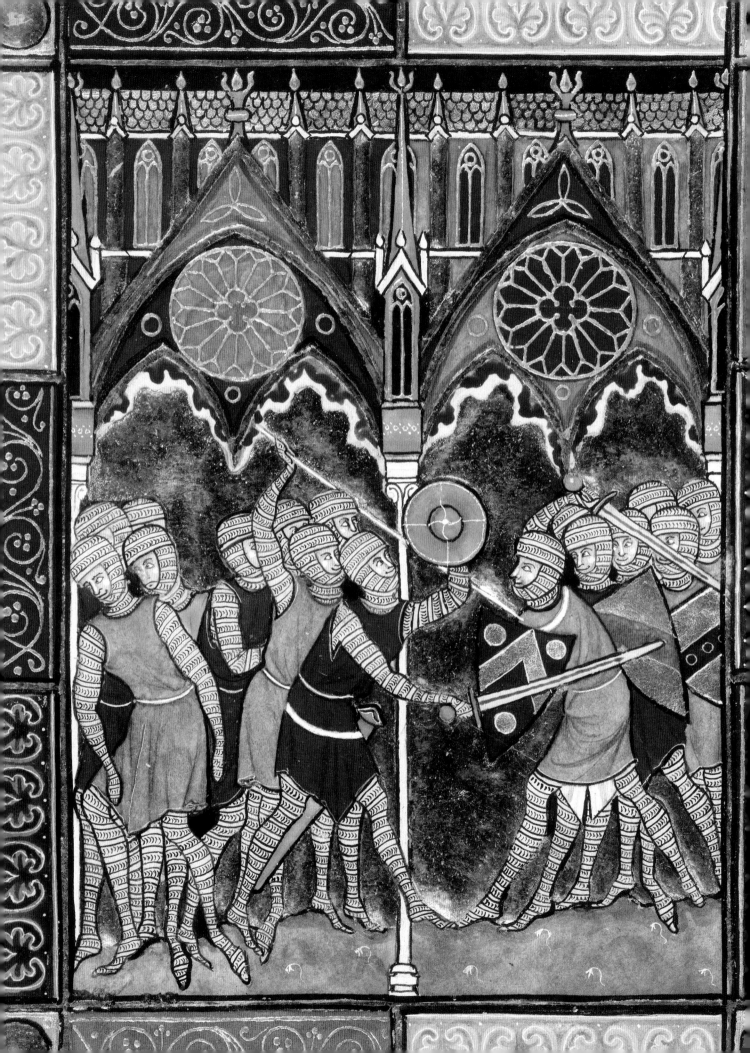

The Artists and Their Paintings

Manuscript Painting in Thirteenth-Century Paris

Several painters collaborated closely to create the Psalter of Saint Louis. The manuscript, however, is the only evidence of what they did and how they worked together, and that evidence is difficult to interpret. The difficulty lies not only in the delicacy of the drawing and painting and in the narrow range of variation in figure types and drapery patterns but also in the irregularities of the initial gatherings and in the subtle, almost continual variations in the larger pictorial and decorative conception. Branner recognized that the irregularities in the first gatherings meant that work began uncertainly, but he believed these tentative beginnings were the result of the large scale of the enterprise and the unusual number of artists and shops that participated, some working on the same page. He attributed the variations in form to the diversity of the painters, who, he believed, belonged to a regular paint shop and who eventually succeeded in repressing their idiosyncrasies and painting in a similar way.[1] In contrast, the analysis in the last chapter has led to the conclusion that design and technique were never really settled and that problematic periods of adjustment gave way to others of sustained experimentation and innovation. Moreover, problems appeared not only in the structure of the first gatherings but in numerous other features of the book, in the text as well as in the prefatory cycle, beginning with such basic matters as the ruling of the page and the relation between facing miniatures. Given the level of expertise in the Paris book trade at this time, it is shocking that such fundamental

Detail of folio 45v, Psalter of Saint Louis

decisions were not made before production began. The quality of the paintings is clearly at odds with the many indications that those in charge were not altogether familiar with how to put a manuscript together. And because one is unable to identify any manuscript—aside from the Isabella Psalter in Cambridge (Cambridge, Fitzwilliam Museum, MS 300)—in which any of these artists worked, one naturally wonders if it is because their experience was in another medium. Either the Psalter was created outside the standard procedures of the market, or the market was far more complex than it appears.

Manuscript production in Paris changed fundamentally during the late twelfth and early thirteenth centuries. Responsibilities for most, if not all, stages of bookmaking had in the past been in the hands of an individual, usually a religious. They were now divided among lay professionals who, working in specialized shops, supplied the parchment or wrote, illuminated, or bound a manuscript, and sometimes sold it as well.[2] Avril found physical evidence for these changes in early-thirteenth-century books, in the homogeneity, patterns of collaboration, and use of common pictorial models.[3] The task of coordinating these various functions might fall to one of the tradespeople—the parchmenter, scribe, or illuminator—but it was normally assumed by a *librarius,* someone who combined the functions of a professional bookseller with those of a modern publisher, reselling used books and producing new ones, usually on commission.[4] The names of the *librarii* and other specialists that constituted the book trade are found in manuscripts and in a range of documents, including rent lists and tax rolls, which make it possible to reconstruct the physical relation of these professionals to each other on specific streets over a period of time.[5] These were not large workshops, or ateliers, but domiciles where a specialist would work alone or with an assistant, normally a member of the family or an apprentice. What emerges is a system of production in which a varied group of specialists collaborated on each project and someone functioned as a producer or dealer. Even in the early fourteenth century, with university regulation and the prominence of certain *librarii,* it remained a market of independent operatives and changing, flexible relationships among a limited number of people.[6]

Recent research has shown just how far-reaching this transformation was for the people involved and the books they produced. A new hierarchy emerged, with the *librarii* becoming the best paid of all the professionals in the book trade.[7] To establish and maintain oneself in the marketplace, specialists took advantage of ties to family and friends and developed connections with other members of the book trade and with patrons or institutions.[8] Activity tended to center on certain streets where *librarii* or painters lived and worked, so that the neighborhood provided the physical context for collaboration, some streets becoming associated with certain kinds of books or clientele.[9] With competition came the need to generate economies of time and scale. This in turn led to new practices and forms, such as written and visual instructions to the illuminator, increased reliance on shop models, development of faster techniques of drawing and illumination, and contracting out certain kinds of work, such as border decoration, which eventually became specialities of their own.[10] Efficiency could also be gained when these various stages of production occurred simultaneously, as when a stationer, a specialized *librarius,* lent out exemplary gatherings, or *pecia,* so that they could be copied in series at several places at once in order to produce and disseminate rapidly accurate university texts.[11] Although *pecia* production was not the norm in illustrated books, it is indicative of how new practices transformed the entire book trade.[12] The system was flexible and efficient, and books with an exceptional range of subjects, quality, and complexity were produced. These changes were hardly unique to Paris, but Paris perfected them and by the end of the thirteenth century had become the foremost center of illuminated books in Europe.

As in the other arts, gains in efficiency may have had a liberating effect, enabling some specialists to apply their energies to new forms, such as denser and more portable books or more distinctive and elaborate designs.[13] But not all the effects of specialization were positive. For part of the market, the need for speed, efficiency, and compatibility led to the development of more generalized forms and to rote ways of painting, really manners of painting, as well as an increased reliance on standard vocabularies of figures and actions, so that both pictorial forms and the way they are generated could be more quickly learned and easily remembered and varied.[14] In some cases, this predictably led to a kind of painting that was more mechanistic and rote

and that often showed signs of the practitioner's fatigue.[15] Moreover, creative possibilities could be severely circumscribed. With several specialists working independently and with a single illumination potentially passing through several hands, some following pictorial models or written instructions on the page, an individual illuminator might see only part of the project. As prerogatives were sharply curtailed, the artist reduced to executing the designs of others, painting tended to be divorced from conception, and responsibilities for content and invention were increasingly vested in whoever planned the program.[16] If many painters seem anonymous, it is not just because we do not know their names—we often do—but because there is sometimes so little that can be called personal in their work, because this form of production, at its most extreme, could create a split between mind and hand. It is therefore not surprising that many studies refer to these people as artisans and illuminators instead of artists and painters.

There were naturally exceptions. Complex and ambitious books are likely to have required special resources, planning, supervision, or physical accommodations exceeding what most shops could provide, and some patrons no doubt wanted highly finished and inventive work that was labor intensive and thus fundamentally at odds with practices geared to speed and efficiency. Indeed, the new kinds of books produced in Paris at midcentury suggest that innovation in product was just as important as innovation in process.[17] Branner realized that certain royal commissions, such as the *Bibles moralisées* or the Psalter of Saint Louis, were special cases, but assumed the illuminators came from regular paint shops and functioned in traditional ways.[18] Those assumptions need to be reexamined. Although the evidence for royal commissions during the reign of Louis IX is sparse, it is helpful to see it in the light of what we now know of similar practices at a later date and in other places. On the whole, the evidence points to a market that was diverse and flexible enough to accommodate innovative exceptions.

Documents from the reign of Louis IX indicate that the royal household obtained manuscripts from several sources.[19] Three are known by name, and each had a different relationship to the Crown. The first was a certain Herbert from whom parchment was purchased in 1234.[20] He was almost certainly the same Herbert the

Parchmenter paid 40 s. for obtaining an ordo for Blanche of Castile five years later.[21] The account entry describes the ordo as illuminated and bound, which suggests that Herbert had the book produced.[22] There is no evidence that he held a regular position at court, but he seems to have found favor there, for Blanche gave him 100 s. on the occasion of his daughter's marriage.[23] Since this amount was equivalent to a dowry, it suggests Herbert was a *familaris regius,* a relationship implied in documents of the English court and a term actually used in the Neapolitan court.[24] This may also have been the case for the second name we know, Master Nicholas the illuminator, who is listed in the Sainte-Geneviève censier of 1239 as paying one of the highest rents in the area.[25] In that year he received from the king a large payment of 100 s. against unspecified debts, almost certainly an indication that he worked regularly for the Crown.[26] The third name is that of Master Richard, whom Blanche used to obtain one of her own psalters. He is probably Richard of Torigny, the queen's agent who controlled expenses and receipts for work then in progress at Maubuisson, the Cistercian abbey Blanche founded.[27] It is uncertain whether Richard had a role in design, for his experience, as far as we know, was in building rather than in the book trade, but he seems to have enjoyed the confidence of the Crown, just as Nicholas and Herbert did. These few names suggest a culture of trusted associates of varied background, any one of whom might become the source for illuminated books.

This situation is similar in the later thirteenth and early fourteenth centuries, when documentation is more abundant. Philippe le Bel paid for at least one book illuminated by Master Honoré, who sometimes sold on the open market the manuscripts he painted.[28] Mahaut d'Artois also obtained books through several agents and sources—her valet, treasurer, chaplain, and other owners—and made payments directly to scribes and illuminators as well as to *librarii.*[29] Charles IV employed agents to obtain books on the market but also retained artists to paint for him and to oversee other works he commissioned.[30] These entrepreneurial roles were probably not uncommon, at least for artists of reputation. When Jean le Bon commissioned a *Bible historiée,* that is, when he needed someone to "convertir en la façon d'une Bible" rather than to produce the usual kind of illuminated Bible, he engaged an illuminator, Jean le Mont-

marte.[31] The artist presumably took charge of the production and compensated the others involved, as Pucelle presumably did for those collaborating with him on the Belleville Breviary or Jean Bondol did in the case of the *Bible historiale* of Jean Vaudetaur.[32] Moreover, there is considerable evidence that the patrons or their confessors often played a role in the production and that illuminators, even when they had texts or written instructions alongside, created their own interpretations.[33]

Whether entrepreneurs or not, certain artists were favored by the Crown. In the early thirteenth century only a few names can be connected with royal patronage. One was Hugo de Plagliaco, who made the tombs of Queen Ingeborg of Denmark and of Barthélemy le Roye, the *chambrier* and trusted confidant of Blanche of Castile.[34] The first evidence we have of a painter who may have enjoyed such special status with the Crown comes from the inscription on the lost tomb of Hugh Pecdoe, which was in the church of Val Saint-Éloi at Longjumeau, near Paris. The inscription referred to the deceased as "pictor regis qui edificavit / Istam eccl[esia]m" and recorded a date 1251.[35] This date corresponds to what is known of the founding of the church and the probable date of its construction.[36] The inscription is particularly important because the term "pictor regis" is otherwise undocumented in France before 1304, when it was used in relation to Evrard d'Orleans.[37] In Hugh's case the term probably does not refer to an official post but is descriptive, a way of naming someone who painted frequently for the king. The circumstances were probably similar to those in England, where the king might have an exceptional relationship with an artist, as Henry III did with Master Walter of Durham, whom he seems to have instructed directly and who was referred to as "our beloved painter," whereas others in the king's employ were directed by the royal clerk, Edward of Westminster, who acted as overseer, advisor, and interpreter of the king's wishes in matters of patronage.[38] At this time the French royal family is also likely to have had clerks, advisors, and painters who functioned in similar ways. As *pictor regis* Hugh Pecdoe would probably have worked on architectural projects, such as the Sainte-Chapelle, but there is no reason to assume he was limited to them, since the king's painter usually worked on whatever painting was needed, be it a mural or banner.[39]

A second, indirect indication of Hugh's status comes from the inscription's reference to him as the person who "edificavit / Istam eccl[esia]m," which can only mean that he was its builder; that is, this painter to the king seems also to have functioned as the designer, or mason, during the construction of the building. Even though artistic facility in two or more distinct media had a certain currency as a literary fiction, several documented cases may be cited from the late twelfth and thirteenth centuries: for example, Gauthier the Silent, who was architect, writer, illuminator, and editor; Hugh of Oignes, a goldsmith and scribe; Matthew Paris, a sculptor and goldsmith as well as author, scribe, and illuminator; and Villard de Honnecourt, someone who knew a great deal about architecture, metalwork, and engineering, whatever his profession was.[40] In the early fourteenth century, a number of artists worked in several media. Pucelle designed a seal and may have worked in metal, ivory, and embroidery as well as illumination.[41] Evrard d'Orleans was both an illuminator and a painter of murals and panels as well as a sculptor and architect.[42] Examples from later in the century are more numerous: among others are Jacquemart de Hesdin and the Master of the Parement of Narbonne, who were panel painters and illuminators, and the sculptor André Beauneveu, who also painted panels and at least one remarkable manuscript, the Psalter of Jean de Berry.[43] It seems that court artists were called on to do many things and were not held to the limits a trade imposed upon others. Although no preserved work is connected with Hugh Pecdoe, his range of competence is consistent with what one would expect of the king's painter.

Expertise in several media can also have implications for the finished work. James Marrow has suggested that Jean de Berry turned to Beauneveu and artists in other media out of a conscious desire to innovate.[44] No doubt the impetus for innovation also came from the artists themselves, who, if not trained in other media, were exposed to new ideas in the work of their peers. Pecdoe worked in a time and a place that provided opportunities for such exchanges, the most important being the Sainte-Chapelle itself, where he might have become involved with masons, goldsmiths, painters, sculptors, and glaziers and where innovations across different media, especially architecture and metalwork, were to have far-reaching implications.[45] Indeed, the Sainte-Chapelle suggests that

the diversity of Pecdoe's talents may have been not only useful but requisite to the kind of arts the king patronized. At the very least, the inscription on Pecdoe's tomb suggests that Louis IX was a patron of painting, that some of the painters working for the royal family were *familiares,* and that a few had diverse training and talents consistent with the high innovation of the works the Crown commissioned at this time.

These relations between the royal family and its artists and agents are best read cautiously. Although the evidence is sparse, it suggests a complex, multitiered market composed of neither strictly regulated shops of artisans nor the bustling ateliers of the great masters, a market neither of illuminators mindlessly working within a vertically integrated market nor of independent artists pursuing a personal vision while sustained on a royal pension. It points instead to a middle ground, one in which an innovative book such as the Psalter of Saint Louis could be produced in a context in which *libraires* and specialists shaped the dominant mode of production and largely determined the materials, procedures, standards, and expectations of the trade. It suggests that those who functioned as *libraires* were enterprising enough to compete at both ends of the market, sometimes farming out routine jobs to ordinary illuminators who painted within well-defined modes and at other times taking on highly customized work that ventured into unprecedented forms and procedures. And it indicates a market expansive enough to accommodate artists with unusual training and flexible enough to incorporate their atypical work into an otherwise traditional book.

The paintings in the Psalter of Saint Louis suggest much about the manuscript's relation to this market. The previous chapter led to tentative conclusions about the organization of work on the prefatory cycle and the phases of production. Those conclusions were based upon the allocation of certain physical features preparatory to painting and upon large changes in painting technique and design. The painters were referred to only in terms of two hypothetical groups, the minimum number in which these diverse features tended to sort themselves out, but no attempt was made to determine the number of painters, the work they did, or their relation to each other, much less what might distinguish them creatively. Making such distinctions, that is, moving from the corporate to the individual, is problematic

at the outset because of the subjective nature of the process and because no Psalter painter has an identity outside of the book itself.

In most writing about Parisian illumination of the thirteenth century, the functional unit is taken to be the shop, or atelier, a unit that has come to stand for both the artists who worked together and the "style" in which they painted. In Branner's pioneering study this equating of style and shop was a useful working assumption intended to facilitate classification, which was the purpose of his study.[46] He identified about twenty styles and thus about twenty shops in Paris at various times during the reign of Louis IX, and found that a shop might have over a dozen artists and could function over several decades, its work sometimes falling into early and late phases.[47] In general, Parisian styles were distinctive and varied until about 1250, when a "large-fold" manner began to dominate. As this core shop grew, its artists developed variations, and some eventually founded shops of their own. This complex of interrelated styles—too large to represent a single shop but not discrete enough to indicate independent ones—he called a "group." The most important group in the latter years of the king's reign was the Sainte-Chapelle group, named after the evangeliary made for the royal chapel about 1260–70 (Paris, Bibl. Nat., MS lat. 17326). In one of its subgroups, the "Royal Psalters Group," he placed the Saint Louis and Isabella manuscripts, together with three others.[48] In a development seen largely in terms of the genealogy of style, they were the last generation of Parisian painting in the reign of Saint Louis.

These "shops" and "groups" enabled Branner to describe for the first time the main lines by which Parisian illumination developed during the reign of Louis IX. But as recent publications have shown, a shop was usually a household where an illuminator was likely to have worked alone.[49] Since Branner correctly found as many as three dozen artists sometimes working in the same "style," many shops must have been working in the same way. Conversely, each artist must have been able to vary his work considerably and adopt new styles.[50] Although conservative pressures were built into the medium through such practices as the use of standard models or schema or simply because of the desire for consistency in a single work, continuity is also partially a contrivance of the modern process of attribution, which,

based as it is on similitude, tends to promote an assumption of stasis. A shop is conceived as providing the unchanging conditions hospitable to attribution, and an artist or "master" tends to be defined in terms of what remains the same in his work. There is no evidence that thirteenth-century artists were so limited. Quite the contrary, flexibility and change were the order of the day from the mid-1240s on, and many manuscripts that were begun in one style and completed in another are not the result of collaboration but a reflection of the changes Parisian art was undergoing at the time. This is especially clear at midcentury, when Parisian painting changed so profoundly. If one equates style with shop, then only one shop working in the first half of the century appears to have functioned beyond 1250. The others did not go out of business, however; the artists just learned to paint in a new way.[51]

Even though each style Branner described cannot be equated with a singular "shop," such terms as "Corpus" or "Aurifaber" are nonetheless valuable when understood as denoting the characteristic forms by which Parisian painting was systematized within the collaborative practice of a complex of small, mostly one-person shops serving the market. They represent the modes of painting normally available in the commerce of illuminated books at a particular time. The terms are applicable to most illuminated books, and so they served Branner well and provided others with a basis for correctly attributing many manuscripts to Paris and dating them.[52] But the terms do not apply to a single shop or illuminator, they are not indicative of the creative range or qualities of individual artists, and they do not enable us to assess the operation of creative intelligence in Parisian painting at this time. Doing so is not critical in every illuminated book, but it is in the Psalter of Saint Louis.

In the absence of documentary evidence, the identification of artists is a subjective undertaking that can result in a largely fictive explanation of how a book was produced. Identifying specific hands in the Psalter miniatures is especially treacherous, for the delicate forms and nuanced effects so central to many miniatures depend upon subtle distinctions that are sometimes difficult to see even in the original manuscript. There are, however, reasons such an undertaking is feasible in the Psalter. One is the availability of related evidence, especially the underdrawing, which can be studied in

relation to the painting. Another is the number of miniatures, which enables hypotheses about artists to be repeatedly tested. A third involves the possible implications of the physical variables, that is, seeing if there is a match between attributions and the structure of work in the various stages of production. And finally there are the miniatures themselves. Unlike many French manuscripts of this time, in which the work under study may be a small initial consisting of only one or two figures in a minimal setting, the Psalter illuminations are relatively large, pictorially ambitious, and in an almost pristine state of preservation.

Another important factor is the likelihood that the painter of a miniature was responsible for several other critical stages of its execution. Although the Psalter exhibits different kinds of underdrawing and different techniques of painting, certain practices of drawing and painting, as noted in the previous chapter, seem to occur in tandem, suggesting that a single artist may often have been responsible for both. The same is true of other features, such as preferences in the treatment of buildings and details from daily life, in the choice of landscape forms and backgrounds, and sometimes in the vocabulary of gestures and narrative strategies. If a detailed set of drawings had served as the artists' model, one would expect more consistency, not sets of variables changing in concert with one another. Some pictorial source was used, as unusual iconographic details suggest, but whether that source took the form of a general program, rough sketches, other manuscripts, or some combination of these, much evidence indicates that each artist adapted it in his own way and was responsible for several stages of execution. Whatever the supervision for the whole project or the collaboration in specific aspects of production, the painters seem to have exercised considerable authority over the single miniatures on which they worked.

If these conditions make it feasible to study the work of the individual artist, it is definitely worthwhile doing so, given the level of invention and ambition of some of these paintings. It is as though one were presented with a gallery of seventy-eight paintings created by several artists responding to an exceptional commission over a limited period of time. Naturally one wants to understand how they worked together, what issues attracted their interest, how ideas circulated among the

group, the pressures that the project brought to bear, and how the painters adapted to them. Even if all of these questions are not answerable, it is still useful to look critically at individual practices, for distinctive forms of creativity also require a historical explanation, as do the ways and conditions in which visual intelligence is exercised, especially in those times and places, such as Paris in the mid–thirteenth century, in which a premium was placed on invention and artists often called attention to the subjective dimension of their work.[53] Of course, distinguishing hands is not writing biography, and absent new discoveries, the painters will have no existence outside of these miniatures. But they do have one *in* them, and their history, though highly circumscribed, is no less valid for being documented only in the work in which it appears.

In attributing these paintings to several people, I have tried to take account of the range of an artist's functions, from the visualization of a subject to its execution and completion on parchment. I have also considered expressive aims and tried not to separate them from period forms or from the pressures of the profession, project, and patron, though naturally all cannot be brought to bear in each case. Not wanting to sever the manual from the mental, I am least of all interested in the Morellian detail, preferring to look to the larger patterns of conceptualization and what is expressively and intellectually distinctive. At the same time, this exercise makes no pretense to finality, and I have no doubt that each reader will sort these paintings out otherwise than I have, whether they study the reproductions in this book or the paintings in the original manuscript. But however one attributes a particular painting, the process and the factors taken into account will be largely the same as those described here, and identity will be manifest in comparable ways.

The Painters

Branner assigned the seventy-eight prefatory miniatures to six artists. Although I identify five, we largely agree on groupings of gatherings by the same hand and on many attributions.[54] We differ primarily on the way the artists collaborated in the early gatherings and on whether some were replaced in the later gatherings or continued to work but in a different manner.

The following sections discuss each phase of production in turn. All the Psalter artists appear in the first phase (gatherings I–IV), including a visitor who painted a single gathering only. This phase, which is characterized by irregular gatherings and frequent changes in production and design, is especially complex, and my concern is less with unraveling a step-by-step process than with sketching the principal hands and the major lines of collaboration. Phase II presents a more normative situation, in which the pressures entailed in adapting to a common language may be examined. In the final phase of production, which is the work of one remarkable painter, I consider the individual, the character and evolution of his work, and the achievement it represents.

PHASE I: GETTING UNDER WAY

Gathering I: Two Groups. As noted earlier, the fourteen folios of gathering I consist of a quaternion of four bifolios into which three independent bifolios have been inserted, and these two groups of regular and inserted folios were prepared in distinctly different but internally consistent ways. Not surprisingly, these are also the two groups in which the artists worked. The following diagram shows the relation of their work to the structure of the gathering:

The first group was responsible for the eight folios of the regular gathering. As noted in the previous chapter, the first four miniatures differ in decorative details from their conjoint miniatures, though each group of four is internally consistent.[55] The same is true for the biblical scenes. The first four paintings (fols. 1v–4r), which I assign to the Noah Master (A), stand apart because of the clarity and large scale of their compositions and the subtlety of palette, especially the pure tones of blue and delicate salmon. The underdrawing is largely reinforced with pen, as is visible in the usually

short fine lines of inner folds of drapery. In the finished drawing, however, the artist employs a longer line that displays the curvature of forms: in the two figures of Cain on folio 2r, for example, long folds and body contours describe how the drapery falls between the arms and from the shoulders and how it rings the lower legs, waist, and neck. These tall, elongated figures, like the figure of Cain on folio 1v, are the most "Reimois" in the manuscript; their forms lighten and diminish upward in steps, the lower body rising into a short torso, long delicate neck, and small rounded head, each part angled and counterpoised in relation to the one below. This conception of the figure finds its counterpart in the way the scenes are composed. The miniatures consist of a few distinct elements—figures and singular landscape forms—which are juxtaposed in a play of curves and diagonals and held in a sometimes teetering balance. Such compositions are especially appropriate in the first two miniatures, where the drama largely hinges on contrasts up and down and disjunctions left and right.[56] The artist's finest work is folio 4r, where, beneath the stabilizing cone of the tent, Noah lies upon a strongly sloping ground, his head at the left and his standing sons at the right. The asymmetry of the groundline and tent opening serves to separate the mental world of the sleeping, groping Noah from that of his pointing, argumentative sons. Yet in the end the whole composition beautifully coheres because of the balanced play of the curves of Noah's body, of the brothers' arms and backs, and of the open folds of the tent and because of the parity of the salmon and pale yellow to the blue. The pictorial construction is one of the most refined in the manuscript and, in spite of its real scale, has a monumentality again suggestive of its Reimois forms.

A different set of values and goals informs the latter four miniatures (fols. 7v, 10r, 13v, 14r). Although numerous similarities mark the underdrawings, figure types, and details of all eight,[57] the line in the latter is more stiff and angular, the palette is darker and less nuanced, and the resulting miniatures are more planar and rigid. In some of their pictorial conceptions the second group parallels the first—for example, the scene at Mamre (fol. 7v) shows a familiar interest in major diagonals and stabilizing central forms—but instead of the unifying rhythms and palette, there is a greater reliance on an underlying geometry, as one sees in Abraham's Sacrifice

(fol. 10r), or on variations in series, as in the two Jacob miniatures (fols. 13v–14r). The differences in these two sets of miniatures raise the question whether they are all by the same person, whose painting for some reason changed, or by two persons, the latter set by a colleague of the Noah Master who wished to work in the manner of the first four miniatures. I am inclined to the former, first, because of the inherent improbability that two artists worked on the same bifolio and, second, because this painter appears to be one of most variable in the Psalter. He continues to work in the manner of the latter four miniatures, but he eventually returns to that of the initial four.

The Abraham Master (B) is one the two principal artists responsible for the inserted bifolios in gathering 1. In his best work, the two scenes of Abraham's Victory and his meeting Melchizedek (fols. 5v, 6r), his strengths lie in singular focal figures, like Abraham, with his large gestures and elegant pinwheel motion. He uses almost no underdrawing and paints with a particularly thin and transparent application of salmon, modeling Abraham's tunic with just enough red-salmon to give the figure impressive mass.[58] However, the secondary figures are packed together in dense groups linked by extended arms and swords, and this results in an unfocused play of gestures and confusion of limbs. In the Lot scenes (fols. 8r, 9v), the broadly stepping figures and their gestures are stiffer, and the artist has relied on overdrawing to clarify drapery folds.[59] Although palette and decorative details link these four miniatures, the evidence is not adequate to determine whether they are by the same hand, as Branner thought, or by two people working in a very similar manner.

The second artist working on the inserted folios is the Rebecca Master (C). He is responsible for only two miniatures (fols. 11v and 12r), but they are sufficient to show that he is one of the finest artists of the Psalter. Like the work by the Abraham Master, his has almost no underdrawing, and the salmon color is lightly applied in a transparent wash. Here, however, the underdrawing is really a sketch, as is clear in the sections where the Rebecca Master departs from it, as he often does.[60] He also models the salmon more extensively, developing drapery forms with thin washes to create tonal variation. The Rebecca Master models equally well with darker colors, as noted in the previous chapter: the figures of

Eliezer and Rebecca at the well are a tour de force, each beautifully defined but in opposite ways, one with clear washes and the other with opaque paint. The artist's strengths lie not only in his drawing and painting but in his narrative conceptions and dramatic detail. He has a tendency toward small scale, toward a layered construction of space and of groups of figures, and toward episodes organized progressively in units that sometimes reverse direction, even across facing pages. Some exchanges are highly nuanced, as when Rebecca serves Eliezer at the well or encounters Isaac in the fields. His is a manner well suited for the mounting action, ceremonial ease, and biographical focus of the miniatures in the later parts of the Psalter cycle.

· · ·

Gathering II: Collaboration. This gathering is devoted entirely to the Joseph story, which unfolds in a dense but evenly paced series of miniatures. Most are divided into two parts, each composed of figures or groups that face other and exchange gestures and glances. The drawing and palette, forms and gestures, are more consistent than in the previous gathering, as are the decorative details. However, when studied closely as bifolios, certain differences in composition, drawing, and painting emerge. The consistency here reflects a degree of collaboration not seen in the previous gathering.

In the two outer bifolios (fols. 15v, 16r, 23v, 24r), figures are often massed together in a homogeneous group, intervals are precisely given, and the exchange of glances and gestures focuses on a single action or relation. The overdrawing on the salmon-colored areas consists of a few fine short pen lines that precisely follow the folds or delimit a shape. In contrast, the large figure groupings in the adjacent two bifolios (fols. 17v, 18r, 21v, 22r) tend to be heterogeneous; intervals are irregular, tight, and sometimes difficult to read; and figures with varied glances and gestures tend to multiply, rather than focus, points of attention. Here the overdrawing usually involves longer, curved lines that describe the roundness or volumes of forms.

The single inner bifolio (fols. 19v–20r) is more closely related to the two outer bifolios, as is evident in the clear disposition of the figures, the focused exchange of glances, and the minimal overdrawing, which is again limited almost entirely to highlighting the way drapery falls straight rather than the way it rounds a form.[61] Yet

bifolio 19v–20r has qualities found nowhere else in the gathering. The overlapping shaping of figure groupings, the sequential play of left and right facing figures, and the subtlety of drawing and modeling all relate to the work of the Rebecca Master.[62] Elegant, complex figures, like Isaac in folio 12r, find their counterpart in the seated butler (fol. 20r, far right), with his beautifully described torso, neck, and head, his poised lean to one side, and his delicate way of resting arm against knee and ankle against leg.[63] Rebecca meeting Isaac in the fields, and Potiphar's wife attempting to seduce Joseph, may be dramatically opposite situations, but they are equally nuanced in the depiction of staging, body language, and characterization. And only the Rebecca Master employs a similar play of figures and groups facing in opposite directions and of progressive and complementary narratives on facing pages.[64]

While the painter of the outer bifolios is strongly influenced by the Rebecca Master, much suggests that he and his colleague, who did the adjacent bifolios (fols. 17v, 18r, 21v, 22r), grounded their work on that of the Abraham Master.[65] However, this attribution can only be tentative, for the miniatures by the Abraham Master in gathering I are few, and their subjects are not analogous. Distinctions become more difficult to make and, in this case, turn mainly on the underlying design and narrative conceptions and on drawing, a connection evident in later miniatures as well. Whatever the precise identity of the painter, it is clear that the gathering depends on the styles of the folios added to the previous gathering.

· · ·

Gathering III: A Visitor. The next four Joseph scenes, painted by the Isabella Master (E), conspicuously stand apart from the rest of the prefatory cycle. The bole is heaviest and darkest and the gold background the most brilliant of any gathering in the cycle. Technique and palette, modeling and finish, are all distinctive, as are physiognomic and other details. After a series of densely interwoven, mostly two-part miniatures, these four scenes present a radical change to sparse, single compositions, clearly circumscribed groups, and large-scale figures. The impact upon the telling of the Joseph story is enormous and comes just at the climactic moment in the narrative when Joseph reveals his identity to his brothers (fol. 25v). Suddenly there are full-page paintings, with blocks of cool, muted figures against a warm,

bright gold, a slowing of action to an almost ritualized pace, and simplified, monumental compositions.

Haseloff and later writers connected these miniatures with those of the Isabella Psalter in Cambridge, and Cockerell attributed them to the hand responsible for the Cambridge initials illustrating the memorials in lauds, one of the finest artists working on the manuscript and very possibly its chief painter.[66] The Cambridge initials are indeed similar to the miniatures of gathering III. The technique, modeling, proportion, and system of folds of folios 25v or 26r in the Psalter are virtually the same as those of the Isabella initial representing the Confessors (fig. 14), and the palette, with its distinctive green, dark orange, and red-brown, recurs in the Cambridge initial to the Prayer for the Many Virgins.[67] The general head type varies considerably within the Isabella manuscript, but the closest parallels are to be found in this same series of initials.[68]

What is distinctive in the four Joseph scenes of gathering III does not apply to the architectural settings above them and to the frames surrounding them. They are painted in a different palette, not the flat blue, blue-gray, russet, and greens of the biblical narratives but in the deep blue and salmon characteristic of all the other Psalter miniatures.[69] The fine, detailed, elegant reversing-vines motifs in the frame are anomalous in this part of the prefatory miniatures but are identical to those in gathering XIII, the last gathering of the Psalter cycle and the work of another artist, the Saul Master, who makes his entrance in the next gathering. It is therefore unclear whether the four miniatures of gathering III are the work of one artist or two and whether either or both parts were painted in the first phase of production or in the last. The questions multiply. If there were two artists, were they both connected with the Isabella Psalter? Why a visitor in the first place, and why at this point in production, working in a manner so different from that of the preceding Joseph scenes and in a gathering less than half as long as those nearby? These questions will be taken up as part of the discussion of gathering XIII.

· · ·

Gathering IV: Interpolations. Like the first gathering, this one consists of a regular quire into which a number of bifolios were inserted, the differences being reflected both in the physical features of the inserted folios and in the allocation of work among the painters. But because the gathering of fourteen folios can be described as a ternion of three bifolios into which four others are "inserted," the additions outnumber the structural "core" of the gathering. The following diagram illustrates that structure and summarizes the attributions to be discussed below:

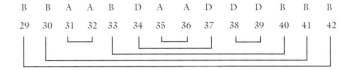

Although there is consistency throughout in architectural enframement and subject matter, the awkwardness of this arrangement manifests itself in various ways. Scenes showing the movement of the Israelites as a group are sometimes split one from the other.[70] Some facing pages are narratively and pictorially complementary, while others have little in common.[71] Change in narrative style is sometimes extreme, and two pages are out of order.[72] Moses is characterized in three quite different ways within eight folios.[73] On the whole, this gathering is the most heterogeneous of the prefatory cycle and the most revealing of the problems that had to be addressed in the subsequent phase of production.

The six miniatures of the "regular" quire (fols. 29v, 30r, 33v, 40r–42r) point to the work of the Abraham Master (B). The palette and the minimal underdrawing are directly comparable to those of the previous works attributed to the Abraham Master, but the almost complete absence of overdrawing makes these miniatures the best indication of how the other paintings attributed to him, especially those in gathering II, looked before they were "clarified" with lead point or pen. Other parallels, which range from the technical to specifics of figures and even head types, recall his paintings in the second gathering and, in some features, also those in the first.[74] As before, the drawing and painting are often uneven, even in the miniatures of the same bifolio.[75] In general, however, his miniatures here carry forward the clarity and simplification that is apparent in the outer bifolios of gathering II.[76]

That clarity is one of several new elements that can best be accounted for by the influence of the Isabella Master, as seen in gathering III. In gathering II the artist often packed the figures in discrete groups (fol. 16r), arranging

them so that one could see the tops of the heads of figures in a row. In folios 30r, 33v, and 40r he takes this tactic one step further, organizing figures into a shape that becomes an element in the composition, just as the Isabella Master does (fols. 25v, 26r). The Abraham Master also introduces new head types, such as that of Pharaoh (fol. 30r), that are typical of the Isabella Master.[77] Moreover, folios 30r and 33v both consist of distinct units—figures, groups, or structures—linked by arching gestures, another characteristic of the Isabella Master (fols. 25v, 26r). Although the Abraham Master also tends to compose by manipulating such groups, the units of his compositions have never before been so distinct or serially ordered. Finally, the figure of Moses in folio 30r may well depend directly on that of Joseph in folio 25v: the similarity in silhouette, the almost identical folds of the gown, and the comparable isolation of the men against a gold background are unlikely to be coincidental.

One of the two artists responsible for the "inserted" folios is the Noah Master (A). His work is difficult to follow in this gathering, because he paints only four miniatures (fols. 31v–32r, 35v–36r), two of which are composite or architectural (fols. 31v, 36r), and he substitutes for the salmon or red-salmon a transparent tan, a color that will become more or less standard in Phase II. One of the miniatures from his first bifolio (fol. 32r) recalls his later miniatures in gathering I, especially in the stiffly angular positions of the figures and the slightly raised and sharply delineated folds.[78] But more pronounced changes are to be found in the Sinai miniature (fol. 35v), from his second bifolio. Here the drapery folds rise in distinct ridges, and the heads, though still having the full, overly rounded crown characteristic of the Noah Master, are smaller and more powerfully modeled.[79] What is new, however, is the isolation of the two figures of Moses and the Israelites against an ample field of gold, and the clustering of the Israelites so that just the eyes and upper heads of the figures in each rear row are visible. These features, so foreign to the earlier work of the Noah Master, again suggest the influence of the Isabella Master's Joseph miniatures (fols. 25v–26r). The visitor seems to have affected the Noah Master even more than the Abraham Master.[80]

The four remaining miniatures (fols. 34r, 37v, 38r, 39v) introduce the Saul Master (D), one of the foremost artists of the Psalter. His paintings are distinguished by a remarkable energy and invention, especially in his treatment of figures. The heads are solid and powerful, their structure and features clearly defined, and there is a new range of types and of expression. Even when figures are part of a group, they are highly individualized in movement, physiognomy, and suggestive force. The human body is both more compact and elastic, its dynamic movements expressive of the figure's energy and suggestive of an independent and willful action. These characteristics immediately set his work apart from that of the other artists.[81] When Cain strikes Abel (fol. 2r), his body swings down with the shovel, but when Moses strikes the rock in the desert (fol. 37v, left), his whole body folds down and undergoes compression. Similarly, when Abraham offers to Melchizedek the booty he won in battle (fol. 6r), he elegantly balances himself on his lance, his body swinging as though hinged to it at the shoulder and hip. In contrast, Moses (fol. 37v, right), his feet holding the ground and his body tautly arched, comes around from behind the column with the Brazen Serpent, pointing and turning and, like the serpent, almost coiling around it. Or take the figure of the angel who addresses Balaam and, on the facing page, that of Joshua as he is entrusted with the leadership of Israel (fols. 39v, 40r). These two figures, separated by only a few inches, are based upon identical figural models, but one is painted by the Saul Master and the other by the Abraham Master. Technically the differences lie in such details as the way the folds connect with the hips and shoulders, but pictorially the figures are in different worlds, for Joshua is a figure of expansive ease, and the angel is tensed like a tightly coiled spring.

The human body is the principal instrument of expression for the Saul Master, but his dynamic approach is most striking in the relations between figures and the treatment of space. As in the work of the Rebecca Master, the exchange of gestures and glances is clear and rich (fols. 19v, 37v), and figures and groups overlap each other and objects as they progressively move across the miniature (fols. 11r, 12r, 38r, 39v). However, the Rebecca Master's paintings depend upon coherent figure groupings and the artist's use of interval and changes in direction to build a narrative sequence across facing pages. In contrast, the Saul Master's compositions depend upon the tension he builds up between his more sculptural figures, the way he focuses or chan-

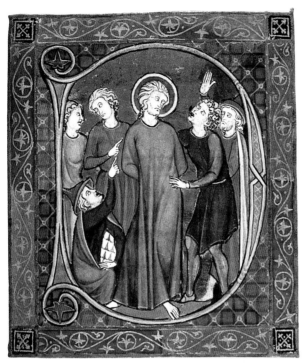

FIG. 15 *Cambridge, Fitzwilliam Museum, MS 300, Isabella Psalter, fol. 191v: Mocking of Christ.*

nels their energy, and the freedom he takes in setting one figure against the other, overlapping shoulders, legs, or arms of neighboring figures, showing them before or behind the ground they commonly stand upon. Thus, the tightening down of Moses' body as he strikes the rock (fol. 37v) builds up from the tense mobile crowd behind him. The two youths closest to him, with their arms out and their legs spread, hold back the crowd but also envelop Moses, pushing him forward and accentuating the downward compression of his body. In the adjacent scene the curve of Moses' back is reversed, and his pent-up energy seems to be released as he stretches up to point to the Brazen Serpent. A different kind of sequence appears in the story of Balaam and Barak on the following page (fol. 38r). There three figure groups are arranged in a series that weaves in and out, before and behind the groundline, the frame, an altar, and a tent of meeting. The frame cuts the full length figure of the Lord in half; Balaam and the king wrap around the edges of the altar as a second figure of Balaam points to the seated Israelites, who are both inside and outside a tent, the side of which piles up against the frame. In

contrast to this space, which folds in and out like a screen, that of the next page is curved into an arc. Balaam on his ass is followed by a retinue of horsemen, one overlapping the other, the densest and deepest part at the far left (fol. 39v). That grouping thins and expands forward, so that a convex path is laid, the movement along it both proceeding out toward Balaam and across to the angel. Once there, it reverses and recedes, directed back by the gestures of Balaam and the man behind him and buttressed by the horses and riders at the left. Thus the angel turns back the procession, and Balaam is caught not in a standoff but in contrary currents that ebb and flow, forward and back, across the page.

The Saul Master's work is also distinctive technically. His underdrawing is unusually sparse and light, notations rather than sketches, so that his small powerful figures are modeled almost entirely in color. His handling of color is notable for its variety. The contrasts are still largely of blue and tan, but other combinations appear, especially blue-grays and, to a lesser extent, pale yellow and red-orange (fol. 39v). He is the only artist to use washes for dark as well as light colors, to employ white freely, especially in facial details, and to thin down colors so that the white of the parchment appears as reflections of light on rounded surfaces. This more diverse palette and technique account for only small differences in the general impression made by these miniatures, but they imply an artist of greater technical range, who is equally at ease with an opaque or transparent tone, a painter for whom color has a special interest. For his peers working in this phase of the project, technique largely involved delicacy of tone, decorative richness, and, for the Rebecca Master, modeling in light and dark; for the Saul Master, it also meant color and light.

Where did the Saul Master come from, and why does he appear only now? Some paintings, such as the Mocking of Christ in the Isabella Psalter, are of similar proportion and solidity, individualism and energy (cf. fig. 15 and Psalter fol. 38r), but the technique of painting and details are different. The Saul Master may have moved in the same circles but, unlike the Isabella Master, seems to have translated, rather than transplanted, ideas from elsewhere. It may be no coincidence that the Isabella Master does not appear again and that, just as his influence is being felt, the Saul Master appears. Perhaps the Isabella Master came to help solve the initial problems of produc-

tion, creating a demonstration piece and then leaving. One can also imagine that the need was felt for another artist, someone to work with the Noah Master in the same way that the Abraham and Rebecca Masters apparently worked in tandem. In any case, the Saul Master did stay on to work with the Noah Master and then to complete the prefatory cycle all by himself.

· · ·

My attributions in the first four gatherings accord with the structure of production discussed in the previous chapter. The artists who worked on the first and fourth gatherings painted either the "regular" or the "inserted" bifolios, so that they divide into two groups, just as the physical variables do. In this first phase of production, the two principal artists worked in gatherings prepared according to a single set of physical features and, moreover, continued to work with folios prepared in that way regardless of how those folios were structured into the gathering. Furthermore, the artists working in the same group had a similar approach to underdrawing and to palette and often to the way lead point or pen was used to clarify and strengthen the paintings. Consistency in other aspects of their work, such as composition or narrative conception, suggest that the painters also played a role in design. At the same time, the independent and sometimes ad hoc nature of their work gave way to collaboration. This is especially the case in gathering II, where the artists of one group, possibly aided by a temporary assistant, developed a common narrative and decorative language, one borrowing especially from the Rebecca Master, the strongest painter in that group. By the fourth gathering the influence of the Isabella Master began to affect painters in both groups. It led to the far-reaching changes in gathering structure and form that mark the next phase of production and make possible the beginning of a consistent visual language. Appendix VII shows that the two working groups continued to function, even if many preparatory features changed. But the new "language" they practiced was less the result of a true collaboration than of a new pressure to conform.

PHASE II (GATHERINGS V–X): A COMMON COURSE

With this phase, painting in the Psalter takes on a very different character. It is likely that some change was seen

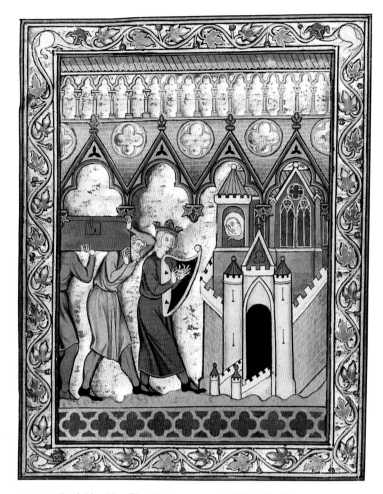

FIG. 16 *Cambridge, Fitzwilliam Museum,* MS 300, *Isabella Psalter, fol.* IV: *David Leading the Ark into Jerusalem.*

as necessary. The previous phase depended upon coordinating several painters and interpolating their work. Although the architectural settings were made consistent in gathering II, the large gatherings, such as that in IV, were unwieldy and led to errors in sequence, to discontinuous narratives, and to modes of painting so varied that the series seemed ad hoc. Many of these problems are solved with the institution of a system of four-folio gatherings and the conferment of responsibility for one entire unit to one artist. But there are also changes in the figural styles, decorative system, and even some aspects of technique that betoken a fundamental shift in orientation.

Some of these changes are no doubt attributable to the example of the Isabella Master and his work in gathering III. His miniatures had an immediate though lim-

ited influence on the Abraham and Noah Masters in gathering IV. Beginning with gathering V, it is likely that the Isabella Master had a more general influence upon all the artists. It is visible less in figural style than in decorative vocabulary and coloristic richness, two of the most notable aspects of gathering III. Cityscapes, previously only single walls or a tower seen in a cutaway view and from above, now become more elaborate and comprehensive structures, brightly colored with concentric walls, multiple towers, gates, and windows with tracery (fols. 43v, 46r, and fig. 16). The frames change fundamentally: they are decorated with motifs penned in gold, subdivided in accordance with the internal architectural divisions, and elaborated with a new range of motifs.[82] Most striking is the use of a heavier bole and more burnished gold leaf in the background. That is, the brilliance of the backgrounds seems to imitate that of gathering III. This change in technique is so fundamental as to suggest that other changes, especially the adoption of binions and a system of one artist per gathering, may also be due to the Isabella Master and to the example of gathering III.

Other characteristics of Phase II cannot be explained either as a reaction to the earlier problems or as the influence of the Isabella Master. The figures, which were already growing smaller in the last works of the Noah, Saul, and Rebecca Masters, are reduced even more. Forms are increasingly simplified, compositions regularized, and narratives condensed. Individual figures as well as entire compositions are built up in a dense vocabulary of serial curves, reversing angles, and counterposed forms. Gestures and movements quicken and tighten, each smaller and more staccato in effect. These tendencies were present in the earlier miniatures but are now more extreme. With reduction in scale and a heightening of effect, energy and color concentrate as never before, and there is a new pulse and richness. These changes are sometimes at the expense of convincing characterization, but the biblical scenes are brought into decorative and coloristic harmony with the architecture and borders, and the viewer is more powerfully absorbed into a world that is more unified, brilliant, and lively.

These characteristics find many parallels in Parisian works of the 1260s and represent a broader phenomenon in French culture at the time. This new direction is consistent with the styles of some of the Psalter artists, particularly the Noah Master, but it is largely antithetical to that of others, especially the Saul Master. In this second phase of production each artist changes and to some extent adopts the viewpoint and goals of the group, sometimes compromising or suppressing native tendencies and strengths to do so. If these miniatures demonstrate the power of the group to mold individual ways of painting, they also testify to the personal resources its artists were able to call up in response. In this new environment one of the artists flowers, two adapt, and the fourth largely fails. This part of the Psalter tells a very human story, one less of styles and influences than of resourcefulness, compromises, and limitations.

Except for the Isabella Master, all the artists who worked in the previous gatherings continue to do so, but each is now responsible for an entire gathering redefined as a unit of four leaves (Appendix V). The four artists continue to work in two groups, each painting three gatherings (Appendix VII). In this phase, however, the "portable" features—prickings and architectural pattern—associated with one group transfer to the other, again suggesting that they drew on the same resources and worked near one another. New architectural patterns are introduced, a change that coincides with the experimentation in frame pattern, coloring, and bole.

The Noah Master's manner was well suited to this phase of production, for the characteristics of his last work, in gathering IV—the reduced figures, the simplified forms and sparse thin folds, and the colorism of the light tan and brilliant gold—are generally applicable to this whole phase of production. His distinctive hand is recognizable in two gatherings (V and X), especially in the figural vocabulary, underdrawing, pattern of folds, and specific head types.[83] The linear and angular aspects of his earlier work have softened into the contours and fine lines seen in folio 35v, and the geometric underpinning has given way to a more conceptual arrangement of groupings or, in miniatures such as folios 43v or 46r, rich patterns of color. In gathering X, scale is reduced a little further, actions are still milder, and the palette of orange and light blue has been softened by the introduction of pink in clothing, in ground forms, even in the gables above. It is ironic that this artist who develops so gentle a style is responsible for scenes of battle and that his rich and glowing landscapes form the setting for the most violent subjects in the manuscript.

The Noah Master has come a long way since the first gathering, with his large compositions and memorable figures. In retrospect it is easier to see how certain tendencies were already present in his earlier work. The figure of Abel kneeling (fol. 1v) is the antecedent of the crouching youth in the miniature of the Benjaminites Taking Wives (fol. 66r), just as the standing angel at Mamre (fol. 7v) looks forward to the woman playing the tambourine in the same late miniature. The Mamre miniature, with its rich interweaving of figures, is particularly instructive, for the structural basis that gives it clarity is still present in the scene with the Benjaminites, only now the figures are of more uniform scale, and patterns are smaller, less geometric, and more undulant, like the vines growing beside the figures or those penned in gold in the frames. Although nothing is quite like the miniature of Noah and his sons (fol. 4r), such miniatures as folios 65v–66r present, on a much reduced scale, a similar balance of form and color. The artist of the monumental figures of Cain, Abel, and Noah has become a miniaturist, more interested in coloristic richness and decorative unity than in description or narrative. In a startling reversal, he is now least successful when staging how bodies engage in space; indeed, these military subjects from Judges are some of the most ambiguous and difficult to interpret in the Psalter.[84]

Seen against his powerful early work, the later has suffered an exceptional loss of narrative power. But these qualities had begun to vanish even by the end of the first gathering, with the Abraham and Jacob scenes, and one wonders if the compositions of the first four folios were really his own invention or something borrowed, perhaps from a monumental source. His figures of Cain and Abel are in some ways overly large, and he is not able to exercise in them the control of line that he has in the Noah miniature. He is not well served by the dark colors introduced in folio 7v and 10r: in the Mamre miniature, the combination of somber robes and glowing flesh-colored faces, of a dark upper building behind a emerald green oak tree, is unproductive. When his color eventually lightened, the linear qualities of his work grew stronger. Against this history of misdirection, the change to small scale, greater coloristic richness, and more curvilinear forms in gatherings v and x can be seen as a positive move, for it enabled him to sidestep earlier

problems and to draw upon his strengths in delicacy and structure in order to create some of the most legible and jewellike miniatures in the Psalter. In a de luxe manuscript in which scale, precious materials, and richness of impression count for so much, these are among its most delicate and luminous achievements.

The Rebecca Master must have found himself in very different circumstances. A strong and accomplished artist with a distinctive approach, his work nonetheless displays the same tendencies that affected all the others in this phase of production, that is, smaller figures described in more linear terms, a more decorative arrangement of forms and colors, and a more condensed narrative of exaggerated movement and gesture. For him, the challenge lay in retaining, rather than in rediscovering, his strengths, in controlling, if not using, the new direction to advantage.

The Rebecca Master is responsible for gatherings VI and VII. As before, the details—folds, physiognomy, gestures—reveal the artist of the first two gatherings.[85] His colored washes have the tonal delicacy of his earlier work, even though they model the figures less. Patterned backgrounds and a brisk play of gestures and glances remain essential to his work (fols. 19v, 48r). A hallmark of the Rebecca Master is his tendency to organize pictures in small compositional units of varying size, defined by different backgrounds and framing devices and arranged in progressive sequences (fols. 11v, 48r, 51v). Related to this is his layering of space so that figures and forms are staggered in planes and seem to slide forward, one ahead of the other (fols. 12r, 47v), or, when they overlap, to spring forward (fol. 51v). No less distinctive is the way those sequences sometimes form a discrete subnarrative that is developed and completed within a double-page composition (fols. 11v–12r, 19v–20r, 47v–48r).

Although the Rebecca Master strengthens the surface of his forms with a short thin line, as the Noah Master does, his underdrawing is still minimal and essentially connotative. In contrast to the Noah Master in this part of the cycle, he does not change his palette, which was already light, or enlarge it with halftones or brighten it with orange or pink. He stays with an alternation of salmon and blue, often using changes of background to clarify a figure or group. He is, however, far more liberal in the ways he deploys the human body.

Although a play of body and limbs was characteristic of his earlier work, gestures and shapes are now more angular and irregular, and movements that were flowing or circling tend to become jerky or dancelike.[86] Increasingly, the entire body seems caught up in the same rapid movement, which usually plays into the next grouping or, in one case, turns in on itself (fol. 52r).

The selectivity of the artist implies that he saw each scene in its own terms, and indeed, the most striking aspect of these eight miniatures is the very different character of each double-page opening. They have different tempos, from the swift pursuit of Deborah and Jael (fols. 47v–48r) to the *allegro* of Gideon's battle (fols. 51v–52r), from the ceremonial slowness of Gideon's sacrifice (fols. 49v–50r) to the steady and deliberate gait leading to Jephthah's tragic sacrifice (fols. 53v–54r). In the face of formal changes that, in the case of Noah Master, tend to undermine narrative clarity and to encourage homogeneity and regularity, the Rebecca Master continues to elaborate narrative and pictorial structures with a fresh eye to underlying content. Thus, the two pages devoted to Sisera (fols. 47v–48r) are divided into halves and then thirds, so that the pursuit begun at the left quickens as Sisera enters Jael's tent at the right. We see his fate literally and figuratively decline, as Sisera stands, reclines, and is finally slain upon the ground. The next two miniatures (fols. 49v–50r) show Gideon's assumption of leadership in terms of parallel scenes of sacrifice, first as instructed by angels and then as performed on his own. The next two miniatures (fols. 51v–52r) can again be read as a preparation and performance, in this case for battle with the Midianites: the figures on folio 51v, like Sisera, are shown progressively lower, for they stand, bend down, and then kneel low. The compression is released in the center of the facing page, where the Midianites explosively engage each other, as though in a deadly dance. These are the kinds of pictorial and narrative relations we saw in the Rebecca Master's earlier work, but now movement is a matter less of contour and rhythm than of solid shapes and tempo.

Gathering VIII I attribute to the Abraham Master, but since his work seems in many respects conditioned by that of the Saul Master, the latter's work in Phase II had best be described first. The hand of the Saul Master unmistakably appears in the four miniatures of gather-

ing IX. It is recognizable in a range of details and especially in the handling of the human body, still the most characteristic aspect of his work.[87] Although smaller and more restrained, the two figures of Samson killing with the jawbone and in prayer (fol. 60r) have the same dynamic and elastic conception, the same downward compression and upward release, of the figures of Moses performing miracles in the desert (fol. 37v). Samson's pose with the jawbone, especially the way he thrusts forward and pushes down the figures kneeling before him, recalls Hellenistic sculpture.[88] But Samson also raises the jawbone over his head, so that the opposing motions of his legs and arms are joined with the curve of the body into a continuous spiraling motion. In spite of its miniature scale, the dynamism of this conception is almost proto-Mannerist and is altogether consistent with the way the Saul Master depicts Samson throughout this gathering.[89]

Like the other Psalter artists, the Saul Master's work takes on the now familiar characteristics of this section of the manuscript: the reduction of form, dependence on line, exaggerated movement, and more decorative use of color. For the Saul Master, however, these tendencies go against the grain. Single figures may still be dynamically conceived, but with the flatter space and more unnatural movements, the characteristics so distinctive of his earlier work—the buildup of forms, the muscular compositions, the channeling of energy through the narrative—are hardly recognizable. It is ironic that this should be realized in the story of Samson, episodes for which the powerful earlier style of the Saul Master would have been ideally suited.

Yet the artist assimilates the new style and responds to it in a wholly unexpected way. The achievement of these diminutive paintings, though evident from the outset, the scene of Samson bound (fol. 59v), is easy to miss. Slightly taller than those around him, Samson stands with his feet braced apart, his body slightly asway, his hands, seemingly limp, resting upon the forearms of those who hold and bind him. In the way Samson's demeanor suggests his active self-restraint, the artist is less concerned to show how he is bound than how he acquiesces. And in the way Samson looks into the face of his countryman, the subject would seem to turn on knowledge, on the unbridgeable difference between their understandings of the moment. The narrative is

internalized, and Samson becomes a complex character.

The third and fourth miniatures are especially revealing because their figures are the most reduced and their compositions the most traditional. In the first scene (fol. 61v, left) Delilah sits on a bench as she cuts Samson's hair, and he is asleep at her feet, with his head in her lap. In the adjacent scene the Philistines hold him to the ground as they blind him. The artist has adjusted certain details so that the two subjects read antithetically: Samson's body is folded and closed as he sleeps, and it is laid out and open when he is blinded; the normally flat ground (on the right) is raised to parallel the brilliantly colored bench (on the left); Delilah's elegant coif is suggested in the terrifying winged headgear of the soldiers. These changes encourage a comparative reading that turns into a juxtaposition of a dream and a living nightmare. A similar juxtaposition of the pictorial and psychological is found in the next two scenes (fol. 62r). At the left Samson turns the granary wheel, and at the right he pulls down the temple of Dagon. In one he stands in the wheel and among its spokes, his hands on its vertical poles; in the other he is between the two columns, as the temple roof begins to break and fall away at the left and right and the people below raise their arms in fear. The two scenes are strangely parallel in the way Samson braces himself against the poles and columns and stands at the center of a rotary motion implied by the wheel and by the circle of falling roofs and raised arms. Most striking of all is the exceptional way the artist indicates Samson's blindness: at the left he paints the background black and has the central pole cross over Samson's face.[90] Thus Samson's actions transfer from one setting to the other, but at the right, depicted full face before a patterned background, he seems freed from the constraints and isolation of the previous three scenes. The artist, a master at showing physical action, here creates a largely subjective narrative.

While these narrative structures are not without precedent, neither the Saul Master's earlier work nor his later work displays the same sharp interest in character, motive, or the implications of setting. How did these aspects of his painting arise? Perhaps the absorbing nature of working in a small scale led him to refocus and concentrate his interest in the individual figure, or perhaps he was responding to his unusual protagonist and his tragic history. With the changes in this section of the Psalter cycle tending to absorb the body in a decorative pattern, it seems natural that he would explore the implications of the figure operating under constraint. But this language was unnatural for him, and in the next phase of the manuscript production, in which the Saul Master works alone, he eventually returns to the expansive ideas of his earlier work. Those pages are also impressive work, though altogether different from these Samson scenes. In the end, these diminutive powerful miniatures stand alone in the manuscript, a testament to a remarkable artist's inventive response to the changing circumstances in which he worked.

If the Saul Master succeeded in adapting to the new directions of this phase of production, the Abraham Master failed to do so, and the result is some of the weakest painting of the Psalter. Often influenced by those around him, the Abraham Master, or perhaps his assistant, imitates in gathering VIII (fols. 55v–58r) the work of the Saul Master in gathering IX, as may readily be seen in the taut movements of the figures and in the linear treatment of folds.[91] In the work of the Saul Master these elements are offset by the plasticity of the figure, the tension between forms, variations in tone, and a pen line that is more descriptive.[92] For the Abraham Master, line fills, rather than articulates, a form, so that the whole figure has a flat, cut-out quality and is described by a silhouette of large weak shapes. These are features of the Abraham Master's previous work: the contours and forms of the elders carrying the Ark on folio 41v are found again in the striding angel on folio 55v, and his attempt to fill a composition by tilting up a large flat area on folio 58r resembles the pictorial strategy on folios 9v and 33v. Many of these characteristics are seen as well in gathering II.[93]

The changes introduced in this phase of production exacerbated the problems already present in the Abraham Master's work. The new style largely depended upon careful drawing, color, the interweaving of accents. His peers accepted this direction and either elaborated on it directly or assimilated it, developing new and compatible interests, whether formal or narrative. These were not real options for the Abraham Master. His strengths lay in his ability to focus on single impressive figures at critical moments and to use large groups and linking gestures to suggest the scale of an event. The smaller scale and more homogeneous and decorative treatment of forms and accents demanded by the

new style were inimical to those strengths. Moreover, the alternatives that other artists developed—lively rhythm and delicacy of detail, richness of pattern and palette, sharpening of narrative structure—were not options either. Of his several earlier styles, the most appropriate for this phase would have been that of the end of gathering II and the beginning of IV, when he was most under the influence of the Rebecca and Isabella Masters. But rather than return to that manner, he pressed on with the way he worked at the end of gathering IV and adapted the exaggerated tight bodily configurations but not the plasticity of the Saul Master. If the trends in this phase of production foreclosed the artist's strengths, his practicing a more severe version of his current style only made the problems in his work—the lack of compositional clarity, the unfocused gestures, the weak drawing—more conspicuous.

Of all the artists in the Psalter, the Abraham Master is certainly the most difficult to define, for he was the most influenced by his peers and he may have worked with an assistant. In any case, the problematic quality of the four miniatures of gathering VIII suggests he found himself in an untenable situation. Unable to follow his peers in their invention, he took up what he could of the new manner of painting but mostly insisted on what he was already doing. It was a natural response but one that was inimical to his own strengths and made his work increasingly at odds with that of his colleagues. The stiff dullness of these four miniatures is striking and, when seen against his own work at the beginning of the cycle, also saddening, especially since the problem may not have been limited to this project alone. In many ways, he was an artist unprepared for the styles of the 1260s and unable to grow alongside those who were. The conspicuous severity of these four miniatures suggests a retrenchment born of alienation, a turning inward and also a turning away. Beyond these shimmering miniatures is a situation with a very human toll. In Paris at this time of such rapid artistic change, the Abraham Master's situation may not have been uncommon.

PHASE III (GATHERINGS XI–XIII): THE SAUL MASTER ALONE

Unlike the previous phase, this one is not introduced by conspicuous differences in the structure and appearance of the gatherings. Four-folio gatherings continue to be

the rule, the border motifs are still penned in gold and based on the same vocabulary of golden vine forms, and, at least initially, the architectural pattern and palette continue that of the two previous gatherings. But these three gatherings do share several new and notable features. The parchment, unlike that of the two previous gatherings, is uniformly pricked in a distinctive pattern. The color of the bole is lighter and is applied more thinly, so that the surface of the gold is less convex and reflective and its color more yellow and less warm. And the collaboration so characteristic of the first two phases ceases altogether, for all twelve folios are by the hand of the Saul Master. Thus, this phase of production is signaled as were those before, by a change in production characteristics, technique, and working relations.

The most striking feature of these three gatherings is not a change in pictorial style in relation to the previous gathering but one that suddenly appears in folios 69v–71v. Opposite the scenes of folio 71v, which are severe and diminutive even in comparison to the Samson miniatures just discussed, those of folio 72r seem to be of another world: tall, graceful figures with more sculptural folds, aglow with more vibrant colors, contrasting tones, and fleeting reflections. The difference between the two pages is so great as to suggest that the two folios were painted by different artists or at different times.

The artist, however, is the same in all three gatherings.[94] The thin curvilinear folds, the delicate modeling in a blue-gray range, and the extensive use of painted reflections that are so striking in folio 72r can already be found on folio 68r. Moreover, many of the underlying forms continue throughout the three gatherings.[95] To be sure, there are changes in scale, foldwork, and technique, just as there are in the frames and architecture, but they are all extensions of ideas found in the five folios preceding folio 72r, and the innovations introduced there—in middle of gathering XII—are no more far-reaching than those introduced in XI and XIII. Two artists are not at work here, just one who is exceptionally innovative.

That artist was certainly the Saul Master, for gatherings XI and XII take up many of the forms seen in the artist's last paintings in gathering IX. The unusually diminutive figures and concentrated, tight compositions of folios 69v–71v were already seen there; only now the figures are more reduced, and their forms are even drier and harder.[96] Other aspects of folios 69v–71v find parallels

in these Samson miniatures, some of which even anticipate the more "advanced" paintings of gatherings XI and XII.[97] Most telling are the parallels between the figures of greatest power and elasticity, such as Samson breaking his ties in folio 60r and the terrified messenger of folio 76r.

If the Saul Master's most recent work in gathering IX anticipates these final three gatherings, his earlier miniatures in gathering IV do so especially. Oddly, these first miniatures by him are most strikingly compared to his last paintings in gathering XIII. In Balak's proportions, striding movement, three-quarter turn, facial features, and even some fold passages, the king in folio 38r clearly anticipates the unusual figure of Saul in folio 78r. Moreover, the exceptional manner of structuring space and of linking up narrative sequences in folio 38r occurs again in folio 76r, just as those in folio 39v are found again in folio 75v. The characteristic physical elasticity and the compression of body seen in earlier figures of Moses in folio 37v are easily recognized in the terrified messenger in folio 76r. Most important, these last miniatures show how the Saul Master takes up the experiments with thin washes, white highlights, and a more varied palette that were only nascent in his work in gathering IV.[98] Numerous details also tie these last gatherings to the artist's earliest miniatures, but the relations just cited are so exceptional, both in the Psalter and in Parisian painting at this time, as to point compellingly to the hand of the Saul Master.[99]

If the final three gatherings of the prefatory cycle are by the same artist, then how are we to account for these changes? Given the advanced character of the technique and style of the last folios, one possibility is that production broke off with folio 71v and was resumed only several years later, when the Saul Master returned to complete this section of the manuscript. This hypothesis is tempting because the style of the last section is current in the next two decades, because the death of Louis IX in 1270 would naturally have halted work on his manuscript, and because the subsequent interest in his legacy and canonization might have led to the completion of his prayer book.[100]

There is, however, no physical evidence to suggest that production was interrupted after folio 71v. The preparation, underdrawing, bole, and gold are the same in all three gatherings, and although the architectural pattern changes, it does so only in the final gathering.[101] Unlike the replacement folios in the psalm text, where the painted and gilded initials employ distinctly different materials, no such differences are visible here.[102] Moreover, these folios exhibit an unbroken evolution in the design and coloring of the upper half of the miniatures and of the frames, the parts of the miniatures most likely to reveal an interruption. In fact, the decorative conception seems to develop directly out of the Saul Master's previous work.[103] If a significant change occurs in decorative concept, it is between gatherings XII and XIII, but the change is not a jump to a more modern conception but just a better way of coordinating the various sections of the page.[104]

The situation is precisely the same for the figural style as for the decorative conception. The technique and palette of folio 72r may be the most conspicuous sign of a change in direction, but the direction it represents was really introduced in folio 68r and anticipated in folio 67v. Moreover, striking innovations are introduced with folio 73v and then again with folio 75v. In the former the artist forgoes the use of white highlights, limits himself entirely to transparent washes on exceptionally thin drapery, and, in the principal figures, works only within a narrow range of blue-gray and gray-blue. In the latter, white highlights reappear but within an expanded palette and on drapery that begins to develop a different system of curvilinear foldwork. Rather than a singular change in direction, these three gatherings present yet another period of sustained invention for the Saul Master.

If the momentum of invention in Phase III continues to the final miniature, the reduced figures and dry style of folios 69v–71v constitute a shocking interruption. They cannot entirely be explained as the continuation of the Saul Master's earlier work, for their style is inimical both to the coloristic richness characteristic of Phase II and to the increasingly light and delicate quality of the architectural decoration above them. This is, in fact, the only instance in the manuscript in which the palette of the upper and lower parts of the miniature are so at odds. Furthermore, because these unusual miniatures extend from the middle of gathering XI and to the middle of gathering XII, this is the only time in the manuscript when a change in style does not correspond to a change in phase, gathering structure, or artist.[105] So exceptional are these circumstances that one must ask if the Saul Master might deliberately have introduced this style at this point in the cycle despite or even because of its incongruity with the nearby miniatures. As the iso-

lated work of one of the other artists, these three minia-tures would be idiosyncratic, but as the work of the Saul Master, they may well be a considered choice.

One explanation for the exceptional style of these three miniatures is the subject they have in common, the Ark of the Covenant in captivity. The Philistines cap-tured the Ark during a battle but could not keep it, for plagues and misfortunes followed wherever it was taken, and so they passed it from one city to another and finally decided to return it to the Israelites at Beth-Shemesh. Although the ostensible subject of these folios is the story of the Ark among the Philistines, in a larger view it represents the dark period in which "the glory [had] departed from Israel," in which the army and priesthood had failed.[106] The three miniatures form a narrative unit, and the Saul Master's harsh and sober description of these episodes are not inappropriate to their subject.

It is, however, impossible to demonstrate that the Saul Master used a severe manner for these three minia-tures because of their subject. But several other miniatures suggest that he did use technique and palette to respond to subject matter and that content, technique, and form are closely linked in his work. As already noted, he used a black background to illustrate Samson's blindness (fol. 62r). If a color is used metaphorically, might not a tech-nique also be used figuratively? There is much in the Saul Master's work to suggest that it is. In the Balaam minia-tures (fols. 38r, 39v), only the prophet's robe is lightened by modeling with a thin wash. The episodes illustrating Saul's three visions (fols. 73v–74r) are painted with a thin-ner wash and have a more evanescent quality than any others in the Psalter. And in these last three gatherings, the miniatures of Samuel's calling, Saul's anointment, and the events leading to his assumption of the crown of Israel (fols. 68r, 72r, 75v–78r) are the miniatures most aglow with reflections and bright colors. It seems unlikely that these several parallels between form and content are coin-cidences. Rather, they show how the artist used palette and technique to extend and interpret the narrative. God's guiding or speaking to Balaam, Eli, or Samuel calls for a different pictorial reality. In folio 72r, after the Ark returns to Israel, painting itself is not the same.

This explanation may help account for the excep-tional treatment of form, color, and light in these last three gatherings as compared to the previous ten. One might argue that because the Saul Master was working

alone in these gatherings, he was less constrained by group pressures and able to return to the ideas germinat-ing in his earlier works. It is likely he was stimulated or emboldened by works he encountered elsewhere, as some of the most advanced Parisian painting and sculpture of the time was moving in a similar direction. But it is also possible that the subject and his understanding of its rele-vance for the patron played a role, for this history of Samuel and Saul is the story of the beginning of biblical kingship. No section of the book more directly pertains to the reader, as the Saul Master must have anticipated.

Of the Saul Master's many innovations in these three gatherings, several of the most precocious are to be found in the last seven folios. A number of these were discussed in the previous chapter, especially the way he paints so thinly and models in color. For the figures in folios 72r–74r, however, he uses dark blue in combina-tion with gray, the latter sometimes shaded in blue. These miniatures concern the Israelites' request for a king, Saul's anointment, and the visions confirming Saul's selection. In all three, Saul's robes are in these col-ors only, the gray being used for his mantle. The figure of Saul in the left half of folio 73v is especially notable, for the artist uses almost no white but limits himself to light washes in a particularly narrow range of blue-gray and gray-blue. The edges are precisely drawn so that the robes appear to be extremely thin, and the modeling is especially tight, staying well within the blue-gray range and following the fall of the drapery around the figure in order to describe its shape in space. The effect is to cre-ate an elegant figure with mass but little weight, one that seems to absorb but not reflect light. In Saul's final two visions, on folio 74r, the leader's gray mantle is no longer modeled in white but becomes transparent to the parchment beneath.

The visions complete, the status of these figures boldly changes in the last four miniatures, in which Nahash threatens the Ammonites and sets in motion the events that lead to Saul's calling up the Israelites, his vic-tory, and eventually his confirmation as king. Although the earlier technique of modeling continues to be found, these folios are marked by figures with strong contrasts of white highlights and dark shadows and, moreover, figures with large folds that hang away from the body and sweep downward, giving the whole figure a greater bearing and statuesque girth. The bearded elder with the

pointed hat at the left of folio 76r and Saul at the right of the same miniature have hips of a breadth and move with a weight not found in the earlier miniatures.[107]

The greater physical presence of these figures also seems to be related to the way the artist structures pictorial space. I have noted that these pages refer back to figures and compositions in the painter's miniatures of Balaam and Barak, and Balaam and the Angel (fols. 38r–39v). Those miniatures were also unusual for their treatment of space, the folded space of the former, the arcing outward of the latter. Similar explorations of space emerge in three of his last four miniatures. Nahash Threatening the Hebrews resembles Balaam and the Angel (fols. 75v, 39v) in the concentration of forms at the sides and in the progressive stretching and bowing out of space toward the mounted figure at the center. The convexity of this arc appears to be greater in the Nahash miniature because of the greater flatness of the architectural setting overhead, the fact that Nahash overlaps the column behind, the strong reflections off the hindquarters of his horse, and the way the two soldiers behind him seem to ride away from him and inward toward the center of the page. The same is the case for Saul's Victory (fol. 77v), where the conquering hero stands out not only because of overlapping but because the other figures increase in scale toward him, as though he were the most outward figure on a convex arc. Saul's greater stature is required by the biblical text, but the gradual diminution of the other soldiers is the artist's invention.

The same strategies pertain in the facing miniature, in which Saul is shown with crown and scepter (fol. 78r). In all these miniatures the narrative seems to move out from underneath the gabled arches overhead as the principal figure strides forward along an arc of curving space. In this one, however, Saul is slightly left of center and pivots outward. His scale, the convexity of the grouping, and the strong reflections on his forward leg all strengthen the movement outward. And because the forms that curve forward from behind him do not recede before him and reenter the depth of the page, as they do in the right half of the composition on the previous folio, there is less to hold in the figure. Having been affirmed as the first king of Israel, Saul, in this final miniature, seems to emerge from beneath the construction in which sacred history has been presented and to turn toward the reader. Here the artist clearly implies

where the next stage of the history of kingship lies.

· · ·

Gathering III and the Psalm Initials. It will be recalled that the Joseph scenes of gathering III are painted in a technique and style found nowhere else in the prefatory cycle but consistent with the paintings in the Isabella Psalter. However, the architectural settings and frames are painted in a different manner, one identical in technique, palette, and design to the settings and frames of gathering XIII.

The evidence that these Joseph scenes were painted during the first phase of production is circumstantial but compelling. I have noted that details and compositional features typical of the Cambridge manuscript begin to show up in the miniatures of gathering IV, which may well have been painted at the same time the Isabella Master was working on gathering III.[108] More important, far-reaching changes introduced in gathering V—the size of the gathering, the cityscapes, and differences in technique, palette, composition, narrative conceptions, and figural style—all appear to respond to practices seen in gathering III and in the Isabella Psalter. Indeed, if there were no gathering III, one would have to hypothesize some form of contact with the Isabella artists in order to account for the fundamental shift in design. It is likely that the Isabella Master arrived after the first gatherings had gotten under way and began working with parchment that was ruled and had architectural designs like that of other Psalter folios. Whether or not he was brought in to help solve the problems so conspicuous in gatherings I and IV, it is not surprising that he would have left the architectural settings and frames of gathering III unfinished, since the design of these parts of the page had been developed in-house and were quite unlike those in the Isabella manuscript.

There can be no doubt that the architectural settings and frames of gathering III were the last parts of the prefatory cycle to be completed, because their design and palette developed only during the final phase of production. The palette used uniquely in the architectural settings of gatherings III and XIII corresponds to that found only in the biblical scenes of XIII, and the unusual practice of using two dramatically different tones for each color in the gables is found only in the two gatherings preceding XIII.[109] I have also noted that the decorative conception of gathering XIII develops out of these

two previous gatherings and out of the earlier work of the Saul Master.[110] And even though the individual floral motifs in the frames of XIII and III find analogies in the psalm initials of both the Paris and Cambridge manuscripts, the way they are organized and used in these two gatherings occurs nowhere else.[111]

It is interesting to see what happens in gathering III when the different kinds of painting so characteristic of these sister manuscripts are brought together in a single image. With gold used so extensively throughout, the two parts are hardly incompatible. But the figures in the Joseph scenes, with their opaque painting and different palette, isolated groupings and distant monumentality, clearly stand out from the surrounding parts, their heightened legibility and dramatic effect appropriately coinciding with the climactic events in the Joseph story. In the final Saul scenes, however, the delicate tonal balance, thin painting, and scintillating form are consistent in all parts of the miniature, so that the whole image has an evanescent quality. Joseph, enframed, visibly reveals himself, but Saul and his setting enjoy a balance and brilliance that is momentary.

The Saul Master was one of the two artists responsible for the eight illuminated initials. He painted the full-page Beatus miniature and three others, his work continuing along the same lines of gatherings XII and XIII.[112] In folio 110v, for example, the figures are confidently modeled with both opaque paint and washes. The parts of the composition are precisely spaced, controlled in scale, and in tension with each other. Individual figures are treated the same way: the parts of Christ's body are dynamically juxtaposed, especially the legs and the upper and the lower body, and the religious figures below are carefully varied in placement, physiognomy, and coloring. In contrast, the figures in folio 126v, by the second artist, are modeled only with opaque pigments, and details and reflections provide highlights and define surfaces but remain flat. The identity of the other artist is more problematic. None of the other Psalter artists is indicated, but several details recall features of the Isabella Psalter.[113]

The Two Royal Manuscripts

The many close connections between the Paris and Cambridge manuscripts, in both their content and form, and the evidence of contact between those working on

them raise the question of the circumstances in which the two manuscripts were planned and produced and the extent to which the situation is or is not typical of illuminated manuscripts made in Paris at this time. The identical format and layout of the two manuscripts and the similarities in parchment and script, in the iconography of most of the psalm initials, and in many aspects of their decoration naturally suggest that the two manuscripts were planned at the same time and produced in tandem. Moreover, the texts of the calendar and psalms represent independent variations on a common source, and the script is similar enough to suggest that the texts were copied in the same place.[114]

However, the paintings of the two books were assigned to different groups of artists. Those who worked on the Isabella Psalter appear to have been experienced illuminators who were well prepared for the assignment. They drew forms with precision and clarity and shaded equally well with pen and brush. The technique they employed is consistent with other manuscripts of the time, though more accomplished than most.[115] The book, its paintings, and decoration are unified in conception and, at least in its present condition, provide no evidence of uncertain beginnings or of changes in conception as work progressed.

In contrast, some of the artists of the king's Psalter, such as the Noah and Saul Masters, appear to have been less experienced in the medium. The many structural, technical, and decorative irregularities in the early gatherings indicate uncertainty regarding how to proceed and the absence of effective coordination, and the numerous adjustments in figure style, decoration, and technique suggest not only a settling into the medium and an attempt at a unified language but a continual reassessment of pictorial goals. Although both manuscripts make extensive use of gold and draw upon a similar figural vocabulary, they differ fundamentally in technique and palette, with the king's manuscript oriented toward a thin application of paint, transparent effects, a balance of hues and reflections, and varied forms of modeling. Some painters are likely to have been trained in a different medium, such as wall painting, which appears to have been moving about this time toward one or more thin layers of paint applied directly on a white ground.[116] The choice of painters with less experience in illumination remains one of the most per-

plexing aspects of the Psalter. It was a risky decision. One would like to think it was an informed choice by someone willing to gamble that artists of a different background might provide a special quality of innovation. But their selection may have resulted from nothing more than a personal connection, a political favor, or, most likely, the continuing obligations of those already working for the king, perhaps in some other medium.

In spite of these differences, or perhaps because of them, contact between those working on the two manuscripts was frequent. However, influence appears to have been in one direction only. An artist working in the style of the Isabella Psalter painted the Joseph scenes in gathering III, and another may have contributed to the psalm initials, but there is no evidence of a Saint Louis Psalter artist contributing to the Isabella Psalter. Both works rely upon the same text of Psalms, but the errors in the Cambridge manuscript were corrected by those working on the Saint Louis Psalter.[117] The decorative motifs in the frames of the Cambridge manuscript are adopted in the latter gatherings of the prefatory cycle in Paris, and some are reiterated in its psalm initials.[118] And the psalm initials of the Isabella manuscript seem to have inspired most of those in the king's Psalter, which often elaborate, correct, or misunderstand those in the Cambridge manuscript.[119] The priority of the Isabella manuscript is clear, and one can only wonder if it reflects the manuscript's having been begun earlier or the greater authority of its experienced illuminators or perhaps both.

Because both manuscripts are so exceptional in content, there must have been a significant preparatory stage in which a program of illustration was developed. It is impossible to know how it was worked out and what form it took. However, as I discuss later in this study, advisors close to the king likely played a role, and other illustrated works were probably consulted and adapted, especially in the case of rare subjects.[120] It remains unknown whether this resulted in a general understanding between the planners and artists about the range of subjects and the intention of the cycle or in something more concrete, such as a plan laying out specific subjects or showing how they were to be treated or blocked out. Considering how so many compositions fit comfortably into the Psalter's double-page format and, after Phase 1, how so many narrative sequences fit so neatly into single gatherings or groups of gatherings, preliminary sketches

would have had to be prepared, if only to allocate these subjects. Some context would also have been required for working out compositions and translating older sources into a modern idiom, although it is possible, at least in principle, that the underdrawing served this purpose. It is certain, however, that the artists were not handed full-scale drawings or detailed compositional sketches, for certain spatial concepts and compositional and narrative preferences are characteristic of specific artists; if detailed renderings had been used, each painter would have had to have created his own.

The artists of both manuscripts clearly relied upon a common vocabulary of compositions and forms. While many forms were current in Parisian art at this time, some specific compositional formulas often recur, like drapery patterns and figures in bed or in certain poses, such as the kneeling position.[121] While they could have been copied from a sketch or shop model, the dimensions are never repeated exactly, and some passages are always improvised to fit the situation, especially the arrangement of head and limbs. Compositional formulas may have been used to situate a few key forms and to render specific drapery patterns, but there is no evidence that whole compositions were built up of such units. It is more likely, given their numerous variants, that many were conventions the artists knew by heart and elaborated according to the iconographic context. Thus even when such formulas are used, artistic differences are still clear, as is evident in the depictions of the angel and Joshua on folios 39v and 40r, each distinctive of the Abraham or Saul Master, even though the same drapery pattern is used. And for most of the painters, the style of underdrawing remains consistently tied to that of the finished work. Numerous other examples could be cited, not only of figures and drapery patterns but also of animals and even standardized forms, such as altars.[122] In the final analysis, such conventions were part of a common language and a means to an end.

My earlier discussion of the Saul Master pointed out his connection to the same group of Cambridge initials that seemed to be the source for the Isabella Master, and raised the question whether it was merely a coincidence that he appeared just after the Isabella Master finished work on gathering III.[123] In retrospect, the Saul Master's connections to the Isabella paintings appear to run much deeper. Samson Bound and Samson Breaking

FIG. 17 *Cambridge, Fitzwilliam Museum,* MS 300, *Isabella Psalter, fol.* IVr: *David Recognizing Solomon.*

ongoing contacts with the Isabella group of artists and that he may even have worked with them before joining the Psalter artists and adapting to its forms and aims. This profile would help explain how the frame motifs of his final miniatures are closest to those in the Isabella Psalter. With the second artist of the Psalter initials also having ties to the Isabella group, it is clear that contacts between the two were ongoing, whatever the differences in pictorial means.

. . .

The three "phases" of production in the Psalter are marked by changes in the gathering structure, decorative concept, and working relations. Since each phase represents some kind of reorientation, the junctures between them may have been times when the painters met or were convened by the *libraire* or whoever coordinated production.[126] In between such occasions, what I have called a "group"—usually two artists—worked closely together. Nor should these groups be considered at too great a physical remove from each other, for the Isabella Master influenced artists in both groups at about the same time, and palette and frame design developed from one gathering to another without respect to group. It is more likely that relationships between the artists operated on several levels and were fluid rather than fixed and hierarchical, that the painters worked alone but had frequent contact with colleagues, singly and in groups, out of necessity or interest.

These relationships suggest that the production of the Cambridge and Paris manuscripts was based in the commercial market, at least insofar as the parchment, scribes, and patterns of collaboration are concerned.[127] At the same time, it is clear that while the court obtained manuscripts on the market, it also commissioned work outside of it.[128] Moreover, practices in slightly later royal manuscripts show that there were exceptional ways of communicating a program of illustration and that the patrons or their representatives had a role in production.[129] Given the extraordinary range and complexity of Parisian bookmaking and illumination during the reign of Louis IX, it is clear that the commercial market was flexible enough to accommodate a royal commission in which both the program and artists were exceptional, especially when a *peinture du roi* was involved.

The pressures of the market in Parisian art at this time probably required that some painters be able to

His Binds (fols. 59v, 60r) closely parallel the Cambridge manuscript's Mocking of Christ (fig. 15) in both figural and narrative conception; moreover, certain drapery-pattern techniques, such as the stabilizing use of several vertical folds falling from the chest to the feet of the figure, are found only in the work of the Saul Master and in the Cambridge manuscript (fol. 38r, fig. 15).[124] Only the same middle group of Isabella miniatures have similar arrangements of small fold forms, even if they are not as dynamically composed or used as a means to explore reflection and light.[125] Even among the several examples of figures in bed in the two manuscripts, no two are as strikingly distinctive as those in the scenes of Samuel's Calling and David Recognizing Solomon (fol. 68r, fig. 17). In short, it seems likely that the Saul Master had

work in different media and that all be able to collabo-rate and adapt to new forms. The Psalter miniatures, I have argued, show the ease of some in doing so and the problems or possibilities for growth it held for others. The lesser artists could only move between modes of painting, but those of greater stature could respond to new influences and, in some cases, to the content of the work or its import for the anticipated viewer. Even so, nothing really prepares one for the range of an artist like the Saul Master, for his innovations of pictorial struc-ture, his experimentation with light and color, or his response to pictorial content. As the next chapter shows, each of these aspects of his work, if taken separately, finds parallels in contemporary works. Together they present us with a person of extraordinary versatility. In the Paris of Jean de Meun, Roger Bacon, Adam de la Halle, and Thomas Aquinas, such qualities of mind are hardly surprising. In these terms the most striking fea-ture of the Psalter paintings is not their spectacular rich-ness and refinement but the creative enterprise they represent. In the final analysis, the production of the manuscript is less about style and collaboration than about painting, perception, and thinking.

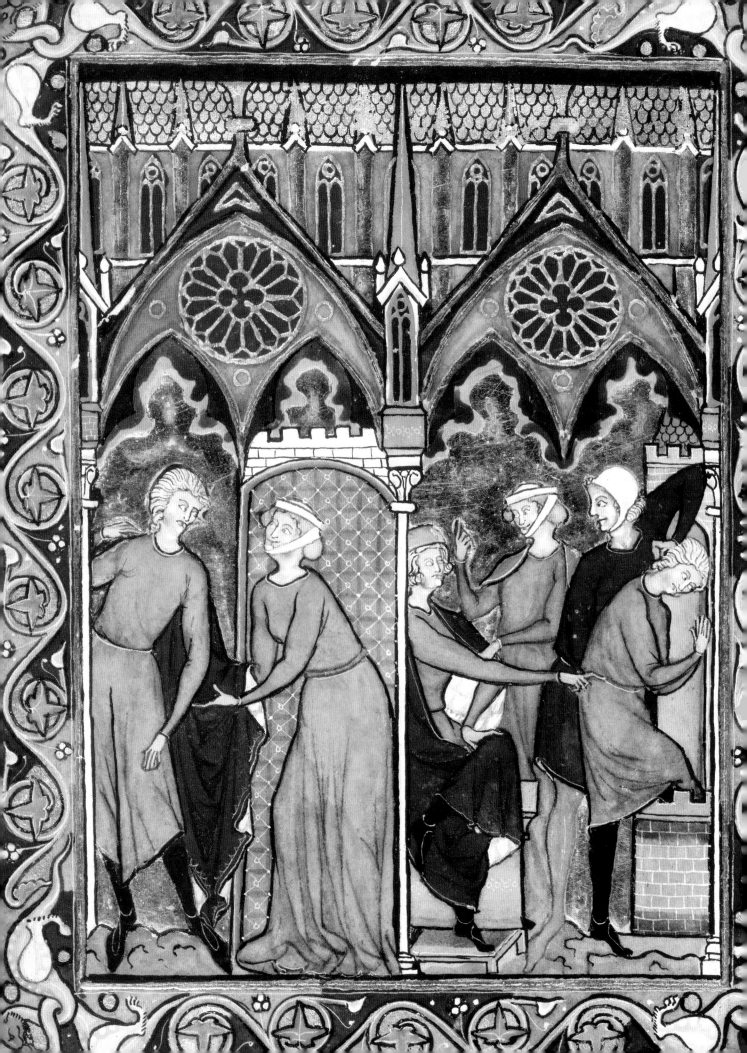

CHAPTER THREE

Constructions and Readings

My interpretation of the full-page miniatures is essentially
fourfold, as reflected in the divisions of this chapter, which
address the architectural superstructure and the semiotics of
the page; the formation of new meanings from varied and
sometimes exotic iconographic sources; the legends and their interpreta-
tion, as well as explanation, of the miniatures; and the exemplification of
new pictorial values through the form, technique, and color in certain
miniatures, motivated in part by an interest in optics in Paris in the 1260s.

Part 1: Architecture and the Pictorial Field

The full-page miniatures of the Psalter have figured prominently in several dis-
cussions of medieval pictorial space.[1] The principal object of interest has been
the architectural structure over the biblical scenes, for virtually every writer has
understood the structure as translating the elements of contemporary architec-
ture into pictorial form. The subject has often been discussed in terms of an
evolution toward a deeper and more coherent space, with the Psalter invariably
representing a High Gothic stage of a development that culminates in the
fifteenth century. Because the subtext of these discussions is the process by
which painting engages the beholder, art historians have been especially atten-
tive to the elements that surround the biblical scenes. These structures have
been described as a "proscenium," that is, an interface between the world of the
viewer and world viewed in the picture. As such the architectural elements not
only mediate vision but help to organize and control it.

Detail of folio 19v, Psalter of Saint Louis

Architectural forms occupy a major part of these miniatures, and several authors have made significant observations about them. Erwin Panofsky is certainly right in stating that the overhanging arches are a delimited space-suggesting device that frees the figures to act within its spatial shell. Miriam Bunim writes about the leap in structural intelligibility that comes with these architectural forms and the way the architecture as a unifying element links action and background. Karl Birkmeyer describes how the architecture affects and gives coherence to the figures and intervals, and how the precocious framing arch motif connects the architecture with pictorial space, and the outer frame, with the codex. Finally, Otto Pächt demonstrates that the architectural superstructure can be a border for the scene below but does not function as a setting, for when the narrative calls for a building, it is illustrated below, within the narrative.[2] But these studies, because of their primary interest in the architectural forms, either do not go far enough in analyzing the architecture or tend to overlook certain contextual elements. According to these authors, the architectural forms over the narrative are understood to constitute a proscenium or canopy or baldachin, a frame or structure, but not a section of a building. And the architecture is generally discussed independently, as though a miniature's architectural and narrative sections were distinct, not units within a whole. Color and gold are not mentioned, although, as I have noted, they have a structural and spatial role. Several of these authors go on to interpret architectural forms symbolically or allegorically, but none does so in the case of the Psalter. And finally, as Richard Krautheimer points out, the space in these paintings is seen as an added dimension, an imperfect forerunner of Renaissance space, for solids are seen on a continuous plane or surface, not as isolated elements.[3]

The space within the rectangular frame of each full-page Psalter miniature is subdivided into left and right halves, and upper and lower halves. It is divided first vertically by three thin colonnettes, one at the center of the narrative and another at each side. Although the colonnettes are sometimes covered partially by the frame or hidden behind figural or scenic elements, each colonnette has a base and capital, the latter carrying a tall abacus that serves as the base for a pinnacle. The pinnacle is decorated like a small tabernacle in the form of an aedic-

ula with tracery, and is topped by a pitched roof that is surmounted by a tall spire and finial. The base of the colonnette rests on the lower frame and its finial reaches to the height of the upper frame, and because the capital or abacus marks the vertical midpoint, the space is divided again, this time horizontally. These forms thus divide the surface into equal upper and lower parts, architectural and narrative.

From points above the capitals and behind the pinnacles spring two identical gabled arches, each enclosing a tympanum with a rose above two pointed arches. Rising behind these gables is the upper flank of a building, with its clerestory windows and buttresses, a level defined by a horizontal molding above and below. Above the upper flank of the building is the roof. The zone above the roof is painted black in most of the miniatures.[4] With few exceptions, the gables and buttresses, like the colonnettes, have small finials that rise through this black zone and just reach the height of the upper frame.[5]

The practice of framing figures and narrative friezes with architectural elements, especially niches or arcades carrying city walls, buildings, and towers, goes back to Early Christian art and is commonplace in manuscripts, especially in Carolingian and later illumination.[6] Thirteenth-century gables and arcading, from a period when urban and architectural forms are recognizably Gothic, create a more pronounced rhythm, but their framing function remains essentially unchanged. However, the architectural superstructure in the Psalter of Saint Louis departs from this norm in several significant ways. First, it is allocated a space approximately equal to the narrative zone below. Second, its distinct levels and overlapping planes suggest a coherent two-storied structure in which the pinnacles, gables, clerestory, and roof are progressively set back. With its colonnette bases resting on the lower frame and its roofline giving way to blackness, the structure is less a proscenium than a section of a structure or a building set into the miniature, with space left over above. And third, the flank of this building is seen at a strict right angle, neither end of it is visible, and its forms are largely gilded. Within the narratives, however, the figures are often given in three-quarters, the buildings are fully legible, and both are painted, not gilded.[7] The two zones thus employ a different kind of optics and, presumably, convey a different meaning.

The architectural forms of this superstructure develop out of contemporary Gothic buildings. A gabled arcade surmounting figures and narratives was a commonplace of early Gothic cathedrals: gabled arcades first appeared in the porches over the sculpted portals of the cathedrals of Laon and Chartres and over the jamb statues of the Coronation of the Virgin portal in Paris.[8] For the arrangement in the Psalter, a critical work is the now destroyed church of Saint-Nicaise at Reims, where a continuous gabled arcade on columns projected from the west façade (fig. 18).[9] Each gable enclosed two trilobed lancets that were surmounted by a large quatrefoil, analogous in proportion to the rose and arcade in the Psalter miniatures. In the façade wall were large narrative panels of relief sculpture that were visible through the columns and beneath the arcade, much like the narrative scenes in the miniatures (fig. 19). The screening of the entire façade was probably the source for the design of the north and south transept portals of Notre-Dame in Paris (fig. 20).[10] Although the proportions have become taller and narrower, the increased planarity and prominence of the pinnacles are especially comparable to those in the Psalter miniatures.

One of the unusual aspects of the Paris transept façades is the relation of the gabled screen to the transept end behind it. The south façade screen, lower transept wall, and upper wall, with the glazed clerestory, rise one

FIG. 18 *Engraving of the façade of Saint-Nicaise, Reims. Private collection.*

FIG. 19 *Engraving of the façade of Saint-Nicaise, Reims, detail. Private collection.*

FIG. 20 *Notre-Dame, Paris, south transept, exterior.*

FIG. 21 *Notre-Dame, Paris, south transept, interior.*

For the handling of specific forms, the blind gabled arcades on the interior south transept wall provide the most appropriate analogy (fig. 21). Although many of the elements again differ, there are important similarities in the thinness of the forms, the taut curves of the arches, the tight spandrels, and the proportion of the gable in relation to the rose and lancets.[12] The darker tones of blue or salmon that follow the forms of the painted gable and tympanum are analogous to the edge moldings in the blind arcade. Crocketing on the gable, a decorative element introduced earlier at Notre-Dame, begins to appear in gathering III.[13] The pointed trilobes, which Branner cited as so distinctive of the south-transept design, are found from the fourth gathering on, and the small black rounded trilobe forms that appear to pierce the spandrels in gatherings XI and XII are similar to those near the Porte Rouge, completed before 1271.[14]

The south transept of Notre-Dame was undertaken in 1257/58 by Jean de Chelles and to a large extent is the work of Pierre de Montreuil, who probably continued to work on it until his death, in 1267.[15] The architectural similarities suggest a date for the Psalter in the same years, and the figural style of the sculpture of the south transept portal points to the same conclusion, as discussed below. At the same time, no part of the design of Notre-Dame can be said to be copied or imitated in the Psalter. The miniatures draw on a similar architectural idiom of planarity, rhythmic play, and decorative richness, but they have their own way of using proportion and setbacks to temper and clarify the whole.[16] In the end the relation between the two works lies in their common pictorial values and goals and in the high level of innovation used to achieve them. The Psalter and the south transept are not just contemporary; they are modern in the same way.

Lancet windows and buttresses were part of a shorthand for indicating a Gothic building, and after the mid–thirteenth century, the gabled arcade was too.[17] These structures appear, at varying scale, in smaller portals and as framing elements in choir screens, tombs, stained glass, ivories, and metalwork, as well as in manuscript illumination.[18] The forms and the contexts of these structures are so varied that their meaning is difficult to determine. In a few cases, however, the architectural reference is specific enough or the circumstances clear enough that at least part of the work's intention is dis-

above and behind the other, each marked by an arcade of different density and height. And the gables, each flanked by a spire, progressively enlarge toward the center. Something analogous happens in the miniatures: the horizontal molding that defines the lower edge of the clerestory level crosses behind the middle of the gable, just as the lower arcade on the south transept wall does, and it similarly divides the densely patterned clerestory and its arcades from the blank wall below it. Although the forms and divisions are naturally very different in the transept and miniature, each creates a precise play between the elevation of the gable and the forms that progressively recede in two stages and proportionally rise behind it.[11] However different the particular forms are, the critical element of the design—the relation of the gables and spires to the horizontal elements behind them—is handled in a similar way and to similar effect.

cernible. For example, the series of high choir windows of the cathedral of Reims depict twelve bishops who represent localities identified by inscription and distinguished by the different church façades overhead. Surrounding an axial window with the archbishop of Reims, they show the relation of these suffrage churches to the cathedral.[19] Metalwork reliquary shrines involve similar specific references.[20] Although reliquaries often have architectural forms and details, the practice of creating a reliquary in the form of a contemporary Gothic building is new to the mid–thirteenth century.[21] Of those preserved, the most thoroughly studied is that of Saint Gertrude at Nivelles.[22] Its architectural forms are precise enough to show that, like the Psalter, the structure draws upon the architectural idiom of a particular period and region in order to create an original design.[23] And the identifiable figures and narratives decorating the sides and roof indicate that the metalwork church, in spite of its contemporary appearance, was intended to represent a sacred building. Moreover, specific forms, such as its flat ends, assimilate the form of a sarcophagus in order to suggest how the saint, whose physical remains were inside, dwells through time in the Jerusalemic church.[24]

By the mid–thirteenth century miniature buildings or small metalwork structures with contemporary architectural details are widely used to house not only the relics of a saint but figures enacting events from the life of the holy person.[25] At the same time, one begins to see manuscript illuminations with precisely drawn architectural elements, often architectural cross sections, and features suggesting metalwork in general and shrinelike structures in particular (fig. 22).[26] They are of interest because their architectural framing and details are often as elaborate as those in the Psalter.[27] However, the subject matter depicted in these structures consists of standing saints, the Virgin and Child, or the enthroned or crucified Christ, not Old Testament subjects. By depicting the figures as enshrined rather than merely enframed, these illuminations use another form of representation, that of reliquaries, to underscore the corporal presence of what they describe pictorially.[28]

The Psalter miniatures have a number of these features, such as the gilding of the architectural structure, but other details set the Psalter miniatures apart from reliquary shrines or structures that house a sacred narra-

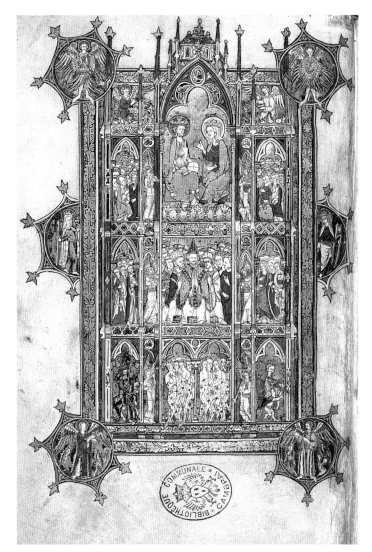

FIG. 22 *Cambrai, Médiathèque municipale de Cambrai, MS 87, fol. 17v.*

tive. First, the architectural forms are exterior forms, with no cutaway views, and no figures of smaller scale occupy the buttresses or pinnacles. Second, the golden forms of the building above do not extend into the lower part of the page (except as background) or enclose the narrative. Whatever the gilded forms above represent, the scenes below are not part of it. And third, the lower part of the page is narratively distinct. The Old Testament scenes take place under an arcade and are separated from it by banks of clouds, an element not found in the other representations. These clouds set off the narrative area as a distinct field of representation. The

boundary it creates is not even crossed by angels and figures of the Lord, for they appear out of banks of clouds *under* the arcadeza; that is, contact with the Divinity takes place within the pictorial field of the Old Testament, not from above or around it.

In the Psalter this imaginary frontier between the upper and lower parts of the page is breached only twice. Both instances are telling. The first occurs on folio 7v, where the Oak of Mamre rises in the center of the miniature, its trunk in the lower section and its bright green foliage entirely in the upper, covering parts of the gables and the building behind it.[29] In the miniature the forward angel at the table points up to the tree to announce that the aging and childless Sarah will conceive, so that the acorn-laden tree is a confirmation God's promise to Abraham to make of him a great and mighty nation.[30] The tree is therefore an image not only of fertility but, as is often the case in medieval art and literature, of genealogy.[31] The relation between the two parts of the page is consequently historical, and so it is significant that the tree's foliage is entirely in the upper half of the miniature, implying the view of Augustine and later writers that the fulfillment of God's promise to Abraham lies beyond the limits of the Old Testament and in the era of the Church.[32]

The second instance is folio 13v of Jacob's Dream, where, at the left, angels ascend and descend a ladder that extends from Jacob sleeping on the ground all the way to the head of Christ, just beneath the upper frame, near the roof of the architectural structure. In the scene at the right Jacob anoints the stone at Bethel. These two Jacob episodes form the central images of the medieval ritual in which a church was dedicated and its altar consecrated.[33] Read in full and repeatedly invoked, the biblical passage about the ladder pertains to the church as the gate of heaven; similarly, that about the stone at Bethel is the culmination of a series of anointments that transform the earthly building into a prefiguration of the Heavenly Jerusalem.[34] These are the terms in which the two episodes identify the structure above, which is conspicuously a religious structure. Taken together, the Abraham and Jacob pages show that the distinction between the upper and lower parts of the Psalter page is historical: the Old Testament events lead to and are fulfilled in the time of the Church above. In contrast to the reliquary of Saint Gertrude, whose body resides in a Jerusalemic setting,

almost all the figures in the lower part of the miniature are locked into their historical epoch.

The relation between the upper and lower parts of the Psalter miniature thus presents an interesting reversal of the relation between the medallions of the *Bibles moralisées*. In those manuscripts Old Testament subjects are above and juxtaposed with incidents from both the New Testament and modern Parisian life. One of the most frequent devices for referring to the era of the Church is the figure of Ecclesia, usually Mary, a female personification of the Church or of Wisdom, and in some cases an image of a modern Gothic building.[35] In the Psalter, Old Testament subjects are below and always juxtaposed with a modern Gothic building, but the temporal construction is similar and the allegorical relation between the eras under the "law" and under "grace" is no less implicit. Indeed, the contemporaneity of the architectural design and the precise rendering of detail only heightens the sense of immediacy and serves to underscore the relevance of the Old Testament events. Moreover, it is entirely appropriate for a building of this kind to frame religious subjects, since building is one of the oldest medieval tropes for recalling Scripture and "constructing" meaning out it.[36] But in contrast to the *Bible moralisée,* the arrangement is reversed and hierarchical; that is, the Church is a constant seen above the unfolding of Old Testament history. The building indeed recalls Augustine's pilgrim church, the church *in time* rather than at the end of time.[37] Its immutable form is always above, superintending the events beneath, which it will supersede.

Many have wondered why the cycle of prefatory miniatures in the Psalter of Saint Louis, unlike those in all other Gothic psalters, illustrates no event from the lives of Christ or Mary. Now it is apparent that although those events are not unillustrated, the eschatological program of which they are usually part does operate in the Psalter. The elaborate architectural "setting" is more than a sign and goes well beyond what is programmatically necessary. Its parallels with the south transept of Notre-Dame give it a vivid modernity. At the time the Psalter was painted, Notre-Dame was probably the most conspicuous construction in Paris, and it is likely that the king often passed by the site, which was near his palace.[38] Moreover, by this time it represented a style of architecture that had become closely associated with

Capetian France and with Louis IX's reign.[39] The setting of the miniatures would therefore have seemed familiar, contemporary, and in some ways personal. Its juxtaposition with the Old Testament scenes thus functions very differently from that in the *Bibles moralisées,* for with no New Testament events and no view of Parisian life, it loses a certain eschatological and critical edge. But it still implies a historical construct between Old Testament events and Capetian France, and the page becomes a pictorial field that is read both syntagmatically and paradigmatically. In short, it sets up a structure that is consistent with Capetian use of Old Testament history and that enables political and moral readings of the Old Testament to be implicitly related to contemporary times and directed to a royal reader.

Part 2: Resources and Re-Visions

The planners and artists of the Psalter of Saint Louis were able to consult a range of pictorial sources as they worked out the conceptions and details of specific miniatures. Some of the most important pictorial sources were relatively current and could be found in recent French works, including those made for royalty, while other sources were older. At least in theory, an exceptional range of pictorial sources could have been available. The French court had diplomatic, economic, and sometimes artistic contacts with centers from Spain to Byzantium and the Holy Land, as well as with London and Rome.[40] The monastic libraries of Paris were among the greatest of Europe, their collections housing older Latin and Greek manuscripts, many of which were illuminated.[41] And by the time the Psalter was created, Louis IX and his immediate predecessors had sponsored two kinds of works—the *Bibles moralisées* and the stained glass of the Sainte-Chapelle—in which virtually thousands of Old Testament subjects were illustrated. These works involved the creation and possibly the mobilization of vast pictorial resources, some of which might still have been accessible when the seventy-eight miniatures of the Psalter of Saint Louis were planned.

None of the pictorial sources used by the artists and planners of the Psalter is identifiable today. Apart from the high probability that such works would have been lost during the intervening centuries, the immediate models may not have been finished works of art—manu-

scripts or wall paintings—but intermediate instruments, such as working sketches, model books, or sets of drawings. Whatever form these sources took, they were certainly modified, for the artists, as noted in the last chapter, employed patterns for many figures, and several had their own compositional and narrative preferences. Most important, the Psalter was not a project inherently concerned with conserving or reviving works of the past. Rather, the project's organizer and the artists had statements of their own to make, and any common interest likely concerned the nature and future of Capetian kingship.

Even if specific sources are no longer recognizable, a study of the miniatures reveals that some details and pictorial conceptions were not new inventions. Under a surface of mid-thirteenth-century forms and fashions lies an uneven foundation of older elements that the artists modified or transformed in some ways and took literally or misunderstood in others. I do not propose to excavate or reconstruct this foundation, but a few soundings in the form of comparisons to preserved works are useful for suggesting the kinds of materials available and how they were used. These examples will not enable any reconstruction or identification of specific sources for the pictures, but they will provide a valuable perspective on how a particular composition is likely to have been understood. That is, they are useful in clarifying intention and innovation. Because some of the rare or archaic details suggest unusual sources, they also raise the questions of why such sources would have been interesting and what the planners' or artists' attitudes were toward the past. These topics are explored in the series of case studies that follow.

· · ·

The first miniature, the Sacrifices of Cain and Abel (fol. 1v), is typical of both the resources available to the artists and how they were creatively transformed. The painting shows the two brothers, left and right, presenting their offerings over a central hillock. At the left Abel kneels beside a tree and lifts up a yearling; as smoke rises from his kindling, he looks up to the hand of God, which descends from a cloud to bless his offering. On the right Cain stands and holds out a sheaf of wheat, which he raises high, its top lying within the trefoiled arcade. The clouds above the sheaf withdraw into the nearby arches, the smoke from his kindling turns downward, and

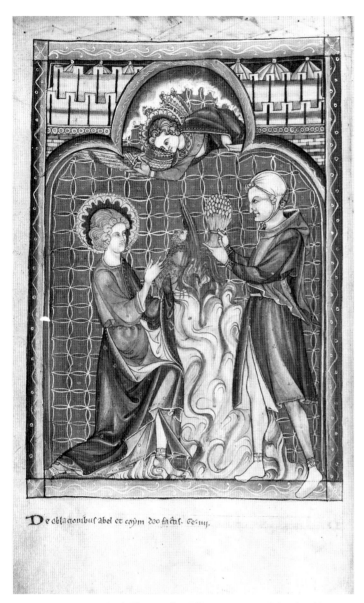

FIG. 23 *Cambridge, St. Johns College,* MS *K.26, English psalter, fol. 6r: Sacrifice of Cain and Abel.*

Cain's body twists around so that he looks in the opposite direction, away from his sacrifice.

The miniature distinguishes the brothers and the acceptance or rejection of their offerings in unusually diverse ways, all of which are found in English works. The contrast between the kneeling and standing positions of the brothers appears in the mid-twelfth-century Winchester Psalter, as does the unusual motif of Cain's turning away.[42] The rarer juxtaposition of the rising and

falling flames or smoke is found in English works at least by 1230/40.[43] Many of these elements, including the sacrifice taking place over a hillock rather than over an altar, occur in a miniature in an English Psalter of about 1270/80 now in Cambridge (fig. 23).[44] Although French works employ one or two of these motifs, none uses so many in the same way.[45] Similar relations to English works are found in many other Psalter miniatures.[46] This is not in the least surprising, for insular iconography is widespread on the Continent from the late twelfth century, and earlier French psalters, such as those of Ingeborg or Blanche of Castile, reveal comparable influences.[47] Blanche owned an English psalter, the one from which Louis is supposed to have been taught to read, and English works seem to have helped shape French expectations of what an illuminated psalter should be.[48]

While these English works fit comfortably into an expected pattern of sources, they tell us nothing about how the Psalter artists developed these resources and gave them a particular meaning. The antithetical motifs suggesting acceptance and rejection are set out in contrary formal structures. The left half of the miniature consists of diagonals that all converge on the lamb. Abel positions the lamb carefully, holding its fore legs and hind legs in different hands and keeping its body level by bending one arm and extending the other, a balancing that is reiterated in the way he positions his own legs on the ground. In contrast, the right half of the miniature sets out a series of divergent and disparate forms. Cain stands frontally but extends the sheaf of wheat to one side as his head turns to the other, looking away from his own actions. The sheaf tilts as he holds an edge of its bundled stalks in one hand and supports the ears diagonally opposite in the other, and each part of his body diverges from the other. The signs of divine acceptance or rejection, the suggestion of humility or arrogance seen in the kneeling or standing positions, depend in the end less on such details as the rising or falling smoke than on the formal construction of two figures, whose actions are coherent and focused or dysfunctional and alienated. The miniature's thematization of favor and disfavor in terms of composition, balance, and height recalls some medieval representations of the weighing of the souls at the Last Judgment, where the favored to the viewer's left are lower, "outweighing" the less fortunate, who rise in

the scale at the right.[49] In much the same way, this first miniature sets out the fundamental alternatives not only of fate but of behavior as well.

The late-twelfth- and early-thirteenth-century compositions, such as those cited from England, constitute one of the building blocks of the early part of the Psalter cycle.[50] More influential still are contemporary French sources, especially those Parisian works created in the circle of the king, such as the *Bibles moralisées* and the stained glass of the Sainte-Chapelle. While these works present numerous analogies to the Psalter miniatures, the meaningful similarities are surprisingly few, and nothing suggests that either work was a direct source for the Psalter.[51] But the artistic milieu and interpretative interests of these works are sufficient to provide a broader perspective on many Psalter miniatures.

For example, the miniature of Joseph Revealing Himself to His Brothers (fol. 25v) depicts one of the supremely dramatic moments of the Old Testament and one of the most compelling images in the Psalter. When Joseph's brothers first come before him, he does not tell them who he is. During three chapters of Genesis his identity remains hidden as he questions and then tricks, arrests, and threatens his brothers. But when he hears Judah's plea for the sake of their father, Joseph can no longer restrain himself. Losing his composure, he dismisses the servants and reveals his identity to his unsuspecting brothers, whom he immediately asks if their father still lives. Oddly, this subject was rarely of dramatic interest in earlier medieval art. In most medieval representations Joseph wears the robe and mantle befitting his office. He sits facing his kneeling brothers, rises from his chair, or bends to embrace Benjamin.[52] In contrast, the Psalter miniature isolates Joseph to one side. He stands before his kneeling brothers, his arms dramatically raised over his head. In contrast to his brothers, who rigidly kneel on the other side of the column, Joseph is a figure of free movement, his youthful, undulant body revealed in its entire length and poised against the shimmering gold.

Although nothing in the biblical text or exegesis suggests that Joseph's body should be made the object of such attention, a similar emphasis is found in the illustrations to this episode in the two *Bibles moralisées* in Vienna (figs. 24, 25). In both Joseph appears before his brothers with his arms spread apart and hands raised,

palms outward; in the French version, his hands are lifted as high as his head. In these *Bibles moralisées*, however, the reason for Joseph's actions is clear, for in the adjacent moralization he is compared to the risen Christ, who appears to the apostles. In the Latin version Christ raises his arms high, his chest is bare, and his wounds are visible, as Peter and Paul and the other apostles kneel in groups to the left and right. The accompanying text makes the comparison to Joseph explicit. The words that reveal Joseph's identity—"I am your brother Joseph"—are paralleled in the French version by Christ's words, "I am the good shepherd who gives his life for his flock."[53] In the longer, Latin version, which explains the broad gesture of Christ's arms as one of all-embracing salvation, he says, "I am your savior; I am your redeemer."[54] Although Joseph is a common typological precedent for Christ,[55] for each was sent ahead to redeem, the *Bible moralisée* and the Psalter miniatures depend not only on similar composition and gestures but on bodily recognition.

The Psalter miniature develops the *Bible moralisée* conception in striking ways. One unusual motif is the fallen mantle. It lies in a heap, the collar visible on top, as though it had just slipped from Joseph's shoulders as he raised his arms. By implying the previous moment, this detail opens up a larger temporal construction and suggests the classical topos of removing an article of clothing as a way of making oneself known, of showing a secret self.[56] The Psalter artist develops the idea further, for not only does Joseph drop his mantle, but he exhibits his body full length, putting himself on display, his gray robe isolated against the gold, his hip swung out toward his brothers, and his arms rising into the arches overhead. There are other impressive figures in the Psalter, but none—except the Bathsheba in the Beatus initial—presents the physical body in such an evidentiary way.[57]

This pictorial conception of Joseph is likely to have found its origin in the *Bible moralisée*, the most likely place for these Old and New Testament figures and the visual language associated with them to have come together.[58] But that does not mean that the immediate source for the Psalter miniature was a *Bible moralisée*. The same subject appears in an anonymous translation of the Bible into French, a mid-thirteenth-century manuscript possibly composed at the royal abbey of Saint-Denis; here Joseph also throws off his mantle and

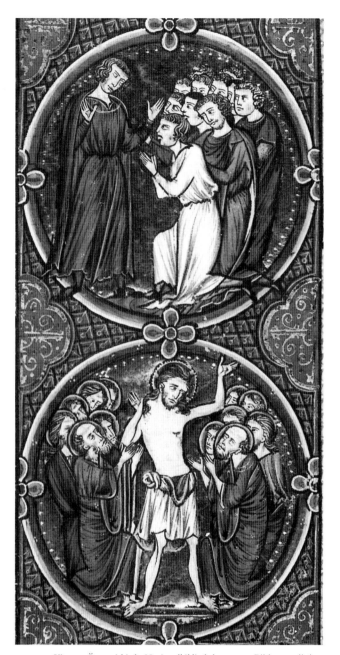

FIG. 24 *Vienna, Österreichische Nationalbibliothek, MS 2554, Bible moral-isée, fol. 13r, first two roundels: Joseph Revealed.*

FIG. 25 *Vienna, Österreichische Nationalbibliothek, MS 1179, Bible moralisée, fol. 22r, final two roundels: Joseph Revealed.*

extends his hands, probably to his brothers.[59] The same subject also appears in a miniature in a Parisian psalter of about 1250/60 in Vienna, a manuscript closely related to works in the circle of the court (fig. 26).[60] Here Joseph is between two groups of kneeling brothers, as Christ is flanked by the kneeling apostles in the Latin moralization discussed above. Joseph is also a frontal figure with arms reaching high over his head, as he is in the Psalter miniature. While this work hardly has the power of the Psalter miniature or the resonance of the juxtaposition in the *Bible moralisée,* it suggests the currency of the composition in contemporary Psalter illustration.

The *Bible moralisée* provides a useful perspective on the misunderstandings as well as the inventions found in the Psalter. Take, for example, the two rarely illustrated subjects pertaining to the history of the Ark of the Covenant among the Philistines (folio 71v). After the Philistines captured the Ark, they suffered plagues wherever the Ark was taken, and so it was sent from one city to another until it was returned to the Israelites at Beth-Shemesh. The left scene in the Psalter illustrates a verse describing how the plague afflicted the Gethrites with hemorrhoids so that both young and old men had to sit on skins in order to consult together.[61] Other medieval representations show older and younger men standing together as swarms of mice or rodents bite their legs and thighs.[62] In the Psalter miniature, however, mice scurry across the earth as men sit unharmed. Moreover, the men are arranged in couples, each with an older and younger man, who suffer no discomfort but lean toward each other. In the center foreground a bearded man beckons to the obliging youth beside him, who wears a pointed hat that normally identifies Israelites. The subject of a plague among the Philistines tends to become a scene of seduction among the Israelites.

The conduct of these couples is not only antithetical to the biblical text but out of place in relation to other Psalter miniatures, where romantic elements, though present, are never homosexual.[63] The *Bible moralisée* suggests the source for this unusual arrangement. Its moralization for this episode concerns the institutional evil of clerics and priests who seduce women and younger men. In the *Bible moralisée* Old Testament events are often the occasion for moralizations condemning various kinds of clerical misconduct, of which the seduction of youths is one.[64] The relevant moralization in the Latin version in

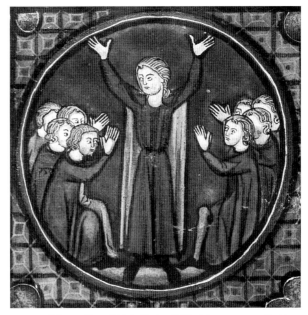

FIG. 26 *Vienna, Österreichische Nationalbibliothek, MS s.n. 2611, Parisian psalter, fol. 13v, first roundel: Joseph Revealed.*

FIG. 27 *Vienna, Österreichische Nationalbibliothek, MS 1179, Bible moralisée, fol. 87v, sixth roundel: Young and Old Clerics.*

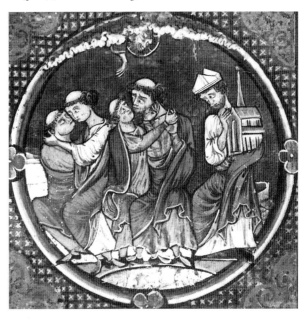

Vienna shows older and younger clerics seated and arranged as couples, very much as they are in the Psalter miniature except that they actively embrace (fig. 27).[65] In the later Oxford version the moralization affected the Old Testament subject above, for the Philistines stand and are bitten, as they usually are, but they too are grouped in

pairs of older and of younger men.[66] Thus by the time the Psalter was illuminated, the moralization had already begun to introduce sexual overtones into the representation of this Old Testament episode.

The clerical concerns, exempla, and moralizations found in the *Bible moralisée* form the culture against which these couples in the Psalter miniature must be understood. But once again this does not mean that the direct source was a *Bible moralisée*. Other texts then in circulation associated the Philistines with unnatural conduct.[67] The Psalter miniature shows the episode of the Gethrites in council, whereas the *Bible moralisée* scene probably illustrates the previous episode of the plague at Ashdod. As before, the specific source cannot be determined. However, it is important that the Psalter artist overlooked the mice and the sexual content of the scene and dressed the Philistines as Hebrews. Moreover, the author of the legend on the reverse of the miniature followed his lead, for he notes the mice and the skins but concludes that the subject is the Israelites sitting in council.[68] He goes on to describe the adjacent scene of the Ark returning to Beth-Shemesh and then sums up with "Thus the holy Ark returned to the tabernacle," a true but surprising statement because the tabernacle is not illustrated either in this miniature or in the one it faces. The author of the legends is evidently aware of the role of the miniature within a larger program. This miniature is indeed part of a series, one that begins with the calling of Samuel (fol. 68r), continues with the captivity of the Ark, and ends with its return and with the Hebrews demanding a king (fol. 72r). Because the latter is the subject opposite this miniature, it is likely that the artist interpreted this penultimate miniature in the series as preparatory to it. In these terms, changing the Philistines into Hebrews means that the Hebrews themselves superintend the return of the Ark, which becomes a preparatory step to demanding a king.

A similar situation pertains in the adjacent representation of the Ark's Return to the Israelites (fol. 71v, right), though with a significantly different twist. The Ark is in a wagon drawn by two milch cows, who raise their heads to low as they advance toward a group of men reaping the fields. Two of the men continue to work, not noticing the cows and the Ark, but two others turn around and respond strongly, one looking upward into space. The responses of these last two can only be

described as grimaces: their mouths are open wide and outlined in white, and curves and shadows at the corners of their mouths indicate the kind of expression of pain found in other Psalter miniatures.[69] Their expressions contradict the biblical text, which recounts how the Israelites at Beth-Shemesh rejoiced when they saw the Ark returning.[70] The other details of the miniature—the landscape, the men reaping, the loaded wagon, the lowing cows—follow the text faithfully, and contemporary works correctly illustrate men gesturing to acknowledge the long awaited return of the Ark.[71]

These strained expressions are, however, appropriate to a slightly later episode in which the Beth-Shemites are struck down for looking into the Ark (1 Sam. 6:19). In the French Vienna *Bible moralisée* this subject is conflated with the Ark's return: in a double miniature the wagon, loaded with the Ark and pulled by the lowing cows, approaches men who grimace as small fiery triangular objects rain down on them from heaven, helped by a small figure of Christ who descends from a cloud bank (fig. 28).[72] The smitten men do not work in the fields and are identified as Saracens, but they clearly respond to the advancing wagon of the previous episode.[73] Once again, the biblical subject is changed in accordance with its moralization, which shows Ecclesia advancing in a cart pulled by priests toward the wicked, who are smitten by a rain of objects from the sky and fall into a hell mouth.

This *Bible moralisée*'s "triumph of Ecclesia" helps account for the agonized expression of the men in the fields. Once again, however, there is enough evidence of the broad circulation of the subject to suggest that the *Bible moralisée* might not have been the direct source.[74] In treating this subject, the artist and the author of the legend seem to have responded more critically. The essential element—the fiery rain—is absent, and the larger-than-usual stretch of empty background into which the anguished men look suggests that the *Bible moralisée* composition was probably adopted but the fiery rain suppressed. To do so would have required a clear understanding of the subject and of its larger implications within the narrative, and that is just what one finds in the legend on the reverse. Its text describes the lowing cows, explains that they cry for their calves (which are held back in the structure at the left), and then ends with a phrase concerning the return of the Ark to the tabernacle. Thus the page shows the Ark return-

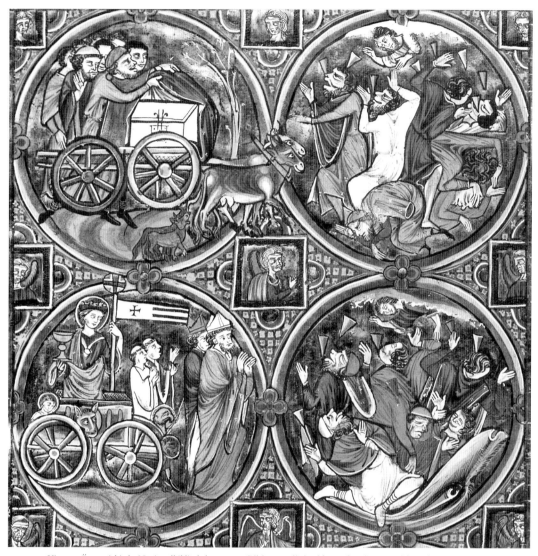

FIG. 28 *Vienna, Österreichische Nationalbibliothek, MS 2554, Bible moralisée, fol. 36v, first four roundels: Ark Returned to Israel.*

ing to the Israelites in the fields as other Israelites con-
sult in the town. And the legend implies that the repos-
session of the Ark marks the normalization of relations
between God and Israel. Whatever the precise source for
this miniature and however different its message, that
source was modified, and details were suppressed, so
that the pictures fit into the larger programmatic con-
cerns of the prefatory cycle.

· · ·

The second work in which we would expect to gain a
perspective on the Psalter is the stained glass of the

Sainte-Chapelle in Paris, the palace chapel that Louis IX
had constructed between 1239 and 1248 to house the
Crown of Thorns and other relics that the king had
recently acquired from the Latin ruler of Constantino-
ple.[75] While the integral program of sculpture, painting,
and stained glass has yet to be fully worked out, the gen-
eral idea is the glorification of the Passion and of the
Crown, which is both its chief relic and a sign of the
royalty of Christ and of the kings of France.[76] Of its
fifteen windows eleven are devoted to Old Testament
subjects, and they originally had over 1,200 narrative

panels. Thoughtfully placed, they form a selective chronology beginning with Creation and ending with the Book of Kings and with the history of the chapel's relics through their arrival in Paris. In the way the glass uses Old Testament imagery to represent concepts of history and kingship, it is one of the most important precedents for the programmatic concepts in the Psalter.

The Old Testament scenes in the Sainte-Chapelle present a situation very similar to that found in the *Bibles moralisées*.[77] A number of Old Testament subjects were elaborated for this building, but there is no evidence that they had a direct influence on the Psalter.[78] The panels that do resemble the Psalter miniatures are usually unremarkable and reflect what was current in Paris at the time. The representations of the Menorah in the Tabernacle or Samson and the Lion or Joseph Explaining the Dreams of the Baker and Butler are no more similar to those of the Psalter than they are to those of other contemporary works, such as the Morgan Picture Book, and usually they are less so.[79] The presence also of one or two exceptionally rare subjects, discussed at length below, reminds us that the designers of the glass had special intentions and that similar themes may well have affected the planners and artists of the Psalter.

Of particular interest, however, are a few panels that do not resemble the miniatures in the Psalter but have similar thematic concerns. For example, in the Psalter the Book of Joshua begins with Joshua shown as a young man dressed in robes and a mantle and standing upon a small platform before a low wall or bridge (fol. 40r, left). He looks up to his right and gestures to a half-length figure of the Lord, who descends from a cloud bank and, looking at Joshua, lays one hand on his shoulder and points with his other hand to a multitude of men and women on the other side of the wall, many of whom look up toward Joshua. In Western biblical illustration, initials to the Book of Joshua usually illustrate verse 2, in which God appears to Joshua and tells him to take the Israelites and cross the Jordan, or verse 10, where Joshua commands his officers to prepare to cross the river. In the normal rendition of this exchange the Lord blesses or instructs Joshua, who turns to him and is sometimes depicted beside the Jordan, or the Lord or Moses invests Joshua with the signs of command, such as a lance. In the latter case Joshua is usually shown in armor, sometimes with the troops whom he will command to cross

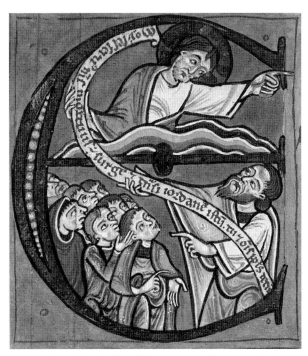

FIG. 29 *Cambridge, Pembroke College, MS 54, twelfth-century glossed Joshua, fol. 4r: Joshua by the River Jordan. Reproduced by permission of the Master and Fellows of Pembroke College.*

the river.[80] For example, in an initial in a twelfth-century glossed Joshua in Pembroke College, Joshua points to the Israelites—also a group of young women and men—as the Lord holds a scroll inscribed with verse 2 and points off to the right, presumably to the Jordan (fig. 29).[81] In the Psalter, however, there is no suggestion of the river or his commission to cross it. And rather than depict the Lord pointing to the Jordan or Joshua pointing to his people, the artist has the Lord point the people out to Joshua; that is, the scene represents the Lord giving Joshua custody of the people. A similar idea is found in the text to this passage in the *Bible moralisée*, which explains that Joshua is entrusted with both the Law and the people, but the accompanying miniature is concerned almost entirely with the Law (fig. 30).[82]

The Sainte-Chapelle panels illustrating these events are quite different. The fourth northern window, though devoted to the life of Joshua, begins with the last events of Deuteronomy, that is, the preparations for the transfer of leadership from Moses. The subjects of the first panels are unclear—they seem to concern the last acts of Moses, including the promulgation of the

FIG. 30 *Vienna, Österreichische Nationalbibliothek, MS 1179, Bible moral-isée, fol. 62v, seventh roundel: The Lord Charges Joshua with the Law.*

FIG. 31 *Paris, Sainte-Chapelle stained glass, L-153: Moses Charges Joshua.*

Law—but the first clear appearance of Joshua involves the passing of leadership to him. That transfer may begin in the fifth panel, with Moses choosing Joshua, but the sixth panel is critical, for there Joshua is shown crowned and kneeling before Moses, who gives him a scroll inscribed "Iosue populus" (fig. 31).[83] The panel may illustrate Moses' general charge to Joshua (Deut. 31:7) to lead the people to the land that God has prom-ised them, but that would not account for the singular attention to the "people" in the inscription or for the crown Joshua wears. The scroll clearly refers to Joshua's charge to take custody of the people, and the crown shows he is already in command. Although not a king and never crowned, Joshua is shown wearing a crown in the subsequent panels too.[84] Only in the context of the Sainte-Chapelle, where crowns function metaphorically as well as literally, does this attribute make sense for vari-ous leaders.[85] It should be seen in the context of other royal images in the chapel, especially the series of crowned "princes" who are seated and acclaimed by their tribes. These "coronations," which again have no justification in the biblical text, occupy a position in the

adjacent third window that corresponds approximately to this sixth panel, a position immediately above what is presumed to be the king's loge.[86] The difference, how-ever, is that the Joshua panel represents a transfer of responsibility, not a ritual accession, and the source and the nature of that responsibility are clearly shown.

The same is true in the Psalter miniature, but power is differently conceived and responsibility differently described. Joshua is not enthroned, kneeling, or crowned, but he is set apart and specially elevated. His responsibility is not transferred from Moses but given

directly from the Lord. The *populus* are not named and joined to Joshua, but they are illustrated, a group of young men and women whom the Lord simply points out to him. Huddled beyond a wall, they look up to their new custodian. They are clearly Moses' people, for a similar group appeared with Moses in previous miniatures, before Pharaoh, during the Exodus, and at Sinai.[87] Moses and Joshua are both leaders, and an important aspect of their leadership is the custody of God's people. Thus Joshua's charge begins as exceptionally in the Psalter as it does in the Sainte-Chapelle; that is, both depictions focus on his appointment to leadership and reception of responsibility. And although they address these issues in different ways, they both see biblical history and certain moments in it as an appropriate place to address these concepts.

. . .

The third of the three contemporaneous works of importance to the Psalter is the Old Testament Picture Book in the Morgan Library (hereafter the Morgan Picture Book), in many ways the most mysterious work of them all. A fragment of forty-three folios, with three more folios preserved in Paris and Los Angeles, the manuscript consists entirely of illuminations, in its present state beginning with Creation and ending abruptly with the story of Joab and Sheba (2 Sam. 20).[88] The paintings display an exceptional realism, monumentality, and breadth, which make it difficult to associate with any other manuscripts or a center of illumination. While there is general agreement that it dates to about 1240–50, it has been attributed both to Paris and to northern France as well as to Flanders, England, and Italy.[89] In its present incomplete state, the manuscript provides no indication that these paintings were ever connected with a text—the words surrounding the miniatures were added in the fourteenth and later centuries—and so its function remains as conjectural as its origin.[90]

Treating the Morgan Picture Book in connection with the two other works makes sense for several reasons. First, the similarities between the Old Testament cycles of the three works are striking, with the Morgan illustrations providing the closest and sometimes the only parallel to a subject in the other two works.[91] Whether it was made in Paris or elsewhere, the milieu of pictorial sources must have been very similar. Second, wherever the artists originated, increasing evidence suggests that their monumental and sculptural manner of painting was known in Paris

in the 1240s. Its impact is reflected in the manuscripts Branner attributed to the "Potocki atelier" and in the stained glass of several windows of the Sainte-Chapelle.[92] Most similar, however, is a painting of the Annunciation and Virgin and Child in the lower chapel of the same building. It is the earliest and best-preserved wall painting in the building and is strikingly similar to one of the Ruth miniatures in the Morgan Picture Book.[93] This relation gives credence to Cockerell's suggestion that the painters of the Morgan manuscript may have been trained in large-scale mural painting.[94] Unique to the Morgan manuscript, however, is the exceptional realism of its miniatures.[95] It may be no coincidence that the manuscript depicts warfare in the Holy Land at a time when one Crusade had just been completed and Louis IX was making preparations for another.[96] Whoever was its patron, Old Testament history provides the context for addressing contemporary interests and obligations, and the same is true for the program of the Sainte-Chapelle and, in a later decade, that of the Psalter.[97]

The Psalter's relation to the Morgan Picture Book is complex, for there are similarities not only in the illustration of half-register single events but in full-register compositions, some of which combine two or three episodes in a single composition, while others consist of a single scene that occupies the whole register. An example of the former is the brief story of Jael and Sisera (Judg. 4:17–22). It relates how Sisera, fleeing on foot from Barak and his troops, was deceived by Jael, who met him at the entrance to her tent and, asking him in, offered him refuge and drink. Once asleep, she killed him by driving a tent spike through his temples, a deed she later showed to Barak. The two manuscripts are the most similar in the first episode, when the two stand outside the tent (Psalter fol. 48r, fig. 32). In the Psalter Jael greets Sisera in the first episode, gives him milk inside the tent in the second episode, and slays him in the third, the spike going through his head and into the ground, as the text describes. The Morgan version elaborates upon several details of the biblical text: Sisera is accompanied by troops, though he should be alone; he is offered milk outside the tent; and he is killed in bed rather than on the ground.[98] No work illustrates all the episodes, but the Psalter follows the biblical text most literally, and only it and the Morgan manuscript have a three-part format.

FIG. 32 *New York, Pierpont Morgan Library, MS M.638, Morgan Picture Book, fol. 12v, upper register: Sisera and Jael.*

The tripartite composition they have in common is noteworthy because nothing in the Bible or in earlier illumination suggests this form. The Morgan miniature is carefully composed, with the bed in the middle and Sisera and Barak and their men at either side. Its sequence is made clear by the thrice repeated figure of Jael, dividing one episode from the other. And the whole miniature is scanned in the regular accents of the arcade above, whose arches repeatedly converge just over her head. The Psalter miniature arranges its three episodes in a more serial fashion: Sisera's fate is traced in his gradual decline from an erect posture to sitting and finally to the prone position in which he is killed.

A preference for these broad compositions is likely to have come from someplace other than manuscript painting, and that source is particularly important, for some of the most striking relations between the Morgan Picture Book and the Psalter are in these multiscene or full-register compositions.[99] One of the most revealing full-register compositions is Deborah Directing Barak to Attack Sisera, the miniature that just precedes the illustration of Jael and Sisera in both manuscripts (Psalter fol. 47v, fig. 33). The story concerns Barak's refusal to do battle against Sisera unless accompanied by the prophet-

ess Deborah, who agreed but told him that Sisera would escape his attack and would be delivered into the hands of a woman, a prophecy fulfilled in the miniature of Jael just discussed. Both illustrations are full-page or full-register battle scenes. The biblical text explains that Deborah tells Barak to attack and that Sisera's men are in chariots, but it hardly accounts for such details as Deborah on horseback or, in the Psalter image, Barak's backward glance at her as she points ahead, directing the pursuit of Sisera's men, who retreat before them in horse-drawn wagons. Deborah is particularly prominent in the Morgan picture, which shows the Hebrews actually engaging the enemy and Sisera being slain, which is clearly contrary to the biblical text.

The Psalter miniature is again the more accurate in relation to the biblical text. Most of the battles in the Morgan manuscript use mounted soldiers, many of whom wear helmets. In the Psalter most other battles are between foot soldiers, but the horsemen in this miniature are noteworthy, especially because, oddly, in the mounted attack only one soldier—the one in the rear of Sisera's retreating troops—wears a helmet. It can be no coincidence that this incongruous element—the singular helmeted soldier in retreat—corresponds precisely

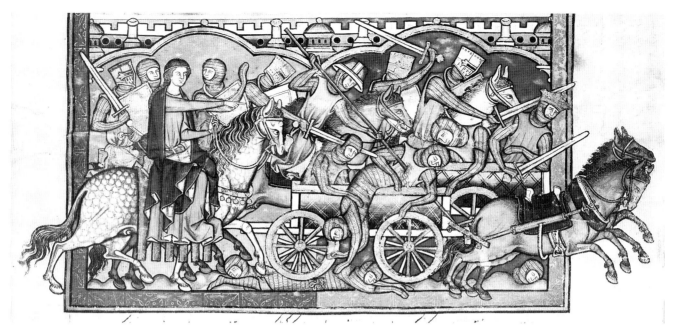

FIG. 33 *New York, Pierpont Morgan Library,* MS *M.638, Morgan Picture Book, fol. 12r, lower register: Deborah Directing Barak to Attack Sisera.*

to the exceptional white-helmeted soldier in the Morgan miniature, the soldier who, contrary to the biblical text, slays Barak. This detail, like the grimacing expressions of the men in the fields of Beth-Shemesh, suggests a critical decision on the part of the Psalter artist to suppress what was contrary to the text, just as he "corrected" the Beth-Shemesh episode by suppressing the fiery rain.

Some of the Psalter's full-page paintings are traditional compositions that happen to be allocated a full page, and others are subjects that are traditionally illustrated in a broad format.[100] The Deborah miniature in the Morgan manuscript falls into the category of full-register battle scenes that are the hallmark of the manuscript. Its movement unfolds in several planes of action: Deborah and her horse are surrounded by Barak's men, who advance and cruelly slash with swords the men in the two wagons. Horses at both ends of the miniature gallop to the right, and Sisera's wounded men fall in, over, and under the two wagons. It is a complex and progressive panorama, and the same is presumably true of the work that, directly or indirectly, influenced the same subject in the Psalter.

In what context might the pictorial conception of the Deborah scene have developed? Cockerell's suggestion that the Morgan artists may have trained in mural painting is still the most likely explanation. Although it remains speculative as an explanation for these scenes, there can be no doubt of the existence and importance of monumental painting at this time, of wall paintings illustrating Old Testament histories or chronicles with battle scenes.[101] We do not know what these artists saw—wall paintings or drawings or model books—or if some of them were experienced in large-scale painting, as has been suggested.[102] What is important is the existence of a context, such as wall painting, in which such monumental, complex, and expansive scenes could develop. That context, which one may assume for almost all periods of European art, would have important implications for the Psalter. It suggests a monumental source for some of the most striking large-scale conceptions, such as Noah Being Covered by His Sons (fol. 4r). It also suggests a context in which many of the Psalter's complex spatial constructions—some almost inimical to its scale—may have been worked out.[103] And it presents the possibility that the kind of narrative nuance seen in highly reductive scenes, such as the latter Samson miniatures, evolved from works on a larger scale.

For the moment, the relation of the two Deborah miniatures to a monumental context remains hypothetical. What is certain, however, is that the artists of the

Psalter of Saint Louis and of the Morgan Picture Book had access to a pictorially more complex and ambitious source of ideas than what is usually found in the *Bibles moralisées* or Sainte-Chapelle glass.[104] Given the potential of that resource, it is interesting to see how differently the two works develop it. In comparison to the Morgan illustration, the Psalter miniature is corrected, quieted, and rearranged; it is an image of pursuit with no killing. Deborah and Barak have switched places—now he is in front—and the action unfolds from the left background to the right foreground, where the fleeing figure of Sisera, almost running out of the miniature, creates a link to the figure of Sisera on the facing page. Deborah's gesture is the same in both miniatures, but her new placement means that she now has to reach across Barak's chest. As she does, they seem to be drawn together, attending to each other more than to the battle. The large and commanding prophetess of the Morgan painting, who rides to victory on a brilliant dappled horse, is now a lady who rides alongside her knight. As Barak looks at her, she points out the escaping prey, whom Jael will catch on the facing page. On this page, however, Deborah has already caught hers.

· · ·

Almost one-third of the miniatures preserve indications, sometimes very striking ones, of compositions or details that are neither recent nor French and of narratives that are difficult to follow, by artists who are highly competent. Thus Eliezer's arms are hopelessly mixed up with Rebecca's in the otherwise beautiful miniature in which she offers him water (fol. 11v); the only time a full-length figure of Christ appears in the prefatory cycle, the frame cuts him in half (fol. 38r); Joshua and his troops rush so quickly toward the Jordan that they seem to overrun the elders carrying the Ark of the Covenant (fol. 41v); and instead of celebrating victory before the walls of Ai, the Israelite soldiers seem to turn in defeat (fol. 45v). These infelicities arise from the artists' interaction with their sources, and almost all are clarified by reference to appropriate *comparanda*. Because of patterns of preservation, the *comparanda* tend to fall into two groups: Byzantine illumination, especially the twelfth-century Octateuchs, and Iberian illumination, particularly works from Castile.[105]

The details in some miniatures are foreign to Western illumination but are explicable with reference to Byzantine illumination. For example, the miniature of

FIG. 34 *Rome, Biblioteca Apostolica Vaticana, MS gr. 746, twelfth-century Byzantine Octateuch, fol. 349v: Moses and the Brazen Serpent.*

Moses and the Brazen Serpent (fol. 37v, right) generally follows late-twelfth-century Western compositions in the position of Moses and the small dragonlike serpent atop the column. But the Psalter miniature includes two groups of Israelites, the evildoers in the foreground, who fall as they are attacked by small white serpents, and the saved, who stand and watch from a hillock on the left. Of the latter group I am aware of no Western precedent for the man at the upper left, who throws his head back and has his mouth open and lips pursed in pain. In twelfth-century Byzantine Octateuchs this figure is a hunchback who has to crane his head back to see the Brazen Serpent, which, in these Greek manuscripts, extends horizontally from atop the column (fig. 34). The Psalter artist seems to have understood this figure as one of the evildoers, for the position of his head and its expression suggest pain rather than redemption.[106]

Another telling detail appears in the composite miniature representing the first nine Egyptian plagues (fol. 31v). The miniature is divided into compartments for the eight plagues, but two full-length standing figures represent the plague of boils. Moses appears at the extreme left, holding up a torch, and a man stands near the center, wearing a blue cloth that partially exposes his legs, arms, and one shoulder, on which boils are visible. The Octateuchs depict each plague separately,

FIG. 35 *Rome, Biblioteca Apostolica Vaticana, MS gr. 746, twelfth-century Byzantine Octateuch, fol. 175v: Plague of Boils.*

and the miniature illustrating the plague of boils, like several others depicting the plagues, shows a line of men standing frontally, with Aaron and Moses at the left, Pharaoh in the center, flanked by two bodyguards, and at the far right two Egyptian sorcerers, each dressed in a cloth that wraps around his body and leaves part of his arms, legs, and shoulders exposed (fig. 35).[107] According to Exod. 9:10–11, Moses initiated the plague of boils by taking ash from a chimney or furnace and throwing it into the air, and boils erupted where it landed on the flesh of Egyptian men and beasts. In the Octateuch miniatures, however, Moses and Aaron hold up in their right hands aspergilla, which the Psalter artist may well have taken for torches. The Psalter miniature thus combines one figure from each end of the Byzantine composition, so that Moses' torch seems to affect the boils on the Egyptian in the center of the composition.

Many other details are inexplicable except by reference to Byzantine painting. But the most interesting are those in which the Psalter artist goes beyond copying a literal or expressive detail and develops a new and powerful conception. The primary example of this is the scene introducing the Book of Joshua (fol. 40r, left), discussed above in relation to the Sainte-Chapelle glass panel. This scene contains two elements foreign to Western painting at this time and occurring nowhere else in

the Psalter: a full-length frontal figure standing on a low rectangular platform in the center of the composition, and behind him a wall of medium height that extends across the scene and separates him from a group of people on the other side.[108] Both are distinctive features found widely in Byzantine art but not in the first Joshua miniatures in the Octateuchs.[109] In Byzantine art of the ninth century and later, a wall or a row columns carrying an architrave was used as a compositional and narrative device for layering space and, in some cases, creating a sequence of episodes. For example, an architrave on columns and a wall appear in the scene of David's Repentance in the Psalter of Basil II, where it separates earlier and later moments in the narrative (fig. 36).[110] A wall is a background element in numerous miniatures in the Menologium of Basil II, where it shapes the background and sometimes surrounds the holy figures.[111] It also occurs in author portraits, such as that in the late-tenth-century frontispiece to the Wisdom of Solomon in a tenth-century manuscript in Copenhagen (fig. 37).[112] There Jesus Sirach addresses Solomon, enthroned before a wall, while a female figure, possibly Holy Wisdom, looks on from behind the wall.

A wall, architrave, or parapet is not uncommon in middle and late Byzantine works, and the other distinctive feature of the miniature—a full-length and frontal figure standing on a pedestal in the middle of composition—is also commonplace. It occurs widely in paintings, ivories, enamels, and other media and is used to set apart a holy figure. Author portraits are again relevant, for middle and late Byzantine illuminated prophet books often have a single standing figure of the prophet introducing his text; the miniatures often include a small image of the Lord or a hand that descends, blesses, or inspires.[113] In some cases the prophets appear before a low wall. However, they usually stand on the bare ground rather than on a pedestal.[114]

In Byzantine art emperors are also shown in this way, that is, standing frontally upon an elevated surface, usually a bejeweled pedestal or textile-covered *suppedion* in the center of the composition.[115] The specific type of platform in the Psalter—one with short legs at each corner—is used for pedestals in some early portraits of seated Byzantine emperors and in later portraits of standing rulers.[116] Although I am unaware of any preserved Byzantine portrait of an author or emperor that

FIG. 36 (left) *Venice, Biblioteca nazionale Marciana, MS gr. 17, Psalter of Basil II, fol. IVv, final scene: David Repents.*

FIG. 37 (below) *Copenhagen, Kongelige Bibliothek, Gl. Kgl. S. cod. 6, tenth-century manuscript, fol. 1r, frontispiece to the Wisdom of Solomon, author portrait.*

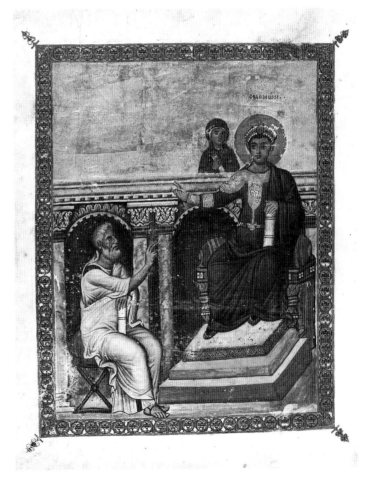

depicts its subject standing on a platform before a wall with a crowd of figures on its other side, the combination is easily imaginable on the basis of existing works. The arrangement is likely to have been an invention of the Psalter artist, for not only does the scene set Joshua apart as the leader chosen by God and as the subject of the narrative that follows, but it also shows his receiving custody of the Hebrew people from the Lord. A narrative circuit is created, leading from Joshua to the Lord to the people and back to Joshua.

The strikingly non-Western elements of this first Joshua episode naturally raise the question whether the right half of the miniature is similarly indebted to Byzantine art. The right scene shows Joshua and his men, now in armor and on horseback, all riding toward the right. Because no city or river is depicted, it is unclear where they are going, but the scene is distinguished by the forward movement of the army, Joshua's drawn sword, his turning around to speak to his men, and the gesture of the soldier behind Joshua. In the Byzantine Octateuchs the initial miniature to the Book of Joshua is divided into upper and lower parts: in the upper scene, the hand of God descends to appoint Joshua Moses' successor, and in the lower scene, Joshua commands his officers. Both scenes describe an exchange of gestures but not much movement between Joshua and the groups of men beside

αωριομ· ὁτι αωριομ ποιινσεικο ὁριμιμῈ
ῖἠνοὑς τὸισ ἰεῥσοιμ· ἀἑαυτὸ τλιωκι θ
κῡ. ὑαῖωπρωπωρβἀσθε τουμλαου· ὑαῖ
βωτομ τὴ σδιαιθΝΗΚΗ σΚῡ. Καὶ δπορβομ̓

Καὶ ὁ
ομη
ῖτε
ωδ
ῖμα
μοͅ
Καὶ
τει
αιρͅ
δια
ἐια
του
Καὶ
σῶ
τοιι
γτε
ρΗι͡
ὁιι

ὁ ΤιΚσ̄ Ζωμ υͅμιμιμυ· ὑαῖ ὁμοθϱασομ ὁμ̓
προυϊμωμ· τὸρχαμαμαιομ· Καὶ τὸμ̓
ᾗῖ ϑθϱϑθαιου· ὑαῖ τὸν ἁαιου· ὑαῖ τομ̓ ᾗͅ

FIG. 38 *Rome, Biblioteca Apostolica Vaticana, MS gr. 747, twelfth-century Byzantine Octateuch, fol. 218r: Joshua Leading His Army.*

him.[117] There is, however, one Octateuch miniature whose depiction of Joshua leading his men is very similar (fig. 38): Joshua is at the right, dressed in armor, his lance resting on his shoulder; as the group moves to the right, he looks back to his men and motions them onward.[118] The soldier behind Joshua also turns to look back at the men. Here too it is unclear where Joshua and his men are going. The miniature represents Josh. 3:6–7, in which Joshua tells the priests to take the Ark of the Covenant toward the Jordan and the Lord tells Joshua, "This day I will exalt you in the sight of all Israel, that they may know that I will be with you as I was with Moses." The ambiguity in the Octateuchs miniature has a clear source, for this miniature is based upon an illustration in the Joshua Roll, a tenth-century imperial Byzantine manuscript imitating the ancient form of a continuous roll.[119] In the Joshua Roll this subject represents a precise event, the Israelites approaching the Jordan, and it corresponds to the left half of a broader composition that, in accordance with the biblical text, continues with the priests carrying the Ark toward the river. Both events are depicted on the Joshua Roll, but they were drawn over two sheets that had become separated by the time the artists of the Octateuchs copied them.[120] Thus the illustrated Octateuchs show the procession as two separate events, the first with Joshua leading his men and the second with the priests carrying the Ark.[121] If the right half of this Psalter miniature is indeed influenced by a scene of Joshua leading his men toward the Jordan, its likely source was either an Octateuch or a work based on it. In any case, the scene is again transformed. The planners or artists who designed the two scenes of folio 40r thus created a miniature with complementary subjects: in one scene Joshua is elevated and receives custody of his people from God, and in the other he leads the army; that is, the page introduces Joshua and shows his civil and military responsibilities. It was an opportune lesson for a king about to depart for a Crusade.

The previous examples show how scenes were enriched both by details and by pictorial conceptions that were borrowed from or inspired by Byzantine works. Although iconographic formulae in illustrated Octateuchs had a broad currency in medieval western Europe, similarities between the Psalter and Byzantine works do not perforce imply direct contact with a Byzantine work or the pervasive influence of a transhistorical recension.[122] As noted earlier, model books, sketches, or some other intermediary may have provided the Psalter artists with the details, formal conceptions, and ideas that they could copy or develop in order to make a unique statement of their own. However, it is very likely that Western artists consulted Byzantine manuscripts in other Latin works.[123] And other Psalter miniatures are painted in a format similar to that of the Octateuchs or have ambiguities that only Byzantine works clarify.[124] Thus, we should consider the possibility of a Byzantine intermediary in Paris in the 1260s.

There are several reasons to suppose that Byzantine works were available in Paris when the Psalter was created. Some evidence suggests that after the Fall of Constantinople in 1204, Greek manuscripts became more readily available in Paris.[125] Other French manuscripts, such as the Morgan Picture Book, independently point to Byzantine sources.[126] Later inventories have tantalizing references to books illuminated with biblical histories and written in a strange language.[127] And if Louis IX acquired the Arsenal Bible with its Byzantinizing pictures when he was in Acre, he may well have obtained other manuscripts, either when he was in the East or through the Latin emperor of Constantinople, Baldwin II, who visited Paris several times in these years and sold the king the Crown of Thorns and other important relics.[128] After 1261, when the Palaeologan house reestablished Byzantine rule in Constantinople, Louis IX received at least one illuminated Byzantine manuscript from the emperor's emissaries.[129] In the 1260s Michael VIII Palaeologus was making overtures to the pope and Louis IX regarding the unification the Greek and Latin churches, and Louis IX might well have considered Byzantium an ally that could help him liberate the Holy Land.[130]

The receptivity to Greek models may well have begun earlier than the reign of Louis IX. From the mid–twelfth century, France had prided itself as the inheritor of ancient Greek culture by way of Rome. When the Psalter was painted, this *translatio studii* was largely understood as centering in Paris and specifically in the university, which had become the preeminent place to study arts, letters, philosophy, and theology.[131] With the fall of Constantinople in 1204, Eastern Christianity's most powerful guardians were replaced by Europeans, mostly Franks, who ruled the former capital and introduced Western customs and religious studies, like those in Paris.[132] Louis IX supported the Latin rulers of Constantinople, just as he was committed to the liberation of the Holy Land.[133] As texts of Aristotle became available, some by way of Constantinople, the cultural transfer must have seemed direct.[134] The same is true for the Crown of Thorns and other relics Louis IX purchased and brought to Paris. They had been imperial Byzantine relics, and in Paris they were housed in the Sainte-Chapelle, a building that imitated in its name, location, and possibly its luminous setting the housing of the same relics in Constantinople, in the *sancta capella*

of the imperial Boukoleon palace.[135] Their transfer to Paris must have seemed natural, for French kings had become new protectors of Christianity, and to some extent Constantinople was within a French cultural sphere.[136] The *translatio studii*, centered in the university, was now part of the larger enterprise of a *translatio imperii*, increasingly centered on Louis IX and the Parisian court.[137] It is within this larger transfer of culture and power that the possibility of Byzantine sources should be considered.

The same is true of other pictorial traditions. An example underlies the miniature of Moses Receiving the Law (fol. 35v), in which Moses is shown twice, first receiving the Law on Mount Sinai (Exod. 31:18) and then, below, throwing the tablets down as he looks toward the Israelites (Exod. 32:19). The Israelites also appear twice, first in a small group of figures kneeling before the golden calf, and second, above them, in a large group of men standing and huddled together. Oddly, Moses does not look at the lower group of worshippers, whose sin provokes him to break the tablets, but he looks toward the group of standing figures. The first of this group is a figure who looks back at Moses and takes hold of the horns of the golden calf with one hand and uses his other to point across the huddled group forcefully to the right. Taking hold of the golden calf in this way can only refer to its destruction, a subject narrated in the next verse (Exod. 32:20) and usually illustrated, if at all, in a separate scene in which Moses destroys the idol, grinds it into powder, and scatters it on the water for the Israelites to drink.[138]

The miniature clearly conflates these two subjects, and the only preserved works I know in which most of these various elements are found together are in a group of Castilian Bibles. The oldest was copied in 960 at the Castilian scriptorium of Valeranica, near Burgos; another Bible, with many similar illustrations, was made there in 1162.[139] In the earlier manuscript the two verses Exod. 32:19–20 are illustrated in two contiguous miniatures (fig. 39). In the first Moses receives the Law and then descends with the tablets as the Israelites kneel around the altar and worship the golden calf.[140] In the second and lower miniature Aaron appears to take hold of the calf's horns, and both he and Moses gesture toward a crowd of Israelites who stand on the other side of a strip of water and hold cups ready for the bitter

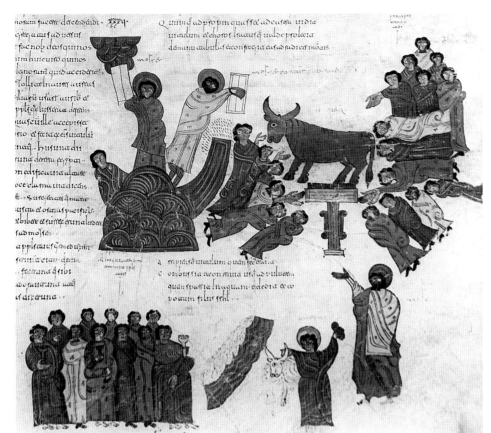

FIG. 39 *Léon, Colegiata de San Isidoro, cod. 2, Castilian Bible of 960, fol. 46r: Sinai.*

FIG. 40 *Léon, Colegiata de San Isidoro, cod. 3, Castilian Bible of 1162, fol. 46r: Sinai.*

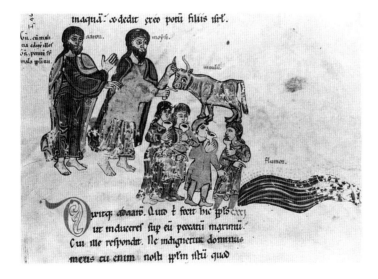

drink. In the Bible of 1162 the two parts are separate, and Moses takes the horn of golden calf, and both he and Aaron point toward the group of standing Israelites (fig. 40). Other than this Psalter miniature, I know of no illustration of this subject in which Aaron both points so forcefully toward the Israelites and takes charge of destroying the idol, which he grasps by the horns. It is clear that the figure grasping the idol and pointing away is Aaron, for he wears a fine mantle and looks back at Moses. The standing group of agitated men, who pull away from Moses, may have been suggested by the group of standing Israelites he punishes in the Léon manuscripts. Part of the ambiguity of the Psalter minia-ture is attributable to its conflating the three episodes but not illustrating a third Moses and not illustrating the body of water that suggests the Israelites' punishment.

These two Castilian Bibles could hardly have been the direct source for the Psalter artists; there is no evi-dence they left Spain during the Middle Ages, and they represent a complex local pictorial tradition.[141] It is thus

impossible to determine if or how the Psalter artists might have encountered it. At this time, however, two general points can be made with confidence. First, the pictorial tradition seen in the Bible of 960 is iconographically distinct from that of the more recent Byzantine, French, and insular works cited elsewhere in this chapter, and indicates that the Psalter artists consulted a wholly different source. Second, the subject of Sinai miniature is not the only one that Iberian works clarify; the Catalan eleventh-century Roda and Ripoll Bibles and the twelfth-century Pamplona Bible provide very suggestive *comparanda* for others.[142] Since these Iberian works have no known historical connection with each other, we can at this point conclude only that they represent a broad and complex tradition.[143]

Although no specific source can be described, one unusual detail in the Sinai miniature (fol. 35v) suggests that the Psalter artists looked at a rare and probably early source: the way in which the lower legs of the Israelites who kneel before the golden calf are cut off by the lower frame. Similar groups occur in nearby miniatures, including Moses Asking Pharaoh to Free the Israelites (fol. 30r), the Exodus (fol. 33v), and Joshua Made Leader of Israel (fol. 40r). The Israelites before Pharaoh are placed so low that the most forward figures are visible only from the knees up; in the Exodus miniature their feet cannot be seen; and in the Sinai episode the frame cuts off the lower legs of the Israelites kneeling before the golden calf.[144] Given this consistency of practice and the proximity and thematic affiliations of these miniatures, these details cannot be accidental.

The relation of these figures to the pictorial field of the Psalter is altogether exceptional. In contrast to slightly earlier French manuscripts, which often show figures and forms crossing *over* the frame and into the margin, the figures and forms in the Psalter miniatures are cut off by the frame, so that the pictorial field seems to continue behind and beyond it. Insofar as this occurs at the sides, it suggests a horizontal field in which the forms and actions of the miniature continue to the left or right and seem to extend indefinitely, like the Gothic structure above, which has no façade and no terminating choir. But the implications are quite different when figures and forms are cut off by the *lower* frame, for this suggests that they have a groundline different from that elsewhere in the manuscript. An extension of the picto-

rial field beyond the vertical sides of the frame is wholly credible, because the narrative moves to the left and right both in individual miniatures and as the pages of the prefatory cycle are turned. Nothing, however, suggests a lower field. The groundline is fixed in all other Psalter miniatures; the earth may rise above the lower frame, but it never sinks beneath it, even when gullies or pits are shown.[145] The highly structured world of Gothic painting is not given to groundlines that abruptly fall out of sight or groups that partially sink from view. These groups, which are so incongruous within their miniatures, are likely to have come from a particular pictorial context.

If that context is not Gothic, it is not Byzantine or Carolingian or Romanesque either, for it presumes an ordering in which pictorial space is unbounded, either because it is coextensive with the whole page or because the organizing element—normally the frame—has the same pictorial status as what is painted within it, a status that enables figures and forms to traverse each other. In the Bible of 960 the field is coextensive with the page, for the unframed column pictures move into the space between the columns as well as into margins of the page and occupy several different levels (fig. 39). In another miniature, the scene of the Departure from Egypt in the Bible of 960, the principal group, at the base of the right text column, includes Moses and Aaron, but there is a higher group of women ahead of them in the right margin, and below and between these two groups is a third group composed entirely of children (fig. 41). When compositions such as these were copied and enframed, the different groundlines were not always reconciled. Sometimes the lower figures were simply cut off. Thus the Roda Bible depicts only the upper half of the Israelites walking at the farthest right in the scene of the Crossing of the Red Sea, and it is unusual to see the feet of those who gather quail or manna in the desert or who fight the Amalekites.[146] The Psalter artists probably used a similar source, that is, one that was produced in a context in which the frame was arbitrarily set over the figures.

The Psalter artists' willingness to copy such figures and violate, even in this small way, the format that elsewhere defines the pictorial and narrative field suggests that these low and partially visible groups had some interest or narrative utility for the artists. One can only guess at what their interest was. Folios 30r, 33v, and 40r

FIG. 41 *Léon, Colegiata de San Isidoro, cod. 2, Castilian Bible of 960, fol. 38r: Departure from Egypt.*

are by the same artist, and the groups in them consist almost entirely of women and young men, with some children as well. These three folios would have been consecutive before the intervening bifolios were inserted, and so the repetition of a particular group, distinctively constituted and placed low, would enable the viewer to follow how the people whose freedom Moses demands from Pharaoh are liberated at the Exodus and finally entrusted to Joshua's leadership.[147] Whatever appealed to the artist when he saw this partial and subordinated group in a pictorial model, he used the group for thematic continuity, as a motif enabling the reader to follow the Israelites as they pass from Egypt to the Holy Land and from one leader to the next. The artist's reformulation of the Sinai miniature is also likely to have been intentional. It is appropriate that the pointing figure is recognizable as Aaron, because he seems to point to the desert tabernacle on the facing page, the first appearance of one of the most important leit motifs in the Psalter cycle (fol. 36r). That gesture becomes the critical link between the two facing miniatures, which show how the Law God gave to Moses on Sinai was transferred to the tabernacle, one of the principal places where the Lord manifests himself in the remainder of the cycle.[148]

As with the Byzantine sources, one cannot identify these early Latin works or show the precise form in which they would have been available to the artists or, in this case, determine what tradition of Old Testament illustration they represent. By the thirteenth century, those traditions had been so widely circulated and so often copied that their separate strains are no longer intelligible. However, one may assume that early manuscripts were available and might have been sought as models.[149] When the Psalter was planned, there had been almost a century of biblical study centered largely in Paris. The interpretation, translation, and correction of the Bible required those involved to search out authentic texts, which meant early Latin sources and biblical texts in Greek and Hebrew.[150] Interest was particularly keen in the Book of Psalms, which appears in new translations of the Hebrew as well as in bilingual texts. At the time the Psalter was painted, this activity centered among the friars, that is, in the religious culture to which Louis IX was most closely drawn himself. Indeed, it may well have touched the Psalter itself, for analysis of its text, as

discussed earlier, suggests that its numerous scribal corrections might have been necessary in order to update a pre-Vulgate version.[151] Of course, there is nothing to indicate that any of these early texts were illustrated— there are only other Gothic manuscripts that independently point to similar Latin sources[152]—but the friars closest to the king would have been educated in a culture that valued historical authority in matters of biblical interpretation, that searched for supporting material in old books, especially those written in archaic Latin forms and in the Greek and Hebrew Bible, and that assumed that authentic readings could be constructed out of various versions of the same text.

We do not know the Latin source the artists used or if it was much older than the thirteenth century. As before, one would not expect the Psalter pictures to look old, because, to function politically, they had to be recognizably modern and Capetian. But for the artists, it is interesting to speculate on what it might have meant to have used an old cycle of pictures. In some ways it would have extended the historiographical enterprise of the program, which develops structures enabling the Old Testament to inform Capetian history, and challenged the project of the artists, which was to make older pictorial structures speak to a modern French king. It also would have given their project a palpable historicity, one that might well have made them conscious of the moment and of their work in relation to that of their predecessors. It would have changed the nature of their enterprise, turning them into translators. Like their literary counterparts at this time, they may have gradually developed more specialized modes of analysis and interpretation with which to perform their art, especially if older narrative models had been adapted since the *Bibles moralisées* and had effectively become a form of discursive production. In any case, acting to conserve was consistent with acting to interpret, as it always had been in medieval art.

The *comparanda* discussed above suggest how the artists responded to their sources, and in the last chapters I shall try to convey how the king might have done so. Fortunately we have one other thirteenth-century reader of the Psalter, the author of the legends on the reverse of the miniatures. He is likely to have been first interpreter of these miniatures and the king's guide to their content.

Part 3: A Thirteenth-Century Reading

As discussed in Chapter 1, the legends were added after the paintings were complete and probably after the folios were collated, and they were created in response to a visual source, either the illuminations themselves, which is most likely, or a set of drawings that showed the relation between facing pages. These legends are therefore a kind of writing about pictures. Some legends are brief and in a straightforward manner identify the events depicted, but others are longer and create a narrative that effectively reconstructs the picture as it guides the reader through it. Although the function of the legends is to identify and describe, they indirectly tell us something about the author and how he saw the pictures.[153] The evidence comes, first, from the content of the legends, from its errors, omissions, and additions, and, second, from its form, from the linguistic ordering of events. Both imply the author's response to the pictures, his understanding and evaluation of their content. They also reveal a point of view; they position the author in relation to the pictures and tell us something about him as a viewer. This information is particularly interesting in the Psalter because its rare subjects, conflated scenes, and nuanced actions are likely to have challenged the perceptual and discursive skills of the author.

· · ·

In the first folios, where the subjects are well known and explanations are very short, the legends are similar to traditional rubrics, which summarize what is to follow. An example is the legend accompanying the miniature of the Flood: "En ceste page est conment Noei est en l'arche au duluge" [On this page is how Noah is in the ark during the Flood]. This legend resembles those in other manuscripts in its brevity, in its denotation of the subject while no mention is made of the moment, in this case the return of the dove and the emergence of land at the right. More characteristic of the Psalter are the legends to later miniatures, such as the one from the beginning of Judges in which the angel calls upon Gideon to serve the Lord. Like all the legends, it begins with *En ceste page est conment:* "On this page is how the angel comes to Gideon by his winepress and tells him what God commands of him, and how Gideon sacrifices on the stone and pours the fat over the sacrifice and the angel who mixes the sacrifice together enters into the flames of the fire."[154] This miniature (fol. 49v) is divided

into two separate episodes, and so is the structure of the legend. The first phrase introduces the subject (the angel comes to Gideon), gives the location, and then describes the specific action (the angel tells Gideon what God commands of him). The second, reintroduced by *conment,* also begins with the subject (Gideon sacrifices), describes his specific action (he pours fat over the sacrifice), and then recounts the angel's participation. This distinction between separate scenes is characteristic of the legends, as is the movement from the general subject to the specific action. The two angels are of course one angel shown in two different actions; the writer understood this convention of continuous narrative, for he describes the angel, named only once, as both mixing the sacrifice and entering into the flames. Finally, in its length, structure, and reporting of details, the legend clearly differs from the earlier Noah legend and, for that matter, from contemporary rubrics and earlier *tituli.*

When several scenes are conflated rather than separated, the writer reads them accurately when the actions are clear. For example, the legend to the miniature of Jael and Sisera (fol. 48r) reads: "On this page is how the king who was fleeing from the children of Israel fell into the hands of a good woman named Jael, who received him in her tent and gave him a hanap of milk to drink, and he fell asleep and she took a mallet and a large nail and drove the nail through the king's temple into the ground and kills him." Once again the legend introduces the subject (how the fleeing king came to the good woman) and then proceeds directly from the first episode (Jael received him in her tent) to the second (gave him milk) and then to the third (drove the nail through his temple and killed him), the latter having been elaborated with earlier details that may be presumed (that Sisera fell asleep, that she took the mallet and nails). In the miniature the sequence of three episodes is clear, and the writer comparably links them in the way he follows the subject with three parallel predicate clauses. The transitional actions make the legend more complete, and such details as the hanap and the nail driven into the ground give the description specificity and vividness.

By the same token, the writer misinterprets illustrations when the conflated images are ambiguous, as he does in the miniature from the story of Joseph (fol. 15v) in which the artist conflates the episode in which Joseph

tells Jacob, his father, of his dreams and that in which Jacob sends Joseph to his brothers, a conflation that leads the author to write in his interpretation of the subject that Jacob explains Joseph's dreams. In the Bible Jacob never explains Joseph's dreams but rebukes him for them.[155] Evidently the writer did not consult the biblical text or have sufficient experience with other representations to catch the problem. He simply read the miniature and made a reasonable assumption about its meaning, much as an intelligent person with a general but not expert knowledge of the Bible and its illustration would do today.

Sometimes errors result from habits of reading probably developed within the pictorial cycle itself. For example, one of the battle scenes from the Book of Joshua (fol. 45v) shows a group of soldiers at the left turning to walk off to the left, while at the right two groups of foot soldiers engage each other with lances and swords. Exceptionally, no element of dress, armor, or heraldry permits one to identify either side as the Hebrews. The writer's explanation is ambiguous: "On this page is how the children of Israel fight against their enemies and how they turned their backs and fled." It is not clear which group is the Israelites and whether they or their enemies turn their backs. What is remarkable about this reading is that it proceeds from right to left — this is always done for a reason — and that one assumes the group at the left is fleeing the battle even though they carry no arms. The miniature in fact represents the Israelites ambushing the men of Ai (Joshua 8). Their strategy was to flee before the men of Ai in order to draw them away from their city and then, at a prearranged signal, to turn and engage them in battle. Comparisons to earlier Byzantine manuscripts make clear that this miniature conflates two episodes, one in which the men of Ai, at the far right, are in pursuit of the fleeing Israelites, at the far left, and another in which the Israelites, in the middle, turn and engage them. In other words, the artist again conflated two scenes, and the group at the right serves for both episodes, just as Jacob did in the earlier example from the story of Joseph. The correct direction of the narrative is thus the normal one, from left to right. Why then did the author read it in the opposite direction? The answer probably lies in the previous double-page opening, which illustrates the Israelites' first encounter with the men of Ai,

when they are repulsed by the enemy before the city walls (fol. 43v). In this case the enemy at the right is denoted by a shield with black designs, and the Israelites are clearly overcome and fleeing in fear to the left, a direction of movement that will characteristically reverse itself in the subsequent scenes of victory. Here the legend is right on the mark: "On this page is how the children of Israel fought against the inhabitants of a city and those of the city put them to flight." Once again the legend to folio 45v implies neither a familiarity with the pictorial model nor a fresh reading of the biblical events. Instead, the reading is a cautious and intelligent extrapolation probably based on the similar and more recognizable subject two folios earlier.

In the previous example the writer's "error" reveals something about his reading of the miniatures. In most cases, however, the writer did not err but selected from different readings. His choices are interesting, for they suggest both the direction and limits of possible interpretations. Here are examples of each.

Samson Destroying the Temple of Dagon (fol. 62r) is usually illustrated with architectural elements falling upon a group of banqueting Philistines. In the thirteenth century women are commonly present at the banquet table, but the Psalter miniature presents a unique variation with only one woman; she is seated at the center of the table just below Samson, and she exchanges knowing glances with a man at the left. The Bible does not mention a woman in this episode, and pictorial precedents are no help in identifying her, but the natural inclination is to assume she is Delilah. Delilah is the focus of the previous miniature, and her dress there is similar to that of the woman in 62r, and the flirtatious behavior of the woman at the banquet table is consistent with Delilah's behavior in earlier biblical episodes. If she is Delilah, her juxtaposition with Samson, her sinful behavior just beneath him, indicates that the artist has introduced something new: Samson's vengeance on the Philistines is directed toward her, so that the story has to some extent been recast in more personal terms. In fact, other miniatures in the Samson cycle point to the same idea and suggest that the artist saw the story as a romance built up of recurring incidents of treachery and revenge.[156] In this case the author of the legend also identified this woman as Delilah and did not equivocate in interpreting Samson's actions as directed primarily

toward her, for he describes how Samson destroyed the palace "around his wife and his enemies" [sor sa feme et seur ses enemis].

In contrast, miniatures with comparably rich implications were sometimes very narrowly understood. The legend to the beautiful miniature of Abraham entertaining the angels at the tree of Mamre (fol. 7v) does not even mention the exceptional oak tree, which, unlike any other in the manuscript, rises into the upper half of the page, covers the architectural form above, and is painted in a brilliant pale green not used anywhere else on the page. Nor does he notice how Joseph rides before the people and exults in his new role after Pharaoh elevates him to office (fols. 22r–23v), even though he has changed his dress, rides a high-stepping dappled horse, and gestures broadly to those above the city gates who watch him approach.[157] The oak is naturally an image of Abraham's progeny—the central angel actually points to it when announcing that Sarah will conceive—but the author of the legend describes only how Abraham serves them and Sarah laughs. In the miniature, however, her grin is hardly noticeable, so that the author seems to be writing from his memory of the episode, not from what he sees. Similarly, rather than portray Joseph as triumphant, the author tells us that Joseph is doing nothing more than "buying and collecting wheat" [achate et quiert les bleiz], an activity suggested by the youth beside Joseph who carries a grain sack and the others at the far right who empty them. At this time, a figure with a retinue received at city gates constitutes a scheme used for the victorious entry of David and of other Old Testament kings into cities.[158] The author was either unfamiliar with these practices or chose to ignore the triumphal implications of the scene.

Not all miniatures are treated so literally. For example, as noted earlier, the writer explains, sometimes in error, the left and right halves of the Philistines Returning the Ark to Israel (fol. 71v) and then adds, almost as an afterthought, "thus the holy Ark returned to the tabernacle" [ensi revint la sainte arche au tabernacle]. However, the tabernacle is not represented in this miniature, though it occurs in six others nearby and is one of the central motifs in manuscript. The author understood that function and uses the tabernacle, though it is not shown, to explain the role of this scene within the larger pictorial cycle. In short, sometimes, as in the Joseph and

Abraham miniatures, the writer either misses the point or chooses not to deal with symbolic or metaphorical meanings; at other times, as in the case of Delilah or the tabernacle, he confirms a larger reading of events but interprets them only from within the narrative.

One of the most interesting aspects of the legends is the writer's use of tense. Most of the legends in the Psalter are written in the present tense, but as they grow longer and the pictorial narratives more complex, changes in tense serve to clarify the narrative, shifting it in time and thus creating a reading with a specific structure, emphasis, and viewpoint. It is here, within the linguistic dynamics of the text, that the writer reveals how he evaluates what he describes and positions himself in relation to it.

The miniature of Moses Receiving the Law (fol. 35v), as noted above, consists of four parts: Moses kneels on Sinai to receive the tablets from the Lord, he breaks them before a crowd of Israelites, the Israelites kneel before the golden calf, and an astonished group of standing Israelites backs off as one begins to destroy the calf. The legend omits this last and most difficult-to-decipher group, but it clarifies the other three phases of the action in a very natural way: "On this page is how God gives to Moses the Law on Mount Sinai and how Moses goes back and finds the people of Israel, who were adoring a golden calf, and how Moses broke their tablets." The writer explains the first action (God gives the Law) and adds intermediate episodes that are not illustrated but are assumed (Moses goes back and finds the people). The author then switches to the imperfect to describe the worshipping Israelites and then to the past tense for the breaking of the tablets. The choice of the imperfect is natural, for the worship of the calf was a secondary and continuing action while Moses was on Sinai, and, visually, this reduced group seems unaffected by the surrounding events.[159] But the use of the past tense is unexpected, for as the last and climactic action of these events, the breaking of the tablets would seem to call for the present. Reported in the past, however, Moses' breaking of the tablets is made to seem a foregone conclusion, iconographically secondary and narratively final, whereas Moses' receiving the Law, reported in the present, is the more actual, vivid, and iconographically important and, narratively, the more continuous with the sacred events in other miniatures that take the

present tense as the norm. There are many instances of similar changes in tense: In the miniature of the Fall of Jericho (fol. 42r), the legend describes how the children of Israel "*go* [in the present tense] with seven trumpets . . . around the walls of Jericho" but "how the walls of the city *fell* and how Joshua and his people *entered therein* and *took* the city" (all in the simple past). In a miniature from the story of Joseph (fol. 18r), the legend describes how, at the left, Joseph's brothers *bring* his coat to Jacob and *say* (both in the present) that a savage beast *devoured him* and how, at the right, merchants *sold* him to Potiphar (both in the past). The brothers naturally recount the fictive circumstances of the coat in the past tense, but no similar situation explains the use of the past tense for Joseph's sale to Potiphar. In all of these examples the historically more recent and narratively more advanced event is described in the past. The change in tense creates a relation between events that is neither temporal nor causal but hierarchical and semantic, and evaluation often depends upon religious considerations external to the narrative. Thus man's receiving the Law is more important than his sinfulness, God's intervention at Jericho is more significant than Joshua's actual conquest, and the brothers' display of Joseph's coat is dramatically and morally charged in ways his sale to Potiphar is not.[160] This use of tense applies not only to single miniatures but frequently to those on facing pages. Thus, the Flood is described in the present tense, but the subsequent miniature, in which Noah's sons cover his nakedness, is in the past (fols. 3v–4r). It is clear that to the contemporary reader these events did not all have the same significance. Although the text does not interpret the pictures, their interpretation is implicit in its narrative construction.

These sequences from present to past tense invite a more careful examination of those from past to present, in order to ascertain whether the latter merely reflect a temporal ordering or might also show a special emphasis. For example, Abraham's battle with the Canaanite kings (fol. 5v) is recounted in the past, but his receipt of bread and wine from Melchizedek (fol. 6r) is in the present; and the scenes of the Finding of Moses and the Burning Bush (fol. 29v) are described in the past, past perfect, and imperfect, but the facing miniature of Moses' appearance before Pharaoh (fol. 30r) is in the present. In both cases the events in these pairs of minia-

tures, when seen together, form a chronological and pictorial sequence. It is a sequence, however, seen from the vantage of the later event, which is in the present. In some cases, the later event is dramatically or symbolically the more significant. This is the case for the episode of Abraham and Melchizedek, which is a well-known type for the Eucharist.[161] But this explanation does not account for the emphasis on Moses' appearance before Pharaoh, for the episode with the burning bush is symbolically the more charged. Other factors must be taken into account, and it is not always clear what they are. One possibility is that the relationship created by the shift in tense reflects an interest in what is exemplary in the lives of these Old Testament heroes. Thus Abraham's offering the spoils of war is more significant than his victory, and Moses' assumption of the leadership of Israel is a more potent model than are the earlier events from his life. This explanation would be consistent with the larger interpretation of the prefatory cycle, an interpretation of which this writer was apparently aware, as evidenced in his legend to the Philistines Returning the Ark. Another possibility is that the shift in tense simply reflects the influence compositional elements exert on the narrative reading. It may depend upon the way each pair of miniatures involves the eye in moving from a miniature at the left that is internally complex and highly concentrated to one at the right that is more transparent, open, expansive, and balanced. This explanation makes tense a perceptive response to the ways these facing miniatures are narratively and formally complementary.

Tense more than anything else shows just how visually sensitive the writer was. Take, for example, the miniature of Joseph Sold by His Brothers (fol. 17v). At the left, Joseph climbs out of the well on a ladder; in the center, his brothers hand him over to the Midianites; and at the right, his brother Reuben, returning later and failing to find Joseph, weeps over the well, believing his brother to be dead. The legends describe the first and last subjects in the present tense and the center one in the past: "On this page is how the brothers take Joseph out of the pit and how they sold him to Egyptian merchants and how Reuben mourns Joseph from above the pit."

As before, this sequence of tenses is inconsistent with temporal and causal relations. However, it is entirely consistent with the composition of the minia-

ture, for the conspicuous wells anchor each side of the picture, and Joseph, seen from behind, rises out of the left one as Reuben, seen from the front, looks down into the right. This movement up and down of figures seen front and back places the left and right parts of the composition in a delicate balance, and Joseph, looking back at his brothers as he is pulled forward by the merchants, is placed at a kind of fulcrum point, belonging for a moment to neither one group nor the other. If the still point he occupies at the center is narratively charged, it is because he is a figure in transition, because his fate—and consequently that of his people—is being determined. The legends do not tell us if the writer understood how the composition focuses on this critical moment, but his choices of tense suggest the way he read the lateral scenes against the center one, emphasizing the actions that are clear and structurally determinant and separating them from those which are ambivalent and incomplete.

The more complex pictorial narratives pose the greatest problem for the writer. When he is most successful, he uses tense to create in the legend a narrative structure that is remarkably similar to that in the miniature. The story of Samson and the jawbone (fols. 59v–60r) is recounted in seven episodes telescoped into two facing miniatures. The left miniature shows the Hebrews' conspiracy to turn Samson over to the Philistines, and then Samson's suffering his countrymen to bind him. In the right miniature Samson first bursts the ropes as the Philistines try to take him; then he overcomes the soldiers with the jawbone; and finally, as water flows from the jawbone in the lower right corner, he offers a prayer of thanksgiving. The legends use a variety of tenses to interweave events both earlier and later. They explain how the Philistines "plot" (in the present) that they "will take Samson" (in the future); how, at the right, they "take" and "bind" him and how he "suffers" them to do so (all in the present); how, in the facing miniature, Samson "broke" his ties (in the simple past), "kills" (in the present) with the jawbone those who "had bound him" (pluperfect), and "gives thanks" (present) for the victory he "has had" (present perfect). The result is that actions in the left miniature are set in the present and use the future to anticipate the first scene of the next miniature; and the latter, set in the past, leads into the two final scenes, each of which is in

the present tense ("Samson kills" and "gives thanks") but uses a perfect tense to refer to the episode immediately preceding ("those who had bound him" and "the victory that he has had"). The use of the present perfect is particularly appropriate to show the present consequences of past actions, that is, offering prayer after victory achieved. This alternation between events moving forward and those looking back gives the events a cumulative character, so that the last episode, with Samson's arms up in prayer, is, in the legends and in miniatures, both a climax and a closure. The author precisely leads his reader through each part of the picture and reveals his own profound level of engagement with scenes that are among the most diminutive in the prefatory cycle. The reduced scale of these miniatures seems only to have absorbed him in their events.

These changes in tense probably represent the writer's response to the complexity and concentration of the narrative, a way of organizing a path through the events. Switching from past to present or vice versa allows the writer to foreground the action with the changed tense. It acts to structure the narrative by bringing one primary action into focus against the background of a series of others. Changes in tense that are inexplicable in terms of temporal or causal relations have also been observed in thirteenth-century French romances and have been explained by Michel Blanc, among others, as a device, arising partly in response to epic parataxis, for differentiating and shaping the narrative.[162] Suzanne Fleischman has discussed the phenomenon linguistically as comparable to the ways narrative discourse is organized in natural speech, and has shown how shifts in tense function pragmatically in both medieval narrative texts and natural language to provide structure and expression and to reveal the narrator's voice and point of view.[163] Although tense functions in the same way in these legends, the pragmatics are somewhat different because these brief texts recount precisely delimited events selected from a field that, because it is visual, already has a cognitive, aesthetic, and narrative order of its own. While this means that tense is not manipulated precisely as it is in textual or oral accounts, its discourse functions are entirely comparable and enable the brief narratives to be studied linguistically as meaningful constructions. The legends are hardly literature, and the paintings are not performed narratives, but

the author employs normative strategies of discourse to reconstitute the pictorial events in his French text. In so doing, he reveals something about his perception of the pictures and their interrelation, his understanding of their events and role in the program, and his competence as a viewer and writer.

How might this viewer and writer be characterized? He was someone who had an impressive command of Old Testament subjects and illustration but was far from expert, who described what he recognized but did not verify his work, who had an eye for detail and was responsive to narrative and compositional elements but sometimes overlooked the conspicuous, who often saw beyond the surface to the larger narrative purpose of an episode or story but chose not to describe symbolic meanings. The more exotic the model, the more conflated the composition, the more difficulty he had. His "mistakes" were usually natural ones; they may have been the fault of habit or of a cursory reading but were never really careless. When he did not know a subject, his guesses were well informed, probable, and intelligent. He was also someone with a point of view: certain events were more important or more potent; they imply the future and inform the present. There is no indication that the person who composed these legends was a theologian, an artist, or an author of note. But he was educated, literate, and highly visual, and the scale of these miniatures was no obstacle to his deciphering the action or responding to its nuances. He was in many ways the reader we would expect to find in the intimate circle of the king. From all we know about him, the king's own reading of his Psalter may not have been very different.

It is normally assumed that legends function as a guide to unfamiliar pictures and that they are in French to accommodate the lay readers for whom picture cycles were supposedly intended. But legends also accompany the most familiar New Testament subjects, sometimes they merely name the subject, and Louis IX would have been just as capable of reading legends in Latin. Whatever functions legends may take on in specific cases, what is perhaps most significant is that they, like the Early Christian *tituli,* refer to pictures as discrete objects, and this implies that the miniatures they describe have undergone a profound change in status, at least in relation to their immediate Romanesque precedents. Nothing exemplifies this change better than the most unusual

feature of the legends in the Psalter: their location on the back of the pictures to which they refer.

This placement is without precedent. It not only means that the accompanying picture cannot be seen as the text is read but that one legend follows the picture to which it refers and the next one anticipates it. The result, however, is not a confusion of reference but a reformulation of the traditional reading of text and image. As already noted, the text occupies a page of its own, one that is lined so that the legends conform to the boundaries of the miniature on the reverse, the first line of text falling just beneath the upper edge of the illumination.[164] Text and image thus lie back to back, each legend physically matching up with the painting it explains. If this conjunction creates an implicit reference, it also implies alternative ways of knowing. Moreover, it alters the way the reader relates to the page of parchment, for the placement of the text now defines the backside of the painting as a discrete locus. Thus the physical and functional relationship of the two sides of the page is less like that of other folios in the Psalter, where the text may continue around a miniature and onto the reverse of the page, than it is like that of a three-dimensional object with an inner and outer face or an obverse and a reverse. This new relationship must in turn be understood in connection with the Psalter's arrangement of the miniatures in facing pairs, left and right pages usually forming a distinct decorative, narrative, and iconographic unit, in short, a pictorial diptych. It is in the turning of the pages that the physical relations between front and back, left and right, order our perception of the cycle. What begins as an alternation of seeing and reading soon becomes one of opening and closing: the texts enclose and describe; the pictures open and reveal.

· · ·

The idiosyncrasy of the relation between the Psalter legends and miniatures makes it possible to see what enables that relation to work in the first place. It works because a full-page miniature is no longer an illustration but a painting that has become an object of reference, one that is imaginatively entered in viewing and in the affective discourse of descriptive writing, in the same contemporary vernacular used for literary and historical texts.[165] The separation of text and picture serves to force looking and to make it an independent activity, and their reintegration requires memory. It is a useful dislocation,

but it implies that both picture and legend have fundamentally changed. They have: these are pictures seen from the outside, framed like windows and separately labeled, and no earlier medieval book had devoted an entire page to an independent description of an unseen painting.[166] These changes in status were decades in coming and have repercussions well beyond the relation between the pictures and their legends.

Part 4: The Psalter and Parisian Art of the 1260s

The principal stylistic parallels for the Psalter are found in the sculpture of the south transept of Notre-Dame, as several scholars have noted.[167] Resemblances in figure type and drapery pattern are striking and fully support the dating of the Psalter to the 1260s. The connections, however, are more profound, for a number of innovations seen in the sculpture as well as in other media at this time indicate a fundamental change in the visual arts, one with wide-ranging aesthetic and intellectual implications. Many of the unusual features discussed in the two previous chapters—the varied approaches to modeling, color, and light; the manipulation of pictorial planes and compositional rhythms; and the interest in the mobility of the figure and its social and mental context—find analogies in Parisian works of the 1260s. In what follows, I first discuss the innovative features of the sculpture and a few other works and then turn to the larger phenomenon.

Two closely related and consecutive phases of Parisian art are visible in the prefatory miniatures. The first is seen in gathering 1, in such figures as Cain (fol. 2r, right) and the forward angel who appears to Abraham at the tree of Mamre (fol. 7v). These elongated figures step forward or back so that as the body turns, a broad convex arc reaches from the lower leg to the high waist; the proportions of the short upper body diminish in an angled play of hip, torso, shoulders, arms, and head. The figure type arises in Parisian sculpture of the 1240s and is fully developed in the 1250s, its best-preserved exemplar being the statue of the Virgin and Child on the trumeau of the north transept portal of Notre-Dame (fig. 42).[168] The type had a major impact on sculpture, especially the extensive program undertaken from ca. 1255 at the cathedral of Reims, where many parallels to figures in these

first gatherings of the Psalter miniatures are found. Thus the angel from the left western portal of Reims (fig. 43) is strikingly similar to the angel at Mamre (fol. 7v), especially in the relation between the parts of the body, the countertilt of the torso and head, the sloping shoulders, and coordinated movements of arms, wings, and head. Similar parallels are to be found in other Reims sculptures of 1255–65.[169]

Several features of the Paris Virgin and Child statue are highly precocious and point to later developments in the Psalter and in Parisian art. First, curvilinear forms become dominant, with the result that the body is built up less of counterpoised forms than of lesser and greater curves and encompassing rhythms.[170] Second, the surface is less broken and planar and more continuous and rounded, so that the forms are shaped more by contrasts and gradations of light. And third, in some areas, such as the thigh and shin, folds of cloth are cut in slight, softly rounded ridges that gradually merge with the rounded form. This suggests thinner drapery and gives the illusion that forms disappear beneath a surface. These features are analogous to those in the paintings at the beginning of the Psalter cycle: the preference for few, thin forms on the rounded body; the curvilinear and rhythmic basis of composition; and the thin, tonal application of color. In these terms, some of the same sculptor's narrative reliefs from the lintel of the north portal, such as the seated figures of Theophilus Receiving Money (fig. 44), may be compared to miniatures from the story of Joseph (fols. 18r, 22r, 24r).

The tendencies just described are not limited to painting and large-scale sculpture. In spite of differences in scale, carving techniques, and use, ivory developed along very similar lines. The two statuettes of angels in the museum of the cathedral of Rouen are Parisian works of about 1250 and have much the same sensibility as the trumeau statue of the Virgin and Child (figs. 42, 45); the same is true of an ivory statuette of the seated Virgin and Child in the Louvre (fig. 46).[171] Ivories in earlier styles also use the natural warm tone of the medium, but what is striking about many of these is the way the carver not only takes advantage of the precise cutting and detailing possible in the medium but also works up a lush opacity of surface in which light is diffused, modulated, and absorbed. The issue here is not the priority of any medium but a common interest in

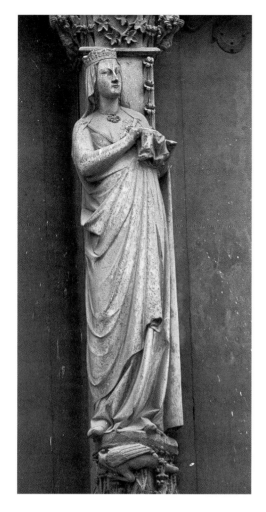

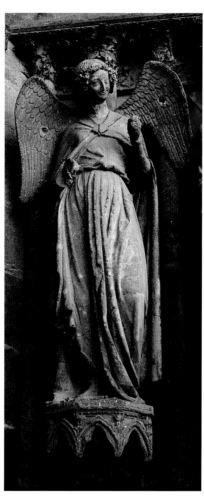

pictorial values, in the way the interaction of light and shadow create a rich illusory surface. There is evidence for similar interests in other media too. One also sees it in contemporary stained glass, in the use of a modeling wash over lines of drapery.[172] One sees it in the increasing use of translucent and transparent materials, such as chalcedony or sardonyx for carvings.[173] And it appears in numerous aspects of the Psalter: in the way the ivory tone of the vellum functions structurally in the page layout, and in the thin transparent application of colors such as salmon.[174]

A transition to a distinctly different and later phase of work at the cathedral may be seen in the sculptural group of the Three Magi from the first eastern buttress of the north transept.[175] It shows the characteristic fold pattern and fluency of the Virgin and Child trumeau but in a less elongated figure. Materials are thinner, forms

more pliable and elastic, and shapes more fluent and richly contrasted. Also noteworthy is the way the figures are placed in space. The forward king faces slightly to the left, his left leg trailing behind; the most rear is frontal; and the intermediate king faces right, his body angled obliquely between the two others. The outer figures give the group coherence, but the inner one serves to build a triad of independent figures. The arrangement is more dynamic than anything on the north portal or in French illuminated manuscripts at this time.[176] However, the last two gatherings of the Psalter have similarly composed figures.[177] Instead of the rather homogeneous groupings one finds in many miniatures, the Saul Master tends to individualize a few figures by age or dress, to place them in discrete units of two or three persons, and to position them so that one or two turn in contrasting or opposing positions.[178] Although

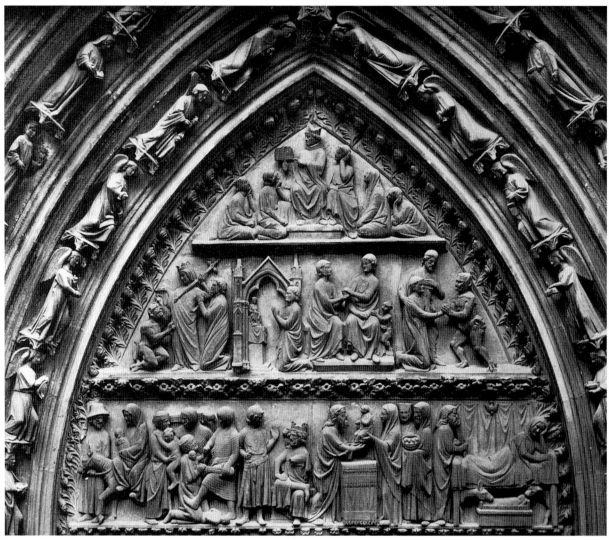

FIG. 44 *Notre-Dame, Paris, north portal, lintel, including Theophilus Receiving Money.*

the Hebrews who demand a king are piled one above the other (fol. 72r, right), Samuel and his two sons are positioned in relation to each other much as the Magi were in the sculptural group discussed above. Several other scenes from the end of the cycle have a group of three figures in which two face the same way and a third, often the one in the middle, looks back.[179]

The Three Magi group anticipates the sculpture of the south transept, a work begun by Jean de Chelles and largely erected under Pierre de Montreuil, who probably worked on it until his death, in 1267.[180] In the lintel's history of Saint Stephen, the figures are more normally proportioned and full-bodied, but their curvilinear drap-

ery forms are more profuse, layered, and crisp, so that in some parts, such as the scene on the lower left, the surface is built up of strong contrasts and a rapid undulant movement (fig. 47).[181] The same changes appear in the last gathering of the prefatory miniatures. Samuel speaking to the Hebrews in folio 72r is the same type of figure as the elder who holds open the scroll in the scene of Stephen disputing on the lower left of the lintel relief. The seated figure of Saul to the right of the same miniature may be compared to the seated Saint Stephen in the same lintel group, especially in the rich elaboration of small contrasting folds in the heavy mantle covering the lower body.[182] But the brilliance of Parisian sculpture at

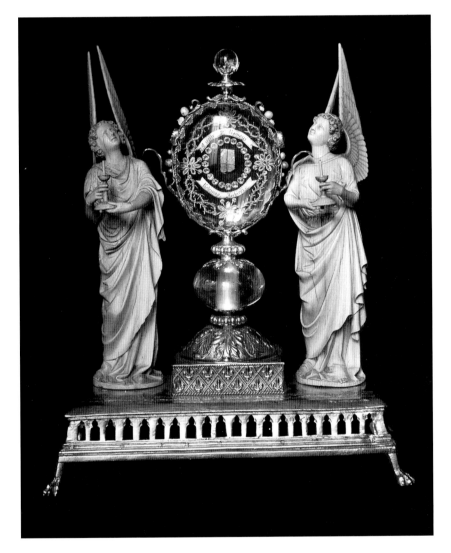

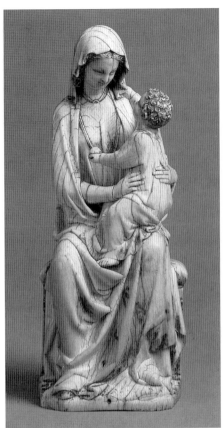

FIG. 45 (left) *Museum of the cathedral of Rouen, two ivory statuettes of angels, Parisian, ca. 1250.*

FIG. 46 (above) *Paris, Musée de Louvre, ivory Virgin and Child, seated.*

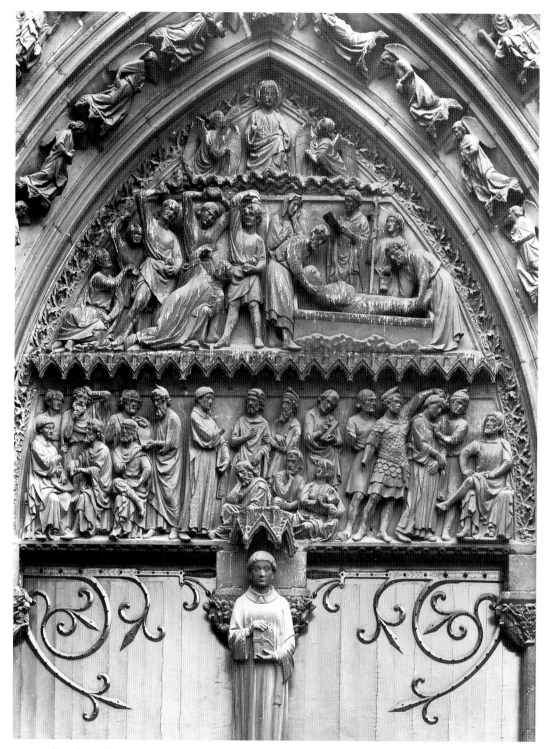

FIG. 47 *Notre-Dame, Paris, south transept, portal lintel, history of Saint Stephen.*

FIG. 48 *Paris, Musée de Cluny, figure from the south jamb of Notre-Dame.*

FIG. 49 *Paris, Musée de Cluny, figure with chasuble from the south jamb of Notre-Dame.*

FIG. 50 *Paris, Musée de Cluny, figure of a bishop from the south jamb of Notre-Dame.*

this time is nowhere seen better than in the jamb statues from the south portal of the cathedral itself, works that, in spite of their fragmentary and damaged condition, develop sculptural effects with an exceptional freedom and richness. One is comparable to the figure of Samuel just cited, but, in relation to the lintel, the surface is far more pliant and richly modeled (fig. 48). Another figure wearing a thin chausable has crisp forms that recall the lintel and the figure of Saul among the prophets (fig. 49).[183] Still others, such as the more heavyset bishop carrying his head (fig. 50), may be compared to the elder who turns to the messenger in folio 76r, above all in proportion and girth and in the bold powerful contrasts between a few folds and the powerful body underneath.

The more thin, precise, and elaborated forms of the lintel reappear in an important but little-known work, a pedestal, now in the Louvre, with reliefs of four prophets (figs. 51, 52, 53).[184] The pedestal is the base of

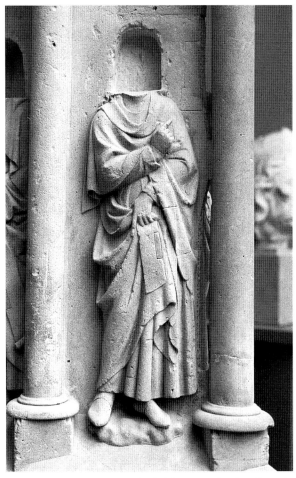

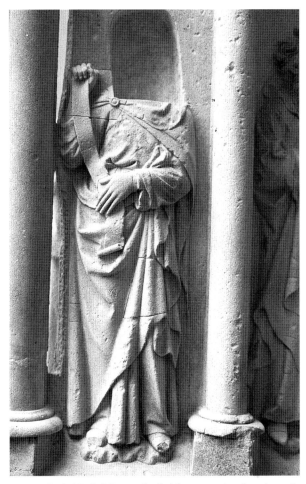

FIG. 51 *Paris, Musée de Louvre, detail of the trumeau base from the north transept portal, Porte de Valois, of Saint-Denis: second prophet of four.*

FIG. 52 *Paris, Musée de Louvre, detail of the trumeau base from the north transept portal, Porte de Valois, of Saint-Denis: third prophet of four.*

the trumeau from the north transept portal, the Porte de Valois, of Saint-Denis. The trumeau was one of the elements carved sometime after 1245, when an earlier twelfth-century portal was reinstalled in the new Gothic transept.[185] Late-eighteenth-century drawings show that the pedestal originally supported a statue of the Virgin and Child.[186] Although the heads of the prophets have been removed, presumably by the nineteenth-century restorers who were preparing to replace them, the high quality of the work is apparent. The thin, broad folds, the dry crinkle of surface forms, and the movement of the rich, undulant drapery upon a stable and well-rounded figure relate these prophets to the lintel of the south transept of the cathedral, and they should be dated to the same decade or slightly later (cf. figs. 47, 51,

52, 53).[187] The precision and quality of cutting are so comparable that one is tempted to see the same shop at work in both.

The figure that is perhaps the most singular and pictorially advanced in the entire prefatory cycle finds its most striking counterpart in these prophet reliefs. I refer to the remarkable figure of Saul at the left of folio 73v and to the third prophet relief (fig. 52). They are figures of the same proportion, roundness, and stance, and they are each dressed in a straight gown and in a mantle that shows, despite the differences in medium, the same exceptional thinness in its flat pleats, a comparably delicate layering of large, precisely cut planes, and a similar fluency and grading in the play of light upon them. The Saul Master's use of color—two near tones of blue-

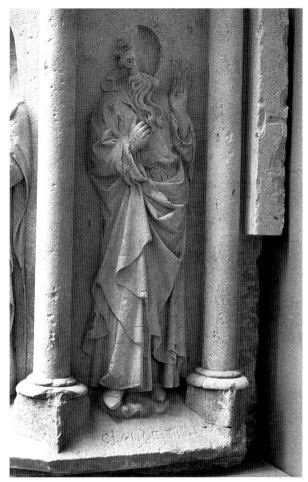

FIG. 53 *Paris, Musée de Louvre, detail of the trumeau base from the north transept portal, Porte de Valois, of Saint-Denis: fourth prophet of four.*

1264 (fig. 55).[189] The matrix for the seal is not preserved, but the thin, leaning, elegant forms of the bishop are like those of other works in metal, such as the rounded figure of Mary on the silver gilt cover with the Crucifixion on one of the Sainte-Chapelle evangeliaries (fig. 56).[190] The royal tombs at Saint-Denis, which were undertaken in 1263–64 with the consent, if not the sponsorship, of the king, display varied artistic currents, but one group of them is clearly related to the prophet reliefs from the north portal.[191] Dating the reliefs to the same period as the tombs suggests that the dynastic concerns that governed the arrangement of the tombs may also have motivated the renovation of the earlier Porte de Valois, with its series of French kings in the archivolts and jambs.[192]

One medium that seems to have enjoyed currency in Paris at midcentury is precious stones. Gem cutters were active in Paris from the beginning of the thirteenth century, and antique gems were collected and often incorporated into the personal seals of high-ranking ecclesiastics.[193] Louis IX apparently possessed the largest of all extant antique cameos, the Grand Cameo of the Sainte-Chapelle, which Baldwin II probably sent him in the 1240s.[194] Although Parisian gems were largely restricted to profile heads *à l'antique,* around the 1260s small heads cut from chalcedony or sardonyx begin to be shown frontally or in three-quarters, scale reaches almost five centimeters, and the features come to resemble sculpture in Paris and Reims.[195] A particularly interesting example is a large chalcedony head in Philadelphia that is very close to the heads of figures in the Psalter and on the lintel of the south transept (fig. 57, fol. 76r). Other heads are finely cut with rounded features like those in the Psalter.[196] These works are of interest not as sources but because the medium mediates between the monumental and miniature and shows the importance of fine cutting that is evident in large-scale works. They also signal a taste for the classical and underscore the diversity of artistic currents in Paris at this time.

Coincident with these changes in figure style are changes in body language and gesture and in the sentient qualities of the figure. For example, now figures touch each other on the shoulder, arm, back, or thigh; both the front and the back of the hand are used; fingers open, close, and are separately folded or extended and

gray—suggests the way the thin mantle closely encircles the gown, as it does in the relief, and he paints the reflections and deep shadows moving up and down edges and furrows of the mantle without interruption, as though light were falling continuously upon its full length, as it in fact does in the relief.

Other works from the 1260s exhibit similar trends. Dieter Kimpel and others have related the jamb statues of the south portal of the cathedral to the plaque on the reliquary shrine of the Beauvais saints Lucian, Maximian, and Julian, which was made for the Sainte-Chapelle shortly after their translation in 1261 (fig. 54).[188] The kind of pictorialism seen in the statues is in evidence both in the shrine and in the seal of Aleaume de Cuissy, bishop of Meaux, which was attached to a document of

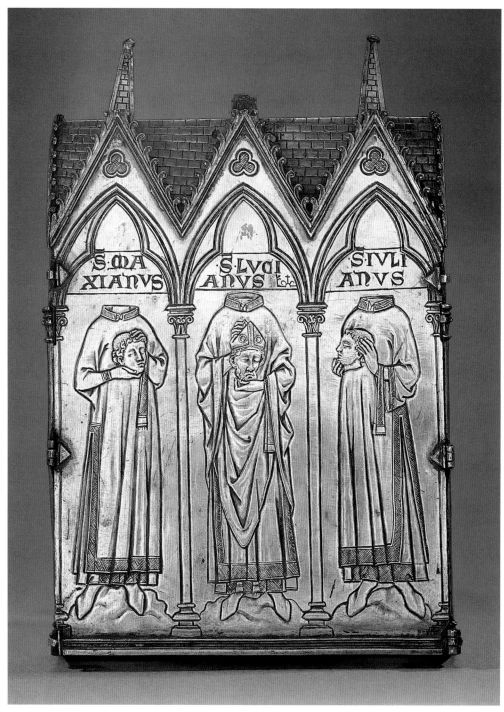

FIG. 54 *Paris, Sainte-Chapelle, treasury, reliquary shrine of Saints Lucian, Maximian, and Julian.*

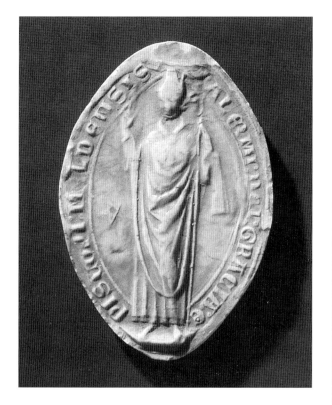

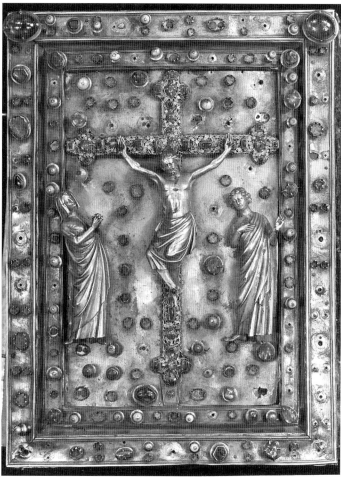

FIG. 55 *Paris, Archives nationales, Sceaux no. 6703, seal of Aleaume de Cuissy, bishop of Meaux.*

FIG. 56 *Paris, Bibliothèque nationale de France, MS lat. 8851, Sainte-Chapelle Evangeliary, cover: Crucifixion.*

FIG. 57 *Philadelphia, University of Pennsylvania Museum of Archaeology and Anthropology, chalcedony gem with head of man.*

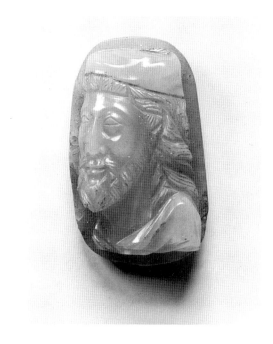

are used not only to grasp objects in varied ways but to count and exhort; and figures forcefully point and refer to what is "up," "down," "here," or "there."[197] Some figures have detailed ears and turn their heads to listen, another will hold his nose when there is a bad smell, and one night scene in the Psalter has a flat black background instead of the usual gold leaf.[198] Such gestures forcefully express intent and a response to others and to one's surroundings. They indicate a new interest in touch and, more generally, in the role of the senses. The latter was partly stimulated by the renewed availability of and interest in the works of Aristotle, especially his *De sensu et sensato,* as well as medical and scientific texts by other classical and Arabic writers.[199] By the 1260s literary works, such as Richard de Fournival's *Bestiaire*

d'amour, were also affected, and illuminations in Aristotle manuscripts of the same date not only illustrate sense organs, such as the ear, with its various convolutions, but also show people listening, tasting, smelling, and so forth.²⁰⁰ The Psalter is one of the first manuscripts in which this new interest in the senses is incorporated into a sacred narrative. With his ear clearly depicted, Cain seems to be hearing the Lord's curse (fol. 2r); similarly, Shem and Japheth hear Ham's angry recrimination as they cover their sleeping father (fol. 4r). With Ham's open mouth placed at the very center of the miniature, their exchange is hardly silent.

Suggestions of a mental world are not limited to the senses but extend to the inner world of thought, emotion, and self-conscious restraint. When Samson confides to Delilah the meaning of his riddle, he uses his hand to refer imaginatively to the lion he subdued in the previous miniature (fol. 57v). When Nahash threatens the Israelites, the terrified reaction of a balding elder is shown in the groping reaction of the fingers of the hand he holds down at his waist (fol. 75v). Samson lays his hands limply on the forearms of those who bind him but gazes intently into the eyes of one of the Israelites (fol. 59v). And when Jacob lies across the foreground of a miniature and dreams of the heavenly ladder (fol. 13v), he turns his back to the viewer and faces into the miniature, as if turning aside toward an inner reality.²⁰¹ These relations between the somatic and the psychological were being explored by Parisian writers ca. 1260, explorations often occasioned by the revived interested in the work of Aristotle.²⁰² Not every miniature operates at these levels, but so many of them do that there can be no doubt that visual narrative is beginning to move in an unprecedented direction.²⁰³

Once again, several narrative parallels are to be found on the Saint Stephen lintel (fig. 47). Each of the three scenes of the lowest register is organized in units of two or three juxtaposed or obliquely related figures whose actions are highly individualized and who sometimes react to each other as well as to the protagonist. In the left scene, in which Saint Stephen debates the synagogue elders, the saint raises a finger as he speaks; with his other hand, he points to a tablet on his lap. The man he faces uses a somewhat different language of gesture, placing two fingers of one hand against the extended fingers of the other. In the second scene, two standing men listen to

Stephen preach. The first has his hand upon his chest, as though Stephen's words move him, and the second man grasps the arm of the first. Below them are three figures seated on the ground: an old man, deep in thought, his lowered head upon his hand; another man, restlessly stroking his beard and clasping his knee; and a woman nursing a child.²⁰⁴ While hands and body language are again used to characterize emotional or mental states, the lintel presents a series of highly singular characterizations, which, like contemporary works at Reims and Auxerre, suggest the influence of ancient sources.²⁰⁵ Although ancient statuary is almost certainly the basis for the nude oversize sculpture of Adam from the inner face of the south transept of Notre-Dame in Paris (fig. 58), the sources for the exterior portal sculpture are less clear.²⁰⁶ As with the cameos or Aristotle's works, such sources must be counted among the currents influential at this time, however much they are absorbed into a contemporary Gothic vocabulary.²⁰⁷

· · ·

Figures and styles similar to those seen in the Psalter and in Parisian sculpture are naturally to be found in other Parisian manuscripts. They appear in manuscripts that Branner connected with the "Corpus" group, the Dominican Painter, and the Sainte-Chapelle Main Line and early Cholet groups, among others.²⁰⁸ Scholars have connected several of them with the Psalter miniatures.²⁰⁹ While all present certain parallels, none can be said to account for the Psalter paintings or to indicate the origin of its artists. Yet on two matters contemporary illumination provides essential evidence: color and painting technique.²¹⁰

Essays with color are typical of Parisian illumination in this period and are found in manuscripts associated with all the manners of painting cited above. In general, the basic palette still centers on a combination of blue and orange or of blue and rose. For example, the final and latest volume of the Dominican Bible, probably dating to about 1260, is painted for the most part in the kind of gray-blue colors with modeling in blue or gray-brown that we see in some Joseph scenes.²¹¹ But in the later "Corpus" group of manuscripts, probably ca. 1260, some miniatures have figures painted in pale pink hues with soft white highlights, sometimes modeled in gray or contrasted with green, as in the Psalter.²¹² Similar examples are to be found in some of the earlier manuscripts of the "Aurifaber" group, where, additionally,

FIG. 58 *Paris, Musée de Cluny, Adam from Notre-Dame.*

Although a profound change in color and technique affects the entire last stage of painting in the Psalter, no singular palette or systematic practice is put in place. Rather, a number of ideas are tried out, some inconsistent with others. Even though the results may be fully realized only in singular figures or miniatures, there is clearly a very different way of constructing the palette and using color descriptively. The flat warm blue and salmon of the earlier miniatures are replaced by a blue and blue-gray and a pale ochre, effectively a salmon with less red; both are modeled from dark to light. Alongside these colors are now found orange and especially green, which had been used primarily for leggings or hats, foliage or water. In the last two folios, for example, the four colors are distributed across the page so that each has an intense local effect. The combinations are often striking: the frequent combination of pale ochre with green approximates the effect of complementary colors, and the pairing of pale ochre with brilliant orange and of blue-gray with copper green creates two color axes and tends to bring up the red and yellow tones of the surrounding gold.[217] The blue end of the palette is considerably extended, and its hues, which vary from a light blue to a blue-gray, point to a considerable sophistication in mixing colors and coordinating their values. Reflections can still be local and sometimes seem to be grafted on, but one also finds that minimal white highlights are worked into all the principal colors, including the orange and green, so that rather than reflections lying on the body, materials have a silky glisten and some colors, especially the ochre, have a creamy lustre. In Chapter 1, I explained how the transparent effects of the earlier parts of the manuscript are not set aside; that is, in some passages the paint is still applied almost as a tint, so that colors are deepened by the addition of a secondary wash of the same hue or are modeled by thinning the paint to expose the whiteness of the parchment beneath, practices that affect the saturation of color but not its value.[218] The result of these changes is that all the figures are brighter, rounder, and more distinct, and in several of the last miniatures they become part of a pattern of color.

Color appears to have played an important role in Parisian painting in the 1260s. A few stained-glass windows near Paris from ca. 1270 show a striking brilliance in palette, which can be composed of four or more main colors, primarily green with golden yellow and violet

orange begins to be paired with green, as in the last Psalter gathering.[213] Only a few miniatures are affected in each of these manuscripts; they seem to be isolated experiments, possibly influenced by other works, not the sustained change in practice one finds in the final Psalter miniatures and initials. During this period painters also take several directions not found in the Psalter. The most important is a tendency to develop hues in the red-blue range.[214] That palette appears prominently and in a sustained way in the Sainte-Chapelle Evangeliary, Bibliothèque nationale de France, MS lat. 17326, a manuscript contemporary with the Psalter and having generally similar architectural elements, drapery forms, and even technical features.[215] There figures are dressed in robes painted in burgundy, purple, lavender, or violet, sometimes complemented by orange, pink, green, blue-gray, or gold, a more extensive palette than that found in the Psalter.[216]

with tan, the effect being so unusual and rich that some have suggested the influence of Parisian illumination or even an identification of the glass painter as an illuminator.[219] A few wall paintings in mendicant churches ca. 1300 have a palette of prominent grays and greens that, in view of the architectural and floral motifs that attend them, are likely to depend upon many of the French works of midcentury already discussed here.[220] And a little after 1270, English painting, strongly under French influence, exhibits many of the same distinctive features described above.[221] But these changes in French art are only one manifestation of a far broader phenomenon in the development of technique and palette occurring in various media. English manuscripts provide considerable evidence of a broadened palette and modeling with white and with gray-blue shadows.[222] Monumental paintings in France and Italy often achieve a desired color by using two coats or even one thin coat of paint, sometimes over a tinted ground, with the bottom color showing through because the overlayer is either reserved or transparent.[223] A color effect is sometimes the result of a complex mixture or layering of a range of materials, which vary considerably within the same work, and oil binders begin to appear in wall painting as well as in polychromed sculpture.[224] Given the loss of most panel painting and the rarity of scientific analysis of wall paintings or illuminations, the larger phenomenon is difficult to assess, yet the mounting evidence points to the years ca. 1260–80 as being critical for the development of color theory and of painting technique.

The Psalter's essays in the technique of painting are consistent with these developments as well as with the exploration of pictorial effects, luminous surfaces, and transparent materials in sculpture and other media. Yet in the Psalter the whole enterprise is pushed unusually far. The tinting of the bole and the variations in the reflectivity of the gold leaf, the broad range of blue-grays, the choice and combination of hues and their allocation across the page, and the use of black to suggest night scenes or blindness all suggest a keen interest in effects that go beyond the pictorial or narrative and might best be described as optical. There can be no doubt that these interests were widespread within a certain level of Parisian culture at this time. In Jean de Meun's *Roman de la rose* of ca. 1277, Dame Nature refers to the rainbow and explains that the way the sun produces its colors can

be understood only by a master good enough to teach optics, to be a disciple of Aristotle, "who had made better observations on nature than any man from the time of Cain" and who knew Alhazen's book of *Observations* (*De aspectibus*).[225] The poet is clearly aware of recent debates on the rainbow and of the two principal authorities behind the new synthesis in optical theory taking place in Paris in just those years. Optics had gained a new prestige—Roger Bacon referred to it as the "flower of the whole of philosophy"—and had drawn the attention of the best minds of the period, including Bacon and Albertus Magnus, who both lectured in Paris in the 1240s.[226] In those years Grosseteste's earlier Neoplatonic views were largely abandoned for an Aristotelian one based upon Averroës' commentary, which had just reached Paris, and upon Alhazen's influential *Book on Optics* (*Optic thesaurus*), which had been accessible in Latin since the early thirteenth century.[227] Albertus's work on the senses and color was well under way in the 1240s and continued into the 1250s, after his move to Cologne, in his *De sensu et sensato*.[228] His remarks on impaired vision were based upon observation, and it is possible that many of his ideas on the psychology of vision were as well.[229] Bacon left for Oxford but returned to Paris in the late 1250s, doing his most important work on optics in the following decade while teaching at the Franciscan *studium* along with John Pecham, another major figure whose works on optics are based largely on Alhazen.[230] Even if Jean de Meun had not read their treatises, optics had become part of the university curriculum through lectures on Aristotle's works, and so it is by no means surprising that the poet would refer to it, especially in relation to the power of mirrors, the knowledge of its constructions, and the truth of its imagery, all ideas thematically central to his text.[231]

While none of these treatises on optics is concerned with painting, they do address the nature and perception of light and color. Alhazen deals with color and light as separate entities, describing how they "radiate" from the surface of an object and pass through a medium into the eye, where the shapes and colors of the object are registered as a whole and transmitted to the optic nerve, to be ordered and understood in the mind. Although he is best known for his mathematical and anatomical work on the shape of the eye and the way light enters it, his comments on color are of great interest.[232] For him, color has prece-

dence; it is the first thing perceived about an object and is identifiable as a property before the object itself is recognized. The perception of color is affected by the intensity of light and by the lighting and coloring of its surroundings; by shadows, reflections, and refractions; by the qualities of surface, including transparency, opacity, and texture; and by such intervening factors as distance and position. All of these can lead to illusions and errors of perception unless the mind makes the correct inferences from the visual sensations it receives. These ideas represent a wholly new direction in relation to earlier thinking, which either had rays of vision emitted from, rather than entering, the eye or had them entering the eye but providing no distinctions within the visual field. Earlier theories had discussed color and light in relation to air, fire, water, and minerals and to a hierarchy of values leading to clarity.[233] The effect of Alhazen's ideas, especially as taken up by Albertus Magnus, was to separate color from all agencies but light, to understand vision as a process of reception, and to focus upon the interplay between physical and environmental factors affecting the information we receive and between psychological and cognitive factors attending its interpretation.[234] Art was not a separate topic of inquiry, but these ideas on perception had far-reaching implications for the visual arts: a painting, like everything else seen, is not just captured by sight and sensibly read; it is discerned, a construct of eye and mind.

Several ideas pertaining to color may bear more directly on painting. In his recent work on color, John Gage has shown how a mid-thirteenth-century commentary attributed to Bacon represents a major synthesis on the matter of color scales.[235] In Aristotle and other early authors, that scale was either linear and took different colors as median or tried to show variation within each hue. The Baconian scale, the most important before the Renaissance, is linear and consists of twenty-one colors extending from white to black and moving, in between, through tones of yellow, red, and then blue. Green is situated beyond purple, so that the two colors most closely related to blue are green and gray, a combination familiar from the last folios of the Psalter cycle. An important alternative to this linear scale is provided by Avicenna, who separated out a black-and-white scale from scales of red and of green/blue. In adding other colors to each of these scales, Albertus made still further distinctions to scales that were already highly refined.[236] The separation

of the black-white scale had the effect of drawing independent attention to changes in the light-dark range, so that Vincent of Beauvais, who based his work on Avicenna's, devotes most of his discussion of the mixing of colors to the scale of values.[237] Vincent describes mixing as dependent upon either of two systems of proportions. The first is predictably arithmetical and addresses the matter of means, but the second, surprisingly, is musical. Although he gives no example of musical proportion in his discussion of mixing, he makes the striking statement in his discussion of color scales that pink mixed from much white and a little red, and a green modified with a little yellow, pleased the eye just as much as a musical fifth or fourth pleased the ear.[238] His choice of pink and green as pleasing colors again recalls the palette of the final Psalter miniatures, and that choice is echoed in a slightly later treatise by Witelo, who cites the beauty of the combination of rose and green in a context having nothing to do with music or proportion.[239] If contemporary color preferences are reflected in the Psalter, it is certainly possible that the relation Vincent saw between them is too. Whether or not the arrangement of colors on folio 77v, for example, can really be understood in terms of musical consonances, the arrangement may well indicate a similar attempt to formulate a harmonic or at least a proportional and pleasing use of color.[240] Vincent's highly original statement also reflects the sensitivity to color of a man who was close to Louis IX and may well have influenced the program, if not the commission, of the Psalter.

The thinning of color in the last miniatures of the cycle deserves special attention. In Chapter 1, I described the exceptional tonal qualities of the Psalter miniatures, how the salmon at the beginning of the prefatory cycle is applied as a wash, and how it seems lit from behind by the whiteness of the vellum.[241] Apart from the way this thinning serves to make forms more luminous, it sometimes in the last folios serves to model the figure. Modeling, as previously discussed, is traditionally done by using darker tones of the general color of the form, the laying-in color, for shadows and using lighter tones of it for highlights, which ambiguously serve as the lighter tones they are and as reflections.[242] The darker tones are created by mixing the laying-in color with something of darker value, a gray or brown, and the lighter tones, usually with white.[243] In several of the final Psalter miniatures, such as folio 74r, this modeling is achieved

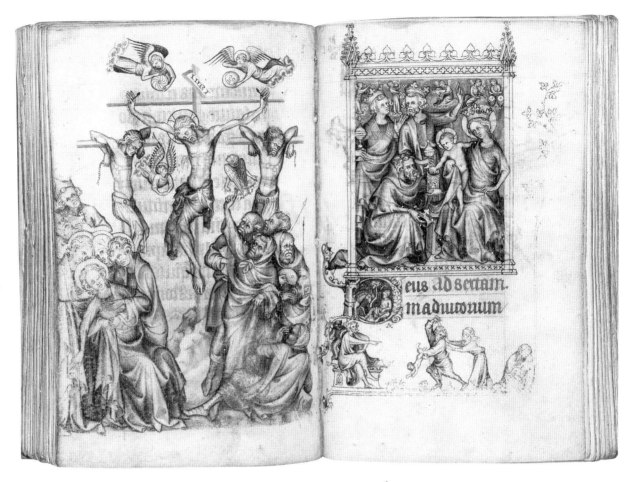

FIG. 59 *New York, Metropolitan Museum of Art, Cloisters Collection, 1954, Hours of Jeanne d'Évreux (54.1.2), fols. 68v and 69r.*

by other means. The blue and the gray colors of Saul's robes are selectively thinned down on the shoulders and upper torso and on ridges of folds that protrude, so that we see the parchment underneath and read it as reflected light. At the same time, the recession in areas of the green robes of the youths results from the addition of a second thin layer of the same color, so that the color becomes more saturated rather than darker. The play between the white parchment and the films of color produces a surface that is more deeply colored and luminous, not more contrasted and reflective.[244]

An important precedent for these practices is found in manuscripts in which figures are drawn in tinted colors and large parts of the figures are left uncolored, so that the bare parchment stands for protruding parts of the body and for the reflections on them.[245] In the

Psalter miniature, however, the entire figure is painted, and modeling is achieved by varying the tones of the laying-in color, an approach normally associated with later painting.[246] The Psalter artist is not concerned with the convexity of surfaces or with the consistent fall of light, so that the viewpoint of the observer and the location of the figure in space are not at issue. But because of the thinness of the laying-in color, something else of interest occurs: the figure, which has been modeled from the whiteness of the parchment, becomes connected with the vellum surface. The implications of these technical approaches are far-reaching and to some extent anticipate the divergent approaches that northern and Italian painting will take to pictorial space. A full tonal modeling of the figure that begins from the white surface of vellum and shades back, developing the figure and the

play of light upon it out of the luminous tones and reflections of the page, is what we find later in grisaille (fig. 59).[247] And the building-up of a form with transparent layers seems to anticipate how oil painting develops in the northern Netherlands.[248] The Psalter betrays only the first hesitant and inconclusive moves in these directions, but it clearly reflects a new breadth of interest in techniques and effects of modeling, luminance, and color, an interest that grows out of contemporary trends in the visual arts and is wholly consistent with contemporary thinking about vision.

. . .

Aspects of the figural style and palette of the Psalter are recognizable in manuscripts of the 1270s and 1280s, especially in the long-lived Aurifaber and Cholet manners of painting. The latter especially continues the preference for small, richly turned foldwork and for a palette with pale pink, green, and gray-blue.[249] Although these later manuscripts are beyond the scope of this study, one of them, a Parisian manuscript of Aristotle's *Metaphysics,* is of interest because the work of one of its three painters is very similar to that of the second artist of psalm initials in the Psalter (cf. fig. 60 and fol. 210r).[250] Not only is the palette a similar deep blue, salmon, orange, and bright green, but the penned vines in the corners consist of the same crosslet motifs that appear in the two royal psalters. In spite of these relations, there is no doubt that the Aristotle miniature is a significantly later work. The modeling is finer, the figures are more solid and bold, and the penned motifs and letter forms are more advanced. These details suggest a date of about 1275/80, which is consistent with the painting by the other artists and with the physical features of the book. Given the difference in date, it is impossible to tell if the Aristotle initial was painted by one of the Psalter artists. However, the Aristotle manuscript shows the longevity of this tradition and helps to clarify what separates such later works from the more tentative and exploratory essays of the final miniatures of the Psalter.

What is the domain being explored? One might suppose that in illuminations in which drawing and dec-

FIG. 60 *Paris, Bibliothèque de l'Arsenal, Bibliothèque nationale de France, MS 702, Aristotle's* Metaphysics: Christ Blessing the Virgin.

oration, figure and setting, are so highly nuanced, only the rhetoric of color remains to be studied. But in the final analysis, the objective of all the changes in palette and technique lies less in the realm of color than in that of luminosity and tone. In the original manuscript, these qualities enrich and unify, the former by creating a setting, the latter by giving distinction and inflection to each narrative voice. They thus serve traditional ends. But a pictorial experience built upon luminosity and tone does so in such a way as to leave no doubt about the ephemeral, illusionistic, subjective nature of the experience. Any pretension to the literal is no longer possible. The king has been given a set of *pictures.* They may instruct him, but they do so by providing a privileged access to the visual. And why not? History and prayer are also places of privileged access.

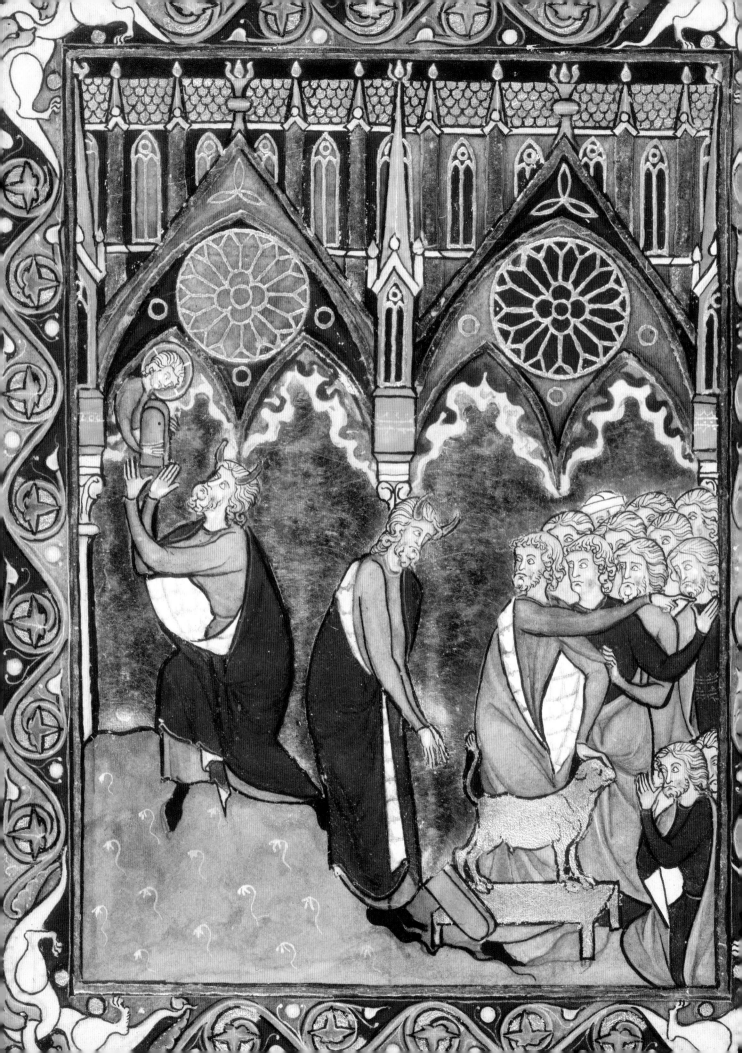

Psalters and the Old Testament

The previous chapters have demonstrated that the seventy-eight full-page miniatures at the beginning of the Saint Louis Psalter constitute a substantial corpus of paintings, one that is entirely Old Testamentary. Although prefatory miniatures are hardly uncommon in thirteenth-century psalters, they are usually fewer in number, invariably center upon the life of Christ, and follow, rather than precede, the liturgical calendar. The arrangement in the Saint Louis Psalter implies that the introductory matter has been reoriented, the emphasis changed, and the visual content given priority. Two distinct practices are involved here, each with a much longer history: first, prefatory psalter illustration and the shaping of its content and structure in relation to the use of the book; second, Old Testament imagery and the modification of its traditional allegorical interpretation in thirteenth-century France. This chapter argues that both practices underwent distinct changes during the reign of Louis IX that especially affected works associated with royal patronage. Because both subjects deserve independent studies, here I give only an overview before turning to the program of the Psalter in the next chapter.

Prefatory Illustration in Psalters

Books with a series of independent pictures, or books in which content is primarily pictorial, are as old as manuscript illumination, and psalters, like other manuscripts, developed their own traditions of illustration.[1] Of these, Latin psalters with prefatory miniatures fall into a special category and in

Detail of folio 35v, Psalter of Saint Louis

many ways should be considered a subgenre of their own, for they formulate structures of meaning that affect the entire book and shape the reading of it. Although the literature on psalter illustration is considerable and there have been significant studies of specific works, no historical study addresses the broad phenomenon. The early history of that phenomenon is Anglo-Saxon, and the royal psalters discussed in this study develop out of them but represent an important period of renewed innovation. In order to understand the larger phenomenon and to see the French works in perspective, the sketch that follows begins with the insular sources.

Recent research has traced the origins of prefatory cycles in Anglo-Saxon psalters to earlier Irish works.[2] Tenth- and eleventh-century Irish manuscripts, like their Continental counterparts, have single full-page miniatures that are placed within the psalter text so as to mark the three major divisions of the psalms. But rather than illustrate the psalms they accompany, the Irish illuminations focus on events from the life of David—his enthronement or his struggle with the lion or with Goliath—that stress his pastoral and royal roles and his victory over evil. Contemporary texts, often found in the manuscripts, interpret these Davidic roles as anticipating those of Christ, a relationship that is usually made explicit by the use of a Crucifixion miniature within the series.[3] In the Anglo-Saxon Tiberius Psalter, additional episodes from the lives of both David and Christ and from the Old Testament are gathered together near the beginning of the book, so that the pictures tend to form an independent visual unit preceding the psalms. Although the symbolic and typological system of the Irish psalters is extended and put into a narrative context, it remains essentially intact: the manuscript includes Old Testament subjects that refer typologically to Christ and anticipate his advent, New Testament episodes that promise triumph over evil and victory over death, and, now, an overarching temporal construct that, in recapitulating biblical history and the plan of salvation, serves to focus on the text at hand as a means of redemption.

These same constituents and functions inform later English psalters and those early French ones that, as previously noted, are likely to have been influenced by them. The two earliest and most extensive prefatory cycles—those of the Tiberius Psalter and Saint Albans Psalter—are also significant because, rather than present a straightforwardly linear series of pictures, they each

develop an internally coherent and complex program shaped for a patron.[4] Later psalters, including French ones, use similar strategies for similar purposes. Indeed, the two early manuscripts show the potential of the form and the characteristics that define it as a distinct subgenre within the larger category of picture cycles.[5] Since each of these books has been the subject of a substantial monograph, the practices they employ will only be summarized here.[6]

There are more than fifteen full-page drawings in the Tiberius Psalter, an Anglo-Saxon manuscript probably created for an unknown prelate at Winchester in the mid–eleventh century, and over forty full-page miniatures in the Saint Albans Psalter, a manuscript painted at the monastery of Saint Albans in 1120–30 for Christina, an anchoress and the first prioress of Markyate. Both manuscripts significantly enlarge the historical range of the cycle, the Tiberius series pushing its beginnings all the way back to Creation, and the Saint Albans Psalter, to the Fall of Adam and Eve. They thus set out a larger temporal framework—creation, the divine plan, the introduction of sin—from which the rest of the cycle develops.[7] The emphasis of the remaining Old Testament subjects also changes. The Tiberius manuscript has the same range of David scenes as the earlier Irish psalters, but David drops from sight at the beginning of the Saint Albans manuscript, appearing only in the initials as an author and spiritual guide, not the protagonist in events that are typologically related to those in the life of Christ.[8] At the same time, the New Testament subjects are greatly expanded. In the Tiberius Psalter they are selective—only the Temptation precedes a long series devoted to the Passion, which ends with the Pentecost and Saint Michael, whereas in the Saint Albans Psalter, with its many infancy scenes, the whole life of Christ becomes the core of the prefatory cycle, which closes with Saint Martin and with the Ascension and Pentecost.

In both manuscripts the full-page illustrations are allocated to discrete sections: the main body of Old and New Testament scenes and those which precede and follow. In the Tiberius Psalter the units concern time (computistical aids and diagrams), biblical history (Old and New Testament scenes), and liturgical performance (musical instruments). In the Saint Albans Psalter a liturgical calendar precedes the Old and New Testament illuminations, which are in turn followed by a section recounting

the story of Saint Alexis and the pilgrims at Emmaus. Both manuscripts attend to the distinctions and interrelations between these sections by creating markers, such as repeated images of David enthroned, by reiterated or obviously contrasting motifs and compositions, and even by change in technique.[9] Also, in both manuscripts the relation of one section to another is temporally and thematically progressive. In the Tiberius Psalter the links between Time and Creation, David and Christ, music and psalms, suggest a development from the historical and authorial to the liturgical and performative. In the Saint Albans Psalter the connections are between the Fall and its reversal in the life of Christ, between the model of Christ and that of Alexis and the Emmaus pilgrims, so the movement is from the historical to the moral, the latter continuing in the powerfully didactic psalm initials.[10] If the former gradually focuses the process of redemption within the prayers and ritual, the latter does so in an *imitatio Christi,* one that comes to center on the monastic profession.[11] These differences in the two cycles are consistent with what we know of the manuscript's owners, for the Tiberius Psalter was made for an unidentified but apparently active priest who seems often to have given confession, and Christina was an anchorite prioress whose personal circumstances closely paralleled those of Alexis.[12]

Another aspect of these cycles is the tendency to subdivide singular narratives into subunits that refer to each other. In the Saint Albans Psalter, for example, the Magi Guided by a Star begins a series of four miniatures, or two consecutive double-page openings, that clearly form a unit, the first and last miniatures, with the Magi on horseback, being entirely analogous but reversed in direction. The next unit is also a four-miniature series, but the interrelations differ, for here the reference is not only between the second and fourth miniatures—the Holy Family's flight and then their return—but between the first and third, the safe deliverance of the Christ child in the Presentation contrasted with the slaying of the innocent children. All of these connections depend on recalling earlier double-page openings, associating what is on the left or right of one double-page opening with what is on another, and making connections that are thematic as well as compositional.

One of the most subtle devices in these manuscripts is the use of purely pictorial means to give thematic coherence or to allude to dramatic reversals in fate. For

example, Kathleen Openshaw has shown that the Tiberius Psalter drawing of David reaching down into the mouth of the lion to save the lamb anticipates a later miniature's representation of Christ freeing the faithful from the mouth of hell (figs. 61, 62); each drawing stresses victory over death, and together they underscore the relation between David and Christ and the fulfillment of Old Testament events in the era under grace.[13] It is also noteworthy that the pinwheel rotation of David's body and the lion's corresponds to the round form of the cosmos on the facing page of the Creation (fig. 63). A connection between these two drawings is also suggested in the similar ways the dove of the Holy Spirit rises from waters and the lamb emerges from the lion's mouth. The round forms of the cosmos are in turn based upon the arcs of the horologium on the other side of the same page (fig. 64). The correspondence is not only physical but thematic, for the horologium is an instrument symbolic of the world as well as a device for calculating the length of a day.[14] This linkage between miniatures of such different subjects naturally affects our interpretation of them: the cosmic aspects of the first two drawings help explain the unprecedented importance of the David scene and connect the Creation with the Resurrection. It thus appears as not only a triumph over death but a new beginning.

A different kind of ingenuity is seen in the Saint Albans Psalter miniature of the Agony in the Garden (fig. 65). This miniature continues the sequence of four-part units discussed above and is the fourth in the series. It shows Christ kneeling near the top of the Mount of Olives, before a large chalice and an angel who bends down to comfort him. He gestures with one hand to the angel and points with the other to the large chalice. Pächt has shown that this literal representation of the Gospel's metaphor for Christ's earthly burden is apparently an invention of the artist, one that changes the content of the miniature from the arrival of the comforting angel to Christ's plea for relief, his prayer that one "remove this cup from me."[15] Oddly, this painting does not find its counterpart in this group of four miniatures but in the fourth miniature of the previous quatrain, which represents the Third Temptation of Christ (fig. 66). The mountainscapes and backgrounds in both miniatures are similar, and such elements as the trees and chalices are entirely analogous.[16] The effect is naturally to call atten-

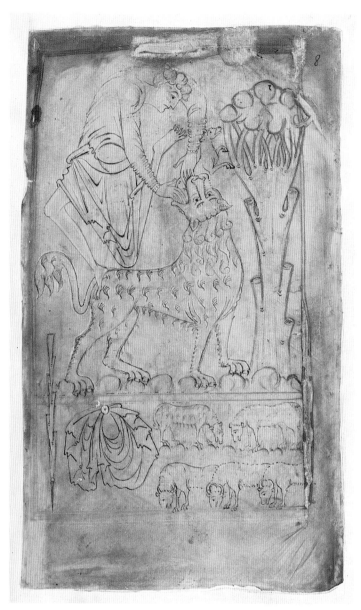

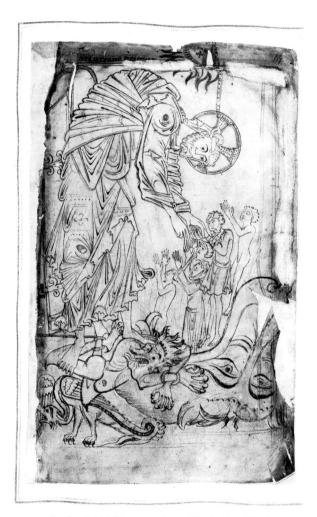

FIG. 61 *London, British Library, MS Cotton Tiberius C.VI, Tiberius Psalter, fol. 6r: David Saving the Lamb from the Lion. Reproduced by permission of the British Library.*

FIG. 62 *London, British Library, MS Cotton Tiberius C.VI, Tiberius Psalter, fol. 14r: Christ Leading Souls from Hell. Reproduced by permission of the British Library.*

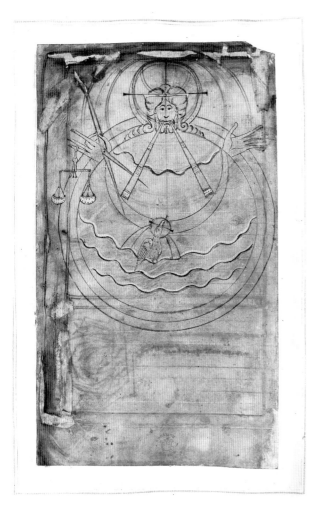

FIG. 63 *London, British Library,* MS *Cotton Tiberius C.VI, Tiberius Psalter, fol. 7r: Creation. Reproduced by permission of the British Library.*

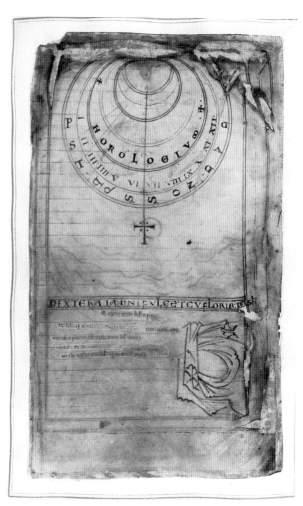

FIG. 64 *London, British Library,* MS *Cotton Tiberius C.VI, Tiberius Psalter, fol. 7v: Horologium and Dextera Dei. Reproduced by permission of the British Library.*

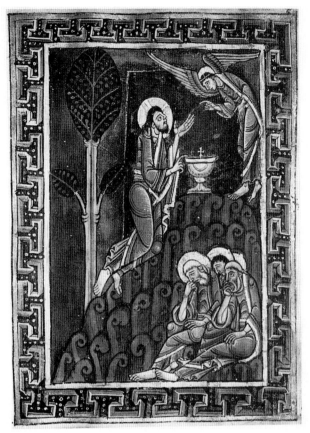

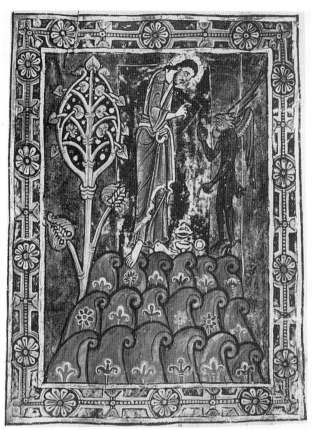

FIG. 65 *Hildesheim, St. Godehard's, Saint Albans Psalter, p. 39: Agony in the Garden.*

FIG. 66 *Hildesheim, St. Godehard's, Saint Albans Psalter, p. 35: Third Temptation of Christ.*

tion to Christ's changed status, how he stood commandingly but now kneels, how he reproved the devil but now beseeches the angel, how he refused one cup, which stood for the "kingdoms of the world," but now gives up another, that of the burdens of this world. Indeed, the Passion is already suggested in the cross above the chalice and in the flat, unarticulated, and lifeless foliage of the tree behind him.[17] Given the statement that the same artist made explaining every detail of another miniature in this manuscript, there can be little doubt that these kinds of details and structures are deliberate.[18]

These cycles of miniatures thus establish authority, a context for attentive devotion, and an eschatological framework for each book as a whole. By carefully distinguishing and orchestrating its parts and by creating more varied and nuanced forms of narrative allusion, one is able to sharpen the drama, to deepen the experi-

ence of it, and to clarify the relation to the overarching themes of salvation and personal redemption through prayer. These paintings absorb the reader in a distinctive construction of reference and meaning and serve as a vivid stimulus to thought and devotion and, ultimately, a preparation for prayer.

Not all later psalters have such depth and coherence or are personalized so conspicuously. In England the model of the Saint Albans Psalter is often repeated but without the Alexis and Emmaus sections and thus without the element that situates the experience of the owner of the book between the pictures and the psalms.[19] One finds new ideas, such as the use of the Tree of Jesse as a bridge between the Old and New Testaments, and many paintings of singular invention, but by the late twelfth century there was a tendency for the miniatures depicting the life of Christ to take on a serial regularity, to con-

sist of paintings relatively uninflected in viewpoint and cycles that are linear and progressive but without internal shape.[20] The manuscripts become luxury picture books.[21] This is likely to have been the case for the psalters that were English precedents for the Ingeborg Psalter and Psalter of Blanche of Castile (Chantilly, Musée Condé, MS 1695, and Paris, Bibl. de l'Arsenal, MS 1186).[22] The latter have two of the earliest French cycles of prefatory psalter illustration, and they are also the two cycles most likely to have been known to Louis IX and to his artists. In many ways, these two manuscripts have a quality of coherence, personalization, and content more like that of the Tiberius and Saint Albans cycles than their immediate precedents. In France in the early thirteenth century, a fresh look seems to have been given to the possibilities inherent in the genre.

· · ·

The prefatory cycle of the Ingeborg Psalter begins with Old Testament subjects, but the choice and function of these subjects are distinctive. They illustrate events only from the lives of Abraham and Moses and are organized "biographically," the events related to each life filling a single opening of two double-register pages (figs. 67, 68). The four Abraham scenes begin with the Angels Appearing to him at Mamre and continue with his Hospitality, the Ascent to Mount Moriah, and the Sacrifice of Isaac; the Moses episodes begin with the Burning Bush and continue with Moses Receiving the Law. A miraculous appearance—the Angels at Mamre and the Lord in the Burning Bush—initiates each series, so that each begins with one of the two principal events in the Old Testament in which God's will is revealed to man.[23] And each series ends with a subject that anticipates and characterizes the era of Christ, the Sacrifice of Isaac foreshadowing the sacrifice of Christ, and the Hebrews who failed to follow the Old Law anticipating those of true faith who followed the New.[24] Thus rather than the Creation or Fall, the cycle takes as its subjects the lives of a patriarch and prophet, and although the miniatures provide a temporal and Christological frame of reference for the rest of the cycle, events are set in motion by God's promise rather than man's sin.

The double-page units are arranged to allow for and encourage multiple readings, not only chronologically from upper to lower register but thematically from left to right. Thus, reading along the top registers, as the angels come to Abraham on the left page, he leads Isaac to the sacrifice on the right; similarly, as Moses looks up to God in the burning bush, the Israelites look up to the golden calf on a pedestal. A horizontal reading of the lower registers is again telling: as one angel gestures to Abraham to approach a table set with bread and wine, another stops him as he is about to sacrifice Isaac on the altar; and as Moses receives the tablets before a crowd of Israelites, he breaks the tablets before an analogous but reversed group on the opposite page. There can be no doubt that these readings are intentional: the angel seated at the far right at Abraham's table points outside the miniature to the right, directing Abraham and the viewer from one page to another and from ritual offering to ritual sacrifice. Like the "quatrains" of miniatures in the Saint Albans Psalter, the two sets of four scenes are meaningfully juxtaposed, for Abraham's true faith is juxtaposed with the Israelites' subsequent idolatry in the desert; by showing what was lost during the period of the Old Testament, these miniatures introduce the subjects of the New Testament.

The Mamre scene also sets up a motif that continues to play out in the manuscript. Florens Deuchler has shown how the most forward angel approaching Abraham at Mamre is based compositionally on the figure of Gabriel in the Annunciation to Mary (fig. 69).[25] However, the same type of annunciate angel also occurs in the upper part of the Beatus initial, in the scene with the angel instructing Samuel to anoint David, a subject apparently fabricated for this miniature (fig. 70).[26] These "annunciations" mark the beginnings of the Old Testament, New Testament, and psalm sections of the book and suggest linkages between them: that God's promise to Abraham is fulfilled in the Annunciation to Mary, that the king and author of the Psalms is divinely chosen and guided, and that a singular process of redemption operates in history and in the very text the reader has in hand. These points, differently made, are familiar to us from the earlier insular psalter cycles.

Deuchler has pointed out five instances of royal imagery in the Ingeborg Psalter. The clearest is the descent of the dove with an ampoule of holy oil in the miniature of the Baptism of Christ, a reference to the legend in which a dove brought oil to Saint Rémi at the baptism of Clovis, the traditional source for the chrism used in the coronation of French kings.[27] But the paint-

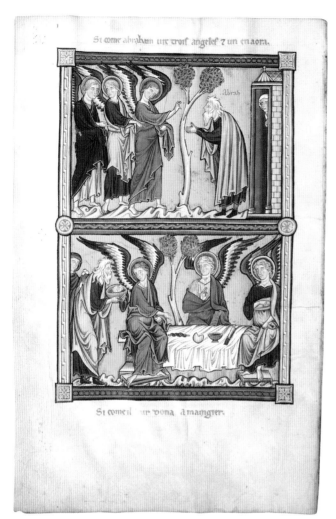

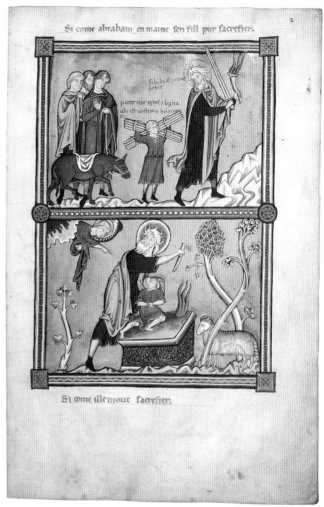

Si come il ur vona a mangter.

Si come ille uiour sacrefier.

FIG. 67 *Chantilly, Musée Condé, MS 1695, Ingeborg Psalter, fols. 10v–11r: history of Abraham.*

ing with the most far-reaching implications for a royal patron may well be the initial to Psalm 109 (fig. 71). Psalm 109 begins, "The Lord says to my lord, 'Sit at my right hand,'" and is usually illustrated by the Trinity or Christ Enthroned.[28] Here, however, the subject is based upon 2 Sam. 1:10 and represents the Amalekite messenger kneeling before the enthroned David to report Saul's death and to show him the deceased king's crown.[29] In Bibles this passage is usually illustrated by David's response in verse 15, his ordering the messenger to be slain.[30] In this miniature, however, the crown is the focus and David responds to its sight with obvious emo-

tion.[31] There is much to indicate that he is not merely reacting to the news of Saul's death. This initial is the last of a series of ten that mark the major divisions of the Psalms and that together constitute a brief narrative cycle devoted to the life of David. It begins with the angel's appearance to Samuel and David's anointment in the Beatus initial and continues with episodes centering upon David's fight with Goliath, his difficulties with Saul, the Amalekite's assistance in Saul's suicide, and finally his reporting it to David in the Psalm 109 initial.[32] In the historical series, the initial is the first time David is shown as a king enthroned and crowned. That is

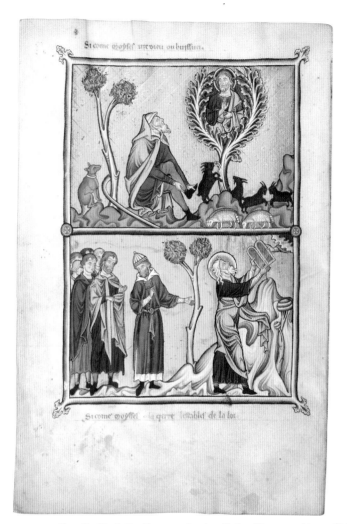
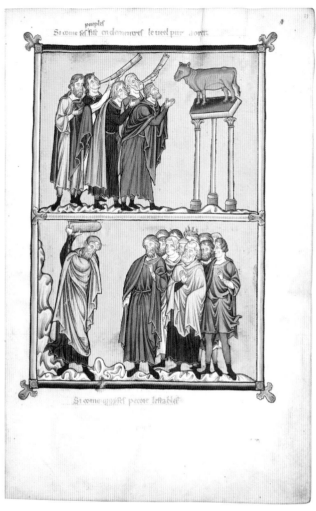

FIG. 68 *Chantilly, Musée Condé, MS 1695, Ingeborg Psalter, fols. 12v–13r: history of Moses.*

appropriate, for Psalm 109 is a royal psalm in which the Lord not only promises victory to the king but his accession to power. The subject in the Ingeborg Psalter better corresponds to verses 2–3: "The Lord sends forth from Zion your mighty scepter. Rule in the midst of your foes!" Or verse 5: "The Lord is at your right hand; he will shatter kings on the day of his wrath."[33] Thus David's first real appearance as a king is not within a traditional coronation miniature or a straightforward one of authority but in one in which he almost seems to be contemplating a crown and in which his attitude is not altogether regal but troubled. One naturally cannot say

if he is confronted either by the memory of his disgraced predecessor or by the realization that failed kings can be removed from office. A similar ambiguity surrounds the image of Saul, David's predecessor, in the final miniature of the narrative cycle in the Psalter of Saint Louis, a subject discussed below.

Two additional initials are smaller than the others and illustrate Psalm 114 and a canticle *Confitebator tibi* (Isaiah 12), not the traditional divisions of the psalter. In both, David, still crowned, prays to the Lord, whose head appears above and who gestures to him (fig. 72). These miniatures break off the biblical narrative of the

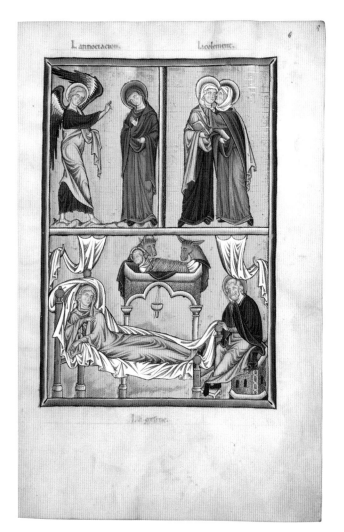

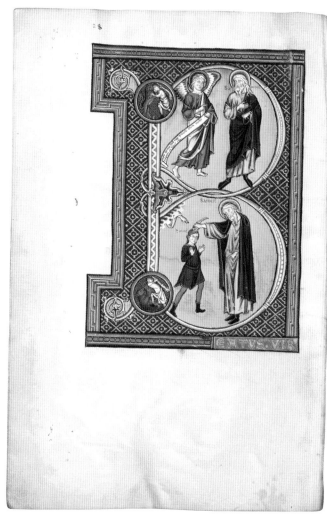

FIG. 69 *Chantilly, Musée Condé,* MS *1695, Ingeborg Psalter, fol. 15r. Upper left: Annunciation.*

FIG. 70 *Chantilly, Musée Condé,* MS *1695, Ingeborg Psalter, fol. 37v, Beatus initial.*

FIG. 71 (left) *Chantilly, Musée Condé,* MS *1695, Ingeborg Psalter, fol. 142v, initial to Psalm 109: Messenger Brings to David News of Saul's Death.*

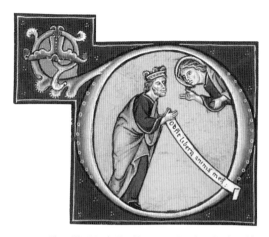

previous initials and present a different kind of subject, that of the king, still crowned, addressing the Lord in prayers of praise and supplication. They are small in scale and hardly as impressive as the other miniatures, but they are the first miniatures that one might call devotional in content, and they complete the program of illustration. In the Psalter of Saint Louis, devotional images such as these form part of each psalm initial.

This attention to royal imagery and concern with featuring a king would not have been a consideration for Ingeborg any more than the male pilgrims at Emmaus would have been an issue for Christina of Markyate; after all, the figure of David was synonymous with Christian royalty and Christian prayer. But are there also miniatures specific to the queen? Ingeborg's life in France, it will be recalled, was particularly ill-fated, for she was rejected by Philip Augustus almost immediately after their wedding, sequestered for seven years, during which she went from cloister to cloister, and unfairly accused of being related by blood to the king's first wife so that the marriage to Ingeborg could be annulled.[34] It is during these difficult years that this manuscript is likely to have been painted.[35] Florens Deuchler, Allison Merrill, and others have pointed out that imagery centering on scenes of anointing and on Mary's exceptional crown in the Pentecost would make the manuscript appropriate either as a wedding gift from the king or as

a token of the legitimacy of her coronation if the manuscript were subsequently made for her.[36] To their observations may be added several others that support the latter view. After the Last Judgment is a sort of historical epilogue: a two-page opening showing her Death and Coronation, and then another two-page opening, historically discontinuous with the earlier miniatures, that illustrates the Theophilus legend, a story less about Theophilus's fate than the Virgin's decisive role in his salvation. Like the Emmaus miniatures in the Saint Albans Psalter, the Theophilus story has a certain relevance to recent events, for it tells how a virtuous person erred in getting worldly power and wealth through a pact with the devil and how the Virgin intervened to break the pact and reestablish the individual.[37] However, Mary is not the only female figure who is specially treated in the manuscript. The Magdalene figures importantly, and female saints are a major emphasis of the calendar.[38] Also surprising is the inclusion of the story of the Woman Taken in Adultery or such details as the weeping daughters of Jerusalem who follow Christ as he bears the Cross.[39] It is quite possible that the prayer to the Virgin, who extricated Theophilus from his legal difficulties, or the model of these women, who proclaim their innocence or stand together in their devotion to Christ, had a special meaning for the mistreated queen who so actively protested the trumped-up charges against her. In these terms, the worldly crown that David looks at in Psalm 109 may have provided an interesting counterpoint to ones that Mary exceptionally wears in some of the prefatory miniatures.

. . .

The Psalter of Blanche of Castile has no explicitly royal imagery, and the woman who kneels in prayer in the initial to Psalm 101, though presumably the patron, is uncrowned.[40] While the content of the manuscript cannot be directly connected with Blanche or with royal patronage, this psalter is certainly Parisian and, in the present context, is especially noteworthy for the distinctive structure of its pictorial program.[41] The Fall of the Rebel Angels (fig. 73), the first miniature of the prefatory series, is unusual in psalter illustration.[42] The miniature shows angels transmogrified into devils as they fall from the heavenly realm above, where the Lord is adored by the good angels, to a vast hell mouth below. The remaining Old Testament miniatures concern the Creation of Eve,

FIG. 73 *Paris, Bibliothèque de l'Arsenal, Bibliothèque nationale de France, MS 1186, Psalter of Blanche of Castille, fol. 9v: Fall of the Rebel Angels (first miniature in the prefatory cycle).*

FIG. 74 *Paris, Bibliothèque de l'Arsenal, Bibliothèque nationale de France, MS 1186, Psalter of Blanche of Castille, fol. 169v: Resurrection (final miniature).*

the Fall, Abraham, and Moses, the latter being a condensed version of the same kind of series as in the Ingeborg Psalter. After a Tree of Jesse, the New Testament miniatures follow a predictable pattern to a final miniature of Christ in Majesty. But this manuscript also has a second cycle, four miniatures of the Last Judgment, which are exceptionally detached from the main series of miniatures, where they occur in other psalters, and inserted after the Psalms and before the canticles.[43] In the final miniature of the manuscript the resurrected, divided into the saved and the condemned, are naturally distributed between heaven and hell, which are described with

clear reference to the first miniature of the Fall of the Rebel Angels: Abraham is enthroned with angels, just as Christ is in the miniature of the Fall, and the condemned suffer at the hands of the devils, like those who fall into the inverted hell mouth (figs. 73, 74).[44]

While the content of this psalter cannot be directly connected to Blanche, it has a distinctive character that is consistent with what is known of her. Most telling are the psalm initials, which are a particularly powerful preparation for the Judgment miniatures that follow them. The Beatus initial shows David sitting and dictating the psalms; below, he stands to one side of a chair

FIG. 75 *Paris, Bibliothèque de l'Arsenal, Bibliothèque nationale de France,* MS 1186, *Psalter of Blanche of Castille, fol. 30v, Beatus initial.*

and keeps at arm's length the group of men on the other side (fig. 75). This unusual and vividly exclusionary scene literally depicts the first verses of the psalm, for David is not walking with the sinners, and he is not seated in the chair of the scornful. Similarly, David holds his tongue before the tempting devil in the initial to Psalm 38, in contrast to the fool of Psalm 52 (fig. 76), who listens to devils both before and behind him.[45] It is noteworthy that the fool and the people David holds back are not acting foolishly or doing evil but only wearing the pointed Jew's hats, an identification made explicit in the argument to Psalm 52, which begins, "De malis et de

adventu judicii . . ."[46] The other initials are traditional, but the anti-Jewish sentiment is no aberration. It reappears in the Last Judgment cycle, in a preliminary miniature concerned with the description and destruction of evil (fig. 77). There Jews in pointed hats lead a well-dressed woman away from an impressive city.[47] Although the manuscript's date precedes Blanche's documented involvement with the persecution of French Jews, the clearly anti-Semitic viewpoint in the psalter is consistent with her actions.

Seen in relation to the initials and to the Fall of the Rebel Angels, these final miniatures suggest a powerful

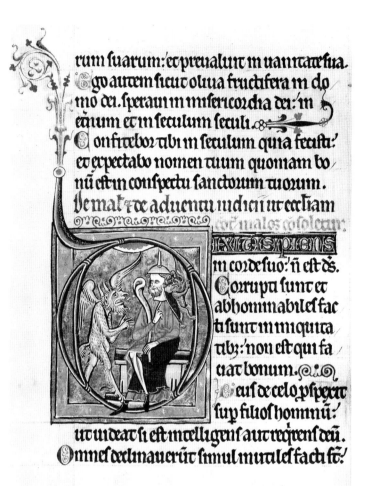

FIG. 76 *Paris, Bibliothèque de l'Arsenal, Bibliothèque nationale de France, MS 1186, Psalter of Blanche of Castille, fol. 77v. Initial to Psalm 52: Fool Listening to Devils.*

concern with tracing the continuity of evil in the world, which is identified with Jews and depicted in clearly judgmental terms.[48] Battling evil was also a major theme in earlier psalter illustration, but in the Blanche Psalter the final triumph of the Church and of the blessed in the Last Judgment occurs neither in the prefatory cycle nor in the miniatures of the Psalms but is postponed until after the last psalm is read, making clear that it is the future event anticipated in these prayers. The whole history of salvation is thus presented within the limits of the book. In the movement from the prefatory to the concluding cycle of illuminations, the reader naturally finds her own image in the psalms, her instrument of salvation and her place within the scheme of redemption.

The Blanche Psalter also has a frontispiece, which precedes the Creation miniatures (fig. 78).[49] The well-known miniature of the astronomers begins the book, just as the Fall of the Rebel Angels begins the Old and New Testament cycles. In the miniature one astronomer holds up an astrolabe to study the stars in the heavens above; although the instrument has no brass plates for calculation, the astronomer apparently holds the alidade, or siting rule, as the cleric before him raises up a book or tablet, presumably with tables for calculations, while the man at the left writes down the results. At this time such calculations essentially depended on Ptolemy's *Almagest* as refined by Alhazen's *Optics,* both of which were no doubt available at this time in Paris.[50] Apart from its scientific functions, the astrolabe was a means of gaining knowledge about the heavens and was therefore a means of communicating with the deity and learning about the future.[51] It embraces all three functions here. Its astronomical function is clear from its setting in the manuscript, for it is painted on a bifolium that has on its other half the table for calculating the date of Easter; between the two comes the entire calendar of saints.[52] However, the astronomer looks up to an arc of clouds, the meaning of which cannot be entirely phenomenal, for it is the approximate place where heaven and Christ appear in the Fall of the Rebel Angels (fig. 73). The arrangement has an interesting parallel in the Tiberius Psalter, which, it will be recalled, also begins with a section on computation and also creates a pictorial and thematic link between its "scientific" miniature of the horologium and its first narrative miniature of the Creation. The layout of the various sections of the Blanche Psalter is thus strikingly logical and coherent: a section about time is followed by one about sacred history. Then come the Psalms and finally a vision of the future, the Last Judgment cycle, followed by songs of thanksgiving.

· · ·

The Blanche Psalter might well have been consulted during the planning of many of the scenes in the psalter made for use at the royal chapel of Saint-Germain-en-Laye (Paris, Bibl. Nat., MS lat. 10434).[53] The shape of its prefatory cycle of illuminations is quite different, however. There are eight miniatures, divided into two groups of four, the first group illustrating history before the advent of Christ, that is, from the Fall of the Rebel Angels and Creation through the life of John the Baptist, and the second group the life of Christ, from the

FIG. 77 *Paris, Bibliothèque de l'Arsenal, Bibliothèque nationale de France*, MS 1186, *Psalter of Blanche of Castille, fol. 168r: Destruction of Evil (Jews) (preliminary miniature in the Last Judgment cycle).*

FIG. 78 *Paris, Bibliothèque de l'Arsenal, Bibliothèque nationale de France*, MS 1186, *Psalter of Blanche of Castille, fol. 1v, frontispiece: astronomers.*

Annunciation to the Crucifixion and Descent into Limbo. The symmetry of this arrangement is not accidental, for a series of parallels are created between analogously placed miniatures within the two series, much as they are between some of the miniatures in the Saint Albans Psalter. In fact, several compositional changes in the schemes used in the Blanche Psalter probably result from a desire to create connections between the two series of miniatures.

For example, the first miniature in the Saint-Germain-en-Laye psalter represents the Fall of the Rebel Angels in the upper register (and in the lower margin) but the Sixth Day of Creation, with the Lord instructing Adam and Eve to name the animals, in the lower register (fig. 79). The latter scene, which is highly unusual at this time, is probably a variation of the scene in the Blanche Psalter showing God instructing Adam and Eve not to eat the fruit of the tree.[54] Here, however, the page clearly parallels the Annunciation and Nativity miniatures that inaugurate the second series: the good angels at the left gesture toward the Creator as Gabriel does toward Mary, and, below, Adam and the Creator exchange the same gestures that Mary and Joseph do, the former referring to the animals at the right, the latter referring to the Christ Child and the ox and ass in the center. The parallels in the upper registers of the next pair are also striking: instead of the standard composition of the Fall, with Adam and Eve on either side of the tree, the two parents are placed on one side of the tree so as to make room for Adam and Eve covering themselves at the far right. The odd depiction of Adam seeming to sit on Eve's lap is not the result of artistic incompetence; rather, the artist has purposefully created a parallel to the analogous New Testament scene where, at the right side of the miniature, Christ sits on the lap of Mary. Similarly, in the lower register, Michael holds a sword and expels Adam and Eve from paradise by oddly taking hold of Adam's shoulder. This is clearly the counterpart to the Massacre of the Innocents, where a soldier with a sword similarly grasps the child he is about to slay. That the Expulsion is also a death is made clear by the difference between the trees in this scene, which are fully painted at the left but barely sketched on the gold leaf at the right, the area to which Adam and Eve are expelled.

There are other analogies among the remaining miniatures, but they tend to be standard typologies.

Some elements may be compositionally or thematically similar, but the effect is to present or confirm an idea rather than to use a juxtaposition to enrich the implications of described behavior, as in the Agony in the Garden miniature in the Saint Albans Psalter. But that enrichment is precisely where these juxtapositions are headed, as seen in the next decade or so in narratives of the life of Christ in choir screens, ivories, and other works. In this psalter, however, the juxtapositions of Old and New Testament still follow the older *Bible moralisée* paradigm, with neither the personal bias nor the eschatological sweep of the two other psalters. On the other hand, this psalter does reveal a comparable freedom in organizing its series of miniatures and in giving them meaning, and a common presumption that the owner could follow the visual cues and make the necessary associations between miniatures.

As in the earlier Tiberius and Saint Albans psalters, the experimentation and innovation of the period could affect any part of the book, even the calendar, the last of the essential sections of the psalter to be drawn into the planners' totalizing concept. Its placement in the program of the Blanche Psalter is anachronistic, for the historical structure of the program suggests that the saints should follow, rather than precede, the "biblical time" of the prefatory cycle. This oddity apparently caught the attention of other psalter planners, for just these elements—the calendar and prefatory cycle—are switched in a contemporary Parisian psalter.[55] The same rearrangement occurs in the Psalter of Saint Louis: it opens with the biblical cycle and continues with the calendar of saints' feasts and liturgical commemorations, which lead directly to the Psalms. One thus moves from what might be called the time of Old Testament history to that of the Church and then to the Psalms, the contemporary instrument of redemption for the actual reader. Thus all the components of the historical cycle are represented, and with the architectural structure in the miniatures interpreted as the Church, miniatures of the life of Christ would seem unnecessary, if not redundant.

· · ·

The model of psalter illustration discussed above has relatively few Old Testament miniatures, usually no more than six or seven, and although each cycle begins with Genesis, the choice of the first subject varies. Around 1150 a somewhat different practice appears, in which Old

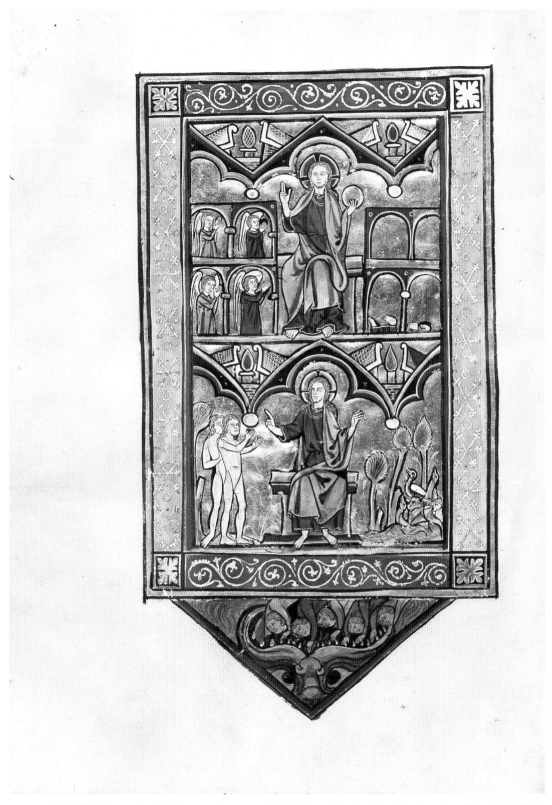

FIG. 79 *Paris, Bibliothèque nationale de France,* MS lat. *10434, psalter for the royal chapel at Saint-Germain-en-Laye, fol. 9v: Fall of Rebel Angels; Sixth Day of Creation (Naming Animals).*

Testament subjects become more numerous, almost always beginning with Creation and then taking on the character of a continuous narrative history, much like the life of Christ and almost equal to it in length. One of the earliest of these expanded cycles is a group of four large illuminated leaves produced in Canterbury and probably detached from the Eadwine Psalter; another is the Winchester Psalter.[56] The Eadwine leaves may originally have had forty to fifty Old Testament scenes; the Winchester Psalter has about half that number.[57] It is believed that these manuscripts draw in part on a rich tradition of Anglo-Saxon biblical illustration, a tradition that resurfaces in the early thirteenth century, when these Old Testament cycles sometimes doubled or trebled in length.[58] The patronage of these manuscripts and the reasons for this interest in Old Testament illustration in England at this time remain unclear.[59] But the critical works—the Great Canterbury Psalter, the Munich Psalter, the Huntingfield Psalter, a psalter in Trinity College, and the Baltimore Old Testament Pictures—richly attest to the breadth of this tradition and the sophistication of its narrative practice.[60] Works of this kind were also influential in northern France. They provide a second model of psalter illustration, one that accounts for certain features of the Saint Louis Psalter cycle.

The miniatures in this group of early-thirteenth-century English psalters are not what a reading of the first ten books of the Old Testament would suggest. They offer no extensive illustrations of the genealogies, the tabernacle and its contents, the rituals, the division of the tribes, or the laws or speeches of Moses. The secondary narratives, such as the stories of Hagar, Laban, Abimelech, Leah, Dinah, or Tamar, are not present. Although the Munich Psalter and Baltimore Old Testament Pictures have extensive and sometimes rare subjects not found in the other manuscripts, a kind of core cycle can be seen in the group as a whole.[61] It begins with stories of Creation and of Adam and Eve and then centers on the lives of the principal figures of Genesis— Cain and Abel, Noah, Abraham, Lot, Isaac, Jacob, and Joseph—each of whom receives only a few scenes. In a few cases the story of Joseph is illustrated in great detail and is as extensive as the rest of Genesis. The history of Moses and the Israelites in the desert is also recounted in a substantial number of scenes, including scenes from Numbers, such as the story of Balaam, through Joshua

and the Conquest of Jericho. Stories from Judges, most notably Gideon and Samson, are frequently omitted, as are those from Leviticus and Deuteronomy. Samuel, Saul, and David normally receive just a few scenes, the last in the Old Testament portion of the cycle.

The Old Testament scenes in the Eadwine leaves and Great Canterbury Psalter are arranged in a grid of twelve scenes per page, arranged in four rows, each subject read independently. The Trinity College leaves have a less dense grid—two scenes in each of three registers— and the subjects are frequently arranged so as to take account of formal and thematic similarities.[62] That trend is also found in the other psalters cited above, which have double-page openings of full-page miniatures, sometimes in two registers, so that the allocation of these more numerous Old Testament subjects between facing pages is no different from that in the earlier psalter cycles. As before, physical relations form the basis for structuring and exploring narrative and thematic relations.[63] Another development, one specific to these longer Old Testament cycles, is the tendency to organize biblical events in small and fairly regular units devoted to the story of a single Old Testament figure. In the Munich Psalter the stories of Creation and of Adam and Eve are each recounted in six medallions on one folio, and there are two folios each for the stories of Cain and Abel, the Tower of Babel, and Noah, Abraham, and Jacob. Isaac receives only one, but Joseph eight, almost as many as all the rest of Genesis, and the story of Moses and the Israelites in the desert, exactly eight again.[64] The cycle in the Huntingfield Psalter has fewer subjects but extends to 2 Samuel; however, the distribution of story to page is generally similar.[65]

The series of histories in the Psalter of Saint Louis corresponds to the same pattern. It illustrates the stories of Cain and Abel, Noah, Abraham, Isaac, and Jacob, each in a pair of facing folios, except for Abraham, who has two pairs; and as in the Munich Psalter, an almost equal number of miniatures is allocated to the story of Joseph.[66] Notwithstanding the double-page units devoted to Abraham and Moses in the Ingeborg Psalter, this biographical construct finds a precedent in a small group of mid-thirteenth-century French psalters in which scenes are usually arranged in roundels, several to a page. Central to this group, which is contemporary or slightly earlier than the Saint Louis Psalter, is the

Parisian psalter in Vienna (ÖNB, MS s.n. 2611), previously discussed in relation to specific compositions, such as Joseph Revealing Himself to His Brothers,[67] and to its unusual program of prefatory miniatures, one that in many ways anticipates the "biographical" organization of the first gatherings of the Saint Louis Psalter. Several other unusual compositions in its prefatory folios are related to those in the Psalter, and whole sequences of scenes, especially those concerning Joseph, draw upon the same sources one finds in the *Bibles moralisées* and the Morgan Picture Book.[68] Each prefatory folio is divided into six medallions devoted to a single subject or history—one folio each for Creation, Adam and Eve, Noah, Abraham, and Jacob, and then five folios for Joseph—with many subjects and entire pages relating to the English group.[69] The illustration of the Vienna manuscript is limited to Genesis, but of the subjects depicted, a significant number are related iconographically to those in the Psalter of Saint Louis.[70] Although the prefatory miniatures are attached to a psalter illuminated in a German style, discussion of this manuscript attributes it to Paris and specifically to the group of manuscripts around the Roman de Poire (Bibl. Nat., MS fr. 2186). The closest stylistic relations are to the Roman de Poire itself, a manuscript that François Avril correctly cites as representing a seminal stage of the style of painting closest to the court.[71] The Vienna psalter indicates that Old Testament sources beyond the four works cited above may have been available, at least in the case of the Genesis scenes, but it seems that one never gets very far away from the royal court.

The English and French cycles discussed so far have other important implications for that of the Psalter of Saint Louis. Just as the Old Testament sections of these manuscripts do not all begin with the same subject, Creation, they do not end with the same subject either. In the manuscripts referred to above, the first subjects could be the Fall of the Rebel Angels, the First Day of Creation, the Fourth Day of Creation, the Fall of Adam and Eve, or the Angels Appearing to Abraham at Mamre; the final subject ranged from the Expulsion from Paradise to the Worship of the Golden Calf, the Fall of Jericho, Samson Destroying the Temple, David's Anointment, David Entering Jerusalem, and the Death of Absalom.[72] Since there seems to be no standard way to begin or end a prefatory cycle, one has to be circumspect about the possi-

bility of missing miniatures, especially when there is no physical evidence of losses. If there is a normative cycle in French psalters at this time, it may be in the decoration of initials, but it is not in the prefatory cycle.

The same observations bear on the problem of the fabrication of the longer prefatory gatherings, discussed in Chapter 1, especially gatherings I and IV. It will be recalled that each of two teams of artists contributed to these gatherings and that one was responsible for the basic, or "regular," set of bifolios and the other for those bifolios which were irregularly "inserted" into it. It is striking that the eight regular folios of the first gathering would have consisted of four double-page openings and that each would have been devoted to a single biblical subject—Cain and Abel, Noah, Abraham, and Jacob—much as the Ingeborg Psalter structured a whole history on two facing pages.[73] Although this is not true of the fourth gathering, it is very nearly so, for its three pairs of miniatures would have concerned Moses, the Exodus and Joshua entering the Promised Land, and the battle of Jericho.[74] This latter sequence, though highly telescoped, is consistent with several English cycles that similarly jump from the Exodus history to the battle of Jericho.[75] Moreover, the facing miniatures would have been related by composition and motif, much as the Abraham and Moses miniatures in the Ingeborg Psalter were, relations that were lost when the other bifolios were inserted.[76]

Despite these precedents for the "regular" sections of each gathering, nothing suggests that the "inserted" bifolios were oversights or afterthoughts or point to the absence of a coherent program. A number of their subjects—the Destruction of Sodom or Moses Receiving the Law, for example—are more or less standard in the early-thirteenth-century cycles, and it is unlikely that any plan calling for the story of Abraham and Jacob would have excluded that of Isaac.[77] Moreover, some of the "inserted" folios have the most compelling contemporary implications, as do Abraham's pseudo-Capetian arms in folio 5v. It is far more likely that these precedents for the "regular" section only underscore the planner's initial reliance on a narrative model that had to be supplemented and his natural inclination to assign the miniatures associated with that model to one of the groups of artists.

Just as the artists quickly developed new patterns of working, they also began to develop new ways to relate

facing pages. In the first gathering a sequence of events is made coherent: thus, Eliezer leaves Abraham to find Rebecca but reverses direction when he brings her back to Isaac on the facing page (fols. 11v–12r); or angels in white descend toward Jacob and then greet and finally engage and bless him (fols. 13v–14r).[78] In the second gathering, relations between miniatures are increasingly a function of repeated gestures and opposing shapes (fols. 19v–20r). In the fourth gathering, these begin to assume a meaningful pattern. For example, folios 29v–30r begin with the Finding of Moses, continue with the episode of the Burning Bush, and end with Moses Asking Pharaoh to Free the Israelites. What the three scenes have in common is a kind of three-way movement, a main figure who points up to a person of authority (Moses' mother, the head of the Lord in the bush or in the clouds) and down to someone or something in their charge (the infant Moses, the flock of sheep, the Israelite woman and children). Although every detail is not analogous, the left miniature establishes a pattern of reading, reiterates it, and thus prepares for the expansive final subject on the facing page. The effect is to introduce the story of Moses in such a way that these three traditional events each stress the idea of custody, and custody is one of the larger themes not only of the other Moses miniatures but of the prefatory cycle as a whole.[79]

By the second phase of production, such strategies become standard and occur not only within a single double-page opening but within a series constituting a distinct subhistory. These series often correspond to a gathering, suggesting that the elaboration of this narrative model was facilitated by the adoption of the four-folio gatherings in this phase of the production.[80] These gatherings, it will be recalled, are frequently concerned with the life of a single figure. For example, the four Gideon miniatures begin with his calling and the sacrifice directed by the angel (fol. 49v); they continue with his proving himself by destroying his father's idols and with his offering a sacrifice on a cleansed altar (fol. 50r). In the next opening he receives the sign of the fleece and selects his soldiers (fol. 51v), and finally is victorious in battle (fol. 52r). The series has a number of devices familiar from other works: the two openings begin in analogous ways, though from the one to the other Gideon trades a winnowing basket for the fleece; he

progresses in one opening to sacrifice, in the other toward victory; and the tight pattern of standing, bent, and lower figures in the selection scene is set loose in the battle scene. But there is something new here, for this kind of biographical cycle is structurally different from those we saw for Christ, Abraham, or Moses, and precedents in Byzantine and earlier Western painting hardly prepare us for the series we find here. The way that Gideon twice changes from civilian to military dress might suggest an epic source, but I believe the selection of these scenes reflects another kind of biographical model, one based upon contemporary hagiography.[81] An apt parallel is found in the stained-glass windows at Chartres, where scenes grouped together in medallions serve to organize the stages in a saint's life.[82] For example, the medallions of the Saint Thomas window begin with his mission (voyage to India, wedding to the daughter of a king); go on to his testing (he builds the king's palace and a church); continue with his selection and his deeds (an angel shows him the celestial city, he preaches, converts); and end in his martyrdom and thus his victory (fig. 80). Although Joseph too is the subject of a window at Chartres and other Old Testament figures are the subjects of windows elsewhere, the hagiographic model was a natural one for the Psalter artists to employ to illustrate these exemplary lives.

At Chartres the thematic emphases and overall structuring have been explained with reference to exegetical and sermon literature, vernacular texts, and liturgical and popular accounts of the lives of the saints. Whatever the circumstances, a very similar narrative model appears in the longer narrative lives in the Psalter of Saint Louis. The story of Gideon, for example, begins with his mission (fol. 49v: the angel calls him and they sacrifice), continues with his trial or demonstration of faith (fol. 50r: he destroys his father's idols and sacrifices alone), then with his deeds (fol. 51v: the miracle of the fleece and the selection of fighters), and ends with his victory (fol. 52r: the sounding of trumpets as the Midianites kill each other). The same kind of reading pertains to the four double pages of the Samson scenes. It begins with his origins and calling (fols. 55v–56r: the annunciation to his parents and the struggle with the lion), continues with his initial engagement with the worldly (fols. 57v–58r: Delilah betrays his secret, and Samson releases the foxes), then by his deeds and miracles (fols.

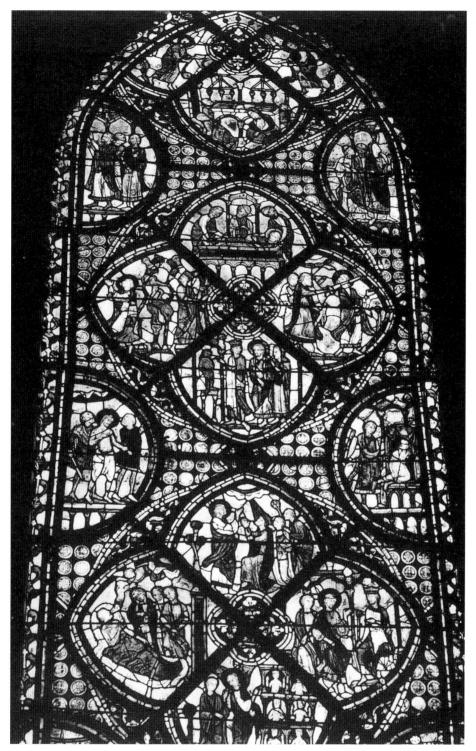

FIG. 80 *Cathedral of Chartres, Saint Thomas window.*

59v–60r: his patience with and victory over the Philistines, the miracle of the ass's jawbone), and concludes with his martyrdom (fols. 61v–62r: his blinding and the destruction of the temple). On the one hand, this four-part structure presents a standard biographical paradigm, and so the analogy with the glass at Chartres is hardly surprising; on the other, the narrative lives of the Old Testament already corresponded to what many contemporary saints' lives had become: hagiographic romances in which the principal character is presented, not as a Christlike figure who is born virtuous, lives morally, and is misunderstood, but as someone who learns morality through worldly experience and realizes his or her sanctity through a series of decisions or events and within a distinct set of social bounds. These narratives described that experience in familiar terms, and the narrative structure of the medallion and double-page units proved useful for thematic clarity while signaling that the narrative was a *vita* in which the status of the protagonist would change.

. . .

Part of the achievement of the Saint Louis Psalter resides in its successful adaptation of long Old Testament cycles to a new set of structures and forms keyed to the formal relations across facing pages and within single gatherings. These relations, which are familiar from earlier French and English prefatory cycles, have been adapted to a modern language of bodily movement and gesture. Emblematic juxtapositions are sometimes lost in a flow from left to right, but a pace and rhythm now operates in the shaping of the narrative to a degree unknown in earlier psalter illustration. In many ways one has the best of both worlds, for the breadth and narrative richness of the longer Old Testament cycles are presented within a structure that still makes possible the same thematic coherence, levels of content, human predicaments, and awareness of the use of the book as were associated with earlier manuscripts. Such composition meant working with and selecting from a far greater range of subjects, to make biographies as well as histories and to create a different kind of comprehensive structure. That structure still corresponded to the traditional view of Christian history, its fulfillment with the coming of Christ, and the redemptive role of prayer. But the Old Testament now had its own overarching themes and a relevance that bore freshly on the present.

Old Testament Imagery

If an explanation for the unusual series of full-page miniatures of the Psalter lies in part in the fact that prefatory cycles became instrumental in shaping the narrative and interpreting the book, it lies also in the ways the Old Testament itself was understood and the kind of vehicle of meaning it had become in the time of Louis IX. In what follows, I argue that the role of Old Testament imagery began to expand significantly in the late twelfth century, conditioning the pictorial and intellectual conception of the Old Testament cycle and affecting the king's reading of it. The general phenomenon is well known, but its constituents—in exegesis, literature, and history—have not been adequately considered in terms of the visual arts in general or of the Psalter of Saint Louis in particular. The role of the Old Testament in medieval culture is so large a subject that what follows can only be a sketch of some of the most relevant factors. In each case, however, I have tried to give concrete examples in the Psalter or in other relevant works.

. . .

The Old Testament is part of the Christian Bible and played an essential role in the evolution of Christian worship, doctrine, preaching, and social and historical thought. The relationship of Old Testament events to the life of Christ and Christian eschatology already appears in the Gospels and Epistles, and Old Testament stories and references are built into the liturgy and, through sermons and the arts, provided a living source of symbols, prototypes, moral examples, and imagery. Adam and Eve, Joseph and David, Sinai and Jerusalem, were as familiar as many of the people and places of the New Testament; and, what is more, they were historical antecedents whose lives could be as vivid and as memorable as those of saints and heroes of legend.

Of the four senses in which scripture was read—literal (or historical), allegorical, moral, and mystical—the allegorical had been the most important for the visual arts, and typology, especially in the form of juxtapositions of Old and New Testament subject matter, was the most common construction in which Old Testament subject matter appeared.[83] The implications of such juxtapositions were by no means closed or limited to the subjects themselves. As already noted, they could extend outward to the whole plan of salvation, including the present and future. Nor did typologically constructed

programs exclude historically progressive readings; indeed, since early Christianity the two kinds of readings have been found together, sometimes coordinated in programs of remarkable sophistication.[84] Most important, the system of references in these programs could work in two directions: as a way of seeing the Old Law realized in the New, and the past unfolding in the present; and as a way of seeing the Old Testament encompassing the New, and the present arising from the past. It is the latter, what Chenu termed "the backward look of typology," that is particularly relevant to the present study, for it invests Old Testament events with a powerful potential and gives it an authority and immediacy that can transform the present.[85]

In twelfth-century France the Old Testament became an object of historical study.[86] For Hugh of St. Victor and the school of canons regular he established on the Left Bank, the literal, or historical, sense of scripture formed the basis for all interpretation. In this view the study of the Bible begins with understanding circumstances and texts: that is, events should be seen within their proper ritual and cultural contexts; they should be seen against a larger history of interpretation, which includes the Hebraic and rabbinic; and they should be read for their larger themes and implications.[87] This orientation had the effect of diminishing the importance of allegorical and mystical readings and promoting new interest in the moral implications of the text.[88] As an inquiry into circumstances and behavior, into the moral import of stories, and into the medium or apparatus of communication, it naturally led to a progressively richer understanding of character and events, narrative values and strategy, and the explanatory power of the Old Testament seen for its own sake, independent of a comparative or allegorical construct. At the beginning of the thirteenth century the Old Testament was still the object of spiritual interpretation and the source of allegory, antetypes, and prefigurations that it had always been; but it had also become the subject of historical study, a fresh source for exempla and a document for moral instruction, and a prescription for action in the present day.

The essential source for this kind of study is Petrus Comestor's *Historia scholastica*, a work that became a standard schoolbook and exerted an influence throughout the thirteenth and early fourteenth centuries.[89] Prob-

ably written in Paris and finished ca. 1169–73, when the author was chancellor at Notre-Dame, the text is primarily a narrative adaptation of the most historical books of the Old and New Testaments—the Pentateuch, Joshua, Judges, Ruth, Kings, Tobias, Ezekiel, Judith, Daniel, Esther, Maccabees, the Gospels, and Acts; other books that were the subject of commentary, such as Job, the Psalms, or the Song of Songs, are omitted. It relies extensively on Josephus's *Antiquitates judaicae,* the richest narrative history of biblical events known before the twelfth century apart from the Bible itself. To this narrative core it adds explanations and references with a strong Victorine influence.[90] For example, the text follows the biblical account closely in the story of Abimelech and Hagar (Genesis 20–21) but breaks off with Abraham's sacrifice of Isaac (Genesis 22).[91] The Comestor treats this important subject by discussing details, such as the location, the altar, the sword, and the angel; by clarifying descriptive terms, for which he refers to the Hebrew; by analyzing certain passages of the text, especially the critical exchanges between Abraham and Isaac and the angel; and by drawing moral lessons from Abraham's response when his son asks what they will be sacrificing. The text relies on Josephus but also cites Alcuin and Rabanus, relates certain details to texts of Deuteronomy and Isaiah, explains how the Hebrews commemorate the event, and refers to the progeny of Isaac in relation to those of Esau. It does not, however, treat Isaac's sacrifice as a prefiguration of Christ's, nor does that event figure within the continuing narrative account, which resumes only with the death of Sarah, in the next chapter (Genesis 23). On the one hand, it presents a more streamlined narrative; on the other, a research and meditation on the circumstances and significance of certain events. This stress upon the historical at the expense of the allegorical prevents the text from becoming a book of commentary arranged historically; at the same time, the frequent references to people or events in the past and future assure that it is more than merely a compendium. In the end this one-volume Bible with integrated commentary produces a historical reading that is selectively narrative, descriptive, explanatory, and reflective.

During the same years, significant changes also appear in the visual representation of Old Testament subjects. No longer excerpted for use as types, figures and scenes are increasingly incorporated into a historical and

dramatic account focusing on exemplary deeds and moral actions. The Old Testament jamb statues of the Coronation of the Virgin portal at Chartres still prefigure Christ, but unlike those of earlier Coronation portals, they are arranged in chronological order and are identifiable not only by their attributes but by their actions, each figure shown in vivid action, the protagonist in a scene the viewer imagines.[92] Or take the right northern portal at Chartres, in which the subject matter is entirely Old Testamentary, a presentation unthinkable only a few years before. The events depicted in its archivolts—from the stories of Gideon, Samson, Judith, Esther, and Tobit—include the standard typological references to Mary and Christ as well as other subjects that fill out the narrative and contextualize the behavior of the protagonists. That some subjects are allegories of the triumph of Christ and the Church does prevent them from also functioning as lessons of faith and virtue.[93] The same lessons are found in stained glass, which, from the late twelfth and early thirteenth centuries, is often devoted to the lives of Old Testament figures. Abraham, Noah, Isaac, Joseph, Moses, Balaam, Joshua, Samson, and David variously appear as the subjects of entire windows at the cathedrals of Poitiers, Bourges, Chartres, Auxerre, Rouen, and elsewhere.[94] Here the Old Testament serves as a source of exemplary lives, its leaders and prophets shown like the saints and confessors in the nearby windows, their actions recognizable through similar situations and narrative formulas, so that their deeds have a comparable moral impact.[95] Even the highly literal illustration of the Morgan Picture Book (M.638), which normally follows the chronology of biblical events, often manipulates its histories. For example, it puts the story of Abimelech after, rather than before, that of Jephthah, a misplacement that enables the viewer to compare Jephthah's righteous sacrifice of his daughter with the adjacent subject of Abimelech's wrongful murder of his brothers; that is, moral lessons are drawn internally, within a framework of two family histories (fig. 81).[96]

The foremost exemplar of this approach, and the one intended for a royal audience, is naturally the *Bible moralisée*. Its pairs of roundels extend traditional typology in several critical ways. Relations between Old and New Testament events, for example, are often highlighted not through a presentation of types but through depiction of analogous actions, situations, or motives. Additionally,

Old Testament events are compared to scenes describing current aspects of secular or religious life in Paris. The latter provide the most compelling evidence that the lessons of Old Testament narrative no longer require the visualization of New Testament subjects but can be applied to modern situations directly. In these miniatures, as in the teachings of Langton and his circle in Paris a little earlier, the point is not symbolic or prefigurative but moral, political, and social.[97] Similarly, in the *Bible moralisée*, as in activities related to exegesis, such as preaching or penitential practices, or for that matter in other forms of representation, such as drama, authors seem to have taken a fresh look at the familiar events of the Old Testament and reconstrued them in terms that are more historical, descriptive, and subjective.[98]

These events are also seen in terms that are more problematic. Exegesis took certain passages of the Old Testament as a focus for a wide-ranging discussion of questions of political theory, such as the relation between royal and divine authority, the limits of the power of kings to govern, the need for popular assent, and the proper influence of the clergy.[99] Since many of the influential writers were Parisian theologians, it is particularly interesting that one of the most critical passages is 1 Samuel 8, where the Hebrews ask Samuel for a king, for this text forms the starting point (fol. 72r) for the final and in many ways culminating unit of the prefatory cycle, which is essentially a narrative of the institution of kingship. The result of this rationalizing of the study of the Old Testament is seen later in the century. For William of Auvergne, theologian and bishop of Paris writing in the second quarter of the thirteenth century, the intention of the Old Testament text was found entirely in its historical and literal meaning. Interpretation required that biblical events be read in the light of their own religious and political values, by historically reconstructing causality and intention and by taking account of textual metaphors and figures of speech.[100] Later, Aquinas and others again emphasized figurative and allegorical meanings, but Beryl Smalley has shown that William made the Old Testament the object of scientific study in its own right.[101] In the context of the present study, the most important aspects of this phenomenon are the willingness to see an event as a complex situation that carries no presumption of any prefigurative function; to accept the contingencies of

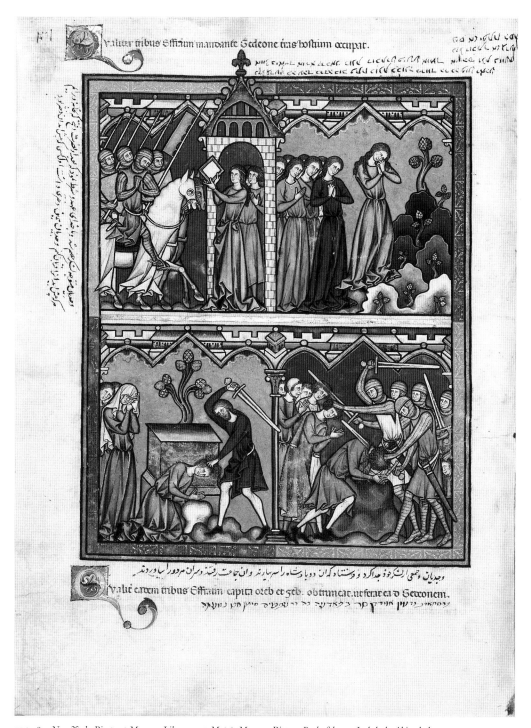

FIG. 81 *New York, Pierpont Morgan Library, MS M.638, Morgan Picture Book, fol. 13v: Jephthah, Abimelech.*

behavior and to address inconsistent or contradictory actions in terms of their specific contexts and motivations; to tolerate unreconciled historical and allegorical interpretations; and to look for intention in the expressive means itself.[102] It is unclear whether William's ideas had an influence on the visual arts.[103] However, they enlarged the parameters of interpretation in the mid–thirteenth century, and bear on the next chapter's interpretations of key subjects. The defeat of the Israelites, the importance given to the representation of the failed king Saul, and the reasons the artist wished to show so vividly the attractions of Bathsheba that led to David's sin—all must be viewed in their context. When behavior and motivation are no longer subsumed under an encompassing spiritual reading, fallibility and failure become real contingencies, both to theologians and to the reader of the Psalter.

· · ·

If the Old Testament took on historical interest and moral force within the interpretation of Scripture, from the late twelfth century it became more widely accessible through adaptations, paraphrases, and condensations in prose and in verse. Among the Latin texts, Petrus Comestor's *Historia scholastica* has to be considered in this light also, along with Petrus Riga's verse *Aurora*. Translations of certain Old Testament books into French prose are known from the mid–twelfth century, and versified paraphrases appear in the late twelfth century.[104] After the mid–thirteenth century, the whole Bible became available in French, both in prose, in the so-called *Bible du XIIIe siècle,* and in verse, in the poem of Geoffrey de Paris.[105] These French-language works generally emphasize historical narrative, omit laws and sometimes whole biblical books, and project an interest in genealogy, in battles and decisive historical events, and in subjects that are dramatic, romantic, full of conflict or that simply move the narrative forcefully ahead.[106] The vernacular texts are especially notable because some are susceptible to unusual emendations and anecdotes and result in the recasting of the narrative in more immediate and socially recognizable terms. Although it is uncertain whether they should be understood as variations of the romance or epic or as a genre in their own right, it is clear that they responded in some measure to trends in both literature and sacred history, and many of the manuscripts with these French Old Testaments were pro-

duced in the same ways as were works in these other "genres."[107] On the whole they provided rich and direct access to the central narrative line of the Old Testament, a point of entry not supplanted until the early fourteenth century by Girart des Moulin's *Bible historiale,* a more literal translation of the Bible, and the *Historia scholastica.*[108]

These paraphrases and vernacular translations of the Bible are largely Parisian works. Either their authors lived and worked there, or, in the case of the *Bible du XIIIe siècle* and the later *Bible historiale,* Parisian stationers produced them in the course of preparing standardized works for the market.[109] The audience for them was largely royal and aristocratic, and several manuscripts can be situated within a milieu suggesting proximity to the king. As noted earlier, the Arsenal Bible—a compilation of earlier translations of several books of the Old Testament—may have been acquired by the king in Acre during his first Crusade and brought back with him to France. Some of the *Bibles du XIIIe siècle* must also have had royal or aristocratic owners, at least to judge from the British Library MS Harley 616, one of the earliest preserved exemplars, a Parisian work of superb quality datable to about 1270–80 on the basis of its illuminations, many of which recall the later Sainte-Chapelle evangeliaries (Bibl. Nat., MSS lat. 8892 and 17326).[110] The popularity of these translations continued: in the fourteenth century, the *Bible historiale* was commonplace in princely collections.[111]

Although almost all the texts cited above have illuminated exemplars, some with hundreds of miniatures, the paintings in the thirteenth-century manuscripts tend to be standard interpretations of little iconographic interest. Their texts, however, are of considerable importance. Morgan has shown that many details in the prefatory miniatures to English psalters are found in the *Historia scholastica,* the *Aurora,* and the "Bible" of Herman de Valenciennes.[112] Madeline Caviness has argued that this latter source accounts for certain details of the Joseph window at Chartres.[113] Similar connections have been made for the Psalter of Saint Louis, such as Jordan's observation that the positive treatment of Saul (fol. 78r) accords with that in the *Aurora.*[114] Some unusual details of the Psalter of Saint Louis that have no counterpart in the Vulgate find echoes in the Arsenal Bible, and several of the most unusual conceptions in the Psalter—Abraham as a conquering hero (fol. 5v), the

imagery of the tree of Mamre (fol. 7v), the drama of Joseph's revealing himself (fol. 25v), the emphasis on the entry into the Holy Land (fol. 53v)—reappear in the French verse Bible written about 1250 at Saint-Denis, just when the early histories of Capetian rule were also being formulated.[115]

None of these French texts is likely to have served as the direct source for a visual representation. When details of text and image correspond, it is likely that they have living and probably oral tradition in common. It is unclear if that tradition centered in a specific vehicle, such as vernacular drama or sermons, or if these exciting and familiar stories of adventure were simply retold in the same way other epic tales were.[116] In any case, the texts in these manuscripts tend to be a conservative amalgam of the sacred and popular. They are of importance because they bear witness to the secularization of sacred history, to the mixing of literary genres, and to the breakdown of distinctions between fiction and history.[117] They reflect the power and familiarity of these Old Testament stories, how they were imagined by their thirteenth-century audience; they demonstrate how a figure's identity was not limited to that described in exegesis or devotional texts.[118] These texts restaged Old Testament stories, and that must have been suggestive and liberating for artists, especially those working for the same aristocratic patrons.

· · ·

Whatever the religious or literary interest of these adaptations and translations, to contemporaries they were read in part as histories. The events of the Old Testament had been chronicled in world histories going back to Eusebius, Cassiodorus, Orosius, and others.[119] Old Testament events either appeared in condensed form, usually an introduction that set the author's subject within a larger temporal framework, or were incorporated into universal histories that reconciled biblical and ancient chronologies and integrated events.[120] By the late twelfth century, this chronicle tradition had changed, in part because of the interest in the historical interpretation of scripture and the influence of works that streamlined the narrative and sorted out relations between events, and in part because of the development of new forms of historical writing, including French forms into which the new translations of the Old Testament could easily be assimilated.[121]

The most important biblical history after the *Historia scholastica* was Vincent of Beauvais's *Speculum historiale.* With the *Speculum naturale,* it originally formed the *Speculum maius,* an enormous florilegium to which the *Speculum doctrinale* was eventually added. Vincent developed the *Historiale* in several stages. The Old Testament section is likely to have been part of an early version he presented to Louis IX in 1244–46.[122] The *Speculum*'s history extends from Creation to 1250 and is one of the richest and most integral compendia of biblical, ancient, and modern history written in the Middle Ages.[123] In fact, the Old Testament portion occupies only the first two of its thirty-one books and is thus far shorter than the equivalent section of the *Historia scholastica.* Complex narratives are frequently summarized, and several well-known stories are simply omitted. It also draws on many other sources, places more emphasis on ancient history, and includes additional materials, such as a section on the orders of creation. The author is less committed to literal interpretation and often explains the meaning of certain events. These meanings, usually prefigurative, function to link not only Old and New Testament events but also those within the Old Testament. Some of these are well known and occur in the *Historia scholastica,* such as the view of Melchizedek as descended from Noah's son Shem and as anticipating Aaron, the priest of the desert tabernacle.[124] But others draw together similar types, as when Vincent recounts the exemplary offerings *"ex charitate"* of Abel, Noah, and Abraham as part of his section on the ritual offerings of the Hebrews in the desert.[125] His emphasis on Abraham is one element that distinguishes his work from the Comestor's. Vincent describes Abraham as a type of Christ and sees Abraham's circumcision as signifying the obedience and faith that Adam lacked.[126] The relation of the Old Law to the New is expressed through the link of Abraham to Christ, and God's promise to Abraham is among the recurring historical "markers" Vincent cites in order to situate events in time.[127] Genealogy, so prominent in the biblical text, is an element that frequently structures this large view. For example, the description in Joshua 21–22 of the possessions of the various tribes of Israel in the newly conquered land is the occasion for referring back to the priest and king Melchizedek and forward to Judah, David, Christ, and subsequent kings who shall arise, a function it hardly has

in the Comestor's more literal reading.[128] Similarly, Vincent removes from his narrative the episode in which Jacob blesses his twelve sons (Genesis 49) and places it in a special section, after the deaths of Jacob and Joseph and at the end of his book 1, where, instead of a poetic evocation of each tribe's character, the text functions to anticipate the future of the tribes, their division of the Holy Land, and the advent of Christ.[129] Also significant is Vincent's repeated references to the priesthood, not only in the persons of Melchizedek and Aaron but in the way he traces a hereditary line of priests.[130] But perhaps most telling is his prologue to the *Historiale*, which, together with his slightly earlier history, the *Memoriale temporum*, makes clear that his general purpose is to describe the progress of the people of God through history.[131] The scheme is clearly indebted to Augustine's *City of God*, which Vincent frequently cites, but has a new emphasis on genealogy and original features that link the parts and function prescriptively. In its focus on the destiny of a people of common birth, it is more of a national history, albeit one of a nation whose frontiers are the entire Christian world.

What emerges from the Old Testament section of Vincent's text is a clear set of thematic concerns: God's promise to Abraham, the Exodus and the Holy Land, kingship and priesthood. An emphasis on these events and ideas is hardly new—similar thematic connections appear even in some of the vernacular paraphrases cited above[132]—but in Vincent's Old Testament they are the elements of a larger thematic structure presented as history and as a national as well as religious destiny. Once the Old Testament is treated as a chronicle, typology doubles as historiography.

This structuring of the past has an important counterpart in another form of historical writing. One result of the larger revival of interest in history in the twelfth century was the rise of vernacular historiography in French royal and aristocratic circles at the beginning of the thirteenth century.[133] The early developments centered in ancient histories that were translated into French at about the same time the Bible was. Gabrielle Spiegel has shown that several of these vernacular histories represent an attempt to link their noble Flemish patrons to a pre-Christian past of authority and prestige, one in which contemporary ideals, roles, and actions could be affirmed and valorized.[134] Although the texts

she studies are primarily ancient histories, several contain sections of Old Testament history. The most important is the *Histoire ancienne jusqu'à César*, the earliest universal chronicle in Old French prose.[135] The author, a clerk writing for Roger IV, castellan of Lille between 1211 and 1230, originally planned to trace history from Creation through the Norman Conquest and the settling of Flanders, that is, to write "livres des histoires" comprehending all of biblical, ancient, and modern history.[136] For unknown reasons he was able to include only Genesis and ancient history to A.D. 57, but his project is of particular interest because biblical and ancient events are intercalated, he provides verse moralizations, and the illuminations are consistent in both kinds of histories.[137] About the same time, the author of the prologue to the *Chroniques de la Bible*, a prose account of biblical and some ancient events written for the count of Auvergne, describes his purpose in terms that are consistent with the vernacular histories: that his reader may "know the beginning and unfolding of the lineages since the creation of the world, as well as the battles that were fought in ancient times."[138] There are other examples, but the point is that biblical and ancient histories could readily be integrated: many of the narrative elements, such as genealogy, reigns, and battles, are the same, and the authority of the Old Testament and the tradition of applying its lessons to the present would only have strengthened the impact of the local histories.[139] Moreover, vernacular Bibles sometimes incorporated ancient histories or were produced with them, thus offering a convenient precedent for assimilating biblical and ancient history.[140]

In these vernacular histories made for aristocratic patrons, the Old Testament is never the sole text. The situation was different in the context of a religious institution. The first three-quarters of the verse Bible written at Saint-Denis about 1250 follows Old Testament events from the Creation to Joshua 1; that is, it leads up to the arrival of the children of Abraham in the Holy Land. The author then announces a change in plan and suddenly begins recounting the history of the Cross. He briefly goes back to the rods of Moses and then recounts its history in the times of David and Solomon, Constantine and Helena, sometimes going back to Adam, Cain, Noah, Abraham, Jacob, and others in order to weave in prefigurations of Christ, the Church, and especially the

Cross.[141] In the last twenty-five lines he arrives at the abbey of Saint-Denis and at two of its most prized relics, a thorn from the Crown of Thorns and one of the nails of the Cross, which he himself saw and kissed.

There can be no doubt that the author was writing at Saint-Denis, for the relics he cites were among Saint-Denis's most prestigious possessions, and he refers to the *abbey*'s Bible from which he worked.[142] But the relic he refers to in the last few lines was accidentally lost in 1232, a shocking event that evoked a horrified reaction at the abbey and elsewhere, especially since it had apparently been given to the abbey by Charles the Bald.[143] Written about fifteen years later, the ending of the poem can be seen not only as a reaction to that event, a fictional claim to possession of an object the abbey may still have hoped to find, but also as a reflection of an anxiety about the status of the abbey at a time when more important relics—the Crown of Thorns and a large piece of the True Cross—were brought to France and not given to the abbey but were placed in the king's own chapel, the Sainte-Chapelle. In these terms, the sudden shift from the history of Israel to the history of the Cross makes sense, for the relic of the Cross was the abbey's principal relic. What begins as a verse paraphrase of the Bible becomes a construction that uses events from the Old Testament to focus on a relic, describe its historical precedents, and characterize its qualities. In the end the author brings the relic home, moving from its miracles at Constantinople to those in France and, finally, at Saint-Denis. This envelopment of the relic in an explanatory history of Old Testament events leading to the present is the literary equivalent of the stained-glass program of the nave windows of the Sainte-Chapelle, which begins with Creation and ends with the translation of the relics into Paris.[144]

These vernacular chronicles, like Vincent's Latin one, are important in the present context because of the way Old Testament events assume a place within traditional literary strategies that use history to construct identity, whether it is familial, institutional, or "national." In the vernacular histories, Spiegel argues, the past becomes a prehistory of Flanders that enables the Flemish aristocracy to see themselves in terms of their prestigious and successful forebears. In the Saint-Denis poem, the past is a prehistory of the relic of the Cross that enables the monks of Saint-Denis to see

themselves as the guardians of a relic entrusted to them, as it had been to Moses, David, and others. For the Capetian kings, the Old Testament past was also a pre-history involving their ancestors. Of course, medieval kings were traditionally linked to the kings of Judah. Although the connection really did not need explaining, these historiographic structures more fully articulated the identity of the king and gave any conception of kingship a more compelling prescriptive force, much as eschatological ones had done earlier.

· · ·

If the Old Testament functions historically and politically in some vernacular histories written for the provincial aristocracy, it functions morally in a royal context. Those who have sought to praise or counsel emperors since Constantine have done so by invoking certain Old Testament leaders and kings, such as Moses or David, whom the Lord chose, guided, and protected.[145] Allusions to biblical models of kingship are especially common during the Carolingian period. They formed part of the royal coronation, where, during the ceremony of consecration, the archbishop asked that the new king be blessed with Abraham's faith and victories, Moses' leadership and generosity, Joshua's leadership and strength, David's humility and deliverance, and Solomon's wisdom and peace.[146] The Old Testament was a principal source of both positive and negative examples in didactic treatises on kingship, the so-called Mirrors of Princes, and in sermons and letters urging kings to specific actions, such as support of the Crusades.[147] In France this use of the Old Testament was also collective. The Franks were the New Israel, while the Carolingians were successors to the prophets. The kingdom of France, so Gregory IX reminded Louis IX, was like the tribe of Judah because it was specially chosen among peoples to serve the Lord.[148] For both king and kingdom the Old Testament formed the basis for invoking not only the blessings but the expectations of divine election.

Apart from these models and allegories, the Old Testament provided a historical explanation of the origins and continuity of kingship. The Hebrews demanded a king, and Samuel anointed Saul and then David, whom the Lord promised a lasting kingdom. It was realized in his successors, the kings of Judah, who were the royal ancestors of Christ and, figuratively, the antecedents of all rulers anointed in his name. Although this applied to

all medieval rulers, much evidence suggests that in France during the reign of Louis IX this allegorical construction effectively became a historical one.

Claims to two types of forebears were made in the period of French history relevant to this study. The first is the Capetian claim of dynastic continuity with the Carolingian kings. That claim depended on two earlier theories, the *reditus regni Francorum ad stirpem Karoli* (that the kingdom of the French would return to the family of Charlemagne) and the so-called Valerian prophecy (that the throne would return to the Carolingian line after seven successions). Although each was known in the court of Philip Augustus, they were combined only in Vincent of Beauvais's *Speculum historiale.*[149] There Vincent states that these expectations were fulfilled both in Philip Augustus's marriage to Isabella of Hainaut, who was of Carolingian descent, and in their son Louis VIII, by Vincent's count the seventh generation from Hugh Capet. About ten years later the same idea is implied in the arrangement of the royal tombs at Saint-Denis.[150] It becomes explicit in the *Grandes chroniques de France,* the first "official" work of French royal historiography, written at Saint-Denis in the very last years of Louis IX's reign.[151]

Alongside this connection to Carolingian kings was the claim of French descent from the kings of Troy. The idea goes back at least to the seventh century and was widely circulated during the reign of Philip Augustus, appearing in Rigord's *Gesta Philippi Augusti* and in Guillaume le Breton's continuation of it and in his later poem the *Philippidos.*[152] The myth of Trojan origins provided the French with a prestigious ancestor among the great nations of the ancient world, something certain aristocratic families also sought at this time. Rigord was a monk at Saint-Denis, and his text formed the basis of compilations of French histories in the mid–thirteen century and later for the *Grandes chroniques,* which begins with the Trojan origins of the Franks.[153] In Vincent's *Speculum historiale,* however, the Trojans are buried among lists of Persian, British, Vandal, and other ancient kings—and their importance is negligible in relation to that he accords to David and the biblical origins of kingship.[154]

To these claims of genealogical descent from the Trojans and dynastic continuity via the Carolingians should be added those of personal authority and historical legiti-

macy based upon the Davidic model of kingship. These latter claims are hardly unique to French kings, but two factors set the French practice apart. The first is the exceptional degree to which Old Testamentary models were assimilated in the public arena, especially in the visual arts, which was one the most significant media through which these ideas circulated. In the twelfth century, statues of Moses, David, Solomon, and other ancient kings were found along with queens and prophets on the "royal" portals of Saint-Denis and Chartres. They were the biblical forerunners of Christ, but because of each institution's ties to the Crown, the statues were probably also associated with French rulers, who would have been honored by the implicit comparison to their ideal prototypes, so that each of them might be seen as a "new" David or a "new" Solomon.[155] The late-twelfth-century stained-glass windows of Saint-Rémi at Reims take the same idea further, insofar as an entire series of Old Testament patriarchs and kings are enthroned above a series of Frankish and possibly Carolingian rulers. This arrangement reaches beyond the metaphorical invocation of singular prototypes and presents a historical construction, a juxtaposition of two lineages that makes simultaneous claims to legitimacy, continuity, and sacrality.[156] The same lineages are probably conflated in the dozens of statues forming the galleries of kings at the cathedrals of Chartres, Paris, Reims, and Amiens, where the evidence again suggests that the figures represent both the kings of Judah and French rulers.[157]

If in these portal programs a king can be biblical, historical, or part of a larger representation of the idea of *regnum* and *sacerdotium,* there can be no doubt that historical figures begin to emerge with greater clarity toward the mid–thirteenth century. A statue of Childebert, now in the Louvre, was on the trumeau of the refectory portal at Saint-Germain-des-Prés.[158] Jamb statues of Clovis and Clothar, the legendary founders of the monastery of Moutiers-Saint-Jean, appear on its Coronation of the Virgin portal in the guise of David and Solomon.[159] Louis IX is one of the principal figures in the Relics window of the Sainte-Chapelle, which was dedicated when he was only thirty-four years old. And about twenty years later, in the tympanum of the Porte Rouge of Notre-Dame in Paris, modern French regents, probably Louis IX and Margaret of Provence, kneel before the Coronation of the Virgin.[160] There is no evi-

dence that the king and queen were donors. Rather, the prototypical royal ancestors of Mary and Christ, the kings of Judah who usually accompany this subject in the Tree of Jesse, are replaced by their living royal successors. One is reminded of Vincent of Beauvais's claim that God's promise to Abraham is renewed in the reign of David and of all Christian kings.[161] If history is fulfilled not only in the advent of Christ but in Abraham's royal incumbents, then the kings of France have claim to the façades of the cathedrals and to the sacred space of its decorative programs and prayer books.

This gradual assimilation of biblical to modern identity also took place on a personal level. Like all kings, Louis IX was educated to a biblical ideal of kingship and operated within a field of action in which signs and rituals with sacred connotations followed him from coronation to death. Personal sanctity had been a defining factor of kingship during the reign of Philip Augustus, and several practices, such as the king's anointment with the holy chrism, his privileged participation in the sacrament, and his miraculous ability to heal scrofula by his touch, only served to codify and give a modern turn to the traditional idea of the sacral status of the king.[162] Louis IX's own character and actions—his piety, charity, justice, and support of religious institutions—would have amply sustained that view.[163] These rituals and actions may have served to accommodate or naturalize a biblical description of kingship, but they hardly explain the degree to which Louis IX personalized Old Testament models of kingship.

Jacques Le Goff has argued that a profoundly pious and moral conception of kingship was built into Louis IX's education and image of himself from the beginning.[164] The degree to which those conceptions were centered in the Bible is seen nowhere better than in the enterprise of the *Bibles moralisées*. Although the manuscripts may have served as illustrated "mirrors of princes," it is significant that the didactic model is not a sermon or exegetical treatise, that there is no theoretical component, and that no classical, patristic, or modern church authority is cited.[165] Nor are these manuscripts merely an illustrated introduction to Parisian theology or a layman's guide to Scripture, for the interpretative lessons are too often keyed to issues in the modern world. The manuscripts presume a lay audience that not only placed an exceptional importance on religious edu-

cation but also saw the Bible as a kind of historical handbook and living guide that rewarded verse-by-verse study even on this grand scale. And as noted in the Introduction, the king would not have had to read very far into the Old Testament in order to frame conceptions of the Church and the priesthood, of temporal and ecclesiastical authority, of royal obligations and personal morality.[166] These books are a remarkable interpretative work of reference, but they are also likely to have laid a moral foundation that informed actions in the present and, to some extent, enabled actual events to be grounded in earlier patterns and images.

The degree to which they did so for Louis IX is indicated by several documents. One of the most instructive is Joinville's *Credo*, a text written about 1250–51, when he and Louis IX were in the Holy Land. It is an elucidation of the Athanasian Creed largely built upon allusions to Old Testament events and presupposes pictures visible to the reader.[167] Powerfully biased to the visual, it reads as though it were an assimilation of a parallel series of Old and New Testament illustrations.[168] The content may reflect the king's own thinking, and the whole formulation of text and image, of Old and New Testaments, would have been familiar from the *Bible moralisée* and may well represent the kind of approach Joinville knew he had to use to reach the king. Although its references are not new—most can be found in the breviary or in the *Bible moralisée*—it is surprising to see how they are used to explain the central articles of Christian faith.[169] The most striking allusion is its consummate image. Following the explanations of each part of the *Credo* and its references to the Last Judgment, Joinville presents his own and concluding moral lesson. However, its image is not one of Paradise or the New Jerusalem but of Jacob fighting the angel.[170] In the end the reader is urged to use the text in order to be like Jacob, to fight the temptations in this world as a *prud'homme* and ultimately to embrace the Lord and be blessed, just as Jacob was blessed when, having seen the Lord face to face, his name was changed to Israel. For most Christian soldiers in the Holy Land, this must have been an odd allusion; Joshua or Gideon might have better served as a model of traditional victory. But for a religious and idealistic king like Louis IX, for whom the Crusade was truly a matter of faith, the model of Jacob would have been particularly compelling, an

example to be internalized, one suggesting that what is won in battle is a blessing, a vision of the Lord, even a change of identity.[171]

Louis received another such lesson some ten years later when his eldest son was killed in an accident. Vincent of Beauvais wrote the king a treatise of consolation in which he provided apposite historical and literary references from Isaiah and Seneca to Corinthians and Augustine. But the most sustained and penetrating model he gave the grieving king was that of Abraham. Rather than present the patriarch or victor or founder of a people, Vincent chooses as his subject the Sacrifice of Isaac, the Bible's most extreme test of a father's faith.[172] Vincent does not merely suggest that Louis imitate Abraham's acceptance of God's will; he actually puts Louis in Abraham's place on the mountain, asking him what he would do and then giving him the Lord's response in Genesis, "Now I know that you fear God and have not withheld from me your only son."[173] Indeed, he did not, but the analogy to Abraham is strikingly inapt because Isaac was ultimately spared, whereas the king's son was not, nor did the king choose such a sacrifice. The analogy could only have worked if Vincent knew he could count on the king's willingness to take on this biblical identity and to make a sacrifice Abraham did not make, to become another kind of Abraham, in many ways a new Abraham.

Vincent would have had an ample basis for positing this kind of assimilative imagery, for many of Louis's public actions had a decidedly biblical and Old Testament cast. He and his brother Robert of Artois were barefoot and modestly dressed when they carried the Crown of Thorns into a jubilant Paris, an entry whose reverse triumphalism is probably modeled on the way David, at least in the *Bible moralisée,* was poorly dressed and unshod when he brought the Ark of the Covenant into Jerusalem.[174] Similarly, the king's sitting under an oak tree at Vincennes to dispense justice has Solomonic overtones; indeed, the versified Bible written at Saint-Denis has Solomon sitting under a tree, learning how to judge, when he has a vision and asks the Lord for the gift of wisdom.[175] Moreover, the texts Louis wrote, the *Instructions* and *Teachings,* pass on moral advice to his children, just as Solomon's Proverbs do.[176] Soon after Louis's death William of Beaulieu, the king's confessor, called him a new Josias, in part because the Old Testa-

ment ruler was a pious king who restored religious order and rituals, rededicated the temple, and rediscovered Old Law. Charlemagne, Charles the Bald, and other early rulers had been compared to Josias, but it was an uncommon way to describe or praise a king in the thirteenth century or to make a case for canonization. Unlike the Carolingian precedents, the references to Josias repeatedly occur and are integral to the organization of William's text.[177] It may be an uncommon allusion, but it is unforced and appropriate to the *vita* he gives. It could well indicate the moral frame of reference the king and his confessor shared during his lifetime and, for that matter, the biblical context in which the king understood himself to be acting.

. . .

The first work in which that historiography is clear is the nave cycle of the Sainte-Chapelle stained glass.[178] Ten windows of extraordinary detail and extent chronicle events from Creation through the dedication of the chapel, in 1242. The Old Testament subjects numerically overwhelm all others, even without counting the windows of Isaiah, Daniel, and Ezekiel that are part of the New Testament cycle in the choir. It is a series of remarkable coherence. The windows of the north nave wall begin, near the western door, with Genesis and read in chronological order eastward to Judges. Whether the windows on the south side are also read eastward from the door, beginning with the History of the Translation of the Relics and the Kings windows and continuing through Esther and Judith/Job to Tobit/Jeremiah, or in the opposite direction, they also form a coherent group, for the mix of Old Testament history, prophets, and writings is similar to that in contemporary French Bibles and the *Historia scholastica,* and the inclusion of the Relics windows is no more unusual than inclusion of histories of the Cross in the vernacular versions of the Bible discussed above.[179] Many have remarked on the unusual importance of this historical cycle as well as the coherence and effect of the program. Louis Grodecki has stressed royal themes, especially sacral kingship and the prototypical role of certain Old Testament figures, and has interpreted the cycle as showing how the sacred nature of kingship comes out of Jewish history.[180] Françoise Perrot has described the cycle as depicting Hebrew history from Creation to the institution of the first monarchy and as exemplifying a theology of history

in which the king has a natural place as vicar of Christ, an interpretation supported by other historians.[181] Apart from the conspicuous theme of crowning and the evident association of Capetian heraldry with certain figures, new thematic concerns are introduced, as evident in the emphasis on Joshua's stewardship of his people.[182] Moreover, the overall structure is manipulated to establish connections. The arrangement puts the earliest and the latest events opposite each other at either side of the doorway, so that the historical sweep of the program is seen from the entrance.[183] Windows of similar narrative character continue to oppose each other down the nave: stories of deeds (Exodus and Kings), images of royalty (Numbers and Esther), scenes of battle (Joshua and Judith), and stories of sacrifice and faith (Judges and Jeremiah/Tobit).[184] It can be no coincidence that the kings and Relics windows are placed side by side, linking the history of David and Solomon with that of early Christian and Capetian kings, and that analogous subjects are sometimes aligned at the same register, such as David's entering Zion and the display of the Crown of Thorns in Paris.[185] A similarly telling juxtaposition is that between the final subjects of the lancets at the extreme corners of the south nave wall: at one end is the Jeremiah window, with the Fall of Jerusalem; at the other end the Translation window, with what was probably the last stage of the translation of relics of the Passion to Paris.[186] The location of these subjects is unlikely to be a coincidence, for their juxtaposition implies a movement along this wall from Jerusalem to Paris, carrying powerful implications of a *translatio imperii* and of a new religious significance for the French capitol.[187]

Kingship is not the only construction within this economy of history centered in the Old Testament. Its most important analogue was the Church, by which I mean a ritual center and priesthood rather than the institutional church or the faithful. Just as the Old Testament always provided models and examples for Christian kings, it provided prototypes and sources for Christian priesthood, sacraments, rituals, and places of worship. In the visual arts, despite a variety of Old Testamentary imagery, including that of the sacraments, two types of this imagery emerge as central. The first involves the desert tabernacle or the temple of Solomon as prototypical places of worship. While most representations are architectural or symbolic, many use Old Testament sub-

jects to describe the altar as a *loca sancta,* where the ceremonies of offering, consecration, and law-giving are centered and where the priesthood officiates.[188] From the Early Christian sanctuary mosaics at San Vitale in Ravenna to the Romanesque mosaic pavement at Saint-Rémi in Reims, representations of Jacob's ladder, the Sacrifice of Isaac, Moses Receiving the Law, and the offerings of Abel and Melchizedek have these functions. The second type of Old Testament imagery involves the medieval concept of *regnum et sacerdotium,* or the expression of the harmony between regency and priesthood. The theme, so essential for the well-being of the Church, implied not only complementary functions of king and priest but also a balance of royal and ecclesiastical authority.[189]

In the visual arts the theme of *regnum et sacerdotium* is found in France, possibly for the first time, in the jamb statues of kings and prophets on the west façade of Saint-Denis and has an important history thereafter in the sculptural programs at Chartres, Paris, Reims, and elsewhere.[190] It appears in the programs of royal and ecclesiastical tombs and in the stained-glass series of patriarchs and archbishops at Saint-Rémi; in the pairing of Old Testament priests and kings, such as Melchizedek and Aaron with David and Solomon in the north rose of Chartres; and in the way Melchizedek, both priest and king, begins to appear crowned *and* in liturgical dress, a paradigm for the integration of royal and secular functions.[191] In the Morgan Picture Book and Saint Louis Psalter, Abraham's meeting Melchizedek and receiving the bread and wine is depicted as a prototypical communion, its traditional interpretation, but it is the communion of a knight and thus an image of religious office and secular homage, a topos found in other guises at this time, sometimes in striking and conspicuously placed sculpture and stained glass.[192] A distinct vision of royal and ecclesiastical partnership appears in some miniatures of the *Bibles moralisées,* as when the ministry of Moses and Aaron is compared to the charity of kings and the teaching of priests, or when Saul's telling the Israelites not to eat until the battle with the Philistines is won is compared to good kings and priests' telling people to sacrifice for the common good.[193] In other *Bible moralisée* miniatures kingship is more complex. David and other kings are not always sinless, and those who are good are submissive to the Church.[194] Thus by the mid–thirteenth century reli-

gious and secular authority are represented in many guises and situations, and the relation between the two can be as highly charged as it is delicate.

Priests and places of worship, like kings, are perceived differently when the perspective is historical. At Reims and elsewhere, the succession of priests is presented as a dynasty of office and, like other displays of historical continuity, as a manifestation of authority and legitimacy.[195] The definition of the priestly succession was a recurrent theme in the *Speculum historiale,* and Vincent of Beauvais was concerned to define the line from Abel and Melchizedek to Aaron against that of the Levitical priesthood. Similarly, in the stained glass of the Sainte-Chapelle the desert tabernacle and its related themes have an important role within the larger cycle. The founding of the desert tabernacle is the final event of the Exodus window and its thematic culmination, occupying all the central medallions atop its four lancettes.[196] It figures prominently in the window of Numbers, especially in scenes of the tabernacle in the desert and of offerings, the latter in the rose that crowns a lancet.[197] It appears also in the window of Deuteronomy/Joshua, with additional offerings and the transport of the Ark across the Jordan.[198] It may be no coincidence that just as the Exodus window ends with a depiction of the altar in the tabernacle and the consecration of Aaron, that is, the institutionalization of the tabernacle, the window just opposite it, of Kings, culminates—at the same height and in the same relative position—with the altar in the temple of Jerusalem.[199] Images of the desert tabernacle, the Ark of the Covenant, and subjects of sacrifice and consecration occur throughout the nave windows. They help form and articulate a kind of subhistory within the larger chronicle of earthly events, a subhistory of priesthood, ritual, and places of worship that together show the process of the realization of the kingdom of God.[200] Biblical history is fulfilled in the successors of Melchizedek and of the desert tabernacle, just as it is fulfilled in Abraham and the successors of David. These are especially apt subjects in the Sainte-Chapelle, considering their relevance to the sacred nature of the building itself, embodying a fulfillment of its own.

In the Sainte-Chapelle program, several factors converged that set the stage for using the Old Testament less as a source of allegorical allusion than as a basis for historical argument. The first and most important was

Louis IX's acquisition of the Crown of Thorns, a momentous event both for France and its king. Its meaning, apart from the eschatological implications all relics have, was largely political: it implied a crowning of France with the crown of Christ, a *translatio imperii,* a recentering of the sacred in Paris, and a confirmation of the Capetian king as the *rex Christianissimus.* To make these meanings accessible, ancient and Carolingian history were largely irrelevant. The nave windows of the Sainte-Chapelle, with their program extending from Creation to the translation of the relics into Paris, provided an extended and continuous narrative in which the kinds of claims and constructions seen in exegesis and in chronicles could be fit into a historiographic presentation linking biblical and modern history, its events, leaders, sacred places, and priests. This program is the first preserved work of the visual arts in which we find crystallized all the most advanced transformations in Old Testament imagery described above, and it is also the work that most anticipates the cycle in the Psalter of Saint Louis.

· · ·

No act of the king raised such historiographic issues more than did his participation in the Crusades. The king's obligation to take the cross was implied in his coronation oath to defend the faith and in the precedent set by earlier Capetian kings, and it assumed urgency because of the frequent threats to Christian and French interests in the Holy Land and because of recurrent pressures from Rome. Apart from the sacred sites connected with Christ and the apostles, the entire enterprise had powerful Old Testamentary associations. The Holy Land was still referred to as the "terre de permissione," and texts such as Jacques de Vitry's *Historia orientalis,* a historical and geographic guide to the Holy Land, explained the significance of Old Testament sites, as did the sections of Vincent's *Speculum historiale* that described the Holy Land in Louis's time.[201] Old Testament references and images were frequently used to justify the Crusades and, after the defeat of Louis's first Crusade, to explain its failure. Whether an incident involved the crusaders' faith, victory, inaction, sin, suffering, or grief, it was often rationalized using an Old Testament precedent. The conflation of biblical and modern that this implies is also clear in the terms that were used: Vincent of Beauvais refers to the Mongols as

Midianites; other contemporary writers speak of the Muslims as Philistines.[202] It would have been difficult, if not impossible, for Louis to divorce the political and moral pressures to take up the Cross from the historical and geographic framework associated with the models and exempla of kingship so familiar to him, most all of whom were leaders who had conquered the enemies of the Lord in the Holy Land. While the Crusades generally stimulated interest in Old Testament history, to someone who lived that history as Louis IX did, this Old Testament imagery is likely to have informed his conception of the Crusade itself and may well have been a factor in some of his actions.

· · ·

In 1267, when the king wanted to pressure the barons into another Crusade, it was again in the Sainte-Chapelle that he assembled them, in proximity both to the relics on which they would swear and to those biblical histories against which their deeds in the Holy Land would have meaning. But the king's own Psalter, which was probably being prepared at this time, presents a somewhat different view of the enterprise. The Psalter's battle scenes are less vivid, but they clearly anticipate this Crusade, and their penitential overtones suggest something of the internal pressures the king faced at the time. The memory of the failure of the 1248 Crusade was still vivid, and the prospects for the success of the next one by no means assured. The Psalter's program is not about crusading per se, but victory and defeat in the Holy Land naturally figures within the larger construction of kingship and its obligations that the cycle presents. In the end the program and indeed the fabrication of the Psalter must be seen against this background of the king's first Crusade and his preparations for his second and fatal one.

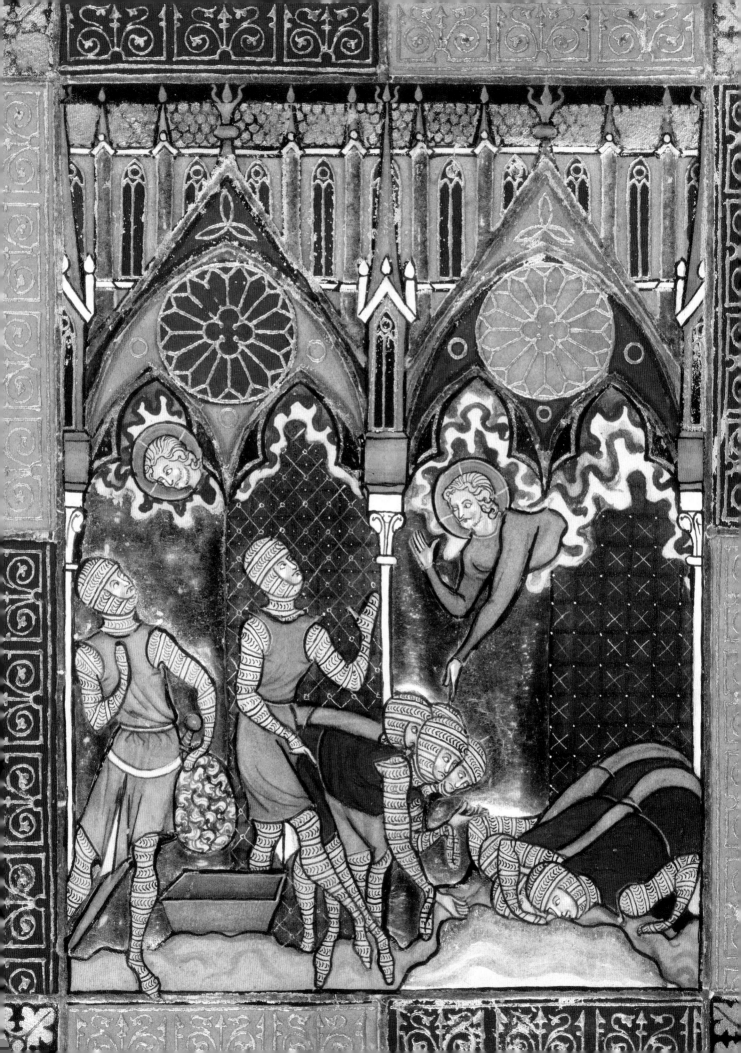

A Royal Program

The Psalter opens with the miniature of the Sacrifices of Cain and Abel. The physical evidence of the book suggests it was always the first miniature, and other psalters provide no compelling reason to believe otherwise. Although the matter can never be definitively settled, one thing is certain: in the context in which the king would have read the Psalter, the Sacrifices of Cain and Abel would have made for a perfectly appropriate beginning, for it initiates what might be called the sacred segment of the *tempus humanorum*.[1] To Vincent of Beauvais that history, the history of the Church in this world, begins with Abel. The point is made clear in his *apologia* to *Speculum maius,* where, in summarizing the content of his work, he describes how his preliminary section on the Trinity, angels, the Holy Spirit, Paradise, the beatitudes, and other large topics leads to temporal history per se and how the latter extends from Abel through the time of the patriarchs, judges, and kings to that of Christ and the apostles.[2] The implications are apparent in the *Speculum historiale* itself. The story of Adam and Eve and the Fall is not part of the narrative and is all but lost within his larger disquisition on the dignity and faculties of man, sin, the virtues, sciences and arts. History, which is to say, genealogy and a narrative of events, begins with Cain and Abel, who, as in Augustine's *City of God,* represent the pilgrim church and the blessed destined for the celestial and Jerusalemic city, as opposed to the sinful, uninhabitable, spiritual Babylon. History is the history of the Church on earth, which begins with Abel, not Adam.[3]

Detail of folio 51v, Psalter of Saint Louis

Vincent's text presents a view of Old Testament history that, though largely a compilation from other sources, is especially relevant here because of its plan and structures of thematic continuity. In fact, the symbolic roles Vincent assigns Cain and Abel are not unusual at this time; what is of interest is their role within the structure of his chronicle.[4] Nor is it surprising that Vincent's text would be relevant. Even apart from its analogies to certain subjects in the stained glass of the Sainte-Chapelle, his work is exceptional in its definition of concepts of kingship and history in the last decades of Louis IX' s reign. The king probably met Vincent in the 1240s, heard his sermons, and may have been instrumental in his appointment as lector at Royaumont in 1246. He was tutor to the king's children and about 1250 wrote, at the request of the queen, his well-known treatise on education of noble children, *De eruditione filiorum nobilium*. That treatise was to become the fourth part of a much more ambitious work on kingship, the *Opus universale de statu principis,* a project Louis may have suggested to him. The first part, the *De morali principis institutione,* was undertaken after he finished the *Speculum historiale* and was completed about 1261–62; the two other parts remained incomplete at his death, in 1264.[5] Kingship was a concern of the king's after his return from his failed first Crusade, and he encouraged others to write about it in these same years.[6] However, Vincent's work is the most ambitious, and insofar as he enjoyed a personal relation to the king and royal family, it is also the most important to the present study. If the *Speculum* provides a vantage point from which to see his view of history, his treatises provide insight into his use of Old Testament kingship.

The pictorial aspects of the Sacrifices miniature also suggest its inaugural function within the cycle. It presents an extended contrast between the two brothers that goes beyond a straightforward antithesis of good and evil and suggests their differing fates through nuances of acceptance or rejection. Unlike other psalters, which close with a Final Judgment set in the future, the Saint Louis manuscript begins with a judgment, one that uses the split between the two brothers to open up the cycle and to pose the issue of fate and behavior at the outset of human history. To the extent that their sacrifices read as a projection of personal virtue, they color subsequent images of sacrifice and offering, of which there are many

throughout the cycle, from Abraham's a few pages later to Saul's in the very last miniature. The Psalter is bracketed by images of sacrifice, and it is thematically central to the pictorial program.[7]

Vincent's Augustinian reference to the two brothers as the two cities and to the split in history that begins with this episode raises the larger question of the almost equal vertical split, in this and every prefatory miniature, between the architectural structure above, so clearly a church, and the Old Testament events that unfold below. While I would not argue that the upper structure is literally Augustine's pilgrim church, it does create something very close to the visual equivalent, for it is clearly ecclesiastical, continuous, terrestrial (there is a sky over its roof), permanent, and, in the history it always encloses, temporal. The relation between the upper and lower halves of the miniature is further clarified by two other miniatures, the only ones in which some element of the lower half of the page continues into the upper half. These transgressions of the arcading that separates the two parts of the page is of no small moment, given the relative inviolability of the separation in the other miniatures and the powerful conceptual implications that delimited or unbounded, overlapping or distinct, forms have in this manuscript.[8] The first element is the tree of Mamre (fol. 7v), which has a prophetic function, so that the flowering of the tree precisely over the building implies the relation of prophecy to fulfillment. The second is Jacob's ladder (fol. 13v), an element that extends beyond the roof of the building to just beneath the frame, where the head of Christ emerges from a bank of clouds and looks down at the angels on the ladder. In placing the source for the angels beyond the building, the miniature effectively describes the building itself as not being heavenly, just as it is not specifically Old or New Testamentary either.[9] These details suggest a conception of the architectural structure not inconsistent with Augustine's and Vincent's idea of the two churches, that is, of events unfolding in time and being fulfilled in the unchanging Church of the faithful that traverses history.

The two miniatures pertaining to the story of Cain and Abel are followed by two more with the story of Noah, the ark on the waters and Noah covered by his sons (fols. 3v–4r), the former a well-known figure of the Church and the latter, like the Cain and Abel story, traditionally underscoring Adam and Noah as progenitors

and their children as propagating virtuous and sinful peoples.[10] For Augustine, as for Vincent, these two stages of history lead directly to Abraham, who inaugurates a period of history that extends to the establishment of the kingship of Israel, the fulfillment of God's promise to make him a great nation.[11] Moreover, Abraham is the *patrem celestem* who, after Abel, embodies the city of God.[12] If these four miniatures are largely introductory, the next ones are critical in setting out the principal themes of the cycle.

Abraham first appears in the miniature showing his victory over the Canaanite kings (fol. 5v). A large figure dressed in a suit of mail, Abraham dominates the composition. With his legs braced wide apart, he swings around, brandishing a sword and at the same time shoving down the head of one of the Canaanite kings. A soldier at the left reaches across Abraham's chest to strike at the enemy at the right, some of whom begin to fall. Between him and Abraham is a shield decorated with white fleurs-de-lis on a field of blue. As other Hebrew soldiers wait and exchange glances at the left, one of the Canaanite soldiers, at the right, raises his arm and turns to flee. Among the fallen are the severed heads of three other kings, still crowned. A fourth king lowers his head for the fatal blow, holding a shield with a black dragon.

The artist transforms the types of sources discussed in the last chapter into an altogether unique depiction of this subject. Abraham fought the Canaanites in order to free his brother Lot, who had been taken prisoner when the Canaanites invaded Sodom. In medieval art the story is usually represented by Abraham leading Lot and his household to safety rather than by the battle itself. The rare scene of the battle is depicted in two ways: either as the Hebrews storming the Canaanite tents or as Abraham physically reaching for Lot as the battle takes place nearby or around them. The latter is found in the late-twelfth-century Munich Psalter (fig. 82), an English manuscript in which the iconography is typical of the kind of Old Testament cycle that was a source for the Psalter.[13] Despite the many differences, the Munich miniature clearly represents the tradition upon which the Louis Psalter miniature is based: the two armies are at the sides, one with swords or lances at the ready and the other reacting fearfully to the progress of the battle; the kings are fought as a group; and one head begins to fall while another is already on the ground.[14] However,

Abraham himself does not fight but stands ready with his lance as he rescues Lot, in contrast to the French tradition, as in the Latin *Bible moralisée* in Vienna (fig. 83), where he is dressed in full armor and strikes five kings as he pulls Lot toward him.[15] In the Saint Louis Psalter, however, Lot is omitted altogether, and Abraham is moved to the center of the miniature, magnified in stature, and shown in a dynamic pose, leading the battle and conquering all the enemy kings.

This depiction of Abraham is unprecedented in Old Testament illustration. Within the Psalter itself, not even the victories of Joshua or Gideon or Samson are shown in such heroic terms. It presents Abraham in a role normally reserved for David in scenes of his battle with Goliath, as they are found in prefatory cycles or as illustrations to the first psalm. That is, it shows that the Lord protects and gives victory to the righteous who walk in his paths.[16] Abraham, however, is no youth fighting a giant with a well-aimed slingshot but an oversized knight with sword and armor overcoming kings. Although not a king himself, the pseudo-Capetian arms leave no doubt this is an allegory of royal victory. That is in fact the meaning this episode had at least from the eighth century on, for it was referred to in Frankish services to the king's victory and, continuing through the later Middle Ages, in the rite of consecration during the king's coronation.[17] Although he is neither the psalmist nor the first king of Judah, in a French context Abraham could well substitute for David as a prototype of royal victory, for he is the founder of that nation from which all Christian royalty derives.

His royalty is also linked to the institution of kingship illustrated at the end of the cycle. It can hardly be a coincidence that only the last miniature in the Psalter cycle—Saul acceding to kingship (cf. fols. 5v, 78r)—presents another figure who is so central and enlarged, who seems to be of a greater stature than even his own representations in other miniatures. These images of the first of the patriarchs and the first of the kings open and close the cycle. Once again it is bracketed, this time not by images of sacrifice but by those of heroic leaders and victorious kings.

The facing miniature (fol. 6r) is the sequel and companion to Abraham's Victory. Returning from the battle with the Canaanite kings, Abraham and his men meet Melchizedek, the priest and king of Salem, who,

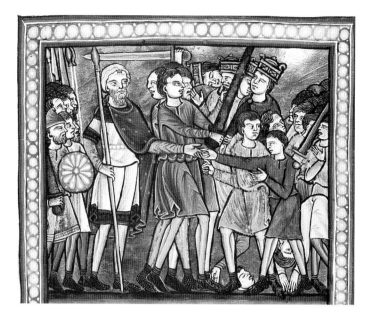

FIG. 82 *Munich, Bayerische Staatsbibliothek, Clm. 835, Munich Psalter, late-twelfth-century English manuscript, fol. 11r, upper scene: Abraham Reaching for Lot in the Midst of Battle.*

FIG. 83 *Vienna, Österreichische Nationalbibliothek, cod. 1179, Bible moralisée, fol. 8r, seventh and eighth roundels: Abraham Rescuing Lot, Christ Liberating Ecclesia.*

dressed in liturgical robes, wears both a crown and miter and raises up the bread and chalice. Abraham turns to look at him as he gestures to the tithe he offers: cattle, a horse with a chest on its back, and a number of bound soldiers. As noted earlier, Abraham's offering recalls Abel's, and Melchizedek embodies the idea of *regnum et sacerdotium.*[18] Here, however, his priestly role is dominant, and in view of the royal connotations of the facing miniature, Abraham stands for *regnum,* and the entire image, for the relative obligations of king and priest.[19]

In the Psalter miniature those obligations are unusually described. Medieval art provides precedents for Abraham shown as a warrior who either approaches with his retinue and receives the bread and wine or makes his offering; conversely, Melchizedek appears as a priest or a king offering the bread and wine or receiving Abraham's gift. Here, however, each gives and neither receives. Melchizedek elevates the chalice and host as in the Mass, but unlike the so-called communion of the knight at Reims, Abraham acknowledges it only insofar as he responds with an offering of his own. Moreover, the givers are equal and, the miniature suggests, so are the gifts, for even though Abraham's bounty physically occupies half the miniature, the force of his gesture to it is matched by the unusual height to which Melchizedek elevates both the bread and wine. It is a standoff: the men approach to fulfill their duties to each other; there is a balance but no interchange. The king's obligation to the faith

is visualized not only by his donation but by his presence, by his participation in this ritual of exchange, with all of its nuances of equality and interdependence. Seen in relation to the facing page, Abraham goes from his victory to his offering of thanksgiving, from his secular to his religious obligation; that is, the two worlds are balanced both personally, in Abraham's actions, and politically, in the institutions he and Melchizedek represent.

Melchizedek is the only person in the manuscript who wears priestly vestments. Aaron, the other symbol of Old Testament priesthood, is inconspicuous, his dress undistinguished. The same is true of the prophets Balaam, Eli, and Samuel, who may be shown ministering or in relation to the Ark or tabernacle but who are not explicitly ecclesiastical in the way Melchizedek is here.[20] What one might call the "locus of the ecclesiastical" only reappears with the founding of desert tabernacle, a critical event, it will be recalled, in the *Speculum historiale*, the *Bibles moralisées*, and the stained glass of the Sainte-Chapelle.[21] Here the tabernacle appears within a double-page opening (fols. 35v–36r): Moses receives the Law on Mount Sinai, and the Israelites worship the golden calf; Aaron, about to destroy the idol, points to the opposite page, where God appears to Moses standing in the outer courtyard of the full tabernacle seen in a cutaway view from the side. In addition to the traditional contrast between false and true worship, the two miniatures link the Lord's giving the Law to his giving the tabernacle, thus according the latter an unusual importance.

That importance is also underscored by the tabernacle's reappearance seven times in later miniatures.[22] Personal offerings and sacrifices to the Lord continue to be illustrated over the kind of block-shaped altar depicted in the miniature of the Sacrifices of Cain and Abel; this is the case for the sacrifices of Balak, Gideon, Jephthah, and the parents of Samson.[23] But where events involve the location of the Ark and the places of common prayer or sacrifice at Mizpah, Shiloh, and Gilgal, where the text refers to the "house of the Lord" or to sacrifices "before the Lord," the artist shows a partial view of the desert tabernacle, as seen in folio 38r: its front end and sometimes also part of the menorah and other objects.[24] Many of these subjects, such as Eli Overhearing Hannah Praying (fol. 67v), require a temple setting. However, that setting is normally represented by the Ark on the usual block-shaped altar in an interior or under a baldacchino, not a

section of the desert tabernacle. The tabernacle even appears in the miniature of the Benjaminites Taking Wives (fol. 66r), an event that takes place among the vineyards and is usually shown without the tabernacle. The latter is justified only by the biblical text describing how the daughters of Shiloh dance at "a feast of the Lord" and by the artist's likely desire to provide continuity with the preceding and following miniatures.[25]

These miniatures indicate that the desert tabernacle is *the* ecclesiastical structure in Judges and 1 Samuel. Its final appearance is in the last miniature of the cycle, where Samuel sacrifices to the Lord as Saul assumes the kingship of Israel (fol. 78r). Apart from the continuity of motif, it links the people who left Egypt with those who came to the Promised Land, and it demonstrates a single divine presence through history. As a locus of ecclesiastical function, however, it refers all the way back to the meeting of Abraham and Melchizedek, for their roles in that miniature closely parallel those of Saul and Samuel in folio 78r. Saul, like Abraham, has just come from a victory on the facing page. Crowned, he approaches Samuel, who exercises his priestly function before the "desert tabernacle." Part of its message should be clear: the continuity of *sacerdotium* and the "return" of *regnum*. Once again there is a backward glance in the history and the familiar bracketing of the beginning and end of the cycle.

The story of Abraham continues with a third miniature, his meeting the angels at the tree of Mamre (fol. 7v), another subject in which traditional iconography is drastically revised in accordance with ideological and programmatic intentions. Two consecutive events are illustrated: at the left Abraham meets and kneels before the three angels; at the right he entertains them as Sarah stands nearby at the threshold of their tent. This double composition appears in Sicilian mosaics and in English and French manuscripts of the late twelfth and early thirteenth centuries. The Psalter representation differs from these in two important respects. First, the oak at Mamre is of exceptional size and pictorial importance. By this time it normally divides the two episodes from each other, denotes the location—one regarded as a special site—and begins to have an important decorative and compositional role.[26] However, nowhere else is the tree of Mamre so large, so luxuriant and dense with acorns, and so resplendent, with pale green leaves highlighted in white. Second, one of the angels becomes the

interpretative agent of the second episode. Usually they just sit behind the table, gesturing to Abraham as he serves them. As pointed out earlier, they began to assume an active role in the Ingeborg Psalter (Chantilly, Musée Condé, MS 1695). Underscoring its eucharistic message, one angel gestures down to the bread and wine on the table while another points to the altar on the facing page, where Abraham is about to sacrifice his son (fig. 67).[27] Their message is different in the Parisian psalter in Vienna discussed earlier (Vienna, ÖNB, MS 2554). There the right angel points to the startled Sarah, a literal depiction of the angels' announcement that she will have a son.[28] In the Psalter of Saint Louis their message is the same, but it is given in a significantly different way, for instead of pointing to Sarah, the forward angel reaches down with one hand to Abraham's shoulder and points with the other hand upward to the luxuriant foliage of the tree of Mamre. In bypassing Sarah and linking Abraham directly to the oak, the point changes from the angel's prediction that Sarah will bear Isaac to what must be a more general prediction of Abraham's offspring. That prediction can only be the promise the Lord made to him in the passages immediately preceding these episodes—"I shall make thee exceedingly fruitful . . . I will make nations of thee . . . and kings shall come out of thee"—the same promise that Vincent referred to when writing about the origins of kingship.[29]

If the idea of using of the tree of Mamre as an image of Abraham's progeny is exceptional—this is the only instance of which I am aware—it is also a natural association. A flowering tree symbolizes fertility; an oak tree, longevity; and a branching tree, genealogy.[30] The notion of temporal continuity implicit in these tree symbols is underscored by another unusual aspect of the tree, the way it transgresses the arcading and continues into the upper miniature. It is noteworthy that the tree flowers only in the upper half, upon but not above or below the architectural structure, which is so clearly ecclesiastical and mid-thirteenth-century. If the tree is a temporal bridge between the two normally distinct realms of the miniature, those realms extend from the time of the patriarchs to that of Christ and his Christian successors; and with the tree flowering only in the latter era, the miniature would appear to visualize not only God's promise to Abraham but also its fulfillment in the time of the Church. Given that Vincent and others

described the fruition of this promise in the kings of Judah and that only two pages earlier Abraham's arms were linked to those of France, the temporal continuity that the tree describes is implicitly royal, at least in the larger sense of standing for the origins of the kings of Judah and of all the nations and kings descended from them. Within the Psalter it thus functions in the same way a Tree of Jesse does in other psalter cycles, as a bridge between historical eras and a display of dynasty. As a key image of the origins of kingship, it provides the historical and prophetic basis for the events of the last folios of the cycle, where the Israelites demand and receive their first king.

Between the Mamre miniature and the end of the Genesis cycle are a number of other scenes that emphasize the continuity and movements of the people of Israel. The only events illustrated from the life of Isaac (fols. 11v–12r) are those concerning Rebecca, that is, how his father's servant found him a wife "de son lignage," as the legend on the reverse states, and brought her back to Canaan. The several events in the two miniatures devoted to Jacob (fols. 13v–14r) all concern the period of his wanderings after his service to Laban, a period Vincent describes under the rubric of how he returned to his native land.[31] The artist seems to have gone out of his way to suggest Jacob's divinely guided mission, first through his vision of the angels on the heavenly ladder, next his meeting the angelic host, a rare subject that also figures in the *Speculum*, and finally his wrestling with the angel.[32] Next comes the long history of Joseph, a traditional sequence until the last four miniatures. The salvific implications of Joseph's Revealing Himself to His Brothers (fol. 25v), discussed earlier, is reinforced by the fact that Pharaoh physically embraces Jacob and gives his children land of their own "d'une part en son regne" (fol. 26v). Suddenly the legends begin to enumerate: Joseph makes himself known "a ces onse freres" (fol. 25r); Jacob blesses the "deus filz ioseph effraym et manasses" (fol. 27r); and "le .xii. frere ensevelissent ysrael leur pere" (fol. 28v). And after consistently referring to the patriarch as Jacob, in this last miniature the author of the legend calls him Israel, the name the angel gave him after they fought some fifteen chapters earlier.[33] These may each be minor points, but together they imply a powerful closure: the journey ends safely, progeny are numbered, and destiny is ful-

filled when Jacob, lowered into his tomb by his sons, finally becomes Israel. The planners of the cycle saw these events in the lives of Isaac, Jacob, and Joseph in a narrow but purposeful way: how the patriarchs and their lineal descendants were guided to Egypt, where they were reunited and the stage was set for the emergence of a nation.

In the Book of Exodus that nation naturally moves center stage. This change is not reflected in traditional Exodus illustration, which continues to center on Moses, but it is significant in the Psalter's miniatures and legends. The legends begin to use the term *le pueple israhel* and to refer to Moses or Joshua and *his* people. Similarly, the Israelites are portrayed not just as a diverse crowd but as a discrete group so consistently as to suggest a collectivity, one that is specially accommodated in the pictorial field.[34] They begin to appear together in the miniature in which Moses asks Pharaoh to "delivre le pueple israhel de servage" and continue to be described at the Exodus, at Sinai, and then in the scene in which God introduces his people to Joshua. The legend for the latter miniature makes clear that Joshua's elevation to leadership is in fact his reception of responsibility for the people: "dieus dit a iosue je te comans mon pueple soies mon seriant en ci con Moyses fu." The patriarchs and their families were guided; the people are entrusted.

In the legends derived from Judges and 1 Samuel, the people of Israel are generally called *le fill israhel.* Although the text of Judges and the illustration in the Psalter tend to move from the life of one judge to another, with different points—often relating to leadership and ethical conduct—highlighted in each one, a concern for continuity and lineage continues throughout. Nowhere is this more evident than in the last four miniatures of Judges, all scenes pertaining to Israel's battle against the Benjaminites in retribution for their sin against a Levite and his wife. Lineal continuity is an issue because so many Benjaminites were lost in the battle that one of the tribes of Israel was in danger of becoming extinct. Eventually the Israelites relented and permitted the Benjaminites who had escaped the battle and hidden in the wilderness to return and to restore their tribe by taking the daughters of Shiloh as wives. The Psalter omits the battle itself and concentrates instead on the fate of the Benjaminites: their sin against the Levite's wife (fol. 63v), their flight as the Israelites

worship at the tabernacle (fol. 64r); their return as the priests pray for them to do so (fol. 65v); and their taking the daughters of Shiloh (fol. 66r). The story, unrecorded in Western art until the thirteenth century, also appears in the *Bible moralisée* and Morgan Picture Book; however, the former omits the subject of the Psalter's fourth miniature, and the latter omits that of its third, so the threat of the loss of the Benjaminites never appears. In the Psalter the point cannot be missed. It is explicit in the legend on the reverse of the final miniature, which explains that the daughters of Shiloh are taken, as the priests in the previous miniature agreed, in order to restore the line of Benjamin ("por restorer ligniee").[35] It is implied in the previous miniature (fol. 65v) by the way a Benjaminite, coming down from the mountains in tattered armor, looks toward the soldiers who follow him and points up to heaven, suggesting that their return is God's command.[36] Divine guidance is also suggested by the abbreviated representation of the tabernacle referred to earlier; it appears in three of these four miniatures and only in the Psalter's version of these events. On one level the tabernacle is not surprising, given the references in the text to prayer or religious celebration. On another level it has larger implications, for this is not the simple altar of earlier illustrations in Judges but the desert tabernacle, with the menorah and golden altar and boards of the outer chamber, which reappear here for the first time since the events in the Sinai. The prototypical sanctuary, once again in a desert landscape, is a reference to an originary period, one that radically grounds these events in a larger context.[37] In the salvation of the Benjaminites is the preservation of Israel, so that the final miniature, with the tabernacle set among the vineyards as the Benjaminites forcibly carry away the maids of Shiloh, is as much an image of fertility and the promise of progeny as it is one of rape. The Judges illustration thus closes somewhat as the Genesis illustration did, with reuniting brothers or tribes and the assurance of the continuity of the people. The stage is again set for the emergence of a nation, now under the rule of a king.

A king does not appear until the final miniature, but royal associations begin much earlier in the prefatory cycle. I have already noted how they thematize ideas of dynastic continuity and of *regnum* and *sacerdotium* and use compositional and narrative relations to describe roles of leaders and priests or prophets, such as Abraham

and Melchizedek.[38] While these latter relations may not be about kings per se, they are relevant in that they describe a construction of authority and influence and show the exercise of leadership.

As in the case of the Abraham and Melchizedek miniature, the most notable are those which conspicuously depart from traditional representations. For example, the full-page painting in which Moses asks Pharaoh to free the Israelites is a carefully worked-out balance of opposing parties: at the left, the seated Pharaoh with his court; at the right, the group of huddled Israelites and the head of the Lord in a cloud bank above; and between them, Moses, who looks toward Pharaoh while pointing up to the head of the Lord with one hand and down to the Israelites with the other (fol. 30r). This is very different from most depictions, in which Moses, standing on one side of the miniature, gestures to the enthroned king at the center or other side. Here Moses is the central figure, his body effectively replacing the central colonnette, so that he becomes not only the narrative intermediary through which God communicates his message to Pharaoh about his people but, structurally, the fulcrum expressing the standoff of interests between Pharaoh on one side and God and his people on the other.[39] He is a remarkable figure, at once independent and in control, his body and arms, like those of the conductor of an orchestra, expressing both his intention and their own instrumentality.

This conception of action and agency is drastically modified in the unusual miniature of Balaam and Balak (fol. 38r). The story concerns king Balak, who calls upon the prophet Balaam to curse the Israelites. Fearful of the Lord, Balaam tells the king to prepare sacrifices. God then appears to the prophet and tells him to say that he cannot curse Israel, which is blessed and to be reckoned with among nations.[40] The prophet then communicates this message to the king in different parables and prophecies, as they "see" Israel from a high place. The Psalter miniature condenses the narrative into a single, highly abridged series of events. At the left is a full-length figure of Christ, who appears to the prophet. At the center the prophet tells the king about the descendants of Jacob, who are shown in their tents at the far right. The king, however, points down to an altar, which is so placed that Balaam, instead of telling the king about the descendants of Jacob, seems to command the

king to sacrifice. And because the Israelites are immediately before the king and prophet and are not seen in the distance, they appear to be the king's own people, not the descendants of Jacob.[41] The result can be read in the legend. Taking his cue from the altar, the writer understood the miniature to illustrate how the prophet is instructed by God to tell the king and his people to sacrifice.[42] The emphasis is not on Balaam's prophecies, even his well-known prophecy of a scepter rising out of Israel, but on the chain of command, one in which the king has a clear, though limited, role. The compositional relations are especially noteworthy: the linear sequence from Christ through prophet and king to the assembly; the crucial positioning of the king, who holds the center and is narratively parallel to Christ; the dual, almost bilateral positions of the prophet, first with Christ and then with the king and people, his two separate zones of influence; and the people who sit on the ground as though they are instructed or preached to rather than commanded.[43] As an image of hierarchy, the painting is remarkable primarily for its horizontality; but as an image of kingship, it is a notable visualization of the king as an intermediary to his own people, albeit one who sacrifices and is advised by the prophet. The text is about a Moabite king, a reluctant prophet, and a messianic prophecy; the miniature is about secular office and some of its authority, functions, and obligations.

No miniature makes that statement more directly than that in which Joshua is made leader of Israel (fol. 40r), a miniature discussed in the last chapter in terms of its exceptional composition and its thematic parallels in the Sainte-Chapelle stained glass. Many aspects that may have seemed unusual are now familiar to the reader, especially the clear identification of parties, the circuit of communication between them, and the way the miniature addresses issues of authority and responsibility, in this case Joshua's acceptance of the leadership of his people. Unlike the examples above in which the leader or king is central and functionally intermediate, here Christ is the critical link, joining the leader and the led, the bearer of office and his responsibility.

Another aspect of Joshua's commission is shown in the other half of the miniature. Now dressed in armor, his sword drawn, he rides ahead of his cavalry, probably leading the Israelites into the Promised Land, as the legend states and as is traditional in the illustration of the first

verses of the text. However, the river Jordan is not shown, and Joshua looks back at his men. The way the soldier beside Joshua looks at him while gesturing to the other soldiers behind them suggests that the principal subject is the army's expression of support. That subject is found in the late-twelfth-century Parisian Manerius Bible (Paris, Bibl. Ste. Geneviève, MS 8, fol. 141v), where Joshua is armed and on horseback beside a group of Israelites who hold a scroll inscribed with part of verse 16, "All that thou commandest us we will do." The right scene thus completes the left: having received custody of the people from God, Joshua takes command. The two halves of the miniature should be seen as complementary: the assumption and exercise of authority, the leadership of the people and of the army, the people who attend and then assent. If any miniature in the Psalter comes close to a religious ritual in which the leader of a people is elevated and acclaimed, it is this one. In this prefatory program, the leaders acquire and practice their roles in various ways, and kings do not always require coronation.

· · ·

The Accession of Saul (fol. 78r) deserves the closest scrutiny. It brings two cycles to conclusion. It is the last subject in a series of seven miniatures showing how kingship was instituted in Israel, and it is the last subject in a prefatory cycle that, among other functions, situates that event within a larger history. Here Saul appears for the first and only time with crown and scepter. This miniature is not the only one to show a king with these signs of office, but because of Saul's stature, physiognomy, bearing, and treatment within the composition, it is certainly the most impressive. If there is any miniature in this cycle likely to have spoken directly to its royal patron, it is this one. Yet Saul was hardly considered a paragon of kingship during the Middle Ages; in fact, he was among the most vilified of all Old Testament kings. How is it then that the illustrations in the prayer book of France's most saintly king culminate with so threatening an image, a king who lost God's favor and ultimately his kingdom?

The painting illustrates the single verse—1 Sam. 11:15—in which the people of Israel celebrated Saul's victory over the Ammonites by going down to Gilgal, where they "made Saul king before the Lord," sacrificed, and rejoiced. Saul is a young man, beardless, his hair coiffed in the short style characteristic of other kings and of many youths in the Psalter, including those behind him.[44] He is, however, larger and taller than they. He wears a golden crown and carries a scepter in his left hand; with his right, he holds the strap of his mantle, pulling it around his shoulders as he briskly strides to the right, toward the tabernacle. Behind him is a group of young men, one of whom looks to the others as he follows the king. In front of him Samuel kneels before the tabernacle and offers up a young lamb in his covered hands. In the background is a youth who sacrifices another lamb.

The miniature is part of a discrete series beginning on folio 72r. The Ark having just returned to Israel, the Hebrews demand a king of Samuel, who at the left explains the evils of kingship and then at the right, following the Lord's instructions, privately anoints Saul. There follows a double-page opening with four subjects, some of exceptional rarity in medieval art: Samuel explains God's intentions to Saul and the three signs he will see, signs confirming that the Lord has chosen him to be king (fols. 73v–74r).[45] The next double-page opening juxtaposes Nahash's terrible threat to blind the men of Jabesh-Gilead and Saul's response, his raising an army (fols. 75v–76r). The last opening shows Saul's victory over Nahash and the episode at Gilgal (fols. 77v–78r). The series thus begins with the Israelites' demand for a king and ends with their getting one.

The seven miniatures form a series in several other ways too. They are all by the same artist and differ from the immediately preceding ones in their palette and their treatment of forms. Although anticipated in earlier miniatures of the Saul Master, especially those involving the early life of Samuel, the strikingly sculptural, luminous forms of these paintings are unique in the prefatory cycle and are pitched at a higher level of pictorial richness. In its exclusive concern with Saul, who appears in all but one miniature, the series also forms a biographical unit. With some subjects unrepresented,[46] the series has the kind of selective four-part structure discussed earlier, as in the history of Gideon, for it begins with Saul's calling, continues with the signs and then with his testing, and concludes with his victory. Lastly, it is a unit in a ceremonial sense. The holy oil and the crown, two of the essential components of the contemporary ceremonial of coronation, appear in the first and last miniatures respectively, so that the whole narrative unfolds between these two ritual markers.

Making a man into a king is a complex process that traditionally involves elaborate rituals of initiation, such as consecration, the recitation of responsibilities, and the taking of oaths.[47] In the Old Testament kings are usually made through a double ritual involving anointment and some form of public recognition or proclamation.[48] In the case of Saul, both the biblical and pictorial narratives include his anointment, the signs of God's selection, its confirmation in his victory, and its public celebration at Gilgal; that is, the anointment substantially precedes the public accession. These two events and thus Saul's change in status occur differently in text and picture. The biblical text describes Saul's exceptional stature as soon as it introduces him, and tells how "God gave him a new heart" after his anointment.[49] In the Psalter that stature and confidence do not appear until the final miniature, where they mark the achievement of kingship. Similarly, the public recognition of Saul comes three times in the biblical text: first, in his prophesying among the prophets; second, in his being chosen by lot at Mizpah, where he is acclaimed with shouts of "Vivat rex";[50] and finally, in the Gilgal episode. Again, only the last subject appears in the Psalter.[51] However much Saul's kingship is anticipated or ritually prepared in the earlier biblical events, in the picture cycle the evidence of Saul's change in status is found only in the final miniature.

In earlier painting the anointment in 1 Samuel 10:1 and the celebration at Gilgal in 1 Samuel 15 are both opportunities for showing Saul's accession, although the representations of either event are relatively rare. In the Psalter and in other extensive cycles of illustration that depict both events, the anointment is usually very literal; that is, the action tends to be limited to the anointment proper, and Saul has no dress or attributes of royal office.[52] If, however, the anointment is the only subject illustrated, it is sometimes elaborated with a crown or some distinctly royal attribute.[53] In contrast, the Gilgal episode is the traditional place for showing Saul's elevation. In Byzantine art the crowned figure of Saul is raised on a shield, anointed, and acclaimed.[54] In the Pamplona Bible (Amiens, Bibl. Mun., MS lat. 108) he also appears crowned as he is acclaimed before a diverse group of younger and older men.[55] The Morgan Picture Book and Queen Mary Psalter follow contemporary coronation imagery and show Saul seated frontally as he is anointed and crowned.[56] In contrast to the earlier anointment

episode, which may be exceptionally elaborated into a scene of crowning or accession, illustrations of the events at Gilgal always show Saul's accession, but there is no norm for doing so. And of the ceremonies that are depicted—some combination of anointing, elevating, crowning, and acclaiming—none is mentioned in the biblical text or illustrated in the Psalter miniature.[57]

Seen against this background, the Psalter's version of the events at Gilgal may appear refreshingly distinctive and straightforwardly responsive to the biblical text. Saul is not being anointed or crowned (though the legend says he is). The sacrifice is illustrated, other Israelites attend, and Saul already possesses the primary symbols of royal office, the crown and scepter. The introduction of these symbols is sudden but not inconsistent with the celebration at Gilgal as a renewal of the kingdom.[58] Saul is handsome, his face round and youthful, and his features, which correspond to those of youthful saints or knights of French jamb statues or tomb sculpture,[59] are idealized. The young men behind him recall the groups who follow Abraham, Moses, and Joshua; that is, they suggest the people are with him even if he is not being acclaimed in a traditional way.[60] In short, the miniature may depart from its visual precedent, but it presents a positive image consistent with the biblical text.

That image is sustained and clarified when the miniature is seen in relation to the themes that are central to the cycle as a whole. Thematically the miniature presents the Psalter's most powerful image of the now familiar subject *regnum et sacerdotium*. Saul and Samuel may not be the prototypical exemplars of the theme that Abraham and Melchizedek or Moses and Aaron are, but it is in fact as *rex* and *sacerdos* that they are frequently cited in commentary.[61] The arrangement of the painting—with Saul and his entourage occupying the left half and Samuel, the sacrificing youth, and the tabernacle limited to the other—separates and effectively defines two functions. At the same time, Saul is clearly linked to the sacrifice through his gaze and movement. The two men act in concert, one standing and the other kneeling but both facing the tabernacle and attending to the sacrifice. With Saul so conspicuously shown as king and Samuel as priest, the description and interrelation of their offices could hardly be clearer.

Yet there are ambiguous and disconcerting elements in the miniature. The Israelites are neither elders nor sol-

diers but well-dressed youths, and they follow, but do not celebrate, the king. Samuel does not attend to Saul, but the king attends to the sacrifice, his gaze clearly directed toward the lamb and into the tabernacle. The unusual character of this miniature becomes clearer when it is compared to the corresponding scene in the Morgan Picture Bible (fig. 84), the only other version of these events, where the sacrifice is shown as a separate but contiguous subject and Saul has no part in it. Moreover, the Lord looks down to see Samuel's sacrifice, whereas in the Psalter there is no indication of its acceptance or rejection. And although the biblical text describes how Saul and all the men of Israel rejoiced greatly at Gilgal, the mood in the Psalter miniature is hardly festive. In fact, it is unclear whose sacrifice is being offered, what the role of the youths is, whether anything is really being celebrated, or how Saul has been made king. With a pictorial hole over the kneeling figure of Samuel, the composition is unbalanced. It is unlike traditional scenes of royal offering, for Saul does not kneel or really offer anything, and it is unlike any other medieval ruler portrait, for Saul is not enthroned or received, blessed or acknowledged. The miniature is also at odds with others in the Psalter. A distinct group of paintings, some of the most innovative in the cycle, meaningfully position a leader or king in relation to the deity on one hand and his people on the other. Whether it is Moses or Balak mediating God's message about his people (fols. 30r, 38r) or Joshua being introduced to his people in the

desert (fol. 40r), the exchange between the parties is clear and the circuit of communication complete. Among these the miniature of Balaam and Balak (fol. 38r) is especially revealing, because it is also the work of the Saul Master and because there are numerous similarities in composition and detail. In terms of narrative structure, the Gilgal miniature is the Balaam composition in reverse. That is, the eye moves not from Christ to the king, prophet, and people, but from the people to the king, prophet, and divinity, at least insofar as the latter is represented by the tabernacle. However, the tabernacle is no narrative substitute for the deity, and nothing returns Samuel's and Saul's attention. Nowhere is the absence of a response more strongly felt than in their act of offering, for there is the implicit expectation that the king and prophet will receive something in return. Unlike the Morgan illustration of this episode, unlike so many Psalter miniatures in which an angel, the head of Christ, or the hand of God responds to a leader or prophet, Saul and Samuel receive no such gesture. One is left with a lopsided economy of exchange, an incomplete circuit of communication, and an unresolved pictorial structure. Much is lacking: a recognizable ritual, a familiar sign of God's blessing, a clear relationship among the king, priest, and people. Instead, the miniature presents carefully positioned figures whose interaction is pending and a king and prophet who seem to attend to something beyond or outside the page, which is in any case the direction in which Saul so elegantly strides.

As a scene of sacrifice, this painting relates to the first miniature, the Sacrifices of Cain and Abel. While there are many scenes of sacrifice and offering in this prefatory cycle, Abel in the first miniature and Samuel in this one uniquely share a number of unusual details: they both kneel, the folds upon their forward legs are similarly arranged, and the lambs are curled up in their hands. Such parallels may be accounted for by a common pictorial source and by the exegetical tradition in which Abel and Samuel both represent the priesthood or Church.[62] The juxtaposition, however, must function on another level too, for it can be no coincidence that these two miniatures open and close the cycle, as Jordan pointed out years ago, a cycle in which sacrifice and offering are thematically so central.[63] But if they are juxtaposed, are then Cain and Saul also being compared? I am aware of no textual precedent for doing so, and visually the two figures have nothing in common.[64] Rather, their relation lies in their being functionally antithetical.

Cain and Saul and their sacrifices could hardly be more different. In the first miniature, most strikingly, Cain turns away, is awkward and alienated, and this creates the decisive split between the two halves of the miniature. In contrast, Saul's powerful participation in the sacrifice, even from a distance, draws the two halves of the painting together narratively. The two halves are also linked formally, especially by the corresponding curves of Samuel's back and Saul's right silhouette and by the connecting line of the youth between them. And Saul not only turns toward the sacrifice but is an image of elegance and self-possession, the key visual element on which the cohesion of the entire composition depends. Given the historical character of the cycle, the antithetical relation of the first and last miniatures has larger implications. In the cycle the *tempus humanum* begins with the breach between Abel, or the priesthood, and a man alienated from God, and it ends with Samuel, or the priesthood, and the first king chosen by God to lead the people whose history is the content of the intervening miniatures. The last miniature of the cycle not only reconciles the pictorial and behavioral differences that are so striking in the first miniature but implicitly suggests that the institution of kingship is a decisive, normalizing event in man's relation to God and the Church. The accession of Saul at Gilgal becomes the opportunity to describe an idealized, prototypical image

of a monarch and of *regnum* and *sacerdotium,* to illustrate not just the renewal of Israel but a turning point in history.

Two other miniatures from the beginning of the cycle inform the reading of the final Saul miniature. Abraham's Victory over the Kings and Abraham and Melchizedek Exchange Offerings are thematically analogous to Saul's victory and accession at Gilgal (fols. 5v–6r, 77v–78r). The two battle scenes are similar in precisely the way the painting of Abraham's Victory is so unique — how the victory is personalized, how the protagonist is brought forward, placed centrally, and heroically enlarged in relation to all other figures on the battlefield. There is much to suggest that the Abraham miniature inspired many of the details of the later battle scene. Saul's effort to push down the face of Nahash, an action that makes no sense if he pulls his sword downward at the same time, was probably inspired by Abraham's effort to push down the head of the king he is about to slay. Similarly, Nahash's splayed legs recall Abraham's braced legs, and the odd soldier in the right foreground of the later episode, who seems to grope along the ground, strongly suggests the falling king whom Abraham is about to strike. There are other similarities too, but these suffice to suggest that the artist did not model the composition on a standard battle scene but on the Abraham miniature itself or a drawing for it.[65]

As in the case of the Cain and Abel miniature, the relation to Abraham's battle is, I believe, a purposeful reference, not just a function of an accessible model. The reference extends to the facing pages as well (fols. 6r, 78r). Although the miniatures of Abraham and Melchizedek and of Saul and Samuel have no details in common, they are thematically analogous in the way each follows a victory with an offering and the way those offerings are so conspicuously formulated around the theme of *regnum* and *sacerdotium.* While this conception is traditional for the Melchizedek episode, it is altogether exceptional for the events at Gilgal, which, as already noted, are normally illustrated by ceremonies of coronation and acclamation rather than sacrifice, ceremonies in which a priest may not figure at all, certainly not by the elaborate exchange or concerted offerings found in these two miniatures. The analogy between these two pairs of miniatures naturally depends upon understanding Abraham as a prefiguration of precisely

that Judaic kingship realized in Saul's accession. The visual connection is hardly surprising, given Abraham's role in coronation ceremony, in the writings of Vincent and others, and in the Psalter itself, expressed notably by the pseudo-Capetian arms associated with him in his battle with the Canaanite kings. As with Cain and Saul, the relation of Abraham and Saul has a pictorial and a thematic basis and a structural function within the larger cycle. These two sets of victories and offerings present the prototypical deeds and obligations of kingship, and these two heroic figures are each shown as ascendant, one dynastically, the other institutionally.

Even though these references to earlier miniatures, to themes of sacrifice and kingship and offering, serve to situate Saul's accession historically, the final miniature remains ambiguous and unsettling.[66] The rejoicing in the biblical text is absent. The representation of the king breaches convention, and he himself appears isolated in the picture. No sign of God or his blessing notarizes the sacrifice; no clue is offered to clarify whose sacrifice is being offered. A certain open-endedness is appropriate in a cycle that closes with a new beginning, but in this case what is absent implies a certain ambivalence about the event itself. There was ample reason to be of two minds about it. On one hand, it marked the beginning of kingship, against whose dangers Samuel himself warns; on the other, it marked the reign of a king who was soon to disobey the Lord and lose his kingdom. If in the Old Testament Saul comes close to being a tragic figure, in medieval exegesis he is not even one of sympathy.[67] He stood for failed kingship, a man condemned for his sin rather than praised as the prodigious founder of a new dynasty or era.

Saul was in fact the foremost example of a bad king. For the church fathers he is impious and ignominious; in political writing from the twelfth century he stands for the iniquity of kings; and in romance texts his deeds lead to misfortune, if they are mentioned at all.[68] In Carolingian Mirrors of Princes he represents the possibility that God will withdraw his favor from an anointed king, and during the Investiture Controversy Gregory VI uses him to characterize Henry IV's sacrilegious acts against the Church.[69] The instances in which he appears in a positive light are few. Jordan pointed out one of the most striking, Petrus Riga's *Aurora*, in which God's crowning Saul is taken as a sign of a new era of Christ and of the king-

dom of which all men are part.[70] I know of nothing similar to this powerful statement, and it is uncertain if it represents a larger tradition of interpretation that may have been known to the planners of the Psalter.

The perception of Saul cannot be divorced from the perception of the kingship initiated with his reign. As Philippe Buc has shown, exegetical writing on the issue of kingship centered on I Samuel 8, the passage in which the Hebrews demand a king and Samuel explains the risks.[71] At first the passage was interpreted as the rejection of Christ's kingdom and a recitation of the abuses of power. By the mid–thirteenth century a more favorable opinion had emerged in which God was believed to have tolerated kingship because it leads to greater good, and the abuses of royal power were seen as a warning against bad kings. This general view is found in Vincent of Beauvais's most important writing on kingship, his *De morali principis institutione,* a treatise completed, it will be recalled, at about the same time the Psalter was being illuminated. Since Louis IX and those designing the Psalter program are likely to have been familiar with it, its content invites some scrutiny. At least in Vincent's work, Saul benefited from this more circumspect view of kingship.

Although kingship is mentioned in Deuteronomy and noted among pagan peoples, Vincent takes the text of I Samuel 8 as the defining event. Like other authors, he wrote that God tolerates the institution of kingship because it compensates for the weakness of the people and their sins, and that God permits it to continue because it makes for peace and leads to salvation of the faithful. It is a dispensation that leads to something greater, just as the kingdom and priesthood of the Jews prefigure that of Christ.[72] Although these ideas are already found in Augustine, the examples Vincent uses and the inflections or variations he gives to his arguments are often strikingly parallel to those depicted in the Psalter. For example, he argues that men rule other men because of a defect in justice. To illustrate the sins for which kingship compensates, he does not cite Adam and Eve but Cain and Nimrud and their sins of avarice and ambition. What their sins destroy is a preexisting equality among men. In the context of this discussion of the sources of kingship, the originary sin is not Adam's but Cain's, and it is not so much the murder of his brother as his role in creating disharmony in nature. That is precisely the Psalter artist's interpretation of the subject.

Vincent gives several other examples of God's toler-ance toward certain events because of the good to which they eventually lead. One example, taken from Gregory, concerns the story of Joseph, how his brothers, who threw him into a pit, eventually came to adore him because he was sent ahead of them for their salvation.[73] Another, this time taken from John Chrysostom, involves God's support of even the weak and evil Philistines for the way they had their people return the Ark to Beth-Shemesh.[74] Although the details of the cor-responding Psalter miniatures, both discussed earlier, are amply accounted for in contemporary works, including the *Bibles moralisées,* Vincent's treatise provides another context for understanding them, recasting the whole cycle as a demonstration that God's providence histori-cally leads to kingship.

Vincent argues that the power to rule is given to good and bad kings alike and that some, like Saul, lose their kingdoms for their sins, while others, such as David, retain them. Vincent describes Saul not as an inherently bad king—he says there is no such thing—but as an essentially good ruler who degenerated into a bad one. In this treatise as well as in the *Speculum historiale,* he notes Saul's virtue: how he towered over others, how he surpassed everyone in goodness, and how there was none better in Israel. In fact, Saul is Vincent's principal example of the virtue of goodness requisite to all princes, and he states that Saul would have retained his kingdom had he not offended God with his pride. Moreover, Vincent sees Saul's failing as arising from the change that comes over rulers once God establishes them in leadership ("illium in ducatu constituit").[75] Moses serves as a counterexample, someone who came closer to God after he assumed the leadership of Israel.[76] Vincent's examples of those who sin include not only Saul but David, Ishboseth, Solomon, and Jeroboam. Thus Saul's offense is not the absolute iniquity it is in other texts but an illustration of how good kings change, how they become more or less perfect according to their virtue, strength of soul, and the help of God. Legitimate rule is obtained through pious acts, the con-sent of the Church and of the governed, and a long period of its exercise in good faith; its retention, how-ever, is a function of merit.

Kings can thus be good or bad—they appear as both positive and negative examples in the *Bibles moral-*

isées too—and they must earn their kingdom, an idea that appears in historical writing at Saint-Denis and else-where as well as in Vincent's treatise. However, a history of kingship, such as the *Grandes chroniques,* serves a diff-erent purpose from a prehistory of kingship, such as the Psalter's. The advantage of bringing these issues into focus around the figure of Saul is that they become a reflection on the *institution* of kingship rather than on specific reigns. And the advantage of doing so in a bibli-cal chronicle beginning with Genesis rather than with 1 Samuel is that it enables the cycle to address the nature and origins of that institution within God's plan and the events through which the piety of kings is revealed in history. In the end what matters is not whether Saul is a good or bad king but merely his status as the first king, the quality of leaders from which he comes, the destiny he fulfills, and the way the rituals, signs, and victories he has experienced have enabled him to assume his office.

Louis IX knew Vincent for at least twenty years, dur-ing which time the Dominican friar was a close advisor. The king heard his sermons, supported him as lector at Royaumont, and took an interest in his work. In the mid-1240s, Vincent prepared, at the king's request, a first clean copy of his *Speculum historiale,* and a few years later authored the *De eruditione filiorum nobelium,* a work Mar-garet of Provence urged him to finish so that her children could be tutored. In 1260, when the king's oldest son died in an accident, Vincent comforted him with the remark-able *Liber consolatorius.* More important, the content of these works clearly shows how Vincent energetically responded to the failure of Louis's first Crusade, revising and expanding the *Historiale* not only to take account of the Tartars and Mongols but, as Elizabeth Brown[77] and others have shown, to reaffirm earlier concepts of Capet-ian legitimacy, to refine the notion of empire, and, as Brenda Schildgen has argued, to present a geopolitical teleology that ends in the rise of the French nation and underwrites an expansionist agenda.[78] The numerous analogies between the Sainte-Chapelle glass and Vincent's work suggest, to my mind, that the *équipe* working on the *Historiale* may have helped shape the program of the win-dows. We do not know whether the content of the *De morali principis* was known to those designing the Psalter program, but it was certainly known to the king.

Vincent's text, now accessible in Richard Schnei-der's fine edition with analysis,[79] considers kingship

under the headings of Power, Wisdom, and Goodness. The first part deals with the origins of kingship and the legitimacy of rule; the second concerns the character and skills requisite for successful rule; and the third is an exhortation to the prince to excel in personal goodness in order to guard against threats to his reign. Vincent begins the section on the Goodness of the Prince by citing 1 Samuel 9, where Saul is introduced as towering over the others and as surpassing everyone in goodness. Goodness, however, is not an immutable quality, as Saul's fate attests. For kings to retain their kingdoms, they must strive continually to merit their special status in the eyes of God, a point that Primat makes a few years later in his prologue to the *Grandes chroniques.* In short, the fate of a king is not assured but depends upon his continued demonstrations of goodness. In the theological terms being debated in Paris at midcentury, the future is contingent, for there is always the possibility of grace. In pictorial terms, Saul is chosen and tested, he is transformed into a king, he accedes to office, but the outcome of his reign is undetermined, the narrative incomplete, the cycle still open.

Medieval painting is normally unambiguous; leaving a story purposefully open-ended is a narrative strategy more common in later painting, such as that of the seventeenth century. It would be unthinkable in this case were it not for Vincent's treatise and for his influence on the king and, quite possibly, on the king's works of art. The effect of reading the miniature in terms of Vincent's text is to link Saul with his obligations but not to prejudge him, to underscore the potentiality of the moment, and to imply an arena of future action. The effect of using Saul as the medium to express this view is a powerful reminder that no anointed king, even a good one, is assured of continuing in office. And this point is driven home especially by what is absent from the miniature—a coronation, an acclamation, a response to sacrifice—as well as the many features that remain ambiguous and unresolved. It is also a highly directed message, for in this final miniature Saul seems about to turn and face the viewer.

The final Saul miniature and the prefatory cycle as a whole amply demonstrate the antecedents, models, and conditions for the emergence of kingship and for Saul's meriting and obtaining office. Moreover, it shows him in a positive light. His physical description is compli-

mentary, and his actions imply an embrace of religious obligation consistent with contemporary concepts of the king's duty.[80] Moreover, he wields crown and scepter as a figure in motion, suggesting that he has not just obtained office but is already functioning in it, an image of reign as well as of accession. More than signs of rank, the crown and scepter have an instrumentality; like the compass the Lord holds in contemporary images of the Creation of the Universe, they define Saul as a the agent of a certain kind of action.[81] We cannot see beyond the figures and actions depicted here, but at this moment, at least, Saul is a fully empowered king behaving appropriately and facing a positive future.

Yet anyone aware of Saul's fate—as Louis IX would certainly have been—would find much in this miniature that is unsettling. As an image of reign as well as accession, the ceremonial isolation of the king and the mood of the scene might be more understandable. However, in view of how powerfully directed their actions are— Saul and Samuel attend to, gaze at, kneel before, and move toward the tabernacle—the absence of a response to their offering remains highly disturbing.[82] One would certainly expect it, given the way an angel, the head of Christ, or the hand of God responds to a leader or prophet who prays or sacrifices in the other Psalter miniatures. Moreover, the components of this miniature—people, king, prophet, and tabernacle—are those of a small group of miniatures that are, as observed earlier, among the most iconographically exceptional and innovative in the manuscript for the way in which they meaningfully position a king or leader in relation to the deity on the one hand and his people on the other. Here, however, the circuit of communication between these different elements, so clear in the other miniatures, is disrupted.[83] Analogously, the cycle too is disrupted, and is thus left open.

If the cycle is left open, it has also changed. The figure of Saul, with his leg boldly turned toward the viewer and his body riding the convex arc of the pictorial field, seems to stride off the page. For a moment he appears to come out from underneath the gabled arcade, to become part of the whole composition, to be seen not just in relation to the tabernacle at the right but in relation to the whole building, which, here as in no other miniature, seems to appear behind and around him. This relation gives the components of the page a different meaning

and changes its status for the viewer. This is no longer the historical Church, divided into its Old Testamentary and more recent epochs, but a king and church that share the same epoch, a church that because of the architectural details can only be a contemporary and Parisian one.[84] The temporal structure of the page that prevailed throughout the whole cycle here collapses, as though the inauguration of kingship were the beginning of modernity. The effect is to address the royal reader through the miniature's temporal reference as well as through its subject and formal construction. The narrative moves powerfully forward, still indeterminate and unsettling, but with a new relation to the viewer.

Would the last miniature have been so indeterminate to Louis IX as well? Would origins have been so important or Saul so problematic? The concerns with the institution of kingship, with the dynastic origins of the kings of Judah, and with the great prototypes of royal virtue are consistent with what is known of the king in these years. I have already cited his interest in royal ideology; the assertions of dynastic legitimacy that appear in the tombs at Saint-Denis, the *Grandes chroniques,* and Vincent's own writing; and his numerous expressions of piety. Many of those concerns have been interpreted as his response to the failure of his first Crusade.[85] In these years, however, they might just as well reflect his anxiety about his second Crusade, the preparations for which had probably already begun.[86] It would be possible to read the victories of Abraham, Joshua, and Saul as prescribing the victories the king would soon face in the Holy Land, or to see Saul's role in this final miniature as a veiled reminder of the loss of kingdom, a subject that had come up before in writings and sermons the king heard.[87] Insofar as kingship, its history, and its obligations were Louis's concern, both interpretations may be accurate to some degree, but in the end the reading of this final miniature may have been no different from Vincent's treatment of Saul, according to which he was a good king who would rise or fall by the merit of his future actions.

The most remarkable aspect of the Saul miniature is that the possibility of Louis's reading Vincent's interpretation in it depends on an indeterminacy that is built into the miniature, into its pictorial and narrative fabric and into its temporal ambiguity. The effect is to link Saul with his obligations but not to prejudge him, to open

up an arena of future actions toward which these initial deeds lead and, in so doing, remove the king from the historical construction of the prefatory cycle. The composition of the miniature powerfully makes the point: the curve that swings down from Saul and back up to the tabernacle seems to keep going, and Saul himself strides forward and appears about to turn from the page. In the end, everything will depend upon the virtue of the ruler, and that is precisely the issue taken up in the illustration that inaugurates the next part of the book. There, however, the ruler is no longer Saul.

On the one hand, using Saul in this way is an indication of the contemporary anxiety about continuation in office and its use, especially after Louis IX's first Crusade, to motivate pious acts. On the other hand, only in the case of someone like Louis IX could one be confident enough of the goodness of the king to use Saul as an example in the first place. That one does so is a striking example of how Old Testament figures, even in official works, can bear complex and problematic messages, ones not always celebratory or entirely positive. And it is also a reminder of how the visual arts could sometimes tell the king something it would be difficult to say in some other way. It should also be noted that the manuscript provided the king a means to retain God's favor, for it is at this point in the book that the king would turn to the Psalms. In Paris at this time, the function of the Psalms was largely penitential, and the initial to the first psalm illustrates the royal sin par excellence, David's watching Bathsheba bathing, a subject ordinarily associated with penitential Psalms 50 and 101. The viewer thus moves from the end of the pictorial cycle and the image of a good king who failed, to the beginning of the Psalms and the image of a sinful king who was forgiven.

Bathsheba and the Psalms

The painting of Saul Acceding to the Kingship of Israel brings to a close the series of seventy-eight illuminations of the first section of the Psalter of Saint Louis. This Old Testament program constitutes a carefully constructed prehistory of biblical kingship that would have stood for the origins of the Capetian institution and for the moral obligations by which rulers deserve God's favor and retain their office.[88] Although the choice of Saul as an

endpoint marks the institution of a form of kingship with which Capetian rulers identified both historically and morally, the event itself is described in surprisingly ambiguous terms. In the previous pages I argued that its meaning, though highly charged, is left purposefully undetermined and that as a result the whole prefatory cycle, otherwise so integrally constructed, seems to lack a conclusion. Fortunately, the Saul miniature is not the final word on kingship but only a pause, for it is followed by an unillustrated calendar of liturgical feasts and commemorations and then by the Psalms of David. The calendar is also highly personalized: it is intended for use in the royal chapels, and it commemorates the anniversaries of the deaths of the king's father, mother, grandfather, and brother.[89] After the calendar come the Psalms, beginning with the last full-page miniature, the Beatus initial (fol. 85v). In this miniature, one of the most personal and visually innovative in the manuscript, the key element is Bathsheba, who is shown entirely unclothed as she sits beside a stream. To a large extent the interpretation of the manuscript hinges on this naked figure and on how the king would have understood her. In many ways, the image provides the closure lacking in the final miniature of the prefatory cycle.

The illumination, framed like the earlier miniatures, consists of a full-page letter *B* and, alongside it, the first seven words of Psalm 1: "(B)eatus vir qui non abiit in consilio," or "Blessed is the man who walks not in the counsel" (of the wicked).[90] The psalm, which continues on the facing recto, contrasts the fate of the wicked, who will perish, with that of the righteous, who meditate on the Law and will prosper. Represented in the upper part of the *B* is David in his palace, looking at a nude Bathsheba, who sits beside a stream as she is bathed by two youthful attendants. In the lower part of the initial, David kneels in prayer before Christ enthroned in a mandorla. Because this incident with Bathsheba led to the commission of several sins for which David was severely punished and, with prayer, eventually forgiven, the miniature would seem to present a straightforward contrast of sinful and righteous behavior, the same kind of contrast found in the text and, appropriately, a lesson drawn from the life of its author. In its most basic terms, the initial may be said to illustrate the text and to conform to the practice of illuminating psalm initials with events from the life of David.

While true, this interpretation hardly does justice to this subtle, complex, and historically exceptional painting. At this time, illustrations to the first psalm usually show David as an author, hero, or king, composing the psalms, triumphing over Goliath, or being anointed.[91] The implicitly penitential message of the Louis Psalter initial is unusual in French psalters, and the Bathsheba incident is unheard of as an illustration to the first psalm. Moreover, medieval commentators generally understood the story in positive terms, as an allegory of Christ's love for the Church, and so earlier representations minimize Bathsheba's exposure and the carnal overtones of David's gaze.[92] Here, however, Bathsheba is not just bathing: she is carefully posed, set in a landscape, and offered for view. The voyeur is not only King David but the reader of the book, and Bathsheba responds to these two kings with a self-consciousness we would hardly expect from a symbol of the Church. It is no accident that the painting employs the body and the gaze as it does, for they enable the page to raise issues of vision and subjectivity at precisely the point in the manuscript where looking intersects with praying and where the depicted king is conflated with the real one.

Medieval art offers few representations of an unclothed woman presented for view in this way.[93] There are, however, two others from this same decade and the same circle of Parisian art. Moreover, they both represent Bathsheba.[94] Each of these unclothed figures is distinctive in conception and context, and each involves a different formulation of the body and construction of viewing. Together, however, they raise the larger issues against which the transparency of allegory in the Louis Psalter must be understood: the exceptional circumstances of bodily exposure in medieval art; the cultural representation of the female body in thirteenth-century France and its conventionalization in art; the relation between vision, the female body, and knowledge. But what this representation is really about is the reinvention of the nude in medieval art and the peculiar circumstances of its appearance in the private prayer books of the royal family.

The biblical text presents the circumstances of the upper subject in only two verses. The incident takes place on a spring day, some time after the death of Saul, when David is king of Israel and Judah. Although his troops are fighting the Ammonites at Rabbah, David

remains in Jerusalem. Late one afternoon, he sees from his roof or terrace a beautiful woman bathing. The action, the only real action, is that of viewing. The ensuing events, though unillustrated, are triggered by this incident. David inquires and is told Bathsheba is the wife of another man, Uriah the Hittite, who is away fighting alongside his countrymen. David is taken by Bathsheba's beauty and summons her and has sexual relations with her. When she subsequently tells him she is pregnant, he tries to cover up his actions by having Uriah sent home to Bathsheba, so that it might appear that the child is theirs. Uriah, however, refuses to enter his own house while his countrymen are still fighting in the field. David responds by sending him back to the front and having him reassigned to the place where the fighting is fiercest and where he soon falls in battle. After a period of mourning, David weds Bathsheba, who soon has their child. The prophet Nathan then comes before David, severely rebukes him, and describes the terrible misfortunes his house will suffer because he has despised the word of the Lord. David acknowledges his sin and is spared, but his child's life is taken. Eventually the Lord finds favor in Solomon, their second child.[95]

Medieval commentators traditionally discussed these events in two ways. First and more commonly, they read the biblical passages allegorically, following Augustine's interpretation of David and Bathsheba as types for Christ and the Church. In this reading David's desire for Bathsheba stands for Christ's love for the Church, whom he sees washing and purifying herself of sin, and David's taking Bathsheba from Uriah is understood as Christ's saving the Church from the devil or the Jews.[96] The couple is compared to the lovers of the Song of Songs, Sponsus and Sponsa, and Bathsheba's washing herself becomes a type for the sacrament of baptism. This is the interpretation one finds in the thirteenth-century *Bibles moralisées,* where David peers into a window and sees Bathsheba, bare-breasted in a tub, washing herself; in the adjacent interpretive roundel Christ looks at Ecclesia in an analogous way, and she is usually shown enthroned, being baptized, or rejecting the Jews.[97] The Latin *Bibles moralisées* also show maidservants who bring Bathsheba water and comb her hair. Although they may reflect contemporary bathing practices, for bathing was becoming increasingly common in mid-thirteenth-century Paris, the maids also characterize

bathing as a more elaborate process, a rite of cleansing and beautification that, in French literature of the time, implied purification.[98] The latter, of course, lies at the heart of the allegory, and so the attending maids, in this and in other works, may be one way of suggesting that the transformation of Bathsheba into Ecclesia has already begun.

The second interpretation was moral, for it evaluated David's motives and actions, their implications and God's judgment, and it historically associated the David of 2 Samuel with the author of the Psalms, especially Psalm 50, which is David's confessional response when Nathan confronts him with his sins. Here interpretation centers on the fallibility of even the most saintly kings or religious figures, the essential role of penance, and the possibility of divine forgiveness. Both the allegorical and moral readings go back to the church fathers, coexisting through the Middle Ages within the different senses according to which scripture is interpreted.

Looking at a specific *Bible moralisée*, Oxford, Bodleian Library, MS 270b, it is clear that both of these interpretations are characteristic of the visual arts just prior to the Psalter of Saint Louis. The allegorical reading appears from the outset in the roundel in which David first sees Bathsheba (fig. 85).[99] The youthful king stands outside Bathsheba's house and peers through a small window to see her naked from the waist up as she bathes in a wooden tub. Just below, in a compositionally analogous roundel, Christ looks through two wide-open doors to see Ecclesia, fully clothed and crowned, as her detractors fall away; the text is explicit that Christ not only sees her but looks at her beauty and purity and loves and cherishes her.[100] The next seven miniatures present the full story, from David's adultery to his marriage to Bathsheba, and in almost all of them David is compared to Christ, Bathsheba to Ecclesia, and Uriah to the devil. The scenes with Uriah provide the opportunity for commentary about Jews and sinful monks. But in the last two roundels, when David is confronted by Nathan and falls to his knees in prayer, the allegory suddenly stops, and the reading turns sharply moral. The roundels below compare David to bad kings and officials who unjustly take from the poor and whose forgiveness, like that of all Christians, requires penitence and the prayers of the Church (Oxford, Bodleian Libr., MS Bodley 270b, fol. 160r). In fact, the last roundel shows that forgiveness also

FIG. 85 *Oxford, Bodleian Library,* MS Bodley 270b, Bible moralisée, *fol. 152r, detail: David and Bathsheba. Reproduced by permission of the Warden and Fellows, New College, Oxford.*

requires a cleric's whip on the king's bare back.[101] David the figure of Christ, whose previous actions reiterated the status and purity of the Church, here becomes David the historical king whose behavior is scrutinized and made into an object lesson. The historical king is present only in these final miniatures, not at the beginning, when David first sees Bathsheba.

. . .

The allegory is expanded in a series of six reliefs from the cathedral of Auxerre, a work strongly influenced by Parisian art, if not actually sculpted by Parisian masters (figs. 86, 87).[102] The reliefs fill the lower jamb walls of the right western portal, which is dedicated to John the Baptist. The Bathsheba cycle begins on the south jamb with David standing in his palace and peering into the adjacent panel, where he sees Bathsheba, nude from the waist up, sitting on a hillock beside a stream as she is washed by a maid. A third relief shows Uriah,

Bathsheba's husband, riding to battle, in accordance with the king's orders; in the fourth, on the opposite wall, Uriah falls in battle, as David planned. Next comes David standing beside the widowed Bathsheba, probably taking her as his wife;[103] and, finally, he plays music for her as they are enthroned together.

The Auxerre reliefs involve three kinds of readings that are normally distinct. First, is the royal love story in which the historical account is almost unrecognizable. There is no suggestion of David's sin or his subsequent penitence. Uriah is a hero fallen in his country's defense rather than David's victim. And Bathsheba, who was the distant object of David's desire in the first relief, sits beside him and listens to his music in the last one. The desire that in the biblical text resulted in rape leads instead to this dignified image of possession and to a cultivated musical expression of love.[104] This transformation is consistent with the way the thirteenth century so often recast Old Testament narrative in the idiom of epic romance.[105]

The second reading is explicitly allegorical. As in the thirteenth-century *Bibles moralisées*, David's desire for Bathsheba stands for Christ's love for the Church, whom he sees washing and purifying herself of sin.[106] At Auxerre, the maid actively washes Bathsheba, whereas in other outdoor representations Bathsheba is fully dressed and merely dips her feet into a stream.[107] Most telling is the way the maid pours water from a jug upon Bathsheba's shoulder, a direct reflection of how John baptizes Christ in the central scene over the doorway. In addition, the personifications of Philosophy and the Seven Liberal Arts, seen in the spandrels above the David and Bathsheba story, effectively describe Ecclesia in terms of religious wisdom, much as they do in the archivolts surrounding the Virgin and Child in the right western portal at Chartres.[108] With similar references appearing in the other reliefs, Wayne Craven and Ursula Quednau interpret the entire series as a history of Christ and Ecclesia, beginning with her purification, or baptism, and ending with her marriage and coronation, the latter based on contemporary images of the Coronation of the Virgin.[109] The compatibility of these two readings is noteworthy: the sacramental, royal, and intellectual descriptions of Ecclesia do not interfere with the narrative power of the Old Testament story, just as the military and romantic imagery does not detract from the religious allegory and its ritual and institutional implications.

FIG. 86 *Cathedral of Auxerre, right western portal, southern embrasure, scenes from David and Bathsheba.*

FIG. 87 *Cathedral of Auxerre, right western portal, northern embrasure, scenes from David and Bathsheba.*

The military and romantic imagery of the David and Bathsheba story sometimes did exist apart from the religious. Take, for example, the series in the Morgan Picture Book (fig. 88). It opens on a street scene in which David, looking out from the balcony window of his stone palace, sees Bathsheba across the way, in the second floor of her wooden house, as she bathes in a wooden tub just before the window. As her maid brings her a caldron of hot water, David commands a servant on the street below to summon her. In the next scene the couple is in bed. David lies behind and above Bathsheba, holding her shoulder with one hand and her breast in the other. With her head lying against the small of his arm, he lowers his face to hers. The covers come to just above their waist, but there is no doubt about what lies beneath, for behind the bed is an enormous erect candle that rises all the way to the top of the split in the curtains. The first episode is less about seeing than about summoning, and in both events more pleasure is taken in power and in the visualization of the physical world than in seduction or in beauty. Indeed, the Morgan paintings treat sexual and military engagements in much the same way (figs. 88, 89): both are opportunities for overlapping bodies, tightly held limbs, a threatening, closing proximity, and aggressive positioning. And nothing suggests an allegory or moral message. Indeed, the smirking courtier at the marriage of David and Bathsheba seems to mock the couple and to suggest that circumstances are less than they appear to be.[110] When Nathan appears before David a few pages later, his message is not of repentance, as it was in the *Bible moralisée,* but of punishment, in this case the death of the child to whom he points; and David merely exclaims to Christ, who appears above, rather than fall to his knees in prayer, as he did in previous miniatures.[111] Typological or moral readings are appropriate for other subjects in the Morgan manuscript, but nothing suggests such readings in its David and Bathsheba miniatures.

The corporal also plays a role in the Auxerre reliefs, but the narrative and artistic conventions and the conception of gender and sexuality are altogether different. Consider the first two reliefs of David and Bathsheba (fig. 86). There Bathsheba, rather than indoors and in a tub, is seated outdoors on a mound with trees to either side, and David is inside looking out, their positions opposite to those in the *Bible moralisée* illustration of

Bodley 270b (fig. 85). David is some distance away, in a different relief but also in a starker setting, and he views Bathsheba through a window and across the architectural frame, so that he would seem to be looking not only into another space but into a different level of reality, much as John in contemporary Apocalypse illustration stands in the margin and looks through a window in the painting's frame to see the visions painted within.[112] In contrast to David's palace, with its geometric forms and flat incised surfaces, Bathsheba's setting has curving mobile forms and rich contrasts of depth and texture. David bends slightly forward to look down through the window, his view passing the tree and maid and falling on the bare breasts of Bathsheba, just where the maid places her hand to wash her. For David and thus for the viewer, sight leads to touch, the maid's hand becoming an instrument of vision. Bathsheba is positioned to be accessible to that vision. She is seated on a hillock, her lower body slightly outward, her chest turned fully to a three-quarter view, and, with her left arm pulled back, her shoulders and breasts thrust outward. Her face is lost, but the position of her head suggests she looked straight ahead. Her robe, lowered to the belly, encircles her torso and still covers one arm. Her lower legs are crossed, the bottom of her right foot emerging from drapery just by the stream of water that seems to flow from the hillock on which she sits.

Neither of the readings above accounts for the Bathsheba the artist presents here. The proportions and the modeling of her body recall antique sculpture, as do certain features and motifs, such as the way her robe falls to the waist and is draped over one arm, how her bare right foot emerges from under the left leg, or the way her left arm is pulled back, as though to steady the figure.[113] The dado of the adjacent portal includes the well-known reliefs of a heroically nude Hercules with the lion's skin and a gracefully dancing faun, both within an Old Testament cycle of the life of Joseph, and below the Wise Virgins on the doorpost of the same portal, an adolescent male cupid slumbers on his torch, his body suggestively turned to the viewer.[114] Although the subjects as well as the forms are classical, Panofsky has argued that they are thematically integral to the portal's Christian content.[115] They are also stylistically connected, for the glorification of the physically powerful or sensuous body promotes the portal's themes of

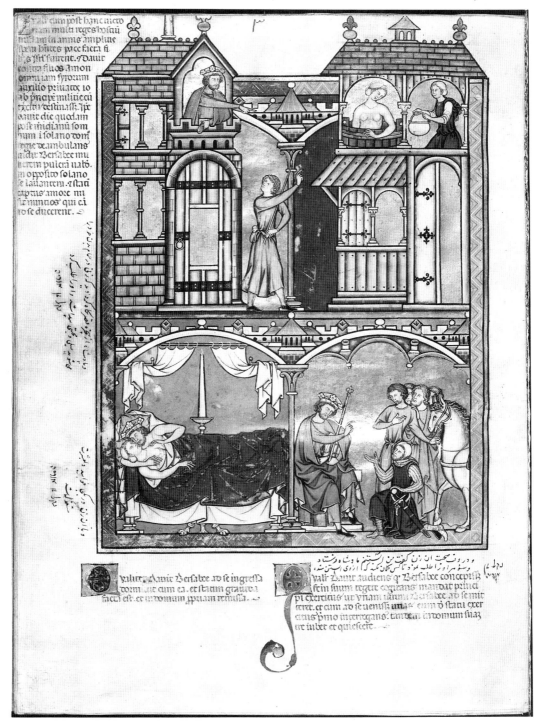

FIG. 88 *New York, Pierpont Morgan Library, MS M.638, Morgan Picture Book, fol. 41v: David and Bathsheba.*

FIG. 89 *New York, Pierpont Morgan Library, MS M.638, Morgan Picture Book, fol. 36v: Joab and Abner.*

the vanquishing of evil and the opposition of carnal and spiritual love.[116]

Classical sources are less conspicuous in the Bathsheba relief, but they account for artistic conventions that are altogether foreign to the Bathshebas of the *Bible moralisée* or the Morgan Picture Book: the progressively turned body, the drapery that seems to have just slipped from the shoulders to the belly, the arm pulled back to balance and display the figure, and the enfolded legs that part and then cross. Contrast, balance, and change are all developed from within the figure, so that in the end the body and actions of the maid merely enframe Bathsheba and are secondary to the play of cloth, skin, earth, and water, to the narrative of how Bathsheba sits, turns, adapts, and balances, to the drama of her arranging herself for vision. Although the parts of her body and limbs are functionally distinct, she is not disassembled for the viewer's gaze. Nor is she thrust on display or made to perform, for her actions are narratively credible and consistent with the setting. She is desirable enough to attract attention but too self-absorbed to attend to it. Complete and self-sufficient, she appears to be in control of herself and of the narrative, that is, of the way she is presented for view.

It would be a mistake, however, to see this figure as an exception that simply quotes ancient art, for the nude is used to construct a narrative of gendered viewing that is integral to the Christian content of the work. It indicates that something has changed in the medieval attitude not only toward the ancient model but toward the body itself and the way it figures in artistic practice. We are accustomed to the patristic view by which, after the Fall, seeing becomes equated with sin and knowledge with sexuality.[117] According to this view, the body is a curse, and so all nudity is shown as nakedness. As Michael Camille has pointed out, unless unclothed figures are virtuous, beatified, or resurrected, artists must show them as evil or banish them to the margins or disguise them in allegory, in fabulous or legitimizing narratives, in the conventions of ancient art, or in artistic techniques that distract and ultimately conceal.[118] For the Bathsheba relief and for many works of the thirteenth century, a different accounting is required. At Auxerre Bathsheba's body is proudly on display—the allegory comes after the fact—and classical conventions are fully absorbed, not made to refer to a bygone age. Similarly,

nothing suggests shame, vulnerability, or inferiority, that is, a weakness that is moral, physical, or social. Nor should we assume that at this time the body and its sexuality are always concealed. The resurrected who playfully emerge from their tombs in the Last Judgment at Reims cathedral (fig. 90) are sometimes more interested in beholding each other than turning to behold the Judge above—the artist carefully positions them so we can see their smooth legs and fleshy buttocks; and the transparent clothing of saintly figures, such as the so-called Ste-Modeste at Chartres or the personification of Ecclesia at Reims, show how at this time the disclosure of corporal beauty can be consistent with sanctity and act as an attribute of it, a way of establishing identity within a visual culture increasingly keyed to an aristocratic social discourse.[119] This should not be surprising, for the thirteenth century is, after all, that point in European art in which spiritual and corporal beauty begin to coincide. It is also the period in which the act of uncovering, of offering oneself to view, begins to take on the suggestion of access to knowledge and to the inner self that it had in antiquity.[120] Nowhere is this better seen than in Auxerre itself, in the spandrel reliefs referred to earlier. Philosophy introduces the series of female personifications of the Seven Liberal Arts (fig. 91), which is keyed to the progression of the episodes below.[121] The youngest of the personifications and the only one whose hair falls in curls over her back, much as Bathsheba's does, she stands above and behind David as he spies Bathsheba. Philosophy is also the only one to lift her mantle up and away from her body, effectively revealing herself behind David as he sees Bathsheba revealed before him. This symbolic action is found as well in the Louis Psalter, in the miniature where Joseph lets his mantle fall to the ground in order to reveal his true identity to his brothers (fol. 25v). In both scenes there is a clear link between the removal of the mantle, or the revelation of one's physical self, and the acquisition of understanding or knowledge. Unlike Philosophy, Bathsheba is not disrobing and is thus not revealing herself, but Philosophy's gesture makes clear that, to David, Bathsheba as Ecclesia is the means to religious knowledge and the person in whom it resides. Nudity thus implies accessibility, and total nudity, in the context of the Beatus initial in the Psalter, suggests the completeness of revelation.

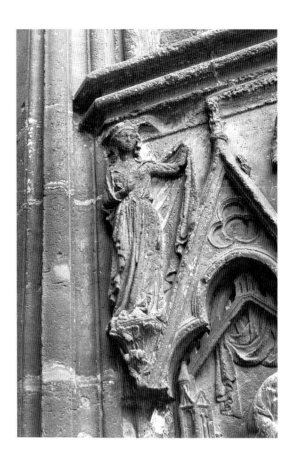

FIG. 90 *Cathedral of Reims, lintel of the north central portal, detail of the resurrected.*

FIG. 91 *Cathedral of Auxerre, right western portal, southern embrasure, detail: Philosophy.*

. . .

These links between knowledge and sanctity, the feminine and the bodily, are topoi throughout the history of Western art, and medieval art is no exception. Nonetheless, in visual as in historical and literary accounts, generalizations are difficult because interpretation often varies even among historically related works ostensibly addressing the same subject and must thus be historically specific to be meaningful. This is particularly striking in the representation of David and Bathsheba in the Isabella Psalter, the second precedent for the Saint Louis Psalter initial (fig. 92).[122] As discussed in the Introduction, the gender of the prayers makes it certain that it was made for a woman, and numerous details suggest its Beatus initial was painted just before that of the Psalter of Saint Louis.[123]

The incident in which David gazes at Bathsheba occupies the upper part of the initial. Even though there is no evidence of antique models as at Auxerre, the contemporary Bathsheba in the Beatus initial comparably manipulates body and gaze (figs. 86, 92). Here again, the details warrant careful attention. The two parts of the Auxerre

scene fill only the upper part in the initial. Again the field is split equally into architectural and outdoor settings. David is similarly distant, conspicuous to the viewer but not intrusive, and positioned to look down upon Bathsheba, who sits on the sloping ground beside a stream whose source is just beside her. Here, however, Bathsheba is entirely undressed. She is youthful and slender like her maids. Her skin, heightened with white, glows against the burnished gold background. Her torso is turned a little outward, and she has small high breasts, faintly drawn. There is now a second attendant, who holds her gown and, like David, sees her from above and behind. The other attendant, kneeling to wash her belly, turns around to look her in the face. Bathsheba's arms, like her legs, are positioned before her, as though extended for washing. They point down toward the open door of Jerusalem and, one assumes, David's palace. In the *Bible moralisée* miniature discussed earlier, Christ looks at Ecclesia sitting in a structure whose doors are open (fig. 85); here it seems that Ecclesia, washed and purified, is being prepared to enter Jerusalem.

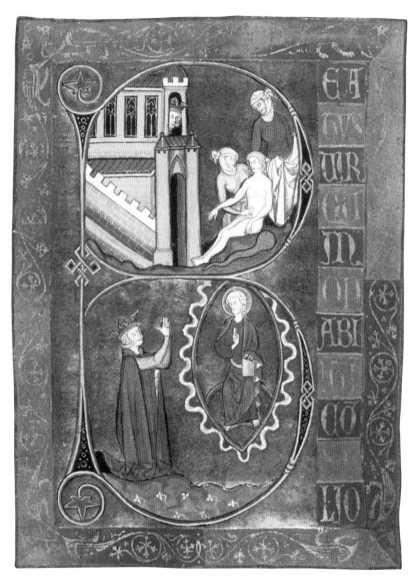

FIG. 92 *Cambridge, Fitzwilliam Museum, MS 300, Isabella Psalter, fol. 13v, Beatus initial.*

Bathsheba is also interpreted otherwise than at Auxerre. The difference lies not so much in the context or medium or in the smaller real size of the painting, which is still large in relation to the text alongside or on the previous pages. Nor does it lie in the different model of female beauty, which at Auxerre corresponds to that of ancient art and, in this initial, to a contemporary ideal as found in romance literature, especially in such features as the slender white limbs, small breasts, delicate head, and fine features.[124] Rather, the critical difference lies in

Bathsheba's encirclement, blocked in by the city and by people before and behind her and fixed in their gazes. It also lies in her passive reaction to this lack of freedom, the way she sits motionlessness, exposed, her limbs outstretched, as if she acted only to make herself accessible. In relation to the Bathsheba at Auxerre, she is more like a docile patient under examination, an object being made ready, a figure unrealized except for her beauty.

A key to these peculiarities is found in the way Bathsheba's meaning is developed in the context of

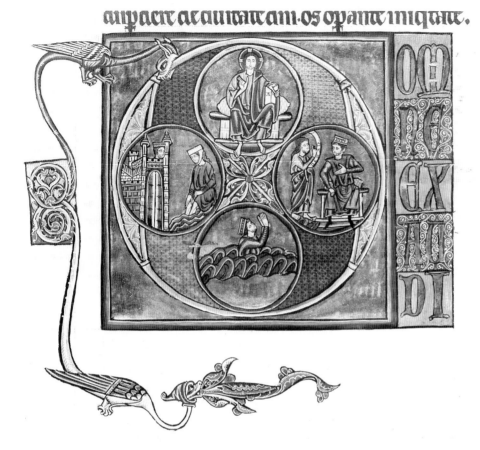

anpatt ac auttattt am os opante mtqtate.

FIG. 93 *Oxford, New College, MS 322, English psalter, ca. 1240, illustration by William de Brailes, initial to Psalm 101. Reproduced by permission of the Warden and Fellows, New College, Oxford.*

psalter illustration. In prayer books, the David and Bathsheba story is normally associated with penitential Psalms 50 and 101, and the episode usually illustrated is Nathan confronting David (2 Samuel 12). One precedent of particular interest for the Beatus miniatures in the Isabella and Louis manuscripts is the initial to Psalm 101 in an English psalter of about 1240 illuminated by William de Brailes (fig. 93).[125] In the leftmost of its four roundels David looks down from the walls of his palace at the clothed figure of Bathsheba, her skirt raised to bathe her legs in a stream. At the right Nathan appears before David and admonishes him for his sin. In the lower roundel David, buried to his waist in the earth, raises his arms high in prayer as he looks toward the uppermost roundel, where the enthroned Christ blesses and holds an opened book with the letters alpha and omega.[126] The combination of the David gazing at Bathsheba with the David in prayer before Christ—both set outdoors—is strikingly parallel to the French initials.

However, in the Isabella page there is no suggestion of admonition, judgment, or penitence. In fact, David kneels on a ground strewn with flowers, a detail found in no other miniature in the manuscript. The Isabella Psalter is the earliest known manuscript in which the bathing episode illustrates the first psalm, and two details—the landscape setting and the water flowing from a source below Bathsheba—point to an altogether different interpretation. They refer to verse 3, which compares the righteous to "a tree planted by streams of water, that yields its fruit in its season." The reference to this verse is more explicit in the related illustration in the Psalter of Saint Louis (fol. 85v), where Bathsheba sits beside a stream between two flowering trees.[127] In the Ordinary Gloss the waters of verse 3 are related to the rivers of Paradise and the Tree of Life or Knowledge.[128] This also coincides with the Gloss's interpretation of 2 Sam. 11:2, where Bathsheba is compared both to the "well of living water," a reference from the Song of

A ROYAL PROGRAM 195

Songs (4:15) that is frequently applied to Mary, and also to the "river of the water of life" from the Apocalypse (22:1).[129] The emphasis has thus shifted from the fate of the wicked to that of the righteous, from a barren landscape to a garden setting, and from the penitential to the restorative. Paradise, even one so minimally described, is an unexpected setting for Bathsheba. Although most earlier representations have Bathsheba in a barrel or tub, a few place her outdoors beside a stream, but she is always clothed, usually washing her feet, and there is no direct reference to paradise.[130] At this time, however, an unclothed woman who is the central figure in a religious narrative set outdoors would immediately have suggested Eve. Nudity in this context becomes an attribute of paradise, another way of asserting the allegorical reading of the subject. Moreover, the allusion to Eve helps explain the unprecedented use of full nudity in this miniature. Eve fits the allegory well. In the *Bible moralisée* Vienna 1179, the miniature of the Lord bringing together Adam and Eve, who was just created (Gen. 2:22), is juxtaposed with that of the Coronation of the Virgin, which is interpreted as the marriage of Christ and the Holy Church (fig. 94).[131] The prelapsarian Eve and Bathsheba each signify the Church; otherwise unrelated, they coincide only when allegorized and idealized, that is, when depicted as nudes in a paradisial setting. But the relation to Eve extends beyond their common nudity. The identity of the prelapsarian Eve is tied to her creation, for almost immediately after she enters the narrative, she and Adam suffer the Fall. Similarly, Bathsheba's prelapsarian identity is tied to her washing, to her being purified. Thus the closest parallel to the figure of Bathsheba being bathed is that of Eve being shaped by the Lord in the Carolingian Bible of San Paolo fuori le mura (fig. 95).[132] In both cases the figure is seated on the bare earth, her legs together and arms limp, looking on passively as her shoulder is molded or her belly is washed. The two figures are thus narrativized in the same way, not only in the sense of being worked upon but of being given an identity.[133] Bathsheba's passivity is as essential as her nudity, for it signals her ritual re-creation, her purification and preparation for Christ.

These positive readings of the upper scene naturally affect the lower one, where David kneels on the flower-strewn earth (fig. 92). In the Psalter the same scene occurs in the upper part of every other major psalm ini-

tial, so that Christ in his mandorla naturally appears at the highest point in the initial, and the figures below frequently join David in looking up to him. Those scenes are usually celebratory and illustrate psalms of praise, whereas here, where the David and Christ image is below, the reading of the initial is necessarily different. In this first initial one reads downward from an Old Testament subject to a scene of Christ enthroned, from a presumably earlier to a later moment in David's life, and from his sin with Bathsheba to his devotion before Christ. This juxtaposition of the two scenes thus follows the personal history of David and, like the text of the first psalm, contrasts the ways of the sinner with the ways of the blessed. The two scenes thus read as a process of personal redemption through Christ and as a contrast of the old dispensation with the new.[134] The scale and placement of Bathsheba and David and the clear diagonal between her extended limbs and his raised hands create a direct link between them, so that David's prayer seems to be addressed as much to her as to Christ. The pictorial treatment of Bathsheba is consistent with her being the object of prayer, for she is passive and still, the focus of attention. But she is also sensuous and beautiful, in many ways a distant ideal. The ambiguity of identity and the contradictions that follow from it are not unusual for this period. Thibaut de Champagne, for example, employs the same themes and poetic style to speak of his lady in love songs and of the Virgin Mary in religious lyrics, and sometimes even addresses them both in a single work.[135] In one poem he does so using Eve as a type for Mary, which enables him to move so easily between paradise and nature, the celestial and the earthly, that it is ambiguous whether specific verses refer to his lady or to Mary.[136] Given the typological imagery of the poem, it is clear that he addresses them both and that each in some measure defines the other. The same applies to Bathsheba, whose physical beauty and originary purity refer both to Eden and Ecclesia. What then does David see? Unlike the small figure who gazes out from his palace, this kneeling David looks at Bathsheba from Christ's vantage, and Christ turns toward him in blessing, affirming his act of prayer. For this David, as for his sculpted counterpart at Auxerre, an idealized, cleansed Bathsheba is inseparable from Ecclesia. A female viewer of the manuscript may well have understood her in the same way.

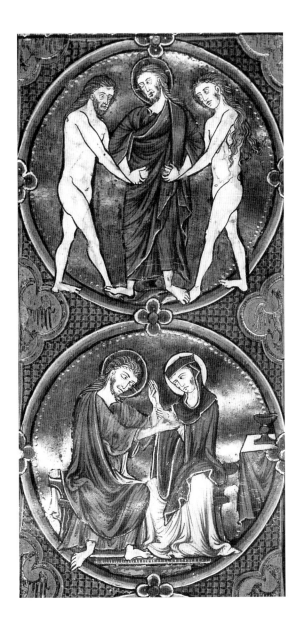

The Ecclesia allegory creates a significant shift in traditional illustration for the first psalm. The pictorial subjects associated with Psalm 1 tend to be originary and deal with authority and history, such as David Playing a Musical Instrument or the Tree of Jesse. Or they are promissory and stress divine guidance and the efficacy of prayer, such as David's Anointment or the Defeat of Goliath. When understood as an allegory of Christ and Ecclesia, the David and Bathsheba miniature can also be construed under these rubrics, especially when read, as described above, as a tableau in which Christ first sees and loves the Church or as the redemptive purification or sanctification of Ecclesia. But as Ecclesia takes on a new prominence, David's traditional role as author or victor is clearly rendered less important. Rather, the emphasis becomes more institutional and should be seen in relation to the depiction of figures from numerous religious orders in the initials to Psalms 26 and 38 (fols. 110v, 126v), figures who are also presented as both models and the intermediaries of prayer.[137] This view of the

sanctity of the Church and of its role in man's redemption is entirely consistent with what a member of the royal family might have found in a *Bible moralisée*. Thus neither the general thematic function of the first psalm nor the emphasis on the Church would have been new. Nor is it surprising to find this institutional emphasis in the introductory illustration to the Psalms in a prayer book probably made for a founder of a Clarissan nunnery and a princess of a family renowned for its financial and moral support of the Church. Many Old Testament women are allegorized as Ecclesia, but Bathsheba is the only one connected with David, the author of the Psalms and the prototype of inspired kingship.[138] Because David was understood to be both the author of the Psalms and the prototype of all Christian kings, many words and images would naturally be seen in terms of office. On the one hand, there are celebratory references to victory and to the blessings of the anointed and invocations of strength and wisdom and guidance. On the other, there is the cry of the abandoned and the requests for forgiveness, deliverance, and restoration. When David writes of kings and invokes the Lord's guidance, forgiveness, and blessing, it could well have a biographical edge. The pictorial imagery of the Psalms, though usually religious in content and traditional in form, is easily construed in terms of office.

A penitential reading of the David and Bathsheba story was traditional, and by the mid–twelfth century, with the commentary of Peter Lombard, the first psalm was understood as key to the interpretation of all the psalms and as centering on the sin of Adam and thus on issues of ethical choice.[139] But whereas Peter Lombard and others continued to interpret the psalms allegorically, as showing how they foretell the coming of Christ, the new Adam, exegetes of the mid–thirteenth century increasingly read David's role historically, interpreting his sins and his psalms in the context of larger patterns of behavior and as evidence for his being a true penitent.[140] Thus, in Paris at this time, it is not surprising that the first psalm would be read penitentially and that David's sin would replace Adam's as the subject for the first psalm. Nor is it surprising to find this interpretation in a manuscript made for Louis IX, whose later years were marked by penitential acts largely in response to the failure of his first Crusade, a failure he was especially keen to reverse in his second Crusade, the preparations for which

were under way about the time the manuscript was painted.[141] What is surprising is the highly personal way the female body is used to define that reading, and how the landscape setting and the pictorial construction of the page function to initiate and sustain it. Rather than a beautiful woman who moves the viewer from desire to redemptive union, as at Auxerre, or a distant ideal who evokes a kind of redemptive vision, as in the Isabella Psalter, the Saint Louis Psalter presents a Bathsheba who guides the king from the memory of sin to penitence. All of these strategies take advantage of a text that requires the desiring male gaze, a cultural discourse in which desire is displaced onto the female body, the availability of artistic conventions that fictionalize that body and construct what we call "the nude" in art, and the existence of an allegory in which this usage can be expressed in a socially and theologically acceptable way.

· · ·

The Beatus miniature in the Saint Louis Psalter is clearly based on the same design as that in the Isabella Psalter, but there are subtle differences that have an enormous impact upon its interpretation. David's palace is placed on a similar gold leaf background, but the landscape is enhanced not only with budding trees but with a textile pattern that is penned in gold on the leaf and that gives the entire right side of the scene a richness and tactility usually reserved in the Psalter for scenes of Christ in a mandorla. Here the bending maid does not wash Bathsheba but places one hand at her feet and the other at her back. Instead of actively washing her, the maid's arms spread to encompass Bathsheba's entire length, emphasizing her whole body and presenting it for view. And Bathsheba herself is arranged differently: her body is more shapely and curved, especially at the shoulders, breast, and calves, and one leg is bent slightly. More important, she moves to cover herself, for her left forearm crosses over her lower belly, and her right hand is raised before her breast. The maid shields Bathsheba from David's look, and Bathsheba seems to shield herself from the viewer's. Most striking of all, Bathsheba's head is lowered. Even though one maid turns to look at her face, Bathsheba does not look back.

Bathsheba thus rejects the viewers' glances by both looking away and covering herself. Recent studies, such as the collection of essays on Rembrandt's Bathsheba in the Louvre, help clarify what the implications of this arrange-

ment are.[142] If Bathsheba had covered herself but looked at us, we would need to determine if she were surprised and ashamed, like Rembrandt's *Susanna at the Bath* in The Hague, or pleased and complicitous, like Rembrandt's early *Bathsheba* at the Metropolitan Museum.[143] And if she had not covered herself but still looked down and away, we might interpret her as reflecting, perhaps on her own moral dilemma, which may be the case in the great, later Rembrandt in the Louvre.[144] But there are no medieval parallels for any of these strategies, and so we can interpret her both covering herself *and* looking away as a sign of postlapsarian self-consciousness.

This is also the case in one of the most remarkable of all nudes preserved from the Middle Ages, the statue of Adam in the Musée de Cluny (fig. 58).[145] The statue comes from a niche in the inner south wall of Notre-Dame in Paris and is precisely contemporary with the Bathsheba in the Louis Psalter. Although the companion statue of Eve is lost, it is clear from their context under the south rose window, with its vision of Christian apotheosis at the end of the world, that the pair was meant to suggest the originary sins from which the saints and the Church redeem the world.[146] Adam's nudity is very much like Bathsheba's, especially in its details suggesting both generalized beauty and particular frailty, its mix of confident self-exposure and embarrassed withdrawal.

But what of David and the viewer? David plays a double role as he is presented with two objects of regard, Bathsheba/Ecclesia above and Christ below. As the author of the Psalms, he is usually the subject of Psalter initials. Here, however, David is less the subject than the observer or student of the subject. It is significant that this aspect of the initial is also found in a *Bible moralisée* roundel to Psalm 1 (fig. 96). David sits pensively at the left, under an architectural canopy, as an angel expels Adam and Eve from paradise at the right. The accompanying inscription makes clear that the miniature forms an introduction to all the psalms and that their context is Christ and the Church, Sponsus and Sponsa, and the redemption of the sins of Adam.[147] David is therefore not participating or even seeing the Expulsion but is reflecting on it and on man's sinful past. His gesture to his cheek is identical to Adam's, the suggestion being that in reflecting on Adam's sin he reflects on his own. Effectively David is shown twice, as he

FIG. 96 *Paris, Bibliothèque nationale de France,* MS lat. 11560, *Bible moralisée, fol. 2r, fifth roundel: David, Adam and Eve.*

is in the Louis Psalter, both sinning and reflecting on it. Most important, in both manuscripts meditation is the key activity associated with David and with the Psalms. The Psalms begin by praising the man who "meditates day and night on the law."[148] In these representations, meditation actually makes possible the typological transference from the Old Testament to the New, as David moves from his former sins or those he shares with Adam to the redemption of Christ and of the Church. Unlike the de Brailes Psalter, which illustrates a penitential psalm with David in penitence, here the Psalms are introduced by an image of meditation. Instead of a model of penitence, David is the model reader, the person who finds penance through meditation.

This interest in devotion as a mental process and in the illustration of intellectual vision is altogether new in medieval art. Because David contemplates his earlier sins, in a sense neither the Expulsion nor the episode with Bathsheba is actually happening. He does not look at these subjects or need to, for they are mental images, the subjects of his thoughts. Furthermore, the reading in the *Bible moralisée,* from David to the subject of his thoughts, his former sin, at the right, suggests a parallel reading in the Psalter initial from David to the subject of

his thoughts, his former sin, up above. The Psalter initial could thus be read in two ways: first, downward, like the text just to the right, as a juxtaposition of David sinful and David blessed, the promise of redemption in the Old Testament being fulfilled in the New; and second, upward, like most of the other illuminated initials in the Psalter, as a juxtaposition of David in prayer and the object of his devotion, the revelation of Christ leading to that of Ecclesia in Bathsheba.[149]

In this second reading, David is presented with imaginary scenes of two kinds. The appearance of Christ is a theophany, as the bank of clouds around his mandorla clearly denote, and this vision of Christ is physically distinct from David, who kneels on a rocky prominence. Bathsheba is, however, a different kind of image, neither historical nor otherworldly, a part of David's devotion otherwise than Christ is. She is a mental image, an exemplum, the object of devotion. The way the artist visually distinguishes between the two images is noteworthy. Below, David kneels on a rock, there is otherwise no setting, and Christ's miraculous appearance is denoted by the clouds and mandorla. In contrast, although the richly textured background behind Bathsheba shares elements with the devotional image of Christ below, the scene above is filled with realistic and sensuous details of anatomy, landscape, and architecture. Unlike contemporary Apocalypse manuscripts, where the imagery is intensified beyond physical experience and becomes visionary, the upper scene is a meditative image in which detail absorbs attention and suggests the nature of experience itself.[150] In this the Psalter miniature in many ways anticipates fifteenth-century Flemish painting in which a donor kneels in prayer before a scene of heightened realism and material richness.[151] The rendering of the less physically real in more physical terms is of course a familiar strategy of religious art faced, as it was already at this time, with the danger of secular interests overwhelming the religious.

Bathsheba's nudity may also represent a response to secular interests, but its use here is certainly purposeful and religious. In earlier representations most of her body was either clothed or hidden by the barrel in which she bathed, and servants carried water or attended to her toilet.[152] By the mid–thirteenth century she is more exposed, and a servant physically washes her body. In Auxerre her maid washes her chest; in the Isabella Psalter, her back

and stomach. When the servant in the Louis Psalter reaches from her shoulders to her feet, she encompasses most of Bathsheba's body, effectively presenting her nudity. The young budding trees behind her, which appear for the first time in the Louis Psalter, similarly mark her head and feet and also delimit her full length. These changes suggest a conscious emphasis to display her body and the completeness of her nudity. As John Plummer has pointed out, they also create a heightened awareness of her being watched, not only by David but by the viewer, who regards her and the right half of the miniature much as David does, as a person looking into a private world. This representation of Bathsheba is perhaps the first instance since antiquity in which the unclothed female body is an object of contemplation. Like later works of art, the Psalter miniature is less a scene about washing or even purification than about looking; nudity is an invitation to look, a means of access, a device to fully absorb the viewer, in this case both David and the reader of this page. Indeed, it is the very nudity of Bathsheba/Ecclesia that makes her a powerful image of meditation, which makes the Psalms that she introduces, that she in part symbolizes, the material of a private devotion totally accessible to the reader. In the context of the baptismal symbolism discussed earlier, the miniature extends the idea of purification from mere contact with water to the description of the figure and, to a limited degree, to the landscape as well. For apparently the first time in northern European art, an ideal purity is vested in the youthfulness and nudity of the female body.

The Beatus initial's emphasis on prayer and meditation and on the Christian fulfillment of history is especially appropriate at this point in the Psalter. The initial juxtaposes an Old Testament subject with the first scene in the manuscript of explicitly Christian content and does so just at the critical transition between the prefatory cycle and the text of the Psalms. It thus reflects the two-part structure of the book and, with its stress on Christian revelation, clarifies the relation between them. Furthermore, it introduces the Psalms by illustrating their redemptive function in private devotion. And, finally, in its contrast between David looking and David praying, the initial recapitulates the change in the viewer's own activity, as he moves from looking and from the physical richness of the pictorial cycle to reading and to the Psalms and prayers that follow.

David's predicament in the Louis Psalter initial (fol. 85v) is different from that in the Isabella page (fig. 92). The fleurs-de-lis background in the lower half of the Psalter initial more directly associates the king with David. However, David kneels at the edge of a bare and rocky mount rather than on a flowered green, and Christ does not return David's glance or turn to bless him directly. Instead, Christ looks out toward the royal viewer, who is also addressed by the grimacing faces at the ends of the spine of the letter *B*, faces in the border that frames the king's relation to his book. The visual and narrative circuit of the Isabella Psalter is everywhere broken: Bathsheba turns inward, Christ faces away, David is isolated, and the royal viewer, who can neither assimilate Bathsheba as religious allegory nor easily remain with the kneeling David, ultimately confronts the image of Christ, who, looking out from the page, finally returns his glance. Thus desire turns to frustration, as Louis is led from female to alter ego to self, that is, from anxiety to subjectivity. And unlike the Isabella initial, where Christ responds to David, here Christ looks out to the royal viewer, whose eye is left with only one place to go: to the text that begins alongside and continues on the next pages. For Louis, redemption becomes possible as long as looking turns to reading, which is precisely the shift that occurs at this point in the book and that the frontispiece so effectively compels.

For the historian, the most interesting issue here is not nudity but nakedness; not the fiction of the body that art provides, but the failure of its social and aesthetic disguises, the resulting transparency to sexuality and weakness, and, most important, the self-consciousness that goes with the viewing of it.[153] The female body did not have to function as it does in the king's Psalter—there were other options—but in the end only the failure of those conventions that dress the body up as a nude could give Bathsheba the discomfiting and mediating role she plays. She is the figure who sets the whole viewing in motion, who fails as an allegory but resists being either the subject or object of desire, who deflects the male viewer's gaze, first to the Father and ultimately to the self. The nakedness of Bathsheba is more potent than her nudity ever would have been. She sits in the landscape before Jerusalem and stops the viewer on the way in. The only way to go is through the text of the Psalms. As it turned out, the crusading king never got to Jerusalem; the Psalms were his only real choice.

Conclusion: The King and His Psalter

By the late twelfth century the psalter had become the most popular devotional book and the most lavishly illustrated of illuminated manuscripts. But in comparison to the impressive experiments in the illumination of earlier Irish, Carolingian, and Anglo-Saxon psalters, it had also become a bit predictable in contents and in meaning. Instead of elaborate literal and allegorical illustrations of the text of the Psalms, it offered a rather standard series of initials marking the liturgical divisions. And instead of the richly typological relationship between David and Christ, the emphasis shifted to the life of Christ and to a narrative program more concerned with the history of salvation than with the metaphors of penitence or the allegories of triumph over evil like those Kathleen Openshaw discussed in earlier Irish and Anglo-Saxon illumination.[1] The prefatory cycles in the later twelfth century often include more Old Testament illustration, especially Genesis, but David is less important. At the same time, the New Testament illustration takes on a serial uniformity, and although there are sometimes images of the Virgin and saints, most of the subjects are narrative rather than devotional. As more people wanted and could afford these devotional books, it was perhaps inevitable that many became ordinary. To be sure, one often finds many marvelous paintings and occasionally brilliant conceptions—one need only think of the Oscott Psalter in England or the Padua Psalter in France—but these tend to be isolated cases. Indeed, one may well ask if there was any new thinking at this time about the psalter as a book. Was the early Gothic psalter still a prayer book connected with pious ideals, or had

Detail of folio 75v, Psalter of Saint Louis

it become, as Nigel Morgan put it, a kind of luxury picture book?[2]

In a few instances, it is both. What is new and different appears most strikingly in the Psalter of Saint Louis. There the prefatory cycle precedes, rather than follows, the calendar. The cycle begins and ends with atypical subjects, so atypical that almost everyone has suggested losses at both ends of the cycle. Moreover, it has no New Testament illustration at all, and not one episode of David's life is among its Old Testament miniatures. And although the prefatory cycle is very long—seventy-eight miniatures—it is carefully built up in narrative units and shaped into overarching themes. Finally, as discussed in the previous chapter, the subject of the Beatus initial—David and Bathsheba—is unusual both as a subject for the first psalm and in its apparent preoccupation with Bathsheba's undress. What is important here is not so much these specific features as the attitudes and viewpoints underlying them. They represent a new freedom in developing a prefatory cycle's beginning and end and a fresh exploration of internal relationships between pictures, of the nature of the transition from picture to text, especially in the Beatus initial, and of the temporal conception of the psalter program as a whole. In these terms, the Saint Louis Psalter has more in common with very early psalter cycles than it does with most late-twelfth-century ones. But the Saint Louis Psalter is not unique in this regard, for similar qualities, expressed in different ways, are also to be seen in the two earliest French psalters with major prefatory cycles: the Ingeborg Psalter, a manuscript made about 1200 for the unfortunate second wife of Philip Augustus, and the manuscript usually called the Psalter of Blanche of Castile.[3] What is significant is that both manuscripts may have been in the royal library and known to Louis IX and possibly to his artists. Also, all three psalters depend upon English sources for the iconography of individual scenes as well as for the essential conception of the prefatory psalter cycle; however, all three interpret that conception quite freely and in distinctive ways. Each of these manuscripts is extraordinarily rich and deserves to be treated alone, but the focus here is the Saint Louis Psalter. The other two provide a context and comparison to the unique qualities of the king's personal prayer book.

The three quite distinct psalters differently record their owners and their owners' interests. The Psalter of Saint Louis does so most directly: the calendar commemorates the deaths of the king's father, grandfather, mother, and brother; the psalm initials and line-endings are full of the heraldry of his family; and the prefatory cycle ends with what is effectively the coronation of Saul as the first king of Israel, making the cycle, among other things, a prehistory of biblical kingship, discussed in detail in Chapters 4 and 5. But what is most striking is how the initials to two psalms (26 and 38) substitute for David a group of diverse religious orders, orders that Louis supported and with whom he closely associated. As every biographer since Joinville has shown, this relationship was important in defining his private and public personae. If David kneeling before Christ in the upper part of a miniature is in some measure Louis, he is also *frater* Ludovicus, praying in the company of those with whom the flesh-and-blood king so often did.

The situation is more complex in the Ingeborg Psalter. Deuchler has pointed to several details with royal significance, such as the ampoule with holy oil that the dove brings to the scene of baptism; there are others too that are quite striking, such as the initial to Psalm 109, with the highly unusual scene of the servant bringing Saul's crown to David.[4] There is also a significant emphasis on the Virgin: she is unusually prominent in the Pentecost miniature. After the Last Judgment, the prefatory cycle has a sort of epilogue with her Death and Coronation, followed by the Theophilus legend, the latter a history less about Theophilus's fate than the Virgin's role in his salvation. There are also fascinating details, such as the daughters of Jerusalem following Christ as he bears the Cross. But most striking in this manuscript made for the rejected and mistreated queen is the unexpected inclusion of the story of the Woman Taken in Adultery, both the scene in which Christ asks who will throw the first stone and that in which he asks her, "Who condemns you now?" and she replies, "No one." It is hard to imagine that these women who weep after Christ, or the Virgin who extricates Theophilus from his bad deal with the devil, or the Christ who saves a woman not only from those who accuse her but also from accusation itself, would not have had a special resonance for the ill-fated Ingeborg.

· · ·

The Blanche Psalter has no explicitly royal imagery, and the woman who kneels in prayer in the initial to Psalm 101, though presumably the patron, is uncrowned, but

the manuscript does have a distinctive character that is consistent with what is known of her. The prefatory cycle begins with the Fall of the Rebel Angels and the Creation and Fall and includes two other Old Testament miniatures and numerous New Testament ones, all following a predictable pattern to a final miniature with Christ in Majesty. However, this manuscript also has an epilogue, four miniatures of the Last Judgment, which are exceptionally placed after the Psalms and before the canticles. Most telling are the psalm initials, which, as noted earlier, contain anti-Semitic elements indicative of Blanche's ownership.[5]

These suggested connections between each of the three psalters and their presumed owners require a great deal more documentation and argumentation than given here, but the preceding suggests something of the ways these manuscripts are personalized. Of course, one would expect a royal manuscript to be made with its special patron in mind, but these are not merely cycles with royal imagery. What makes these illuminated manuscripts function so powerfully as books of prayer is precisely what Pächt describes with reference to Christina of Markyate and her psalter a century earlier: subjects about choice and self-control, biblical scenes that speak to one's distinctive concerns or predicament, images placing the owner within a larger history of salvation and showing the Psalms to be his or her ideal instrument of redemption.[6]

One of the unusual aspects of prefatory cycles is the way miniatures appear on facing pages. The earliest cycles—the Tiberius and Saint Albans Psalters—use that relation not only to emphasize certain points but also to create narrative building blocks within the long series.[7] For example, in the Saint Albans Psalter the Magi Guided by a Star begins a series of two consecutive openings that clearly form a unit. The next four scenes are also built as a unit but in a more subtle way, for here the reference is between the first and third and between the second and fourth miniatures, as discussed earlier. Other openings in the Saint Albans Psalter are far subtler and richer as new variations are progressively elaborated within and among these narrative units.

Later psalters often present powerful juxtapositions of facing pages, but they rarely are developed with such complexity or sophistication. One does, however, find two important forms of experimentation in the French

psalters. In the Ingeborg Psalter, Abraham and Moses are each allocated two facing miniatures, so that the double-page opening becomes a biographical unit, a development found in a number of French and English manuscripts at this time. Within them, one is encouraged to read the scenes not only downward in chronological order but across and comparatively. Thus, in the upper registers, Abraham ascends Mount Moriah as though the angels at Mamre on the facing page instructed him to do so, and in the lower registers the table at the left is compared to the altar at the right, which one of the seated angels indicates to Abraham, again directing him from one page to another and, in this case, from ritual offering to ritual sacrifice.

The facing pages in King Louis's Psalter are especially striking. The book opens with a nearly blank page. All it shows is a legend, that is, a description of what is on the verso of the page. Turning the page is like opening a door or the panel of a diptych. The prefatory cycle is in fact a series of diptychs, the facing images alternating with facing pages of legends. After the opening page and the following diptych, the king would read the description of the event just seen and then read of the event to be seen, creating a sense of confirmation and anticipation at once. From verbal description, he would then move to a completely visual one, constantly opening and closing, understanding and seeing, in a complex interplay of text and illumination. Within the illustrations, more complicated levels of looking emerge. In all three royal psalters there is a tendency to compose miniatures on facing pages in such a way that pictorial relationships suggest narrative and thematic relationships. Comparison and juxtaposition are of course well-known ways of eliciting meaning in medieval exegesis as well as in medieval art, and such works as the Hildesheim doors develop the human implications of their typological juxtapositions of Old and New Testament scenes.[8] But these manuscripts differ from these textual and visual precedents in that comparison is between successive episodes, and so the point is not allegorical, tropological, or anagogical, but narrative. At its most basic, compositions or motifs or expressions are repeated in order to give coherence to a two-part unit within a more extensive series, thus building the narrative out of visual relationships rather than out of specific actions alone. For the most part, the juxtapositions elicit

reflection on the events, so that the ironies and turns of fate, the changes in conditions and mood, are clearer. At its best it creates a visual metaphor that provides a different kind of coherence on another level of meaning.

In the Saint Louis Psalter two important variations of these narrative devices occur. The first involves repetition of actions rather than compositional elements: for example, in the story of Moses (fols. 29v–30r), as demonstrated earlier. The patterns of actions introduce the narrative in such a way that the separate events not only convey the progression of the story but evoke one of the larger themes of the other Moses miniatures, the idea of custody, of caring for a people, which is cental to the prefatory cycle as a whole.

The second significant variation in the construction of these narrative units is the way the events in the life of a specific figure are selected, as though the actions were to follow a certain expected sequence. For example, the four Gideon miniatures begin with his calling and sacrifice; continue with his proving himself by destroying his father's idols and cleansing the altar, and with his receiving the sign of the fleece and selecting his soldiers; and conclude with his victory in battle. Other subjects found in Byzantine and earlier Western painting are omitted. This kind of biographical cycle is structurally different from those we saw for Christ, Abraham, or Moses. As discussed in Chapter 4, this may reflect a restructuring based upon models of contemporary hagiography. Take, for example, the thematic arrangement of the scenes of saints' lives in the windows at Chartres. They are often organized according to a four-part structure: (1) origins and mission, including childhood and sometimes profession; (2) youth, which may involve travel or other ways of engaging the worldly, and miracles and other early demonstrations of competence; (3) works, including later miracles, trials, and bold deeds; and (4) a resolution, normally ascension but sometimes martyrdom or some other form of victory, often crowned by an image of Christ and angels at the apex. In Chartres this structure is especially legible because the sequence of multiscene medallions often expresses the thematic unity of each section and the interrelation between them. Just as the hagiographic windows at Chartres and elsewhere sometimes include the lives of Old Testament figures, the narrative cycles in some manuscripts appear to be reconfigured in terms of contemporary hagiographic structures, even though their pictorial sources lie in earlier biblical illustration.

While many of the prefatory cycles with Old Testament subjects begin with the Days of Creation or the Fall or with David scenes, those subjects are by no means standard. The Ingeborg Psalter begins with the Angels Appearing to Abraham at Mamre. Deuchler has pointed out that the angel is based upon a model from the Annunciation.[9] The choice is significant, for it signals a beginning, implies the parallelism between Old and New Testaments, stresses the Old Testament antecedents for the Passion, and sets up the Annunciation to the Virgin as the historical fulfillment of God's promise to Abraham. The Blanche Psalter is more complex because it has two beginnings. The first is that of the prefatory cycle—the scene of the Fall of the Rebel Angels—a subject that echoes the scene of the damned falling into the hell mouth in the very last roundel of the four-miniature sequence devoted to the Last Judgment, a sequence that comes at the conclusion of the Psalms and of a series of initials largely concerned with judgment and vengeance taken on the wicked. The other beginning is the frontispiece to the entire manuscript, the famous miniature of the astronomers.[10] The intellectual circumstances surrounding this miniature are complex and rich, the subject for a separate book. Suffice it to say, astrolabes were used for astronomical calculations, and so it can be no accident that the other half of the bifolium with this miniature is the table with Easter calculations and that the calendar of saints comes between the two. Now, the Easter table leads directly to the Fall of the Rebel Angels and the Creation cycle, an arrangement that finds an interesting parallel in the Tiberius Psalter, which also begins with a section on computation, whose final miniature, with the horologium, leads directly to and formally anticipates the next one, of the Creation. Thus the layout of the various sections of the Blanche Psalter is strikingly logical and coherent: a section about time is followed by one about sacred history. Then come the Psalms and finally a vision of the future, a judgment cycle, followed by songs of thanksgiving. The only odd aspect of this sequence is the location of the calendar, for the time of the Church and the saints should follow, rather than precede, biblical time. That oddity is ironed out in the Psalter of Saint Louis, for that book opens with the biblical cycle, after

which comes the calendar of feasts and commemorations. One thus moves from what Jacques Le Goff has called "le temps d'histoire" to "le temps de l'Église" and then to the Psalms, the contemporary instrument of redemption in the hands of the actual reader, who finds himself in its initials.

This sense of sacred time informs the first miniature of the Saint Louis Psalter, the Sacrifices of Cain and Abel. The history of the Church in this world begins with the brothers, according to Vincent of Beauvais, and is an appropriate beginning for a history close to the king's heart.

The Old Testament stories are here no longer single exemplary scenes, as they are in Romanesque capitals or the *Bibles moralisées*. In the Saint Louis Psalter the narratives are presented as small biographies and histories in which the primary action is linked vaguely to larger issues of existence. Behavior becomes symbolic, complex, and nuanced, rather than simply allegorical. This is the case particularly in the Joseph, Samson, and Saul stories. There is some precedent for this kind of reading in the Hildesheim doors,[11] but here it is grounded in larger phenomena that happen within the Old Testament, not in the New, reflecting the relevance the Old Testament was seen to have on national history. The focus on moral issues reveals a new attitude toward personal destiny. The scene of Joseph before his brothers, for example, is rarely represented,[12] but here makes a powerful statement about revelation of truth and personal identity.

The last miniature of the Psalter cycle—Saul Becomes King of Israel—is also far more complex than it may appear, for it stands outside of traditional coronation imagery, and the subject, found as it is in a prayer book for a French king, is altogether shocking. On the one hand, it is the climax of the cycle, the first appearance of a king of Judah and thus of the biblical ancestors with whom the Capetians most closely associated. Saul was hardly considered a paragon of kingship during the Middle Ages. He lost God's favor and ultimately his kingdom. Why include Saul at all then? Could he have constituted a warning to the king? It is not unthinkable, for Joinville reports that in 1254, when returning to France from his disastrous first Crusade, Louis heard Hugh de Digne's sermon warning him about loss of kingdom. At the time the Psalter was illuminated, many, including the king

himself, would have been mindful of the terrible losses France had suffered in the earlier Crusade and anxious about the prospects of another failure. If any miniatures in the Psalter address the king about the obligations of his office and his prospects for the future, they are these final miniatures of the history of Saul.

The final series begins with the scene of the Israelites demanding a king of Samuel. The left-hand side shows Samuel's reply to them. Backed by his two sons, Samuel explains the disadvantages, indeed the horrors, of kingship. The Psalter omits Samuel's subsequent exchange with God, his meeting Saul, and continues directly with Samuel's privately anointing and kissing Saul on the right half of the page. The next scene takes up the events immediately following the anointment. Samuel explains to Saul that he will see three signs confirming that God has chosen him. Here Saul holds a thin scepter surmounted by a fleur-de-lis. The next three illustrations detail each of the signs. These four scenes illustrate only six verses and thus form the most densely illustrated narrative sequence in the entire Psalter. They are extremely rare, all three signs otherwise found only in the fifth-century Quedlinburg Itala, a work with no real iconographic relation to these miniatures. In the Psalter these two folios create a coherent narrative unit recounting a spiritual journey in which three miraculous signs culminate in Saul's prophesying. The series is also compositionally progressive, for in the first scene Saul is partly out of the miniature and a crevice separates him from the tomb of Rachel; in the second, he is at the left and receives the foretold breads; and in the third, he is brought to center and surrounded by youths. This last scene is less about his spiritual transformation than about his social integration and festive reception by the people. As the legend on the reverse of the page explains, "the people receive him with great joy and a great flourish of instruments."

The Psalter omits the important episodes at the end of 1 Samuel 10, where lots are cast to select a king, Saul is chosen, and is acclaimed with shouts of "Vivat rex," the acclamation used at this time in the French coronation ordo. Instead, the next miniature illustrates another rare subject, the siege of the Israelites at Jabesh-Gilead by Nahash, king of the Ammonites. Although the Israelites offer a peace treaty, Nahash agrees to accept it only if he plucks out their eyes first, a threat he delivers

by reaching down from his horse to take hold of the head of an elderly Israelite and putting a sharp silver sliver to his eye. At the left of the facing page, a terrified messenger reports Nahash's threat to the Israelites. At the far right, the Israelites inform Saul, who dismembers a team of oxen and sends their parts throughout all Israel as a call to assemble. One can well imagine that such images would have resonated with Louis, who was also responding to threats against the Holy land and assembling an army.

The next opening illustrates the Israelites' battle with the Ammonites and its aftermath. The left miniature centers almost entirely on Saul and his slaying of Nahash; the right one represents the important events after the victory. I Samuel 11 describes how, after their military success, Samuel tells the Israelites to go to Gilgal and renew the kingdom, and how they go there and "make Saul king before the Lord," offer sacrifices, and rejoice greatly. The interpretation of this beautiful but puzzling image hinges on the influence at this time of new and more tolerant ideas about the institution of kingship and specifically on the influence of Vincent of Beauvais. His most important writing on kingship, his *De morali principis institutione,* was composed just about the time the miniature was painted. In Vincent's writing, as seen earlier, Saul emerges as an essentially good king who later changed and eventually failed. Vincent makes clear what virtues a king should have, to earn and to retain his kingdom, virtues that are illustrated by the actions of Saul's predecessors in the previous miniatures. But when the cycle ends, Saul is just at the beginning of his reign and is neither a good nor a bad king. This subtle reading of contradictory meanings is consistent with Louis's own use of exempla and lessons. In his writings for his children he expresses himself in a double-sided, multilayered way. Moreover, the ambiguous features of this painting, especially in relation to standard coronation imagery, have the effect of making the reading of the miniature as indeterminate as possible. At a time when Louis would already have been planning his last Crusade, no doubt with the failure of the first one still in mind, the fate of this prototypical king was left hanging in the air.

The relation between the Crusades and the visual arts of the Latin West is difficult to assess in the case of Louis IX, but using Saul in this way suggests the continued need for right actions to ensure a successful reign. One naturally wonders if the lack of closure in the cycle could be due in part to the knowledge of the king's plans to crusade again and fears of a second failure. Had the planners of the cycle followed Saul's Victory over the Ammonites with a celebration of the renewal of kingdom, as the text of Kings describes, it might have seemed overly optimistic, even presumptuously congratulatory. And had the battle been followed by a coronation, as in other manuscripts, the cycle would have been read as historical, culminating in the creation of the institution of kinship, rather than as a series of histories that put before the reader the question of kingly merit, of what kind of king is being made. We cannot know how much this interest in the contingency of kingship was a general lesson about the nature of kingship or was related to contemporary doubts. In the mid-1260s, it is a complex image, evoking the hopes and fears of the Crusades.

Perrot has suggested that the Sainte-Chapelle program may represent a penitential act of the king in preparation for his first Crusade.[13] As she recognized, one difficulty with this idea is that the king took his Crusade vow in 1244 but the planning for the Sainte-Chapelle was probably under way in early 1240, or shortly after the first shipment of relics arrived in Paris.[14] Also, the glass makes no explicit reference to the Crusades, in its battle scenes, inscriptions, or choice of subjects.[15] In the end its imagery focuses primarily on the relics, and its vision of history is westward. But in 1248, when the chapel was dedicated and the king left for the East after three years of arduous preparations, the Old Testament cycle may well have had broad implications for crusading. After all, its program put the relics in the context of a universal history, especially of the king and the Church, and many subjects raised broad issues about leadership and royal conduct. But there is no internal evidence that the Old Testament cycle was shaped to support royal policy toward the Holy Land or in anticipation of the king's departure.[16]

The Morgan Old Testament manuscript presents a different case.[17] Once again, the illuminations are likely to have been well under way, if not finished, when Louis swore his vow, and nothing in the miniatures has been related to the specific circumstances surrounding the Seventh Crusade, such as the Mongol invasion.[18] Given what a royal enterprise this Crusade was, the absence of the fleur-de-lis or other royal trappings in the manu-

script is conspicuous. But the manuscript does reveal an uncommon interest in modern French arms, armor, and strategies of warfare and was evidently intended for someone who would relish its spectacular panoramas of battle, with all their energy, chaos, and bloodiness. As in all medieval illustrated histories, the costumes and settings are contemporary rather than ancient, but here the Israelites battling in the Holy Land appear as modern French knights fighting dark-skinned enemies wearing alien armor. In the 1240s an association with the Crusades would have been irresistible.

However, the connection need not have been to the Seventh Crusade, for the king was very much involved with crusading well before his vow of 1244. He bore the brunt of the expense of the Barons' Crusade of 1239–41 and gave important gifts to many who participated. Among those who left for the Holy Land were most of the great nobles of France, including some of the king's royal officers. And because Louis gave his constable permission to bear the arms of France, the barons' campaign was tantamount to a royal Crusade. Thus the Sainte-Chapelle and Morgan Old Testament programs are likely to have been designed and at least partially painted between these two Crusades, that is, during or not long after the period when France fought in the Holy Land and succeeded in regaining a part of Jerusalem and Galilee. But in this war France was represented by its barons and officers, not by its king. Although modern historians tend to view the Crusade as cross-purposed and an exercise in confusion, it may not have seemed that way to Louis in the mid-1240s.[19] Richard has suggested that the king's oath in 1244 should be seen against the background of his absence in the Barons' Crusade and the aura of glory surrounding the returning crusaders.[20] The same is true for these works. Indeed, one could imagine the Morgan manuscript having been a gift from Blanche of Castille or from one of the principal barons of the earlier Crusade, such as Thibaut IV of Champagne, to Louis IX as substitute for the experience he would forgo or in gratitude for his assistance.[21] Whatever the origin of the Morgan manuscript, in some degree both Old Testament cycles may initially have reminded Louis of his absence and his obligation, later serving to solidify his commitment and enabling him to envision his future campaign.[22] After all, both works present war in the Holy Land as something

that is not only familiar but part of a comprehensive historical program consistent with royal ideology and paradigms of behavior. They embody a view of the historical present that domesticates the Crusade, normalizes it as a royal action, and predicts its success.

There is no such assurance of success in the king's private prayer book. Nor could there be, made as it was in the face of the defeat of the 1248 Crusade and as plans were already under way for the second, ultimately fatal Crusade. Although the battle scenes are less important than in the Morgan Picture Book, they suggest the military and personal pressures facing the king in his decision, while they are still charged with a righteous prescription for victory. If the crusading message is implied, the political one is clear. The Old Testament imagery offers a definition of French kingship seen through the perspective of its legitimacy, sanctity, and role in a Christian state. These interpretations are not simply standard for the period but are sharpened, with a new focus, under Louis IX. The Psalter focuses not so much on the sacral as on the political aspects of kingship. Instead of emphasizing spiritual ideals, it stresses political ones, formulating an enabling doctrine by constructing history in terms of royal responsibilities to the Church and state. This imagery, however, is not simply laudatory but is fraught with warnings about possible failure, given the weight and responsibility of kingship, and is laden with a penitential anguish, reflecting Louis's personal response to the failure of the first Crusade. This is especially reflected in the inconclusive ending Saul offers. In a sense, the miniature directs Louis to the recourse offered in the rest of the book, to the observation of the feasts and the memories of his ancestors in the calendar, and especially to the Beatus miniature of David and Bathsheba.

Saul is not shown as a sinner, but David is. Salvation, which is institutional in the prefatory miniatures, is a personal issue in the full-page initial. David appears not as a king but as a penitent, and his psalms are meant for penitential reading. In the two-part initial to Psalm 26 David kneels in prayer before Christ, and below, a group of male and female figures, almost all from various religious orders, look up to a triangle of hanging lamps, a reference to the first words of the psalm, "Dominus illuminatio mea." The background behind David is decorated with the fleurs-de-lis of France alter-

nating with the pales of Provence (for Louis's wife, Margaret). Behind the religious, the fleurs-de-lis alternate with castles of Castile (for his mother, Blanche). These kneeling figures are exceptional in psalm illustration, but we know from Joinville and others that religious were among the king's closest friends and advisors and that the king often prayed with them, going out of his way to do so when he traveled. Through the Psalms and prayer, David and all sinners are forgiven. In this particular prayer book, replete with Louis's arms and with initials peopled by his mendicant orders,[23] the king himself stands in for David, and in this part of the manuscript, he too prays and is forgiven.

Does David reflect the general obligation a Christian has toward penitence, or is penitence here especially important to Louis? It is possible to see several incidents in the Old Testament program as particularly relevant to the king's life. Joseph in prison could reflect Louis's own three months held prisoner during the first Crusade. The return of the Benjaminites from Mount Remnon, depicted in folio 65v, could equally suggest the king's return after his release, but these are not critical images that define the cycle. The major images cannot be so directly linked with events in Louis's life. David, however, holds richer possibilities. Each of the two kings had lost a young son, but while David's firstborn died because of his father's sin, his conduct with regard to Uriah and Bathsheba, Louis held no such responsibility for his child's death. Did the French king, however, feel punished by God for the failure of the first Crusade? Did he see his own reign as tainted or flawed?

In this context, the second Crusade can be seen as a second chance. The preparations for it were highly systematic.[24] Despite the growing signs of serious problems developing in the East, Louis only swore his vow publicly in 1267. His careful efforts to build a strong force suggest that whatever guilt or misgivings he may have had about the failure of the first Crusade, he now felt positive of success.[25] Although the king was devout, nothing about him suggests that he sought martyrdom; nothing in his actions of the last three years hints at depression or desperation. Whatever anxiety he felt grew from concern not for his own sanctity but for his legacy.[26]

Seen as a whole, the Psalter echoes this concern. Saul, though an ambiguous figure, is shown at the moment of his kingship's greatest promise, when he is responsive to the needs of his office, fresh from victory, and heralding a new beginning. David, though a sinner, is shown in prayer, mindful of his past sins and turned toward redemption. With these two kings, the official and the private, the historical and the moral, the study and the practice, are all joined together. Whereas Saul is seen as symbolic of renewal, of a fresh beginning, David evokes prayer and self-determination. The whole manuscript is organized as a procession of history leading into the reader's recitation. The historical imagery creates an understanding of the king's role and responsibilities, while the Psalms end the book in an open question, a focus on the self. Thus the history and origins of biblical kingship lead to the year and its cycle of feasts, to the moment and its devotion. The Old Testament has here been transformed into a way of contextualizing devotion itself, preparing the reader, in this case the king, to travel from an institutional sense of himself to a distinctly personal one.

The decoration of the Saint Louis Psalter, like that of its predecessors, is a great deal more than mere embellishment. Looking closely at the formal strategy of the painting aside from stylistic details and subject matter, it is clear that the artists in the Psalter reacted to developments in contemporary narrative by rejecting them. They painted scenes that are not about figures and actors capable of choice, but about history and destiny. The naturalistic trend in earlier literature and art is here reversed in a highly structured visual world. The emphasis on the richness of the book as an object adds to this sense of an ordered creation. The gold leaf imbues the book with the status of a religious object, like a chalice or liturgical vessel, granting the miniatures the dignity of something used in prayer. The luxurious nature, though indicative of the status of the user, is not meant as a sign of vanity, self-congratulation, or self-indulgence. Rather, for Louis, the richness of the gold is part of the construction of kingship, as important to its definition as heraldry.

All these elements are consistent with the king at the end of his reign, before his final Crusade. The manuscript was not made by people around Louis to show him what they wanted him to be, nor did it function as an institutional history for a court audience promoting an institutional self-interest, as Saint-Denis and Notre-Dame did. It is a personal book made for an audience of

one, the king. If it can be seen as meant for other eyes, those eyes would have been those of his children, the Psalter as a part of Louis's legacy.

It is a commonplace to put one's affairs in order before leaving on a major expedition. Could this have been part of the Psalter's role? Certainly it makes a visual statement about kingship, one where the grand lines of Old Testament history are made to intersect in modern times with timeless religious imagery. The Old Testament here makes a fitting testament to the royal children. The Psalter provides a scholarly reading of sacred history and its political implications, offering a form of teaching combined with devotion much as sermons do, a natural formulation of the legacy Louis would want to pass on to his sons. There is no reason to think that Louis needed yet another psalter, but psalters were traditionally made as gifts. The manuscript may have been made for Philip III, the eldest son, whom Louis addresses in the *Instructions,* just as the Cambridge Psalter was probably meant for Isabella, whom he addresses in the *Teachings*. The emphasis is the same in both didactic texts and the psalters: the ethics of leadership, the role of the Church, the relationship of ruler to Church, and the role of prayer in general. These preoccupations are not new. They are conspicuous already in the Arsenal Bible.[27] In any case, the psalters both continue the tradition of instructing visually, as do the *Bibles moralisées,* and realize Joinville's call for using history as a means of instruction, looking to the Old Testament for lessons on origins, ethics, and the responsibilities of rule.

The miniatures are essential to the very conception of the book and its intended use. They establish authority, an attentive context for devotion, and a historical and allegorical framework for the book as a whole. They permit the owner of the book to take possession of it, cognitively and functionally. The subtle and ambiguous interpretations are a measure of the book's success in reaching its intended audience, a learned man grappling with his role as the head of Christendom, with the very nature of kingship and redemption.

The Saint Louis Psalter is perfectly conceived to fulfill these functions. The text and illustrations are integrated so that the entire manuscript succeeds as a preparation for and instrument of prayer. The content is self-consciously open-ended; the structure is process oriented. Ultimately we cannot know what Louis's role was in the conception or execution of the book, whether it was prepared for him and reflects the intentions of his advisors or developed with him and reflects his own vision and values. Either way, the manuscript bears clearly the mark of his singular reign. Louis himself may never even have used the Psalter, but like the meaning of the king's rule itself, the book would have been absorbed by his descendants, his modern namesakes, passing on to them the institutions of the nation Louis helped create.

En ceste est page est conment caym z abel offrent leur disme
adieu:

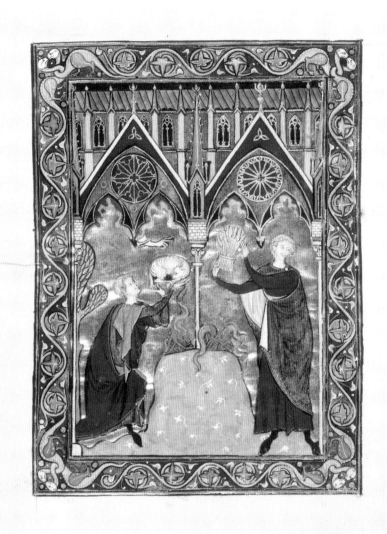

Folio iv

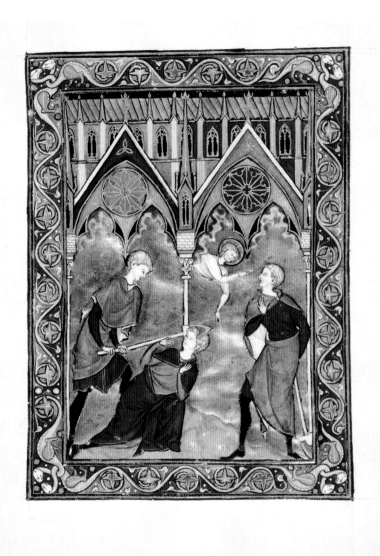

Folio 2r

En ceste page est conment caym ocit abel sonfrere et
conment dieul li demande quil afait de sonfrere abel

En cestte page est conment Noel est en larche au duluge

Folio 3r

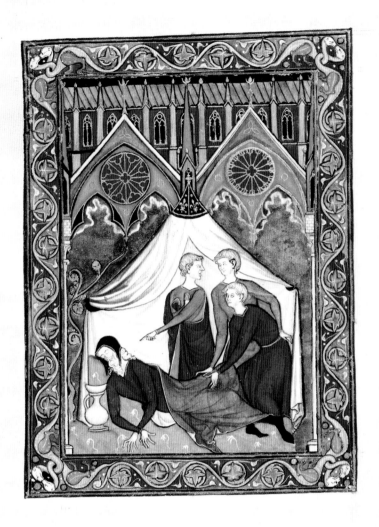

Folio 4r

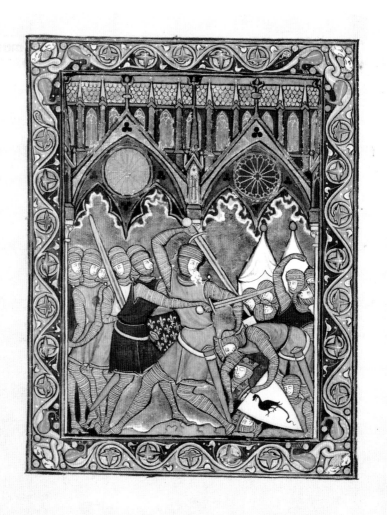

Folio 5v

Folio 6r

Folio 7v

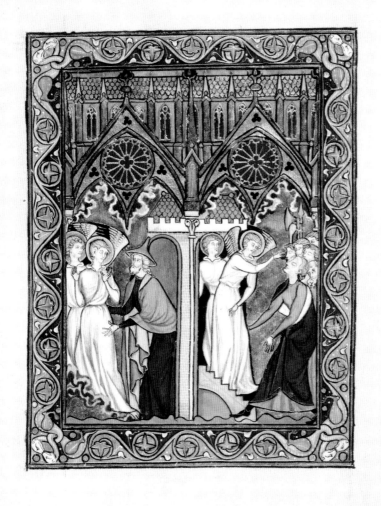

Folio 8r

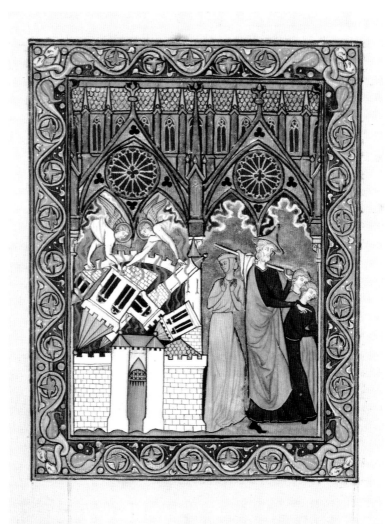

Folio 9v

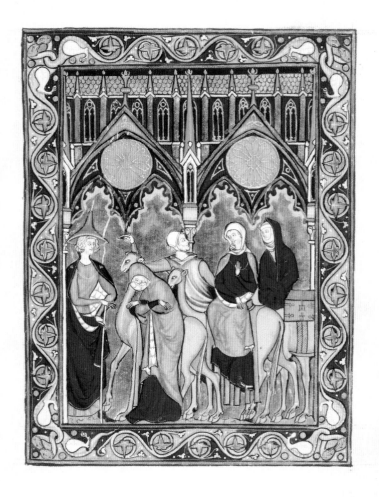

Folio 12r

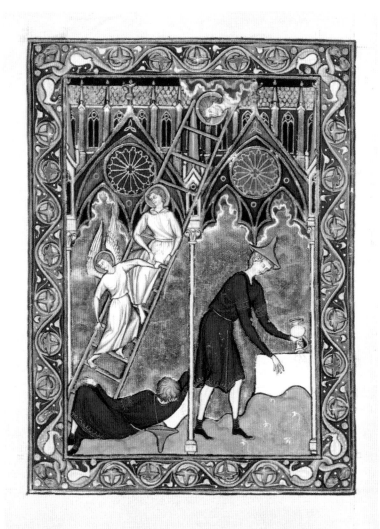

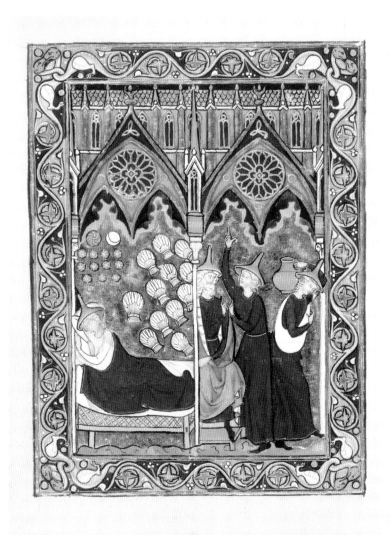

Folio 15v

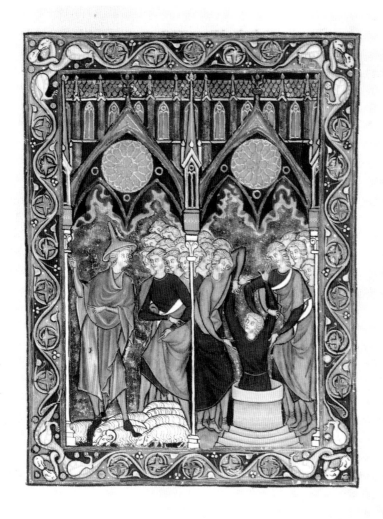

Folio 16r

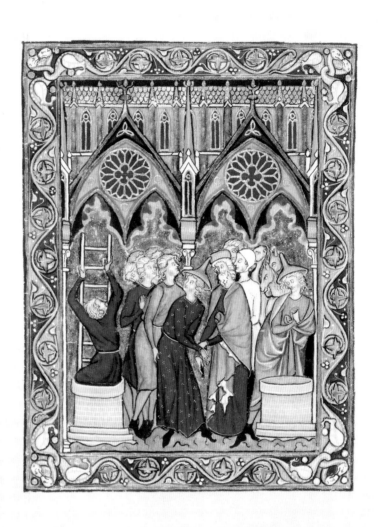

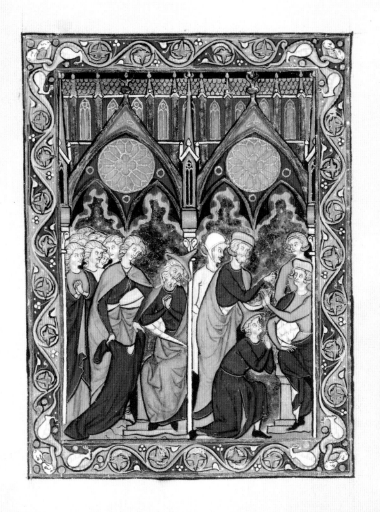

Folio 18r

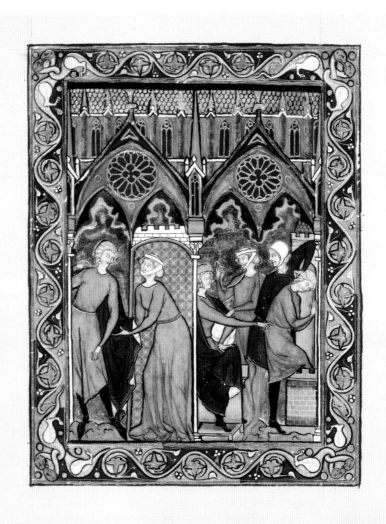

Folio 19v

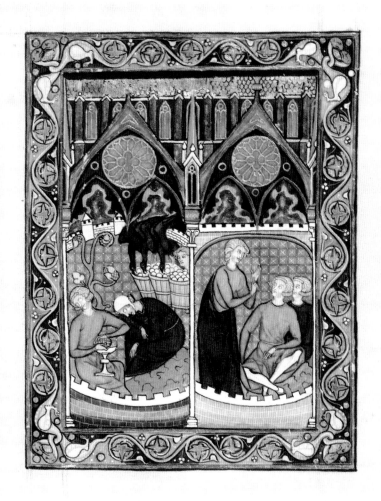

Folio 20r

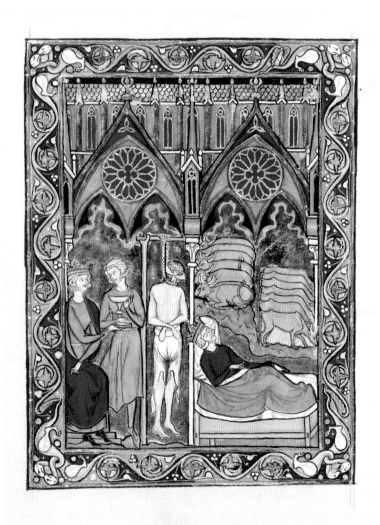

Folio 21v

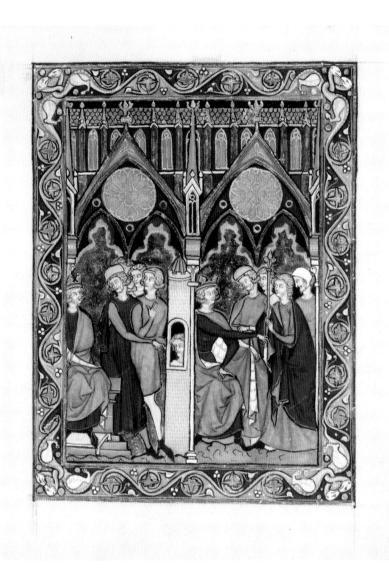

Folio 22r

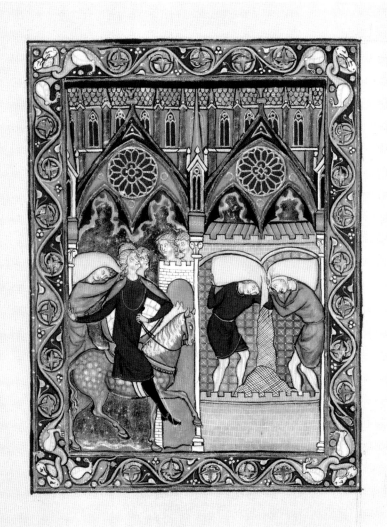

Folio 23v

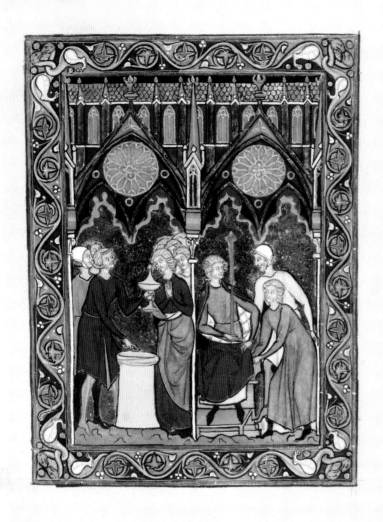

Folio 24r

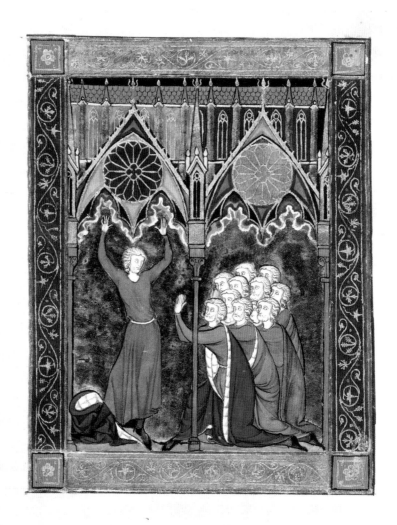

Folio 25v

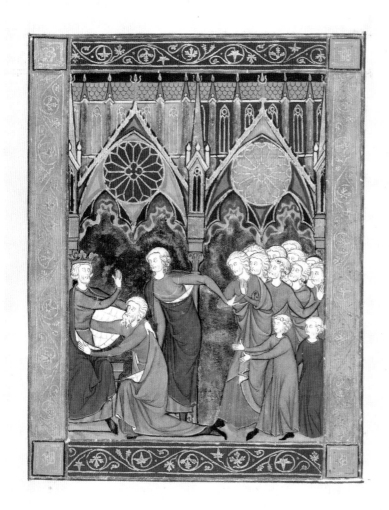

Folio 26r

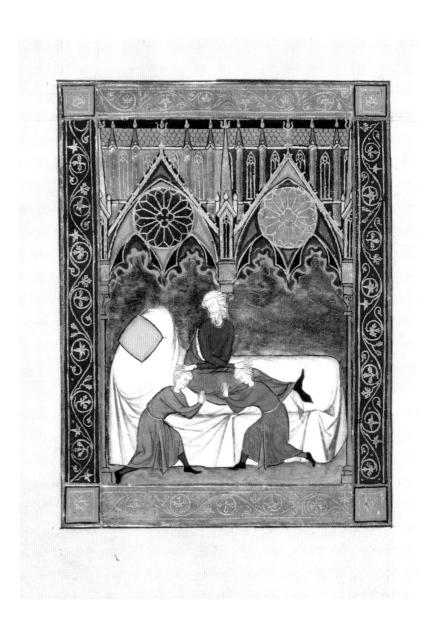

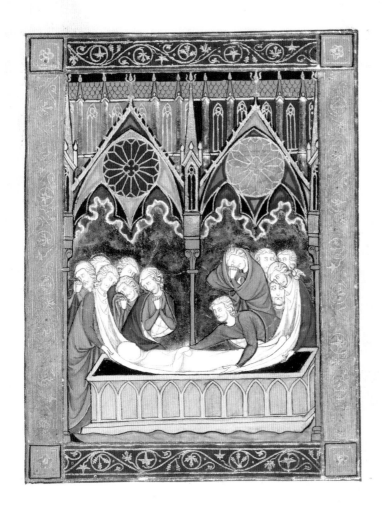

Folio 28r

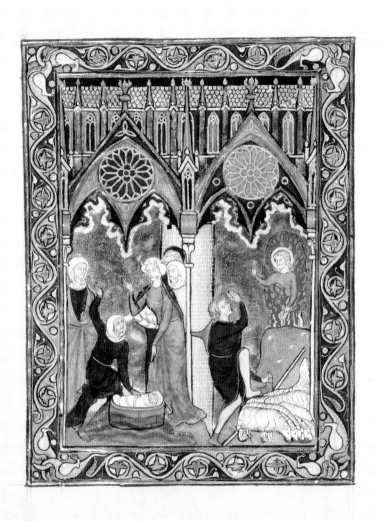

Folio 29v

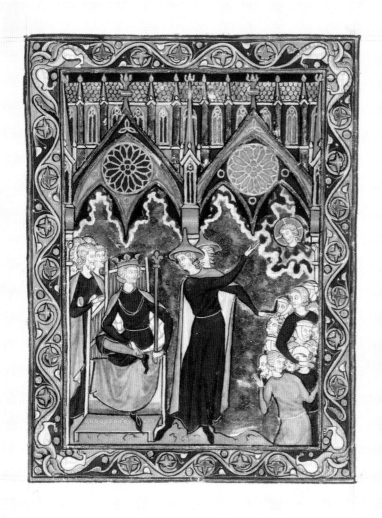

Folio 30r

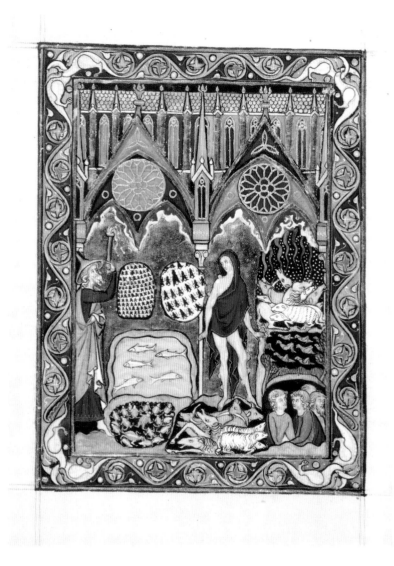

Folio 31v

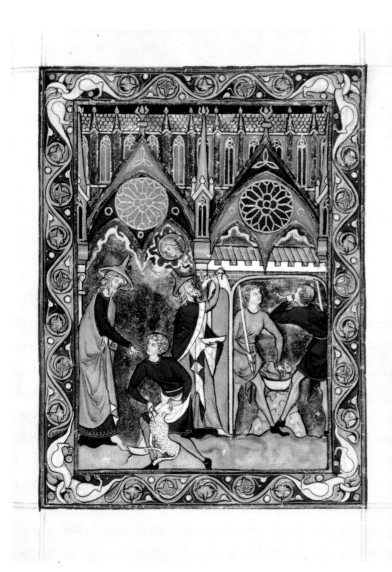

Folio 32r

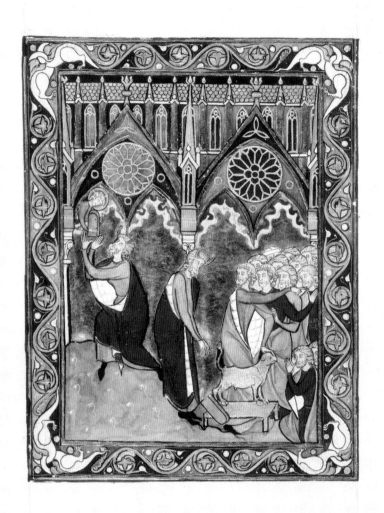

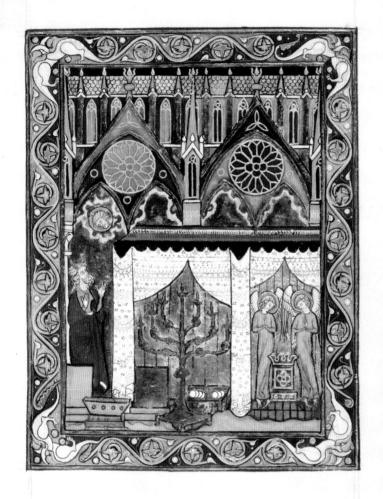

Folio 36r

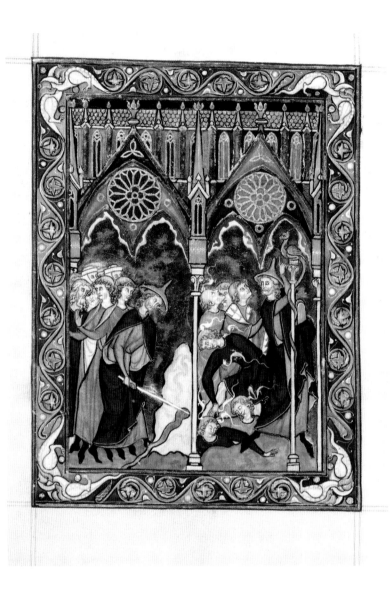

Folio 37v

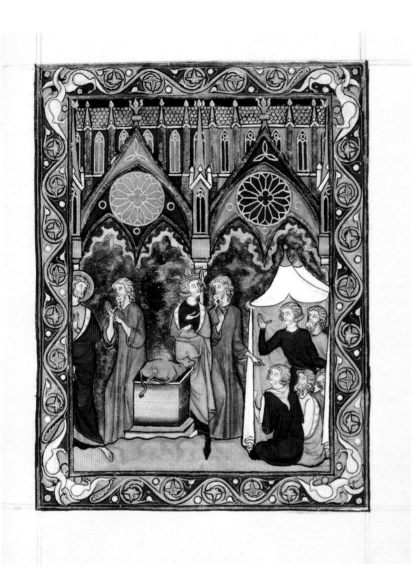

Folio 38r

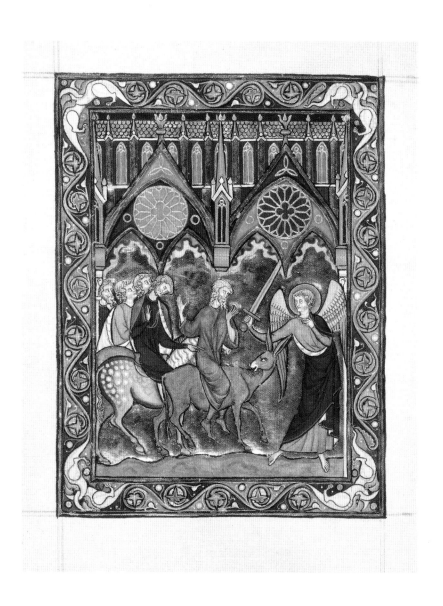

Folio 39v

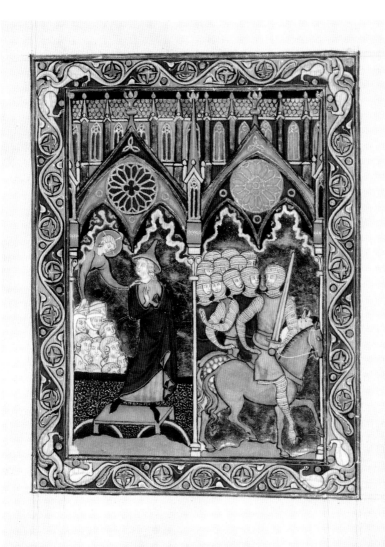

Folio 40r

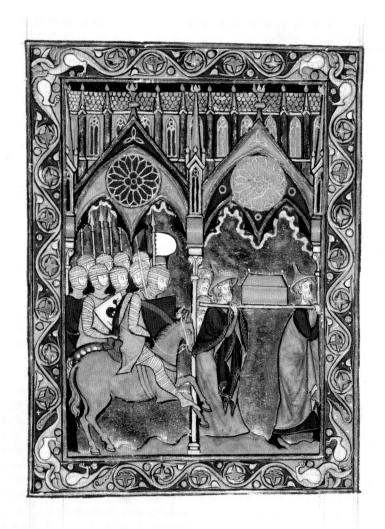

Folio 41v

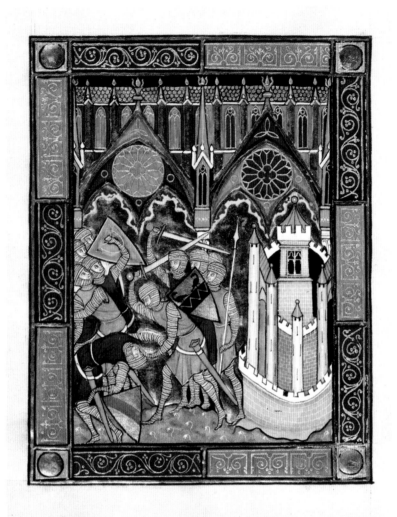

Folio 43v

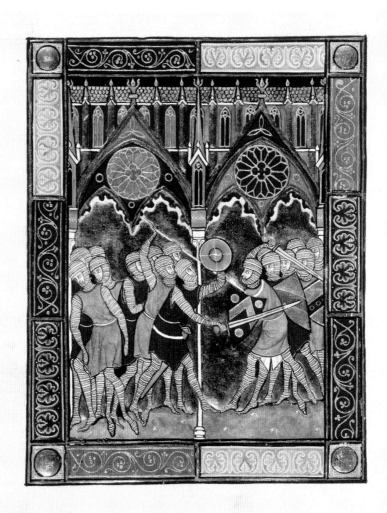

Folio 45v

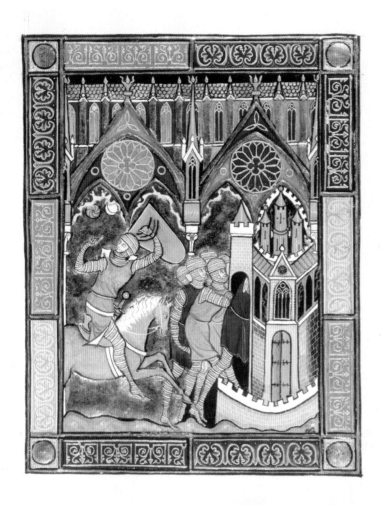

Folio 46r

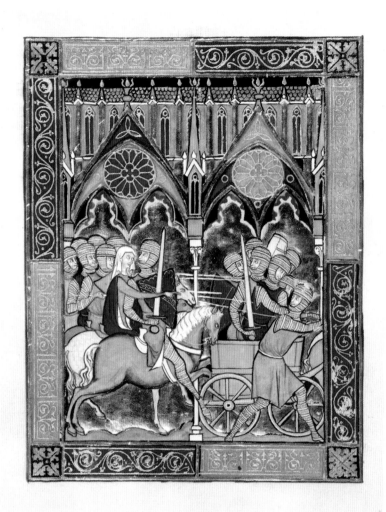

Folio 47v

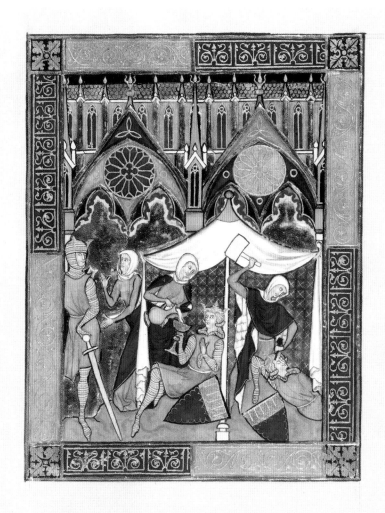

Folio 48r

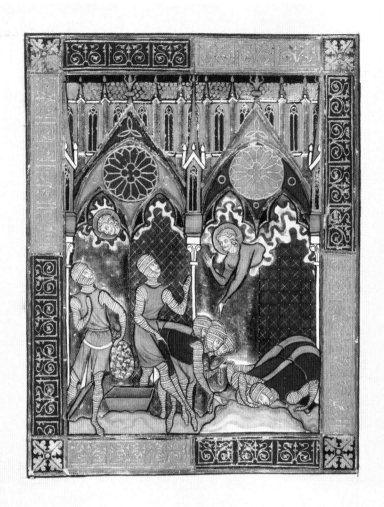

Folio 51v

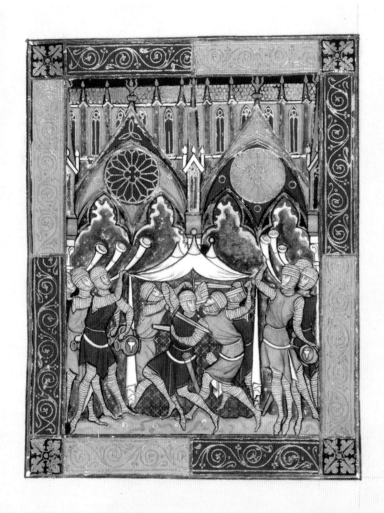

Folio 52r

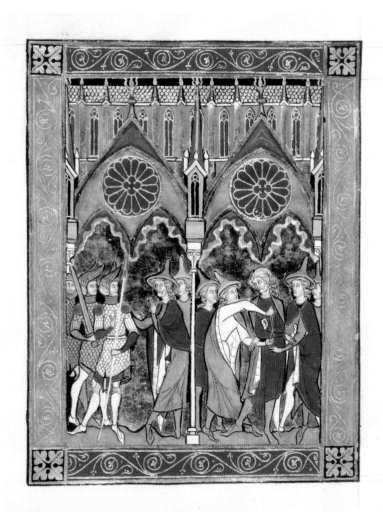

Folio 59v

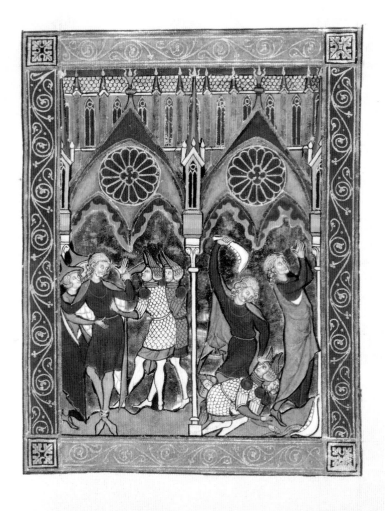

Folio 60r

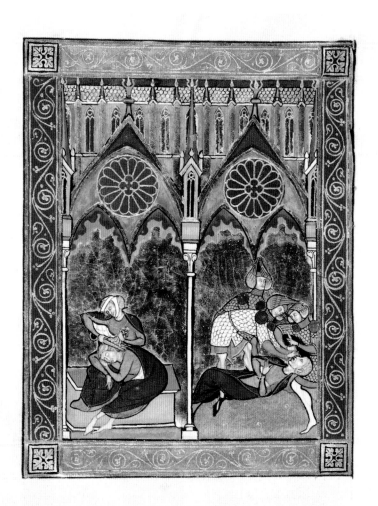

Folio 61v

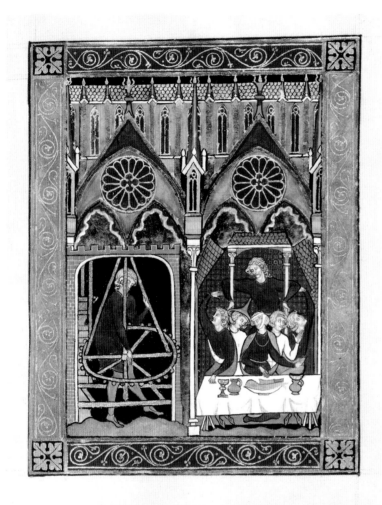

Folio 62r

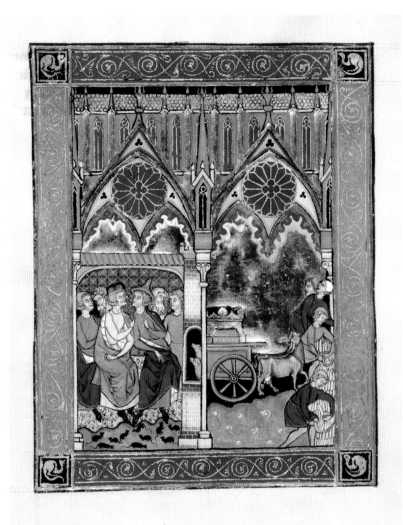

Folio 71v

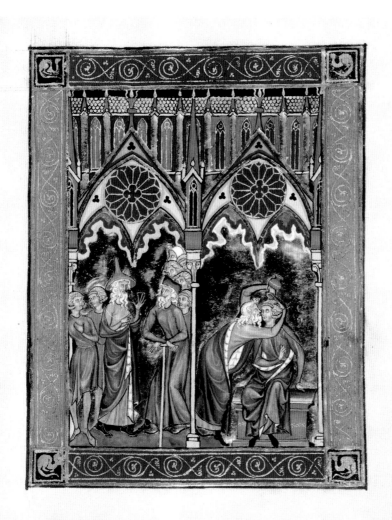

Folio 72r

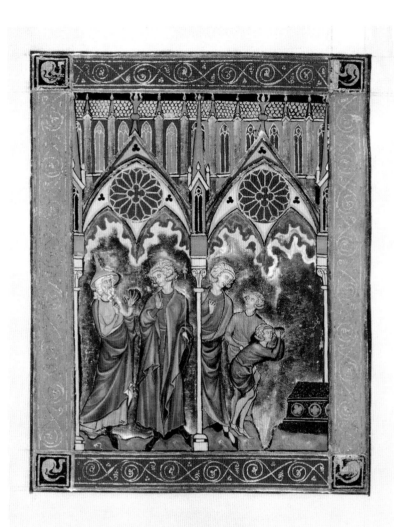

Folio 73v

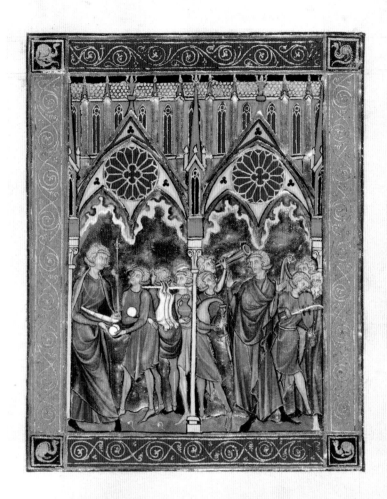

Folio 74r

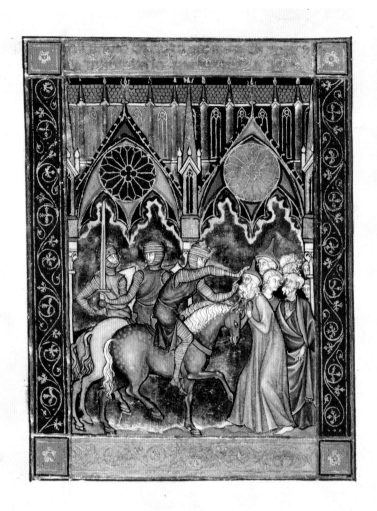

Folio 75v

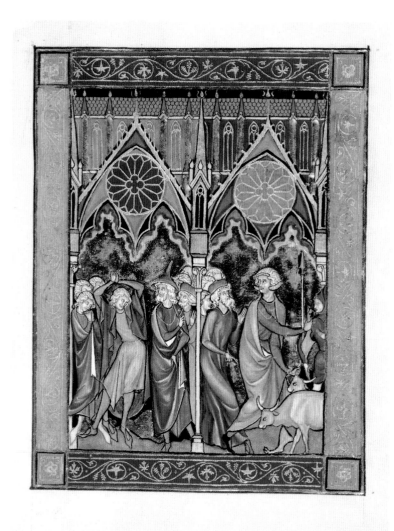

Folio 76r

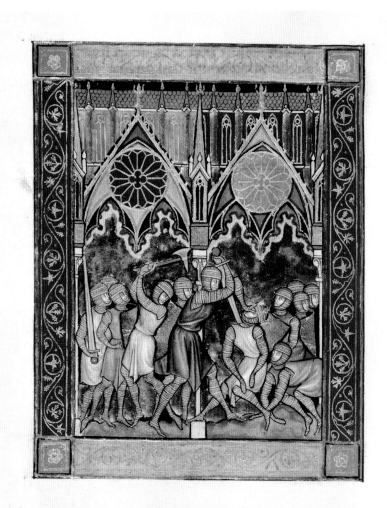

Folio 77v

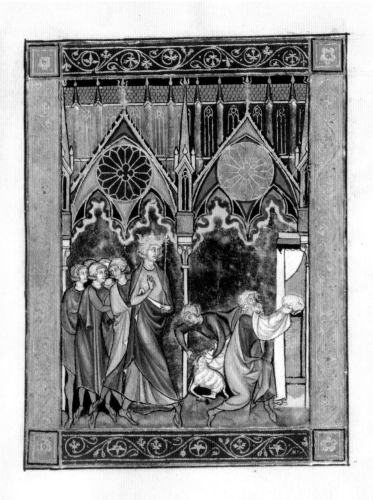

Folio 78r

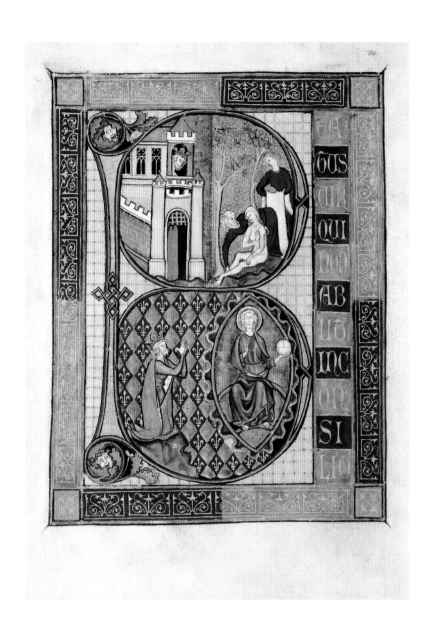

Folio 85v

impiorum et in uia peccatorum non ste
tit: et in cathedra pestilentie non sedit.
Sed in lege domini uoluntas eius: et
in lege eius meditabitur die ac nocte.
Et erit tanquam lignum quod plan
tatum est secus decursus aquarum: qd
fructum suum dabit in tempore suo.
Et folium eius non defluet: 7 omnia
quecumcp faciet prosperabuntur.
Non sic impij non sic: sed tanquam
puluis quem proicit uentus a facie ter
re.
Ideo non resurgunt impij in iudicio: ne
cp peccatores in consilio iustorum.
Quoniam nouit dominus uiam iu
storum: et iter impiorum peribit.
Quare fremuerunt gentes: 7 popu
li meditati sunt inania.

Pes meus stetit in directo: in ecclesijs be
nedicam te domine.

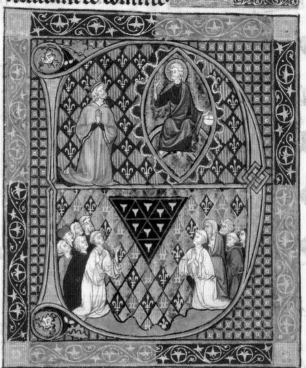

ominus illuminatio mea ↄ salus me
a: quem timebo.

Dominus protector uite mee a quo trepidabo.

Dum appropiant super me nocentes: ut edant carnes meas

Qui tribulant me inimici mei ipsi infir mati sunt et ceciderunt

Si consistant aduersum me castra non timebit cor meum

Si exurgat aduersum me prelium: in hoc ego sperabo

Unam pecij a domino hanc requiram: ut inhabitem in domo domini omnibus diebus uite mee

Ut uideam uoluntatem domini et ui sitem templum eius.

Quoniam abscondit me in tabernaculo suo in die malorum: protexit me in abscondito tabernaculi sui

In petra exaltauit me: et nunc exaltauit

oderunt me inique;

Qui retribuunt mala p bonis detrahebat michi: qm sequebar bonitatem.

Ne derelinquas me domine deus meus: ne discesseris a me.

Intende in adiutorium meum: domine ds salutis mee. domine in celo miseckia tua.

meaſ: ut non delinquam in lingua mea.
Poſui ori meo cuſtodiam: cum conſiſteret
peccator aduerſum me
Obmutui et humiliatuſ ſum et ſilui a bo
niſ: et dolor meuſ renouatuſ eſt.
Concaluit cor meum intra me: et in medi
tatione mea exardeſcet igniſ.
Locutuſ ſum in lingua mea: notum fac
michi domine finem meum.
Et numerum dierum meorum quiſ eſt: ut
ſciam quid deſit michi.
Ecce menſurabileſ poſuiſti dieſ meoſ: et
ſubſtantia mea tanquam nichilum ante te.
Verumtamen uniuerſa uanitaſ: omniſ
homo uiuenſ.
Verumtamen in ymagine pertranſit ho
mo: ſed et fruſtra conturbatur.
Theſaurizat et ignorat cui congregabit ea.

et expectabo nomen tuum qīn bonū
est in conspectu sanctorum tuorum.

IN
SI
PI
EN
S: IN

corde suo non est deus
Corrupti sunt et ab hominabiles facti
sunt in iniquitatib; suis non est
qui faciat bonū: ñ est usq̃ ad unum.

plebi sue·lenedictus deus

qm intrauerunt aque usq̃ ad ani
mam meam

Infixus sum in limo profundi·et nõ
est substantia·

Folio 156v

nrenfa igni et fuffolla: ab mcepatione

uultus tui peribunt.

Fiat manus tua super uirum dextere tue:

et sup filium hominis que confirmasti t.

et non discedimus a te: uiuificabis nos et

nomen tuum muocabimus.

Domine deus uirtutum conuerte nos: et

ostende faciem tuam et salui erimus

de manu peccatoris liberabit eos

Lux orta est iusto: et rectis corde leticia

Letamini iusti in domino: ꝭ confitemini
memoriae sanctificationis eius.

nouum: quia mirabilia fecit.

Saluauit sibi dextera eius: ꝭ brachium sāc

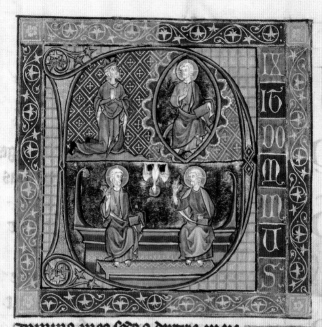

domino meo sede a dextris meis ;

D onec ponam inimicos tuos scabellum
pedum tuorum.

V irgam virtutis tue emittet dominus ex
syon dnare in medio inimicoz tuoz

T ecum principium in die virtutis tue. m

Appendix I: Description

1. Summary

Paris, Bibliothèque nationale de France, MS latin 10525. *Olim* Supplément latin 636, N 67 (Musée des souverains).

Parchment, 260 folios (numbered consecutively) + 1 ("A," fifteenth century); paper, 1 (nineteenth century). Codex: 211 (h) × 155 (w) × 62–70 mm (d: spine to opposite side). Page: 211 × 148 mm.

Psalms with calendar and canticles, in Latin, and explanations of the miniatures, in French. Written in Gothic textualis, one column, 121 × 85 mm, 18 lines of 8 mm height, probably by two hands. 78 full-page introductory miniatures, 8 historiated initials (1 full-page), 176 painted initials, numerous painted line-endings, and verse initials in blue ink and in gold.

Summary collation: i⁴ (pastedown and 3 flyleaves) + ii¹ (fol. A) + I¹⁴, II¹⁰, III⁴, IV¹⁴, V⁸XIII⁴, XIV⁶, XV¹⁴, XVI⁸XIX¹², XX¹² ⁻ ¹ ⁺ ⁴, XXI–XXIV¹², XXV¹² ⁻ ¹ ⁺ ¹, XXVI–XXVIII¹², XXIX² ⁺ ¹, + iii⁴ (3 endleaves + pastedown).

Binding: blue velvet, 1970; previously, wooden boards, ca. 1400, covered with a red double-layered lampas of silk with gold brocade, Italian, late fourteenth century, now detached, and a protective cover of red velvet (nineteenth century), also detached; clasps lacking.

Paris, ca. 1260–65. For Louis IX of France. Ex coll.: Charles IV, Jeanne d'Évreux, Charles V, Charles VI, Marie de France, Alexis Golovkin (Moscow), Mikhail Golitzyn (Moscow).

2. Contents

A. PREFATORY MATTER

Endleaf: accession numbers—"lat. 10525/1515-11," "Lat. 10515," and "N 67."

Three folios, unnumbered (modern)—two blank, the third with a note, pasted and typed, concerning the rebinding in 1970 of a letter of August 29, 1818, from the minister of the interior, transmitting the manuscript to the director of the Bibliothèque du Roi.

Fol. Ar—*suppl^t l. 636* and *nunc: latin 10525.*

Fol. Av—inscription (fifteenth century):
Cest psaultier fu saint Loys. Et le don[n]a la royne Jehanne d'Evreux au roy Charles filz du roy Jehan, l'an de n[ost]re S[eigneur] mil troys cens soissante et nuef. Et le roy Charles p[rese]nt filz dudit roy Charles le donna a Madame Marie de Fra[n]ce sa fille religieuse a Poyssi. Le jour saint Michel, l'an mil iiiiᶜ. . . .

B. FULL-PAGE MINIATURES AND EXPLANATORY TEXTS (Fols. 1r–78v)

See section 5 below and Appendix III.

C. TEXTS

Psalms 1 to 110—fols. 85v–245r
canticles and creed—fols. 245v–260v

fol. 245v	Confitebor tibi	(Isa. 12)
246r	Ego dixi in dimidia	(Isa. 38:10–21)
247r	Exultate cor	(1 Sam. 2:1–20)
248r	Cantemus domino	(Exod. 15:1–20)
249v	Domine audivi	(Hab. 3)
251r	Audite caeli	(Deut. 32:1–43)
254v	Te deum	
255v	Benedicite omnia	(Dan. 3:57–89)
257r	Benedictus dominus	(Luke 1:68–79)
257v	Magnificat	(Luke 1:46–55)
258r	Nunc dimittis	(Luke 2:29–32)
258v	Quicumque vult salvus esse	

D. END MATTER

Three modern parchment leaves, blank and unnumbered.

3. Contents in Relation to Gatherings

Introductory cycle:

I (14 fols.): fols. 1–14 — Cain, Noah, Abraham, Lot, Isaac, Jacob

II (10 fols.): fols. 15–24 — Joseph I

III (4 fols.): fols. 25–28 — Joseph II

IV (14 fols.): fols. 29–42 — Moses, Balaam, Joshua I

V (4 fols.): fols. 43–46 — Joshua II

VI (4 fols.): fols. 47–50 — Deborah, Jael, Gideon I

VII (4 fols.): fols. 51–54 — Gideon II

VIII (4 fols.): fols. 55–58 — Samson I

IX (4 fols.): fols. 59–62 — Samson II

X (4 fols.): fols. 63–66 — Benjaminites

XI (4 fols.): fols. 67–70 — Samuel: Philistines Take the Ark

XII (4 fols.): fols. 71–74 — Samuel: Saul Chosen

XIII (4 fols.): fols. 75–78 — Saul Triumphs

Calendar:

XIV (6 fols.): fols. 79–84

Psalms and concluding prayers:

XV (14 fols.): fols. 85–98 — Ps. 1–16:14

XVI (12 fols.): fols. 99–110 — Ps. 16:14–26:1

XVII (12 fols.): fols. 111–22 — Ps. 26:1–36:5

XVIII (12 fols.): fols. 123–34 — Ps. 36:5–45:2

XIX (12 fols.): fols. 135–46 — Ps. 45:2–58:1

XX (15 fols.): fols. 147–61 — Ps. 58:2–71:10

XXI (12 fols.): fols. 162–73 — Ps. 71:10–78:12

XXII (12 fols.): fols. 174–85 — Ps. 78:13–89:14

XXIII (12 fols.): fols. 186–97 — Ps. 89:14–103:8

XXIV (12 fols.): fols. 198–209 — Ps. 103:8–108

XXV (12 fols.): fols. 210–21 — Ps. 109–118:100

XXVI (12 fols.): fols. 222–33 — Ps. 118:101–135:24

XXVII (12 fols.): fols. 234–45 — Ps. 135:25–150 and canticles

XXVIII (12 fols.): fols. 246–57 — canticles

XXIX (3 fols.): fols. 258–60 — canticles and creed

4. Construction of Irregular Gatherings

5. Decoration

A. FULL-PAGE MINIATURES

Folio	Miniatures	Biblical Reference	Legend
1v	The Sacrifices of Cain and Abel	Gen. 4:3–5	1r
2r	Cain Kills Abel; God Questions Cain	4:8, 9–12	2v
3v	The Dove Returns to Noah in the Ark	8:5–11	3r
4r	The Drunken Noah Is Covered by His Sons	9:20–23	4v
5v	Abraham's Victory over the Kings	14:14–15	5r
6r	Abraham and Melchizedek Exchange Offerings	14:16–20	6v
7v	Three Angels Appear to Abraham at Mamre; They Foretell His Progeny	18:1–10	7r
8r	Lot Receives the Two Angels; They Blind the Sodomites	19:1–3, 4–11	8v
9v	Lot and His Family Flee the Destruction of Sodom	19:24–26	9r
10r	The Sacrifice of Abraham	22:9–13	10v
11v	Abraham's Servant Is Sent to Find a Wife for Isaac; He Meets Rebecca	24:1–9, 17–20	11r
12r	Rebecca Journeys to Canaan and Meets Isaac	24:61, 64–65	12v
13v	Jacob's Dream; He Anoints the Stone	28:11–15, 18–19	13r
14r	Jacob Meets the Angels of God; He Wrestles with the Angel	32:1–2, 24–30	14v
15v	Joseph's Dream's; Joseph Is Sent to His Brothers	37:7, 9, 10, 13–14	15r
16r	Joseph's Brothers See Him Approach; They Lower Him into a Well	37:18–20, 24	16v
17v	Joseph Is Sold to the Midianites; Reuben's Despair	37:25–30	17r
18r	Jacob Is Shown Joseph's Robe; Joseph Is Sold to Potiphar in Egypt	37:31–36	18v
19v	Potiphar's Wife Tries to Tempt Joseph; He Is Imprisoned	39:11–12, 16–20	19r
20r	The Dreams of the Baker and the Butler; Joseph Interprets Their Dreams	40:9–19	20v
21v	The Butler Serves Pharaoh but the Baker Is Hanged; Pharaoh's Dream	40:20–41:3	21r
22r	Joseph Is Remembered in Prison; Pharaoh Elevates Him to Office	41:8–13, 39–42	22v
23v	Joseph Buys Wheat from the Egyptians; The Storage of Grain	41:43, 46–48	23r
24r	The Chalice Is Found in Benjamin's Sack; He Is Returned to Joseph	44:11–12, 18	24v
25v	Joseph Reveals Himself to His Brothers	45:1–3	25r
26r	Joseph Presents Jacob and His Family to Pharaoh	47:1–10	26v
27v	Jacob Blesses the Sons of Joseph	48:13–16	27r
28r	The Entombment of Jacob	50:10–13	28v
29v	The Finding of Moses; The Burning Bush	Exod. 2:5–9; 3:1–5	29r
30r	Moses Asks Pharaoh to Free the Israelites	5:1	30v
31v	The First Nine Plagues	7–10	31r
32r	The Pascal Sacrifice; The Israelites Prepare for Passover	12:1–11	32v
33v	The Tenth Plague; The Exodus	12:29–34	33r
34r	Aaron and Hur Hold Up Moses' Arms; Israel Overcomes the Amalekites	17:10–12	34v
35v	Moses Receives the Law; The Golden Calf	31:18; 32:19	35r
36r	The Desert Tabernacle	40:1–7, 16–28	36v
37v	Moses Brings Forth Water in the Desert; The Brazen Serpent	Num. 20:9–11; 21:6–9	37r
38r	Balaam and Balak	23:4–12; 24:1–2	38v
39v	Balaam and the Ass	22:28–31	39r
40r	Joshua Is Made Leader of Israel; The Army Is with Him	Josh. 1:1–2, 12–18	40v
41v	The Israelites Carry the Ark Around Jericho	6:6–11	41r
42r	The Fall of Jericho	6:12–21	42v
43v	Israel Is Defeated Before Ai	7:4–5	43r

fol. 85v Psalm 1 (Beatus vir): David and
 Bathsheba; David Kneels in Prayer
 Before Christ

110v Psalm 26 (Dominus illuminatio mea):
 David Kneels in Prayer Before Christ;
 Religious Kneel Before Lamps

126v Psalm 38 (Dixit custodiam vias meas):
 David in Prayer Before Christ; Religious
 Kneel and Point to Their Mouths

141v Psalm 52 (Dixit insipiens in corde suo):
 David in Prayer Before Christ; Two Men
 Wrestling

156v Psalm 68 (Salvum me fac): David in
 Prayer Before Christ; David in the
 Waters

175r Psalm 80 (Exultate deo adiutari nostro):
 David Kneels in Prayer Before Christ;
 A Young Musician

192r Psalm 97 (Cantate domino canticum
 novum): David Kneels in Prayer Before
 Christ; Religious Singing

210r Psalm 109 (Dixit dominus domino
 meo): David Kneels Before Christ;
 The Trinity

Excellent except for very minor changes, as follows:
some flaking of background gold (esp. fols. 54r, 56r);
smudging of gold penwork (fols. 47v, 51v, 52r), of
gold roof tiles (fols. 8r, 10r, 20r), and of Joseph's
face (fol. 15v, left); sewing holes above miniatures,
probably for protective cloths (fols. 1, 3, 5, 8, 9, 12);
some soiling of parchment edges (e.g., fols. 1, 2,
85, 86).

Appendix II: Legends

Note: The transcriptions retain the capitalization and spelling of the original, but abbreviations are resolved, and apostrophes are added for clarity. Interlinear additions are enclosed between slashes (/). Translations are idiomatic rather than literal. Care has been taken to use the English equivalents of the French tenses wherever possible.

1. The Sacrifices of Cain and Abel (Gen. 4:3–5)

 En ceste page ẹṣṭ* conment caym et abel offrent leur disme a dieu: (fol. 1r)
 [On this page is how Cain and Abel offer their tithe to God]

 *Dots under this word indicate it should be expunged.

2. Cain Kills Abel; God Questions Cain (Gen. 4:8, 9–12)

 En ceste page est conment caym ocit abel son frere et conment dieus li demande qu'il a fait de son frere abel (fol. 2v)
 [On this page is how Cain kills Abel, his brother, and how God asks him what he did with his brother, Abel]

3. The Dove Returns to Noah in the Ark (Gen. 8:5–11)

 En ceste page est conment Noei est en l'arche au duluge (fol. 3r)
 [On this page is how Noah is in the ark during the Flood]

4. The Drunken Noah Is Covered by His Sons (Gen. 9:20–23)

 En ceste page est conment Noei fu yvres et s'endormi descovers et conment si enfant le covrirent (fol. 4v)
 [On this page is how Noah was drunk and fell asleep uncovered and how his children covered him]

5. Abraham's Victory over the Kings (Gen. 14:14–15)

 En ceste page est conment abraham ce conbati encontre ses enemis et conment il ocist les trois rois et gaaingnai leur despuelles (fol. 5r)
 [On this page is how Abraham fought against his enemies and how he killed the three kings and won the spoils]

6. Abraham and Melchizedek Exchange Offerings (Gen. 14:16–20)

 En ceste page est conment abraham offre et presente ses prisons et sa proie et son gaaing a melchicedech le roi et esveque et conment melchicedech li presente le pain et le vin (fol. 6v)
 [On this page is how Abraham offers and presents his captives and his herd and his plunder to Melchizedek the king and bishop and how Melchizedek presents him with bread and wine]

7. Three Angels Appear to Abraham at Mamre; They Foretell His Progeny (Gen. 18:1–10)

 En ceste page est conment li .iii. angle vindrent a abraham et conment il en aoura l'un et conment il les sert au mangier, et conment saire rit darrier l'uis de l'abit (fol. 7r)
 [On this page is how the three angels came to Abraham and how he adored one of them and how he serves them (food) to eat, and how Sarah laughs behind the door of the dwelling]

8. Lot Receives the Two Angels; They Blind the Sodomites (Gen. 19:1–3, 4–11)

 En ceste page est conment li angle vindrent a loth et conment loht les resoit en son hostel et conment li sodomeien li voudrent brisier son hostel et conment li angle issirent et les aveuglerent (fol. 8v)
 [On this page is how the angels came to Lot and how

Lot receives them in his house and how the Sodomites wanted to tear down his house and how the angels went out and blinded them]

9. Lot and His Family Flee the Destruction of Sodom (Gen. 19:24–26)

En ceste page est conment les .v. citeiz de sodome et de gormorre fondirent de feu et de souffre et conment loth et sa feme et ses .ii. filles s'en vont et conment la feme regardai darrier soi et fu muee en pierre salee (fol. 9r)
[*On this page is how the five cities of Sodom and Gomorrah were destroyed in fire and brimstone and how Lot and his wife and his two daughters leave and how his wife looked behind her and was changed into salt stone*]

10. The Sacrifice of Abraham (Gen. 22:9–13)

En ceste page est conment abraham volt sacrifiier ysaac son fil a dieu et conment l'angle li monstre le mouton (fol. 10v)
[*On this page is how Abraham wants to sacrifice Isaac, his son, to God and how the angel shows him the ram*]

11. Abraham's Servant Is Sent to Find a Wife for Isaac; He Meets Rebecca (Gen. 24:1–9, 17–20)

En ceste page est conment abraham fet jurer a son serjant qu'il querra a son fill ysaac feme de son lignage et conment Rebecca la pucele donne a boivre de l'iague du puis au serjant abraham et a ses betes (fol. 11r)
[*On this page is how Abraham makes his servant swear that he will look for a wife for his son, Isaac, of his [own] lineage and how the maiden Rebecca gives the servant of Abraham and his animals water from the well to drink*]

12. Rebecca Journeys to Canaan and Meets Isaac (Gen. 24:61, 64–65)

En ceste page est conment li serjans abraham amainne Rebecca et conment il li monstre ysaac as chans et conment ele dessent de son chamei et encline son seigneur honteuse (fol. 12v)
[*On this page is how the servant of Abraham brings Rebecca back and how he shows her Isaac in the fields*

and how she gets down from her camel and humbly bows before her lord]

13. Jacob's Dream; He Anoints the Stone (Gen. 28:11–15, 18–19)

En ceste page est conment iacob voit .i. eschiele /en dormant/ des le ciel a la terre et les angles qui montoient et dessendoient et coument iacob oint la pierre d'uile (fol. 13r)
[*On this page is how Jacob, while sleeping, sees a ladder from heaven to earth and angels who were going up and down and how Jacob anoints the stone with oil*]

14. Jacob Meets the Angels of God; He Wrestles with the Angel (Gen. 32:1–2, 24–30)

En ceste page est conment iacob voit une grant multitude d'angles et conment iacob lutte a l'ange (fol. 14v)
[*On this page is how Jacob sees a great multitude of angels and how Jacob fights the angel*]

15. Joseph's Dreams; Joseph Is Sent to His Brothers (Gen. 37:7, 9, 10, 13–14)

En ceste page est conment ioseph songe et conment iacob son pere li espont son songe et conment ioseph porte a maingier ses freres (fol. 15r)
[*On this page is how Joseph dreams and how Jacob, his father, explains to him his dream and how Joseph carries (food) for his brothers to eat*]

16. Joseph's Brothers See Him Approach; They Lower Him into a Well (Gen. 37:18–20, 24)

En ceste page est conment ioseph vient a ces freres et conment li uns des freres dit veez ci le songeur or nos en venions, et conment il le gietent en une fosse (fol. 16v)
[*On this page is how Joseph comes to his brothers and how one of them says, "Look, here comes the dreamer, and let's be on our way," and how they cast him into a pit*]

17. Joseph Is Sold to the Midianites; Reuben's Despair (Gen. 37:25–30)

En ceste page est conment li frere metent hors ioseph de la fosse et conment il le vendirent as marcheans d'egypte, et conment Rubem regrete ioseph sor la fosse (fol. 17r)
[*On this page is how the brothers take Joseph out of the pit and how they sold him to Egyptian merchants and how Reuben mourns Joseph from above the pit*]

18. Jacob Is Shown Joseph's Robe; Joseph Is Sold to Potiphar in Egypt (Gen. 37:31–36)

En ceste page est conment li frere aportent a leur pere iacob la cote ioseph et dient que une beste sauvage l'a devorei et conment li marchant le vendirent a putiphar le prevot (fol. 18v)
[*On this page is how the brothers bring the coat of Joseph to their father, Jacob, and say that a savage beast has devoured him and how the merchants sold him to Potiphar the provost*]

19. Potiphar's Wife Tries to Tempt Joseph; He Is Imprisoned (Gen. 39:11–12, 16–20)

En ceste page est conment la feme putiphar requiert ioseph d'amer et conment ioseph li laiche son mantel et conment ele se plaint a son seigneur de ioseph et conment l'en met ioseph en la chartre (fol. 19r)
[*On this page is how the wife of Potiphar asks for Joseph's love and how Joseph leaves his mantle with her and how she complains of Joseph to her lord and how he puts Joseph in prison*]

20. The Dreams of the Baker and the Butler; Joseph Interprets Their Dreams (Gen. 40:9–19)

En ceste page est conment le penetier et le boutallier le roi pharaon sont en la chartre avoec ioseph et conment il songent et conment ioseph leur espont leur songe (fol. 20v)
[*On this page is how the baker and the butler of the king Pharaoh are in prison with Joseph and how they dream and how Joseph explains to them their dreams*]

21. The Butler Serves Pharaoh but the Baker Is Hanged; Pharaoh's Dream (Gen. 40:20–41:3)

En ceste page est conment li rois rent au boutallier son mestier et conment le penetier est pendus: et conment li rois pharaons songe (fol. 21r)
[*On this page is how the king returns the butler to his post and how the baker is hanged and how king Pharaoh dreams*]

22. Joseph Is Remembered in Prison; Pharaoh Elevates Him to Office (Gen. 41:8–13, 39–42)

En ceste page est conment /li rois/ requiert consoil de son songe et conment en li dit de ioseph et conment il le mande et conment ioseph li espont son songe et conment li rois le fait seigneur et baillif de toute sa terre (fol. 22v)
[*On this page is how the king asks advice about his dream and how one tells him of Joseph and how he summons him and how Joseph explains his dream to him and how the king makes him lord and bailiff of all his land*]

23. Joseph Buys Wheat from the Egyptians; The Storage of Grain (Gen. 41:43, 46–48)

En ceste page est conment ioseph achate et quiert les bleiz et coument il fait emplir les greniers (fol. 23r)
[*On this page is how Joseph buys and collects wheat and how he has the granaries filled*]

24. The Chalice Is Found in Benjamin's Sack; He Is Returned to Joseph (Gen. 44:11–12, 18)

En ceste page est conment la coupe d'or fu trovee es sas as freres ioseph et coument ioseph retient beniamin (fol. 24v)
[*On this page is how the cup of gold was found in the sacks of Joseph's brothers and how Joseph keeps back Benjamin*]

25. Joseph Reveals Himself to His Brothers (Gen. 45:1–3)

En ceste page est conment ioseph se fait quenoitre a ces onse freres et coument il l'aourent tuit (fol. 25r)
[*On this page is how Joseph makes himself known to his eleven brothers and how they all adore him*]

Mount Sinai and how Moses goes back and finds the people of Israel, who were adoring a golden calf, and how Moses broke their tablets]

36. The Desert Tabernacle (Exod. 40:1–7, 16–28)

En ceste page est coument dieus devise a Moyses le saint tabernacle (fol. 36v)
[*On this page is how God describes to Moses the holy tabernacle*]

37. Moses Brings Forth Water in the Desert; The Brazen Serpent (Num. 20:9–11; 21:6–9)

En ceste page est conment /Moyses/ fiert de sa verge la dure pierre et la douce iauve en salli et conment Moyses montre le serpent d'arain sor la columbe au pueple qui estoit tormentes de menus serpentiaus (fol. 37r)
[*On this page is how Moses strikes the hard stone with his staff and the sweet water gushed out and how Moses shows the brazen serpent on the column to the people, who were tormented by small serpents*]

38. Balaam and Balak (Num. 23:4–12; 24:1–2)

En ceste page est conment dieus parole au prophete et conment le prophete dit au roi qu'il sacrifiee et face sacrifieer ses genz qui sont es paveillonz (fol. 38v)
[*On this page is how God speaks to the prophet and how the prophet tells the king that he should sacrifice and have the people who are in the tents sacrifice*]

39. Balaam and the Ass (Num. 22:28–31)

En ceste page est conment balaam bat l'arnesse et conment l'angle tient l'espee nue devant l'arnesse et conment l'arnesse parole a balaam (fol. 39r)
[*On this page is how Balaam strikes the ass and how the angel holds a drawn sword before the ass and how the ass speaks to Balaam*]

40. Joshua Is Made Leader of Israel; The Army Is with Him (Josh. 1:1–2, 12–18)

En ceste page est coument dieus dit a iosue je te comans mon pueple soies mon seriant en ci con

Moyses fu. et conment iosue chevauche a armes contre lor enemis en la terre de promision (fol. 40v)
[*On this page is how God says to Joshua, "I entrust to you my people, be my servant in this as Moses was," and how Joshua rides into battle against their enemies in the promised land*]

41. The Israelites Carry the Ark Around Jericho [The Israelites Approach the Jordan] (Josh. 6:6–11) [3:1–6]

En ceste page est conment iosue et son pueple font porter entor la citei de iherico la sainte arche nostre seigneur (fol. 41r)
[*On this page is how Joshua and his people cause the holy Ark of our lord to be carried around the city of Jericho*]

42. The Fall of Jericho (Josh. 6:12–21)

En ceste page est conment li fill israhel vont a vii. boisines et portent la sainte arche entor les murs de iherico et conment li mur de la citei cheirent et conment iosue et son pueple entrerent dedens et gaaingnerent la citei (fol. 42v)
[*On this page is how the children of Israel go with seven trumpets and carry the holy Ark around the walls of Jericho and how the walls of the city fell and how Joshua and his people entered therein and took the city*]

43. Israel Is Defeated Before Ai (Josh. 7:4–5)

En ceste page est conment li fill Israhel se conbatirent a ceus d'une citei et ceuz de la citei les desconfirent (fol. 43r)
[*On this page is how the children of Israel fought against the inhabitants of a city and those of the city put them to flight*]

44. Joshua Condemns Achan; The Stoning of Achan (Josh. 7:19–23, 25)

En ceste page est conment .i. des filz israhel embla une riule d'or et deniers d'or et i. mantel et conment iosue le fist lapider de pierres (fol. 44v)
[*On this page is how one of the children of Israel stole a rule of gold and golden deniers and a portion of cloth and how Joshua had him stoned*]

45. The Israelites Ambush the Men of Ai (Josh. 8:14–21)

En ceste page est conment li fill israhel se conbatent contre leur enemis et conment il tornerent le dos et foirent (fol. 45r)
[*On this page is how the children of Israel fight against their enemies and how they turned their backs and fled*]

46. Joshua Stills the Sun and Moon [The Israelites Take the City of Ai] (Josh. 10:12–13) [8:19]

En ceste page est conment li fill israhel chacent leur enemis en la citei et coument il entrerent en la citei et ardirent et prindrent et ocistrent leur enemis et conment iosue leva ses mains et son escu et li soleus fu en estal (fol. 46v)
[*On this page is how the children of Israel pursue their enemies into the city and how they entered and burned the city and took and killed their enemies and how Joshua raised his hands and his shield and the sun stood still*]

47. Deborah Directs Barak to Attack Sisera and His Troops (Judg. 4:14–15)

En ceste page est conment /li fill israhel/ se conbatirent contre les rois de leur enemis par l'amonestement d'une vaillant dame qui ot a nom delbora et conment il les vainquirent et ocistrent et gaaignarent leur curres et chassarent le roi (fol. 47r)
[*On this page is how the children of Israel fought against the kings of their enemies by the orders of a valiant woman named Deborah and how they vanquished and killed them and took their chariots and pursued the king*]

48. Jael and Sisera (Judg. 4:17–21)

En ceste page est conment li rois qui fuioit devant les filz israhel chei ammains d'une bone dame qui ot a nom iael qui le resut en son paveillon et li dona a boivre let a .i. henap et il s'endormi et cele prist .i. grant maill et i. grant clou et cloua le roi parmi la temple en terre et l'ocit (fol. 48v)
[*On this page is how the king who was fleeing from the children of Israel fell into the hands of a good woman named Jael, who received him in her tent and gave him a hanap of milk to drink, and he fell asleep and she took*

a mallet and a large nail and drove the nail through the king's temple into the ground and kills him]

49. The Angel Appears to Gideon; His Offering Is Consumed (Judg. 6:11–12, 19–21)

En ceste page est conment l'angle vient a iedeon en son presseoir et li dit ce que dieus li mande. et conment iedeon sacrifie sor la pierre et espant la grasse desus son sacrifice et l'ange qui muet tout ensemble le sacrifice et se met en la flame du feu (fol. 49r)
[*On this page is how the angel comes to Gideon by his winepress and tells him what God commands of him, and how Gideon sacrifices on the stone and pours the fat over the sacrifice and the angel who mixes the sacrifice together enters into the flames of the fire*]

50. Gideon Destroys the Altar to Baal; He Sacrifices to God (Judg. 6:25–27)

En ceste page est conment le fill israhel coupent le bois et destruisent les fauces ydoles: et conment iedeon sacrifie le toriau a dieu (fol. 50v)
[*On this page is how the children of Israel cut the woods and destroy the false idols, and how Gideon sacrifices the bullock to God*]

51. Gideon and the Fleece; Soldiers Are Selected to Fight Midian (Judg. 6:36–38; 7: 4–7)

En ceste page est conment dieus parole a iedeon et conment il tient la toison d'un mouton et le laveoir desoz: et conment dieus dit a iedeon qu'il prengne de ces gens ceus qui beveront a la main et ceus qui bevront a ventrillon doint congie. et voit seur ses enemis et il auront victoire (fol. 51r)
[*On this page is how God speaks to Gideon and how he holds the fleece of a sheep and the basin below; and how God tells Gideon that he should take with him those people who will drink with their hands and should send away those who drink on their bellies, and how he should go against his enemies, and they will be victorious*]

52. The Israelites Terrify the Midianites, Who Kill Each Other (Judg. 7:19–22)

En ceste page est conment les gens iedeon ont chacun .i. boisine a la bouche et en la main .i.

cruche brisee par deverz leur enemis endroit la mie nuit et en chacune cruche .i. lampe ardant la clartei par devers leur enemis et avironerent l'ost de toutes pars et sonerent leur boisines et leverent leur cruches haut et leur enemi furent si espoente qu'il s'entrocistrent tuit en leur pavellons et enci furent delivre li fill israhel de leur enemis et gaaignerent leur despuelles (fol. 52v)

[*On this page is how the people of Gideon each have a trumpet at their lips and in their hand a broken-off vessel extended toward their enemies in the middle of the night and in each vessel a burning lamp shining toward their enemies and they surrounded the army on all sides and sounded their trumpets and raised their vessels high and their enemies were so terrified that they all began to kill each other in their tents and thus the children of Israel were delivered of their enemies and they took their spoils*]

53. Jephthah Is Met by His Daughter (Judg. 11:34–35)

En ceste page est conment li fill israhel repairent de bataille et ont eu victoire et conment les puceles leur vienent encontre demenant grant ioie et conment iepte encontre sa fille et conment il despiece sa vesteure de duel por ce que il devoit sacrifier a dieu la premiere chose qu'il encontreroit apres la victoire (fol. 53r)

[*On this page is how the children of Israel return from battle and have had a victory and how the maidens come out to meet them with great joy and how Jephthah meets his daughter and how he tears his garments from grief because he was to sacrifice to God the first thing that he would encounter after the victory*]

54. Jephthah's Daughter Laments Her Virginity; He Sacrifices Her (Judg. 11:38–39)

En ceste page est conment la fille iepte et ces puceles plaignent et pleurent son pucelage ainz montaingnes. et conment iepte sacrifie sa fille seur l'autel (fol. 54v)

[*On this page is how the daughter of Jephthah and her maiden friends bemoan and lament her virginity in the mountains, and how Jephthah sacrifices his daughter on the altar*]

55. The Annunciation of Samson's Birth; His Mother and Father Sacrifice (Judg. 13:2–5, 19–20)

En ceste page est conment l'angle anunce sanson a sa mere et conment le pere et la mere sanson sacrifient et l'angle qui se mella en la flame de leur sacrifice (fol. 55r)

[*On this page is how the angel announces (the birth of) Samson to his mother and how the father and mother of Samson sacrifice and (how) the angel mixes with the flame of their sacrifice*]

56. Samson Overcomes the Lion; He Takes Honey from Its Carcass (Judg. 14:5–6, 9)

En ceste page est conment sanson ocit le lyon et conment il prent la ree de miel en la gueule au lyon et la mainiue (fol. 56v)

[*On this page is how Samson kills the lion and how he takes the honeycomb from the mouth of the lion and eats it*]

57. Samson's Riddle (Judg. 14:11–17)

En ceste page est conment sanson parole as philistiiens et conment il dit a sa feme son consoil et conment sa feme raconte a philistiiens son consoil sens le seu de son seigneur (fol. 57r)

[*On this page is how Samson speaks to the Philistines and how he tells his wife his secret and his wife explains his secret to the Philistines without the knowledge of her husband*]

58. Samson and the Foxes (Judg. 15:4–5)

En ceste page est conment sanson lie les brandons /ardans/ as queues des goupis et les laissai aler parmi les bleis et tous les bleis furent ars (fol. 58v)

[*On this page is how Samson ties the flaming firebrands to the tails of the foxes and let them go among the wheat and all the wheat was burned*]

59. The Men of Judah Agree to Deliver Samson; They Bind Him (Judg. 15:9–10, 12–13)

En ceste page est conment li philistiien porparllent qu'il prenderont sanson. et conment il prennent sanson et le lient de fors liens et il soeffre tout (fol. 59r)

[On this page is how the Philistines plot that they will take Samson and how they take Samson and bind him with strong ties and he suffers it all]

back dead before his door and, when her husband found her dead, he took his sword and cut his wife into twelve pieces]

60. Samson Breaks His Binds and Slays the Philistines; He Prays for Water (Judg. 15:14–19)

En ceste page est conment sanson rompi ses liiens et conment il de la ioe d'un arne ocit seus qui l'avoient liee et conment il rent graces a dieu de la victoire qu'il a eue (fol. 60v)
[On this page is how Samson broke his ties and how he kills with the jaw of an ass those who had bound him and how he gives thanks to God for the victory that he has had]

61. Delilah Cuts Samson's Hair; The Philistines Blind Him (Judg. 16:19, 21)

En ceste page est conment dalida la feme sanson tondi son seigneur en dormant. et conment li philistiien le pristrent et lierent et creverent les ieus (fol. 61r)
[On this page is how Samson's wife, Delilah, sheared (the hair of) her sleeping husband, and how the Philistines took him and bound him and pierced his eyes]

62. Samson in Prison; He Destroys the Temple of Dagon (Judg. 16:21, 25–30)

En ceste page est conment sansons torne le mollin et conment il abati le pales sor sa feme et seur ses enemis (fol. 62v)
[On this page is how Samson turns the mill and how he destroyed the palace around his wife and his enemies]

63. The Benjaminites Abuse the Levite's Wife; He Finds Her Dead and Cuts Her into Twelve Pieces (Judg. 19:22–25, 26–29)

En ceste page est conment males gens tollirent .i. soir a i. prodome sa feme a force et la raporterent au matin morte devant son huis et quant son seigneur la trova morte si prist s'espee et fist de sa feme .xii. pieces (fol. 63r)
[On this page is how wicked people one night abducted the wife of a good man and in the morning brought her

64. The Israelites Pray Before the Ark; The Surviving Benjaminites Flee to the Mountains (Judges 20:23, 26–28, 41–42, 45–47)

En ceste page est coment li fill israhel prient dieu dieu [sic] devant le tabernacle. et conment il furent desconfit et ocis et le remenant d'eus foi ains monteignes (fol. 64v)
[On this page is how the children of Israel pray to God before the tabernacle and how they were put to flight and killed and those who remained fled to the mountains]

65. The Israelites Lament the Deaths of the Benjaminites; They Make Peace with the Survivors (Judg. 21:2–3, 13)

En ceste page est conment li fill israhel qui estoient foi en monteignes repairent au tabernacle as prestes et as levites qui estoient en hares et cendre seur leur chies et fesoient penitance a dieu qui les delivrast de leur enemis (fol. 65r)
[On this page is how the children of Israel who had fled into the mountains go back to the tabernacle to the priests and Levites, who were in hairshirts and with ash on their heads and were doing penitence to God to deliver them from their enemies]

66. The Benjaminites Take Wives (Judg. 21:20–23)

En ceste page est conment li fill israhel se tapirent en vignes et quant les puceles qui fesoient une grant feste au tabernacle passent par iluec et chacuns d'eus prist la soie et fu acorde par les sages por restorer ligniee (fol. 66v)
[On this page is how the children of Israel hid themselves among the vines and, when the maidens, who were making a great feast in the tabernacle, pass by this place, each of them took his own, as was granted by the wise men in order to restore their lineage]

67. Eli Overhears Hannah Praying; She Presents Samuel in the Temple (1 Sam. 1:9–11, 24–28)

En ceste page est conment la mere samuel prie au tabernacle a dieu qu'il li doint enfant et ele donra l'enfant a dieu pour servir au tabernacle et conment ele offre l'enfant au tabernacle et conment ele offre .iii. sas plains de farine et plain pot d'uile et iii. toriaus (fol. 67r)

[*On this page is how the mother of Samuel prays in the tabernacle to God that he give her a child and she will give the child to God to serve in the tabernacle and how she offers up the child in the tabernacle and how she offers three sacks full of wheat and a pot full of oil and three bullocks*]

68. Samuel Is Called in the Night; Eli Explains That the Lord Calls Him (1 Sam. 3:3–9)

En ceste page est conment samuel l'enfant se gist et conment dieus parole a lui et conment il se lieve et reconte au prevoire du tabernacle se que dieus li a dit (fol. 68v)

[*On this page is how the child Samuel lay down and how God speaks to him and how he gets up and explains to the priest of the tabernacle what God has told him*]

69. The Philistines Prevail in Battle and Take the Ark; A Messenger Informs Eli, Who Is Shocked and Falls Over (1 Sam. 4:10–11, 12–18)

En ceste page est conment li fill israhel se conbatirent et conment leur enemi les desconfirent et ocistrent et tolirent la sainte arche et quant samuel sot ses noveles si chei pasmez devant l'uis du tabernacle (fol. 69r)

[*On this page is how the children of Israel fought and how their enemies put them to flight and killed them and stole the holy Ark and, when Samuel learned the news, he fell into a faint before the threshold of the tabernacle*]

70. The Philistines Place the Ark in the Temple of Dagon; They Find the Statue of Dagon Broken (1 Sam. 5:1, 4–5)

En ceste page est conment la sainte arche fu assise sor l'autel de coste .i. ydole qui avoit nom dagon et conment dagon fu trovez en le matin a terre le col et les bras trenchiez sor le lintier de la meson (fol. 70v)

[*On this page is how the holy Ark was placed on the altar next to an idol named Dagon and how Dagon was found the next morning on the ground, his cut-off neck and arms above the lintel of the house*]

71. The Philistines Suffer Plagues; The Ark Returns to Israel (1 Sam. 5:6–9; 6:2–9, 10–13)

En ceste page est conment li fill israhel sont a consoill et sieent seur piaus de moutons et plentei de souris entr'eus. et conment les gens muerent es chans et conment deus vaches traient la sainte arche et muaillent por leur veaus ensi revint la sainte arche au tabernacle (fol. 71r)

[*On this page is how the children of Israel are in council and seated on lambskins and many mice are among them, and how the people die in the fields (of this plague) and how two cows pull the holy Ark and moo for their calves; thus the holy Ark returned to the tabernacle*]

72. Samuel Explains the Risks of Kingship; He Anoints Saul (1 Sam. 8:10–18; 10:1)

En ceste page est conment li fill israhel demandent a samuel le prophete qu'il leur face roi. et conment samuel enoint saul et le baise (fol. 72v)

[*On this page is how the children of Israel ask Samuel, the prophet, to make for them a king, and how Samuel anoints Saul and kisses him*]

73. Samuel Describes the Signs Saul Will See; The First Sign (1 Sam. 10:1–2)

En ceste page est conment samuel le prophete parole a saul et conment saul regarde joenes gens qui saillent par devant une tumbe (fol. 73r)

[*On this page is how Samuel, the prophet, speaks to Saul and how Saul looks at young people jumping about in front of a tomb*]

74. The Second and Third Signs (1 Sam. 10:3–4, 5–6)

En ceste page est conment li pueples israhel presentent a saul en nom de seigneur .iii. pains

de blainche farine et .iii. chevriaus blans et plain
pot de vin. et conment li pueples le resoit o grant
/joie/ et grant feste d'instrumens (fol. 74v)
[*On this page is how the people of Israel present to Saul
in the name of the Lord three loaves of white bread and
three white kids and a full pot of wine, and how the
people receive him with great joy and a great flourish
of instruments*]

75. Nahash the Ammonite Threatens to Blind the Men of Jabesh-Gilead (1 Sam. 11:1–2)

En ceste page est conment le rois des enemis israhel
menasse le pueple israhel a crever les ieuz c'il ne le
tienent a seigneur (fol. 75r)
[*On this page is how the king of the enemies of Israel
threatens to pluck out the eyes of the people of Israel if
they do not accept him as their lord*]

76. The Israelites' Anguish; Saul Summons the People (1 Sam. 11:4, 5–7)

En ceste page est conment li pueples israhel se
plaint a samuel le prophete du roi qui les a
menassies a crever les ieuz et mainent grant duel. et
conment samuel les mainne a saul et conment saul
despiece .i. buef et le donne au mesagier et li dit
que ensi depiecera il ses enemis (fol. 76v)
[*On this page is how the children of Israel complain to
Samuel, the prophet, of the king who has threatened to
blind them and (how) they are very sorrowful, and how
Samuel leads them to Saul and how Saul cuts up an ox
and gives it to the messenger and tells him that thus will
he dismember his enemies*]

77. Saul and the Israelites Slay the Ammonites (1 Sam. 11:11)

En ceste page est conment saul et li fill israhel se
conbatent contre leur enemis et coument saul ocit
le roi et vainquirent leur enemis (fol. 77r)
[*On this page is how Saul and the children of Israel
fight their enemies and how Saul kills the king and they
vanquished their enemies*]

78. Saul Becomes King of Israel; Samuel Makes Peace Offerings (1 Sam. 11:15)

En ceste page est conment li fill israhel coronent
saul a roi et coument samuel sacrifie l'engnel a dieu
on tabernacle (fol. 78v)
[*On this page is how the children of Israel crown Saul
king and how Samuel sacrifices the lamb to God in the
tabernacle*]

Appendix III: The Calendar (Folios 79r–84v)

The liturgical calendar is relatively standard for its period and place. To calendars found in Paris missals of about 1250, however, that in the Psalter makes several characteristic changes or additions, of which all occur in the Cambridge manuscript and many in the Washington manuscript, a contemporary breviary in the Library of Congress.

Delisle published the calendar of the Psalter of Saint Louis, noting differences with the Cambridge manuscript, and Cockerell published the calendar of the Cambridge manuscript with comparative notes about that in the Louis Psalter.[1] Here I again publish the Psalter calendar but with variants noted in both the Cambridge and Washington calendars. In addition, several minor errors in the Delisle and Cockerell publications are corrected, and additional notes are provided.

Note: Feasts written in red in the Psalter are here printed in small caps; those written in blue are so noted. All other information, such as the Egyptian days, the memoriae, or the number of lessons, is printed in lowercase italics, regardless of the color in which it appears in the manuscript. Entries or parts of entries that appear in Cambridge, Fitzwilliam MS 300, but not in the Psalter of Saint Louis are enclosed in brackets [].

January

Jani prima dies et septima fine timetur
Januarius hebet xxxi, luna xxx

1. CIRCUMCISIO DOMINI, *duplum*. *Dies.*
2. Oct. s. Stephani, *iii. l. si domenica fuerit ix. l.*
3. GENOVESE V., *ix. l.* Oct. s. Johannis. [*Memoria*]
4. Oct. s. Innocentum, [*iii. l.*] *si domenica fuerit.* [*ix. l.*]
5. Oct. s. Thome ep. et m. [*iii. l.*] Symeonis conf. [*mem.*] *Missa de vigilia.*
6. EPYPHANIA DOMINI, *annuum festum.*
7. *Hic ponitur claves lxxᵉ.*
8. Luciani et Maxiani[1] et Juliani mr. [*mem.*]
9.
10. Guillelmi Bituricensis archiepiscopi, *semiduplum.*
11.
12.

13. Oct. Epyphanie, *duplum.* Hylarii et Remigii ep., *mem.*
14. *Februarii.* Felicis in pincis, *iii. I.*
15. Mauri ab., *iii. l.* Boniti ep. et conf., *mem.*
16. Marcelli pape et mr., *iii. l.* Fursei conf. [*mem.*]
17. Antonii ab. Pseusippi Eleusippi Meseulippi[2] mr.,* *iii l.* Sulpici ep.* [*iii. l.*]
18. Prisce virginis, *iii. l. Sol in Aquario. Initium lxxᵉ.*
19. Lannomari[3] abbatis.
20. Fabiani et Sebastiani, *ix. l.*
21. Agnetis v., *ix. l.*
22. Vincencii[4] mr., *semiduplum.*
23. Emerentiane virginis, *iii. l.*
24. Babile sociorumque eius mr., *iii. l.*
25. CONVERSIO SCI PAULI, *duplum.* Prejecti mr.,* *mem. Dies.*
26. Policarpi epi. et m. *iii l.*
27. Juliani, ep. et. conf. *ix. l.* Johannis, ep. et conf. [*mem*]
28. Agnetis secundo, *iii. l.* {Karolus magnus}[5]
29. Paule matrone, *iii. l.*
30. Baltildis regine, *iii. l.; si domenica fuerit, ix. l.*
31. Metranni mr., *mem.*

*In blue.
[1] For *Maximiniani* in both MSS.
[2] For *Speusippi* and *Meluusippi* in both MSS.
[3] For *Launomari* in both MSS.
[4] *Vincentii* in the Cambridge MS.
[5] Added in a fourteenth-century hand.

February

Quarta subit mortem, post sternit[1] tercia fortem.
[At februi quarta est procedit tercia finem.]
Februarius habet dies xxviii, luna xxix.

1. Ignatii ep., *iii. l.* Brigide v., [*mem.*]
2. PURI.CATO B. MARIE, *annuum festum.*
3. Blasii ep. et mr., *duplum.*
4. *Dies.*
5. Agathe v. et m., *ix. l.*[2]
6. Vedasti et Amandi ep., *iii. l.*
7.
8. Obitus Roberti Comitis Attrenbatensis[3]* *Inicium xlᵉ.*

9.

10. Scolastice v., *iii. l.*

11.

12. Eulalie v. et mr. [*mem.*]

13.

14. *Marci.* Valentini mr., *iii. l.*

15.

16.

17. *Sol in piscis.*⁺*.Ultimus terminus lxxᵉ.*

18. *Adam hic peccavit.*

19.

20.

21.

22. Cathedra s. Petri [*ix. l.*] *Initium veris.⁵*

23.

24. MATHIE APOST., *duplum.* [*Locus bisexti, quota feria et⁶ concurrens*]

25.

26. *Dies.*

27. Honorine v. et mr.

28.

*In blue
¹*Prosternit* in the Cambridge MS.
²Also written on the previous line (February 4) but erased.
³For *Attrebatensis* in both MSS.
⁴For *pisces* in both MSS.
⁵*Neris* in the Cambridge MS.
⁶For *est.*

March

Primus mandentem disrumpit quarta bibentem.
[*Martius prima necat cuius sub cuspide quarta est.*]
Marcius habet dies xxxi, luna xxx.

1. Albini ep. et conf., *mem.*
 Hic mutantur concurrentes. Dies.

2.

3.

4.

5.

6. *Ultima incensio lune.*

7. *Prima incensio lune.*

8.

9.

10.

11. *Clavis pasche.*

12. Gregorii pape, *ix l.* *ix. l.*¹

13.

14.

15.

16.

17. Gertrudis v., *mem. Sol in ariete.*

18. *Primus dies² seculi. Hic mutantur anni ab origine mundi.*

19.

20. *Equinoctium.*

21. Benedicti ab.

22. *Primum pascha. Sedes epactarum. Hic incipit ciclus decennovenalis.*

23.

24. *Locus concurrentium.*

25. ANUNCIATIO DOMINI, *annuum festum.* *Adam psalmatus.³ Christus passus est.*

26.

27. RESURRECTIO DOMINI, *annuale festum.*

28. *Dies.*

29.

30.

31.

¹Repeated near the right margin.
²Absent in the Cambridge MS.
³For *plasmatus* in both MSS.

April

Denus et undenus est mortis vulnere plenus.
[*Aprilis decima est undena a fine salutet.*]
Aprilis habet dies xxx, luna xxix.

1.

2.

3.

4. AMBROSII EP. ET CONF., *iii l.*

5.

6.

7.

8.

9.

10. *Dies.*

11. Leonis pape et conf., *mem.*

12.

13. Eufemie v., *iii l.*

14. *Maii.* Tyburcii, Valeriani et Maximiani¹ m., *iii l.*

15. *Claves rogationum.*

16.

17. *Sol in tauro.*
18.
19.
20. (*Dies.*)
21.
22. INVENTIO CORPORUM DYONISII SOCIORUMQUE EIUS, *duplum.* Oportune v. [*mem.*]
23. Georgii m., *ix l.*[2] Reguli ep., [*mem.*]
24.
25. MARCI EVANG., *ix. l.*[3] *Letania major. Ultimum pascha.*
26. DEDICATIO SANCTE CAPELLE PAR., *annuum festum.*
27.
28. Vitalis m., *iii l.*
29. PETRI M., *ix l.*[4]
30.

—————————

[1]For *Maximi* in both MSS.
[2]*qi. ix. l.* in the Cambridge MS.
[3]*qi. ix. l.* in the Cambridge MS.
[4]*qi. ix. l.* in the Cambridge MS.

May

Tercius occidit et septimus ora relidit.
[Tercius in maio lupus est et septimus anguis.]
Maius habet xxxi, luna xxx.

1. PHYLIPPI ET JACOBI APOST., *duplum.* Amatoris epi., *mem.*
2. OCT. DEDICATIONIS ECCLESIE, *duplum.*
3. INVENTIO SANCTE CRUCIS, *annuum festum.* Alexandri, Eventii et Theodori m.
4. Quiriaci ep. et m., *ix. l.*[1]
5. Fortunati ep. et. conf., *mem.*
6. JOHANNIS ANTE PORTAM LATINAM, *ix. l.*[2]
7.
8.
9.
10. Gordiani et Epimachi m., *iii. l.* Maturini conf. [*mem.*]
11. Mamerti ep. et conf., *mem.* Maiolis[3] ab., *mem.*
12. Nerei et Achillei[4] et Pancracii m., *iii. l.*
13.
14.
15.
16. *Junii.* Honorati ep. et conf., *mem.* Adventus spiritus sancti.

17.
18. *Sol in geminis.*
19. POTENTIANE V., *mem.*
20.
21.
22.
23.
24. Donatiani et Rogatiani m., *iii. l.*
25. URBANI PAPE ET M., *iii. l. Initium estatis.*
26.
27.
28. GERMANI EP. PARISIENSIS, *semiduplum.* [Caurani[5] m., mem.]
29.
30.
31. Cancii, Canciani et Cancianille m., *iii. l.* Petronille v., *mem.*

—————————

[1]*qi. ix. l.* in the Cambridge MS.
[2]*qi. ix. l.* in the Cambridge MS.
[3]Instead of *Maioli* in both MSS.
[4]*Archillei* in the Cambridge MS.
[5]Instead of *Carauni.*

June

Denus palescit quindenus federa nescit.
[Junius (in) decimo quindenum a fine salutat.]
Junius habet dies xxx, luna xxix.

1. Nichomedis m. [*iii. l.*]
2. Marcellini et Petri m. [*iii. l.*]
3. *Ultima incensio lune.*
4.
5.
6.
7.
8. Medardi et Gildardi ep., *iii. l.*
9. Primi et Feliciani m., *iii. l.*
10. Landerici[1] ep. et conf., *ix. l.* ([2])
11. [BARNABE AP., *duplum.*]
12. Basilidis, Cirini, Naboris, Nazarii et Celsi m., *iii. l.*
13.
14. *Julii.* BASILII EP., *ix. l.* Rufi et Valerii m., [*mem.*] *Solsticium.*
15. Viti, Modesti et Crescentie m., *iii. l.*
16. Cirici et Julite matris ejus, *iii. l.* *Sol in tauro.*[3] [*Dies.*]
17. Aniti[4] abbatis, *iii. l.*
18. Marci et Marcelliani m., *iii. l.* Fortunati ep., *mem.* Marine v., *mem.*

19. Gervasii et Prothasii m., *iii. l.*
20. *Solsticium estivale.*
21. Leufredi abb. [ix. l.]
22. Paulini ep. et conf., *iii. l.*
23. *Missa de viglia.*
24. NATIVITAS S. JOHANNIS BAPT., *duplum.*
 [Agriberti[5] et Agoardi, *mem.*]
25. TRANSLATIO S. ELIGII, *ix. l.*
26. Johannis et Pauli m., *iii. l. Si domenica fuerit ix. l.*
27.
28. Leonis pape, *mem. Missa de viglia.*
29. APOSTOLORUM PETRI ET PAULI, *duplum.*
30. COMMEMORATIO S. PAULI, *duplum.*
 Marcialis ep., *mem.*

[1]For *Landrici* in both MSS.
[2]*Dies* omitted in both MSS.
[3]*Cancro* in the Cambridge MS.
[4]For *Auiti* in both MSS.
[5]For *Agliberti.*

22. MARIE MAGDALENE, *duplum.* Wandregisili abb.,
 mem. ([2])
23. Appollinaris v. et m., *iii. l.*
24. Cristine v. et m., *iii. l.*
25. JACOBI AP., *duplum.* Christofori et Cucufatis m.,
 mem.
26. Translatio S. Marcelli ep. et conf., *ix. l.*
27. TRANS.GURATIO DOMINI, *iii. l.; si dominica fuerit,*
 ix. l.
28. Anne matris beate Marie v., *ix. l.* Pantaleonis m.,
 mem. [Sansonis ep., *mem.*]
29. Felicis, Simplicii, Faustini et Beatricis m., *iii. l.*
 Lupi et Guillelmi ep. et conf., *mem.*[3]
30. Abdon et Sennes m., *iii. l.*
31. Germani Antisiodorensis[4] ep., *ix. l.*

[1]For *Nummii* in both MSS.
[2]*Dies* omitted in both MSS.
[3]Omitted in the Cambridge MS.
[4]*Autisiodorensis* in the Cambridge MS.

July

Tredecimus mactat iulii decimus labefactat.
Julius habet dies xxxi, luna xxx.

1. OCT. S. JOHANNIS BAPTISTE, *ix. l.*
 Leonori ep. et conf.
2. Processi et Martiniani m.
3.
4. TRANSLATIO ET ORDINATIO S. MARTINI [ix. l.]
5.
6. OCT. APOSTOLORUM, *ix. l.*
7. TRANSLATIO S. THOME, ix. l. Claudii sociorumque
 ejus, *mem.*
8. Nunnii[1] conf., *iii. l*
9. Zenonis m., *mem.*
10. Septem fratrum, *iii. l.*
11. Translatio S. Benedicti, *ix. l.*
12.
13. Turiani ep. et conf., *ix. l.* *Dies.*
14. OBITUS PHILIPPI REGIS FRANCORUM.
15. *Dies caniculares hic incipiunt.*
16. *Augusti.*
17. *Sol in leone.*
18. Arnulfi ep. et m., *ix. l.*
19.
20. MARGARETE V. ET M., *iii. l.*
21. S. Victoris m., *ix. l.* Praxedis v., *mem.*

August

Percutit ut funda lux prima diesque secunda.
Augustus habet dies xxxi, luna xxx.

1. AD VINCULA S. PETRI, *ix. l.* Machabeorum m.,
 mem. Eusibii m., *mem.* [Exuperii ep., *mem.*
 Fidei et Spei et Caritatis et Sapientie matris
 earum, *mem.*]
2. Stephani pape et m., *iii. l.*
3. INVENTIO S. STEPHANI CUM SOCIIS SUIS,
 semiduplum.
4.
5. DOMINICI CONF., *ix. l.* Ynnii[1] m., *mem.*
 Mennii[2] ep. et conf., *mem.*
6. Sixti[3] ep. et m., *iii. l.* Felicissimi et Agapiti, *mem.*
7. Donati ep. et conf., *iii. l.*
8. Justini m., *ix. l.* Ciriaci, Largi et Smaragdi, *mem.*
9. Romani m., *iii. l. Missa de viglia.*
10. LAURENTII M., *semiduplum.*
11. SOLLEMPNITAS SANCTAE CORONE, *annuum*
 festum.
12. Tyburcii m., *mem.*
13. Ypoliti sociorumque eius, *ix. l.*
14. *Septembris.* Eusebii presb., *mem.*
15. ASSUMPTIO BEATE MARIE V., *annuum festum.*
16.
17. OCTAVE S. LAURENTII, *mem.*

18. OCTAVE SANCTE CORONE, *duplum*.
19.
20. Philiberti abbis [*mem.*]
21.
22. OCTAVE B. MARIE V., *duplum*. Thimotie[4] et
 Simphoriani, *mem.*
23. Timothei et Apollinaris m., *mem.*
24. BARTHOLOMEI AP., *duplum*. Audoeni ep. et conf.,
 mem.
25. BERNARDI AB. CLAREVALLENSIS, *semiduplum*.
 GENESI M. *mem.* {Ludovici}[5]
26. Herenei et Habundi m., *iii. l.*
27. Georgii et Aurelii m., *ix. l.* Rufi m., *mem.*
28. Augustini ep. et conf., *semiduplum*. Hermetis et
 Juliani m., *mem.*
29. DECOLLATIO S. JOHANNIS BAPTISTE, *duplum*.
 Sabine v., *mem.* [Mederici ab., *mem.*]
30. Felicis et Audacti m., *iii. l.* Agili et Fiacri conf.,
 mem.
31.

[1]For *Yonii* in both MSS.
[2]For *Memmii*.
[3]*Syxti* in the Cambridge MS.
[4]*Tymothei* in the Cambridge MS.
[5]Added in a late-thirteenth- or fourteenth-century hand.

September

Tercia septembris et denus sunt[1] *mala membris.*
September habet dies xxx, luna xxx.
Septembris

1. Egidii abbatis, *semiduplum*. [Prisci m., *mem.*]
2. Antonii m., *iii. l.*
3. Lupi ep. et conf., *ix. l.* [Godograndi ep. et m.,
 mem.]
4. Marcelli m., *mem.*
5. Victorini ep. et m., *iii. l.* Bertini ab., *mem.*
6.
7. Glodaldi[2] conf., *ix. l.* Godograndi ep. et m.,
 mem.[3]
8. NATIVITAS BEATE MARIE V., *annuum festum*.
 Adriani m., *mem.*
9. Gorgonii m., *mem.*
10.
11. Prothi et Jacincti m., *mem.*
12. Siri et Inventii conf.,[4]·*mem.*
13. Maurilii ep. et conf., *mem.*

14. *October.* EXALTATIO S. CRUCIS, *annuum*
 festum.
 Cornelii et Cypriani m. [*mem.*]
15. OCT. B. MARIE, *duplum*. Nichomedis m.,
 mem.
16. Eufemie v. et m., *mem.* Lucie et Geminiani
 m., m.[5]
17. Lamberti ep. et m., *mem.* [*Sol. in libra.*]
18.
19. OCT. S. CRUCIS, *duplum*. Signi conf., *mem.*
20. *Viglia. Equinoctium autumpnum.*
21. MATHEI AP. ET EVANG., *duplum*. *Dies.*
22. MAURICII SOCIORUMQUE EIUS, *ix. l.*
23. Tecle v. et m., *iii. l.* Paterni ep. et conf., *mem.*
24. Antochii, Tyrsi et Felicis m., *mem.*
25. Firmini ep. et conf., *iii. l.*
26. Senatoris ep. et conf., *mem.*
27. COSME ET DAMIANI M., *ix. l.* CERANNI EP. et
 CONF., *mem.*
28.
29. SANCTI MICHAELIS ARCHANGELI,
 duplum.
30. TRANSLATIO SACROSANCTARUM RELIQUARUM,
 annuum festum.

[1]For *fert* in both MSS.
[2]Correctly as *Glodoaldi* in the Cambridge MS.
[3]Normally on September 3; in the Cambridge MS it occurs on both
dates.
[4]As a martyr in the Cambridge MS.
[5]Incorrectly for *mem.*, as in the Cambridge MS.

October

Tercius et denus est sicut mors alienus.
October habet dies xxxi, luna xxx.

1. Remigii ep. et conf., *ix. l.* [Germani et Vedasti et
 Bavonis, *mem.*]
2. Leodogari ep., *ix. l.* Sereni conf., *mem.*
3. FRANCISCI, *ix. l.* CANDIDI M., *mem.* *Dies.*
4. AUREE V., *ix. l.*
5. Jeronimi presb., *ix. l.*
6. Fidis v. et m., *mem.*
7. Oct. translationis reliquarum, *duplum*. Marci
 pape, *mem.* [Sergi, Barchi,[1] Marcelli et Apulei,
 mem.]
8. Symeonis conf., *ix. l.* Demetrii m., *mem. Vigilia.*
9. DYONISII, RUSTICI et ELEUTHERII M., *annuum*
 festum.

10. Gereonis sociorumque eius, *mem.*

11. Nichasii, Quirini et Firmini ep., *mem.*

12.

13.

14. Calixti pape et m., *mem.*

15.

16. *Novembris.* OCT. DIONYSII, *duplum.* [Luciani Marciani et Juliani, *mem.*]

17. Gerbonii ep. et conf.

18. LUCE EVANG., *ix. l.* Erblandi conf., *mem.* *Sol in scorpione.*

19. Saviani[2] et Potentiani sociorumque eorumdem, *ix. l.*

20. Caprasii m., *mem.*

21. UNDECIM MILIUM VIRGINUM., *ix. l.*

22. Hylarionis monachi, *iii. l.* Mellonis ep. et conf., *mem.* [*Dies.*]

23. Severini ep. et conf., *iii. l.*

24. Maglorii ep. et conf., *ix. l.*

25. Crispiniani et Crispini[3] m., *iii. l.* Lupi ep et conf., *mem.*

26.

27. *Vigilia.*

28. SYMONIS ET JUDE AP., *duplum.* Faronis ep., *mem.* Translatio Genevese v., *mem.*

29.

30. Luciani m., *ix. l.*

31. Quintini m., *iii. l; si dominica fuerit, ix. l. Vigilia.*

[1] For *Bacchi.*
[2] *Saviniani* in the Cambridge MS.
[3] The two saints are listed in reverse order in the Cambridge MS.

November

Scorpius est quintus et tercius ad male cunctus.[1]
November habet dies xxx, luna xxix.

1. FESTIVITAS OMNIUM SANCTORUM, *annuum festum.*

2. COMMEMORATIO OMNIUM .DELIUM DEFUNCTORUM, *duplum.*

3. MARCELLI EP. PARISIENSIS, *duplum.* Guinalis[2] ab., *mem.*

4. Clari m., *mem.* *Dies.*[3]

5. Leti presb., *mem.*

6.

7. Herculani ep. et m.

8. OBITUS LUDOVICUS REGIS FRANCORUM. OCT. S. MARCELLI, *ix. l.* [Quattuor coronatorum.]

9. Maturini conf., *ix. l.* Theodoris[4] m., *mem.*

10. Martini et Varauni ep. et conf., *iii. l.*

11. MARTINI EP. ET CONF., *duplum.* Menne m., *mem.*

12. Leonis[5] conf., *mem.*

13. Gendulfi ep. et conf., *ix. l.* Briccii[6] ep. et conf., *mem.*

14.

15. Eugenii m., *mem.* Macuti ep. et conf., *mem.*

16. Edmundi ep. et conf., *ix. l.*

17. Aniani ep. et conf., *ix. l. Sol in sagittario.*

18. Oct. S. Martini, *ix. l.* Aude v., *mem.*

19. S. ELYZABETH, *ix. l.*

20.

21. Columbani ab., *mem.*

22. CECILE V. ET M., *ix. l.*

23. CLEMENTIS PAPE ET M., *duplum.*

24. SEVERINI MONACHI, *ix. l.* [Grisogoni m., *mem.*]

25. KATHERINE V., *semiduplum.*

26. GENOVESE V. DE MIRACULO, *ix. l.* MARCELLI EP., *mem.*

27. AGRICOLE ET VITALIS M., *mem.* OBITUS BLACHIE[7] REGINE FRANCORUM.

28. OCT. S. CLEMENTIS, *ix. l.*

29. Saturnini ep. et m., *mem.* *Vigilia.*

30. ANDREE AP., *duplum.*

[1] The correct reading in both MSS should be *est nece cinctus.*
[2] For *Guinali* in both MSS.
[3] Listed on the fifth in the Cambridge MS.
[4] For *Theodori* in both MSS.
[5] For *Leonii* in both MSS.
[6] *Bricii* in the Cambridge MS.
[7] *Blanchie* in the Cambridge MS.

December

Septimus exanxius viosus et anguis[1]
December habet xxxi, luna xxix.

1. ELIGII EP. ET CONF., *ix. l.*

2.

3.

4. PARISIUS SUSCEPTIO RELIQUARUM.

5.

6. NICOLAI EP. ET CONF., *duplum.*

7. Oct. S. Andree, *mem.* Fare v., *mem.* *Dies.*

8.

9.

10. Eulalie v. et m., *mem.*

11. Germani[2] et Fusciani et Victorici m., *ix. l.* Damasi pape, *mem.*

12.

13. Lucie v. et m., *ix. l.*

14. *Januarii.*

15. MAXIMI[3] ABBIS, *mem. O. Sapientia.*

16.

17.

18. *Sol in capricorno.*

19.

20.

21. THOME AP., *duplum.*

22. (+)

23.

24. *Vigilia. Sine prostrata.*

25. NATIVITAS DOMINI, *annuum festum.* ANASTASIE V., *mem.*

26. STEPHANI PROTHOMARTYRIS., *duplum.*

27. JOHANNIS AP. ET EVANG., *duplum.*

28. SANCTORUM INNOCENTIUM, *duplum.*

29. THOME M., *duplum.*

30.

31. SILVESTRI PAPE, *ix. l.* COLUMBE VIRG., *mem.*

[1] Both manuscipts should read *Septimus exsanguis virosus denus ut anguis.*
[2] For *Gentiani* in both MSS.
[3] For *Maximimini* in both MSS.
[4] *Dies* omitted in both MSS.

Appendix IV: Text Signatures and Catchwords

Because the parchment has been only slightly trimmed, a number of the catchwords and, exceptionally, almost all signature or gathering numbers are preserved. As is usually the case, both are found on the verso of the last folio of each text gathering. The catchwords are written in ink at the lower right, probably by the hand responsible for that of text of the same page, and the signature numbers are lower-case Roman numerals lightly written in lead point at the bottom of the folio, just to the right of center.[1] The numbering begins with the first text gathering; no signatures are preserved for the prefatory cycle or calendar.

The gathering signatures are noteworthy only in the final gathering, where the numeral "xv" is faintly preserved on folio 260v, the last folio of the manuscript. This gathering has only three leaves and ends with the prayer *Quicumque* rather than with the traditional litany and subsequent prayers.[2] Since the signature shows that folio 260 was the last of the gathering and the *Quicumque* prayer is complete, this gathering never had more folios than it does today.

The text gatherings of the Psalter exceptionally preserve two and sometimes three series of page signatures that indicate the sequence of folios. They are very small lowercase letters—a, b, c, through f or g—found at the lower right edge of the rectos in the first half of each gathering.[3] Each series of letters is normally accompanied by another letter or sign characteristic of that gathering. The use of such letters is not unusual in Parisian manuscripts at this time, although normally there is only one series, and rarely are they so well preserved.[4] Their use permitted the leaves to be easily assembled, especially after they had been distributed to several persons working at the same time.[5] In the Psalter the first series, like the gathering signatures, is in lead point; the second, to its right, is written in ink.[6]

The reason for the two series of signatures becomes clear from an examination of gathering xx, the only gathering in which the two series do not correspond to each other or to the sequence of the folios. Four leaves (fols. 149, 150, 151, and 157) have only ink signatures, and these are clearly additions, for they differ from the other folios of Psalter text in almost all production characteristics.[7] Their ink letters indicate a gathering of fifteen leaves, the number present today. In contrast, the letters written in lead point indicate a gathering of only twelve leaves, the same number found in most of the other text gatherings. The letters written in lead point also correspond in form to the tiny letters often visible in the verse initials, letters the scribe used to indicate what initial should later be placed in the space he provided.[8] The central, lead-point series thus represents the original set of signatures, and the penned signatures were added after four folios were inserted.[9]

Although only one other folio (224) was replaced, dozens of others have been altered in an extensive campaign of text corrections.[10] Most corrections involve only a few words or a few lines that were scraped away and rewritten, but they have precisely the same features as the texts of the added folios, and so the corrections, additions, and the second, or ink, set of folio signatures were all made at the same time.[11] The distinctive characteristics of the added folios, especially the thinner parchment and lighter ink, indicate that the corrections were made at a time when the original materials or scribes were no longer available, that is, after the text had left the shop. It is unlikely that they were added much later, however, for the script of the corrections is very similar to the original script.

Why did the collator not use the original foliation numbers for these gatherings, especially since the number and sequence of folios is different only in gathering xx? Perhaps the first series of signatures, in which the numbers were written on the parchment in lead point, was too faint, or perhaps the new collator, knowing that new folios were added but unsure where, was just being cautious. Whatever the reason, the number and extent of corrections must have required the disassembly of the codex or, at least, the text part of it.[12]

Summary of Catchwords, Signatures, and Collation Marks

Gathering	Folios	Signature	Catchwords	Folio Signatures I[a]	Folio Signatures II[b]	Other
XV	85–98	i		[ā, ƀ], c̄ . . . ḡ[c]	{a}, b, c . . . g	98v {numerical notes}
XVI	99–110				â, b, c, . . . f	
XVII	111–22	iii		{ā}, ƀ, c̄ . . . f̄	a_o, b_o, . . . f_o	[c]
XVIII	123–34	iiii	{audiutor}	[a], b, c . . . f	a, b, c, . . . f	
XIX	135–46	v	{eripe me}	[-a], -b, -c . . . -f	a, b, c, . . . f[d]	[c]
XX	147–61	vi	reges a	{a, b, d, e, f}	a, b, [c], d, [e], f, g	[f]
XXI	162–73	vii	{nos}	a⁺, ḃ⁺, ċ⁺, d⁺, . . . f̄	a⁺, b⁺, c⁺, d⁺, . . . f̄	
XXII	174–85	viii	ultivimus[g]	a̠, ḇ, c̠, d̠, . . . f	a>, b>, . . . f>[h]	
XXIII	186–97	ix		~a, ~b, . . . ~f	oao, obo, . . . ofo[i]	
XXIV	198–209	x		a~, b~, . . . f~	aII, bII, . . . fII	
XXV	210–21	xi		a^o, b^o, . . . f^o	xa, xb, . . . xf	
XXVI	222–33	xii		a_o, b_o, . . . f_o	a_p, b_p, . . . f_p	
XXVII	234–45	xiii		oa, ob, . . . of	as, bs, . . . fs	245v {numerical notes}
XXVIII	246–57	xiiii		ao, bo, . . . fo	ar, br, . . . fr	257v {numerical notes}
XXIX	258–60	{xv}[j]				260v {numerical notes}

[] = lost or too faint to decipher

{ } = visible but incomplete

[a]Impression made by a sharp instrument, lower right corner of the rectos, except as noted.

[b]In ink, in lower right corner of the rectos, except as noted.

[c]A third series of letters, also in ink and on the rectos, at the lower edge of the page, between the left pair of vertical guide lines.

[d]Lower edge of the rectos, center (about 45 to 50 mm from the right).

[e]Folio 140r has "f" situated as in note d.

[f]As in note c above, with the series continued to "g" on folio 180r; the letter is partially erased and certainly an error.

[g]Written in a cursory hand.

[h]Very faint, in the lower right corner of the page.

[i]Lower edge of the rectos, center (about 45 to 50 mm from the right).

[j]Very faint, in the lower right corner of the page.

Appendix V: Concordance of Attributions

Gathering	Folios	Branner	Stahl
I	1–4, 7, 10, 13, 14	A	A (Noah)
	5–6, 8–9	B	B (Abraham)
	11–12	A	C (Rebecca)
II	15–18, 21–24	C	B
	19–20	C	C
III*	25–28	[E]	E (Isabella: scenes only)
IV	29–30, 33, 40–42	D	B
	31–32, 35–36	D	A
	34, 37, 38–39	D	D (Saul)
V	43–46	C	A
VI	47–50	C	C
VII	51–54	C	C
VIII	55–58	D	B
IX	59–62	D	D
X	63–66	D	A
III*	25–28	E	D (decoration only)
XI	67–70	F	D
XII	71–74	F	D
XIII	75–78	F	D

Appendix VI:
The Previous Binding and Its Textile Covering

Part A: The Binding

In 1970 the Bibliothèque nationale rebound the Psalter in its present blue-velvet covering. The sewing was left undisturbed, but the thongs were cut so that the earlier covers could be detached and the binding loosened. The earlier covers were of wood with a textile covering. They had suffered considerably. The textile was abraded and almost entirely lost on the two outer faces, and a portion of the wood of the upper cover had been replaced.[1] Now boxed with the manuscript, these covers, in spite of their condition, provide important evidence of the earlier appearance of the book and of the changes it underwent during the Middle Ages.

The twenty-nine gatherings of the manuscript are sewn around eight whitened double leather thongs, and these were inserted into the beechwood boards that formed the upper and lower covers. The boards are flat on the inner side, slightly convex on the outer, and rounded at the edges and corners. They are notably thin—6 mm at the center and about 4 mm at the edges—and slightly larger than the book block.[2]

The thongs are flat and enter the side of each board through flat, broad holes almost four to five times wider than the thongs themselves. The thongs continue into V-shaped channels that open onto the inner face of each board and extend alternately to 30 and 45 mm from the inner edge. They are fastened in place by pegs entering from the outer face of the board and piercing the ends of the thongs. Mastic now fills the open channels in the boards and covers the thongs lying in them.

Two nails, 9 mm apart, protrude through the lower cover; they were probably intended to hold the clasp for the fastening straps.[3] The head of one nail is broken off, but the other is in the form of a quatrefoil. It is unclear whether the nails and clasp antedate the addition of the textile.

Many of these details are characteristic of a development, beginning in the mid–thirteenth century, toward lighter and mechanically more flexible bindings. Although several of these features are found in bindings contemporary with the Psalter, the most advanced ones point to a later stage of development. For example, thinner boards are already seen in the finer French bindings of the mid–twelfth century, but those of the Psalter are especially thin, and their convex faces and rounded sides are typical of the "cushion-bevel" cut frequently found in fourteenth-century bindings.[4] The way the thongs enter the side, rather than the top, of the board is another early feature, one common in the thirteenth century and continuing at least through the fourteenth. In contrast, the wide slits through which the thongs enter the board allow them considerable play and are characteristic of more advanced periods—the fourteenth century and later—for they enabled the edges of the book to be gilded or decorated by shifting, rather than removing, the covers.[5] Again, the depressed channels for the thongs are widely found in thirteenth-century bindings, but the alternation in their length is a later feature, necessitated by the use of thinner covers and more thongs.[6] The number of thongs is also noteworthy. Their number generally increased from about 1250 to 1400 and then began to decrease, six commonly found in the thirteenth century, even in much larger books.[7] The old sewing holes, still visible in the gutters, make it likely that the Psalter originally had six thongs, the present eight clearly the result of a later resewing.[8] Finally, the extension of the covers slightly beyond the book block—the projection of the squares—is a particularly late characteristic, usually associated with the fifteenth century. These features are clearly interrelated, all the most recent ones pointing to a period from the mid–fourteenth to the early fifteenth century.[9]

The book was covered in a finely figured silk, a gold-brocaded lampas with a double-weave ground. The part of the textile that is folded around the inner side of the boards, to about 2–4 cm from the edges, is relatively well preserved (figs. 97–98). The part on the outer faces has almost entirely worn away, but the base layer is still visible over about half the total surface (figs. 99–100). These fragments have permitted Sophie Desrosiers of the École des hautes études en sciences sociales to reconstruct part of the pattern and, together with Gabriel Vial of the Centre international d'étude des textiles anciens at Lyon, to analyze and describe its technical aspects (see below).

The pattern is based upon palmettes arranged in horizontal rows and oriented on the diagonal, their direction alternating by row (diagram 6). Between the palmettes are large

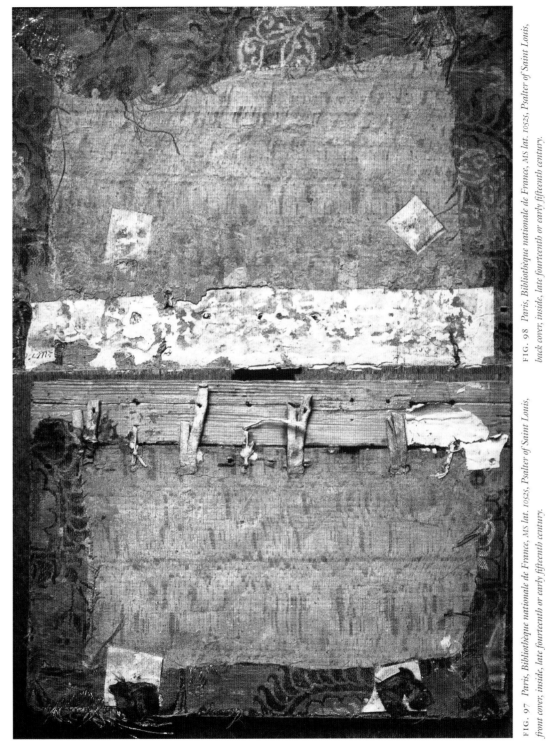

FIG. 97 *Paris, Bibliothèque nationale de France, MS lat. 10525, Psalter of Saint Louis, front cover, inside, late fourteenth or early fifteenth century.*

FIG. 98 *Paris, Bibliothèque nationale de France, MS lat. 10525, Psalter of Saint Louis, back cover, inside, late fourteenth or early fifteenth century.*

flowers. Their stems probably continued upwards, weaving between the palmettes and forming a vertical matrix for the entire design. The intermediate areas are decorated with the shoots and leaves growing from the stems as well as with small flowers and birds. The field, now pale cherry in color, must originally have been a warmer and softer tone, as the inner folds of the cloth still suggest. The principal motifs, notably the large fronds around the palmettes, are turquoise green, the large flowers are of gold brocade, and a few fine details—the neck and wings of the birds and the petals of the small flowers—are deep blue. Against the red satin, the juxtaposition of turquoise and gold must have been very striking, and the play between the radiant palmettes and the reversing curves of the flowers and stems no doubt gave the pattern a rich and vivid movement.[10]

The pattern of the textile shows strong oriental influence. The basic layout—a principal motif arranged in rows with alternating diagonal orientation, and vines with secondary floral motifs weaving in between them—is ultimately related to Chinese textiles.[11] Similarly, the shape of the palmette and its inner decoration and radiant fronds suggest an oriental influence transmitted through Persia.[12] But the small leaves and birds and the pattern of the gold flowers point to northern Italy, where these Eastern sources exerted a powerful influence on silks from the middle to the end of the fourteenth century.[13] Although no textile with the same pattern is known, almost all of the features cited above can be found separately in Italian silks.[14] Technically, the most

DIAGRAM 6 *(above)* DIAGRAM 7 *(below)*

BACK

SPINE

FRONT

FIG. 99 *Paris, Bibliothèque nationale de France, MS lat. 10525, Psalter of Saint Louis, front cover, outside, late fourteenth or early fifteenth century.*

FIG. 100 *Paris, Bibliothèque nationale de France, MS lat. 10525, Psalter of Saint Louis, back cover, outside, late fourteenth or early fifteenth century.*

notable aspects of the textile are its silk ground and gold thread, the latter a composite in which a lamella of metal (probably gilt silver) is wound around a silk core. This exceptional structure and thread, which point to elaborate facilities and costly materials, are found in Italian silks from at least the middle of the fourteenth century.[15] Thus motifs and technique both point to an Italian origin and a date in the later fourteenth or early fifteenth century, that is, the same general period indicated by the features of the wooden covers.

Several physical aspects of the manuscript indicate that it underwent significant changes in the course of the fourteenth and early fifteenth centuries. The parchment sides of the book have been shaved, gilded, and engraved with criss-crossing lines. The shaving resulted in the loss of several of the letters used to number the folios in the second foliation, which, as discussed earlier, probably dates to the late thirteenth or early fourteenth century.[16] In addition, the shaving would have necessitated replacement of the headband and tailband, the cords attaching the covers across the ends of the spine. On the Psalter the sewing around these bands, composed of silk threads of five colors, is decorative. The practice of decorating the bands in this way is Italian in origin and was especially current in France in the fifteenth century.[17] Moreover, the colors decorating the bands approximate those of the textile and almost certainly represent an attempt to match the headband to the textile over the nearby spine. It is thus likely that the edges of the book were decorated and that the two bands were replaced at the same time the Psalter was re-covered, that is, toward the end of the fourteenth or early in the fifteenth century.[18]

Documentary and historical evidence support the same conclusion. The entry for the Psalter in the inventory of the library of Charles V describes the clasps, now lost, with the arms of Evreux and France, but no mention is made of a textile covering, although those on other books—even textiles of plain linen and those used for slipcases and as part of fasteners—are described in detail.[19] The first mention of the Psalter's textile binding ("satin figuré vert et rouge") is in the inventory of Charlotte de Savoie, where two clasps are also cited but not enamels or arms.[20] Thus, the manuscript underwent changes between 1380 and 1484, the dates of the two inventories. These dates correspond to those calculated above for the addition of the textile and other changes in the binding.

During this period the Psalter also received a prefatory leaf (fol. A), which identified the manuscript as the Psalter of Saint Louis and named its royal owners from Jeanne d'Évreux to Marie de France, explaining how the latter was given the Psalter by her father, Charles VI, on the feast of Saint Michael (September 27). An incomplete date ends the inscription and suggests that the leaf was inserted partly to commemorate the gift. But since the gift is described in the past tense and Marie de France, called a religious at Poissy, did not enter the order until 1408, the leaf must have been written and inserted in the Psalter after she received it. It may have been placed in the book when she entered Poissy or, at least, before her death in 1438.[21]

It is tempting to believe that the rebinding of the Psalter coincided with the insertion of the leaf and with its presentation to Marie de France. The luxury of the new binding certainly suggests a high patron and a special presentation. The arrival of the Psalter at Poissy, the foundation dedicated to Saint Louis and one of the places he was especially venerated, may have been just such an occasion. The Psalter, like other objects connected with the saintly king, had probably acquired a special status. In this regard it is significant that there is no evidence the text or miniatures were altered at this time; the changes in decoration were all external. Like a relic, the manuscript was rehoused in a new and more sumptuous container, along with the inscription authenticating its contents. The rebinding may reflect less a change in ownership than the manuscript's *"translatio"* to Poissy.

Although the latter circumstances remain hypothetical, there can be little doubt that the binding, now separated from the Psalter, dates to the late fourteenth or early fifteenth century and the textile to the last third of the fourteenth century. Nothing is known of the original thirteenth-century binding. The history of the medieval and later changes in the Psalter may therefore be summarized as follows:

1. Late thirteenth or early fourteenth century: The text was extensively corrected and the folios renumbered and resewn (this change may have coincided with the next). New boards may have been added.
2. 1324–69: Clasps (now lost) enameled with the arms of Evreux and France were placed on the Psalter.
3. 1380–1484 (probably 1408–38): The Psalter was either rebound with new boards or, more likely, just re-covered with late-fourteenth-century silk of Italian origin; at the same time, the edges were gilded and decorated, and folio A was added. The gatherings were not resewn, although new headbands and fasteners were added.
4. Seventeenth–nineteenth century: Part of the upper board was replaced, the whole reconsolidated with mastic, and the repairs were masked with paper; a protective cover of red velvet was added (perhaps nineteenth century).
5. 1970: The Bibliothèque nationale replaced the cover and rebound the volume in blue velvet.

Part B: La Couverture en Soie du Psautier de Saint Louis

Sophie Desrosiers, École des hautes études en sciences sociales, avec la collaboration de Gabriel Vial, secrétaire technique du Centre international d'étude des textiles anciens, Lyon

De la couverture en soie du Psautier, il ne reste que des fragments, collés sur les deux plats en bois de l'ancienne reliure qui sont aujourd'hui indépendants du manuscrit (figs. 99–100). L'examen des plats a révélé la présence de trois tissus différents:

1. une soierie façonnée qui recouvrait le volume
2. deux rubans qui faisaient partie de son fermoir
3. deux fragments d'un tissu de soie uni ayant servi, semble-t-il, à la pose des rubans.

Après analyse des fragments restants de la soierie façonnée, nous sommes arrivée à identifier la structure du tissu—un lampas à fond double-étoffe—et les autres éléments de sa contexture et à reconstruire approximativement son décor ainsi que l'apparence extérieure du Psautier.

En ce qui concerne les rubans, leur tissage et leur décor sont classiques—tissage aux cartons avec trame d'or lancée, décor géométrique basé sur des diagonales. Leurs fils métalliques ont par contre des caractéristiques tout à fait intéressantes. D'une part, la construction des fils d'or lancés est exceptionnelle: il s'agit d'une feuille de métal enroulée autour d'une âme en soie—comme le serait du papier autour d'une cigarette—seulement dans la partie centrale du galon. D'autre part, les filés d'or appliqués en décoration sur un des rubans sont très semblables à ceux qui sont brochés dans la soierie façonnée. Si ces deux filés d'or étaient de même nature—ceci pourrait être vérifié par une analyse du métal et de la soie—nous pourrions supposer que les rubans aux cartons et la soierie façonnée ont une même provenance, ce qui fournirait un élément de comparaison supplémentaire.

Le tissu de soie uni est un satin de cinq bleu foncé. Il ne présente aucun intérêt particulier et ne sera donc l'objet d'aucune description ici.

ANALYSE DE LA SOIERIE FAÇONNÉE

I. Dimensions générales (y compris les replis)

(La chaîne du tissu est parallèle à la hauteur des plats.)
 A. Tissu recouvrant le plat supérieur:
 largeur maximale — 159 mm env. aujourd'hui,
 mais probablement

 — 177 mm avant restauration
 du plat[22]
 hauteur maximale — 272 mm env.
 B. Tissu recouvrant le plat inférieur:
 largeur maximale — 187 mm env.
 hauteur maximale — 279 mm env.
 C. Tissu d'origine:[23]
 largeur approximative—424 mm
 hauteur approximative—295 mm

II. Contexture

 A. Eléments généraux
 Qualification technique:
 Lampas à fond double-étoffe, 2 lats de lancé, broché.
 Chaînes:
 proportion—4 fils pièce pour 1 fil de liage
 matières—chaîne pièce: fils doubles,
 poil Soie Z, rose saumon.
 —chaîne de liage: fils simples, soie sans
 torsion (grège?), vert
 découpures—3 fils pièce, parfois 4
 réduction—60 fils pièce et 15 fils de liage au
 cm environ
 Trames:
 proportion—1 coup de chaque lat
 matières—1er lat (fond): trame Soie x bouts,
 faible torsion Z, rose saumon.
 —2ème lat (lancé): trame Soie x bouts,
 sans torsion appréciable, vert
 —3ème lat (lancé, latté): trame Soie x
 bouts, sans torsion appréciable,
 blanc ou bleu foncé
 —4ème lat (broché): filé d'or couvert;
 lame de métal (argent doré?)
 montée S sur âme en soie
 jaune orange (S)
 découpures—1 passée
 réduction—22–23 passées au cm
 B. Construction interne du tissu
 Fond: double-étoffe
 À l'endroit: satin de 5 chaîne décochement de
 3, formé par la chaîne pièce et la trame
 de fond (1er lat)
 À l'envers: taffetas à deux coups dans le pas,
 formé par la chaîne de liage et par les 2
 trames lancées (2ème et 3ème lats)
 Décor:
 1. Effet de trame lancée 2ème lat, vert

2. Effet de trame lancée 3ème lat, latté
blanc et bleu foncé
Ces deux effets sont liés en taffetas par
la chaîne de liage et reposent sur le
satin du fond. À l'envers, la trame
lancée qui est momentanément inutile
est liée en taffetas.
3. Effet de trame brochée 4ème lat, or, lié en
serge 3 lie 1 direction S par la chaîne de
liage et reposant sur le satin du fond. A
l'envers, les trames lancées 2ème et 3ème
lats sont liées en taffetas.
Lisières:
absentes

III. État de conservation

Étant donné la fragilité de la soierie — particulièrement dans le fond double-étoffe — seuls les replis qui étaient protégés à l'intérieur de la reliure sont en bon état de conservation. Sur les faces extérieures des plats, à part quelques rares endroits où l'étoffe s'est conservée dans son entier, ce qui reste visible de celle-ci n'est qu'une partie de son envers.

Du fond double-étoffe en satin rose, il reste parfois la couche inférieure, le taffetas à deux coups dans le pas fait par la chaîne de liage et les deux trames lancées. Ce même taffetas présentant une apparence de sergé signale des parties qui étaient brochées d'or. Dans ce cas, l'apparence de sergé est dû à la disparition des fils qui liaient les trames d'or sur l'endroit. Enfin des effets de trame lancée 2ème et 3ème lat, il subsiste encore par places un taffetas fait par la chaîne de liage et la trame lancée inutile sur l'endroit.

Le lattage de la trame lancée 3ème lat qui est tantôt blanche tantôt bleu foncé, est nettement visible aux endroits où le tissu a été fragmentairement conservé.

IV. Reconstruction du décor (diagram 6)

Fleurs, tiges et feuilles, palmettes de forme ogivale et oiseaux sont visibles sur les fragments encore entiers de l'étoffe, ainsi que sur les parties qui sont moins bien conservées mais témoignent de ce qui apparaissait à la surface du tissu. Ces parties du dessin réellement observées sur l'étoffe ont été représentées en trait plein. Il en a été de même de leur répétition en hauteur et en largeur, après que nous ayons remarqué que le rapport de dessin ne comporte qu'un seul chemin suivi. En effet, cette caractéristique est attestée par la répétition des palmettes en largeur et en hauteur, avec les mêmes découpures chaîne et trame, dans les fragments de tissu demeurés en assez bon état de conservation.

Vu l'état fragmentaire du décor restant et le fait que le tissu n'a pas été collé vraiment droit fil sur son support, nous n'avons pas pu situer les motifs de façon précise les uns par rapport aux autres. Notre reconstruction n'est donc qu'approximative.

Pour compléter cette reconstruction, nous nous sommes fondée sur une autre caractéristique du rapport de dessin, sa composition, qui est probablement de type "retournée" comme l'indique la répétition retournée de très nombreux détails en trait plein. Les parties des motifs qui ont été reconstruites en retournant l'autre motié du dessin on été représentées en pointillés.

La rapport du dessin ainsi obtenu mesure 180 mm de large et 238 mm de haut.

V. Restitution de l'apparence extérieure du Psautier (diagram 7)

Tout ce qui est conservé aujourd'hui du Psautier et de son ancienne couverture en soie permet de penser qu'un seul morceau d'étoffe recouvrait le manuscrit et qu'il avait été placé de telle manière que la large fleur en filé d'or soit presque au centre de chaque plat et visible sur le dos du volume.

Nous avons trouvé deux éléments qui se complètent pour avancer cette hypothèse. Le premier élément est un défaut résultant d'une erreur de tissage: une trame verte passée dans le pas d'une trame blanche. Ce défaut est clairement visible sous la forme d'un trait horizontal vert dans la partie blanche des palmettes situées sur les replis latéraux des deux plats (figs. 97–98). Sa présence sur les deux ais, presque à la même hauteur, prouve que les deux fragments d'étoffe encore conservés aujourd'hui provienne du même tissu d'origine, pris dans une même hauteur. Le deuxième élément est la largeur du tissu manquant entre les deux plats. D'après la reconstruction de le diagramme 6, cette largeur est approximativement de 60 mm. Cette dimension correspond à l'épaisseur des feuillets dans leur reliure actuelle augmentée de celle des deux plats le long du dos. Les deux fragments d'étoffe proviennent donc très probablement d'un même morceau du tissu d'origine.

ANALYSE DES FRAGMENTS DE RUBANS

Des rubans qui faisaient partie du fermoir du manuscrit, il ne reste que deux fragments correspondant au parties clouées sur la face extérieure du plat supérieur. Ils étaient autrefois recouverts par la soierie façonnée. Le fragment situé en haut est dans un état de conservation relativement bon; il est encore partiellement protégé par la soierie façon-

née. Celui qui est situé en bas est par contre très usé; les trames d'or lancées qui constituaient son décor ont presque entièrement disparu. Ce qu'il reste est cependant suffisant pour montrer que les deux rubans avaient originalement une même contexture et un même décor.

I. Dimensions générales

Le fragment du haut a ses deux lisières et mesure 18 × 18 mm; celui du bas est incomplet et mesure 17 × 17 mm.

II. Contexture

A. Eléments généraux

Qualification technique: Tissu aux cartons, à décor d'une trame lancée

Chaîne: matière—soie, organsin S, de 2 bouts, orange

réduction—34–35 torsades au cm, soit 136–40 fils au cm

Trames: proportion—1 coup de fond pour 1 coup de lancé

matières: fond—même que la chaîne

lancé—fil d'or de construction particulière: des feuilles de métal (argent doré?) sont successivement enroulées en tube autour d'une âme en soie rouge orangé. Chaque tube recouvre l'âme dans la partie centrale du galon et s'arrête avant les lisières dans lesquelles seule la soie est prise.

réduction: 18–20 passés au cm

B. Construction interne

L'endroit est entièrement recouvert par les trames d'or lancées qui reposent sur un fond de torsades classiques, de 4 fils chacune, alternativement Z et S, produites avec la trame de fond. Le liage des trames lancées est fait par 1 fil repris sur les 4 de la torsade. Ce sont les liages qui forment le décor.

III. Décor des rubans

Semis de petits losanges occupant toute la surface du galon. Le rapport de dessin est construit sur 6 passées et 10 torsades. Il mesure environ 3 mm en largeur comme en hauteur.

IV. Décoration appliquée

Les fragments de deux retors de filés d'or de direction contraire, Z pour l'un et S pour l'autre sont encore cousus sur une lisière du galon du haut. Cette décoration s'intègre parfaitement au ruban parce qu'elle imite des torsades qui pourraient être visibles en lisière. Il est probable même qu'elle constitue une "fausse lisière" destinée à cacher l'absence d'or en cet endroit, une absence qui est liée à la construction particulière des trames lancées. Ce détail est d'une certaine importance parce que les filés d'or qui sont la base de cette décoration presque nécessaire sont très semblables en dimension et de même construction que ceux de la soierie façonnée.

Appendix VII: Prefatory Miniatures: Working Groups with Physical Variables

	FIRST GROUP				SECOND GROUP			
Gath'g	fols.	prck'g	arch	bole*	fols.	prick'g	arch	bole*
First Phase								
I	1–4	a	A	dark grey	5–6, 8–9	b (a)**	B	yellow-green
	7, 10, 13–14	a	A	yellow-grey	11–12	b (a)**	B	yellow-green
II					15–24	b	B	yellow
III	25–28	a	C	black				
IV	31–32, 34–39	a	C	grey and dark grey	29–30, 33, 40–42	b	B	green
Second Phase								
V	43–46	b	B	dark grey				
VI					47–50	a	C	yellow
VII					51–54	a	C	yellow-green
VIII					55–58	a	C	yellow-green
IX	59–62	b	D	brown				
X	63–66	b	D	brown				
Third Phase								
XI	67–70	a	D	light brown				
XII	71–74	a	D	light brown				
XIII	75–78	a	C	light brown				

* color as seen from reverse
** double pricked

Notes

Abbreviations

BÉC *Bibliothèque de l'École de Chartes*

CCSL *Corpus Christianorum, series Latina*

CNRS Centre national de la recherche scientifique

DOP *Dumbarton Oaks Papers*

FSt *Frühmittelalterliche Studien*

GRLMA *Grundriss der romanischen Literaturen des Mittelalters,*
 ed. Hans Robert Jauss et al. (Heidelberg, 1968–)

JWCI *Journal of the Warburg and Courtauld Institutes*

LCI *Lexikon der Christlichen Ikonographie,* vols. 1–4, ed.
 Engelbert Kirschbaum (Rome and Freiburg,
 1968–72)

ÖNB Österreichischen Nationalbibliothek

PL J.-P. Migne, *Patrologiae cursus completus, series
 Latina* (Paris, 1844–64)

RHF *Recueil des historiens des Gaules et de la France,* ed.
 M. Bouquet et al., 24 vols. (Paris, 1708–1904)

SFRMP *Bulletin de la Société française de reproductions de
 manuscrits à peintures*

SH Vincentius Bellovacensis, *Speculum Quadriplex sive
 Speculum Maius,* vol. 4, *Speculum historiale.* Douai,
 1624; repr. Graz, 1965

SN Vincentius Bellovacensis, *Speculum Quadriplex sive
 Speculum Maius,* vol. 1, *Speculum naturale.* Douai,
 1624; repr. Graz, 1965

ZKg *Zeitschrift für Kunstgeschichte*

Introduction

1. See, for example, Deshman, "The Exalted Servant."

2. In this study I use the capitalized form of "Psalter" to refer to the Psalter of Saint Louis.

3. For the problematics of interpreting this king, see Le Goff, *Saint Louis,* and the Conclusion above.

4. For a summary description of the manuscript, see Appendix I.

5. Cambridge, Fitzwilliam Museum, MS 300; see Cockerell, *Psalter and Hours,* and Wormald and Giles, *Descriptive Catalogue of Additional Illuminated Manuscripts,* 280–84. The manuscript has been referred to as Isabella's since Cockerell's suggestion (*Psalter and Hours,* 8–10) that it was made for Louis IX's pious sister of that name, who founded the Clarissan monastery of the Humility of the Blessed Mary, later known as Longchamp, in 1255. Because it lacks Franciscan prayers, Branner, "St Louis et l'enluminure parisienne," 83, and idem, *Manuscript Painting in Paris,* 133, has suggested that the manuscript was made for either another Isabella, the king's daughter, or his wife, Margaret. In view of the many obits for the king's ancestors, Margaret is an unlikely candidate. Because the king's sister and daughter remain the most likely candidates, in this study I continue to refer to the manuscript by its traditional name, the Isabella Psalter.

6. Philip was born in 1245, and Robert was killed in 1250, during the king's first Crusade. Although the king's first son, Louis, was born a year earlier, work on the Psalter may not even have begun before he died in an accident, in 1260. Although the Provençal pales appear on the tombs of Louis IX's children, Blanche and Jean, there is no evidence that the children bore those charges in life, since the will of Margaret's father made clear that upon her death they would revert to her sister, Beatrice of Provence; see Bourilly and Busquet, *La Provence au Moyen Âge,* 61. Cockerell, *Psalter and Hours,* 9, correctly notes that the pales occur only twice in the Fitzwilliam manuscript and are far less prominent than in the king's Psalter, where they are found in painted initials and in many line-endings. For a discussion of the heraldry in the Psalter, see the section on heraldry near the end of Chapter 1.

7. Van Moé, "Sur la date du petit psautier de Saint Louis," 423, argues that because of the absence of the feast of Saint Clare, the Psalter must antedate her canonization, in 1255. However, Clare rarely appears in French calendars of the thirteenth century and never in royal ones. For the calendar, see Appendix III.

8. Branner, *Manuscript Painting in Paris,* 133, and Samaran and Marichal, *Catalogue des manuscrits en écriture latine,* 3:185.

9. For the original binding, see Appendix VI.

10. Here I give the text in corrected form; for a transcription and translation of the full text, see Appendix II.

11. Duchesne, *Historiae Francorum Scriptores,* 5:438–40.

12. Marie took up residency at Poissy in 1397, when she was

less than five years old, but the ceremony of her profession did not occur until June 1408. She died at Poissy in 1438. Although the date on the flyleaf ("14—") could have been 1408, the text could not refer to the ceremony of her profession, which fell on the feast of the Trinity rather than that of Saint Michael. For the precise dates, see *Chronique du religieux de Saint-Denys*, 2:554–55 and 4:8–9. See also Delisle, *Notice de douze livres*, 37, and, for a different interpretation, Grandeau, "Les enfants de Charles VI," 837. For Charles VI's gifts and loans from the library assembled by his father, see Delisle, *Recherches*, vol. 1, pp. 130–37, and, for example, vol. 2, art. 1202 (1381) or 19 (1388).

13. Labarte, *Inventaire*, 340. The book, kept at Vincennes, in the private chamber of the king, is described thus (item 3304): "Item, ung autre Psautier mendre, qui fut aussi monsᵉ Saint Loys, trés bien escript et noblement enluminé, et a grant quantité d'ystoires au commancement dudit livre, et se commance au second feuillet *vas figuli*, auquel a deux petiz fermouers d'or plaz, l'un esmaillé de France et l'autre d'Évreux; a une pippe òu il a ung trés gros ballay et quatre trés grosses perles." *Vas figuli* are the first words of folio 87r (Ps. 2:9).

14. Tuety, "Inventaire des biens de Charlotte de Savoie," 357. "Item, ung sautier ystorye, couvert de satin figuré vert et rouge, à deux fermouers, appellé le sautier saint Loys, lequel lad. dame avoit emprunté de la dame de Poyssy, et estoit son intention le luy rendre, ainsi que ont rapporté les femmes de chambres de lad. dame, lequel sera baillé ès mains de madame de Beaujeu pour le rendre."

15. The only other feast added was that of Charlemagne, probably during the reign of Charles V; see note 105 to Chapter 1. Louis IX was canonized in 1297. For Philip IV and the canonization and cult of Saint Louis, see Carolus-Barré, "Les enquêtes pour la canonisation de Saint Louis"; Hallam, "Philip the Fair and the Cult of Saint Louis"; E. A. R. Brown, "Philippe le Bel and the Remains of Saint Louis"; idem, "The Chapels and Cult of Saint Louis at Saint-Denis"; idem, "The Prince Is the Father of the King," esp. 310–15; and Le Goff, *Saint Louis*, 301–10.

16. For her will, see Leber, *Collection des meilleurs dissertations*, vol. 2, no. 19, which describes an exceptionally elaborate reliquary she gave to the College of Navarre (pp. 150–51); a silver gilt bowl with the king's life depicted in enamels on its cover (p. 134); and, in a codicil that also refers to a small book of prayers illuminated by Pucelle, a part of the armor Louis IX wore at Al-Manskra (p. 165). On the queen's idealization of Saint Louis, see Holladay, "The Education of Jeanne d'Evreux."

17. See Labarte, *Inventaire*, no. 498, for the ruby ring belonging to Louis IX that she gave to Charles V, and, more

recently, *Le trésor de Saint-Denis*, 262–63. It is likely that the silver reliquary of Saint Louis, which Charles V kept in the oratory of the chapel at Vincennes (Labarte, *Inventaire*, no. 2521), was given him by Jeanne, since it included an effigy of her father (who died in 1319), kneeling before a silver statuette of Saint Louis. Charles V owned at least five other objects that had belonged to Louis IX (Labarte, *Inventaire*, nos. 363, 364, 370, 372, and 491, the latter a ring with a large ruby that had been owned by successive kings of France); five other reliquaries of Saint Louis (Labarte, *Inventaire*, nos. 166, 168, 2486, 2521, and 2526); and five other works given him by Jeanne d'Évreux or obtained from her estate (Labarte, *Inventaire*, nos. 15, 493, 1699, 2706, and 3648).

18. On Charles VI's giving away relics of Saint Louis on the occasion of the translation of his shrine at Saint-Denis in 1392, see Montesquiou-Fezensac, *Le trésor de Saint-Denis*, 2:313, and also Jean Richard, in Gousset, Avril, and J. Richard, *Saint Louis, roi de France*, 11.

19. Marie's interest in fine illuminated books is well known. She owned the Belleville Breviary, a gift from Jean de Berry in 1413, and gave the duke in turn a book of hours that was removed from the royal library sometime between 1373 and 1413. For the breviary, Paris, Bibl. Nat., MSS lat. 10483–84, see *Les fastes du gothique*, 293–96; for the book of hours, see Delisle, *Recherches*, 2:47, art. 264. See also Grandeau, "Les enfants de Charles VI," 837, who cites payments for textiles to bind her manuscripts. Delisle, *Notice de douze livres*, 115–22, claims Marie was the owner of a Dominican breviary with special observances in honor of Saint Louis and was at Poissy in the fifteenth century; however, see Avril, "Autour du bréviaire de Poissy."

20. On the Valois assertion of succession to the Louis myth, see Martin Kauffmann, "The Image of St. Louis," 281.

21. On the dissolution of the convent, see Moreau-Rendu, *Le prieuré royal de Saint-Louis de Poissy*, 291–94.

22. Dibdin, *Bibliographical, Antiquarian, and Picturesque Tour*, 2:160–68.

23. Ibid., esp. [2]:400–404. Chardin held a number of public sales in Paris from 1806 on, but I have been unable to determine if other Poissy manuscripts passed through his hands. On Chardin, see Munby, *Formation of the Phillipps Library*, 1:23–25, 147, 149.

24. *Catalogue des livres de la bibliothèque du Cte. Alexis de Golowkin*, no. 659: "Le Pseautier [*sic*] de St. Louis. pet. in 4. étoffe d'argent recouvert en velours cramoisi." Alexis Gavrilovich Golovkin was an important collector of manuscripts and fine books. His knowledge of the Psalter may have come by way of his first cousin Count Aleksandr Aleksandrovich Golovkin, who was living in Poissy at the

time of his death, about 1782; see Lobanov-Rostovskii, *Russkaia rodoslovnaia kniga*, 1:163.

25. Several of the most important works come from the 1784 sale of the collection of the duke of Vallière.

26. Thirteen of the nineteen books in the supplement were bound by Derome; see Devauchelle, *La reliure en France*, 2:53–59.

27. When Golovkin's catalogue gives the provenance of a book, it always cites well-known collections. The reference to Poissy corresponds to Dibdin's account. The full text of the catalogue note reads: "On trouve ce MANUSCRIT dans l'inventaire des effets précieux qui ont appartenu à St. Louis. Voyez le trésor de Chartres [*sic*]. En 1369 il appartenait à Charles Cinq dit le Sage. Charles Six le donna à Mad. Marie de France sa 3ème fille qui avoit consacré ses jours dans l'Abbaye de Poissy. Il paroit que ce Manuscrit a longtems resté dans cette Abbaye et que les circomstances de la revolution qui en ont necessité la vente."

28. *Catalogue des livres de la bibliothèque de Cte A . . . G . . .* (Moscow, 1811).

29. *Istoriia Rodov Russkogo Dvorianstva*, vol. 1 (Moscow, 1860), 358. Many of Mikhail Petrovich Golitzyn's books were acquired by his more famous relative, Mikhail Aleksandrovich Golitsyn, whose collection was eventually sold to the Hermitage. On this latter Golitsyn and his library, which also had books once belonging Golovkin, see Gunsbourg, *Catalogue des livres de la bibliothèque du Prince Michel Galitzin*, and Makedonskaia, "Ob odnoi biblioteke v dome na Volkhonke."

30. *Notice de manuscrits, livres rares, et ouvrages sur les sciences, beaux-arts, etc.; tirée du cabinet de Son Excellence le prince M. Galitzin* (Moscow, 1816), 18. The entry for the Psalter quotes the fourteenth-century inscription and describes the manuscript thus: "Manuscrit sur velin, écrit en lettres gothiques, contenant 78 miniatures qui réprésentent une partie de l'histoire de l'ancien Testament; la première est l'offrande de prémices par Cain et Abel; et la dernière le sacrifice d'Agnel par Samuël; il s'y trouva un Almanach et un Pseautier [*sic*] écrit en lettres gothiques à longues lignes; les tournures sont en or et couleur; la couverture est de satin broché or et soie verte; le tout est enveloppé dans du velours cramoisi." The remainder of the collection was sold in 1820.

31. Antoine Claude Dominique Juste de Noailles, prince de Pau, was ambassador from 1814 to 1819. I have found no evidence to support Dibdin's statement that a "Russian gentleman" sold the Psalter to the grand duke Nicholas and that the count acquired it from him in return for two Sèvres vases. The correct information first appeared in a notice published in *Le moniteur universel* of August 21,

1818, 1, and in the *Journal des débats politiques et litteraires*, August 22, 1818, 3, and was confirmed seven days later in the letter from the French minister of state and of the interior officially transmitting the Psalter to the Bibliothèque nationale (the letter is presently bound with the manuscript). Both the article and letter state that the Psalter was in the library of Prince "Michel Galitzin" (Mikhail Golitzyn) and was "offered" to the king of France. These details were reconfirmed by a statement given to the library by the count of Noailles in 1844, two years before his death, and preserved in the library archives. It is unclear how the count of Noailles learned of the Psalter; it may have been through family connections, for Jean Louis Paul François, the count of Ayen and Noailles, had married Golovkin's widow and was a sometime resident of Moscow; see *Le moniteur universel*, February 3, 1825.

32. Mansel, *Louis XVIII*, 285; Waquet, *Les fêtes royales sous la Restauration*, 73, 134–35.

33. Waquet, *Les fêtes royales sous la Restauration*, 92.

34. Identical reports appeared in, for example, *Le moniteur universel*, *Journal de Paris*, and *Journal des débats*. For the June date, see Dibdin, *Bibliographical, Antiquarian, and Picturesque Tour*.

35. The language of the report of August 24 is straightforward: "Le trône de saint Louis est impérissable, et ce sont ses enfans qui vont le rétablir sur les bases antiques et sacrées. Un autre Louis est parmi nous" (*Journal des débats*, August 25, 1818, 1–2). The three were also celebrated in a song, "Trois tête-à-tête de notre monarque," presented that day; see *Journal de Paris*, August 26, 1818, 3.

36. The emperor's decree is reprinted in Henri Barbet de Jouy's catalogue *Notice des antiquités, objets du Moyen-Âge, de la Renaissance et des temps moderne composant le Musée des souverains*, v–vi. The museum occupied the present rooms 1 and 2, which Félix Duban repainted with insignia, regalia, and military victories. The Psalter was presumably exhibited in the room designated the Salle de la monarchie. See also *Le moniteur universel*, March 4, 1852, and comte de Nieuwerkerke, *Rapport de M. le comte de Nieuwerkerke*, 61–66, 113, 176–77.

37. Barbet de Jouy, *Notice des antiquités*, vii.

38. Its reserve status and present number date to 1862. See Delisle, *Le cabinet des manuscrits*, 2:325. In his *Notice de douze livres*, 37–38, Delisle movingly describes the return of the Psalter of Saint Louis, the (Godescalc) Gospels of Charlemagne, the two Bibles of Charles, and "d'autres épaves."

39. *RHF*, 20:xxvii–xxviii. The engraver's name is not given.

40. On December 20, 1843, Duban, the first architect in

charge of the restorations, wrote to the minister of public works and asked that he intercede with the minister of instruction so that the director of the Bibliothèque royale would enable him and those he delegated to see the "missel" of Saint Louis more often and more easily than the library's rules permitted (Paris, Archives de la Commission des monuments historiques, dossier 1223 [Correspondance Duban, 1836–44]). A second letter (February 20, 1844) from Duban restated the request, this time specifically in reference to the restoration of the medallions. Three days later the minister replied that the director of the library had been contacted. Pattern sheets preserved in the archives (dossier 1221, Croquis et dessins, nos. 27, 28) are clearly based upon the line-endings in the Psalter. For the figure studies, compare, for example, the standing Egyptian of folio 31v to Saint Sebastian in Branner, "Painted Medallions," fig. 28.

41. The relation of these wall paintings to the Psalter miniatures has not been noted in the previous literature. In the left tympanum are, above, the Brazen Serpent (fol. 37v) with the anguished figure borrowed from the story of Saul and Nahash (fol. 76r); below, Samuel Makes Peace Offerings (fol. 78r) and the Israelites Prepare for Passover (fol. 32r). In the right tympanum are, above, Abraham and Melchizedek (fol. 6r) and, below, the Sacrifices of Cain and Abel (fol. 1v) and the Sacrifice of Abraham (fol. 10r). This arrangement differs from an earlier plan by Duban, who had not yet consulted the Psalter; that plan is reproduced in Leniaud and Perrot, *Sainte Chapelle,* 36. See also Stein, *Le Palais de Justice et la Sainte-Chapelle,* 206; Rudolf Echt, *Emile Boeswillwald als Denkmalpfleger: Untersuchungen zu Problemen und Methoden der französischen Denkmalphlege im 19. Jahrhundert,* 92, 209; Leniaud and Perrot, *Sainte Chapelle,* 40–41.

42. Labarte, *Histoire des arts industriel,* 3:157 and pl. 92. Barbet de Jouy, *Notice des antiquités,* 41–53, no. 32. The long entry describes the Psalter and its binding and publishes the full inscription on the flyleaf, a summary of contents and concluding prayers, and the legends found on the reverses of all seventy-eight full-page miniatures. It also summarizes the calendar, noting the royal obits, and quotes the relevant passage from the 1380 inventory of Charles V. A reproduction also appeared in Société de l'École des Chartres, *Album paléographique.*

43. Omont, *Psautier de Saint Louis* (Macon, 1902), and *Le Psautier de Saint Louis* (Graz, 1970).

44. Lecoy de la Marche, *Les manuscrits et la miniature,* 202–13, and Delisle, "Livres d'images," esp. 264–68. On the latter, see Hamburger, "A 'Liber Precum' in Selestat," and Hull, "Rylands MS French 5." Another early and

notable contribution is Delisle's brief discussion of Louis IX's manuscripts in terms of the beginnings of a royal collection and as a reflection of the king's interest in religious study; see *Le cabinet des manuscrits,* 1:7–10.

45. The late nineteenth century saw the publication of several essays notable for the ways their authors construed the evidentiary value of the manuscript for the study of French history. See, for example, Delisle, *Le cabinet des manuscrits,* 1:7–10, on the formation of the royal library; idem, "Livres d'images," esp. 264–68, where the same author stresses the expanded role of pictures in private devotion; and Lecoy de la Marche, *Les manuscrits et la miniature,* 202–13, where the author distinguishes between the symbolic content of the imagery in earlier manuscripts and the larger perspective of history and chronicles he saw in the Psalter's Old Testament miniatures.

46. A. Haseloff, "Les psautiers de Saint-Louis"; Cockerell, *Psalter and Hours.* Haseloff was the first to point out that both manuscripts must have been made between 1252/53, the dates of their most recent commemorations, and 1270, the death of Saint Louis.

47. On the Sainte-Chapelle evangeliaries (Paris, Bibl. Nat., MSS lat. 8892 and 17396), see Branner, *Manuscript Painting in Paris,* 236–37, with bibliography.

48. For example, Branner, *Manuscript Painting in Paris,* 133, sees the Cambridge manuscript as having been made first; for Beer, "Pariser Buchmalerei," 79, the Psalter has precedence. The authors also find different stylistic parallels for the Psalter.

49. In his *Notice de douze livres,* 37–42, Delisle again discussed and compared the Paris and Cambridge psalters. He more fully laid out the provenance of the Saint Louis Psalter, provided a detailed description of its eight historiated psalm initials, and published its entire calendar, including its variants from the Cambridge calendar. He described the latter as a replica of the Paris manuscript; within his chronological presentation of royal manuscripts, it follows the Saint Louis Psalter. Like Haseloff, he observed how the subjects of the full-page miniatures in the Cambridge manuscript seem to continue those of the Saint Louis Psalter. They in fact do so in Henri Omont's album of plates (*Psautier de Saint Louis* [1902]), where they form a supplement to the plates of the Psalter. About the same time, the Psalter figured as one of the earliest works in the important Paris exhibition *Les primitifs français.* For the brief catalogue description, see Léopold Delisle, "Manuscrits à peintures," in Bouchot, *Les primitifs français,* pt. 2, 7, no. 6. The exhibition was held in the Musée des arts décoratifs, but manuscripts were exhibited at the Bibliothèque nationale. See also Bouchot, *Les primitifs français,*

51, and Durrieu, "Le Psautier de Saint Louis."

50. A. Haseloff, "La miniature des XIIIe et XIVe siècles."

51. Vitzthum, *Die Pariser Miniaturmalerei,* iii, 1–3, 14–16. See the review by Paul Durrieu, "Un siècle de l'histoire de miniature parisienne à partir du règne de Saint Louis." From the same period dates the influential survey by Henry Marie Radegonde Martin, *Les peintures de manuscrits et la miniature en France: Étude critique,* 19–20, 32.

52. The most important prewar contributions were two studies on psalters: Günther Haseloff's 1938 book on illuminated psalter initials of the thirteenth century (*Die Psalterillustration im 13. Jahrhundert: Studien zur Geschichte der Buchmalerei in England, Frankreich und den Niederlanden,* 31, 88–90) and Victor Leroquais's catalogue of psalters preserved in French public libraries (*Les psautiers: Manuscrits latins des bibliothèques publiques de France,* 2:101–5). Neither work brought new information to light on the Psalter, but both studies provided a means for seeing it in a larger context: Leroquais's, within a general history of the psalter as an evolving book of private devotion, and Günther Haseloff's, in relation to traditions of psalm illustration elsewhere in Europe. Haseloff concludes his study with a notable discussion of Parisian painting, where, among other observations, he draws attention to the way the Psalter models in color. Among the more important surveys were Henry Marie Radegonde Martin, *La miniature française du XIIIe au XVe siècle* (1923), 86; Camille Couderic, ed., *Les enlumineurs des manuscrits du Moyen Âge (du VIe au XVe siècle) de la Bibliothèque nationale* (1927), 57–58; H. M. R. Martin, *Les joyaux de l'enluminure à la Bibliothèque nationale* (1928), 101; *Les plus beaux manuscrits français du VIIIe au XVIe siècle conservés dans la bibliothèques nationales de Paris* (1937), 35, no. 37; Émile Van Moé, "Le Psautier de Saint-Louis" (1937); and Henri Focillon, *Art d'Occident* (1938; 2nd ed., 1983), 266.

53. Deschamps, *Saint Louis et le rayonnement de l'art français.*

54. Dupont and Gnudi, *La peinture gothique,* 34–36; Bibliothèque nationale, *Les manuscrits à peinture en France du XIIIe au XVIe siècle,* 12–14, no. 11; Porcher, *L'enluminure française,* 43; cf. also *Saint Louis,* exh. cat. (Paris, 1960), 94–95, no. 191.

55. Cf. also Porcher, "Séance du 8 juillet," 105.

56. Branner, *St. Louis and the Court Style,* 12.

57. For a different view, see Kimpel and Suckale, *Gotische Architektur,* 376–409.

58. The most far-reaching statements appeared in the exhibition catalogues *Art and the Courts: France and England from 1259–1328* (Ottawa, National Gallery of Canada), 50 and passim, and *Transformations of the Court Style: Gothic Art in Europe 1270 to 1320* (Providence, Rhode Island School of Design Museum of Art and Brown University), 10, 101, and passim. A symposium on the "court style" was organized as part of the Providence-Brown exhibition and again in 1981 at the annual meeting of the College Art Association. The notion of a court style has been especially prominent in stained-glass studies related to the Sainte-Chapelle; see, for example, Grodecki, "Saint Louis et le vitrail"; Raguin, "Isaiah Master of the Sainte-Chapelle"; and Papanicolaou, "Stained Glass from the Cathedral of Tours." For a recent review of the problem, see Kurmann-Schwarz, "La châsse de Sainte Gertrude."

59. There is no comprehensive study of the people surrounding the king and their relative importance at various times during his reign. For his counselors, see Griffiths, "New Men Among the Lay Counselors of Saint Louis' Parlement."

60. Bumke, *Courtly Culture.*

61. Salimbene di Adam, *Cronica,* 213; Le Goff, *Saint Louis,* 746–50.

62. Its extreme statement has been noted by others; see recently Erlande-Brandenburg, *L'art gothique,* 81, and Pächt, *Book Illumination,* 192.

63. Avril, "L'enluminure à l'époque gothique" (1979), 227 ("figurines gracieuses mais frôlant parfois la mièvrerie"). See also Focillon, *Art d'Occident,* 2nd ed., 266, who describes a "Humanité plus nerveuse, plus active, et plus fragile que jadis," or Swoboda, *Die Gotik von 1150 bis 1300,* 165, who refers to the puppetlike character of the figures, or Sauerländer, *Le siècle des cathédrales,* 270, who interprets their artificiality in terms of a systemization and a loss of freedom.

64. Branner, *Manuscript Painting in Paris,* 135; idem, "Painted Medallions," 22.

65. See, for example, the contrast between a *béguin* and a *prud'homme* in Jean de Joinville, *Vie de Saint Louis,* chap. 32; cf. Bériou, "Robert de Sorbonne, le prud'homme et le béguin." For the intellectual milieu, see Le Goff, *Saint Louis,* 754–77, 585–88.

66. Sterling, *La peinture médiévale à Paris,* 1:26–40, esp. 28.

67. *Manuscript Painting in Paris,* esp. 4–10, 132–36; for the earlier articles, see 147.

68. Writing in 1868 on the formation of the Bibliothèque impériale, Delisle discussed the Psalter against a background of the king's commitment to provide books for religious study; see Delisle, *Le cabinet des manuscrits,* 1:7–10; see also 54, 403, 2:285, 3:118. An earlier discussion of Louis IX's library had appeared in Brial et al., "Discours sur l'état des lettres en France au XIIIe siècle," 34.

69. For a discussion of structures of production and their relation to artistic practice, see Chapter 1.

70. Branner, *Manuscript Painting in Paris,* 156. For the most complete and well-documented description of Parisian

manuscript production at this time, see Rouse and Rouse, *Manuscripts and Their Makers.*

71. Branner, *Manuscript Painting in Paris*, 134–35, 176–77. It is unclear whether he believed those working in gold and silver were also specialists. For his atttributions, see Appendix V.

72. In Branner's study only the production of the *Bibles moralisées* is analyzed in similar detail; see ibid., 49–64 and app. 3A–D.

73. Cockerell, *Psalter and Hours*, 26; A. Haseloff, "La miniature des XIIIe et XIVe siècles," 344; Branner, *Manuscript Painting in Paris*, 133.

74. W. C. Jordan, "The Psalter of Saint-Louis."

75. W. C. Jordan, *Louis IX and the Challenge of the Crusade*, esp. 127–32. See also J. Richard, *Saint Louis*, 151–52, chap. 9 and passim.

76. W. C. Jordan, "The Psalter of Saint-Louis," 79.

77. Stahl, "Old Testament Illustration."

78. For the Old Testament picture book, New York, Pierpont Morgan Library, MS M.638, see *Old Testament Miniatures* and Weiss et al., *The Morgan Crusader Bible.* The manuscript's origin and connection with Louis IX remain controversial; see pages 97–101 and 153 above, see note 22 to the Introduction and notes 139 and 165 to Chapter 4.

79. For a comprehensive statement, see Baldwin, *Government of Philip Augustus*, chap. 14. See also Strayer, "France: The Holy Land"; E. A. R. Brown, "La notion de légitimité"; A. W. Lewis, *Royal Succession in Capetian France*, chap. 4; J. Richard, *Saint Louis*, 744–79.

80. Studies include Hedeman, *Royal Image*, 1–29; Sadler, "The King as Subject"; idem, "Lessons Fit for a King"; Brenk, "Bildprogrammatik"; idem, "Der Concepteur und sein Adressat," 431–50; idem, "The Sainte-Chapelle as a Capetian Political Program"; A. A. Jordan, "Narrative Design"; Weiss, "Architectural Symbolism"; idem, *Art and Crusade;* and Bennert, "Art et propagande."

81. Le Goff, *Saint Louis*, 126, 461–72, 520–22, and passim.

82. Ibid., 520.

83. Leroquais, *Les psautiers*, 1:v–lxxxv; A. Hughes, *Medieval Manuscripts for Mass and Office*, 224–38 and passim.

84. The king's Psalter has the Athanasian Creed but lacks the Apostles' and Nicene Creeds as well as the Paternoster and litany, all of which are customary in French psalters of the period. For a discussion of their absence in the Psalter, see pages 50–51 above.

85. For Louis IX and the Leiden Psalter, see note 89 below. See also Riché, *Les écoles et l'enseignement.*

86. J. Richard, *Saint Louis*, 238–39; Le Goff, *Saint Louis*, 766–74. The different accounts of his life vary in such details as when he said the Short Hours of the Virgin and the number and kind of masses he attended, but the general pattern of devotion is the same in all sources. The discussion here is based primarily upon Gaufrido de Belloloco [Geoffroy de Beaulieu], *Vita Ludovici noni*, 13–14, the earliest and most reliable of the writers. See also Jean de Joinville, *Histoire*, para. 54, and Guillaume de Saint-Pathus, *Vie de Saint Louis*, 33–39. Cf. also Le Nain de Tillemont, *Vie de Saint Louis*, 5:331–39, and Labande, "Quelques traits de caractère du roi Saint Louis." Le Goff, *Saint Louis*, 370, cites an exemplum that has the king reciting the entire psalter on Good Friday.

87. On the possibility that the Bibliothèque nationale manuscript, which is incomplete at the end, contained these texts as well, see pages 50–51 and note 171 to Chapter 1. The psalter for Dominican use, as revised in 1256 by Humbert of Romans, included responses and verses as well as the Office of the Virgin; see Brett, *Humbert of Romans*, 86.

88. Guillaume de Saint-Pathus, *Vie de Saint Louis*, 36; Carolus-Barré, *Le procès*, 124.

89. Leiden, Bibliotheek der Rijksuniversteit, MS lat. 76A; Morgan, *Early Gothic Manuscripts*, 1:60–62, no. 14, with bibliography. An obit commemorating the death of Blanche's father, Alphonso VIII of Castile, was added to the calendar in an unpracticed hand that Delisle, *Notice de douze livres*, 101, dates to the thirteenth century. The manuscript was later in the collection of Blanche of Navarre; according to her will, it passed from Louis IX to his youngest daughter, Agnes; ibid., 25.

90. Chantilly, Musée Condé, MS 1695. For a full description with earlier bibliography, see Deuchler, *Die Ingeborgpsalter;* and, more recently, Allison Merrill, "A Psalter of the Ingeborg Psalter Atelier."

91. Deuchler, *Ingeborgpsalter*, 5–6, is probably right in suggesting that the manuscript was for Louis IX. Davidsohn, *Philipp II. August*, 279, stresses the king's cordial relations with and support for Ingeborg toward the end of her life. According to Sivéry, *Blanche de Castille*, 220, Blanche benefited from Ingeborg's estate, so that her psalter, like that in Leiden, might first have belonged to the Queen Mother. On the possible influence of the Ingeborg Psalter upon the designers of the Psalter of Saint Louis, see pages 30–31 above.

92. Cf. note 5 above. For the Ingeborg Psalter, see Labarte, *Inventaire*, no. 3303, and Deuchler, *Ingeborgpsalter*, 6.

93. Labarte, *Inventaire*, no. 3046 ("Item, le Psaultier saint Loys, à une chemise de toile, à deux petiz fermoers d'argent").

94. It is recorded in Mary's will as "Psalterium librum qui fuit sancti Ludoyci Regis Francie" and thus could not be the unidentified manuscript in the inventory of Charles V; see

Manieri-Ricci, *Saggi di codice diplomatico,* suppl. 2, 102. Fuiano, "La biblioteca di Carlo I d'Angiò," 202–3, suggests she inherited this and other books from Louis's brother Charles I, in which case the manuscript dates to the thirteenth century. On Charles's piety during his youth, see Salimbene di Adam, *Cronica,* 216.

95. MS 1186. See Delisle, *Notice de douze livres,* 27–35; Martin, *Psautier;* and Branner, *Manuscript Painting in Paris,* 30–31, 204.

96. Martin, *Psautier,* pl. LIV. Although the kneeling woman in the initial to Psalm 101 is uncrowned, there is no reason to doubt the attribution of the manuscript to Blanche. It may have been painted before her coronation, in August 1223. By then, she had lived at the courts of Philip Augustus and Louis VIII for more than twenty years; see É. Berger, *Blanche de Castille,* 5, and, on the cultural interests of Blanche and Louis VIII during this period, Sivéry, *Blanche de Castille,* 26–27. Branner, *Manuscript Painting in Paris,* 204, suggests the manuscript was ordered while Blanche was a queen in her own right (1223–26). Stirnemann, "Les bibliothèques princières," 178, interprets the fleurs-de-lis painted beside the Tree of Jesse (fol. 15v) as supporting the attribution to Blanche, but the motifs there and on the Beatus page (fol. 30v; Martin, *Psautier,* pls. XXI, XXXVI) are painted with a technique different from that of the rest of the miniatures and are likely to have been added later, probably in the fifteenth century, when Charles VI had a silken chemise of fleurs-de-lis made for the book.

97. The inventories are quoted in Martin, *Psautier,* 3–7. It is unclear when the manuscript was deposited in the Sainte-Chapelle.

98. Leroquais, *Les psautiers,* 2:95–97. Branner, *Manuscript Painting in Paris,* 60, 65, 208; Tesnière, "Medieval Collections of the Bibliothèque Nationale," 54–55.

99. Stirnemann, "Les bibliothèques princières," 178, 190 n. 42.

100. Labarte, *Inventaire,* no. 2090 ("Item, ung Psaultier, aux armes de France et de Castelle, à deux fermoers d'argent, et une chemise blanche").

101. The arguments were first made by Marie-Hélène Tesnière, "Medieval Collections of the Bibliothèque Nationale." For the chapel, see Branner, *St. Louis and the Court Style,* 51–55; Kimpel and Suckale, *Gotische Architektur,* 393–98.

102. E.g., *RHF,* 23:609c.

103. See notes 72, 74, and 76 above.

104. For the 1241 entry, see Bougenot, "Comptes de dépense de Blanche de Castille," 90. For the three others, see Delisle, *Le cabinet des manuscrits,* 1:7 n. 1, and cf. Branner, "St Louis et l'enluminure parisienne," 70.

105. For the 1463 Maubuisson inventory, see *L'abbaye de Maubuisson,* ed. Dutilleux and Depoin, 154, or Delisle, *Notice de douze livres,* 35.

106. MS 1273. The manuscript is closely related to the Arsenal MS 1186. Cf. *SFRMP* 5 (1921): 31–36; Leroquais, *Les psautiers,* 2:152–53; Branner, *Manuscript Painting in Paris,* 205.

107. See note 6 above.

108. Wilhelm von Rubruk, "Itinerarium," 202, 204 ("psalterium pucherrimum in quo erant picturae pulchrae"). See also Beazley, *Texts and Versions,* 166. Along with a letter from Louis IX, the psalter was the chief gift to be presented to the Tartars. A Bible and breviary are also described as having pictures the Tartars wanted to have explained.

109. For overviews, see Branner, "St Louis et l'enluminure parisienne," 70–77; idem, *Manuscript Painting in Paris,* 4–9; and Stirnemann, "Les bibliothèques princières," 177–84. The following notes give additional references as applicable.

110. Blanche owned the Bible, Paris, Bibl. Nat., MS lat. 14397, which she gave to Saint Victor, and Louis once owned Paris, Bibl. Nat., MS lat. 10426, according to a fifteenth-century note added by Jean Flamel, Jean de Berry's librarian. For the breviary, now Washington, D.C., Library of Congress, MS 15, see Schutzner, *Medieval and Renaissance Manuscript Books,* 1:106–12. The content and decorative plan of the manuscript's incomplete calendar are almost identical to that in the Cambridge Psalter (Fitzwilliam Museum, MS 330) and approximately contemporary with it. Rebecca Baltzer made the attribution to Robert Clermont. On the basis of style, Stones, "Secular Manuscript Illumination in France," 91, suggests that the Paris, Bibl. Nat., MS fr. 9081, manuscript of Guillaume de Tyr's *Histoire de la guerre sainte* was also made for Louis IX.

111. Paris, Bibl. Nat., MSS lat. 8892, 9455, 17326, and Bari, San Nicola; see Branner, "Le premier évangéliaire," and idem, "Two Parisian *Capella* Books in Bari."

112. *RHF,* 22:605E; Guillaume de Saint-Pathus, *Vie de Saint Louis,* 46–47. The preserved accounts describe donations for construction, chalices, vestments, and the exceptional statue but not for books.

113. *RHF,* 20:14–15. See Delisle, *Le cabinet des manuscrits,* 1:7, and Simone Balayé, *La Bibliothèque nationale,* 3.

114. Paris, Bibl. Nat., MSS lat. 16357, 17439, and Boston, Museum of Fine Arts, 06.138. See Branner, "St Louis et l'enluminure parisienne," 71. Inscriptions establish the provenance of these manuscripts.

115. Ibid., 73–74.

116. Cf. Branner, *Manuscript Painting in Paris,* 4–5.

117. Delisle, *Recherches,* vol. 1, was able to identify 104 of 1,239

manuscripts, or less than 10 percent of the items inventoried in Charles V's library before its dispersal. Although more recent scholars, especially François Avril (in Avril and Lafaurie, *La librairie de Charles V*, and elsewhere), have been able to identify other works, the losses are still overwhelming.

118. For a summary based upon these texts, see David-Roy, "Saint Louis bâtisseur."

119. See note 000 above. The period in question is from her coronation, in 1223, to her death, in 1252. I do not count the few known purchases that the king's *hôtel* made for Blanche.

120. Listed as expenses under the rubric *dons et hernesia;* see *RHF,* 21:lxi–lxvi. The accounts recorded during the remaining periods largely pertain to expenses and receipts of bailiffs and provosts and military campaigns.

121. For Hugh's breviary, see *RHF,* 21:230A; for the Maubuisson Ordo, *RHF,* 22:605E; for the presumed evangeliary, *RHF,* 22:603E; and for the Sainte-Chapelle breviary, *RHF,* 22:599E. The entry for the evangeliary on September 4, 1239, which follows closely upon several others related to the Sainte-Chapelle, reads, "Pro quodem texto regis illuminando," with a note, "Id est evangelorum codice picturis ornando." Hugh of Athies was the king's powerful *panetier,* who received oaths of fidelity from knights and cities, especially in Flanders; see Sivéry, *Blanche de Castille,* 129.

122. This aspect of the Sainte-Chapelle is discussed on pages 164–67 above.

123. For these manuscripts, see Laborde, *Bible moralisée,* vol. 5, and the important study by Lowden, *Bibles Moralisées.* Among earlier literature, see Branner, *Manuscript Painting in Paris,* 32–55, and the general introductions in the facsimiles published by Haussherr, *Bible Moralisée;* Stork, *Bible of St. Louis;* and Guest, *Bible Moralisée.*

124. For the frontispieces, which have been variously interpreted and named, I use here the terminology proposed in Lowden, *Bibles Moralisées,* 1:50 and passim.

125. For Vienna, ÖNB, MS 2554 (French), see Haussherr, *Bible Moralisée.* Here I follow the dating of Haussherr, Stork, and Lowden, from the facsimile introductions mentioned in note 123; cf. Tachau, "God's Compass," 7, who dates the French version to 1208–15.

126. For New York, Pierpont Morgan Library, M.240, see the facsimile and commentary volume of Stork's, *Bible of St. Louis.* Laborde, *Bible moralisée,* reproduces selected pages from all of the thirteenth-century manuscripts and all folios of the set divided between Oxford, Bodleian Libr., MS Bodley 270b; Paris, Bibl. Nat., MS lat. 11560; and London, Brit. Libr., MSS Harley 1526, 1527.

127. Another indication that the manuscripts were royal commissions is the number that were given to other royal collections or subsequently copied for them. The Toledo/Morgan set was in Spain at least by 1284 and may have been sent there as a gift soon after it was made, probably between 1248 and 1269. And the *Bible moralisée* now dispersed between Oxford, Paris, and London was copied in England in the late thirteenth century and later found its way back to France, where it was copied in the early fourteenth century for Jean le Bon. For detailed discussion of the provenance of these manuscripts, for the suggestion that all were royal commissions and circulated through royal and ducal collections, and for proposals about what events occasioned their commissions, see Lowden, *Bibles Moralisées,* 2:200–204 and passim.

128. In contrast to those who usually take the figure to be a lay scribe, Lowden, *Bibles Moralisées,* 1:129, correctly identifies him as the artist working on one of the roundels. Moreover, Lowden succeeds in discerning the text in the book beside the cleric and therefore the content of his gesture, which concerns the role of faith in painting.

129. The queen could also be Louis IX's wife, Margaret, whom he married in 1234, but I am aware of no writer who has argued for this identification; cf. Laborde, *Bible moralisée,* 5:58–59; Branner, *Manuscript Painting in Paris,* 48; Haussherr, *Bible Moralisée,* 29.

130. Earlier scholars have variously identified the king, depending largely on the date implied by stylistic analysis; see Laborde, *Bible moralisée,* 5:87 (Louis IX); Branner, *Manuscript Painting in Paris,* 48 (Philip Augustus); and Haussherr, *Bible Moralisée,* 33, Stork, *Bible of St. Louis,* 12, and Lowden, *Bibles Moralisées,* 1:94 (Louis VIII). It is unlikely the figure is Louis IX, who was in his teenage years in the 1220s and is shown beardless on the Toledo/Morgan page, or Philip Augustus, who could not read Latin. However, Louis VIII and Blanche of Castile were important patrons even before their coronations; see notes 108 and 110 above.

131. Lipton, "Jews in the Commentary," 12–14.

132. For what remains of the inscription, see Laborde, *Bible moralisée,* 5:87–89; Hermann, *Die westeuropäische Handschriften,* 47; and Lowden, *Bibles Moralisées,* 1:88, who notes that the king is not addressed directly in the vocative form.

133. Although the inscription is contemporary, it could have been added a few years later, and so the reader being addressed might well have been a later one.

134. Lowden, *Bibles Moralisées,* 1:90.

135. Apoc. 22:16.

136. Apoc. 22:18–20. A figure holds a scroll identifying the

group as "iudei.heretici.falsi.decretis." The moralization alongside reads, "Hic sunt excommunicati et maledicti iudei qui negant veritatem et veram expositionem sacre scripture. Et heredici qui in ea suas falsitatis admittent. Et falsi decretisti qui sacram scripturam inducunt ut per eam litigent de terrenis." Lipton, "Jews in the Commentary," 197; Stork, *Bible of St. Louis,* 78.

137. Stork, *Bible of St. Louis,* 78–82. Lowden, *Bibles Moralisées,* 1:128, notes that the artist changed his mind about the gesture, for the underdrawing shows the queen holding her mantle strap. For a similar speech gesture, see, for example, the illustration to Cant. 1:9 in Laborde, *Bible moralisée,* pl. 293. Typical is the arrangement of a seated older figure strongly gesturing, usually with open hand or pointed finger indicating explanation or enumeration, to a younger, attentive one, usually seated lower. There is no study of the iconography of pedagogy in this period; see, however, Camille, "Oxford University Textbook," esp. figs. 2 and 5.

138. For the queen's responsibility for her son's education, see Gaufrido de Belloloco [Geoffroy de Beaulieu], *Vita Ludovici noni,* 4; Jean de Joinville, *Vie de Saint Louis,* chap. 71; and Carolus-Barré, *Le procès,* 68 (Charles of Anjou). Cf. also Le Nain de Tillemont, *Vie de Saint Louis,* 1:438, and É. Berger, *Blanche de Castille,* 104–7. A century later Blanche uses almost identical gestures in the miniature representing her educating Louis IX in the Hours of Jeanne de Navarre; see Thomas, "L'iconographie de Saint Louis," fig. 1.

139. The foremost examples are the first Bible of Charles the Bald, Paris, Bibl. Nat., MS lat. 1, fol. 423r; the Carolingian Bible of San Paolo fuori le mura in Rome, now fol. 1r but originally the final folio, 337v; and the Pericopes of Henry III and Queen Gisela in Bremen, Universitätsbibl. Cod. b. 21, fol. 125r. See Schramm, *Die deutschen Kaiser,* nos. 36, 41, and 156. For a discussion of the ruler portraits, see Plotzek, *Das Perikopenbuch Heinrichs III.,* 20–27; Kessler, *Illustrated Bibles from Tours,* 125–38; *Das Reich der Salier,* 301; and Diebold, "Ruler Portrait of Charles the Bald." For the problematic relation between scribe, painter, and patron in early dedication images, see H. Hoffmann, *Buchkunst und Königtum,* 1:42–91. Lowden, *Bibles Moralisées,* 1:90, cites these precedents but sees a different meaning—one that exalts the king—in these *Bibles moralisées,* because of the way king and craftsman are placed in a structure that juxtaposes biblical images and moralizations.

140. Diebold, "Ruler Portrait of Charles the Bald," 10–15. The scribe bending over his work on this last *Bible moralisée* folio may also refer to the full-page Creator, with compass in hand, who formulates the cosmos at the beginning of the manuscript; cf. Laborde, *Bible moralisée,* pls. 625 and 672, and Lowden, *Bibles Moralisées,* vol. 1, color pls. 1 and 11. Camille, "Visual Signs," 124, and Alexander, *Medieval Illuminators,* 143–44, see the relation in terms of the frontispiece images of Christ and the final-page image of the king, who are each sources of wisdom in their respective realms. For interpretation of the frontispieces, see also Heinlein, "Ideology of Reform," chap. 1; Tachau, "God's Compass"; and especially Lowden, *Bibles Moralisées,* 1:47–50, 87–88, 90, and 151, who convincingly argues for the self-referential relation between the Creator's use of the compass to fashion the cosmos and artists' use of the compass to draw the roundels so characteristic of the manuscript.

141. Although the images of monarchs and the ambition of the enterprise make it likely that the Crown footed the bill, cost alone would not have prohibited any number of institutions or wealthy individuals from doing so. The most expensive manuscript we know from these years is the lost illuminated breviary of the Sainte-Chapelle, for which the king's *hôtel* paid 21 £ in 1248; see note 121 above. But this is hardly a high price at this time, when a new tower for a provincial priory church cost 200 £, or when the bishop of Auxerre was 700 £ out of pocket to get the first year of his cathedral's construction under way, or when the shrine for the relics of Saint Geneviève cost 800 £; for these works, see Kimpel and Suckale, *Gotische Architektur,* 221–22. A century later a *Bible moralisée,* now Paris, Bibl. Nat., MS fr. 167, cost Jean le Bon 320 £, not including the binding and chemise; Avril, "Un chef d'oeuvre," 122.

142. Lowden, *Bibles Moralisées,* 2:208–9. For a different view of the intended reader, see Camille, "Visual Signs," 126, who suggests that the clergy devised these manuscripts for their own use, as a handy way to instruct themselves in the details of biblical exegesis, and R. M. Wright, *Art and Anti-Christ in Medieval Europe,* chap. 3, who concludes (on p. 111) that the impact of the theology of the miniatures could only have been grasped by the clergy who devised the program the king underwrote. However, Haussherr, *Bible Moralisée,* 4–5; Stork, *Bible of St. Louis,* 22; and especially Lowden, *Bibles Moralisées,* 2:9, 200, and passim, emphasize the theological limitations of these manuscripts.

143. Haussherr, "Eine Warnung"; Heinlein, "Ideology of Reform"; Lipton, "Jews in the Commentary"; idem, "Jews, Heretics, and the Sign of the Cat"; Tammen, "Bilder der Sodomie"; Tachau, "God's Compass."

144. Branner, *Manuscript Painting in Paris,* 32, and Lowden, *Bibles Moralisées,* 1:30, both refer to the manuscripts as

"picture books," and Lowden correctly stresses the priority of the visual in both the production and reading of the book.

145. W. Kemp, *Narratives of Gothic Stained Glass*, chaps. 4–6, and Manhes-Deremble, *Les vitraux narratifs de la cathédrale de Chartres*, chap. 5. For these constructions and their visual, historical, and cognitive implications, see C. Hughes, "Visual Typology in Early Gothic Art."

146. For the first roundel: "Filii isr[ae]l venerum xii. lapides p[re]ciosos et alio[s] xii. apposuerunt." For its moralization: "Ilii qui xii lapides acceperunt p[re]ciosos et alios xii prauos apposuerunt s[ignificat] iesus [christu]m q[ui] dimissus iudeis et xii apostolos accep[erunt] p[re]cious." Cf. Isidore of Seville, *Questiones in Vetus Testamentum*, in *PL*, vol. 83, col. 373. In later *Bibles moralisées* the two sets of stones refer to men who enter religious life; see Laborde, *Bible moralisée*, pl. 96.

147. Of the roundels on this page, this is the only one with a traditional composition; see Psalter fols. 41v–42r (41v included in this book's reproductions).

148. E.g., Laborde, *Bible moralisée*, pl. 680.

149. Beside the third roundel: "Josue accepit tubas [et] audito sonitu ear[um] fecit archam deportare circa iherico septes [et] septima vice cecideru[n]t muri [et] post debellaverunt villam. Beside the moralization in the fourth: Filii Isr[ae]l bucinantes [et] archam deportantes sig[nificavi]t p[o]p[u]l[u]m iesu [christ]i qui p[r]edicavit voce[m] evangelii. [et] judei [et] ydola sua fiunt nulla."

150. The connection between the Ark and Mary would have been familiar at the time; compare, for example, the lintel of the Coronation of the Virgin portal at Notre-Dame in Paris or other folios of the *Bible moralisée*; [see the relevant plate in Sauerländer, *Gotische Skulptur*, and folios in Vienna, ÖNB, MS 1179]. For another example of reversal of field as a visual strategy in this manuscript, see Lowden, *Bibles Moralisées*, 2:151 and figs. 69 and 70, where, in my view, the reversal of field in relation to the the biblical scene underscores the powerful shift to the crucifix and enables a nonliteral reading.

151. Beside the fifth roundel: "Raab apposuit in sua fenestra filum coccineum et exploratores ill[u]d signum cognoveru[n]." Beside the sixth, moralizing roundel: "Raab que fecit suu[m] sig[num] apparere s[ignificat] sanctam eccl[es]iam que facit apparere suum signum s[ciulicet] iesum [christu]m. et beatus petru[s] [et] paulus ea[m] precepto d[o]m[in]i salvaveru[n]t."

152. Josh. 2:15–21.

153. Josh. 6:19, 24.

154. Beside the seventh roundel: "Precepit iosue ma[n]dato d[o]m[in]i o[mn]ia q[ue] erant i[n] villa anatha hem. [et]

precipit q[uo]d offerent aurum d[o]m[in]o." Beside the eighth: "Illi qui obtulerunt aurum d[o]m[in]o s[ignificant] bonos reges qui offerunt cor suum domino [et] de suo contextu eccl[es]ie s[an]c[t]e dant tributum."

155. Many other pages display a similar thematic coherence; see Lowden, *Bibles Moralisées*, 2:65, and note 150 above. This is already the case for certain folios of Vienna, ÖNB, MS 2554, where the roundels often constitute a narrative unit; see, for example, Haussherr, *Bible Moralisée*, pls. 4 (Adam and Eve), 5 (Cain and Abel), 6 (Noah and the Flood), and 8 (Abraham and Lot).

156. Vienna, ÖNB, MS 1179, fol. 63v; cf. also fols. 69v and 82r.

157. John of Garland, *Parisiana Poetria*, 128–29.

158. Grodecki, "Les vitraux allégoriques de Saint-Denis," and K. Hoffmann, "Sugers 'Anagogisches Fenster' in Saint-Denis."

159. See, for example, the series of conundrums he presents Jean de Joinville in *Vie de Saint Louis*, chaps. 26–32.

Chapter 1

1. The standard surveys remain Leroquais, *Les psautiers*, 1:li–lix and passim, and G. Haseloff, *Psalterillustration*.

2. The folios are numbered in the upper right corner of each recto in a nineteenth-century hand. For a detailed description of contents, including the modern additions, see Appendix 1.1–2.

3. For the complete collation, see Appendix 1.3. The collation of the prefatory miniatures was first published by Branner, *Manuscript Painting in Paris*, 134, 176–77.

4. Regular gatherings of eight or twelve leaves are most common in Parisian manuscripts at this time.

5. For the normal formulation of gatherings, see Gilissen, *Prolégomènes*, 26–35. The bifolios of the second and fourth gatherings are intact, and although the tight binding makes it impossible to determine whether the same is true of gathering 1, an examination of the parchment shows that the patterns of follicles and of markings made during the scraping and polishing of the parchment continue across the bifolios. See especially the continuing parallel lines on folios 4v and 7r and the scraping along the tops of 7r and 10v; in contrast, the hair pattern toward the right of folio 14v reappears on folio 13r but not on folio 7r. In addition to confirming the originality of the present conjunction of folios, these relations indicate that the second binion was folded and placed inside the first one rather than that the two sheets were folded together; that is, they too were treated as an in-quarto unit of four folios. For the systems of folding, see Gilissen, *Prolégomènes*, 26–28, figs. 4 and 5.

6. Twelve-folio gatherings are also standard for the text of the Cambridge Psalter. But because of alterations and pos-

sible losses, the structure of its prefatory gatherings is not preserved; see Cockerell, *Psalter and Hours,* 10.

7. The first text gathering (xv) has fourteen folios, the usual twelve plus an outer bifolio (fols. 85/98) of heavier parchment with the full-page Beatus initial (fol. 85v). Gathering xx, which has fifteen folios, is the only one in which folios have been removed and thinner ones added. The last gathering (xxix) has only three folios, but its text is complete. The implications of each case are discussed on pages 50–54 below.

8. See, for example, the heavier parchment of gathering iii or the extra bifolio 85/98, with the Beatus illumination, or the thinner parchment of the gathering with the liturgical calendar or of the inserted folios with text corrections, discussed on pages 41–42, 50–54, and 77–78 above.

9. The pages are lined in plummet, probably lead point.

10. For another exception, see Lowden, *Bibles Moralisées,* 1:24.

11. For example, folio 19r is ruled for five lines, although the legend requires only three.

12. As expected, there are frequent inconsistencies, such as double-spacing (fol. 71r) or lines that are askew (fol. 39r).

13. On this phrase, see page 42 above.

14. Cf. Gilissen, *Prolégomènes,* 125 and passim, and Bozzolo et al., "L'artisan médiéval et la page."

15. For a contemporary elevation that takes account of the relation between vertical shafts and a wall in between, see Hahnloser, *Villard de Honnecourt,* 250–52, pl. 62.

16. On the first full page of text (fol. 86r) the first line of each psalm verse is indented to make room for the initial, but this practice is dropped on the following pages, where the shaft of space at the left is often used to center the verse initials on their respective lines.

17. A ratio of about .7, width to height.

18. Although the scribal practice goes back to the twelfth century, what is unusual is the layout. The space between two lines of script is divided approximately into eighths: the descenders generally occupy the lowest eighth, to the baseline; the script falls principally between the second and fourth, the upper edges coming just above midline; the ascenders are in the fifth and sixth; and nothing inhabits the upper two-eighths.

19. There is unfortunately no general study of the history of page design in the early Gothic book. However, see Donovan, "The Mise-en-page of Early Books of Hours in England." The principal impediment to its study is the degree to which so many surviving manuscripts have been trimmed down in rebinding so that the original proportions of the page are unknown. In what follows, I have chosen for study those manuscripts in which lateral pricking lines, signatures, or catchwords are still visible. I have

also assumed that these vestiges of production mark the limits of the compositional field and have taken measurements accordingly. In the case of Parisian and northern French luxury psalters, it is sometimes reasonable to estimate one uncertain dimension if the others are definite and if other indications of conformity to current practice are present. Because of these difficulties, in addition to the question of what constitutes an adequate sampling, the following discussion should be understood as tentative and preliminary.

20. The basic patterns of page layout may be seen in the diagrams in Gilissen, *Prolégomènes,* 137 and passim. This important book is concerned with internal measurement and formulas of construction, not the history of medieval page design, a subject that requires a study of its own. Metrology but also aesthetic and economic considerations need to be taken into account and seen against the larger changes in medieval art. The placement of the text column and miniature decisively toward the binding goes back at least to the tenth century and is particularly important in formulating double-page layouts; the latter is discussed briefly in Calkins, *Illuminated Books,* 77, 90, 147, and passim, though not as the product of page design.

21. Most prominent among the larger manuscripts is the Ingeborg Psalter (30.7 × 20.0 cm), which, although it may have been created in northern France, represents a decorative conception related to later Parisian psalters, including the Psalter of Blanche of Castile, Bibl. de l'Arsenal, MS 1186 (28.4 × 19.8, cut down); Paris, Bibl. Nat., MS n.a.l. 1392 (29.8 × 20.0); and Rouen, Bibl. Mun. 3016 (31.8 × 20.6); see also London, Brit. Libr. Addit. 47674 (28 × 20, cut down). The most important smaller-scale psalters are Albenga, Bibl. Capitolare, MS A.4 (21.7 × 14.6, cut down); the Christina Psalter, Copenhagen, Kgl. Bibl. 1606, 4° (19.7 × 14.5); Leningrad, Publ. Bibl. Lat. Q. v. i, 67 (21.3 × 15.3); the Psalter of Jeanne de Navarre, Manchester, John Rylands 22 (25.8 × 16.6); Paris, Bibl. Ste. Geneviève, MS 1273 (20.5 × 14.2); Paris, Bibl. Nat., MSS lat. 1075 (20.5 × 14.5, cut down), 10434 (21.5 × 15.3, slightly cut down), and 16311 (19.8 × 13.7, cut down). A somewhat later group of the same format includes Malibu, J. Paul Getty Museum, MS Ludwig VIII, 4 (19.4 × 13.3, cut down); London, Brit. Libr. Addit. 17868 (21.3 × 14.4); and New York, Pierpont Morgan Library M.101 (21.7 × 14.3, cut down). For Bib. Nat. 16311, see Leroquais, *Les psautiers,* 2:26–27; for the other manuscripts, see Branner, *Manuscript Painting in Paris,* with bibliography. The Leningrad manuscript is reproduced in Mokretsova and Romanova, *Les manuscrits enluminés français du XIIIe siècle,* 112–43.

22. In general, the proportion of the page changes to 2:3, but that of the text column remains 3:4. The problem is particularly clear in the Christina Psalter and related manuscripts (see Haussherr, "Ein Pariser martyrologischer Kalender"), where the ratio of the width to the height of the page tends to be about .72, whereas the same ratio for the text column averages about .6. In psalters from the middle or third quarter of the century—such as London, Brit. Libr. Yates Thompson 18; New York, Pierpont Morgan Library M.101, or Malibu, J. Paul Getty Museum, MS Ludwig VIII, 4—both ratios approximate .65. Similar relations obtain between the margins and the text column/miniature. For example, in the Christina Psalter group the ratio of the width of the right margin to the width of the text column is about .6, whereas that of the height of the lower margin to the height of the text column is about .45. In the later group they both approximate about .25–.3. It is typical that both sets of ratios are comparable in the Ingeborg Psalter: the page and text-column ratios are .65 and .6, and those of the right and lower margins to the text, .55 and .54; that is, the proportions of the page are similar to the proportions of the text column/miniature, and those of the margins to the text approximate those of the text. For observations on the large margins in Bibles at this time, see Petitmengin, "La Bible de Saint Louis," 84–89, esp. 87.

23. An attempt to regularize the horizontal elements and to maintain strict left and right margins is already seen in the Ingeborg Psalter (Chantilly, Musée Condé, MS 1695). For these and other characteristics, the most precocious manuscripts are the Christina Psalter and related works. Cf. also Copenhagen, Kgl. Bibl., MS 108, 8°, and Paris, Bibl. Nat., MS lat. 16311, both from the second quarter of the century; Branner, *Manuscript Painting in Paris.* To my knowledge, the earliest Parisian psalters with true bar line-endings are Paris, Bibl. Nat., MS n.a.l. 1392, and Albenga, Bibl. Capitolare, MS A.4, both of ca. 1220.

24. For Paris, Bibl. Nat., MS lat. 10434, see page 14 above. The system of rulings and proportions is similar, but the measurements are not. The differences are approximately .5 cm in width and 2 cm in height for both the full-page miniatures and the text column; in the latter, the number of lines and other details also differ. For the similarities in the frames of the prefatory miniatures; see fig. 79 and page 149 above.

25. See especially the manuscripts cited in note 21 above, in which each lower margin remains about a third of the height of the page but the outer margin becomes about one-quarter of its width, even though the relation of the format of the miniature to that of the page remains unchanged. The shift toward a central position may be linked to the appearance of even smaller psalters, now about 15 × 10 cm, a format that grows increasingly common in northeast France and Flanders, e.g., Warsaw, Bibl. Narodowa 8003, and Oxford, Bodleian Libr., MSS Douce 48 and 50. Because of sometimes severe trimming, the chronological and geographical connections are difficult to establish. Branner, *Manuscript Painting in Paris,* 206, attributes Brit. Libr. Egerton 2652 to Paris, which would make it the only pre-1235/50 psalter of this small format in his catalogue.

26. See especially the Ingeborg Psalter (the proportions of the page, text column, and lower margin to column height are .65, .6, and .54, respectively) and Yates Thompson 18 (.66, .6, and .5); for the Psalter of Saint Louis the ratios are .65, .68, and .49. In earlier manuscripts where the column and page proportions do not correspond, the ratio of the lower margin to the text column nonetheless holds: see Bibl. Nat., MS n.a.l. 1392 (.52); Leningrad, Publ. Bibl. Lat. Q. v. i, 67 (.55); Manchester, John Rylands 22 (.55, est.).

27. In the Psalter of Saint Louis the ratio between the width of the lateral margin and the height of the lower one is .58; the comparable ratios for the page and the text column are .65 and .68, respectively. An analogous correspondence appears in two of the most luxurious earlier psalters, those of Ingeborg (.66, .62, and .65, respectively) and of Jeanne de Navarre (.60, .60, and .64, respectively).

28. For the Ingeborg Psalter, then in the royal collection, see note 21 above and notes 90–92 to the Introduction.

29. Among Carolingian manuscripts, see, for example, the page layout for the slightly larger Psalter of Charles the Bald, Paris, Bibl. Nat., MS lat. 1152, in Köhler and Mütherich, *Die karolingischen Miniaturen,* 5:133. In terms of elegance of page design, especially in ample borders and ruling of the text column, Ottonian manuscripts provide striking parallels; see, for example, the reproductions in *Das kostbare Evangeliar des heiligen Bernward.* Although its format is very different, the Ottonian Gospel Book, Paris, Bibl. Nat., MS lat. 8851, was almost certainly in the Sainte-Chapelle during these years, judging from the heraldic motifs painted on the parchment edges; see *Les fastes du gothique,* 252–54. For the stylistic relation of the manuscript's thirteenth-century cover to the Psalter miniatures, see Appendix VI.

30. See, for example, the discussion of Saint-Martin-aux-Bois in contrast to that of the Virgin Chapel at Saint-Germer-de-Fly in both Kimpel and Suckale, *Gotische Architektur,* 428–34, and Bony, *French Gothic Architecture,* 427–31.

31. Branner, *Manuscript Painting in Paris,* 13.

32. E.g., Beer, "Pariser Buchmalerei," 80.

33. This is generally the case in Parisian illumination at this

time; see Branner, *Manuscript Painting in Paris,* 13.

34. For a detailed discussion of materials and techniques, see the fine survey in Alexander, *Medieval Illuminators,* esp. chap. 2. See also Branner, *Manuscript Painting in Paris,* 34; Calkins, "Stages of Execution"; and van Buren, in *The Turin-Milan Hours,* 2:275. For techniques of modeling, see Morgan, "Aspects of Colour," and Hills, *Light of Early Italian Painting,* 19–25. Related issues of programs, models, and optics are taken up in Chapters 3 and 5.

35. Oxford, Bodleian Libr., MS Douce 180. James, *Apocalypse in Latin and French;* Klein, *Endzeiterwartung;* Morgan, *Early Gothic Manuscripts,* 2:141–45; Alexander, *Medieval Illuminators,* 40–42.

36. For the gathering structure, see Klein, *Endzeiterwartung,* 320–21.

37. E.g., the angel's wings in fol. 44v.

38. E.g., fols. 44r–v. Folio 54r has sections that are entirely finished and others that are blank.

39. It is possible that several folios were bundled together and pricked in groups, a practice Lowden, *Bibles Moralisées,* 1:66, finds in some of the *Bibles moralisées,* though it is less likely in the Psalter, given the errors (see the following paragraph in the text) and the variation in placement.

40. The first, or single-hole, type of pricking is found in folios 1–4, 7, 10, 13, and 14 of gathering I; all of III; folios 31, 32, 34–39 of gathering IV; and all of VI, VII, VIII, XI, XII, and XIII. The remainder use the second, or three-hole, pattern. The latter has the advantage of providing a setting for the inner edge of the frame.

41. Another revealing error occurs in the first gathering. All folios pricked with a three-hole pattern (5, 6, 8, 9, 11, and 12) have a single hole 12.6 cm from the top of the miniature. As in the example above, these were pricked one way and then turned upside down and pricked again. In this case, however, a different frame, that with a one-hole pattern, was used.

42. Pouncing or some similar technique may have been used. One contemporary pattern sheet seems to have survived in Paris, Bibl. Ste. Geneviève, MS 1624, fol. 1r; see Alexander, *Medieval Illuminators,* 46, fig. 67, with bibliography.

43. Pattern A is used for folios 1v–4r, 7v, 10r, 13v, and 14r of gathering I; pattern B, for the remainder of I, all of II, folios 29v, 30r, 33v, 40r–42r of IV, and all of V; pattern C, for III, the remainder of IV, VI⁸VIII, and XIII; and pattern D, for IX⁸XII.

44. Patterns A and C are found only with the one-hole punch, and B, only with the three-hole punch. Only the D pattern occurs with both. See Appendix VII.

45. Four different tracery patterns are found on folios 1v–4r, and a fifth is used for the rest of gathering I; all the other

gatherings use a sixth pattern, in which the principal variations are in drawing rather than design.

46. Paris, Bibl. Nat., MS fr. 25425; see *L'art au temps des rois maudits,* no. 231 (by François Avril).

47. White bole is the most common in Parisian thirteenth-century painting, although red bole is used in the early Vienna *Bibles moralisées* (Haussherr, *Bible Moralisée*) and dark colors appear in several of the most important manuscripts, such as the Sainte-Chapelle Evangeliary, Paris, Bibl. Nat., MS lat. 17326, as well as in some twelfth-century English works, such as the Bury Bible (cf. Roosen-Runge, *Farbgebung und Technik,* 1:103–4). I am unaware of green bole in any other French manuscript. Nor do I know of any systematic study of various boles in illumination or of their visual implications. For a recent and perceptive overview written from a practitioner's point of view, see Whitley, *The Gilded Page,* esp. 62–67.

48. Exceptions are found in gatherings III and XIII, where the gables are painted, probably because they are crocketed.

49. Fol. 35v. This is also the case for the gold objects in the tabernacle (fol. 36r), the gold boards of its interior (fols. 36r, 64r, 66r, 67v, 69v, 78r), some shields (fols. 43v, 45v, 48r), the objects stolen by Achan (fol. 44r), and pagan statues (fols. 50r, 70r).

50. Silver is also used to represent silver objects, although it appears much less often. Silver leaf is used for the floor tiles of the tabernacle (fol. 36r) and the epaulettes of the Philistines (fols. 59v–61v). It occurs only once in the architectural decoration, within the large arches of folio 5v. It was evidently intended to contrast with the golden arches on the facing page, an idea abandoned in the following pages. The silver has tarnished in most places.

51. It is likely to be white lead but might possibly be chalk. This layer is most clearly visible in several unfinished details, probably oversights, such as the feet of some figures in folios 75v and 76r, the base of the colonnette in folio 74r, and the base of the tabernacle in folio 78r.

52. It has not been possible to examine the surface microscopically or to analyze the chemical composition of the pigments used by the artists. The painting technique of the unfinished line-endings in the Cambridge manuscript is discussed in Cockerell, *Psalter and Hours,* 24.

53. Two different blue pigments may have been used, for crystals are visible on the parchment surface only in these first folios, where the effect is the richest.

54. The technique is anticipated in French painting of the second quarter of the century, as in the Morgan Picture Book (*Old Testament Miniatures*), where shadows are often modeled across a rounded surface in addition to falling in

deep recesses or grooves; see Morgan, "Aspects of Colour," 112.

55. E.g., fols. 1v, 4r, 7v, 19v.

56. Cockerell, *Psalter and Hours,* 29.

57. For other figures in white, see fols. 7v, 13v, and 14r; in light blue, see the shepherd in fol. 16r. The modeling in the latter is closer to that of Rebecca and Eliezer, described here, than to Reuben.

58. A brown tint is sometimes used for shadows both here and in other miniatures of this section, such as the the mantle of the shepherd on folio 16r; in other cases, such as folios 22r and 35v, the gray is painted more evenly and flatly.

59. The color is used in the Ingeborg Psalter (Chantilly, Musée Condé, MS 1695). Along with blue and gold, it is one of the colors used as a background in the ordinary psalm initials.

60. The pigment is probably a cinnabar; cf. Roosen-Runge, *Farbgebung und Technik,* 2:20–22, especially M 23.

61. The overlay appears to be less dilute. This technique differs from that of most contemporary tinted drawings, where color overlays are used to build contrast; for example, cf. Morgan, *Early Gothic Manuscripts,* 2:33, and *Die Zeit der Staufer,* no. 745.

62. For the gray-blues, see fols. 73v–74r; for the other colors, esp. fols. 75v and 77v. In the former the white is entirely the color of the parchment. Elsewhere both sources of white are found. A striking example is the left scene of folio 72r, where the white of Samuel's blue mantle is pigment, but that of the elder he faces is the white of the parchment.

63. See especially fol. 77v, where the white is a delicate highlight over two tones of gray, orange, or pink.

64. The dark heavy bole in gathering III is like that used throughout the Isabella Psalter (Cambridge, Fitzwilliam Museum, MS 300).

65. Flaking, such as that in the area to the upper right of Moses' head on folio 30r, clearly shows the green coloration of the bole.

66. A comparable technique is found in several earlier manuscripts, such as the Ingeborg Psalter (Chantilly, Musée Condé, MS 1695) and Rouen, Bibl. Mun. MS 3016 (Leber, *Collection des meilleurs dissertations,* vol. 2, no. 6).

67. Among others, see Beer, "Marginalien zum Thema Goldgrund," and BiaBostocki, "Ars auro prior," in *The Message of Images,* 9–13.

68. Metropolitan Museum of Art, Cloisters Collection, 54.1; see also Boehm, *The Hours of Jeanne d'Évreux.* A parallel situation develops in English painting, especially in the Apocalypse manuscripts of the 1260s and 1270s, where the earlier

practice of painting with colored tints, by which the parchment is left unpainted and stands for highlights, is sometimes combined with a delicate tonal modeling over large folds or with a fuller painting technique involving a colored ground and laying-in color. In such manuscripts as the Gulbenkian Apocalypse (Lisbon, Calouste Gulbenkian Museum, MS L.A.139), the two approaches are sometimes used in the same miniature, as they are in the Louis Psalter. Although the Gulbenkian artists are less concerned with the overall balance of color tones in the miniature, they are unusually innovative in the way they make more general areas of dark tones function as shadow on figures.

69. For the considerable literature on the development of grisaille and its interpretation, see Krieger, *Grisaille als Metapher,* and idem, "Die niederländische Grisaillemalerei des 15. Jahrhunderts." One of the most revolutionary aspects of Pucelle's use of grisaille is technical: his modeling from light to dark rather than the contrary. For the two approaches to modeling, the most eloquent statement remains E. H. Gombrich, "Light, Form, and Texture in Fifteenth-Century Painting North and South of the Alps." Although what Gombrich, following Leonardo, describes as *lustro* applies, in this case, both to the surface of the page and to the surface of forms. On a related point, see Marrow, "Symbol and Meaning," esp. 158–60.

70. It is unclear when the Psalter came into Jeanne d'Évreux's collection. Before it did so, it was presumably in the royal collection, and so Pucelle might have had access to the Psalter in either event.

71. The fifth gathering is the only other regular gathering to vary border design within its four folios: gilded and painted motifs face each other on folios 43v–44r but alternate with each other on folios 45v–46r.

72. Forty-four folios in pattern A and thirty-four in pattern B.

73. A "production," or "working," group could naturally consist of several people working at different locations but sharing materials and methods.

74. For the implications of beginning with some other variable, such as architectural patterns rather than pricking patterns, see pages 69–70 above.

75. In folios 1v–4r the architectural structure has undulating roofing, painted buttresses, and white gables, and the gold in the borders is restricted largely to the backgrounds of the floral motifs. In folios 7v, 10r, 13v, and 14r, the roofing is gold and shingled; the buttresses and gables are gilded; gold, rather than salmon or pink, alternates with blue in the borders; and the principal "light" color is a dark red used in all parts of these miniatures, a color not found at all in the first four miniatures.

76. Branner, *Manuscript Painting in Paris,* 134, proposes that

these gatherings originally consisted of five bifolios, as gathering II still does, and that two bifolios were added, presumably folios 8/9 and 11/12 and folios 31/32 and 38/39. Diagram 5 suggests that gathering I might better be described as a regular quire of eight leaves augmented by three bifolios and gathering IV as one of six leaves augmented by four bifolios.

77. Folio 38r illustrates the story of Balaam and Barak (Num. 23:4–12 and 24:1–2), and folio 39v, the story of Balaam and the Ass (Num. 22:28–31).

78. The painter of this bifolio had likely just joined the group.

79. Maekawa, *Narrative and Experience*, 43 n. 67, argues that these folios were added after the iconographic program had been determined, because they involve long trips and thus relate thematically to Louis IX's role as a crusading king. For a further discussion of this issue, see the Conclusion above.

80. The architectural and pricking patterns are standardized from the outset; the architectural and decorative motifs, by gathering II; and the gathering structure, by gatherings III and V.

81. The folios with legends are all reproduced in *Le Psautier de Saint Louis.*

82. For the texts of the legends and their translation, see Appendix II. At this time the French word "page" could apparently refer to a large or full-page painting; see Martin, "Les esquisses des miniatures," esp. 20–21. The term does not appear in earlier French legends; the most common introductory formulas are *Si come . . .* (Ingeborg Psalter) and *Ici est comme . . .* (John Rylands French 5). These legends could never be confused with instructions to the illuminator, which, even apart from their different content, are normally written in a small and highly abbreviated script intended to be scraped away and which usually begin with *fais* or some similar term rather than with the formulae above. On instructions to illuminators, see Alexander, *Medieval Illuminators,* chap. 3 and passim, with earlier bibliography.

83. See R. W. Gaston, "Studies in Early Christian 'Tituli,'" and Arnulf, *Versus ad Picturas.* Among several specialized studies addressing the relation between *tituli* and images both in books and wall painting, see Brenk, "Le texte et l'image"; Kessler, "Pictorial Narrative"; and idem, "Diction in the 'Bibles of the Illiterate.'" In books the issue is complex because chapter titles and rubrics can sometimes serve as explanations, which is probably the case, for example, in the late-eleventh-century life of Saint Cuthbert in Oxford, University College, MS 165; see Baker, "Medieval Illustrations of Bede's Life of Cuthbert." For rubrics, see, for example, Huot, "The Scribe as Editor."

Conversely, the rubrics can serve as guides to the illuminator, especially in later romances and histories; see Stones, "Indications écrites et modèles picturaux," and Hedeman, *Royal Image,* 37–41.

84. I know of no general study devoted to these texts in Gothic picture cycles. Although the legends in many twelfth-century manuscripts are little more than titles, as in the Winchester and Ingeborg Psalters (see Wormald, *Winchester Psalter,* and Deuchler, *Ingeborgpsalter*), others can sometimes be complex and explanatory; see, for example, Berlin, Kupferstichkabinett MS 78 A 6 (Klemm, *Ein romanischer Miniaturzyklus*); Amiens, Bibl. Mun., MS 106 (Bucher, *Pamplona Bibles*); The Hague, Rijsbibl., MS 76.F.5 (Cahn, *Romanesque Manuscripts,* 165–67, no. 138); or the French octosyllabic couplets in the Life of Saint Albans (Morgan, *Early Gothic Manuscripts,* 1:130–33, no. 85).

85. See, for example, the Anglo-Norman legends in the Winchester Psalter (Wormald, *Winchester Psalter*) or the German legends in the early-thirteenth-century *Cursus Sanctae Mariae* (Harrsen, *Cursus Sanctae Mariae,* 37–42).

86. One of the most complex arrangements of legend and picture is that of Malibu, J. Paul Getty Museum, MS Ludwig VIII, 4, where Roman numerals are required to order legends relating to the eight roundels of each miniature (Plotzek and von Euw, *Handschriften der Sammlungen Ludwig,* 1:322–29, with transcriptions). Marginal texts also surround the prefatory miniatures of the Psalter of Jeanne de Navarre (Manchester, John Rylands 22), although these are not legends but, exceptionally, biblical excerpts; they are printed in James, *Descriptive Catalogue,* 65–71.

87. This is especially the case in the longer pictorial cycles, such as Manchester, John Rylands French 5 (transcribed in Fawtier, *Bible historiée,* 3–6); the so-called de Brailes "Picture Bible," divided between the Wildenstein Collection and Walters Art Gallery, MS 106 (Morgan, *Early Gothic Manuscripts,* 1:117, no. 71); the Life of Edward, Cambridge University Library MS Ee.3.59 (Morgan, *Early Gothic Manuscripts,* 2:94–98, no. 123); and, to a lesser extent, Malibu, J. Paul Getty Museum, MS Ludwig VIII, 4 (see the previous note).

88. A similar function can be observed in some shorter texts of slightly earlier date, such as the "captions" in London, Brit. Libr. Addit. 49999, for which, see Donovan, *The de Brailes Hours,* 38, or the "descriptions" accompanying the psalms in the Toledo copy of the *Bible moralisée,* discussed in Affilé, *Psalms in the Thirteenth-Century Bible Moralisée,* 27–29. Lengthy legends like those in the Psalter of Saint Louis are more common in later manuscripts, such as the Queen Mary Psalter (Warner, *Queen Mary's Psalter,* and

Sandler, *Gothic Manuscripts*, 2:64–66, no. 56), the Holkham Bible Picture Book (Sandler, *Gothic Manuscripts*, 2:105–7, no. 97), and the Rovigo Bible (Folena and Mellini, *Bibbia istoriata Padovana*).

89. For example, fols. 39 and 63. One would not expect the text of the legends to leave an impression on the miniatures.

90. One scribe was responsible for gatherings I, II (fols. 15–20 only), III, IV (fols. 35–38 only), V, VIII, X, and XII; the other, for the remainder of the legends.

91. The spacing between phrases or the slight shift in the angle of the pen between them suggests the kind of regular breaks where pauses in dictation would haved occurred. See, for example, fols. 13r, 53r, 60v. The former is typical ("//" indicates a larger-than-normal space between words): "En ceste page est comment iacob voit .i. eschiele // des le ciel a la terre // et les angles // qui mo[n]toient // et dessendoient et // coument iacob // oint la pierre // d'uile." Above "eschiele" the scribe added "e[n] dorma[n]t."

92. The protagonist is omitted and later inserted on folios 22v, 37r, 47r. The fourth (fol. 13r) adds the essential observation that Jacob is sleeping when he sees the ladder ascending to heaven, and the fifth (fol. 58v), that the firebrands Samson attaches to the foxes' tails are aflame. The sixth addition is the word "joie" on folio 74v. The only real error is in the prefatory formula of the first folio, where "est" is unnecessarily repeated.

93. E.g., fols. 32v, 34v, 35r, 38v.

94. For a discussion of this miniature, see pages 76 and 93–94 above.

95. Similar conclusions were reached by Fawtier, *Bible historiée*, 6–7, for the earlier of the two hands that wrote legends in the John Rylands French 5, and by Hassal, *Holkham Bible Picture Book*, 17–19. See also Hull, "Rylands MS French 5," 4–5, 12–13, 18–19, who also argues that the legends were written from the pictures. That the scribes in the longer Louis Psalter gatherings worked on runs of miniatures suggests that these gatherings were already collated; see note 90 above.

96. For similar Parisian calendars, see especially Bibl. Nat., MSS lat. 830 and 9441; cf. Leroquais, *Les sacramentaires*, 2:114, 137. All the folios of the Psalter calendar are reproduced in color in *Le psautier de Saint Louis*.

97. For the breviary, see Schutzner, *Medieval and Renaissance Manuscript Books*, 1:106–12. I am grateful to Rebecca Baltzer for calling this manusript to my attention and for sharing her notes on it.

98. Branner, "Two Parisian *Capella* Books in Bari," and idem, "Painted Medallions," 13 n. 41.

99. *Acta Sanctorum*, ed. Bollandus and Henschenius, 6:682–84; "Translatio S. Honorinae virginis et martyris et ejusdem miracula"; *RHF*, 9:153; and Perdrizet, *Le calendrier parisien*, 103.

100. Honorine appears in the litany of Paris, Bibl. Nat., MS n.a.l. 1392, a Parisian psalter ca. 1225, and the northern, probably Noyon-diocese calendar of the Ingeborg Psalter, but I know of it in no Paris calendar before these royal psalters. In later Parisian manuscripts her feast is commemorated, for example, in the calendars of Bibl. Nat., MSS lat. 1107, 12834, and 824. See Leroquais, *Les sacramentaires*, 1:cxii, and idem, *Les psautiers*, 1:139 and 2:138. Her name also appears in the litany of the Cambridge Psalter; see Cockerell, *Psalter and Hours*, 21.

101. Paris, Bibl. Nat., MS lat. 1023, fol. iv, has "nih[il] in k[a]l[endari]o parisien[ensis]." The saint does not appear in the breviary's sanctorale; [see the relevant page in Leroquais, *Les sacramentaires*]. The identical inscription appears in the related breviary in New York, Pierpont Morgan Library, M.1042 f 2; cf. Delisle, *Recherches*, 1:410.

102. The date is given as September 24 in the journal of Eude Rigaud and as September 29 in the chronicle of the Abbey of Bec. See Rigaud, *Journal des visites pastorales*, 95; *RHF*, 21:575 and 23:454.

103. Cf. Lebeuf, *Histoire de la ville et de tout le diocèse de Paris*, 2:88 and 92–93 n. 1.

104. Fols. 110v, 126v, and Cockerell, *Psalter and Hours*, figs. 31, 32. Also characteristic of the two psalter calendars is the entry for Saint Jerome on October 5 instead of September 30, when the feast of the relics of the Sainte-Chapelle is observed. In the first years after the founding of the Sainte-Chapelle, the feast day of Saint Jerome apparently varied; in the sanctorale of the Sainte-Chapelle Evangeliary, Bibl. Nat., MS lat. 9455, the reading for him falls between that of Saints Rémi (October 1) and Francis (October 3).

105. Delisle, *Notice de douze livres*, 38 n. 1. For Charles V and Charlemagne, see Avril and Lafaurie, *La librairie de Charles V*, no. 93 (by François Avril), and *Les fastes du gothique*, nos. 202, 212 (by Danielle Gaborit-Chopin). Although canonized in the twelfth century, Charlemagne does not appear in French calendars until the promotion of his cult in the fourteenth century; see Perdrizet, *Le calendrier parisien*, 84–85.

106. Cockerell, *Psalter and Hours*, 12. Variants in spelling are noted in Appendix III. Comparable variants found in contemporary manuscripts suggest the differences are not misspellings in the modern sense. The independence of the two calendars is also suggested by an error in the entry for Saint Godograndi, which should be listed on September 3 but appears in the Cambridge manuscript on both

September 3 and 7 and in the Louis Psalter on September 7 only.

107. Haussherr, "Ein Pariser martyrologischer Kalender." The same arrangement is found in the breviary in the Library of Congress.

108. Color is not used as consistently as it is in graded calendars in which ordinary feasts are in black, more important ones in blue or green, and major observances in gold. The earliest calendar in which I have found the curious approach of the Saint Louis Psalter is that of the early-thirteenth-century Parisian Pontifical in Montpellier, Bibl. de l'École du Medicine, MS H.399, where blue is reserved for major feasts and astrological notes, and red for lessons and grading.

109. It recurs from time to time in contemporary Parisian calendars, for example, that of the Saint-Denis Missal, Paris, Bibl. Nat., MS lat. 1107.

110. Compare the spacing of the entries on October 1, 7, 16, and November 8 to those of the Cambridge Psalter, where the observances are not omitted.

111. For the arms of Provence, see note 156 and pages 45, 46, and 49 above.

112. For a discussion of these initials, see Chapter 5.

113. Even though the red is in fact the same salmon color used in the miniatures, the backgrounds are here described as "red" or "blue" in order to parallel "gueules" and "azur."

114. Fols. 87r, 87v, 90r, 123v, 126r, 127r, 127v, 128v, 130v, 131v, 132r, 133v, 134r, 134v; see fol. 127r in this book's Psalter reproductions.

115. Fols. 86v, 87v, 88r, 88v, 92v, 123r, 124r, 125r, 126v, 127r, 129r, 131v, 133r, 134r, 134v; in this book's Psalter reproductions, see fols. 126v, 127r.

116. Fols. 86v, 87r, 87v, 88v, 89r, 90v, 92r, 93r, 94r, 96r, 98r, 98v.

117. Fols. 123v, 124v, 125v, 126v, 127r, 128r, 130r, 131r, 132r, 133r, 133v; folios 126v and 127r are reproduced in this book.

118. Fols. 89r, 91v, 93v, 94r, 94v; the checkered rectangle occurs alone and within a lozenge, on red and blue, on folio 90r and once within a series of fleurs-de-lis (fol. 93v).

119. Fols. 86v, 92r, 92v, 97r, 101r.

120. Fols. 126v, 133r, 133v; folio 126v is reproduced in this book.

121. Fols. 90r, 93r.

122. Fol. 98v.

123. The three appear together, sharing a line-ending or alternating with each other, on folios 109r, 120v, 143r, 164r, 214v, 218r, 218v, 220r, 233v, 236r. The fleurs-de-lis and castles appear throughout the manuscript, and fleurs-de-lis and pales, while less frequent, occur together on numerous pages, both alternating and sharing line-endings. More unusual is the combination of castles and pales; they occur in an alternating arrangement only once, on

folio 90r, and oppose each other on folios 129r, 187v, 188r, 193v, 197v, and 230r. These are also the motifs that appear in many of the line-endings of the Cambridge manuscript; see Cockerell, *Psalter and Hours,* 24–25.

124. Cf. gatherings 18 I v.

125. This broader range of motifs in gatherings xv and xviii seems to have been another idea tried out only briefly and soon abandoned. Nothing in the content of these gatherings suggests this special vocabulary in the line-endings.

126. Arbois de Jubainville, "Les armoires des comtes de Champagne d'après leurs sceaux"; London, "Glover's and Walford's Roll," 164–65; Pinoteau and Le Gallo, *L'héraldique de Saint Louis,* 18–20; Pinoteau, "La date de la cassette," 100.

127. The reverse is not the case, suggesting the reference is to Champagne and to Champagne-Navarre, never to Navarre alone. In fact, the royal family's relation to Navarre was only through Thibaut, whose father became king of Navarre at the death of his mother, Blanche of Navarre. In contrast, there were many connections to Champagne, most importantly through Adéle of Champagne, Philip Augustus's mother. The arms of Champagne occur alone but with castles only once (fol. 132r) and with pales once (fol. 128r). Büttner, "Bilderzyklen," 138–39, however emphasizes the possible Spanish connection.

128. Branner, *Manuscript Painting in Paris,* 133.

129. Jean de Joinville, *Vie de Saint Louis,* chap. vi. 37; Carolus-Barré, "Saint Louis et la translation," esp. 1102, which describes Louis and Thibaut walking together in procession, carrying on their shoulders the reliquary shrine of Saint Maurice and his companions (Senlis, 1262); and J. Richard, *Saint Louis,* 424–25, for the dedication of new buildings of the Hôtel Dieu at Compiègne.

130. Eagles share line-endings with fleurs-de-lis (fol. 130v) and castles (fols. 130v, 133v) but alternate with pales (fols. 126r, 134v).

131. Douët d'Arcq, *Sceaux,* no. 275 (1288); Adam-Even and Jéquier, "Un armorial français du xiiie siècle," *Archives héraldiques suisses* 65, nos. 2–3 (1951): 101–10 (no. 130): *d'or à l'aigle de sable.* On Jean d'Acre and the eagle, see especially Pinoteau and Le Gallo, *L'héraldique de Saint Louis,* 30–32. In the first section of the Wijnbergen Armorial, covering vassals of the Île-de-France about 1265–70, only two individuals (nos. 37, 76) have arms using the same device.

132. The Brienne arms are *d'azur billeté d'or.* For the seal of Jean d'Acre, see Douët d'Arcq, *Sceaux,* no. 275 (with a fleur-de-lis above, an eagle to the right, and a castle to the left); for his brother, Alphonse de Brienne or d'Eu, see ibid., no. 922 (with a border of sixteen castles).

133. About 1190 Gauthier of Joigny married the widow of

Andre II de Brienne, the brother of Jean d'Acre's grandfather Erard II; see Evergates, *Feudal Society in the Bailliage of Troyes*, 35, 198. For the Joigny arms, see Douët d'Arcq, *Sceaux*, nos. 518 (1214)–525 (1314), and London, "Glover's and Walford's Roll," 2:177 (Walford's Roll 44). The more general association of the eagle with Jean de Brienne has been suggested by Pinoteau and Le Gallo, *L'héraldique de Saint Louis*, 32. The eagle is the well-known device of the arms of Germany (cf. Brault, *Eight Thirteenth-Century Rolls of Arms*, nos. C 42, Cl 44, Cd 22 [Walford's], D 165 [Camden]), but it appeared on the Joigny seal the year before Frederick II married Jean de Brienne's daughter Isabelle.

134. Le Nain de Tillemont, *Vie de Saint Louis*, 2:53, 64; Evergates, *Feudal Society in the Bailliage of Troyes*, 102–3.

135. Duchesne, *Historiae Francorum Scriptores*, 5:408, cited in Le Nain de Tillemont, *Vie de Saint Louis*, 2:308; J. Richard, *Saint Louis*, 90, 254. See also Bourgeois, *Histoire des comtes de Brienne*, 30–37, 358–67; Böhm, *Johann von Brienne*; Buckley, "The Problematical Octogenarianism of John of Brienne"; Prawer, *Histoire du royaume latin de Jérusalem*, 2:170–73.

136. Griffiths, "The Counselors of Louis IX," 8–9, 24, 138; idem, "New Men Among the Lay Counselors of Saint Louis' Parlement." Le Nain de Tillemont, *Vie de Saint Louis*, 4:63–64, places the appointment of Jean d'Acre slightly later. Carolus-Barré, *Le procès*, 165, cites their names and titles on a royal diploma of 1258.

137. J. Richard, *Saint Louis*, 254, refers to the brothers as among the most influential of the king's counselors; Carolus-Barré, *Le procès*, 166, refers to Jean as one of the close counselors of the king.

138. He was also referred to as the son of the king of Jerusalem and by his title, "bouteilier de France." In 1272 he was referred to as the "buticularius regni"; see *RHF*, 20:61, and Carolus-Barré, *Le procès*, 26, 166.

139. Griffiths, "The Counselors of Louis IX," 8–9. Accounts of the king's *hôtel* are not preserved from the years in question, but in May 1239 Guillaume de Braye, *chambellan* from 1234 to 1239, witnessed the payment of twelve pounds "pro una ymagine" and other works; see *RHF*, 22:588. Payments were made for manuscripts, but the agent of record was the keeper of the seal, Jean de la Cour d'Aubergenville.

140. For Jean, see Carolus-Barré, *Le procès*, 164–68. Griffiths, "The Counselors of Louis IX," 24, aptly credits Jean d'Acre with having institutionalized the privileges of his office.

141. See also *RHF*, 21:lvi, 333, 340, 359, 377, 381; Le Nain de Tillemont, *Vie de Saint Louis*, 5:100, 108; Langlois, *Le*

règne de Philippe III le Hardi, 99–101, 289 n. 356; Campbell, "Temporal and Spiritual Regalia," esp. 357.

142. For the knights, see, for example, Douët d'Arcq, *Sceaux*, nos. 1462 (1230), 1582 (1229), 1619 (1231), 1843 (1286), 1980 (1248); for the seals of women, see nos. 523 (1295), 526 (1306), 2853 (1275), 3045 (1265), 11802 (1234). For the motif, see M. Pastoureau, *Traité d'héraldique*, 159.

143. *L'art au temps des rois maudits*, 395, no. 306 (by Denis Caillaux). Norton and Horton, "A Parisian Workshop at Canterbury." The latter see the *marguerite* as a reference to the queen and date the pavement to the last quarter of the century. See also Norton, *Carreaux de pavement du Moyen Âge et de la Renaissance*, 52–53.

144. The cinquefoil continues to be linked to the royal arms in at least one later pavement connected with the royal family, the pavement from the chateau of Marguerite de Bourgogne, wife of Charles of Anjou, Saint Louis's brother, near her maison-dieu at Tonnerre. The pavement juxtaposes the arms of France and Burgundy, the former accompanied by the cinquefoil, or *marguerite*, the latter, by the fleur-de-lis; see *Les carreaux de pavage dans la Bourgogne médiévale*, 44, with bibliography. The association of the fleur-de-lis and *quintefeuille* is also suggested by contemporary seals in which the former substitutes for the latter; see, for example, the 1275 and 1295 seals of Marie de Mercoeur, countess of Joigny (Douët d'Arcq, *Sceaux*, nos. 522, 523).

145. Saint Bonaventure, *Opera Omnia*, 9:114. The refernces are to Apoc. 22:16 and Prov. 25:12.

146. Duchesne, *Historiae Francorum Scriptores*, 5:443.

147. See the useful summary in Pastoureau, "La fleur de lys: Emblème royal, symbole marial ou thème graphique," in *L'hermine et le sinople*, 158–80, and Lombard-Jourdan, *Fleur de lis et oriflamme*, esp. 123–24.

148. The checkered rectangle (number 9) occurs both in a decorative context, with birds on panels, and alone in lozenges. The latter, particularly the one instance in which its lozenge form alternates with a fleur-de-lis, raises the possibility that it carries a specific heraldic reference. The arms of Dreux (*échiqueté d'or et d'azur*), the most likely connection, are usually quartered *d'hermine* (for Brittany) but also appear alone at this time, as in the 1268 seal of Robert IV of Dreux. Douët d'Arcq, *Sceaux*, no. 730; J. Richard, *Saint Louis*, 533. For the Dreux arms on the cassette of Saint Louis, see Pinoteau, "La date de la cassette," 101. The *échiqueté* is an old motif that appears in the arms of a number of contemporary families, including the seal of the countess of Joigny cited above, note 133. Its reference here remains unclear; see Pinoteau, "Les origines de l'héraldique capétienne," in *Vingt-cinq ans d'études dynas-*

tiques, 68, 82–84. A similar situation pertains for the most important of the other devices, the cross (number 10). For the *croix ancrée,* see, for example, Adam-Even and Jéquier, "Un armorial français du xiiie siècle," nos. 118, 126, 236. The best-known use of the *croix recercelée* was for Jean Clement, who figured importantly in arranging the king's ransom in 1254 but whose cross is *à la bande de gueules;* see Pinoteau and Le Gallo, *L'héraldique de Saint Louis,* 28–30. As in the arms of Champagne or Navarre, some variation appears in the way the cross is rendered in these line-endings, especially in the degree to which the ends are curled, or *recercelé.* Although a common charge at this time, it is perhaps worth noting that the *croix potencée* figures prominently on the cassette of Saint Louis as the Jerusalem arms of Jean de Brienne, the father of Alphonse and Jean d'Acre. The Jerusalem arms are normally given as *d'argent à la croix potencée d'or, accompagnée de croisettes du même;* in Matthew Paris (I 6, 12) they are simply *d'or, a cross argent.* See Pinoteau, "La date de la cassette," 100–101, 105–7, 113 n. 44; Tremlett, "The Matthew Paris Shields," 23, 66 (MP I 53, 101; II 1). On these variations, see Brault, "The Cross in Medieval Heraldry," and idem, *Early Blazon,* 64–65, 154.

149. A notable example is the mythic arms of Jerusalem, which vary considerably until 1275/85; cf. Tremlett, "The Matthew Paris Shields," 12.

150. Brault, *Early Blazon,* 173; Pastoureau, *Armorial des chevaliers de la Table Ronde,* esp. nos. 6, 53, 62. On the eagle, see Pastoureau, *Traité d'héraldique,* 148–50, and idem, "Quel est le roi des animaux?"

151. Although he had no rights there, he referred to himself as Jean d'Acre at least by 1269; see É. Berger, *Layettes du Trésor des chartes,* 4:402a. His father's title to Jerusalem was through his first wife, Marie de Montferrat; cf. Böhm, *Johann von Brienne,* 102–5 and passim.

152. Pastoureau, *Traité d'héraldique,* 253–55; Lillich, "Early Heraldry," 45–46.

153. For the contrast of good and evil arms, see Pastoureau, "Figures et couleurs péjoratives en héraldique médiévale."

154. For further discussion on this, see Chapter 4; cf. also Büttner, "Bilderzyklen," 140.

155. Pinoteau and Le Gallo, *L'héraldique de Saint Louis,* 6.

156. Ibid., 8. For the queens' arms, see *La France de Saint Louis,* nos. 27–30. Pinoteau, "La date de la cassette," 110 n. 24, argues that Eleanor did use the pales, especially after Louis's death. Pastoureau, "L'origine suisse des armoiries du royaume d'Aragon," points out that the number of pales varies between three and five. In the Psalter, there are normally three in the line-endings and five in the larger diapered background of folio 110v. The reference of the pales is of some importance because of the marriage in

1262 of Philip III to Isabelle of Aragon. Cf. also A. Haseloff, "Les psautiers de Saint Louis," 38, and Cockerell, *Psalter and Hours,* 25.

157. See note 123 above.

158. Pinoteau, "La date de la cassette," 99, notes that the children of the king began to use the arms of both France and Castile after 1237. The pales appear together with arms of France and Castile in the enamels of the tomb of Saint Louis's children Blanche and Jean, who died in 1243 and 1248, and in the cassette of Longpont; see *La France de Saint Louis,* no. 32, and Vaivre, "Le décor héraldique de la cassette d'Aix-la-Chapelle"; cf. Pinoteau and Le Gallo, *L'héraldique de Saint Louis,* 8.

159. For these possibilities, see Pinoteau and Le Gallo, *L'héraldique de Saint Louis,* 8; Lillich, *Rainbow like an Emerald,* 88–89; Büttner, "Bilderzyklen," 138–39.

160. Cf. Branner, "St Louis et l'enluminure parisienne," 83.

161. For discussion, see pages 204 and 209–10 above.

162. For a discussion of the inconclusive precedents in other psalters and for arguments for programmatic integrity of the present arrangement, see Chapters 4 and 5.

163. See page 12 above and notes 75 and 76 to the Introduction.

164. Gathering 1 has many other examples of errors and much evidence that uncertain procedures were followed. Apart from the extremely tentative and labor-intensive design that characterizes the first four bifolios and the awkward insertion of additional bifolios, as discussed above, all six folios used by the second group working on gathering 1 were prepared according to one pricking pattern and then turned upside down and pricked again according to another pattern, which became a standard (see Appendix VII); for a discussion of these points, see notes 39–41 above.

165. It is the only entry in brown ink and the only trace of the calendar to have transferred, a stain made when the ink was still wet rather than an impression caused by dry ink rubbing off.

166. Bischoff, "La nomenclature des écritures livresque." The script is sometimes referred to as *textus praecissus;* cf. Morrison, *"Black Letter" Text,* 17–25; M. Brown, *Guide to Western Historical Scripts.* The scribe of the first two text gatherings (XV and XVI) was probably also responsible for XIX, XX, XXXIII, XXIV, and XXVI⁸XXIX.

167. Leroquais, *Les psautiers,* 1:li–lix. For a description of the contents of the Psalter, see Appendix I.

168. Cockerell, *Psalter and Hours,* 19; Leroquais, *Les psautiers,* 2:102.

169. For a discussion of the gathering signatures, see pages 50–51 above and Appendix IV.

170. A relevant example is the Psalter of Blanche of Castile

(Bibl. de l'Arsenal, MS 1186). Although the entire text is written in eight folio gatherings, the canticles and *Quicumque* form a gathering of only six folios (180–85), their text ending just a few lines before the bottom of the last page (fol. 185v), as it does in the Psalter of Saint Louis. Beginning the litany with a new and thus separate gathering probably reflects the way its content, like that of the calendar, varied according to the person for whom the manuscript was intended. For the contents of the Fitzwilliam manuscript, which now has 309 folios, see Cockerell, *Psalter and Hours,* 10, 19–23.

171. Cockerell, *Psalter and Hours,* notes that the boards binding the manuscript at the beginning of this century left room for only a few more folios, and the same was the case in 1967, when I first examined the manuscript. For the fifteenth-century date of that binding, which has since been removed, see Appendix VI. If the Paris manuscript were completed by the same texts found in the Cambridge manuscript, it would have had about 375 folios, assuming the layout and system of illumination continued to be similar. Or it would have spilled over into a second volume, for which, again, there is no evidence.

172. See figure 12 and folio 127r (included in this book's Psalter reproductions), where the last five words are written in the later hand, or folio 142r, where the last word is an addition.

173. For example, both manuscripts add "mea" to Ps. 11:3, yielding "labia mea dolosa" (Cambridge fol. 10r and Paris fol. 95r), and "exo" to Ps. 72:23, yielding "et ego exo semper tecum" (Cambridge fol. 77v and Paris fol. 163v). In contrast, in Ps. 32:10 ("Dominus dissipat consilia gentium, reprobat autem cogitationes populorum et reprobat consilia principum") the Cambridge manuscript, folio 33r, omits "autem cogitationes populorum et," whereas the Paris scribe, on folio 117v, substitutes "gentium" for "principum." Thus, each scribe made his own error, the first because "reprobat" appears twice, the second because "consilia" appears twice; neither error would have caused the other. In general, however, there are far more corrections in the Paris manuscript than in the Isabella Psalter.

174. The folios lacking in the Cambridge Psalter correspond to Pss. 61:1–63:8. The gathering in question has ten, rather than the usual twelve, leaves, so that either the faulty text was never replaced or the replacement folios have been lost. The corresponding folios (149–51) in the Psalter of Saint Louis contain the text of Pss. 60:3–64:8. The text of Cambridge folio 71 is Ps. 68:3–16 through "absorbeat me." In the Louis Psalter the text of folio 157 is Ps. 68:3–16; "absorbeat me" is found on the top line of folio 158v, an original folio, where it is rewritten. The hand of Cambridge folio 71 is very much in the style of the Paris manuscript.

175. In addition to folio 71, Cambridge folios 75–76 (Pss. 70:18–72:6) and 80 (Pss. 74:2–75:9) have also been replaced. The longest correction in these sections of the Louis Psalter text is "Quia neque ab oriente neque ab occidente neque a" of Ps. 74:7 (fol. 166r). One presumes the error resulted from the repetition of words, as in the example cited in note 173 above. In the Psalter the most important corrections of several lines are as follows: "[lo]cuti sunt labiis . . . ne dicesseris a me" (Ps. 21:8–12, fols. 105r–v); "Abscondes eos . . . a contradictione linguarum" (Ps. 30:21, fols. 115v–116r); "ne revoces me . . . opera manuum tuarum sunt celi" (Ps. 101:25–26, fol. 195v); "eius non deleatur . . . corde mortificare" (Ps. 108:14–17, fols. 208v–209r); "circumdederunt me sicut apes . . . dominus suscepit me" (Ps. 117:12–13, fols. 215r–v), and "[iu]stificationes tuas . . . mandata tua" (Ps. 118:68–69, fol. 220r). None of these passages is corrected in the Cambridge manuscript.

176. Cockerell, *Psalter and Hours,* 23. Cf. our figure 13 to fol. 86r or 111r in this book's Psalter reproductions.

177. Cockerell, *Psalter and Hours,* 24–25, recognizes the similarity between the line-endings of these four replacement folios and those of the Psalter and attributes them to the same artist. However, he also gives this artist the line-endings of a number of other folios in the Cambridge manuscript—I find these to be by a different artist, who uses similar vocabulary of motifs—as well as all the line-endings in the Paris manuscript.

178. See Appendix IV.

179. Very few traits distinguish the script of the corrections from that of the original text. The most characteristic feature may be the wavering diagonal ascender of the *d.* Only the minor corrections on Psalter folios 90v and 97v are by a different hand.

180. See, for example, folio 135v, where "Quoniam rex omnis terrase deus psallite sapientur" was erroneously written between verses 3 and 4 of Psalm 46 and then crossed out and written correctly as verse 8. In contrast, "Quia satiavit animam inanem" from Ps. 106:9 was written twice, on the eighteenth and last line of folio 205r (where it was erased) and the first line of folio 205v. For repetition of single words, see fols. 182v ("tuos" in Ps. 88:11), 192r ("novum" of Ps. 97:11), 194v ("peccatores," Ps. 100:8), and so forth. For words added, see "[et] exultate mea" in Ps. 31:7 (fol. 116v) or "ego [exo] semper tecum" in Ps. 72:22 (fol. 163v).

181. In a few places it is possible to see one or two words of both the original and the corrected texts, because words have been added or crossed out but not deleted. The corrections restore the text to the Gallican version used at this time, for example, the psalm text of Paris, Bibl. Nat.,

MS lat. 32, but the uncorrected original text corresponds to none of the variations current a little earlier in Paris, when the Bible was undergoing revision. In a few instances, however, the uncorrected original version is comparable to that found in early texts of the psalter, particularly the Vetus Latina and Mozarabic. See, for example, the inclusion of "omnes" in Ps. 148:4, which R. Weber, *Le psautier romain et les autres anciens psautiers latins*, notes only in the Vetus Latina, or of "me" in Ps. 118:84, which he notes in an eighth-century Corbie manuscript; or the substitution of "conturbatione" for "contradictione" in Ps. 30:21, the former occurring in Paris, Bibl. Nat., MS lat. 6. Less precise but still notable are those instances where only two or three words are changed; although one cannot be certain of the original text, alterations occur in the same places in earlier versions. For example, Ps. 98:6 is corrected to read "Moyses et Aaron" but is "Moyses et Samuel" in the Mozarabic and the rewritten passage; "deus mane diluculo" (Ps. 45:6) is found in the Gallican and in contemporary Parisian manuscripts, such as Bibl. Nat., MS lat. 32, but differs in the Mozarabic, Roman, and Vetus Latina versions. Until one is able to identify an early manuscript with most, if not all, of these variations, its use remains only a hypothesis. For contemporary changes in the Parisian Bibles, see Light, "Versions et révisions du texte biblique," with earlier bibliography, and idem, "The New Thirteenth-Century Bible and the Challenge of Heresy."

Chapter 2

1. Branner, *Manuscript Painting in Paris,* 134–35.
2. Avril, "À quand remontent les premiers ateliers d'enlumineurs laïcs à Paris?"; Branner, *Manuscript Painting in Paris,* 7–9; De Hamel, *Glossed Books of the Bible;* and Alexander, *Medieval Illuminators,* chap. 1, esp. 12–24. For the fullest discussion of the phenomenon as it developed in the twelfth and early thirteenth centuries and a detailed analysis of the historical evidence in archives and books, see Rouse and Rouse, *Manuscripts and Their Makers,* vol. 1, chap. 1. For related trades, still useful is Gustave Fagniez, *Documents relatifs à l'histoire de l'industrie et du commerce en France,* vol. 1.
3. Avril, "À quand remontent les premiers ateliers d'enlumineurs laïcs à Paris?" Most accounts attribute the change in Paris to an increased demand for books, which paralleled the growth of the university, and the installation of a stationary court. Rouse and Rouse, *Manuscripts and Their Makers,* 1:14, 27–30, 36–39, and passim, also stress the literacy and wealth of the expanding clientele in the capital. No doubt the market was also responding to changes in

the use of books and in reading and writing as well as to developments in other trades, in lay devotion, and in intellectual life more generally, as seen in the extraordinary increase in titles, including translations and miscellanies, changes in the forms and functions of books, and the rise of private and institutional collecting. For useful overviews of these topics, see *Histoire de l'édition française,* vol. 1, esp. the essays by Pascale Bourgain ("L'édition des manuscrits," 49–76), Richard H. Rouse and Mary A. Rouse ("La naissance des index," 77–86), and Paul Saenger ("Manières de lire médiévale," 131–41).

4. On the emergence of the term "librarius," or "libraire," see Rouse and Rouse, *Manuscripts and Their Makers,* 1:24–25. The earliest Parisian bookseller we know by name seems to be Guillaume de Poitiers, mentioned in the document of 1231; see ibid., 44.
5. For the rent lists and tax rolls, see Branner, "Manuscript-Makers"; Michaëlsson, *Le livre de la taille de Paris l'an 1296;* idem, *Le livre de la taille de Paris l'an 1297;* idem, *Le livre de la taille de Paris l'an de grace 1313;* Baron, "Enlumineurs, peintres et sculpteurs parisiens des XIIIe et XIVe siècles d'après les rôles de la taille"; idem, "Enlumineurs, peintres et sculpteurs parisiens des XIVe et XVe siècles d'après les archives de l'hôpital Saint-Jacques-aux-Pèlerins"; Fianu, "Les professionnels du livre." Based upon these and numerous additional, primary sources, Rouse and Rouse, *Manuscripts and Their Makers,* 2:10–142, have compiled a biographical register of people associated with commercial book production in Paris between 1200 and 1500.
6. See, for example, the discussion of the *libraires,* scribes, and illuminators in Rouse and Rouse, *Manuscripts and Their Makers,* vol. 1, chaps. 7–9.
7. Fianu, "Les professionnels du livre," 208.
8. Baron, "Enlumineurs, peintres et sculpteurs parisiens des XIIIe et XIVe siècles," 42. For one family of booksellers and their relation to the Dominican convent of Saint Jacques over several generations, see Rouse and Rouse, *Manuscripts and Their Makers,* 1:82–97.
9. Roesner, Avril, and Regalado, introduction to *Roman de Fauvel,* 47–48; Rouse and Rouse, "Commercial Production." For a vividly imagined evocation of the physical environment and working relationships in Paris at a somewhat later date, see Camille, *Master of Death,* 13–40.
10. Beer, *Beiträge zur oberrheinischen Buchmalerei;* Branner, *Manuscript Painting in Paris,* 15–21; Avril, "Un enlumineur ornemaniste parisien"; Udovitch, "The Papeleu Master," esp. 92–110; Diamond, "Manufacture and Market"; Alexander, *Medieval Illuminators,* chap. 3.
11. Rouse and Rouse, "The Book Trade," esp. 44–47, 52–53, and idem, *Manuscripts and Their Makers,* 1:85–87.

12. For a notable example of *pecia* used in an illuminated book, see Rouse and Rouse, "Thomas of Wymondswold."

13. For analogous implications in contemporary architectural practices involving the cutting of stone in series, see Dieter Kimpel, "Le développement de la taille en série," and idem, "Ökonomie, Technik und Form in der hochgotischen Architektur."

14. Branner, *Manuscript Painting in Paris*, 37.

15. Ibid., 51–52; Roesner, Avril, and Regalado, introduction to *Roman de Fauvel*, 46.

16. See Hindman, "The Roles of Author and Artist in the Procedure of Illustrating Late Medieval Texts," and idem, *Christine de Pizan's "Epistre Othéa,"* 64–68.

17. For this useful distinction, see Montias, "Cost and Value in Seventeenth-Century Dutch Art."

18. Branner, *Manuscript Painting in Paris*, 35–36, 46–47, 134–36. It is clear now that *Bibles moralisées* were not commercially produced manuscripts; see Stirnemann, "Note sur la Bible moralisée en trois volumes conservée à Oxford, Paris et Londres, et sur ses copies."

19. For the first comprehensive overview of the surviving documentary evidence, see Branner, *Manuscript Painting in Paris*, 5–7.

20. *RHF*, 21:235D.

21. *RHF*, 22:605E; Rouse and Rouse, *Manuscripts and Their Makers*, 2:52.

22. Branner, *Manuscript Painting in Paris*, 6, refers to him as a retainer "with special duties in the field of manuscript fabrication."

23. Paris, Bibl. Nat., MS lat. 1097, fol. 69; Rouse and Rouse, *Manuscripts and Their Makers*, 1:41, 45–46, suggest he illuminated the Psalter of Blanche of Castille (Paris, Bibl. de l'Arsenal, MS 1186).

24. Binski, *Painted Chamber*, 107; Coulter, "The Library of the Angevin Kings at Naples," 143.

25. Branner, "Manuscript-Makers," 65; Rouse and Rouse, *Manuscripts and Their Makers*, 1:46, 2:97–98.

26. *RHF*, 22:607J; Branner, *Manuscript Painting in Paris*, 6.

27. Branner, "Manuscript-Makers," 67 n. 16, suggests the connection with Richard of Torigny, who submitted bills over at least three terms; see Sivéry, *Blanche de Castille*, 228, and Kimpel and Suckale, *Gotische Architektur*, 538.

28. For Honoré, see Havet, "Comte du Trésor du Louvre," 252; Kosmer, "Master Honoré"; and Rouse and Rouse, *Manuscripts and Their Makers*, 1:128–36, who suggest (p. 133) that Honoré was on royal retainer. For Maciot, another illuminator who worked commercially and illuminated manuscripts for Philippe le Bel (as *valet du roi*), see Rouse and Rouse, *Manuscripts and Their Makers*, 1:120–26.

29. J.-M. Richard, *Une petite-nièce de Saint Louis*, 100–106. In England, Louis IX's sister-in-law Queen Eleanor of Provence kept a *pictor* and two scribes in her employ but still purchased manuscripts on the market and from one of the king's squires; see Parsons, *The Court and Household of Eleanor of Castile*, 13–14, 86–87.

30. For example, see Viard, *Les journaux du trésor de Charles IV le Bel*, nos. 2970 and 10261, for the painter Peter of Brussels surveying work at Saint-Germain-en-Laye and for a certain Thomas who obtained a *Vita Sanctorum* through the *librarius* Thomas of Mauberge; cf. Rouse and Rouse, *Manuscripts and Their Makers*, 1:139, 212, 264.

31. Delisle, *Recherches*, 1:332–33; Avril, "Un chef d'oeuvre," 123. Rouse and Rouse, *Manuscripts and Their Makers*, 2:78, stress that although Jean was called an illuminator in the royal accounts, he functioned like a *libraire*.

32. For Pucelle, see Avril in *Les fastes du gothique*, 293–96; for Bondol, see Meiss, *French Painting*, 1:21–22.

33. For the patrons' role in production, see, for example, Rouse and Rouse, *Manuscripts and Their Makers*, 1:114, 146–47, and 231–32. For illuminators' deviations from texts and instructions, see the many examples in the *Bibles moralisées* as cited on pages 19–23 of the Introduction and in Lowden, *Bibles Moralisées*, 2:65; see also Sandler, "Notes for the Illuminator," esp. 558–59.

34. Ingeborg's tomb is in the church of Saint Jean en l'Isle at Corbeil, and Barthélemy le Roye's is in the Premonstratensian Abbey at Joyenval; see Davidsohn, *Philipp II. August*, 287, and Erlande-Brandenburg, *Le roi est mort*, 163. Sivéry, *Blanche de Castile*, 170, stresses the power of Barthélemy even into the 1230s.

35. The full inscription reads: "HIC JACET HUGO PECDOE PL . . . A . . . // PICTOR REGIS QUI EDI.CAVIT / ISTAM ECCL(ESIA)M OBIIT V KL / IAN(UA)RII AN D(OMI)NI MCCLI." It was published in Mély, "Nos vieilles cathédrales et leurs maîtres d'oeuvre," 347, citing Eugène Piot, *Le cabinet de l'amateur*, n.s., Q (1861), 32.

36. The priory, near Corbeil in the diocese of Paris, was founded about 1234 by Jean de Dreux and his wife, Alix, countess of Macon, and became a dependent of Sainte Catherine du Val-des-Ecoliers in Paris; see *Gallia Christiana*, 7:863. The church was demolished in 1792, but Lebeuf, *Histoire de la ville et de tout le diocèse de Paris*, 4:70–71, writing in the 1750s, notes that the choir contained original capitals and keystones suggestive of the epoch of Louis IX as well as stained glass with the fleurs-de-lis and the arms of Dreux. Théodule Pinard ("Le prière de Longjumeau," 385–86), who visited the site a century later, affirmed several of Lebeuf's observations and also noted the tombstone of Raoul de Chevry, bishop of

Évreux, who died in 1269, and several statues with damaged or lost heads. See also Nicot, *Histoire et évolution d'un fief royal*, 61–63.

37. Prost, "Recherches sur les 'peintures du roi' antérieurs au règne de Charles VI."

38. Binski, *Painted Chamber*, 107; Lancaster, "Artists, Suppliers, and Clerks," esp. 98–99. Eleanor of Castile may also have communicated her wishes directly to those she patronized; see Parsons, *The Court and Household of Eleanor of Castile*, 14, 94.

39. For example, Jean Coste painted murals as well as banners for Charles V; see Le Roux de Lincy, "Comptes des dépenses faites par Charles V." For Pecdoe and the Sainte-Chapelle, see Branner, "Painted Medallions," 15 n. 50.

40. See, for Gauthier, Stirnemann, "Quelques bibliothèques princières," 36–37; for Hugh of Oignes, Haenens, "*Liber scriptus intus et foris*"; for Matthew Paris, S. Lewis, *The Art of Matthew Paris*, esp. chap. 1; and for an overview of the still-unsettled question of Villard's profession, Barnes, "Le problème Villard de Honnecourt." Italy presents a special case, but see, for example, White, *Art and Architecture in Italy*, 93–112, on Arnolfo di Cambio, or Romanini, "Arnolfo pittore." Other examples are given in Martindale, *Rise of the Artist in the Middle Ages and Early Renaissance*, 35, 70, 83, 106, and passim. For the literary fiction, a representative case is Chrétien de Troyes's *Cligès*, in which the protagonist lauds his artist in terms suggesting he was an architect, sculptor, and possibly painter (line 5382); see Söhring, "Werke bildender Kunst in altfranzösischen Epen," esp. 499–50, and also Ferrante, "Artist Figures in the Tristan Stories."

41. Avril, *Manuscript Painting at the Court of France*, 20.

42. See the excellent summary in *Les fastes du gothique*, 430.

43. Paris, Bibl. Nat., MS fr. 13091. For Jacquemart, see the concise discussion in *Les fastes du gothique*, nos. 297, 298, 299, 333, and 430–31; for the Master of the Parement of Narbonne, ibid., nos. 295 and 324; and for Beauneveu, ibid., no. 429. For the whole group, the fullest discussion remains Meiss, *French Painting*, 1:99–118, 135–76. See also van Buren, in *The Turin-Milan Hours*, 2:281–83, on the Parement Master's identification as Jean d'Orléans, on his diverse work in several media, and for Jan van Eyck as an illuminator.

44. Marrow, "Introduction," in *The Turin-Milan Hours*, 2:223–31, at 226.

45. Branner, *St. Louis and the Court Style*, 57; Bucher, "Micro-Architecture"; and Bony, *French Gothic Architecture*, 400–405.

46. Branner, *Manuscript Painting in Paris*, 11.

47. Ibid., 86.

48. Ibid., 132–37, 238–39.

49. Diamond, "Manufacture and Market," 105; Rouse and Rouse, "The Book Trade," 90.

50. In this chapter I use the masculine pronoun when referring to painters. Although women were almost certainly illuminators in Paris at this time, very little evidence of it has been preserved. Rouse, "The Book Trade," 92–103, identifies only one female illuminator but six *librarii* in documents between the late thirteenth and mid–fourteenth centuries, and Branner, "Manuscript-Makers," 65, finds one female parchmenter. In every case they practiced their spouse's profession, and no mention of them appears in the records during their husbands' lifetimes. Once widowed, they took the oath to the university. See also Michaëlsson, *Le livre de la taille . . . 1313*, xviii, and Meiss, *French Painting*, 1:3–4. On the general topic of women as illuminators, see Oliver, "Worship and the Word," with bibliography.

51. Branner seems to be of two minds about this. At some points (*Manuscript Painting in Paris*, 86, 95) he describes an atmosphere of excited experimentation, even a crisis among artists regarding what was to be considered new and modern; at another (p. 51) he finds it deplorable that so many artists vanished when their styles became outmoded. The precise ways these artists adapted and the relations between formal convention and individual practices can be carefully followed in those manuscripts created over periods of important change. For example, the four-volume folio Bible Bibl. Nat., MSS lat. 11539–42, was begun about 1235 in a *Muldenfaltenstil* that Branner correctly relates to that of the Toledo and Oxford Moralized Bibles, and it was completed a few years later in the manner of the so-called Potocki atelier. As is often the case, the order in which the miniatures were painted follows that of the volumes themselves and, more or less, that of the gatherings. In the first volume, composition is flat, figures are thinly painted, and drapery is pulled across them in a pattern of curving folds and deep troughs. By the third volume, figures and forms, as well as the space they are in, have become more rectilinear, rigid, and distinct, the coloring and modeling more varied and contrasted, and the folds more angular; cf. lat. 11539, fol. 86, to 11541, fol. 4. Two other miniatures—lat. 11540, fol. 39, and lat. 11542, fol. 99—this time with standing figures, show how the same development continues to the final volume and to the volumetric, broken-fold manner that distinguishes a major trend of the 1240s. This Bible is particularly telling because all four of its volumes are painted by one artist and because its formal development follows the contemporary evolution of Parisian art and is unaffected by the

model used; see Branner, "Le premier évangéliaire," 45–46. I believe the same conclusions apply to other folio Bibles painted in Paris at midcentury, although the situation is usually more complex because several artists were involved.

52. For example, L. Randall et al., *Medieval and Renaissance Manuscripts in the Walters Art Gallery,* vol. 1, use the terms for Parisian manuscripts of this period.

53. The case has been made best in the literature of the time; see, for example, Zink, *La subjectivité littéraire.*

54. See Appendix v. Branner refers to each hand by a letter from A through F. In order that his attributions and my own can easily be compared, I also assign each painter the letter Branner used in the first gathering in which our attributions agree. I find three artists (A, B, and C) in his artists A and B, and one artist (D) in his hands D and F. We agree on E. I also name the artists after the protagonists of characteristic works and refer to them as "masters" to distinguish them from possible assistants working in the same manner.

55. See pages 40–42 above.

56. In the first miniature, the acceptance or rejection of the brothers' offerings is signaled by their kneeling and standing positions, the rising and falling flames of their kindling, etc.; in the second miniature, Cain is caught between the accusations of the Lord above and of Abel's blood, which cries out from the earth below. For a discussion of these elements, see pages 89–90 above.

57. Among other similarities, compare the proportion and foldwork of Cain at the right of folio 2r to that of the principal angel in folio 7v, or the positioning of legs, torso, and arms to those of Jacob at the left of folio 14r. The preference for drapery breaking into fine small folds or tautly enwrapping or looping around the foreleg or knee appears in the figures of Abel and in folio 7v. The heads of Cain in folio 2r or of Noah's sons in folio 4r are especially similar to those of the angels seated at the table in folio 7v. The distinctive gray of folio 7v is the same as that of folios 2r and 4r, including the roof tiles. There are also similarities in decorative details: compare the brickwork bases to the tabernacles (fols. 1v–4r, 7v, 10r), the design of the roses and the decoration of the spandrels and trefoils, and the double-level capitals (fols. 2r, 14r) and unusual column bases (fols. 4r, 7v, 10r, 13v).

58. A few short, thin, straight lines mark the placement of legs and turn of the torso, but the paintings generally ignore them.

59. The forms of the painted folds are not always followed.

60. See especially Eliezer's hanging sleeve at the left of folio 11v and the mantle over Rebecca's lap at the right of folio 12r.

61. Compare folio 19v to folios 21v–22r, especially Joseph and Potiphar's wife to Joseph and Benjamin, at the right of folio 22r.

62. Also distinctive is the Rebecca Master's use of asymmetrical or irregular forms; see, for example, the grouping of prisoners asleep at the left of folio 20r or of the two women on camels in folio 12r.

63. Compare also the positioning of the arms and exchange of gestures between Abraham and Eliezer and between Joseph and Potiphar's wife, or the rich treatment of drapery of Isaac's mantle and Joseph's (fols. 12r, 19v).

64. Folios 11v–12r and 19v–20r all move from pairs of figures at the left, at least one of whom in each pair faces left, to groupings of three or more figures at the right. In each pair, this parallelism in opposing pages is clearly purposeful, for Abraham is replaced by his son Isaac (and Rebecca is repeated), and Joseph, stepping into prison, reappears fully standing, as he was in the first scene, again wearing a blue mantle, like the one he lost to Potiphar's wife. Both sequences come full circle, as Rebecca returns to Canaan and Joseph is restored.

65. The diverse and irregular groupings and some fold forms are analogous (fols. 6r, 18r); also, compare the drawing and details of Lot and his daughters in folio 9v to the depiction of the merchant and other figures in folio 18r, or Lot at the left of folio 8r to Joseph at the right of folio 22r. Although the salmon color is less pink and more brown in gathering 11, the modeling is very similar.

66. Cockerell, *Psalter and Hours,* 27f., attributed to him the twenty-six initials in folios 191v–209r, or his Group b. I find he also painted the initial on folio 212v, so that his work corresponds to all of gatherings XVII and XVIII (fols. 190–201 and 202–13). Branner, *Manuscript Painting in Paris,* 238, divides the hands differently. However, his Hand 11 is responsible for most of the miniatures belonging to Cockerell's Group b, including all those I here compare to gathering III.

67. Cockerell, *Psalter and Hours,* fig. 38 (fol. 207v).

68. Cf. ibid., fig. 24 (fol. 201r). The differences are also notable. The four Paris miniatures are planar compositions in which single figures and groups form distinct units arranged in regular shapes, such as triangles, often linked by arms and contours. The flatness of the figures and the simplicity of these formulas are quite at odds with the rounder bodies and more complex relations evident in the Cambridge initials. Similarly, the remarkable figure of Joseph Revealing Himself (fol. 25v) is still fundamentally angular, whereas the most advanced figures in the Cambridge initials are each developed in an elegant continuous line and in reversing curves; see ibid., figs. 28 (fol. 202v),

31 (fol. 204r). In composition, however, the Paris miniatures accord better with the paintings found at the beginning of the Isabella manuscript, especially the full-page miniatures, with their cool, patterned beauty and slow, precise actions; cf. especially Cambridge fols. iv, v, and vi to Paris fols. 27v, 26r, and 28r, respectively. That is, the artist of gathering iii may be that of the Cambridge Lauds initials, as Cockerell thought, but here he is working more in the manner of the full-page Cambridge miniatures. Many details in the full-page miniatures still betray his connection to the later Isabella paintings; for example, the arrangement of figures around of the tomb of Joseph (fol. 28r) is closer to that around the bed of the Virgin (Cambridge fol. 281r; Cockerell, *Psalter and Hours,* fig. 50) than to that around the tomb of David (fol. vi; Cockerell, *Psalter and Hours,* fig. vi).

69. Whoever painted the biblical scenes also painted the colonnettes within and alongside them, which are in the same russet color as the garments of some of the figures, not the brighter and yellower orange used for the roof and corners of the frame.

70. See the way folios 31v–32r intervene between folios 30r and 33v, or how folios 34r–39v do so between 33v and 40r.

71. The first two openings (fols. 29v–30r and 31v–32r) are complementary, but the third (fols. 33v–34r) is not.

72. The change from folio 30r to the almost nonnarrative folio 31v is particularly unexpected. Folios 38r and 39v are reversed.

73. Compare Moses before Pharaoh (fol. 30r), ordering the plagues or at Passover (fols. 31v, 32r), and in the desert (fol. 37v).

74. Compare the striding figure of Joseph (fol. 15v) to Moses (fol. 33v), or the striding figure of Joseph (fol. 22r) to the priests carrying the Ark (fol. 41v), or the striding Lot (fol. 9v) to the trumpet blowers (fol. 42r). Some of these are reused schema, as are the several instances of sleeping figures (fols. 21v, 33v), but many details, such as the heads in folios 23v–24r and 40r, or those of the female figures in folios 9v and 29v, are distinctive.

75. E.g., fols. 30r and 41v.

76. Cf. especially fols. 23v–24r to fol. 40r.

77. I refer to the square jaw, short beard, and compact shape; see also the heads of Moses and Pharaoh on folio 33v.

78. Compare the second figure of Moses (fol. 32r) to Abraham in the Sacrifice of Isaac (fol. 10r), or the several youths to Jacob in folios 13v and 14r.

79. For the head type, cf. fols. 7v, 10r, 32r.

80. One wonders too if the introduction of the taut ridges of drapery and the more extensive use of blue-gray might reflect the influence of gathering iii. Also, his shift to a light tan, as the color paired with blue, works to bring up the color of the gold, especially in these miniatures with thick dark bole and high burnishing. This change in coloristic interest to the more rich and decorative becomes more or less standard in the second phase of painting.

81. Folio 34r is an exception. There either the Saul Master tried to work in the style of the Noah Master, or the miniature was painted by the Noah Master because the Saul Master had not yet arrived.

82. Cf. fig. 14 to Psalter fol. 43v and especially fol. 46r. Cockerell called the motifs of these frames "cufic"; see *Psalter and Hours,* 27.

83. For the figures, cf. fol. 31v or 32r to fol. 44r; for the heads, cf. fols. 35v and 44r. For the relation between gatherings v and x, cf. fols. 44r and 63v, 35v and 65v.

84. For discussion of the iconography of folios 43v, 45v, 46r, 64r, and 65v, all of which illustrate military developments, see pages 99–104, 111, and 175 above.

85. E.g., cf. fols. 11v and 20r to fol. 48r. And there can be no doubt that gatherings vi and vii are work of the same hand: compare the figures of Sisera (fol. 48r), Gideon (fol. 51v), the soldiers (fol. 52r), and Jephthah (fol. 54r). Branner attributes the frames of gatherings v–vii to one artist, but I believe those of gatherings vi and vii differ from v in drawing and technique. In gatherings vi and vii the vine forms, while analogous to those in gathering v, are less rounded and more taut, and the reversing movements more sharp, much like differences in the gestures of figures by the Noah and Rebecca Masters. The application of the gold line is technically quite different too, for in contrast to the fine and precisely applied gold of the frame and architectural motifs of gatherings v and x—see especially the treatment of the roses and clerestory windows—the gold of gatherings vi and vii is grainy and has frequently been smudged and rubbed away (see the roof or gables of folio 52r or the borders of folio 50r). It may be no coincidence that one finds this condition in some of the earlier miniatures of the Rebecca Master, such as folio 20r.

86. Cf. fols. 19v–20r to fols. 48r, 51v.

87. Compare, on folios 37v and 60r, the facial features and characteristically small, compact, and rounded heads of Moses and Samson and, on folios 38r and 60r, the heads King Balak and the youth beside Samson. Although the range of colors and of techniques of painting is more narrow, his distinctive pale yellow becomes more important, a role it will have in the artist's subsequent work; cf. fols. 37v, 39v, 59v, 60r.

88. For example, groups of wrestlers, such as the bronze group from Alexandria in Bieber, *Sculpture of the Hellenistic Age,* fig. 643.

89. For example, Giambologna's early Samson Slaying the Philistine, which may itself be based upon an antique work; see Avery, *Giambologna*, 75–76 and fig. 84.

90. For a discussion of the use of black and its implications, see pages 128–29 above.

91. For example, the extreme turn of the figure created by bringing one stiff, straight leg across the other (cf. fol. 57v to fol. 59v).

92. Compare especially the striding angel in folio 55v to Samson praying in folio 60r.

93. A similar facial type is found in the figures of Joseph, Moses, and Samson (fols. 23v, 30r, 56r). The tripartite composition of folio 57v may have been suggested by the iconographic source, but the way figures are built up in groups, the confusion of limbs, and the tall slow-moving figures recall folios 17v–18r and 21v–22r. Whether some of these miniatures are the work of the Abraham Master or an assistant, the issues described here still apply.

94. Branner also attributed all of these miniatures to the same artist, but he believed the artist was a newcomer to the Psalter. His conclusions appear to be accepted by Beer, "Pariser Buchmalerei," 79–80.

95. Compare, for example, the heads in folios 70r and 71v to those in 76r; the soldiers pushed down in folios 69v and 77v; the youths in folios 72r and 78r; or the modeling in folios 68r and 78r.

96. Compare especially the seated figures in folios 62r and 71v.

97. For the poses and gestures, compare the Israelite addressing the Philistine in the left half of folio 59v to the man before the door in folio 70r or to the young man with the bagpipes in folio 74r. In spite of the differences in technique and palette, the conception of the body and of patterns of foldwork of Samuel in folio 73v is essentially an elaboration of that of Samson praying at the far right of folio 60r. For physiognomy, cf. fols. 62r, 71v. For the similar use of the distinctive pale yellow, cf. fols. 59v, 62r, 67v–68r, and 71v. A relation is also suggested in the development of motifs in the frames. Their characteristics are best followed from gathering IX. Although the pattern of vines in gathering IX is basically the same as in gathering VIII or X, they are differently drawn. In the latter two gatherings the spirals and shoots are evenly distributed and have the same regular curl. In contrast, the vine forms of gathering IX are more tightly wound, the spirals are made distinct from the intermediate and secondary shoots, and there is more space between these forms (cf. fols. 55v, 59v, 63v). These features equally apply to gatherings XI and XII, where the elasticity and spring of the forms are the same. This typically more dynamic approach, which we also see in the figures of the Saul

Master, is developed one step further in these two gatherings, insofar as the secondary shoots cross the main stem and end in a tight curl of contrasting form, a development that in many ways anticipates the frames of gatherings XIII and III. Folio 74r is especially telling because in the upper border the artist reverted, presumably in error, to the pattern of gathering IX, another indication of the relation between these gatherings in Phases II and III. The parallels between changes in decorative motifs and those apparent for artists are striking; if different painters were responsible for the narrative scenes and for the frames, they were certainly working in concert.

98. Compare especially Balaam in folio 39v to figures in folios 72r and 74r.

99. Despite variations, the repertoire of heads and expressions found in folio 37v remains fundamentally unchanged through Phases II and III; cf. fol. 37v to fols. 62r, 75v, 76r, and 78r.

100. For the currency of this style in the next decades, see pages 116–26 above.

101. The earlier pattern C is reused; see Appendix VII.

102. For the replacement folios, see the discussion on pages 51–54 above.

103. The evolution of the architectural decoration is particularly clear. Gatherings XI and XII start from the design of gathering X, for they continue to use the same architectural pattern (D), light colors for the gables and arcades, and salmon for the flank of the building (except for the left halves in folios 72r and 73v). In gathering X, however, the characteristic pink is accompanied by a comparably light blue; tiny black trefoils are penned, rather than painted, in the spandrels, so that the latter appear pierced and more planar; and the tabernacles are bright orange, a color the Saul Master especially favors. For the vine motifs, see note 97 above.

104. The changes in gathering XIII represent a recombination of earlier ideas rather than an introduction of new ones. After a couple of trials in gathering XII (fols. 72r, 73v), the building flank is regularly split into blue and salmon halves; the paired gables, roses, and spandrels alternate in color; the lancets are decorated with trefoils; and the underlying pattern (C) is reused. All of these features are found in previous gatherings, though rarely together. What is new in gathering XIII is the crocketing on the gables and, most indicative, the orange, rather than gold, of the roofs and the gold, rather than orange, of the pinnacles and their bases. These complementary changes are probably interrelated and can be understood as an attempt to flatten the architectural setting. By gilding the pinnacles, the towers appear in the same plane as the buttresses,

and by making the roof orange, it becomes a flat form that caps the structure below it. By adding crockets but no longer piercing the gables and spandrels, and by reverting to the bipartite coloring of the flank of the building, a more planar and patterned design of alternating colors and gold motifs results. These architectural changes in gathering XIII accompany others in composition, so that figures advance before the architecture instead of being sheltered beneath, a change very likely linked to the content of this last gathering.

105. It also means that the Saul Master painted some bifolios in these gatherings with miniatures of similar technique and style (fols. 72r, 73v) and others with miniatures of quite different technique and style (fols. 68r and 69v, 71v and 74r).

106. 1 Sam. 4:21. Cf. Laborde, *Bible moralisée*, pl. 130, where this failure is particularly clear, for the capture of the Ark is compared to the capture of priests by devils, who drive them into a hell mouth while a statue of the Virgin weeps. The notion of the failed priesthood as represented by Eli's two sons goes back to Augustine, *De civitate Dei*, bk. 17, and influenced more recent narrative accounts of these episodes, such as Petrus Riga's *Aurora*; cf. Beichner, *Aurora*, 252 (Liber Primus Regum, lines 139–40).

107. For the earlier approach to both foldwork and the weight of the figure, compare Samuel at the left of folio 73v to the elder in folio 76r or Saul at the left of folio 74r and at the right of folio 76r. Both concepts appear in contemporary sculpture; see pages 116–26 above.

108. These two gatherings are the first to use architectural pattern C; see Appendix VII.

109. A darker tone is used to line the inner edges of the gables in all of the miniatures, but the difference between the two tones is exaggerated only in XI⁸XIII. Only in gathering XIII is the lighter tone of blue as dark, which accords with the change in palette in XIII, as described above.

110. See notes 103 and 104 above.

111. Several details suggest that the the pattern of motifs evolved in gathering XIII. The frames of gatherings XIII and III involve three floral motifs. The first, a three-pointed leaf, is familiar in its painted form from the frames of Psalter gatherings I–IV; as gold penwork design, it is common in the frames of the text initials in both the Cambridge manuscript (e.g., fol. 174; cf. Cockerell, *Psalter and Hours,* fig. 15) and the Saint Louis Psalter (e.g., fol. 110v). The second motif, a straight line crossed by three or four very short lines, sometimes resembles a pine cone. The third is a palmate motif in which three straight lines, each with a short crosslet, split away from a common point, a form more broadly elaborated in the

painted borders of the full-page miniatures of the Isabella Psalter (e.g., fol. 125; Cockerell, *Psalter and Hours,* fig. 14). In the Psalter this motif is denser and sometimes resembles a trilobed leaf, like a maple leaf. In Paris folios 76r, 77v, and 78r these three motifs generally occur in series as the central figures within the circular vines of the frames. All of these motifs are found in folio 75v but not in the regular distribution of the subsequent three folios and not exclusively: the three-pointed leaves are hardly used, and other forms are tried out, such as the five-petal "margarite" in the lower margin. Since folio 75v is the first of gathering XIII, it may show the Saul Master was still working out the design. At the same time, the greater regularity of spacing and clarity of design in the frames of gathering III suggest that they copy and improve upon the design of folios 76r–78r.

112. The Saul Master was responsible for the initials of folios 85v, 110v, 175r, and 210r; the second artist, for those of folios 126v, 141v, 156v, and 192r. The two groups are also distinguishable by the design of the frames.

113. The singing clerics of folio 192r can be compared to their counterpart in the Cambridge manuscript, folio 107 (Cockerell, *Psalter and Hours,* no. 13); the unusual russet color of their mantles is found only in the work of the Isabella Master and in the Cambridge manuscript. Compare also the kneeling David in folio 126v to the same figure in the Cambridge Beatus initial, folio XIIIv (Cockerell, *Psalter and Hours,* no. 7). The golden floral motifs in the frames of the second artist have crosslet forms analogous to those in gathering XIII but closer to those of the Cambridge manuscript (cf. Cockerell, *Psalter and Hours,* nos. 10–12).

114. For the calendar, see Appendix III; for psalm texts, see pages 50–54 above. The texts of some text pages correspond exactly, so that one cannot exclude the possibility that the Paris manuscript was copied from the Cambridge manuscript.

115. Although clearly by a different hand, the Sainte-Chapelle Evangeliary (Paris, Bibl. Nat., MS lat. 17326), especially the first gatherings, remains the closest parallel in terms of quality of drawing, palette, and various details.

116. This is the case for the painted medallions in the upper chapel of the Sainte-Chapelle as well as painting elsewhere in France and England; cf. Subes-Picot, "Peinture sur pierre"; Binski, *Westminster Abbey,* 159–62; Stahl and Hugon, "La peinture murale du 13ième siècle à la Sainte-Chapelle de Paris." For a slightly later example of a monumental painter employed in the illumination of a prayer book, see the comments of Alison Stones in *Le livre d'images de Madame Marie,* 19–20, and my review in *Speculum.*

117. See page 51 above and note 175 to Chapter 1.

118. In addition to those motifs cited in note 111 above, compare the "cufic" motifs in the frame of folio 85v to those in the Cambridge manuscript, folio 107 (Cockerell, *Psalter and Hours*, no. 13).

119. Only the Psalter of Saint Louis has heraldic backgrounds, and it multiplies figures in Psalms 26 and 38 and links the whole series of psalm initials together by consistently showing Christ as full-length. To the initial to Psalm 109, it adds the dove of the Holy Spirit, which the Isabella artist had overlooked in his depiction of the Trinity. Other details are elaborated but less well understood. For example, the initial to Psalm 97 (fol. 192r) shows a cutaway view of a building in which two clerics sing. In the Isabella Psalter the exterior wall of the building has two windows and a buttress, from which springs an arch enclosing the cutaway view of the interior, an arrangement found elsewhere in the manuscript; cf. Isabella fols. 111v and 107r (Cockerell, *Psalter and Hours*, nos. 3, 13). The Saint Louis Psalter (fol. 192r) uses two buttresses, one of which has a flier; because the arch springs from that buttress, the cutaway view seems disconnected from the building whose interior it is intended to reveal. Another example is the initial to Psalm 26, which shows a large triangular form with hanging lamps, a reference to its first verse ("The Lord is my light"). In the Paris manuscript (folio 110v), the geometric form is reduced in size, and its undulating edge is eliminated, changes that succeed in adapting it to the pattern and scale of the heraldic background but that make the visionary nature of the form less clear.

120. See Chapter 3 and the Conclusion.

121. For figures in bed, see fols. 15v, 21v, 33v, 68r, and Cockerell, *Psalter and Hours*, figs. 4, 31, 47; for kneeling figures, see fols. 1v, 26r, 58r.

122. For example, compare the figures of Rebecca and Saul in folios 11v and 74r, the former typically more angular, the latter with typically tense curves. Or compare the horses in folios 41v and 46r; the Abaham Master, in folio 41v, makes forms more taut and springing, as he does in folio 23v. Other distinct breeds are the large and powerful horses of the Rebecca Master (fols. 47v, 53v) and the small and compact horses of the Saul Master (fol. 75v). Unlike the uniformly or decoratively colored planes of the block-like altars elsewhere in the manuscript, such as those on folios 10r, 50r, 54r, and 55v, those of the Saul Master, at least in the final gatherings, divide the surface plane between light and dark zones, the lighter in the foreground (fol. 70r; cf. also Saul's bench in fol. 72r), a change consistent with his interest in reflections, as discussed above. Many drapery patterns, however, are indicative of a particular painter and were not shared at all, as in the case of the Abraham Master's folios 15v and 33v or 22r and 41v.

123. See pages 65–66 above.

124. Cf. also fols. 72r, 75v, 78r, and Cockerell, *Psalter and Hours*, figs. 6, 16, 42, 48.

125. Cf. fol. 72r to Cockerell, *Psalter and Hours*, fig. 24, and the figure of Christ in fol. 85v to ibid., fig. 26.

126. Rouse and Rouse, *Manuscripts and Their Makers*, 1:62–63, suggest that Nicholas Lombardus might have been the *libraire* of the two manuscripts, not because of any evidence in the manuscripts but because he was very rich in comparison to his contemporaries in the book trade during the period in which the psalters were made. He had the leaseholds on at least seventeen houses by his death in 1277 and was already wealthy in 1248, when he bought what was the most imposing house on the rue Neuve.

127. The similarities in page layout and measurements between the Isabella and Louis manuscripts and the earlier royal psalter Paris, Bibl. Nat., MS lat. 10434, suggest that the court had been using some of the same sources for almost fifteen years. Although the illuminations, iconography, architectural details, and text decoration are all dissimilar, the earlier manuscript has the same unusual system of text layout (diagram 2). All are lined only with double verticals flanking the text column and blocking in its guidelines. Although the text column of the earlier manuscript is 5 mm wider and two text lines (12 mm) higher, the differences are essentially stylistic and reflect an earlier attitude toward proportion and page layout. More indicative are the pattern of punch holes and the measurements between them, both of which correspond to the later royal psalters. (The holes in the upper and lower margins are about 19.2 cms apart; those of the left and right margins, about 9.9.) Also, the broad frame of the prefatory miniatures is the same in both its measurements and many of the vine and other motifs that decorate it; cf. Psalter gatherings VIII and IX. The width of the narrative zone is about 7.0 cm in all the manuscripts, and that of the frame about 1.0 cm, as measured from the lining for the frames. However, the painted area of lat. 10434 appears a full centimeter wider because of the thicker forms around the inner and outer edges of the frames. For the evidence that this psalter is also a royal manuscript, see note 98 to the Introduction.

128. The foremost example would be the *Bibles moralisées;* see pages 16–17 above and note 121 to the Introduction.

129. See notes 33 and 38 above.

Chapter 3

1. Panofsky, *Early Netherlandish Painting*, 1:15–17, 52–53; Bunim, *Space in Medieval Painting*, 108–14; Birkmeyer, "The Arch Motif in Netherlandish Painting," esp. 5–6; Pächt, *Book Illumination*, 148–49, 190–94.

2. Pächt, *Book Illumination*, 148–49, 190–94. Pächt states that the superstructure is decorative and has no local reference, and he compares it to shallow tracery and diaphanous wall reliefs of the time. He discusses the Psalter as an early example of the depiction of architectural depth, which he sees as the "death knell" of illumination. See also J. Wirth, "Peinture et perception visuelle au xiiie siècle," who suggests that the architecture develops out of the techniques of architectural drawing, so that frontality always pertains; he also finds that the flatness of the superstructure contrasts with the three dimensionality of the figures. He sees this studied abstraction and analysis as an indispensable step toward the spatial coherence of Giotto.

3. Krautheimer, review of *Space in Medieval Painting.* Later writers failed to take up Krautheimer's brilliant perception about how planes function in the Psalter; see pages 84 and 100 above.

4. For exceptions, see especially fols. 5v, 6r, 8r, and 9r, but also 55v, 56r, 57v, 58r, 60r, and 61v.

5. The exceptions are fols. 19v, 20r, and 23v.

6. The best general discussion remains Bunim, *Space in Medieval Painting.*

7. The buildings in the narrative zone usually have painted interiors, in the form of patterned backgrounds, not the gold leaf that appears everywhere else; that is, a distinction is made between the space within represented structures and that within the architectural superstructure. See, for example, fols. 19v, 20r, 48r; the exceptions are fols. 32r and 36r, the Passover and the Desert Tabernacle.

8. Sauerländer, *Gotische Skulptur,* figs. 68, 76, 152.

9. Lautier and Bideault, "Saint-Nicaise de Reims." On Hugh Libergier and the problem of dating the Saint-Nicaise façade and relating it to Notre-Dame in Paris, see Kimpel and Suckale, *Gotische Architektur,* 345–47.

10. Kimpel and Suckale, *Gotische Architektur,* 410.

11. In the miniature the proportions are 5:3:2 when measurements are taken from the column base to the base of the capital, then to the lower clerestory molding, and finally to the finials. This does not apply to the later miniatures, where the proportions change because of the taller clerestory area; however, it does to gathering xiii. For the south transept, where I have been able to make measurements only from reproductions, the proportions appear to be approximately 6:4:2.5 when measurements are taken from the base of the blind arcade of the outer jamb wall of the portal to the base of the pinnacle, and then to the base of the lower-wall arcade (which passes before the buttresses), and from there to the base of the upper arcade (below the windows). For the extensive

restorations to the south transept, which would not have affected these proportions, see Kimpel, *Querhausarme von Notre-Dame,* 71–77.

12. The overall proportions are analogous. In the blind arcade of the inner south transept, the colonnette capital is midway between the colonnette base and the apex of the gable; in the miniatures, it is midway between the column base and roof. More unusual is the approximately 5:3 ratio one finds both in the relation of the height of the lower lancets to that of the upper wall enclosed by the gable and in the relation of the corresponding heights of the narrative and gable zones of the miniatures. This assumes that in the inner south transept the lower portion is measured from the base of the colonnette to the middle of the quatrefoil and from there to the apex of the gable. In the miniature, the measurements are taken from the column base to the base of the pinnacle and from there to the apex of the gable. Again, this does not apply to the taller, latter gatherings but does apply to gathering xiii.

13. I am unaware of its use in Paris before the transepts and side chapels of Notre-Dame. For Amiens, see Murray, *Notre Dame, Cathedral of Amiens,* 72.

14. Branner, *St. Louis and the Court Style,* 102 and, for rounded forms, 104 and fig. 118.

15. Pierre de Montreuil was named *magister operum* in 1265, but Kimpel, *Querhausarme von Notre-Dame,* 85–92, has shown that he was active much earlier on the northern chapels. The 1257/58 date is given in an inscription close to the ground on the south transept. Since the north transept preceded and formed the basis for the design of the south, one presumes Jean de Chelles died shortly after the work began on the south transept and was named in the work of his successor. See Aubert, *Notre-Dame de Paris,* 138; Branner, *St. Louis and the Court Style,* 76, 101–4. For the problematic figure of Pierre de Montreuil, see Prache, "Un architecte du xiiie siècle et son oeuvre"; Bony, *French Gothic Architecture,* 369–71, 523 n. 15; Kimpel and Suckale, *Gotische Architektur,* 404f., 410–22; Bruzelius, *The 13th-Century Church at St-Denis,* 173f.; Robert Suckale, "Pierre de Montreuil," in *Les bâtisseurs des cathédrales gothiques,* 181–85; and Kurmann, "Un colosse aux pieds d'argile," esp. 146–47.

16. For a detailed characterization of the transept, see Kimpel, *Querhausarme von Notre-Dame,* 78–79.

17. Bony, *French Gothic Architecture,* 411–13. The author reproduces folio iv of the Psalter and discusses this aspect of Rayonnant architecture specifically in relation to the transept façades of Notre-Dame.

18. The closest parallel to the Psalter is found in the architectural framing of a group of ivories created in northern

France and possibly Paris ca. 1250–70. Among the earliest is Baltimore, Walters Art Gallery 71.157; see R. Randall et al., *Masterpieces of Ivory*, 200, no. 266, and its counterpart at the Cluny; for a discussion of the two ivories, see *Images in Ivory*, 132–33. For a similar architectural fragment, from the north portal of Notre-Dame in Paris, see Erlande-Brandenburg and Thibaudat, *Les sculptures de Notre-Dame de Paris*, fig. 265.

19. Frodl-Kraft, "Zu den Kirchenschaubildern in den Hochchorfenstern von Reims"; see also Caviness, *Sumptuous Arts*, 133. Although the architectural elements are clear, the glass does not copy the actual elevations of the depicted façades.

20. Braun, *Die Reliquiare des christlichen Kultes*, 493–97.

21. The practice may have received its impetus from the Sainte-Chapelle, which Louis IX had built to house some of the most precious relics of Christianity; for the Sainte-Chapelle reliquary and the shrinelike character of the building, see Branner, "The Grande Châsse of the Sainte-Chapelle," and idem, *St. Louis and the Court Style*, 56–59. A critical but unknown factor in the evolution of this type of shrine is the earlier but lost *châsse* of Saint Geneviève; see Bapst, "La châsse de Saint-Geneviève."

22. See the remarkable dossier and series of studies published in *Un trésor gothique*. Also studied is the shrine of Saint Taurin at Évreux; see Braig, *Der Schrein des Heilgen Taurinus in Evreux*, and Taralon, "La châsse de Saint-Taurin d'Évreux." Cf. also Bucher, "Micro-Architecture."

23. Kurmann, "Cathédrale miniature ou reliquaire monumental?"

24. Boerner, "Interprétation du programme iconographique de la châsse de Sainte Getrude à Nivelles."

25. See the examples dating from the 1260s in Gaborit-Chopin, "Nicodème travesti."

26. Von Euw, "L'enluminure," esp. 264–66, 274. The author recognizes the distinct character of these illustrations but refrains from connecting them with shrines in specific ways. On the influence of metalwork in Gothic illumination more generally, see Rau, *Die ornamentalen Hintergründe in der französischen gotischen Buchmalerei*, esp. 109–15, and Beer, "Marginalien zum Thema Goldgrund."

27. See *Un trésor gothique*, nos. 51, 53, 54, and von Euw, "L'enluminure," figs. 3, 11, 12.

28. See Stahl, "Heaven in View," and idem, "Les frontispices enluminés d'un livre d'heures à Cambrai."

29. For detailed discussion, see pages 173–74 above.

30. Gen. 18:18.

31. Esmeijer, *Divina Quaternitas*, 104–9; Klapisch-Zuber, "La genèse de l'arbre généalogique."

32. See Augustine, *Quaestionum in Heptateuchum libri VII*, in *PL*, vol. 34, col. 557—that from Abraham will come Ecclesia—or his description in the *City of God* (chap. 29) of the double promises at Mamre concerning the nations of Israel according to the flesh and all nations according to the faith; cf. Anselm of Laon, *Glossa ordinaria*, in *PL*, vol. 113, col. 128.

33. See the Pontifical of Durandus of Mende, in *Le pontifical romain au Moyen-Âge*, 3:472, lines 15–17; 477, lines 99–100; 487, line 22; and, for a summary account, Andrieu, *Symbolism of Churches and Church Ornaments*, 96, 118, 188. See also "In dedicatione ecclesiae," in *Thesauri Hymnologici Hymnarium*, 1:112–14.

34. Heck, *L'échelle céleste dans l'art du Moyen Âge*, 211–14. For a discussion of the import of the ritual, which applies equally at a later date, see Remensnyder, *Remembering Kings Past*, 30–35.

35. For the latter, see the examples in Haussherr, "Templum Salomonis und Ecclesia Christi."

36. Carruthers, "The Poet as Master Builder." Although the author does not discuss architectural frames, see her remarks on how the trope of building serves both the static function of containing and the dynamic one of providing access to subject matter for thought, devotion, and invention.

37. For possible references to the Augustinian idea in the miniature of Cain and Abel (fol. 1v), see pages 169–70 above. For tenth-century miniatures that use architectural frames to represent a similar idea of Ecclesia, see Rosenthal, "The Unique Architectural Settings of the Arenberg Evangelists." See also the interpretation in Reudenbach, "Die Londoner Psalterkarte und ihre Rückseite."

38. Guérout, "Le Palais de la Cité" (1949); on Louis IX, see 157–74. Birkmeyer, "The Arch Motif in Netherlandish Painting," 5, comments that the contemporaneity of the architecture serves to earmark the manuscript for a specific user.

39. Branner, *St. Louis and the Court Style*, 112–13; Kimpel and Suckale, *Gotische Architektur*, 468.

40. For diplomatic and artistic relations, see J. Richard, *Saint Louis*, 55–61, 90–91, 100, 198–205, 264–66, and passim.

41. For Saint-Denis, see Nebbiai-Dalla Guarda, *La Bibliothèque de l'Abbaye de Saint-Denis*. Several writers have noted the existence at Saint-Germain-des-Prés of a seventh-century Greek Bible in folio written in uncial, "une très belle Bible" in folio and in Latin sent by Justinian to Childebert, a sixth-century Psalter, and a fragment of a text by Virgil; see Maichel, *Introductio ad historiam literariam de præcipuis bibliothecis parisiensibus*, 62–64; Nemeitz, *Le séjour de Paris*, 1.159; Franklin, *Les anciennes bibliothèques de Paris*, 1:127–30; and Lesne, *Histoire de la propriété ecclésiastique en France*, 4:37. It is unclear if any of these books at Saint-Germain were illuminated.

42. Wormald, *Winchester Psalter*, fig. 5; Haney, *Winchester*

Psalter, 13–14, fig. 2. For Cain's turning away, see the eleventh-century Ripoll Bible in Neuss, *Bibelillustration*, fig. 5a, and cf. Haney, *Winchester Psalter*, 13–14, fig. 2, and idem, "Some Old Testament Pictures," esp. 37–38. Cf. also Weitzmann and Kessler, *Cotton Genesis*, 60, who interpret Cain's turning away as referring to his curse, not his rejection. Cf. also the Arsenal Old Testament in Buchthal, *Miniature Painting*, pl. 58. Both Cain's turning away, presumably in anger, and the contrast between the kneeling and standing brothers continue in English works of the late twelfth century: for example, the Munich Psalter, folio 9r, and the Malmsbury and Warwick ciboria, where Cain faces Abel but his head and feet are already turned away. See Graham, "Old Testament Cycles," 62–63, and Stratford, "Three English Romanesque Enamelled Ciboria," 204–16 and figs. 36, 37. The motif of the *manus dei*, which makes its unique appearance in the Psalter in this miniature, widely occurs in English and Spanish works.

43. See the psalter leaf illuminated by William de Brailes in Cambridge, Fitzwilliam Museum, MS 330, no. 2; Morgan, *Early Gothic Manuscripts*, 1:118–19, no. 72. The juxtaposition is found in the late-twelfth-century Roman fresco at San Giovanni a Porta Latina and is likely to go back to an earlier Italian tradition; see Wilpert, *Die römischen Mosaiken und Malereien* (1916), 4:256; Styger, "La decorazione a fresco del sec. XII della chiesa di S. Giovanni a Porta Latina"; Bergman, *Salerno Ivories*, esp. 14 n. 14.

44. For Cambridge, St. Johns College, MS K.26, see Morgan, *Early Gothic Manuscripts*, 2:182–83, no. 179. Henderson, "Sources of the Genesis Cycle at Saint-Savin-sur-Gartempe," 18–21 (rpt., 121), notes the unusual number of ways the brothers are differentiated in this manuscript and earlier at Saint-Savin.

45. E.g., Fawtier, *Bible historiée*, pl. 22; Laborde, *Bible moralisée*, pl. 8; *Old Testament Miniatures*, 31, no. 11.

46. Among others, see fols. 4r, 5v, 7v, 12r, 13v, and 17v in this book's Psalter reproductions. This is not to exclude relations to French and Mosan works of about the same date, as folios 10r and 11v reflect.

47. Pächt, Dodwell, and Wormald, *Saint Albans Psalter*, 51–52; Buchthal, *Miniature Painting*, 56; Stahl, "Iconographic Sources," 226–29 and passim. Deuchler, *Ingeborgpsalter*, 140–41. This aspect of the Blanche Psalter has not been addressed in the literature. However, subjects like the Fall of the Rebel Angels (Martin, *Psautier*, pl. 20) are more similar to early English painting, such as the Aelfric Paraphrase, than to more recent Continental works; cf. Stahl, "Iconographic Sources," 65–67.

48. For further discussion, see the next chapter. On the Leiden Psalter, see note 89 to the Introduction.

49. Panofsky, *Early Netherlandish Painting*, 1:270–71.

50. See, for example, fols. 3v, 5v, 7v, and 8r (the last three to be found in this book's Psalter reproductions).

51. In addition to those discussed in this chapter, see especially fols. 5v, 8r, 30r, 50r, 52r, 63v, 64r (5v, 8r, 30r, and 52r reproduced in this book).

52. E.g., Manchester, John Rylands French 5, fol. 39v; *Old Testament Miniatures*, no. 44; Bucher, *Pamplona Bibles*, pl. 88a.

53. Vienna, ÖNB, MS 2554, fol. 24r: "Ce qe ioseph se mostra a ses freres et lor dist ie sui vostre frere senefie iesu christ qi dist a ses apostles ie sui li boens pastor et met mon ame por mes oelles."

54. Vienna, ÖNB, MS 1179, fol. 22r: "Ostendens manib[us] expansis q[uo]d p[ro] mundi salute pie passus est dioens. Ego sum salvator n[os]t[e]r. Ego sum redemptor v[os]t[e]r."

55. Derpmann, *Die Josephgeschichte*, 74–75 and passim.

56. In antiquity, removing one's mantle had similar connations of self-revelation; see Harrison, "Apollo's Cloak," 91–98.

57. For Bathsheba, see Chapter 5. For a Jewish legend that explains why Joseph revealed himself bodily, see Ginzberg, *Legends of the Jews*, 1:112. For discussion of possible implications of the Joseph figure for the king, see the Conclusion.

58. It is indicative that the most telling relations are those between the Psalter and the two early *Bibles moralisées* manuscripts in Vienna, the two that Haussherr has shown depend most directly on the lost archetype. The differences are especially clear in the representations of Joseph Revealing Himself, for the Toledo and Oxford versions revert to standard compositions; cf. Toledo fol. 25v; Laborde, *Bible moralisée*, pl. 31. In some cases quite singular elements, such as the heroic figure of Abraham (Psalter fol. 5v) or the ladder Joseph uses to climb out of the cistern (Psalter fol. 17v), are found only in the Latin copy, Vienna 1179, folios 8r and 14r, one of the manuscripts in which there is clear evidence of royal patronage; cf. pages 16–19 above. This early phase in the evolution of *Bible moralisée* imagery seems to have been critical for the Psalter.

59. Szirmai, *La Bible anonyme*, lines 3223–28.

60. The prefatory miniatures, which precede a psalter written in Germany, were attributed to northern France by Haussherr, "Zum Psalter cod. S. n. 2611," and Branner, *Manuscript Painting in Paris*, 101–2; but see Pächt and Thoss, *Französische Schule I*, 121–26, who relate the Genesis miniatures to those in a group of manuscripts centering on the Roman de Poire (Bibl. Nat., MS fr. 2186). Similarities include figure style, decorative borders, backgrounds, technique, and palette. For other relations between the Vienna manuscript and the Psalter, see pages 91–94 above.

61. 1 Sam. 5:9.

62. 1 Sam. 5:6–9. The passage refers to the plague affecting old and young alike, but the Vulgate cites only tumors, whereas the Septuagint (6:1) refers to swarms of mice. The Morgan Picture Book and most versions of the *Bibles moralisées* depict a plague of mice or small rodents; cf. *Old Testament Miniatures*, no. 138 (fol. 21v); Haussherr, *Bible Moralisée*, pl. 88; Vienna 1179, fol. 87v; Toledo fol. 101v.

63. E.g., fols. 57v, 62r.

64. Cf. Haussherr, *Bible Moralisée*, pl. 88; for heterosexual abuse, see pl. 108. See also Heinlein, "Ideology of Reform," chap. 3, and Tammen, "Bilder der Sodomie."

65. Cf. also Haussherr, *Bible Moralisée*, pl. 88; Toledo fol. 101v.

66. Laborde, *Bible moralisée*, pl. 131.

67. *Les quatre livres des rois*, 12, where the statement that the men are attacked in their most private parts is explained thus: "E por çó les volt la turmenter, kar servid aveient de ord mestier ki est contre nature."

68. For the text, see Appendix 11.

69. Cf. fols. 37v, 61v.

70. 1 Sam. 6:13.

71. *Old Testament Miniatures*, no. 139 (fol. 21v). Cf. also Warner, *The Guthlac Roll*, pl. 25.

72. See also Laborde, *Bible moralisée*, pl. 131, and Toledo fol. 88r.

73. The *Bible moralisée* identifies both the Philistines and evil Beth-Shemites as Saracens, its term in this period of the Crusades for the enemies of God and Israel. Cf. Comfort, "The Literary Role of the Saracens in the French Epic," and Jones, "The Conventional Saracens in the Songs of Geste." The triangular objects are typical of scenes of heavenly punishment; cf. Haussherr, *Bible Moralisée*, pl. 60.

74. Cf. *Les quatre livres des rois*, 23; Petrus Comestor, *Historia scholastica*, in *PL*, vol. 198, col. 1301C; Babilas, *Untersuchungen*, 100–102, 266–68. See also the history of the Ark's return to Israel in the reliefs of the column-statue bases of the north transept at Chartres cathedral (Sauerländer, *Gotische Skulptur*, figs. 55–57). In the final scene an angel leads the wagon with the Ark back to Israel. With the *Bible moralisée* omitting some essential details, such as the men who reap in the fields, none of the extant manuscripts could have been the direct source for the Psalter minature.

75. G. Cornut, *Historia susceptionis corone spinee*, in Riant, *Exuviae sacrae constantinoplitanae*, 1:47; Morand, *Histoire de la Sainte-Chapelle royale de Paris;* Branner, *St. Louis and the Court Style*, 56–84; Grodecki, "Sainte Chapelle de Paris"; Kimpel and Suckale, *Gotische Architektur*, 400–405, 528; Leniaud and Perrot, *Sainte Chapelle;* A. A. Jordan, "Narrative Design"; idem, *Visualizing Kingship.*

76. Grodecki, "Sainte Chapelle de Paris," 78–84; von Simson, "Opere superante materiam"; Leniaud and Perrot, *Sainte Chapelle;* Brenk, "Sainte-Chapelle"; and Weiss, "Architectural Symbolism"; A. A. Jordan, *Visualizing Kingship.*

77. On the possible relation between the two works, see Christe, "Les Bibles moralisées et les vitraux de la Sainte-Chapelle."

78. Grodecki, "Sainte Chapelle de Paris," 126–27, 143, 160, is appropriately cautious, given the evidence that some panels are reordered, restored, or lost. For revisions to his reconstruction, see A. A. Jordan, "Narrative Design."

79. The similar battle scenes in the episode of the Israelites fighting the Amalekites (fol. 34r and Grodecki, "Sainte Chapelle de Paris," N-65) reflect a pictorial formula widely in use. For other details or motifs with similarities to the Psalter, see Grodecki, "Sainte Chapelle de Paris," L-86, K-32, K-48, D-102, and M-62. Other compositions and details of the glass are far more similar to the Morgan Picture Book; for example, cf. Grodecki, "Sainte Chapelle de Paris," O-255, N-108, K-9/10, B-133, and B-134 to *Old Testament Miniatures*, nos. 3, 51, 101, 137, and 140, respectively. See also Stahl, "Iconographic Sources," 35–37 and passim. Grodecki, "Sainte Chapelle de Paris," 83, is cautious about earlier views that explain the glass in relation to the *Bible moralisée.*

80. For the Lord instructing Joshua, see Neuss, *Bibelillustration*, fig. 15, and Bucher, *Pamplona Bibles*, figs. 161b–162a. In thirteenth-century French Bibles the Lord appears to Joshua, who is accompanied by two men and standing beside the Jordan; cf. Branner, *Manuscript Painting in Paris*, 84f. This arrangement is found earlier in the Stavelot Bible (London, Brit. Libr. Addit. 28106, fol. 75v) and is especially characteristic of the Bibles that are contemporary with the Psalter, for example, Arras, Bibl. de la Ville, MS 1, fol. 130r. In the *Bible moralisée*, the Lord gives Joshua the Law (Laborde, *Bible moralisée*, pl. 93). For the more common military interpretations, see the Winchester Bible (in Oakeshott, *Two Winchester Bibles*, fig. 73), the Admont and Gumpert Bibles (G. Swarzenski, *Die Salzburger Malerei*, figs. 98, 118), and a Bible in Einsiedeln, Stiftsbibl. MS 1 (*Scriptoria Medii Aevi Helvetica*, vol. 5, pl. 23). In the Octateuchs Joshua stands in the center of the miniature and glances up to the hand of God as soldiers stand at either side; see Hesseling, *Miniatures de l'Octateuque*, fig. 268, or Ouspensky, *L'Octateuque*, no. 216. The pictorial tradition of Joshua's commission to bring the Israelites into the Holy Land may go back to Early Christian art; see Tronzo, *The Via Latina Catacomb*, 56.

81. James, *A Descriptive Catalogue of the Manuscripts in the Library of Pembroke College*, no. 54.

82. Cf. Vienna 1179, fol. 62r, and Oxford, MS Bodley 270b, fol. 93v (Laborde, *Bible moralisée,* pl. 93). The Lord gives Joshua a book or sheaf of parchment as a group of young men stand to the right; the Oxford text reads in part, "Commendant dominus josue mandata legis et custodiam populi."

83. Grodecki, "Sainte Chapelle de Paris," 151 (L-152/53), cites Deut. 34:9 for the fifth panel and Deut. 31:7 and 34:9 for the sixth; cf. A. A. Jordan, "Narrative Design," 434, and idem, *Visualizing Kingship,* 22–23, 100, 164.

84. He exceptionally wears a crown in one miniature in the eleventh-century Octateuch, Rome, Bibl. Apost. Vat., MS gr. 747, fol. 212v, where he is crowned as Moses' successor; see Weitzmann and Bernabò, *The Byzantine Octateuchs,* vol. 2, fig. 1018.

85. Even Gideon, who refused to rule, is shown crowned in panel K 42/43; see Grodecki, "Sainte Chapelle de Paris," 167, and von Simson, "Opere superante materiam," 604–5. However, prophets or judges, such as Moses, are not crowned.

86. Grodecki, "Sainte Chapelle de Paris," 83, 128–29 (M-147 to M-180, esp. M-160 to M-167). These "coronations" of the heads of the tribes are exceptional; for the royal implications, see Brenk, "Sainte-Chapelle." I know of no medieval documents that attest to this recessed space as the king's.

87. Cf. fols. 30r, 33v, and 35v. For the possible sources of this motif, see pages 105–6 above.

88. New York, Pierpont Morgan Library, MS M.638; Paris, Bibl. Nat., MS n.a.l. 2294; Los Angeles, J. Paul Getty Museum, MS Ludwig I, 6. The manuscript is sometimes referred to as the Maciejowski Bible or Shah Abbas Bible, after two of its later owners. It has been published in full three times, first by Cockerell, James, and Ffoulkes, *A Book of Old Testament Illustrations of the Middle of the Thirteenth Century* (1927); second, in *Old Testament Miniatures* (1969); and third by Weiss et al., *The Morgan Crusader Bible* (1998–99). In these notes I refer to the Morgan miniatures by number, which are the same in both *Old Testament Miniatures* and *The Morgan Crusader Bible.* For a comprehensive review of the issues as well as earlier bibliography, see Plotzek and von Euw, *Handschriften der Sammlung Ludwig,* 1:72–79, and Weiss et al., *The Morgan Crusader Bible.*

89. For Paris, see Buchthal, *Miniature Painting,* 56; Grodecki, "Les origines de la peinture gothique," esp. n. 59; Stahl, "Old Testament Illustration," 89–90 n. 9; and Weiss et al., *The Morgan Crusader Bible,* 233–37 (Weiss prefers the dates 1244–54). For England, see Vitzthum, *Die Pariser Miniaturmalerei,* 15–16; Branner, *Manuscript Painting in Paris,* ix. For northern France and possibly Flanders, see

Stones, "Sacred and Profane Art," esp. n. 24; Avril, "L'enluminure à l'époque gothique" (1979), 226–27; Beer, "Pariser Buchmalerei," 78–79; Bräm, "Buchmalerei des 13. und 14. Jahrhunderts," esp. at 81. In two reviews in the *Burlington Magazine* 113 (May 1971): 278–79, and 121 (June 1979): 390, Janet Backhouse suggests northern French artists working in Naples about 1270.

90. The Latin, Persian, and Hebrew texts were added in the fourteenth, seventeenth, and nineteenth centuries; see Plotzek, *Das Perikopenbuch Heinrichs III.* On the question of picture books at this time, see Hull, "Rylands MS French 5," 13.

91. Stahl, "Iconographic Sources," 22–37, 56–57, 84–85, 201–9.

92. Grodecki, *Sainte-Chapelle,* 100, and idem, "Les origines de la peinture gothique," 61; Weiss et al., *The Morgan Crusader Bible,* 236, 243–44.

93. Stahl, "Old Testament Illustration," 90 n. 9. An analysis of the paint and understructure undertaken by Paulette Hugon of the Laboratoire de recherche des monuments historiques leaves no doubt regarding the originality of the paintings and their relation to what remains of the wall paintings of the upper chapel. Others have recognized the restricted currency (if not the origin) of this style of painting in Paris; see Avril, "L'enluminure à l'époque gothique," and Beer, "Pariser Buchmalerei."

94. In Cockerell, James, and Ffoulkes, *A Book of Old Testament Illustrations of the Middle of the Thirteenth Century,* 6, 21.

95. Weiss et al., *The Morgan Crusader Bible,* 246–48.

96. The barons returned from their Crusade in 1241, and Louis IX vowed to lead another in 1244. Although Innocent IV did not proclaim a Crusade until June 1245, this phase of the crusading movement dates at least to Gregory IX's encyclical *Rachel suum viden* of 1234. See W. C. Jordan, *Louis IX and the Challenge of the Crusade,* 3–13, esp. 9; J. Richard, *Saint Louis,* 92–95; Cole, *The Preaching of the Crusades,* 159–64.

97. Stahl, "Old Testament Illustration," 87–89; Leniaud and Perrot, *Sainte Chapelle,* 200; Caviness, "The Simple Perception of Matter," 51; A. A. Jordan, "Narrative Design," chap. 1; Weiss, "Architectural Symbolism, " 317–19; Weiss et al., *The Morgan Crusader Bible,* 229–33.

98. The Psalter's more literal approach to the story is also found in the *Bibles moralisées,* which do not illustrate the episode outside the tent but do have Sisera's body shown to Barak, the final epsiode in the Morgan painting. See Laborde, *Bible moralisée,* pl. 106.

99. See, for example, fols. 46r, 47v, 58r, and 66r (46r and 47v reproduced in this book). For other, tripartite compositions, see *Old Testament Miniatures,* nos. 77, 115, 203, and the Psalter fols. 17v and 57v (17v reproduced in this book).

100. Among the former are several miniatures at the beginning of the cycle, such as the Drunken Noah Covered by His Sons (fol. 4r); among the latter, Samson and the Foxes (fol. 58r). The latter category includes a number of subjects in the Morgan manuscript that are not illustrated in the Psalter—for example, *Old Testament Miniatures,* no. 64 (the Passage of the Red Sea).

101. Between the eighth and thirteenth centuries extensive Old Testament cycles are recorded at Charlemagne's palace at Ingelheim, the cathedral at Mainz, Henry III's castles at Winchester and Windsor, Saint Stephen's chapel at Westminster, and in the bedroom of Adele of Normandy's palace. Nothing remains of these paintings, and preserved wall paintings executed before the mid–thirteenth century give no hint of the complex and sophisticated compositions of the Morgan Picture Book. However, a few decades later, the Painted Chamber at Westminster Palace, recorded in watercolors, and the extant murals at Sainte-Radegonde (Aveyron) and the cathedral of Clermont-Ferrand strongly imply they existed. For descriptions of the earlier cycles, see *Poetae Latini aevi Carolini (II),* 64–65; von Schlosser, *Quellenbuch zur Kunstgeschichte des abendländischen Mittelalters,* 158–73, 218–31; Tristram, *English Medieval Wall Painting,* 2:1, 567–77, 610–11, 622–23. For the Westminster Palace paintings as well as a discussion of the documents and possible French sources, see Binski, *Painted Chamber,* esp. 86–96 and pl. x. For Sainte-Radegonde and Clermont-Ferrand wall paintings, see Deschamps and Thibout, *La peinture murale en France au début de l'époque gothique,* 117–18, pl. LVII, and 145–46, pl. LXXVIII, respectively. The authors date these paintings to the reign of Saint Louis or Philippe III. Cf. also Deschamps, "Combats de cavalerie et épisodes des Croisades." On the extensive losses of painted murals in one region of France, see Mesuret, *Les peintures murales du Sud-Ouest de la France.*

102. See page 98 and note 90 above. For a later illuminated manuscript with figures of similar monumentality and realism and in which one of the two artists was trained in monumental painting, see Stones, *Le livre d'images de Madame Marie,* 19–20, and the related comments in my review in *Speculum.*

103. E.g., fols. 5v, 38r, 52r, 57v, 75v.

104. The *Bible moralisée* scenes are unrelated (cf. Laborde, *Bible moralisée,* pl. 105), and the two relevant Sainte-Chapelle panels are modern (cf. K-61/62).

105. For the illustrated Octateuch manuscripts, see Lowden, *Octateuchs,* and Weitzmann and Bernabò, *The Byzantine Octateuchs;* for the Castilian Bibles, see Williams, "The Bible in Spain."

106. Cf. Hesseling, *Miniatures de l'Octateuque,* fig. 238; Ouspensky, *L'Octateuque,* fig. 173; Huber, *Bild und Botschaft,* fig. 32; Weitzmann and Bernabò, *The Byzantine Octateuchs,* vol. 1, pp. 204–5, and vol. 2, figs. 966–70.

107. Weitzmann and Bernabò, *The Byzantine Octateuchs,* vol. 1, p. 159, and vol. 2, figs. 664–67. No boils appear on the sorcerers' skin.

108. The platform on which Joshua stands is like the pedestals used by Joseph in folio 24r or by Pharaoh in folio 30r. Because the wall has two arches and a surface like that of the Tomb of Rachel (fol. 73v), the artist may have intended to show a particular quality of stone, such as marble, and a roadway or viaduct of some sort. However, it cannot be a bridge over the Jordan, because no water is shown; it may, however, imply a transition.

109. Weitzmann and Bernabò, *The Byzantine Octateuchs,* vol. 1, p. 224, and vol. 2, figs. 1122–26. Dressed in armor, Joshua stands in a landscape between two groups of Israelites armed with lances, and he looks up toward the hand of God, who appoints him as Moses' successor.

110. See Cutler, "The Psalter of Basil II," esp. 15, and idem, "The Aristocratic Psalters in Byzantium." The architrave and wall separate David's throne and his kneeling in penitence before Nathan, both in the foreground, from the domed ciborium and David's subsequent prayer in the background. The architectural elements thus separate the court setting from the devotional setting.

111. See, for example, Rome, Bibl. Apost. Vat., MS gr. 1613, fols. 29, 81, 98, 177, reproduced in *Il Menologio di Basil II.*

112. Belting and Cavallo, *Die Bibel des Niketas,* esp. 33–37 and 41, appropriately relate its use in this manuscript to developments in architectural backgrounds, on the one hand, and to the tradition of author portraits, on the other. For the Copenhagen manuscript, see also Lowden, *Illuminated Prophet Books,* 15–16, 20, 31.

113. E.g., Lowden, *Illuminated Prophet Books,* figs. 26, 76.

114. Ibid., figs. 123, 124, 127, 128. There is some evidence to suggest that such portraits were an early practice in the books of the Septuagint, for standing portraits appear in a sixth-century Syriac Bible in Paris, Bibl. Nat., MS syr. 341, fol. 52v. There an image of Joshua in armor, standing frontally, alone, and looking up to the hand of God introduces the eponymous biblical text. The illustrations to the books of the Pentateuch and Job are narrative. Cf. also the late-twelfth-century Bible in Cambridge, University Library, MS 001.002, fol. 63v. See Leroy, *Les manuscrits syriaques,* 208–19, 241–53, esp. 209–10, 242, and pls. 44,1 and 62,1. See also Lowden, *Illuminated Prophet Books,* 72, 82, 89–90.

115. See, for example, Spatharakis, *The Portrait in Byzantine Illuminated Manuscripts,* figs. 6, 7, 72, 79.

116. E.g., ibid., figs. 69, 71, 95.

117. Weitzmann and Bernabò, *The Byzantine Octateuchs,* vol. 1, p. 224, and vol. 2, figs. 1122–26.

118. Ibid., vol. 1, pp. 227–28, and vol. 2, figs. 1153–58.

119. Rome, Bibl. Apost. Vat., MS Palat. gr. 431; Weitzmann, *Joshua Roll,* and Lowden, *Octateuchs,* 50–52, 105–19, and passim.

120. Lowden, *Octateuchs,* 109–10.

121. Weitzmann and Bernabò, *The Byzantine Octateuchs,* vol. 2, figs. 1153–64.

122. For a summary of Octateuch-inspired works, see Weitzmann and Bernabò, *The Byzantine Octateuchs,* 1:5–6. See also Lowden, *Octateuchs,* 94–104, 122–23. Lowden's cogent and incisive remarks about the fallacies connected with using an Octateuch recension as a historical explanation or historiographic construction require that many earlier arguments be revised, including several of my own in Stahl, "Iconographic Sources." Lowden sensibly argues that the only manuscripts in the Octateuch recension are the Octateuchs themselves and that in the absence of a context in which a direct connection with these works can be demonstrated, the relation is likely to depend upon the influence of famous pictures or other intermediaries.

123. Harvey Stahl, paper on the Saint Louis Psalter given in Parma, 2001.

124. In addition to the subjects discussed in this chapter, see especially fols. 41v–43v, 45v–46r, 55v–57v, 62r.

125. For example, Guillelmus Brito's account attributing the availability of new works by Aristotle to translations of texts recently brought to Paris from Constantinople; see Grabmann, *I divieti ecclesiastici di Aristotele sotto Innocenzo III e Gregorio IX,* 11.

126. Stahl, "Iconographic Sources," 122, 127–56. See also Haussherr, "Beobachtungen an den Illustrationen zum Buche Genesis in der Bible Moralisée."

127. For example, the inventory of the Clarissan abbey of Longchamp, for which, see MBynarczyk, *Ein Franziskanerinnenkloster im 15. Jahrhundert,* 298, item 263: "Item, autre livre de plusiers ystoires de la Bible en estrange langue." Many of the Longchamp books belonged to the princesses of France. See also the fifteenth-century inventory of the library of Charles V, which records "un psautier très ancien, historié et enluminé d'ancienne façon," in Delisle, *Recherches,* 2:12, no. 57.

128. Le Nain de Tillemont, *Vie de Saint Louis,* 2:305–11, 344, and 3:5–6, 161, places Baldwin II in Paris in 1237, 1239 (in May, after the sale of the Crown of Thorns), and 1247. He seems to have been constantly in debt to both Louis and his mother.

129. Paris, Bibl. Nat., MS Coislin 200. For this thirteenth-century New Testament, which Louis IX received in 1269, see *La France de Saint Louis,* no. 210.

130. J. Richard, *Saint Louis,* 321.

131. See Gassman, "Translatio Studii," 413–609, esp. chap. XIV, on Vincent of Beauvais. For earlier literature, see Gilson, *La philosophie au Moyen Âge,* 193–99; Grundmann, "Sacerdotium—Regnum—Studium"; Jongkees, "Translatio Studii." For the Carolingian roots of the *translatio studii* and its political implications during the reign of Louis IX, see Lusignan, "L'Université de Paris comme composante de l'identité du royaume de France." An interesting parallel is the later translation of ancient texts into French, together with the increasing frequency with which they were dedicated to the king, during the reigns of Philippe the Fair and Charles V; see Copeland, *Rhetoric,* 133–35, and C. R. Sherman, *Imaging Aristotle,* 3–12.

132. For Innocent III's pleas to the masters and scholars of Paris to renew the study of letters in Constantinople, see his "Ad magistros et scholares Parisiensis," in *Chartularium Universitatis Parisiensis,* pt. 1, no. 3 (1:62–63); see also Gassman, "Translatio Studii," 351–63.

133. J. Richard, *Saint Louis,* 90–91, 139, 149, 266.

134. See note 125 above.

135. For the two chapels, and for Robert of Clari's description of the *sancta capella* as so filled with a heavenly light from the brilliance of the materials that the visitor was almost blinded, see Weiss, "Architectural Symbolism," 318–19.

136. Baldwin, *Government of Philip Augustus,* 378–80; Le Goff, *Saint Louis,* 169–75, 181.

137. Goez, *Translatio imperii,* 167–70, 199–202; and see Schmidt-Chazan, "L'idée d'empire dans le *Speculum historiale* de Vincent de Beauvais," esp. 282.

138. E.g., Weitzmann and Bernabò, *The Byzantine Octateuchs,* vol. 2, figs. 794–97; Haussherr, *Bible Moralisée,* pl. 56.

139. Léon, Colegiata de San Isidoro, cod. 2 (Bible of 960), the work of the monks Sanctius and Florentius. See Pérez Llamazares, *Catálogo de los códices y documentos de la Real Colegiata de San Isidoro de Léon,* 3, 4–18, and Galindo, "La 'Biblia de Léon' del 960." For the copy of 1162, now Léon, Colegiata de San Isidoro, cod. 3, see Pérez Llamazares, *Catálogo,* 19–24, and Cahn, *Romanesque Bible Illumination,* 66–70, 290. For both, see Pijoán, "Les miniatures de l'Octateuch à les Bibles romàniques catalanes"; Neuss, *Bibelillustration,* 72–75 and passim; and Williams, "The Bible in Spain." A third manuscript of this group is a two-volume Bible of San Millán, a thirteenth-century manuscript now in Madrid, Real academia de la historia (Cod. 2–3), for which, see Williams, "Castilian Tradition." The two later Bibles copy some miniatures in the Bible of 960, but each one adds others or alters the model.

140. Cf. fol. 35v in this book's Psalter reproductions.

141. In earlier articles, such as "Castilian Tradition," John

Williams has noted the use of the Vetus Latina in the marginal glosses and the unframed and presumably early "papyrus" style of painting, both of which suggest that the Bible of 960 was copied after a manuscript of Visigothic or earlier date. In "The Bible in Spain," however, Williams sees the influence of Carolingian art and of local liturgical lections and concludes that many scenes in the Bible of 960 were invented at Valeranica as the artist and scribes worked. They influenced only the Bible of 1162 and the Bible of San Millán.

142. See Psalter fols. 23v, 30r, 33v, 38r, 45v, 51v, 52r (all but 33v reproduced in this book). For the Bible from Sant Pere de Roda (Paris, Bibl. Nat., MS lat. 6) and that from Santa Maria de Ripoll (Rome, Bibl. Apost. Vat., MS Vat. lat. 5729), see Neuss, *Bibelillustration,* 10–15; Cahn, *Romanesque Bible Illumination,* 70–80, 292–93, with bibliography; for the Pamplona Bible, see Bucher, *Pamplona Bibles.*

143. In light of the cultural relations the French court maintained with Castile, an Iberian model cannot be ruled out; in fact, a Pamplona Bible was copied in Paris ca. 1320 and may have been there earlier; see Bucher, *Pamplona Bibles,* 69–70. Nevertheless, works from other regions—both early manuscripts and later works that are apparently modeled after them—are no less relevant. Two such works are the late-sixth- or seventh-century Ashburnham Pentateuch and the fourteenth-century Italian Rovigo Bible. For the Ashburnham Pentateuch, which has been attributed to North Africa, Spain, and Italy, see Gebhardt, *Miniatures of the Ashburnham Pentateuch;* Narkiss, "Towards a Further Study of the Ashburnham Pentateuch"; Rickert, *Studien zum Ashburnham Pentateuch,* esp. 12–19; D. Wright, "Canon Tables of the Codex Beneventanus," esp. 147–51; Verkerk, *Liturgy and Narrative,* esp. chap. 5; idem, "Exodus and Easter Vigil in the Ashburnham Pentateuch"; and idem, "Biblical Manuscripts in Rome 400–700 and the Ashburnham Pentateuch." For the complex case of the Rovigo Bible, which in places has much in common with the Octateuchs, see Folena and Mellini, *Bibbia istoriata padovana,* and especially Arensberg, "Padua Bible," chap. 3, who finds that the manuscript depended in part on an Early Christian cycle as transmitted back across the Alps through such northern Gothic pictorial cycles as that of the Psalter of Saint Louis.

144. The lower frame is not a factor in folio 40r, where the figures are behind a wall, though some are so low that only the very tops of their heads are visible. Here the pictorial field imaginatively extends beyond the frame not only to the left and right but also downward.

145. E.g., fols. 37v, 73v, 85v.

146. See the first, third, and sixth registers of the miniature. Interestingly, the other examples of figures cut off by the lower frame in the Roda and Ripoll Bibles are limited to Old Testament illustration, especially Genesis through Kings and Job; see also, for example, Neuss, *Bibelillustration,* figs. 86, 87, 102, 103, 123–25, and cf. Bucher, *Pamplona Bibles,* figs. 65, 79, 80, 82.

147. Maekawa, *Narrative and Experience,* 43 and n. 67.

148. The two facing miniatures may also contrast false and true faith; cf. Deuchler, *Ingeborgpsalter,* pls. 8–9, discussed on pages 139–43 above; for the desert tabernacle, see pages 165–66 above.

149. See pages 104–5 and notes 123–24 above.

150. Smalley, *Study of the Bible,* 331–46. Guérout, "Le Palais de la Cité" (1949), 167, suggests that the rolls and books confiscated from the Jews, some of which found their way into the royal library, were already in the Trésor des Chartres during the reign of Louis IX.

151. Cf. page 54 above and note 181 to Chapter 1.

152. For the Morgan Picture Book, see Stahl, "Iconographic Sources," 84–120. Although I would now hesitate to make several of the comparisons cited there, I still find those involving Spanish and Early Christian works to be particularly provocative.

153. I assume there was one author, although there may have been more.

154. For the French texts, see Appendix II.

155. Gen. 37:10.

156. See especially fol. 57v.

157. In earlier works the illustration of Pharaoh making Joseph his minister is usually followed either by a depiction of the Egyptians acclaiming Joseph in a chariot or wagon or by a depiction of the next episode, his ordering the storage of grain (fol. 23v). By the thirteenth century these two subjects were often conflated into a single scene, as they are here.

158. *Old Testament Miniatures,* nos. 221, 236. These reflect the pictorial influence of Christ's Entry into Jerusalem.

159. For the properties of tenses within the structure of narrative discourse, see Hopper, "Aspect and Foregrounding in Discourse."

160. For example, see, respectively, the moralizations in Laborde, *Bible moralisée,* pls. 55, 24, and 48; the emphasized subjects all relate to the Passion or the Last Judgment.

161. See the discussion on pages 173–74 above.

162. Blanc, "Time and Tense in Old French Narrative." Another line of explanation would consider the role of speculative grammar; see Chenu, *La théologie au douzième siècle,* chap. 4, esp. 93–96.

163. Fleischman, *Tense and Narrativity,* chaps. 6 and 7.

164. See pages 42–44 above.

165. See Spiegel, *Romancing the Past,* esp. chap. 2, on the status and truthfulness of writing in French.

166. A later and, if Pierre Cockshaw is right, apt, though far more explicit, parallel would be the text pertaining to the calendar of the Belleville Breviary, which, that author believes, served as a guide to miniatures originally executed for a psalter; see Cockshaw, "Le Bréviaire de Belleville."

167. Vitzthum, *Die Pariser Miniaturmalerei,* 14; Beer, "Pariser Buchmalerei," 80; Stahl, "Bestiaire de Douai."

168. The origins of the style are usually traced back to the Louvre statue of King Childebert of ca. 1239–44 and the apostle statues from the Sainte-Chapelle; see Sauerländer, *Gotische Skulptur,* 57–59, 149, 152–53. Although the style appears in the angel holding the Cross and nails on the tympanum of the central west portal of Notre Dame, it is unclear if the statue is an addition of the 1240s or a highly precocious work of the 1220s. For the former view, see Erlande-Brandenburg, "Les renaniements du portail central à Notre-Dame de Paris"; idem, "Nouvelles remarques sur le portail central de Notre-Dame de Paris"; and idem, *Notre-Dame de Paris,* 110. For the latter view, see Williamson, *Gothic Sculpture,* 52. The north transept was completed before 1259 (see note 13 above); however, it is unclear how early the sculptural work began. Kimpel, *Querhausarme von Notre-Dame,* 30–43, prefers a date in the 1240s, based upon an analysis of the side chapels; see also Lasalle, "Les fenêtres des chapelles de la nef de Notre-Dame de Paris," and Bruzelius, "The Construction of Notre-Dame in Paris," who concludes that Jean de Chelles's predecessor worked on the south tower until the late 1240s. For the dating of the Virgin and Child trumeau figure, see Sauerländer, *Gotische Skulptur,* 154 (ca. 1250), and Williamson, *Gothic Sculpture,* 151–52 (ca. 1245–50).

169. Cf. Melchizedek (fol. 6r) to his counterpart on the central portal of the inner west wall, in Sauerländer, *Gotische Skulptur,* pl. 230, or the shepherd (fol. 16r) and Joseph (fol. 26r) to the sculptures of the inner west wall, in Kurmann, *La façade,* vol. 2, figs. 487 and 499, respectively. The same type appears in metalwork where the Parisian sources are evident; see, for example, the Namur statuette of Saint Blaise in *Un trésor gothique,* no. 24. For the Reims sculpture, I follow the dating of 1255/65 in Kurmann, *La façade,* 1:22–23, 271–86, and Williamson, *Gothic Sculpture,* 159.

170. Vöge, *Bildauer des Mittelalters,* 121; Bunjes, *Die steinernen Altaraufsätze,* 39–41; and, for the most detailed discussion, Kimpel, *Querhausarme von Notre-Dame,* 127–36. The latter addresses other aspects of the statue, such as the double

viewpoint and other constructed ambiguities, which I take as further evidence of the illusionism described here. Erlande-Brandenburg, *Notre-Dame de Paris,* 180, remarks on the role of light in creating this illusionism of surface. For the general type, see Suckale, *Studien zu Stilbildung und Stilwandel der Madonnenstatuten der Ile-de-France zwischen 1230 und 1300,* 113–19.

171. For the Rouen ivories, see *Images in Ivory,* 126; for the Louvre ivory, Gaborit-Chopin, "Une Vierge d'ivoire du XIIIe siècle." Among earlier literature, see especially Bunjes, *Die steinernen Altaraufsätze;* C. Little, "Ivoires et art gothique"; and Williamson, *Gothic Sculpture,* 150.

172. Lillich, *Rainbow like an Emerald,* 27, citing glass thought to come from the lost royal chateau at Rouen.

173. For the gems, see note 191 below. Although no extant Parisian transluscent enamels predate the 1280s, there is some evidence that the technique of *émaux de plique* might go back to the era of Philip Augustus; see Montesquiou-Fezansac and Gaborit-Chopin, *Le trésor de Saint-Denis,* 3:26.

174. Cf. pages 35–36 above.

175. Sauerländer, *Gotische Skulptur,* 154–55 (ca. 1260); Kimpel, *Querhausarme von Notre-Dame,* nos. 211, 212, and 147–48, 283–84; Erlande-Brandenburg and Thibaudat, *Les sculptures de Notre-Dame de Paris,* no. 267.

176. E.g., the Adoration of the Magi in the psalter of ca. 1260 in Padua, Biblioteca del seminario, MS 353, fol. 17v.

177. For the forward magus, cf. Samuel in fol. 73v; for the groupings, cf. fols. 74r, 76r, 78r.

178. Similar relations are also found in many of the miniatures in gathering I and in the early work of the Rebecca Master.

179. Fols. 73v, 75v, 76r, 78r. The arrangement is a commonplace of post-Iconoclastic Byzantine works and becomes a comparably dynamic arrangement in the Palaeologian period; cf. Lazarev, *Storia della pittura bizantina,* figs. 108, 116, 246, 363, 377, 387, 394.

180. Pierre de Montreuil presumably took over after Jean de Chelles's death, in 1257/58, and was named *magister operum* in 1265. However, Kimpel, *Querhausarme von Notre-Dame,* 85–92 argues that he was active earlier on the northern chapels. See Marcel Aubert, *Notre-Dame de Paris,* 2nd edit. (Paris, 1929), 138; Branner, *St. Louis and the Court Style,* 76, 101–4. For Pierre de Montreuil, see Anne Prache, "Un architecte du XIIIe siècle et son oeuvre: Pierre de Montreuil," *Archéologia* 47 (Nov., 1980), 26–38; Bony, *French Gothic Architecture,* 369–71, 523 n. 15; Kimpel and Suckale, *Gotische Architektur,* 344, 410–22; Bruzelius, *The 13th-Century Church at St-Denis,* 173 f; and Robert Suckale, "Pierre de Montreuil," *Les batisseurs des cathèdrales,* 181–85.

181. For a perceptive analysis, see Bunjes, *Die steinernen Alta-*

raufsätze, 43–49. This proliferation of form and individual intensity and drama have led several writers to assume the principal sculptors came from elsewhere; see Sauerländer, *Gotische Skulptur,* 169; Erlande-Brandenburg, "La sculpture à Paris au milieu du XIIIe siècle," esp. 39; and Kimpel, *Querhausarme von Notre-Dame,* 188–89. Apart from the arrangement of figures, the style of at least one sculpture seems related to the group who did the Three Magi; see Erlande-Brandenburg and Thibaudat, *Les sculptures de Notre-Dame de Paris,* no. 281.

182. Saul can also be compared to archivolt figures, for example, Kimpel, *Querhausarme von Notre-Dame,* nos. 135–38. The rich drapery forms and the contrasts of light and shade are also found in the seated sibyls and prophets of the central western portal at Auxerre, a portal also dating to the 1260s and strongly influenced by Parisian art, if not the work of Parisian sculptors; although Quednau, *Westportale,* 47, associates the figures with her Reimois atelier, Kurmann, *La façade,* 1:279–86, has argued that these works are indebted to Paris.

183. Compare Saul at the right of folio 74r.

184. The base, RF 478, entered the Louvre in 1881 along with other pieces from the so-called *chantiers* of Saint-Denis; see Baron, "Remarques sur le décor sculpté de Saint-Denis," and *Sculpture française du XIVe siècle,* 6, no. 7; Baron, Jankowiak, and Vivet, *Sculpture française,* 96. In the latter publication, the relief is dated to the last third of the thirteenth century; in the two earlier publications, to the end of the century.

185. On the Porte de Valois, see Crosby, *L'abbaye royal de Saint-Denis,* 60; Sauerländer, "Marienkrönungsportale"; idem, *Gotische Skulptur,* 92–94. For the date of the Gothic north transept, see Bruzelius, *The 13th-Century Church at St-Denis,* 106, 127; idem, "L'achèvement de la basilique au XIIIe siècle," esp. 40 (1260s).

186. Blum, "Fingerprinting the Stone at Saint-Denis," esp. 21–24; in n. 14 the author announces a comprehensive study of the portal to be undertaken with Françoise Baron. The trumeau statue was restored as a Virgin and Child, but Sauerländer, "Marienkrönungsportale," 151 n. 96, suggests the original statue may have been Saint Denis.

187. Compare the prophets in figures 52 and 53 to the standing figures in the central group of the lower lintel. Sauerländer and Kimpel, who were apparently unaware of these pedestal reliefs, proposed a relationship to the south transept of Notre-Dame on the basis of the style of the Valois doorway corbels, which were also carved when the twelfth-century portal was installed in the thirteenth-century transept; see Sauerländer, "Marienkrönungsportale," 151, and Kimpel, *Querhausarme von Notre-Dame,* 187.

188. Taburet-Delahaye, *L'orfèvrerie gothique au Musée du Cluny,* no. 25; *Un trésor gothique,* no. 16; *Le trésor de la Sainte-Chapelle,* 164–66 (by E. Taburet-Delahaye). As the latter notes (p. 166), an important aspect of the relief is its surprising quality of modeling. The combination of repoussé and engraving is used to create both precise edges and shallow recesses that catch the light; the effect on the middle figure, Saint Lucian, is especially comparable to that in figure 50.

189. Douët d'Arcq, *Sceaux,* no. 6703. The contrast between the treatments of the upper and lower parts of the body is especially striking. The matrix could not have been struck earlier than 1255, when Aleaume was confirmed as bishop of Meaux by the Council of Paris; see *Gallia Christiana,* vol. 8, cols. 1628–29.

190. For the metalwork lower cover of Bibl. Nat., MS lat. 8851, see Gauthier, "Le tableau de la crucifixion," who dates the cover "vers 1270," and *Le trésor de la Sainte-Chapelle,* 215–20, by Marie-Pierre Laffitte and Danielle Gaborit-Chopin, who date the figures, which come from another work, to 1260–70; they were probably attached to this manuscript as the upper cover during the reign of Louis IX, when the sides of the book were decorated with fleurs-de-lis and castles of Castile.

191. For the tomb program, see G. S. Wright, "A Royal Tomb Program"; Erlande-Brandenburg, *Le roi est mort,* 127–29; and E. A. R. Brown, "Burying and Unburying the Kings of France." The tomb sculptures vary in quality. Bunjes, *Die steinernen Altaraufsätze,* 60, believed the tomb of Robert the Pious might have been by the workshop of the south transept portal of the cathedral, although he found most of the tombs indebted to sculptural styles from Reims. The tombs relevant to the prophet reliefs are those by Wright's Capetian Master; compare the tomb of Robert the Pious or Philip (Wright's figs. 25, 28) to the prophet reliefs in our figures 52 and 53 respectively. Wright's important observation that these tombs were carved to be seen from the side must be borne in mind when making any comparison. See also Joubert, "Les retables du milieu du XIIIe siècle à l'abbatiale de Saint-Denis," who suggests that some artists working on the south transept of the cathedral may have come from the abbey.

192. Works at Saint-Denis also relate to the style of the Isabella Psalter; for example, compare Montfaucon's engraving of the lost enthroned Dagobert (Sauerländer, *Gotische Skulptur,* fig. 101) to Cockerell, *Psalter and Hours,* fig. 24.

193. Hans Wentzel, "Portraits 'à l'antique' on French Mediaeval Gems and Seals."

194. During the later Middle Ages and possibly in the thir-

teenth century, the cameo was thought to represent the Triumph of Joseph at the Court of Pharaoh. See E. Babelon, *Catalogue des camées antiques,* 120–36, no. 264, esp. 126–29; *Le trésor de la Sainte-Chapelle,* 90–92. It is first documented in the Sainte-Chapelle inventory of 1341.

195. E. Babelon, *Catalogue des camées antiques,* LXVII⁸LXXIII; Hans Wentzel, "Die vier Kameen"; and idem, "Eine Pariser Kamee des 13. Jahrhunderts." In general, see Wentzel, "Mittelalter und Antike in Spiegel kleiner Kunstwerke des 13. Jahrhunderts."

196. See Wentzel, "Die vier Kameen," 12 and figs. 30–37.

197. For touching on shoulder, see fols. 33v, 57v, 67v; for the arm or hand, fols. 17v, 18r, 35v, 63v; for the back, fols. 4r, 33v; for the thigh, fols. 8r, 17v, 24r, 57v, 62r, 63v; and for fingers and hands, fols. 17v, 18r. The use of the base of the palm is particularly striking in folios 19v (far right) and 24r. See also the way the fingers are positioned as Joseph climbs up the ladder (fol. 17v) or enumerates (fol. 20r) or the way Pharaoh gives—and his servant receives—the chalice in folio 21v. Although pointing is found in almost every miniature, the interplay is unusually rich in folios 4r, 19v, 29v, and 38r. For references to location, see fols. 2r, 7v, 14r, 15v, 16r, 17v, 21v, 51v, 55v, 68r.

198. For ears, see fols. 1v, 2r, 4r, 8r, 10r, 13v, 14r; for smell, fol. 56r; for night or darkness, fols. 32r, 50r. For blindness, see also the characterization of the groping Sodomites in fol. 8r.

199. Nordenfalk, "Les cinq sens dans l'art du Moyen Âge."

200. Sears, "Sensory Perception and Its Metaphors in the Time of Richard of Fournival," and Camille, "The Eye in the Text."

201. Schmitt, "Bildhaftes Denken." The situation is clearly different in earlier scenes of figures sleeping; see Manhes-Deremble, *Les vitraux narratifs de la cathédrale de Chartres,* 195–200.

202. See, for example, Kruger, *Dreaming in the Middle Ages,* 84–115.

203. See Branner, *Manuscript Painting in Paris,* 121–22, for several insightful observations on related narrative forms in the contemporary Dominican Bible.

204. The distinctive qualities of this narrative formulation are especially clear when it is compared to the top register of the north transept portal; see Sauerländer, *Gotische Skulptur,* fig. 186.

205. For Reims, an example of particular interest is the buttress reliefs of the Invention of the True Cross (Kurmann, *La façade,* vol. 2, figs. 405, 406, 409). Although these reliefs are not as conspicuously classicizing as the earlier, well-known sculpture of the cathedral, their narrative, as well as pictorial, structure points strongly to a source in ancient Roman relief; see, for example, the relief of the *Institutio Alimentaria* in Rotili, *L'Arco di Traiano a Benevento.* Kurmann, *La façade,* 1:198–200, aptly describes the sophistication of the Reims reliefs, concluding that "[l]'art du relief atteint ici à un sommet qui restera à nouveau inaccessible jusqu'à la Renaissance." In several interesting ways the three-part structure of the True Cross reliefs recalls that of the lower lintel in Paris. Each constitutes a frieze in which figures who turn toward the center provide a strong accent at either end. Both are composed of three episodes, each focusing on the protagonist—Helena or Stephen—who appears at the left of the first two scenes and at the center of third. And in both, the figures at the juncture of the first and second scenes are back to back, whereas those at the juncture of the second and third overlap, so that the final scene has already begun as the second finishes. The Paris frieze regularizes the semicircular groupings of the Reims reliefs, has fewer figures, and organizes them on forward and rear planes. For Auxerre and its figures of Hercules, Eros, and others, see Adhémar, *Influences antiques dans l'art du Moyen Âge français,* 283–85, and Panofsky, *Renaissance and Renascences in Western Art,* 93–94. Panofsky finds these figures "explicable only" by the presence in Auxerre of the treasure of Saint Didier, a collection of ancient silver known to be at the cathedral through the late thirteenth century. For a description of the now lost treasure of Saint Didier, see Adhémar, "Le trésor d'argenterie donné par Saint Didier." Cf. also Quednau, *Westportale,* 107, 110, 113; Raguin, *Stained Glass in Thirteenth-Century Burgundy,* 87–88; and idem, "Mid–Thirteenth Century Patronage at Auxerre." The latter connects these reliefs with the patronage of the Auxerre bishop Guy de Mello, who studied classical literature and was close to Louis IX.

206. Erlande-Brandenburg and Thibaudat, *Les sculptures de Notre-Dame de Paris,* 314–18 and no. 324, with earlier bibliography. Erlande-Brandenburg, "L'Adam du musée de Cluny," compares the statue to ancient works and cites Villard de Honnecourt's copies after antique bronzes and ivory diptychs. On the latter, see Hahnloser, *Villard de Honnecourt,* 32, 34, 59–60, 159, and passim.

207. The figures seated on the ground in the scene of Saint Stephen preaching are types that occur widely in ancient art; in fact, a few are to be found in the exergue of the Grand Cameo of the Sainte-Chapelle (cf. note 192 above). Of interest also for the gestures and attitudes of specific figures are the classicizing cameos created in the circle of Frederick II in mid-thirteenth-century south Italy; compare, for example, the Noah cameo in London, in *Die Zeit der Staufer,* vol. 1, pp. 692–93, no. 885, and vol. 2, fig. 658. See Kahsnitz, "Staufische Kameen."

208. Cf. Branner, *Manuscript Painting in Paris*, figs. 303, 310, 340, 347, 350, 365, 385.

209. Branner, *Manuscript Painting in Paris*, 135, calls the Sainte-Chapelle Evangeliary an ancestor and the Cholet group "a parent or brother," while Beer, "Pariser Buchmalerei," 80, cites the Corpus group, with decorative precedents elsewhere.

210. On the overarching importance of color, see Vitzthum, *Die Pariser Miniaturmalerei*, 14–15.

211. E.g., fol. 16r. Cf. Paris, Bibl. Nat., MS lat. 16722, fols. 41r, 78v, 170v. The palette seems to me more adventuresome than that of contemporary manuscripts in the so-called Dominican manner, such as Paris, Bibl. Nat., MS lat. 32. Compare also manuscripts from the so-called Saint-Denis atelier, such as Paris, Bibl. Nat., MS lat. 824, fol. 179v.

212. E.g., Paris, Bibl. Nat., MSS lat. 16541, fol. 109r, and 13144, fol. 387; Oxford, Bodleian Libr., Auct MS D.5.17, fol. 71v. One already sees it coming in Paris, Bibl. Nat., MS lat. 16722, fol. 130r, and later. The gray-blue and green contrast is commonplace in earlier manuscripts, such as the Morgan Picture Book.

213. Paris, Bibl. Nat., MS lat. 10426, fols. 107v, 120v.

214. Ibid., fol. 202v.

215. I refer to the use of black bole; Branner, *Manuscript Painting in Paris*, 135–36, saw the evangeliary as the source for the Psalter's architectural conception. For the evangeliary, see *L'art au temps des rois maudits*, 261, no. 169 (by François Avril), and *Le trésor de la Sainte-Chapelle*, 159–63, no. 37 (by Marie-Pierre Laffitte and Elisabeth Taburet-Delahaye).

216. The range is particularly pronounced after folio 95v, the work of a second artist in the manuscript.

217. On the relation of green and gold, see the perceptive remarks in Hills, *Light of Early Italian Painting*, 37, which are relevant here because yellow effectively drops from the palette once green begins to figure significantly.

218. See pages 38–39 above.

219. See especially the discussion of the east, or Passion, window (Bay O) at Mantes-Gassicourt in *Les vitraux de Paris*, 131–32, and Lillich, *Armor of Light*, 60–62. The suggestion of the influence of illumination also appears in a notice by C. S. Harwood in *Medieval and Renaissance Stained Glass from New England Collections*, 31–32, who also describes changes in technique and palette. Narratively and stylistically the Passion window is closely connected with the currents in evidence around the south transept portal of Notre-Dame; cf. Kimpel, *Querhausarme von Notre-Dame*, 119. For Saint-Sulpice-de-Favières, another important monument with stained glass related to these currents, see Françoise Gatouillet, "À Saint-Sulpice-de-Favières." See

also Grodecki and Brissac, *Le vitrail gothique au XIIIe siècle*, 140–44, 259.

220. Michler, "Die Dominikanerkirche in Konstanz."

221. See, for example, Nigel Morgan's observations on the palette of the Apocalypse, Paris, Bibl. Nat., MS lat. 10474, as against that of its sister Apocalypse, Oxford, Bodleian Libr., MS Douce 180, in *Early Gothic Manuscripts* 2:145–46.

222. See Henderson, *Studies*, 186–88; Morgan, "Aspects of Colour."

223. See Subes-Picot, "Peinture sur pierre," and Bruno Zanardi, "Relazione di restauro."

224. Jo Lynn, "Appendix: Preliminary Technical Report on the Westminster Panels," and Liversidge and Binski, "Two Ceiling Paintings from Westminster Palace"; Subes-Picot, "Peinture sur pierre," 90–91; Santamaria and Santopadre, "Il maestro Oltremontano."

225. I quote from Dahlberg's prose translation, *Romance of the Rose*, 300. For the French, see Guillaume de Lorris and Jean de Meun, *Le roman de la rose*, lines 18013–44.

226. Bacon's remark is from Burke's translation, *The Opus Majus of Roger Bacon*, 2:420.

227. Lindberg, *Theories of Vision*, chaps. 4 and 6.

228. Weisheipl, "The Life and Work of St. Albert the Great," 35, places the commentary on Aristotle in the later 1250s, but Steneck, "Albert on the Psychology of Sense Perception," 265, stresses how his major ideas were already in place in his *Summa de creaturis*, written in Paris in the 1240s, a view also found in Dewan, "St. Albert, the Sensibles, and Spiritual Being," 292–93.

229. Theiss and Grüsser, "Vision and Cognition in the Natural Philosophy of Albert the Great."

230. Lindberg, *Theories of Vision*, 107–18.

231. Eberle, "The Lovers' Glass."

232. Alhazen makes his most important remarks on color in bk. 1, chap. 3, 110, 125–26, which are not found in any medieval Latin translation; see *Optics of Ibn al-Haytham*, 2:lxxiii–lxxv. But much of the essential information is given or can be inferred from other parts, such as bk. 1, chap. 4, 6, 22, 23, and bk. 11, chap. 3, 49–66, on which my remarks here depend; see also bk. 1, chap. 8; bk. 11, chap. 3, 4; and bk. III.

233. Lindberg, *Theories of Vision*, esp. chap. 2 and 58–60; Fayet, "Le regard scientifique"; Gage, *Colour and Culture*, 71–73. For earlier views on color, see the fine overview by Peter Dronke, "Tradition and Innovation in Medieval Western Colour-Imagery."

234. Steneck, "Albert on the Psychology of Sense Perception," 280; Dewan, "St. Albert, the Sensibles, and Spiritual Being," 294–96.

235. See Gage, *Colour and Culture*, 165–66, for a useful sum-

mary of the problem and of Bacon's scale, as one finds it in his *Liber de sensu et sensatu*, in *Opera Hactenus Inedita*, fasc. XIV (1937), 64–77. Fayet, "Le regard scientifique," 67–69, finds similar scales in Bartholomeus Anglicus and Alexander Neckham.

236. Hudeczek, "De lumine et coloribus," 127–31.

237. *SN*, bk. 11, chap. 66, 122; cf. Bacon, *Sensu et sensatu*, 77–79.

238. Cited by Gage, *Colour and Culture*, 228. The text (*SN*, bk. 11, chap. 67, 123) reads as follows: "Nam sicut semitonum cum diapente proportionem facit dulcem in auditu, sic multum albedinis cum modico rubedinis, et multum viriditatis cum modico cintrinitatis facit delectationem in visu, sicque fiunt multicolores, et simetri quidem delectabiles, asimetri vero indelectabiles."

239. Witelo, *Opticae*, bk. v, sect. 148 (p. 184): "Color etiam facit pulchritudem, sicut color viridis et roseus." I see no reason to believe this is anything but his own opinion. Aristotle cites the "attractive concord of purple and red" in his *De sensu et sensatu*, chap. 3 in the *Parva Naturalia*, 233.

240. Vincent comes back to music in the *Speculum doctrinale* and discusses proportion but not in reference to the other senses; see Göller, *Vinzenz von Beauvais O.P.*

241. The optical theories of the time discuss transparency and opacity, but I know of nothing related to the effects in the Psalter, although similar tendencies to thinness and transparency appear in some wall paintings. Among the relevant optical treatises, see *Optics of Ibn al-Haytham*, bk. 11, chap. 3, 12–14, 195–97; Hudeczek, "De lumine et coloribus," 124.

242. For a particularly clear explanation and discussion of the pictorial implications, see Hills, *Light of Early Italian Painting*, 19–25.

243. Morgan, "Aspects of Colour," 112–13, refers to this as a three-stage process he finds widely in the period 1250–70.

244. On the useful and in this period apt distinction between film color and surface color, see Hills, *Light of Early Italian Painting*, 31.

245. Morgan, "Aspects of Colour," 112–13.

246. Hills, *Light of Early Italian Painting*, 32–34. For Pucelle's grisaille, see Ferber, "Jean Pucelle and Giovanni Pisano," and Marrow, "Symbol and Meaning," esp. 158–60. The former sees grisaille as promoting sculptural solidity; the latter, as creating a self-referential treatment of space. Although form and space are both involved in grisaille, I see as more important the way the artist models from light to dark rather than the contrary, a practice that very possibly grows out of experiments like those described here for the Psalter, if not out of the Psalter itself. For the history and implications of the two approaches to modeling, see Gombrich, "Light, Form, and Texture." It is interesting

that in these manuscripts what Gombrich describes as *lustro* would be more closely related to the surface of the page, and hence to the creation of a spatial medium, than to the surface of forms. The page surface, like the gold background, permitted what Panofsky, in *Early Netherlandish Painting*, 1:16, aptly described as the consubstantiality but three dimensionality of High Gothic form and space. The spatial implications for the medium continue to be of overriding importance to such later painters as Robert Campin and Jan van Eyck. In fact, it seems unlikely that they made the same distinction between form and space that appears in both early and modern literature on ancient and Renaissance painting. In northern painting, space instead developed out of the luminosity of the medium of oil painting, not out of reflections or textures of surfaces, a direct carryover of the role of luminescence and tone that is seen in the Psalter and Pucelle.

247. See the discussion on pages 38–39 above, and cf. Hills, *Light of Early Italian Painting*, 38. Given the trans-Alpine traffic in works of art and the influential series of French popes and high ecclesiastical patrons appointed after the French pope Urban IV came to office in 1261, developments in Italy and in northern Europe should be seen together. For later in the century, see Meiss, *French Painting*, 1:140, on Beauneveu's "new color." In the painting of these figures the luminous depth of the parchment page becomes a spatial medium, as though the contemporary conception of *lumen*, or the diffusion of light in an illuminated body, had become a place. A distinction had long been made between the source and diffusion of light. For Albert the Great the medium of color is the illuminated transparent, which has a spiritual aspect; see Dewan, "St. Albert, the Sensibles, and Spiritual Being," 308.

248. Gage, *Colour and Culture*, 131, emphasizes transparent colors on light ground in stained glass and sculpture but, oddly, not in illumination, a medium in which we know Jan van Eyck worked.

249. For example, see the Saint-Denis Missal, Paris, Bibl. Nat., MS lat. 1107, a page from which is reproduced in color in the frontispiece to Branner, *Manuscript Painting in Paris*. It is one of the three Cholet-group manuscripts he compared to the Saint Louis Psalter, but it, as well as the two others (Paris, Bibl. de l'Arsenal, MS 25, and Le Mans, Bibl. Mun., MS 262), is likely to date into the 1270s or even 1280s. For example, the calendar of the Saint-Denis Missal indicates only that it was made during the abbacy of Mathieu Vendôme, which lasted until his death, in 1286, and the decorative elements all point to an advanced date. One looks forward to the results of Alison Stones's research on this complex group of manuscripts.

250. Martin, *Catalogue des manuscrits de la Bibliothèque de l'Arsenal*, 2:45; Lacombe, *Aristoteles Latinus*, 1:482, no. 506. The artist was responsible for the miniatures of Christ Blessing the Virgin, Christ Crowning the Virgin, and the Virgin and Child. This manuscript is related to a large group of fine manuscripts of ancient texts that includes a manuscript of the works of Hippocrates, Galen, and others in Vienna, ÖNB, MS 2315, which Branner placed near the end of his list of Cholet-group manuscripts; see *Manuscript Painting in Paris*, 238, with bibliography.

Chapter 4

1. There is no recent survey of programmatic illustration in Western medieval psalters. For a general discussion of Western psalter illustration, see Leroquais, *Les psautiers*, 1:lxxxvi–xc, and, more recently, Suckale-Redlefsen, "Psalmen, Psalterillustration," and Calkins, *Illuminated Books*, 207–14. G. Haseloff, *Psalterillustration*, 1–7, only summarizes the problem in his study of the illustration of psalm initials. For the origins of the early system, see Kurz, "Ein insulares Musterbuchblatt"; Pächt, Dodwell, and Wormald, *Saint Albans Psalter*, 52–53; Haney, *Winchester Psalter*, 46–53; Kahsnitz, *Der Werdener Psalter*, 115–67; idem, "Der christologische Zyklus im Odbert-Psalter." See also Mütherich, "Die verschiedenen Bedeutungsschichten in der frühmittelalterlichen Psalterillustration," and H. Meyer, "Der Psalter als Gattung in der Sicht der mittelalterlichen Bibelexegese."

2. Wormald, "An English Eleventh Century Psalter with Pictures," 7, left open the question of earlier models. See Openshaw, "The Battle Between Christ and Satan"; idem, "The Symbolic Illustration of the Psalter"; idem, "Weapons in the Daily Battle."

3. See especially Openshaw, "The Symbolic Illustration of the Psalter," 45–47.

4. For the Tiberius Psalter, Brit. Libr., MS Cotton Tiberius C.VI, see Temple, *Anglo-Saxon Manuscripts*, 115–17 (no. 98); for the Saint Albans Psalter, Hildesheim, St. Godehard's, see Kauffmann, *Romanesque Manuscripts*, 68–70 (no. 29).

5. They present a genre distinctly different from continuous illustration of saints lives or other forms of psalter illustration, for example. For the latter, see note oo below; for the former, see Barbara Abou-El-Haj's description of "core scenes" in *The Medieval Cult of the Saints*, 53–60.

6. Openshaw, "Images, Texts, and Contexts," and Pächt, Dodwell, and Wormald, *Saint Albans Psalter*.

7. Openshaw, "The Battle Between Christ and Satan"; Pächt, Dodwell, and Wormald, *Saint Albans Psalter*, 49–50.

8. Pächt, Dodwell, and Wormald, *Saint Albans Psalter*, 147–52.

9. Openshaw, "The Battle Between Christ and Satan," 19–28.

Both cycles combine tinted drawings and fully colored miniatures, and since the techniques are used differently in the two manuscripts, they may well serve to underscore a difference in function, as articulated below.

10. Pächt, Dodwell, and Wormald, *Saint Albans Psalter*, esp. 138–40, 153–63.

11. See also Dodwell in Pächt, Dodwell, and Wormald, *Saint Albans Psalter*, chap. 12, esp. 196–97.

12. Openshaw, "Images, Texts, and Contexts."

13. Openshaw, "The Battle Between Christ and Satan," 22.

14. Heimann, "Three Illustrations from the Bury St. Edmunds Psalter," esp. 46–50.

15. Pächt, Dodwell, and Wormald, *Saint Albans Psalter*, 61, 89.

16. The Third Temptation is the fourth miniature in one unit (pp. 32–35); the Agony in the Garden is the fourth in the subsequent unit (pp. 36–39).

17. The tree in this miniature is quite different from the luxuriant ones elsewhere in the cycle; cf. Pächt, Dodwell, and Wormald, *Saint Albans Psalter*, figs. 18a, 19b, 22b, 24b, etc. The transitional status of the Agony in the Garden miniature is also seen in its position as the last picture within this four-miniature group introducing the Passion; its counterpart, in the next series of four, is the Mocking.

18. Pächt, Dodwell, and Wormald, *Saint Albans Psalter*, 148–49.

19. A few English psalters continue the Saint Albans practice of only one or two Old Testament miniatures; see Morgan, *Early Gothic Manuscripts*, 2:188, no. 118 (Carrow Psalter), and 167, no. 167 (Huth Psalter). In France during the same period most cycles are also New Testamentary. The significant exceptions, the Ingeborg Psalter and Bibl. Nat., MS lat. 10434, are discussed here. However, see also Amiens, Bibl. Mun., MS 19, and Paris, Bibl. Nat., MS lat. 16272; Leroquais, *Les psautiers*, 1:lxxxvii–lxxxviii and passim.

20. The subject, the Tree of Jesse, which is also found in contemporary sculpture and stained glass, functions in psalters as a transition and pivot between the Old and New Testament illustration, clarifying the historical and typological relation between the two sections of the cycle. See Henderson, "'Abraham Genuit Isaac': Transitions."

21. Morgan, *Early Gothic Manuscripts*, vol. 1, *1190–1250*.

22. Deuchler, *Ingeborgpsalter*, 163–64 and n. 284.

23. E.g., Petrus Comestor, *Historia scholastica*, in *PL*, vol. 198, col. 1028.

24. Cf. Haussherr, *Bible Morialisée*, pls. 10, 49.

25. Deuchler, *Ingeborgpsalter*, 27.

26. I know of no precedent for this subject in the illustration of Beatus initials. Although it occurs in biblical illumina-

tion, Samuel is normally instructed by the Lord himself rather than by an angel; cf. Weitzmann, *Miniatures of the Sacra Parallela*, 77–78; Laborde, *Bible moralisée*, pl. 135; *Old Testament Miniatures*, no. 159. The subject of the lower half of the initial, Samuel Anointing David, illustrates the initial to Psalm 26 in contemporary English psalters. Deuchler, *Ingeborgpsalter*, 78, following G. Haseloff, *Psalterillustration*, 100, incorrectly finds a precedent for the Anointing in the Beatus initial of the British Library MS Arundel 157. The subject is found there in the Munich Psalter but not as the principal subject of an initial; see Morgan, *Early Gothic Manuscripts*, 1:70.

27. Deuchler, *Ingeborgpsalter*, 111–15.

28. G. Haseloff, *Psalterillustration*, 10, 12, 18, and passim; Branner, *Manuscript Painting in Paris*, 192–93; Merrill, "A Psalter of the Ingeborg Psalter Atelier," 130–32.

29. Deuchler, *Ingeborgpsalter*, 80, understands the initial to represent 2 Sam. 2:4, the episode in which David is anointed king at Hebron, but no anointment is illustrated.

30. Branner, *Manuscript Painting in Paris*, 184–85.

31. David's slightly lowered head, his gesture to the strap of his mantel, and the raised index finger of his otherwise relaxed left hand all suggest his pained response to the news of Saul's death; compare the "normative" attitude of the seated kings in Deuchler, *Ingeborgpsalter*, figs. 42, 46. A similar focus on David's emotional response is found in the Lyre Psalter, London, Brit. Mus. Addit. 16975; see Ragusa, "An Illustrated Psalter from Lyre Abbey," esp. 275.

32. Deuchler, *Ingeborgpsalter*, figs. 41–50; Büchler, "Haseloff-Schule II.," 152–61.

33. Compare the illustration to Psalm 109 in Laborde, *Bible moralisée*, pl. 253, in which a crowned hieratically posed king is enthroned in a mandorla in the midst of a city. Psalm 109 is not the only instance in the Ingeborg Psalter in which an initial seems to refer to verses other than the first, as is usual. For example, Psalm 38, beginning "I said, 'I will guard my ways, that I may not sin with my tongue'" and usually illustrated with David pointing to his mouth, is here illustrated with David playing before the anguished Saul, probably a reference to the next verses ("my distress grew worse, my heart became hot within me"). A striking combination of picture and verse is found in the initial to Psalm 51. The initial illustrates David's challenge to Goliath and shows David as a shepherd pointing forcefully at Goliath; between them is a scroll with Goliath's words: "Am I a dog, that you come to me with sticks?" (1 Sam. 17:43). David points toward Goliath as if lecturing him, but how are we to construe his words? Are they the words given in the biblical narra-

tive ("You come to me with a sword and with a spear and with a javelin; but I come to you in the name of the Lord of hosts" [1 Sam. 17:45]) or those of the psalm text ("Your tongue is like a sharp razor, you worker of treachery" [v. 2])?

34. Baldwin, *Government of Philip Augustus*, 82–87.

35. Deuchler, *Ingeborgpsalter*, 108–15, 147–48, dates the manuscript to about 1195, during the period in which Ingeborg was cloistered at Cysoing, and argues for its execution in northern France near Saint-Quentin. For a different dating, see the review of Deuchler's book by Reiner Haussherr and idem, "Der Ingeborgpsalter: Bemerkungen zu Datierungs- und Stilfragen."

36. See Merrill, "A Psalter of the Ingeborg Psalter Atelier," 361–94, with earlier literature.

37. Cothren, "The Iconography of Theophilus Windows."

38. Schapiro, review of *Der Ingeborgpsalter*.

39. Deuchler, *Ingeborgpsalter*, 54–55, fig. 31. Opposite the women and at the other side of the composition are the men who pull Christ along.

40. Martin, *Psautier*, pl. XLIV.

41. For the attribution to Blanche, see page 14 above. Stirnemann, "Les bibliothèques princières," 178, suggests that the fleur-de-lis painted alongside the Tree of Jesse and the crenelated wall at its base (Martin, *Psautier*, pl. XXI) are the arms of Blanche. Although nothing stands in the way of Blanche's being the manuscript's patron, these details are of limited use, for in my opinion the fleur-de-lis, both in this miniature and the Beatus initial, are painted differently from the rest of the illumination and are almost certainly later additions, probably made in the fourteenth or fifteenth century, when the manuscript was in the collection of the Sainte-Chapelle and Charles VI gave the fleur-de-lised cloth in which to wrap the psalter. The walls at the base of the Tree of Jesse miniature are crenelated city walls, not the towered façade traditionally used to identify Castile; cf. *La France de Saint Louis*, nos. 27, 32, and see Lillich, *Rainbow like an Emerald*, 88. The best arguments for seeing Blanche as the owner of the manuscript are still its exceptional place within contemporary French painting, the later inscription, and its provenance; see Delisle, *Notice de douze livres*, 34–35.

42. The Anglo-Saxon subject, possibly of Carolingian inspiration, usually appears in biblical illustration; about 1230 it begins to appear in English psalters but remains exceptional in French ones. See Broderick, "Iconographic and Compositional Sources," 91–108, 193–99; Temple, *Anglo-Saxon Manuscripts*, nos. 58, 86; Morgan, *Early Gothic Manuscripts*, vol. 1, nos. 71, 72.

43. An English precedent is the Munich Psalter, fols.

146r–48r; see Morgan, *Early Gothic Manuscripts,* 1:70. Cf. also Büchler, "Haseloff-Schule II.," 171–79.

44. Even the eyes and ears are similar. The same juxtaposition occurs in the approximately contemporary de Brailes leaves from a psalter in the Fitzwilliam Museum, MS 330; see Morgan, *Early Gothic Manuscripts,* vol. 1, no. 72a, figs. 237–38.

45. For the initial to Psalm 38, see Martin, *Psautier,* pl. XXXVIII. David holds his hand to his mouth, in accordance with the first verse of the psalm ("that I may not sin with my tongue"); cf. also Ps. 38:2, 8–9.

46. Delisle, *Notice de douze livres,* 31.

47. This problematic miniature has never been adequately interpreted. Delisle, *Notice de douze livres,* 52, and Martin, *Psautier,* 26, relate it to the story of Enoch and Elias, but the details do not fit. Until the specific source is found, one must base one's conclusions on an analysis of the miniature itself. It has a small circular medallion in the center and four semicircular medallions, one at each side. The medallion at the top, referred to in the text above, depicts four men (three of whom wear pointed hats) leading a woman away from a city whose gates are shut; a rooster stands atop one of the city towers. Alongside this group is another, consisting of two men; the older one carries a book and points ahead, as if leading the man behind him away from the city. The city, the place of culture, should be seen in positive terms, and so the closed gates, the rooster, with its suggestion of the Denial of Christ, and the Jews who lead the woman from the city all have strongly negative implications. The same is true of the left panel, in which a man speaks to a group seated below. Although flanked by youths dressed as acolytes and resting his hand on a kind of altar cloth, he wears no liturgical vestments and speaks from above a crenelated wall rather than within a church. In the right panel a bearded man, barefoot and dressed like an apostle, wields his sword to strike the heads of two nimbed men, who fall bleeding against a hill. In the lowest scene, devils attack a man in bed and carry off his soul as flames emanate toward them from a diabolical mouth in the central medallion of the page. The latter relates to the hell mouths in the first and last miniatures and suggests that the whole page should be read as a description of evil and its punishment in this world. It would thus form a suitable preface to the general resurrection on the next page and the ultimate judgment and punishment of evil in the succeeding miniatures. This page, with its warning against false leaders and false prophets, thus has the import of Apocalypse 13. Cf. Laborde, *Bible moralisée,* pl. 263. For the metaphorical image of the city, which may also be relevant to the crenelated wall in the Tree of Jesse miniature (see note 41 above), see Le Goff, "Une métaphore urbaine."

48. Evildoers in Christian iconography are often identified as Jews and appear in narrative contexts (as pagans, detractors of Christ) or in symbolic contrasts of Church and Synagogue. Furthermore, they do not simply illustrate the sense of the psalm text, for they do not do evil in the initial to Psalm 1 or act foolishly in that of Psalm 52. Similar depictions do, however, appear in the contemporary *Bibles moralisées,* where Jews are again shown as an ungodly threat; cf. Haussherr, *Bible Moralisée,* pl. 36. Anti-Jewish sentiment is far more pronounced and explicit in the later versions; cf., for example, the moralizations to the death of Jacob in Haussherr, *Bible Moralisée,* 27, and Laborde, *Bible moralisée,* pl. 34. On anti-Jewish sentiment during the reign of Saint Louis, see page 186 above. On the general topic, see Mellinkoff, *Outcasts,* and Lipton, "Jews in the Commentary."

49. Delisle, *Notice de douze livres,* 28. Udovitch, "Three Astronomers in a Thirteenth Century Psalter."

50. Lindbaum, *Beginnings of Western Science,* 262–65. A fine illuminated copy of Ptolemy's *Almagest* is Paris, Bibl. Nat., MS lat. 16200, dated 1213 and produced from a St. Victor exemplar; see Branner, *Manuscript Painting in Paris,* 27–29, 201. The *Optics* was probably translated in the late twelfth or early thirteenth century; for the thirteenth-century Latin manuscripts, see *Optics of Ibn al-Haytham,* 2:lxxiii–lxxix.

51. Among more or less contemporary representations, see the initial to Ecclesiastes in the Bible of ca. 1180, Paris, Bibl. Nat., MS lat. 16745, fol. 108r, in which Solomon holds up an astrolabe between himself and the sun, a reference in part to Eccles. 1:5 ("The sun rises and the sun goes down"); see Cahn, *Romanesque Bible Illumination,* 278–79. David holds a similar astrolabe in the Lewis Psalter, ca. 1220, Philadelphia Free Library, MS 185, fol. 37, in the initial to Psalm 9, the rubric of which concerns David's inquiry about the future of the world; on this manuscript, see Peterson, "Accidents and Adaptations." In the *Bibles moralisées* the astrolabe appears, *inter alia,* as a warning to dialecticians and astronomers that in aspiring to heaven they risk the fate of those who built the Tower of Babel; see Haussherr, *Bible Moralisée,* pl. 7; Laborde, *Bible moralisée,* pl. 11.

52. Martin, *Psautier,* pls. 11⁸XIV.

53. Martin, *Psautier.*

54. Ibid., pl. XVII.

55. Paris, Bibl. Nat., MS n.a.l. 1392; see Branner, *Manuscript Painting in Paris,* 206–7, with bibliography.

56. For the four leaves, now divided among the Pierpont

Morgan Library (MSS M.521 and M.724), British Library (MS Add. 37472 [I]), and Victoria and Albert Museum (MS 661), see Kauffmann, *Romanesque Manuscripts,* 93–96 (no. 66), and *Eadwine Psalter,* esp. 25–42. For the Winchester Psalter, Brit. Libr., MS Cotton Nero C. IV, see Wormald, *Winchester Psalter;* Kauffmann, *Romanesque Manuscripts,* 105–6 (no. 78); Haney, *Winchester Psalter;* and note 40 above. The Winchester Psalter begins with the Expulsion, but scholars disagree on whether other folios, presumably with earlier events from Genesis, have been lost; see Wormald, *Winchester Psalter,* 69; Witzling, "Winchester Psalter"; Henderson, "'Abraham Genuit Isaac': Transitions," 130–31.

57. The estimate is based upon the comparable cycle in the Great Canterbury Psalter, Paris, Bibl. Nat., MS lat. 8846; see Morgan, *Early Gothic Manuscripts,* 1:47–49 (no. 1). Henderson, in *Eadwine Psalter,* 36, raises the question whether any Eadwine leaves are lost and argues that the first of the four leaves (Pierpont Morgan Library, M.724), which illustrates Exodus, may have constituted a valid beginning.

58. Morgan, *Early Gothic Manuscripts,* 1:16; see also Pächt, *Rise of Pictorial Narrative.*

59. A summary of the evidence is Morgan, "Old Testament Illustration," 161–63, 172–73.

60. The Byzantine, late Carolingian, and early Italian sources also require mention. For the Great Canterbury Psalter, see note 57 above; for the Munich Psalter, Bayerisches Staatsbibl., Clm. 835, see Graham, "Old Testament Cycles," and Morgan, *Early Gothic Manuscripts,* 1:68–72 (no. 23); for the Huntingfield Psalter, Pierpont Morgan Library, MS M.43, see ibid., 77–79 (no. 30); for Cambridge, Trinity College, MS B.11.4, see ibid., 98–99 (no. 51); and for the Baltimore Old Testament Pictures, divided between the Walters Art Gallery (MS 106) and the Musée Marmottan, see ibid., 117 (no. 71), and Musée Marmottan, *La Collection Wildenstein,* no. 113. The Trinity psalter and Baltimore Old Testament Pictures are incomplete, and the Munich Psalter may also have suffered some losses. Morgan, "Old Testament Illustration," 155–56, discusses the same group but includes two medium-length cycles, the Leiden Psalter (see note 64 below) and the psalter in Cambridge, St. Johns College, MS K.26, as well as a brief discussion of Old Testament cycles in sculpture and wall painting.

61. The best indication of the shape of the cycles may be found in Morgan's descriptions of the contents of each of the manuscripts rather than in his cumulative listing in "Old Testament Illustration," 174–84.

62. E.g., figures with similar postures or similarly unfurled

scrolls, groups moving in similar or opposing directions, etc.; cf. Morgan, *Early Gothic Manuscripts,* vol. 1, fig. 173.

63. See especially the Huntingfield Psalter, fols. 14v–15r, for the highly effective juxtaposition of the wholly unrelated stories of Jephthah and Elkanah, or fols. 11v–12r, which contrast events from the lives of Isaac and Jacob. The former emphasize the dilemma of the father/husband against the faith of the daughter/wife; the latter, the chosen son against his less-favored brothers. These juxtapositions depend on reading horizontally, from one upper or lower subject to the other, as was the case in the contemporary Ingeborg Psalter, discussed above.

64. Cf. Graham, "Old Testament Cycles," and the listing in Morgan, *Early Gothic Manuscripts,* 1:68–69. I count the conquest of Jericho as the last of the events of the history of the Exodus, for reasons that will become clear above. See also the more abbreviated Leiden Psalter (Morgan, *Early Gothic Manuscripts,* 1:60–62, no. 14), which has one folio for Creation, two for Adam and Eve, one for Abraham, and another for Samson; Noah receives a half page more; Cain and Abel, Isaac, and Joseph, a half page less.

65. One folio is allotted for each of the stories of Creation, Adam and Eve, Cain and Abel, Noah, Lot, Joseph, Jephthah, and Absalom; Abraham, Jacob, Moses, Samuel, and David receive more, usually two. For a description, see Morgan, *Early Gothic Manuscripts,* 1:77.

66. The miniatures in the Munich Psalter parallel, usually quite directly, thirty-eight of the first forty-two in the Saint Louis Psalter.

67. For discussion, see page 93 above. Related to the Vienna cycle are those in Oxford, Bodleian Libr., MS Douce 48, which is incomplete, and Malibu, J. Paul Getty Museum, MS Ludwig VIII, 4 (ex Dyson-Perrins 32), the most freely elaborated of the group. For the former, see Branner, *Manuscript Painting in Paris,* 211, 226; for the latter, Plotzek and von Euw, *Handschriften der Sammlung Ludwig,* 1:322–29.

68. Related, though less consistently so, is the prefatory psalter cycle in Oxford, Bodleian Libr., MS Douce 48 (Branner, *Manuscript Painting in Paris,* 211, 216).

69. E.g., cf. Noah ordered to construct the ark (Pächt and Thoss, *Französische Schule I,* fig. 173) to representations in the Aelfric manuscript (London, Brit. Libr., MS Cotton Claudius B. iv, fol. 13v), the Munich Psalter (Munich, Bayerische Staatsbibl., Clm. 835, fol. 10r), and the Leiden Psalter (fol. 10v; Morgan, *Early Gothic Manuscripts,* vol. 1, fig. 46); for discussion, see Stahl, "Iconographic Sources," 71–74. For similar pages, cf. Pächt and Thoss, *Französische Schule I,* fig. 174, to Morgan, *Early Gothic Manuscripts,* vol. 1, fig. 76.

70. See the Psalter fols. 4r, 7v, 17v, 20r, 21v, 22r, 23v, 25v, and 26r.

71. Avril, "L'enluminure à l'époque gothique."

72. For the beginnings of the cycles, I refer to, respectively, the Saint Albans and Ingeborg Psalters; for the concluding subjects, to the Psalter of Blanche of Castile, the Leiden Psalter, the Great Canterbury Psalter, the first Eadwine leaf (Pierpont Morgan Library, M.724), and the Huntingfield Psalter.

73. The gathering would have consisted of folios 1, 2, 3, 4, 7, 10, 13, and 14; see page 27 and diagram 1 above.

74. The miniatures in question are folios 29v, 30r, 33v, 40r, 41v, and 42r.

75. E.g., the Huntingfield Psalter, fols. 13v–14r, which jumps from Sinai to Jericho. In the first Eadwine leaf (Pierpont Morgan Library, M.724) and the Great Canterbury Psalter, folio 2v, the battle of Jericho is the only subject between the the desert miracles and Samuel anointing Saul. In the Munich Psalter, folio 20v, it completes the first of several series of Old Testament subjects and, in the present collation, leads directly into the life of Christ. The collation is described but not analyzed in Graham, "Old Testament Cycles," 9–11.

76. Cf. fols. 7v and 10r. The two Abraham miniatures are each composed with prominent diagonals, that of folio 7v moving down from the upper left and that of folio 10r moving up from the lower right. Iconographically they repeat the juxtaposition, discussed above, of the lower miniatures of the Ingeborg Psalter opening.

77. Both the Sodom and Sinai subjects are found in the Eadwine leaves, Munich Psalter, Huntingfield Psalter, and Baltimore Old Testament Pictures.

78. On the implications of divine guidance that the final subject, Jacob Wrestling with the Angel, would have had in the circle of Louis IX, see pages 174–75 above. The exceptionally rare subject of Jacob Meeting the Angels of God is difficult to explain unless the artist or planner wanted to support these implications. For the Isaac miniatures, see pages 151–52 above.

79. Cf. pages 97–98 and 103–4 above.

80. Joshua II (V), Deborah, Jael, Gideon I (VI), Gideon II (VII), Samson I (VIII), Samson II (IX), Benjaminites (X), Samuel: Saul Chosen (XII), Saul Triumphs (XIII). Apart from the inserted folios in the first and fourth gatherings, no history in the Psalter is less than two facing pages, and every one begins on a left page and ends on a right; none concludes in the middle of a double-page opening. Inserted folios 8r–9v (the story of Lot) break up the Abraham series, and folios 38r–39v (the story of Balaam) break up the Moses-Joshua series. I count folios 63v–66r as a

single history concerning the salvation of the Benjaminites.

81. On the hagiographic model, see Manhes-Deremble, *Les vitraux narratifs de la cathédrale de Chartres;* Johnson and Cazelles, *Le vain siècle guerpir;* and Cazelles, *The Lady as Saint;* cf. also Hahn, "Picturing the Past."

82. I am not suggesting the influence of stained glass on illumination but a parallel interest in what Thomas Heffernan has called sacred biography, an interest seen also in vernacular saints' lives at this time. In the early thirteenth century, single Old Testament figures were the subjects of entire windows at Poitiers, Bourges, Chartres, and Auxerre (see note 180 below). The implications for the visual arts have yet to be drawn; see, however, W. Kemp, *Sermo Corporeus;* Heffernan, *Sacred Biography;* Grodecki, "Les vitraux de la cathédrale de Poitiers"; and *Recensement des vitraux anciens de la France,* 2:28, 34, 174–75, and 3:11–120.

83. For an overview of theological issues, see Daniélou, *Sacramentum futuri;* Lubac, *Exégèse médiévale;* and Chenu, *Nature, Man, and Society,* chap. 2. For summaries of types in the visual arts, see Cornell, *Biblia Pauperum;* Molsdorf, *Christliche Symbolik der mittelalterlichen Kunst;* and the overview in P. Bloch, "Typologie." For twelfth-century works specifically, see Röhrig, "Rota in medio rotae"; Grodecki, "Les vitraux allégoriques de Saint-Denis"; Kauffmann, *Romanesque Manuscripts,* 42–45; Morgan, "The Iconography of Twelfth-Century Mosan Enamels"; Esmeijer, *Divina Quaternitas;* W. Kemp, *Sermo Corporeus,* 56–116; K.-A. Wirth, *Pictor in Carmine;* and Toubert, *Un art dirigé,* esp. chap. 6. The term "spiritual" is sometimes used to refer to the allegorical sense, "typological" to the moral, and "anagogical" to the mystical.

84. E.g., Davis-Weyer, "Komposition und Szenenwahl."

85. Chenu, *Nature, Man, and Society,* 158. See also Auerbach, "Figura," and F. Kermode, "The Plain Sense of Things."

86. The most insightful study remains Chenu, *Nature, Man, and Society,* esp chaps. 4 and 5. For a general survey, see *Le Moyen Âge et la Bible,* with further bibliography.

87. Grabmann, *Die Geschichte der scholastischen Methode,* chaps. 7–8; Spicq, *Esquisse d'une histoire de l'exégèse,* xx; and esp. Smalley, *Study of the Bible,* esp. chaps. 3–5.

88. Especially in the late-twelfth-century teaching of Stephen Langton, Peter the Chanter, and others of the "biblical moral" school. Smalley, *Study of the Bible;* and Baldwin, *Masters, Princes, and Merchants,* chaps. 1–4 and passim; Dahan, "Exégèse et polémique"; Minnis, *Medieval Theory of Authorship,* esp. chap. 3.

89. The following remarks are based largely upon Luscombe, "Peter Comestor."

90. The Comestor makes clear in the prologue that his princi-

91. pal interest is historical; *PL*, vol. 198, cols. 1053–54.

91. *PL*, vol. 198, cols. 1104–5.

92. See especially the statues of the left jamb at Chartres, in Sauerländer, *Gotische Skulptur,* pl. 82. For the several levels of interpretation of these statues, see Katzenellenbogen, *Sculptural Programs,* 61–64.

93. Alongside such standard typologies as Gideon's Fleece or Samson's Carrying the Gates of Gaza are Gideon's leading away the two captured princes and the Sacrifice of Manoah. Katzenellenbogen, *Sculptural Programs,* 70–74, interprets the portal's Old Testament subjects as allegories of the endurance of the Church against its enemies, whereas Kidson, *Sculpture at Chartres,* 49–54, relates them to the transept's larger sculptural program, which illustrates the Church's deliverance of the people of God. See also Hollengreen, "Exemplary Old Testament Narratives." The tradition of illustrating these deeds as examples of personal piety, for moral exhortation, goes back to early Christianity; see, for example, the atrium of Paulinus of Nola's church of Saint Felix, where the subject matter was surprisingly, though coincidentally, similar to that of the Chartrain portal. For interpretation of the lost paintings, which are known only through their accompanying *tituli,* see R. W. Gaston, "Studies in the Early Christian 'Tituli,'" esp. 24, 46–75.

94. For Poitiers, see Grodecki, "Les vitraux de la cathédrale de Poitiers"; for the other windows, see *Recensement des vitraux anciens de la France,* 2:28, 34, 174–75, and 3:111–20. In general, and for the Joseph window at Chartres in specific, see Caviness, "Biblical Stories," 103–17.

95. Caviness, "Biblical Stories," 130. For Chartres, see also W. Kemp, *Narratives of Gothic Stained Glass,* and Manhes-Deremble, *Les vitraux narratifs de la cathédrale de Chartres.* For the Sainte-Chapelle glass, see pages 164–66 above and A. A. Jordan, *Visualizing Kingship,* chaps. 1–2, 5.

96. *Old Testament Miniatures,* nos. 168–69. The biblical text is itself highly moralizing, but its lesson lies in fitness to rule. In the *Bible moralisée,* where the story of Judges 9 is illustrated at length, Abimelech is interpreted as the Antichrist; cf. Laborde, *Bible moralisée,* pls. 110–12. In stressing the sacrificial, the Morgan painting follows a venerable tradition; cf. Augustine, *Quaestionum in Heptateuchum libri VII,* in *PL,* vol. 34, cols. 811–12, where Jephthah is compared to Abraham. In the Morgan manuscript there are numerous other instances where the selection, placement, or composition of subjects are manipulated to emphasize certain interpretations, usually moral. That its two Abimelech illustrations ignore the issues of kingship raised in the text is not atypical.

97. Haussherr, "Sensus litteralis und sensus spiritualis in der Bible Moralisée"; idem; "Petrus Cantor, Stephen Langton, Hugo von St. Cher und der Isaias-Prolog der Bible Moralisée"; idem, "Eine Warnung vor dem Studium von zivilem und kanonischem Recht in der Bible Moralisée"; Heinlein, "Ideology of Reform," chaps. 4–5 and passim. Grodecki, "Sainte Chapelle de Paris," 83, makes a similar point about the Old Testament subjects in the Sainte-Chapelle. On the import of this emphasis in the Sainte-Chapelle and in works of Capetian patronage more generally, see also A. A. Jordan, *Visualizing Kingship,* chaps. 2 and 5; Weiss, *Art and Crusade;* Sadler, "The King as Subject"; idem, "Lessons Fit for a King."

98. E.g., Spicq, *Esquisse d'une histoire de l'exégèse,* esp. 144–46; Zink, *La prédiction en langue romane,* 464 and passim; van Uytfanghe, "Modèles bibliques dans l'hagiographie." See also Bataillon, "Intermédiaires entre les traités de morale pratique et les sermons," notably 214–15 for the example of Maurice de Provins. For drama, see Dahan, "L'interprétation de l'Ancien Testament." Although the *Jeu d'Adam* predates the works discussed here, its moral impact and its implications for architectural sculpture are relevant; see Justice, "The Authority of Ritual in the *Jeu d'Adam.*" For an interesting study of the diverse influences upon the developing interpretation of Job, see Sargent-Baur, *Brothers of Dragons.*

99. Buc, *L'ambiguïté du livre,* pt. 3; for a brief discussion, see idem, "Pouvoir royal et commentaires de la Bible (1150–1350)."

100. Smalley, "William of Auvergne, John of La Rochelle, and St. Thomas Aquinas on the Old Law."

101. Ibid. (1981), 165, and also idem, *Study of the Bible,* 299–302. See also M. Seckler, *Le salut et l'histoire,* 183–201.

102. Minnis, *Medieval Theory of Authorship.*

103. Cf. Grodecki, "Sainte Chapelle de Paris," 84 n. 3, or von Simson, "Opere superante materiam," 610–11.

104. Berger, *La Bible française au Moyen Âge;* Bonnard, *Les traductions de la Bible en vers français du Moyen Âge;* Robson, "Vernacular Scriptures in France"; Poerck and van Deyck, "La Bible et l'activité traductrice dans les pays romans avant 1300"; Smeets, "Les traductions, adaptations et paraphrases de la Bible en vers"; and Bogaert, "Adaptations et versions de la Bible."

105. There is no agreement on the date of the *Bible du XIIIe siècle* and whether it is a discrete work or only a stage in the developments leading to the more standard works of the early fourteenth century. See Robson, "Vernacular Scriptures in France," esp. 446 n. 1; DeCoo, "La Bible française du XIIIe siècle et l'Evangile selon Marc"; Sneddon, "The 'Bible du XIIIe Siècle,'" esp. 135; and Bogaert, "Adaptations et versions de la Bible," 271. The

critical manuscript is the de Thou Bible, Paris, Bibl. Nat., MS 899, the oldest and linguistically purest exemplar. Following Berger, van Deyck, in Poerck and van Deyck, "La Bible et l'activité traductrice dans les pays romans avant 1300," 57, compares its single miniature to those in the Jacobin Bible, Paris, Bibl. Nat., MSS lat. 16719–22, but see Branner, *Manuscript Painting in Paris,* 104–6, 229, who attributes the illumination to his Bari atelier, active at midcentury.

106. The general narrative interests are new only in vernacular manuscripts. For parallels in Latin paraphrases of the Old Testament in late antiquity, see Roberts, *Biblical Epic and Rhetorical Paraphrase in Late Antiquity,* 116–18, 181. Cf. also Herzog, *Die Bibelepik der lateinischen Spätantike,* and Kartschoke, *Bibeldichtung.* Of note in these later works is the occasional inclusion of typological and moral explanations, especially from the *Glossa ordinaria,* and sporadic reliance upon Josephus, rabbinic sources, and the *Historia scholastica.* The introduction of gloss and moral commentary is especially prominent in the earlier texts, for example, Evrat or Herman de Valenciennes; cf. Szirmai, *La Bible anonyme,* 64, a later rabbinic source.

107. On differing views on the genre of these works, see Grimm, "Den Grenzfall des Bibelepos," and Smeets, "Les traductions-adaptations versifiées de la Bible en ancien français." As for production, the characteristics of the de Thou Bible, Paris, Bibl. Nat., MS 899, are consistent with standard Parisian production of Latin manuscripts of ca. 1260, for example, Paris, Bibl. Nat., MS lat. 16, a Bible. Branner attributes both manuscripts to his Bari atelier. However, miniatures produced in this manner are frequently found in tandem with illuminations of the following decade, so that a precise dating is not possible; see Branner, *Manuscript Painting in Paris,* 106, 229–30.

108. On the relation between the *Bible historiale* and the *Bible historiale complétée,* see Poerck, in Poerck and van Deyck, "La Bible et l'activité traductrice dans les pays romans avant 1300," 29, and Sneddon, "The 'Bible du XIIIe Siècle,'" 129–30.

109. The mid-thirteenth-century works, such as the Geoffrey de Paris Bible, Bibl. Nat., MS 763, and the *Bible du XIIIe siècle,* are all in the dialect of the Île-de-France; see van Dyeck, in Poerck and van Deyck, "La Bible et l'activité traductrice dans les pays romans avant 1300," 56–57. On the role of stationers in the *Bible du XIIIe siècle,* see Sneddon, "The 'Bible du XIIIe Siècle,'" 129, 137–40, and, for a differing view, Bogaert, "Adaptations et versions de la Bible," 272.

110. Vitzthum, *Die Pariser Miniaturmalerei,* 165; Poerck and van Deyck, "La Bible et l'activité traductrice dans les pays

romans avant 1300," 56–57. The second volume of this two-volume Bible is London, Brit. Libr. Addit. 41751. On the matter of audience, I agree here with Bogaert, "Adaptations et versions de la Bible," 269; in contrast, see Sneddon, "The 'Bible du XIIIe Siècle,'" 138, who argues that the thirteenth-century owners were devout bourgeois of no particular social or economic distinction.

111. Sneddon, "The 'Bible du XIIIe Siècle'"; Robson, "Vernacular Scriptures in France," 448–51. For these purposes I make no distinction between the *Bible historiale* and the *Bible historiale complétée.*

112. Morgan, "Old Testament Illustration," 164–66.

113. Caviness, "Biblical Stories," 142–45.

114. W. C. Jordan, "The Psalter of Saint-Louis," 74–75.

115. Paris, Bibl. Nat., MS fr. 763; cf. Szirmai, *La Bible anonyme,* 16.

116. On the evolution of sermon composition and the increasing incorporation of current events and popular exempla in sermons, see Zink, *La prédication en langue romane;* Le Goff, "Philippe Auguste dans les 'exempla.'"

117. Grimm, "Den Grenzfall des Bibelepos," 498–501; Gumbrecht, "Die kaum artikulierte Prämisse," esp. 799–809.

118. On the possible devotional function of vernacular scriptures, see Sneddon, "The 'Bible du XIIIe Siècle,'" 136–37.

119. E.g., Eusebius's *Chronographia,* Orosius's *Historiarum adversum paganos,* Cassiodorus's *Historia tripartita.* All remained influential in the later Middle Ages; cf. Guenée, *Histoire et culture historique,* 29–32, 149–50, 301–3; R. H. Bloch, "Geneology as a Medieval Mental Structure and Textual Form."

120. Gregory of Tours's *Historia Francorum* had already used a summary of Old Testament events to introduce French history. I know of no study specifically concerned with the various uses for and changing views of Old Testament history within diverse forms of historical writing, that is, chronicles, histories, encyclopedias. See, however, Grundmann, *Geschichtsschreibung im Mittelalter;* R. Schmidt, "Aetatis Mundi"; Brincken, *Studien zur lateinischen Weltchronistik;* idem, "Die lateinische Weltchronistik"; Marsch, *Biblische Prophetie und chronographische Dichtung;* Krüger, *Die Universalchroniken;* Guenée, *Histoire et culture historique,* 149–52; Ebenbauer, "Historiographie zwischen der Spätantike und Beginn volkssprachlicher Geschichtsschreibung im Mittelalter."

121. On twelfth-century historical writing, see Haskins, *The Renaissance of the Twelfth Century;* Spörl, *Grundformen hochmittelalterlicher Geschichtesanschauung;* Classen, "*Res Gestae,* Universal History, Apocalypse," with bibliography.

122. It probably assumed its final form by 1250. See Paulmier-Foucart and Lusignan, "Vincent de Beauvais et l'histoire du *Speculum maius.*"

123. Melville, "Spätmittelalterliche Geschichtskompendium."

124. Cf. Petrus Comestor, *Historia scholastica*, in *PL*, vol. 198, col. 1094, to the *Speculum historiale*, bk 1, chap. 104, p. 38.

125. *SH*, 2:12 (p. 51).

126. *SH*, 1:105 (p. 38).

127. E.g. *SH*, 1:124 (p. 45).

128. *SH*, 2:55 (pp. 64–65); cf. Petrus Comestor, *Historia scholastica*, in *PL*, vol. 198, cols. 1268–69. Vincent also refers to the line of priests from Ephraim and Levi.

129. *SH*, 1:124–25 (pp. 44–45).

130. He derives Judah and Levi from Joseph's sons Ephraim and Manasseh, respectively; cf. *SH*, 1:126 (p. 45), 2:42 (p. 61), and 2:55 (p. 65).

131. Brincken, "Geschichtsbetrachtung bei Vincenz von Beauvais"; Melville, "Spätmittelalterliche Geschichtskompendium," 82–83; Paulmier-Foucart, "Histoire ecclésiastique et histoire universelle."

132. E.g., the late-twelfth-century translation of Kings, cited and discussed in Robson, "Vernacular Scriptures in France," 442–44.

133. See Spiegel, *Romancing the Past*, with bibliography.

134. Ibid., 106 and passim.

135. P. Meyer, "Les premières compilations françaises," 36–63.

136. Ibid., 59; for the prologue, see 53–56. The quote comes from the first rubric in the base manuscript, Paris, Bibl. Nat., MS fr. 20125. Buchthal, *Miniature Painting*, 70–73, 77, cites this work as representative of French manuscripts of this text, which he refers to as the *Histoire universelle*, whereas Folda, *Crusader Manuscript Illumination*, 95–102, 188–92, attributes this exemplar to Acre ca. 1287.

137. P. Meyer, "Les premières compilations françaises," 38–39. In his prologue the author makes no distinction between biblical and ancient history. The verse moralizations clearly speak for the author; see Blumenfeld-Kosinski, "Moralization and History." Between Buchthal, *Miniature Painting*, and Folda, *Crusader Manuscript Illumination*, all the miniatures are published. On the attribution and cycle, see my review of Folda's book in *ZKg* 43 (1980), 419–21, and Oltrogge, *Die Illustrationzyklen zur "Histoire ancienne,"* 20–22. The biblical illumination probably added another dimension to that of ancient events, for the miniature of Holofernes approaching the walls of Jerusalem may well have brought to mind the very similar compositions of David's approach to the same city, just as Pompey's triumph in Rome may well have recalled Joseph's acclamation in Egypt; cf. Folda, *Crusader Manuscript Illumination*, figs. 81 and 93, to *Old Testament Miniatures*, no. 236, and Laborde, *Bible moralisée*, pl. 28, respectively. Because the compositional and narrative vocabulary of the base-manuscript miniatures is far closer to works contemporary with the text (ca. 1230) than to those contemporary with the exemplar (ca. 1250), it is likely that the text was illuminated very early on, if not in its original version. Cf. Oltrogge, *Die Illustrationzyklen zur "Histoire ancienne,"* 13–20, 128, who takes London, Brit. Libr. Addit. 19669 of ca. 1260 as standard for the early cycle, noting that it is linguistically the most original, even if it is slightly later than the Paris manuscript. However, she notes that its pictorial cycle is already heterogeneous and, in the absence of a modern philological study of the text, leaves open the question of the priority of this *Histoire ancienne* cycle over the others she identifies.

138. Cited in Cahn, "Moses ben Abraham's *Chroniques de la Bible*," n. 2: "a savoir les nessances et les lignies des le commencement del siecle et velt savoir les batailles qui ont este faites anciennement." The prologue identifies the author as a Jew working for the count of Auvergne and says that he translated the biblical text from Latin and Hebrew. The text omits Creation and goes directly to the generations of Adam. Just as the children of Noah are the starting point for considerations of the origins of European and ancient peoples, Daniel's visions are the pretext for commentary on later events in ancient history. Cahn dates the preserved manuscript (The Hague, Royal Library, MS 131 A 3) to about 1300 and suggests the patron is to be identified as William X of Auvergne. It is unclear what relation the text had to William's circumstances at that time.

139. Such works relate to two broader developments in early-thirteenth-century France, the growth of vernacular historiography and the writing of universal chronicles. If vernacular historiography was often concerned with justifying the rights and promoting the interests of its patrons, usually the aristocracy or Crown, universal chronicles often integrated biblical and ancient history and thus put in place a totalizing view of history, one in which the geography, events, and institutions of the Old Testament became continuous with those of the ancient and modern worlds. The interest in biblical history was not just for the story of humankind's creation and promise of salvation but for those recognizable and divinely given structures of precedence, continuity, and authority that could bear upon present and future events. In current terms, this usually meant dynasty, kingship, church and state, and military action.

140. The most conspicuous example is Benoît de Sainte-Maure's *Roman de Troie*, which follows the death of Moses in the Bible of Jehan Malkaraume, ca. 1300; see Smeets, *La Bible de Jehan Malkaraume*, xxx. At the end is also a series of vignettes that pair antique and biblical figures,

for example, Pyramus and Thisbe with Samson and Delilah. The story of the Maccabees is frequently linked with the history of Alexander the Great; cf. Grimm, "Den Grenzfall des Bibelepos," 491–92, 498–500.

141. There is a change at lines 7131–67. The author claims that he no longer has access to the Bible he was using as a source and so, switching to divine inspiration, begins a "devine page" (line 7140).

142. Moreover, some parts of his poem correspond closely to the imagery on the lost cross of Suger; see lines 8656ff.

143. Le Goff, *Saint Louis*, 124–26.

144. Since the Sainte-Chapelle was dedicated in 1248, we cannot exclude the possibility that the poet saw it.

145. Kantorowicz, *Laudes Regiae*, 42–60; Schramm, "Das Alte und das Neue Testament in der Staatslehre und Staatssymbolik des Mittelalters"; Steger, *David Rex et Propheta*, xxx; Kottje, *Studien zum Einfluß des Alten Testamentes auf Recht und Liturgie*; Riché, "La Bible et la vie politique," esp. 387–98. For comparison of Carolingian emperors to biblical figures, see the following note.

146. The passages had been in use at least since the coronation of Louis II the Stammerer in 877 and were doubtless used for the coronation of Louis IX. Although the ordo for his coronation is not preserved, the same prayers are found in the so-called ordo of Sens, which Richard Jackson believes to have been written about 1250 (the relevant passages are in Paris, Bibl. Nat., MS n.a.l. 1202, fols. 128v–130r); see Richard Jackson, "Les *ordines* des coronation royaux au Moyen Âge." Cf. also Kantorowicz, *The King's Two Bodies*, 42–86. On the Old Testament and Carolingian kingship, see Schramm, *Der König von Frankreich*, 178–81; Ewig, "Zum christlichen Königsgedanken im Frühmittelalter"; Ullmann, *The Carolingian Renaissance and the Idea of Kingship*, x; Mohr, "Christlich-alttestamentliches Gedankengut in der Entwicklung des karolingischen Kaisertums"; and Kottje, "Karl der Große und der Alte Bund." For the Carolingian Mirrors of Princes, see the following note.

147. Wilmart, "L'admonition de Jonas au roi Pepin"; Anton, *Fürstenspiegel und Herrscherethos in der Karolingerzeit*; Eberhardt, *Via Regia*. Several studies have pointed to these texts in order to explain the Old Testament imagery in certain Carolingian works of art; see Cwi, "A Study of Carolingian Biblical Theology"; Deshman, "The Exalted Servant"; and Nees, *A Tainted Mantel*, esp. 263–82. See also Weiss, "Biblical History," and idem, "Three Solomon Portraits." The basic study of the Mirrors remains Berges, *Die Fürstenspiegel des hohen und späten Mittelalters*; see also Schramm, *Der König von Frankreich*, 188–92; Born, "The Perfect Prince," provides a good overview of the primary

tenets espoused in the Mirrors; see also the useful summary in Le Goff, *Saint Louis*.

148. Riché, "La Bible et la vie politique," 388–98. Schramm, *Der König von Frankreich*, 184–88; Strayer, "France: The Holy Land," esp. 302–5; A. W. Lewis, *Royal Succession in Capetian France*, 131–33; Baldwin, *Government of Philip Augustus*, 386–89. For Gregory IX's bull to Louis IX, "Dei Filius," issued at Anagni and dated October 21, 1239, see Teulet, *Layettes du Trésor des chartes*, 2:416 (no. 2835). This is a highly specific application of the much earlier and more general notion linking all Christian peoples with Israel, as in Augustine, *Super Psalmos* (no. 114, sect. 3).

149. E. A. R. Brown, "Vincent de Beauvais and the *Reditus Regni Francorum ad Stirpem Caroli Imperatoris*," with earlier bibliography.

150. In the mid-1260s the tombs were arranged with the line of the Merovingian/Carolingian kings on one side and the Capetian kings on the other, both seeming to merge in the tombs of Philip Augustus and Louis VIII, which lie between them; see G. S. Wright, "A Royal Tomb Program," and Erlande-Brandenburg, *Le roi est mort*, 81–83. The authors correctly point out that the arrangement of this "royal cemetery" must have required the king's approval, if not his participation.

151. Viard, *Les grandes chroniques*, 5:1 and 7:2–4. The first copy of Primat's text, the prologue to the *Grandes chroniques*, dates to about 1274 (Paris, Bibl. Ste. Geneviève, MS 782), but it was commissioned during the reign of Louis IX and is based in part upon Latin sources from the middle of the century. See Spiegel, *Chronicle Tradition*, 83–92; idem, "The *Reditus Regni ad Stirpem Karoli Magni*"; and Hedeman, *Royal Image*, 1–29. The latter especially underscores the royalist character of the text and illustration and its continuity with political ideology during the reign of Louis IX.

152. Baldwin, *Government of Philip Augustus*, 372–74, 396–97.

153. Spiegel, *Chronicle Tradition*, 68–69; Viard, *Les grandes chroniques*, 1:1ff., and see also the prologue, 3–4. The frontispiece of the earliest copy shows an episode of the Trojan history; see Hedeman, *Royal Image*, 12.

154. *SH*, 16:3 (p. 619); cf. also 2:66 (p. 68). For David, see *SH*, 2:69–74 (pp. 69–70).

155. Katzenellenbogen, *Sculptural Programs*, 27–30, and esp. Sauerländer, *Das Königsportal in Chartres*, 59–72.

156. Caviness, *Sumptuous Arts*, 55–58, 63. Both patriarchs and kings are shown with regalia. The nave clerestory apparently consisted of a series. See Brenk, "Bildprogrammatik." A comparable juxtaposition of lineage is developed in the stained-glass windows of Reims cathedral, in which the clerestory windows contain apostles

and Evangelists surmounting depictions of Reimois bishops or the suffragan churches of Reims. See Sadler-Davis, "The Sculptural Program of the Verso of the West Façade of Reims Cathedral," 238–45.

157. See Katzenellenbogen, *Sculptural Programs;* Sadler, "The King as Subject"; idem, "Lessons Fit for a King."

158. Sauerländer, *Gotische Skulptur,* pl. 175, pp. 59, 467–68.

159. Now at the Cloisters in New York. See Forsyth, "A Gothic Doorway from Moutiers-Saint-Jean."

160. Sauerländer, *Gotische Skulptur,* 170, no. 271. For the representation of contemporary rulers on other portals at Notre-Dame, see Hinkle, "The King and the Pope on the Virgin Portal at Notre-Dame," 2–3, and Horste, "A Child Is Born." The identity of the figures in the earlier portals remains problematic; however, the representation of contemporary regents in the Porte Rouge is generally accepted. On the inclusion of Louis IX in the Sainte-Chapelle, see A. A. Jordan, *Visualizing Kingship,* chap. 5; and on the inclusion of Louis IX in the Porte Rouge, Gaposchkin, "The King of France and the Queen of Heaven."

161. *SH,* 2:71 (p. 69).

162. Baldwin, *Government of Philip Augustus,* 355–93. See also A. W. Lewis, *Royal Succession in Capetian France,* 122–33. There are no reports of scrofula or the healing touch between Louis VI and Louis IX, who may have performed the ritual as early as the 1240s. It is unclear if the practice was revived or merely became more visible during Louis IX's reign, but it was certainly associated with him. See M. Bloch, *Les rois thaumaturges,* esp. 127–28; Barlow, "The King's Evil"; Baldwin, *Government of Philip Augustus,* 390–92; W. C. Jordan, *Louis IX and the Challenge of the Crusade,* 110. Cf. also Nelson, "Inauguration Rituals," esp. 58–60. For coronation, see R. A. Jackson, "Manuscripts, Texts, and Enigmas of Medieval French Coronation Ordines," esp. 54–58. Le Goff, "A Coronation Program for the Age of Saint Louis," stresses how the balance of emphasis between king and priest shifts decisively toward the king after the coronation.

163. Le Goff, *Saint Louis,* and W. C. Jordan, *Louis IX and the Challenge of the Crusade.*

164. Le Goff, *Saint Louis,* 90–99. Very little is known about that education. The text describing Saint Louis's rigorous upbringing was written after his death, and the Mirrors of Princes that can be associated with his rule date to the middle of his reign.

165. In the visual arts of the Middle Ages, this "chronicle" tradition of illustration has a limited history. It is known in secular works and, as gleaned from descriptions, from fresco cycles at the Carolingian palace at Ingelheim, in the Norman castle of Adele de Blois, and possibly in Henry III's Painted Chamber at Westminster Palace. Thirteenth-century manuscripts such as the *Histoire ancienne* precede the chapters on Roman history with Old Testament miniatures of fairly standard iconography. Much like crusading chronicles, the Morgan Picture Book presents a linear chronology punctuated by explosive images of battle or physical contest that mark the major turning points of its history. In contrast, the stained glass of the Sainte-Chapelle does seem to fit the Old Testament into historiographic structures, as described above. Indeed, it shows many of the same characteristics seen in the *Speculum historiale,* a work composed by Vincent at the same time the chapel was glazed.

Of the extensive work on audience and reception relative to the *Bibles moralisées,* see in particular Guest, "Queens, Kings, and Clergy," 171–254; Heinlein, "Ideology of Reform."

166. Heinlein, "Ideology of Reform"; Guest, "Queens, Kings, and Clergy," 56–74, 76–104. In Vienna 1179, Old Testament scenes originally took up 88 percent of the total book; because of losses, they now take up 90 percent.

167. Friedman, *Text and Iconography for Joinville's "Credo,"* 1, 26–27.

168. And in fact it may have been inspired by wall painting. See Folda, *Crusader Manuscript Illumination,* 102–10.

169. Their organization is also surprisingly historical, beginning with Creation. They are thought to have been inspired by the king's own lessons as Joinville reported them in his *Vie.* Given the closeness of the two men and Joinville's elevation of his friend as a model of piety, we may assume that the *Credo* is consistent with Louis's own ideas or, at the very least, those current in his entourage. The text explains the twelve articles of the Creed, one phrase or point at a time, usually with several exempla from Scripture. A significant number—almost half—are from the Old Testament.

170. Friedman, *Text and Iconography for Joinville's "Credo,"* 51.

171. The usage is consistent with the view of W. C. Jordan, *Louis IX and the Challenge of the Crusade,* 213, who sees Louis's Crusades as a quest for personal salvation.

172. See von Moos, "Die Trostschrift des Vincenz von Beauvais für Ludwig IX."

173. "Quid si vobis eciam unigentum propriis manibus preceptum esse occidere? *Nunc,* inquit, *cognovi, quod timeas deum et non peperceris unigenito filio tuo propter me.*"

174. Vienna, ÖNB, MS 1179, fol. 102r (medallion 5). A comparable historical model existed in the Legend of Heraclius, the Byzantine emperor. When Heraclius attempted to return the True Cross to Jerusalem on horseback and in lavish

dress, he was barred from entering the city gate by an angel who instructed him that he would be allowed to enter only if he approached in a humble fashion. Heraclius then entered the city simply attired and on foot. Jacobus de Voragine, *The Golden Legend*. Not surprisingly, the Sainte-Chapelle's representation of this thirteenth-century event uses the composition of the David episode; cf. Grodecki, "Sainte Chapelle de Paris," panel A-94. That depiction, however, is also strongly reminiscent of the scene in the Joshua window, in which Joshua carries the Ark of the Covenant across the river Jordan. See Grodecki, "Sainte Chapelle de Paris," pl. 35, A-127, and pl. 86, A-84, A-98.

175. Szirmai, *La Bible anonyme,* lines 7871–88.

176. Jean de Joinville, *Vie de Saint Louis* (on Jean de Joinville, see *GRLMA,* XI/1), and Pisaro; Gautier de Cornut for description, though David is not mentioned. For the *Teachings,* see Weiss, "Architectural Symbolism."

177. Le Goff, "Royauté biblique et idéal monarchique médiéval," has made the important point that this parallelism between the lives of Louis IX and Josias underscores the importance of historical resemblance, how Louis IX's life so naturally aligns itself with biblical history that it effectively extends the latter into the present. When William writes at the end of the *vita* that Louis is "our Josias," he implies not only that the French king is a thirteenth-century Josias but that he is Josias to us, that we have a sacred history, and that the biblical past lives on in Josiases like him. In the *vita implicita,* praise and moral lesson subtend a historical vision, just as they do in church sculpture and stained glass.

178. The position of Josias, however, is unclear in the Sainte-Chapelle; cf. *RHF,* 20:3–4, 9, 25.

179. For the direction of readings, see Stahl, "Old Testament Illustration." On the versions of the legend of the True Cross that circulated in Old French, see Napier, *History of the Holy Rood-Tree.*

180. In the early thirteenth century, single Old Testament figures were the subjects of entire windows at the cathedral of Poitiers (Noah, Isaac, Joseph, Moses, Balaam, and Joshua) and to a lesser extent at the cathedrals of Bourges (Joseph), Chartres (Noah, Joseph), and Auxerre (Abraham and Lot, Joseph, Saul and David, and possibly Samson, and other figures from Genesis and Exodus). For Poitiers, see Grodecki, "Les vitraux de la cathédrale de Poitiers." For the other windows, see *Recensement des vitraux anciens de la France,* 2:28, 34, 174–75, and 3:111–20.

181. Leniaud and Perrot, *Sainte Chapelle;* Brenk, "Sainte-Chapelle"; von Simson, "Opere superante materiam"; Sauerländer, *Gotische Skulptur;* A. A. Jordan, *Visualizing Kingship,* chaps. 2 and 5; and Weiss, "Architectural Symbolism"—all support this interpretation.

182. See pages 97–98 above; A. A. Jordan, *Visualizing Kingship,* 21–28; and Sadler, "The King as Subject."

183. Grodecki, "Sainte Chapelle de Paris," 78; and pages 164 and 168 above and notes 184 and 185 below. See also Sadler, "The King as Subject."

184. Continuing into the choir are the opposed windows of Samson/Dagon and Jeremiah/Jerusalem. Opposition is well known in earlier nave programs, though usually the stories opposed are Old Testament/New Testament.

185. These shifts between the biblical and the historical identities—and between the sacred and the worldly persons—of the king operate on the level of symbols, of types and models, and of analogy and allusion. They assert the prestige and authority of biblical forebears, but the argument is not historical. On the two nonbiblical groups of forebears to which claims of kingship were made during this period, see page 162 above.

186. In the Sainte-Chapelle, biblical history merges with ancient and modern times as the narrative of the window illustrating the Book of Kings leads directly onto that of the Relics, which begins with their invention by Constantine and Helena and ends with their translation by Louis IX.

187. For example, the fall of Jerusalem is narratively linked with the rise of the Sainte-Chapelle. Grodecki, "Sainte Chapelle de Paris," A-47, panels E-9. The final register of panels is restored, but it probably represented the translation of relics into the Sainte-Chapelle and/or the building's dedication. It is also noteworthy that directly across from the Jeremiah panel of the destruction of Jerusalem is Samson destroying the temple of Dagon (K-7). In these terms the moral lessons of the Tobit, Judith/Job, and Esther windows function differently, for they become preparatory to and almost a condition of the series of royal deeds in the Kings and Translation windows.

188. Moreover, the desert tabernacle occupies a major place in the *Bible moralisée;* it prefigures the Church and the objects and rituals of devotion, such as the Cross. (In the *Bible moralisée* the components of the desert tabernacle are compared less to the Church's objects than to its sacraments; that is, the connection is functional as well as symbolic; cf. Laborde, *Bible moralisée,* pls. 53, 54, 57, and 163, 164. For a discussion of its symbolic role in the earlier decoration of Saint-Rémi, see Caviness, *Sumptuous Arts,* 41–44.) Along with Solomon's temple, it accounts for one of the longest sections of *Speculum historiale.*

While Daniel Weiss has argued in *Art and Crusade,* 53–74, for a multivalent identification of the Sainte-Chapelle and its architectural and sculptural elaboration with the temple and palace of Solomon, I agree instead

with Caroline Bruzelius, in her review of Weiss's book, regarding the problems she sees in such an interpretation.

189. Katzenellenbogen, *Sculptural Programs.*

190. Ibid. and Sauerländer, *Gotische Skulptur* (esp. at Chartres, Reims, Paris). For the theme in the visual arts, see *LCI.*

191. See Caviness, *Sumptuous Arts;* Brenk, "Bildprogrammatik."

192. Sauerländer, *Gotische Skulptur,* on Reims; Sadler, "Lessons Fit for a King"; Brenk, "Bildprogrammatik," on Chartres. See also Manchester, John Rylands French 5, fol. 17v (Fawtier, *Bible historiée,* pl. XXVII).

193. Laborde, *Bible moralisée,* pls. 78 (Num. 16:3), and 133 (1 Sam. 14:24).

194. On the importance of royal submission to the Church, see Heinlein, "Ideology of Reform."

195. See Sadler-Davis, "The Sculptural Program of the Verso of the West Façade of Reims Cathedral," 238–45; Sadler, "The King as Subject"; idem, "Lessons Fit for a King"; Caviness, *Sumptuous Arts.*

196. Grodecki, "Sainte Chapelle de Paris," 122, pl. 20.

197. Ibid., M-21. The central subject of the principal rose, the altar with cherubim (M-6), is modern, but the surrounding subjects suggest it is inappropriate; ibid., 140, pl. 26. On the thematic emphasis placed on the tabernacle in the Numbers window, see also A. A. Jordan, *Visualizing Kingship,* 24–26, 94–99, pl. M, and fig. 45.

198. Grodecki, "Sainte Chapelle de Paris," 122, 130, 152–53; pls. 20, 28, 34; N-40–43; M-120, 124–27, and M-2, 11, 21; and L-97, 100, 101, 127. The latter are especially striking, coming as they do after the reiteration of the Jews' idolatry in L-140.

199. Ibid., 123, 292, pls. 20, 78; N-38, 39; B-39. All of the immediately preceding scenes concerning the destruction of the temple under Nebuchadnezzar are modern; no evidence indicates the subject was part of the window.

200. Chenu, *Nature, Man, and Society,* 156.

201. At least one mid-thirteenth-century copy of a French translation of *Speculum historiale* is part of a compilation of French royal histories.

202. This conflation is also apparent in medieval imagery, as in the panel from the Sainte-Chapelle Isaiah window (J-108), in which two men worship before an idol, identified by inscription as "Mahometa" (Mohammed). Grodecki, "Saine Chapelle de Paris," 179, pl. 42.

Chapter 5

1. W. C. Jordan, "The Psalter of Saint-Louis," 74.

2. Brincken, "Geschichtsbetrachtung bei Vincenz von Beauvais," 489: "post hec autem iuxta seriem temporum per ordinem continet historiam rerum in mundo gestarum, dictorumque memorabilium ab initio seculi usque ad tempus nostrum: et primo quidem describit initium Ecclesie, quod habuit ab Abel, eiusque progressum per tempora patriarcharum, judicum, regum, ac ducum usque ad tempora Christi et Apostolorum iuxta ordinem Sacrae Historie, multa etiam interserens utilia de gestis ac dictis ethnicorum."

3. *SH,* 1:57 (pp. 22–23) (De ortu Ecclesia ab Abel): "In his itaque duobus primis filius Adae, scilicet Cayn & Abel ortum habuerunt duae civitates secundum August. una sanctorum, quae civitates peregrinavit in terris, & habitationem expectabat in coelis, haec est Hierusalem caelestis. Altera reproborum, qu[a]e habitationem suam constituit spem futurorum non habens, haec est Babylon spiritualis. Unde & ab Abel dicitur incapaepisse ecclesia: quia si ab Adam incaepisset non fuisset continua."

4. For the exegetical treatment of Cain and Abel at this time, see Dahan; for alternative ways of organizing such texts, see Melville, "Spätmittelalterliche Geschichtskompendium."

5. See R. Schneider, "A 'Mirror for Princes,'" also R. Schneider and R. Rouse, "Medieval Circulation of the *De Morali Principis Institutione.*" On the versions and dating of the *Speculum historiale,* see Paulmier-Fouquart, "Histoire ecclésiastique et histoire universelle."

6. Guibert de Tournai, *Eruditio regum et principum,* of 1259, and Guillaume Perrault, *De eruditio principum,* ca. 1265. For the former, see Poorter, *Le traité;* for the latter, Thomas Aquinas, *Opera Omnia,* 16:390–476.

7. This was already recognized by W. C. Jordan, "The Psalter of Saint-Louis," 74.

8. Cf. page 88 above.

9. The larger viewpoint is also implied by the depiction of the sleeping Jacob; see page 88 above. It is unclear why the Lord and arriving angels are shown emerging from beyond the building. Because this episode is recounted in the ceremony of church dedications, especially of altars—a ceremony possibly signified in Jacob's anointment of a slab rather than a stone—the placement of the ladder may allude to the church itself and its Jerusalemic function.

10. *LCI,* esp. Augustine, Isidore, Hugh of St. Victor, Comestor, and Vincent.

11. Augustine, *De civitate Dei,* bk. 16, chap. 24; Petrus Riga, *Aurora,* lines 769–73 (Beichner, *Aurora,* 57).

12. Petrus Riga, *Aurora,* line 741 (Beichner, *Aurora,* 56). For Cain and Abraham as representing the two cities, see Dahan, "L'exégèse de l'histoire de Cain et Abel du XII⁸XIV siècle" (1982), 59–63; ibid. (1983), 23–24, citing especially Langton, *Expositio super Genesim.*

13. Graham, "Old Testament Cycles"; Morgan, *Early Gothic Manuscripts.*

14. It is tempting to see in Abraham's gesture as he reaches across his own soldiers to rescue Lot the source for the highly unusual gesture of the soldier reaching across Abraham's chest.

15. The subject is compared to Christ liberating Ecclesia from five devils.

16. There is much to suggest that psalter representations of David victorious over Goliath are the source for this image. In both the Munich and Saint Louis Psalters the Hebrew soldiers, at the left, who watch the contest and stand at the ready, contrast markedly with their enemies, at the right, who already perceive their defeat and turn to flee. This construction derives from Byzantine representations, was known in the West very early, and is used in French art of the thirteenth century for battles other than that between David and Goliath. In the Psalter of Saint Louis, however, two details refer to the original story of David: the raised arm of the fleeing soldier at the right and the magnified central figure with his windmill of limbs. Our interest is not in identifying the exotic pictorial models that were available to the Psalter artists—I have addressed that issue earlier—but in understanding how such models inspired new formal and expressive possibilities and how their use might clarify the intent of the Psalter artists. For representations of David fighting Goliath in French psalter initials, see G. Haseloff, *Psalter-illustration*, and Leroquais, *Les psautiers*. For earlier Western cycles, see the discussion in Haney, *Winchester Psalter*. The subject in the so-called Byzantine aristocratic psalters probably originated as a reference to imperial victory; cf. Weitzmann, *Miniatures of the Sacra Parallela;* Buchthal, *Miniature Painting;* and Cutler, "Aristocratic Psalters in Byzantium."

17. For the Frankish ritual, see McCormick, *Eternal Victory*, 344–45; for the coronation ritual, see note 146 to Chapter 4.

18. Among others, see *SH*, 1:116 (p. 42), where Vincent refers to their each offering a tithe.

19. Ibid. Vincent refers only to Melchizedek's priestly role.

20. The prophets are primarily distinguished by their beards rather than their dress. The single exception is the anonymous priest with the mantle over his head who prays before the tabernacle in folio 65v, discussed further in Chapter 5.

21. See pages 165–66 above. The desert tabernacle is a major topic of the church fathers and continues to be so in scholastic exegesis; see especially Isidore of Seville, Bernard of Clairvaux, Richard of St. Victor, Hugh of St. Cher, and William of Auvergne. The king heard Saint Bonaventure's sermon on the tabernacle in 1248.

22. Fols. 64r, 65v, 66r, 67v, 69v, 78r.

23. Fols. 38r, 50r, 54r, 55v.

24. Judg. 20:23, 26, 27; and 1 Sam. 1:7, 11:15.

25. Judg. 21:9.

26. Jacques de Vitry, *Historia orientalis*, chap. 85, 43 (Buridant, *La traduction*, 137).

27. Cf. pages 139–40 above.

28. Gen. 10:12–14.

29. Gen. 17:4–6, and pages 159–64 above.

30. The tree is thus a metaphor for Abraham's progeny, and the miniature, in reiterating God's promise to him, represents the beginning of the Hebrew nation and, ultimately, the source of all nations descended from the kings of Judah. The development of the Tree of Jesse as an iconography to depict the genealogical lineage of Christ accompanied the rise of genealogy as an organizational construct in thirteenth-century literature and historiographic chronicles. See Watson, *Early Iconography of the Tree of Jesse*, and Spiegel, "Genealogy." The particular import of genealogical writing for the French court, as evidenced in the compilation of the *Grandes chroniques*, is outlined by Speigel, *Chronicle Tradition*. A. A. Jordan, *Visualizing Kingship*, 18–21, has argued for the incorporation of both the iconographic and rhetorical elements of medieval genealogy in the Sainte-Chapelle Old Testament windows.

31. *SH*, 1:116 (p. 42).

32. Ibid. After Louis's death Jacob's mission is used as a parallel to Louis's own in the liturgical office for the canonized king; see Epstein, "*Ludovicus decus regnantium*," esp. 291–92.

33. Gen. 32:28. The final chapters of Genesis are not consistent in calling him "Israel." In chapter 42, where his death is recounted, he is called Jacob.

34. Cf. pages 105–7 above.

35. This is one of only two instances in the Psalter in which the author of the legends oversteps a description of the action in order to explain its larger meaning. For the other, the Ark Returns to Israel (fol. 71r), see page 112 above. In both cases the events are uncommon and the story very complex.

36. The gesture, which has no textual basis whatsoever, occurs only in the miniature in which Joseph points upward to relate his dreams to Jacob (fol. 15v). In both cases it is a gesture of someone instructed in God's will. In all other cases the Lord or an angel descends and personally directs the protagonist.

37. It is also the period when the tribes were first numbered and its leaders crowned, events that had powerful royal associations in both the *Bible moralisée* and the Sainte-Chapelle stained glass; see Laborde, *Bible moralisée*, pls. 67–70, and Grodecki, "Sainte Chapelle de Paris," M-164–51, and cf. pages 164–66 above.

38. Cf. pages 171–74 above.

39. Aaron is present behind Moses, as the writer of the legend on the reverse notes, but he is barely visible and thus hardly functional within the contexts described here.

40. Num. 23:9 and 24:2, 16, 17.

41. For the varied sources of this complex and richly composed miniature, see pages 76–77 above.

42. "En ceste page est conment dieus parole au prophete et conment le prophete dit au roi qu'il sacrifiee et face sacrificer ses genz qui sont es paveillonz."

43. Cf. fig. 47.

44. The same elegant hairstyle is worn by Pharaoh (fol. 21v and 30r), Sisera (fol. 48r), the Philistines (fol. 57v), and the youthful Benjaminites (fols. 63v, 65v, and 66r).

45. In the Bible these events are transformative, for God gives Saul "another heart" (1 Sam. 10:9), and he is "turned into another man" (1 Sam. 10:6). In the miniatures, however, I see nothing to suggest that these events endow or change him. Rather, the change in his appearance comes only in the final miniature, in the last step of the whole process.

46. For example, Saul with the army he has successfully raised, a subject found in both Byzantine and Western art; see Lassus, *L'illustration byzantine du Livre des Rois,* no. 25, and *Old Testament Miniatures,* no. 149 (fol. 23r).

47. Nelson, "Ritual and Reality in the Early Medieval Ordines." On the elaboration of the French coronation ritual relative to these elements, see R. A. Jackson, *Ordines Coronationis Franciae,* and Le Goff et al., *Le sacre royal à l'époque de Saint Louis.*

48. Major biblical examples are Saul and David.

49. 1 Sam. 9:2 and 10:9.

50. 1 Sam. 10:10 and 24. For a biblical overview, see Polzin, *Samuel and the Deuteronomist.*

51. Although the right half of folio 74r depicts the third sign, which should involve Saul's meeting prophets with musical instruments and prophesying among them, the miniature shows only youths with musical instruments. For Saul among the prophets, see *Old Testament Miniatures,* no. 146 (fol. 22v).

52. See, for example, the Vatican Book of Kings, the Pamplona Bibles, and Morgan Picture Book.

53. There are few examples in which it is certain that the anointment of 1 Sam. 10:1 is illustrated; for example, in the Gumpert Bible Samuel holds a crown as he anoints Saul (see G. Swarzenski, *Die Salzburger Malerei,* fig. 123).

54. Lassus, *L'illustration byzantine du Livre des Rois,* 44–45, fig. 25.

55. Bucher, *Pamplona Bibles,* 227.

56. Warner, *Queen Mary's Psalter,* pl. 96; *Old Testament Miniatures,* no. 151.

57. In the absence of inscriptions or other evidence, it is not always possible to tell if the anointment or Gilgal episode is represented, especially since crowns and anointing can figure in either one: for example, in the Arsenal Bible (Buchthal, *Miniature Painting,* pl. 69), where Saul is already crowned when he is anointed. In the Carolingian San Paolo Bible Saul stands, facing outward, and is anointed and acclaimed by youthful soldiers; Gaehde, "Carolingian Interpretations of an Early Christian Picture Cycle," 363–64, argues that the Carolingian miniature is indebted to a Byzantine formula, in which case it would represent the Gilgal episode. Kauffmann, *Romanesque Manuscripts,* no. 66, fig. 173; Morgan, *Early Gothic Manuscripts,* vol. 2, no. 1, fig. 2.

58. 1 Sam. 11:14.

59. Theodore at Chartres, Jean d'Alluye at the Cloisters.

60. Cf. fols. 5v, 37v, 40r, 41v; note especially the recurring motif of one person who turns back toward the others.

61. See W. Kemp, *Narratives of Gothic Stained Glass;* Kirn, "Saul in der Staatslehre"; J. Funkenstein, "Malkizedek in der Staatslehre"; idem, "Samuel und Saul in der Staatslehre des Mittelalters"; and Schramm, "Ordines Studien 11."

62. J. Funkenstein, "Samuel und Saul in der Staatslehre des Mittelalters," esp. citing Bernard of Clairvaux.

63. W. C. Jordan, "The Psalter of Saint-Louis."

64. Cf. *LCI,* Samuel and Saul. I know of no commentary that compares their sins. The reason, in part, is that Cain's sin was avarice, whereas Saul's was pride. In any case, Saul in this part of his life has not sinned; see pages 181–82 above.

65. Compare also the figure at the left who swings an axe over his head but at no one in particular, a gesture similar to the way Abraham wields his sword. A model book is unlikely because most thirteenth-century "model-book" drawings are concerned with groupings of figures, whereas the similarities here involve compositional parallels and reallocated gestures and limbs. Cf. Scheller, *Exemplum: Model-Book Drawings.*

66. See pages 178–79 above.

67. For the modern view, see Alter, *World of Biblical Literature,* and Josipovici, *The Book of God.*

68. Jerome, Isidore of Seville, Gilbert of Sempringham (Poorter, *Le traité,* 8); Bernard of Clairvaux, John of Salisbury, Aquinas; Herman de Valenciennes and Petrus Comestor (*PL,* vol. 198, col. 1306); most in Smeets, *La Bible de Jehan Malkaraume,* lines 8560–929. The only general survey is in Kirn, "Saul in der Staatslehre."

69. See Anton, *Fürstenspiegel und Herrscherethos in der Karolingerzeit,* and C. Schneider, *Prophetisches Sacerdotium und heilsgeschichtliches Regnum im Dialog, 1073–1077;* cf. Bouman, *Sacring and Crowning.*

70. Beichner, *Aurora*, 257; W. C. Jordan, "The Psalter of Saint-Louis," 74–75.

71. Buc, *Potestas*. See, however, idem, "Pouvoir royal et commentaires de la Bible."

72. Or as the star led the Magi to Bethlehem. Vincent of Beauvais, *De morali principis institutione*, 24–25, esp. lines 114–15.

73. Ibid., 16, lines 76–89.

74. Ibid., 24, lines 86–89.

75. Ibid., 68, line 71.

76. Ibid., 69, line 79 ("accepto ducatu").

77. E. A. R. Brown, "Burying and Unburying the Kings of France."

78. Brenda Deen Schildgen, "Vincent of Beauvais' *Speculum Historiale*, the Medieval Encyclopedia, and the Fall of the Middle Ages" (unpublished paper).

79. R. Schneider, "A 'Mirror for Princes.'"

80. For example, Vincent's advice that the first duty of a king is to take care, with the whole intention of his soul, that he not doubt God as his help in anything; see Vincent of Beauvais, *De morali principis institutione*, 70, lines 96–97.

81. See the *Bible moralisée*, in Heinlein, "Ideology of Reform."

82. It is also narratively independent of the victory on the facing page, for though this victory may be a divine gift, the giving is assumed rather than illustrated.

83. See pages 178–79 above.

84. The conceptualization of the setting and decorative program of the Psalter is realized in terms that are specifically Capetian, Parisian, and contemporary, that selectively reiterate the familiar world of the king. This is reinforced by the way the Old Testament miniatures of biblical kingship define contemporary kingship, especially in the attention given to subjects that address national identity, the responsibility of leaders, and the origin of kingship. Compare Ottonian illumination, in which a reigning monarch may be depicted making a donation to a contemporary building, for example, in the Escorial gospels.

85. See, for example, J. Richard, *Saint Louis*.

86. E. A. R. Brown, "The Chapels and Cult of Saint Louis at Saint-Denis"; R. Schneider and R. Rouse, "Medieval Circulation of the *De Morali Principis Institutione*." On the administrative preparations, see W. C. Jordan, *Louis IX and the Challenge of the Crusade*, and J. Richard, *Saint Louis*; for the preaching, see Cole, D'Avray, and Riley-Smith, "Application of Theology to Current Affairs."

87. S. Lewis, *Reading Images*, and Buc, "Pouvoir royal et commentaires de la Bible."

88. First, in its conceptualization of the setting and decorative program; second, in its definition of contemporary kingship via biblical kinship, both as discussed in note 84

above; and third, in a devotional interest that reflects Louis's character and, I believe, his use of Psalter.

89. For the calendar, see Delisle, *Notice de douze livres*, 38–39, 105–11.

90. The framing appears to imitate the design of folios 51v and 54r, although the motifs and coloring are misaligned.

91. G. Haseloff, *Psalterillustration*, 104–16 and passim.

92. Kunoth-Leifels, *Über die Darstellung der "Bathsheba im Bade*," 4–11. Idem, "Bathseba."

93. The exception may be the Byzantine Sacra Parallela (Paris, Bibl. Nat., MS gr. 923), where not only Bathsheba but Susanna and David seem to be posed for the viewer's gaze; see Weitzmann, *Miniatures of the Sacra Parallela*, 83–84, figs. 131, 134, 393.

94. Kunoth-Leifels, *Über die Darstellung der "Bathsheba im Bade*," 11–14, was the first to group together most of the works discussed in this section.

95. 2 Sam. 11:1–12:24.

96. Augustine, *Contra Faustum Manichaeum*, I, XXII, col. 87, in *PL*, vol. 42, cols. 458–59. For a discussion of this passage and the exegetical tradition, see Kunoth-Leifels, *Über die Darstellung der "Bathsheba im Bade*," 5–11.

97. The text alongside the interpretive roundel reads, "Hoc significat Ihesum Christum qui vidit Sanctam Ecclesiam lavantem et mundantem sordes peccatorem et eam respiciens et suam munditiam tenere adamavit" (Oxford, Bodleian Libr., MS Bodley 270b, fol. 152r). For reproductions, see Haussherr, *Bible Moralisée*, pl. 106; Laborde, *Bible moralisée*, pl. 152; Lipton, *Images of Intolerance*, 39, fig. 19.

98. On the currency of bathing in Paris at this time and its strong connection with rites of purification in contemporary texts, see Larmat, "Les bains dans la littérature française du Moyen Âge." The relevant medallion in the earliest *Bible moralisée* (Vienna, ÖNB, MS 2554, fol. 45r) has no attending servants, but the corresponding text explains that Bathsheba "se baignoit et lavoit son cors." See Stork, *Bible Moralisée*, 133, no. 106C.

99. Haussherr, *Bible Moralisée*, pl. 106.

100. As stated above, Ecclesia is usually shown enthroned, being baptized, or rejecting the Jews. For the text of the moralization and for references with reproductions, see note 97 above.

101. This view seems to be specific to the *Bibles moralisées*. Heinlein, "Ideology of Reform." (In the later *Bibles moralisées* prayer alone suffices for penance, Uriah is viewed less harshly, but the role of the Church, at least of clerics, canons, and officiants, is expanded; cf. Laborde, *Bible moralisée*, pls. 152–54. However, kings continue to get whipped in other moralizations, e.g., Laborde, *Bible moralisée*, pl. 100.)

102. F. Nordström, *The Auxerre Reliefs*, 98–127; Craven, "The Iconography of the David and Bathsheba Cycle"; Sauerländer, *Gotische Skulptur*; Quednau, *Westportale*, 30–31, 73–80; Raguin, "Mid-Thirteenth-Century Patronage at Auxerre." For the Parisian sources of the Saint John portal, see Kurmann, *La façade*, 1:284–85.

103. Craven, "The Iconography of the David and Bathsheba Cycle," 75–76, prefers to see in this relief David taking Bathsheba to his house. My intermediate interpretation is based upon the episode in the *Bible moralisée*, where the text makes clear that the couple embracing represents David taking Bathsheba as his wife, even though no *dextrarum junctio* is depicted; cf. Haussherr, *Bible Moralisée*, pl. 107.

104. The reliefs read outward from the doorway on one side and inward, toward it, on the other, so that it is a closed series, the end opposite the beginning and nearest to the door. The physical placement strikes me as appropriate in several other ways. Behind David and thus closest to this entrance to the cathedral is an elaborate towered façade suggesting Jerusalem, of which all churches are symbolic. The two scenes with Uriah face each other at the greatest distance from the door, so that when Uriah rides to the front, he rides away from the entrance, and when he falls in battle, it is not only before the gates of Rabbah but at the "gate" of the doorway, the outer edge of the doorway's limit.

105. Stahl, "Old Testament Illustration."

106. As noted earlier (note 96 above), this interpretation ultimately goes back to Augustine, *Contra Faustum Manichaeum*, I, XXII, col. 87, in *PL*, vol. 42, cols. 458–59. French Gothic painting of the second quarter of the thirteenth century usually illustrates 2 Sam. 11:2 with Bathsheba in a barrel or tub as David looks from his palace or peers in through a window. In the later *Bibles moralisées*, she is attended by two maids, who pour water over her and comb her hair; see Laborde, *Bible moralisée*, pl. 152.

107. For example, see Bucher, *Pamplona Bibles*, 231, pl. 225, and Harrsen, *Cursus Sanctae Mariae*, pl. 13 (1). For the de Brailes Hours, see figure 93 (Morgan, *Early Gothic Manuscripts*, 1:121–23, no. 74).

108. Katzenellenbogen, *Sculptural Programs*, 15–22.

109. See note 102 above. Kunoth-Leifels, *Über die Darstellung der "Bathsheba im Bade,"* 14, interprets the final relief as Bathsheba enthroned with her son Solomon.

110. Fol. 42v, the figure at the far right; *Old Testament Miniatures*, no. 257.

111. Cf. fol. 40r; *Old Testament Miniatures*, no. 243; on the proskynesis, see Stahl, "Old Testament Illustration."

112. See S. Lewis, *Reading Images*, pt. 1.

113. F. Nordström, *The Auxerre Reliefs*, 109–11, correctly cites the type as derived from classical river goddesses or water nymphs. However, the figure occurs in other guises as well; see, for example, Koch, *Die mythologischen Sarkophage*, vol. 6, no. 168, and Göbl, *Antike Numismatik*, vol. 2, pl. 135, no. 2925.

114. Adhémar, *Influences antiques dans l'art du Moyen Âge français*, 283–85.

115. Panofsky, *Renaissance and Renascences in Western Art*, 93–94. Panofsky finds these figures "explicable only" by the presence in Auxerre of the treasure of Saint Didier, a collection of ancient silver known to be at the cathedral through the late thirteenth century. Compare, however, page 126 above for my earlier discussion of the interest in ancient art and narrative in these years. For a description of the now lost treasure of Saint Didier, see Adhémar, "Le trésor d'argenterie donné par Saint Didier." Cf. also Quednau, *Westportale*, 107, 110, 113.

116. It also seems to influence the nearby Old Testament subjects; compare the treatment of the body of Hercules to that of the half-nude figure of Joseph lowered into and lifted out of the well, or the faun to the dreaming Pharaoh, or the sleeping Cupid to the dreaming Joseph, in Quednau, *Westportale*, figs. 57–59, 67, 83.

117. Camille, *Gothic Idol*, 88. See also R. H. Block, *Medieval Misogyny and the Invention of Western Romantic Love*, chap. 2, esp. 50–52, and Baldwin, *The Language of Sex*, chap. 4, esp. 116–23.

118. Camille, *Gothic Idol*, 95–100.

119. See the essays collected in the section on the body in medieval art in *Künstlerischer Austausch/Artistic Exchange*, 2:341ff.

120. See, for example, the Psalter folio 25v, where Joseph reveals himself to his brothers by throwing off his mantle and raising his arms so as to exhibit his full length. For ancient art, see Harrison, "Apollo's Cloak," 91–98.

121. Quednau, *Westportale*, 77–80, does not consider their meaning in relation to the scenes below, but the selection cannot be accidental: Grammar instructs two children above Bathsheba, interpreted here as revealing religious knowledge; Uriah rides into battle below Dialectic and Rhetoric and is fatefully killed below Arithmetic and Geometry; above the Enthronement are Music and Astronomy.

122. Wormald and Giles, *Descriptive Catalogue of Additional Illuminated Manuscripts*, 280–84. As discussed earlier, on page 8 above, the Cambridge manuscript, called the Isabella Psalter, has been correctly termed the sister of the Saint Louis Psalter, for it was produced by an allied team

of artists, and many miniatures are almost identical. Cf. A. Haseloff, "Les psautiers de Saint-Louis," and Cockerell, *Psalter and Hours*. The reference to it as the Isabella Psalter has been established since Cockerell's suggestion in *Psalter and Hours*, 8–10. Because it lacks Franciscan prayers, Branner, in "St Louis et l'enluminure parisienne," 83, and *Manuscript Painting in Paris*, 133, attributed the manuscript to another Isabella, the king's daughter, or to his wife, Margaret.

123. Seven of the eight historiated initials in the two psalters have the same iconography; however, those in the king's psalter elaborate and sometimes clarify or correct details in the Cambridge manuscript.

124. For example, the ideal of female beauty in Chrétien de Troyes's description of Philomena; see Burns, *Bodytalk*, 109, 115.

125. Morgan, *Early Gothic Manuscripts*, 1:121–23, no. 74.

126. For the beginning and the end, the completeness of God's word. The unusual detail of the half-buried David depends upon a reinterpretation of the parable Nathan tells David about the rich man who stole a poor man's lamb. Instead of the judgment David renders in 2 Samuel 12—that the stolen animal should be returned fourfold—he says the man should be buried alive. This exchange is described in a French caption written above the initial to Psalm 6, the first of the Penitential Psalms, in the de Brailes Hours (London, Brit. Libr. Addit. 49999, fol. 66r). The initial itself illustrates the exchange between Nathan and David, and the sentence David pronounces upon himself is illustrated in the next initial, much as it is in the lower roundel in the New College Psalter. See Donovan, *The de Brailes Hours*, 104–6, pl. 12, figs. 69–70; the author believes that the sentence David pronounces on himself is an invention of de Brailes.

127. Although there is no reference to the David and Bathsheba story, the tree and stream of water, complete with river god, figure prominently in the illustration to Psalm 1 in the Utrecht Psalter.

128. Anselm of Laon, *Glossa ordinaria*, in *PL*, vol. 113, col. 845B; see also Ambrose, *Enarratio in Psalmum I*, in *PL*, vol. 14, cols. 984–88, and Peter Lombard, *Commentarium in Psalmos*, in *PL*, vol. 191, col. 63.

129. Anselm of Laon, *Glossa ordinaria*, in *PL*, vol. 113, col. 571. These references to Bathsheba may explain not only the stream in the Auxerre relief but the exceptional richness of the landscape.

130. Cf. Bucher, *Pamplona Bibles*, 231, pl. 225; Harrsen, *Cursus Sanctae Mariae*, pl. 13 (1). For the Psalter, Oxford New College, MS 322, see [the relevant plate in Cockerell, *The Work of W. de Brailes*, and] Morgan, *Early Gothic Manu-*

scripts, 1:121–23. Cf. also Egbert, *The Tickhill Psalter*, pl. LIV.

131. See also Vienna, ÖNB, MS 2554, fol. 2r; Haussherr, *Bible Moralisée*, pl. 4.

132. Kessler, *Illustrated Bibles from Tours*, 17, fig. 4. The subject also appears in the mosaics of San Marco and may be reflected in the Hildesheim doors.

133. Camille, *Gothic Idol*, 88, makes a similar observation about both Adam and Eve before the Fall in Paris, Bibl. Nat., MS lat. 10434, a Parisian psalter now thought to be made for a member of the royal family; see Tesnière, "Medieval Collections," 54–55. The figures most similar to Eve are those in the extended early Creation cycles, like that in the Carolingian Bible of San Paolo fuori le mura.

134. When the Psalms are seen as stages in personal redemption, the first fifty are sometimes seen collectively as penitential in nature; cf. Anselm of Laon, *Glossa ordinaria*, in *PL*, vol. 113, col. 844.

135. *The Lyrics of Thibault de Champagne*, xxix–xxx.

136. See especially lines 12–33 of "Mauves Arbes ne puet florir," in ibid., 242–46.

137. Cf. page 204 above.

138. Among those in the *Bible moralisée* alone are Rebecca, Tamar, and Abigail; see Haussherr, *Bible Moralisée*, pls. 12 and 98. One interpretation of the Bathsheba story might have made it especially apt for these two royal psalters. Chapter 11 in 2 Samuel makes clear that Bathsheba was bathing in order to cleanse herself during her menstrual period and that she was "[purified] from her uncleanness" when David slept with her. Buc, "David's Adultery," has shown that Parisian glosses of the late twelfth and early thirteenth centuries interpreted this passage as a historical prototype of the miraculous power of the healing touch that French kings were believed to have by virtue of their sacral anointment on the model of David and subsequent kings of Judah. Although this interpretation appears in the *Historia scholastica* and Ordinary Gloss, it is by no means certain that it would have been relevant for the bathing episode, for the "touch" was associated with David's sexual encounter with Bathsheba, not with his looking at her. Moreover, this royalist interpretation of the biblical passage had become a partisan issue connected with royal prerogatives and was omitted in many commentaries at the time the Isabella Psalter was painted. Still, because Louis IX revived the practice of the healing touch, one cannot exclude the possibility of an allusion to it in a prayer book probably made for his sister, especially since the issue was controversial. In addition, the imaginative projection of sight, particularly the desiring look, is inseparable from touch, an association evident in the Auxerre relief and in

medieval literature and later paintings of nudes as well as in psychology (see, for example, Spearing, *The Medieval Poet as Voyeur*, and Armstrong, *Odd Man Out*, on Degas and his nudes). Understood in these terms, David's role is comparable to that of the maids, for Bathsheba is purified by his look as well as by the water. Thus she is as much exposed to his curative power as to his desire.

139. Peter Lombard, *Commentarium in Psalmos*, in *PL*, vol. 191, cols. 59–62. M. Colish, "*Psalterium Scholasticorum.*"

140. Minnis, *Medieval Theory of Authorship*, 105–9.

141. W. C. Jordan, *Louis IX and the Challenge of the Crusade*, chap. 6.

142. See Adams, *Rembrandt's Bathsheba Reading King David's Letter.*

143. *Susanna at the Bath*, 1636, Koninklijk Kabinet van Schilderijen, Mauritshuis, The Hague (Bredius, *Rembrandt: The Complete Edition of the Paintings*, 505); *Toilet of Bathsheba*, 1643, Metropolitan Museum of Art, New York (idid., 513).

144. *Bathsheba with King David's Letter*, 1654, Paris, Musée du Louvre (Bredius 521).

145. Von Simson, *Das Mittelalter II*, fig. 79a. Erlande-Brandenburg and Thibaudat, *Les sculptures de Notre-Dame de Paris*, 115–18, no. 324.

146. The south rose originally represented Christ in Majesty surrounded by apostles, martyrs, confessors, and virgins; see Lafond, "Notre Dame de Paris." Adam and Eve thus appeared in relation to, but on the exterior of, a vision of the heavenly court, much as one sees in later works. On this iconography, see Stahl, "Heaven in View."

147. Laborde, *Bible moralisée*, pl. 226. The text reads, "Huic psalmo titulus non apponitur et aliis quia psalmus iste principium est et praefacio siuve prologus totius libri. Materia enim huius libri est totus christus, scilicet sponsus et sponsa. Intentio est homines in adam deformatus christo nono homini confirmare, et hoc praedictione verbi dei."

148. Ps. 1:2.

149. It is possible that one reason the scene of David in prayer is placed below is that the Bathsheba scene has to be above him in order to read as the subject of his meditation.

150. No satisfactory study exists on the pictorial techniques developed in Apocalypse illustration, especially that of the thirteenth century, to define the visionary as a distinct category of experience; for the later Middle Ages, see Panofsky, *The Life and Art of Albrecht Dürer*.

151. Panofsky, *Early Netherlandish Painting*.

152. Cf. note 106 above.

153. See Clark, *The Painting of Modern Life*, chap. 2, and Nead, *The Female Nude*, chaps. 1–4.

Conclusion

1. Openshaw, "The Battle Between Christ and Satan."

2. Morgan, *Early Gothic Manuscripts*.

3. This attribution to the mother of Louis IX is hypothetical, but I am inclined to agree with Delisle, in *Notice de douze livres*, Branner, in *Manuscript Painting*, and others that the weight of the evidence—mainly early inscriptions and inventories—suggests that it was made for her, probably in Paris ca. 1220.

4. Deuchler, *Ingeborgpsalter*.

5. For anti-Semitic imagery, see Lipton, *Images of Intolerance*, and Mellinkoff, *Outcasts*.

6. Pächt, Dodwell, and Wormald, *Saint Albans Psalter*.

7. See note 4 to Chapter 4.

8. See Stahl, "Eve's Reach."

9. Deuchler, *Ingeborgpsalter*.

10. See note 50 to Chapter 4.

11. See Stahl, "Eve's Reach."

12. Even later, neither Pucelle nor the Rohan Master chose this subject. Artists like Giotto, Roger van der Weyden, and Rembrandt, however, were drawn to this kind of subject, in which extraordinary situations are normalized, reflecting how the undertow of destiny affects ordinary responses. The figures in such scenes are naïve to the larger meaning of their actions, as we humans usually are. The artist finds the momentous in the ordinary, the enormous resonance of a single gesture, the defining moment before the determinant action.

13. Leniaud and Perrot, *Sainte Chapelle*.

14. The deposit of the initial shipment of relics in the chapel of Saint-Nicholas in August 1239 implies that the relics were intended to be housed near the royal palace and not at the cathedral or Saint-Denis. That the relics were sent to Saint-Denis in October of the same year suggests that Saint-Nicholas was intended as a temporary solution and that the royal abbey was only a better short-term home for them. I therefore incline toward the early dating for the beginning of work, as do Branner and Kimpel-Suckale. The Translation window, with its history of the True Cross and representation of Louis IX carrying the relic, could not have begun before 1241, when negotiations started for the second shipment, which included the True Cross.

15. One exception is the idol labeled "Mahometa," discussed in note 202 to Chapter 4. See Helene Toubert's discussion of how the political and biblical allegories work together in the scene with Gideon's victory against the Saracens at Sant'Angelo in Formis; *Un art dirigé*, 166–92.

16. For a different conclusion, see Weiss, *Art and Crusade*, and Caroline Bruzelius's *Speculum* review disputing his findings.

17. See Weiss et al., *The Morgan Crusader Bible.*

18. Although the manuscript cannot be dated except by its formal relations to other works, the increasingly refined chronology of north French and Parisian works that has emerged in recent years indicates a dating in the early or first half of the 1240s, especially in relation to works at Saint-Germain-des-Prés and at the Sainte-Chapelle itself.

19. The view of Sydney Painter, "The Crusade of Theobald of Champagne," is characteristic.

20. J. Richard, *Saint Louis,* 93–94. W. C. Jordan, *Louis IX and the Challenge of the Crusade,* 42, sees the negative memory of the Crusade as a basis for the initial opposition to the Seventh Crusade.

21. Thibaut IV, an important poet, had at one time been Blanche's adversary but at this time was a loyal ally of the Crown; she and, later, Louis IX twice intervened to save his county, and he celebrated the Queen Mother in his chansons; see J. Richard, *Saint Louis,* esp. 12–19, 42–47.

22. Caviness, "Biblical Stories," has suggested that the manuscript may have served as an illustration of conduct to Christian kings about to embark on Crusade.

23. The psalm initials show mendicants in a variety of dress and a range of orders. The initial for Psalm 38 (fol. 126v), for example, shows Dominicans and is precise in the way they gesture and kneel, some pointing to their eyes, others to their mouths. Above the kneeling religious, David prays before Christ in a mandorla. Inasmuch as Louis identified himself with David, he would here be both taking on the role of the friars below him and mediating between them and God. Many contemporaries of the king worried that the mendicant orders were too influential on Louis, and certainly their recurring placement in the psalm initials suggests a powerful role for them.

24. The need for the second Crusade arose as early as 1262, when the Mamluks refused to renew the treaty of 1255. When the French clergy agreed to the tax called for by the Papacy in 1263, the gravity of the disintegrating situation in the East was manifest. See J. Richard, *Saint Louis,* 298–313.

25. The troubling specters of the loss of the Latin kingdom of Jerusalem that we know about are all earlier, after the first Crusade.

26. See W. C. Jordan, *Louis IX and the Challenge of the Crusade.*

27. The so-called Psalter of Blanche of Castille. See Weiss, "Biblical History."

Appendix III

1. Delisle, *Notice de douze livres,* 105–11, and Cockerell, *Psalter and Hours,* 13–18.

Appendix IV

1. The exception is folio 185v, where the catchword is written in a contemporary cursive hand and is probably preparatory. A second set of signatures may have been indicated in ink, for indistinct markings are visible near the lower left edge of folios 98v, 245v, 257v, and 260v, the last folios of gatherings XV, XVII, XXVIII, and XXIX, respectively.

2. The text of folio 260v ends on the seventeenth line; the eighteenth, or last, line is blank.

3. See folios 111r (at the left) and 210r in this book's Psalter reproductions.

4. Cf. Bibl. Nat., MS lat. 13144 or 17439. The latter manuscript contains the Letters of Pope Gregory and may be dated, on the basis of script and penwork, to about 1260. An inscription on folio 197 states that it was given to the Dominicans at Compiègne in memory of Saint Louis. See Delisle, *Le cabinet des manuscrits,* 1:8, 2:264 n. 5, 3:322.

5. Vezin, "La fabrication du manuscrit," esp. 42.

6. The notations in ink appear in the lower center, instead of the right of the page, in gatherings XV, XIX and XXII. A third series, also in ink, occurs in gatherings XVII and XX at the lower left edge. See page 236 above for a summary of these letters and differences between the series.

7. Most conspicuous are the lighter-weight parchment and the lighter tone of blue used in the verse initials. The ruling, script, punctuation marks, and application of gold in line-endings and initials are also different. For discussion, see page 51 and note 174 in Chapter 1 above.

8. For similar letter forms in the verse initials, see especially gathering XVII, where these scribal indications are particularly clear. Otherwise, compare the *a* of folio 147r to that of folio 146v, line 7, or the *f* of folio 152r to that of folio 136r, line 8, or of folio 145v, line 12. A similar correspondence can be demonstrated for the added folios.

9. In gathering XX, the insertions required a restructuring of the entire gathering. An analysis of the two sets of letters indicates that in addition to the four leaves that were added, one leaf between folios 152 and 153 was removed. Although folio 157 was simply inserted, the original bifolios had to be cut so folios 149–51 could be joined to them. Unfortunately, the tightness of the binding makes it impossible to determine precisely how the folios were cut and joined. If one assumes a regular reconstruction, the following diagram would illustrate the original and present organization of the gathering.

10. See pages 50–54 above.

11. The similarity between the corrections and the replacement folios is especially clear when the former includes a verse or psalm initial that is repainted, as in folios 115v, 126r, and 132r.

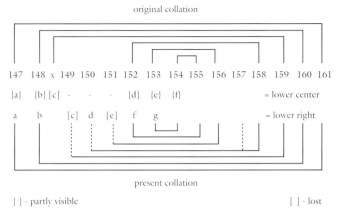

original collation

147 148 x 149 150 151 152 153 154 155 156 157 158 159 160 161

{a} {b} {c} - - - {d} {e} {f} = lower center

a b [c] d [e] f g = lower right

present collation

{ } - partly visible [] - lost

12. Aside from a few additions to the calendar and legends, there is no indication of comparable alterations or reworkings in the text or decoration of the other sections of the manuscript.

Appendix VI

1. The outer 28 mm of the front cover is a modern wood replacement. The repair probably coincided with a modern consolidation of the covers. The consolidation included the insertion of paper backings under the strap attachments and textile ends and over the metal nails on the back of the front cover, and the recutting of the depressions for the fittings, presumably to provide for larger ones. The script on several of the paper backings indicates these alterations were no earlier than the eighteenth century.

2. They measure 211 × 148 mm, as against 211 × 155 for the book.

3. I owe this suggestion to Marie-Pierre Laffitte.

4. Pollard, "The Construction of English Twelfth-Century Bindings," 8–9; idem, "Describing Medieval Bookbindings."

5. Vezin, *Évolution des techniques de la reliure médiévale*, 11–12. The earlier method in which the thongs enter the side of the board may still be seen in the thirteenth-century Glossed Psalter from Clairvaux, Montpellier, Bibl. de l'École de Medicine, MS H.5; that in which they enter the top of the board, for example, in the thirteenth-century Sorbonne Bible, Paris, Bibl. Nat., MS lat. 15467. The earlier method continued into the fifteenth century (e.g., Paris, Bibl. Nat., MS lat. 6351), but more characteristic is Montpellier MS H.7, where the entry of the thongs, the wide channels, and the alternation in the length of the channels are especially similar to those of the covers of the Psalter of Saint Louis. This practice also inhibits the splitting of the wood covers; but it was not sufficient in the

Psalter, because the upper cover is split at the level of the channels.

6. Ibid. Of the two fifteenth-century manuscripts cited in the previous note, alternation occurs in Montpellier MS H.7, which has eight thongs, but not in lat. 6351, which has only five.

7. For example, there are five in Bibl. Nat., MSS lat. 15467 and 9455, and six in Bibl. Nat., MS lat. 10434.

8. An examination of the parchment confirms that the present sewing is not original, for unused holes made by earlier sewings are visible, especially in the gutters of the central bifolios of gatherings XV and XVI. The small number of holes suggests there was only one resewing, although more cannot be excluded. If there were only one, the spacing of the two upper holes—one about 3 cm and the other about 8 cm from the upper edge of the book—indicates the manuscript originally had six thongs.

9. For the features described above, see Pollard, "Describing Medieval Bookbindings"; Vezin, *Évolution des techniques de la reliure médiévale*, 11–13; and Gilissen, *La reliure occidentale antérieure à 1400*, 37–58.

10. Desrosiers's reconstruction (diagram 7) shows textile placed on the covers so that gold-brocade flower, palmette, and bird were aligned along the spine.

11. Cf. Falke, *Kunstgeschichte der Seidenweberei*, 2:50–53, fig. 323; Klesse, *Seidenstoffe in der italienischen Malerei*, 114, fig. 146.

12. Pope and Ackerman, *A Survey of Persian Art*, vol. 5, fig. 665 and pls. 535 and 1323.

13. Falke, *Kunstgeschichte der Seidenweberei*, 2:69–89; Wardwell, "Stylistic Development," esp. 182–86. The Persian and Italian elements are sometimes very similar; cf. Tietzel, *Italienische Seidengewebe*, 458, no. 159.

14. For example, for birds in fourteenth-century Italian silks, cf. Falke, *Kunstgeschichte der Seidenweberei*, fig. 427, and another unpublished silk of the same date and origin in the Cleveland Museum (inv. 77.44). For the palmettes and vines, see ibid., figs. 396, 417, 540; Klesse, *Seidenstoffe in der italienischen Malerei*, 95, fig. 112, and esp. 438, no. 448; Markowsky, *Europäische Seidengewebe*, 121, no. 10; a fourteenth-century silk (inv. no. 22774) in the Musée des Tissus, Lyon; and the textiles from the tomb of Cangrande della Scalla, who died in 1329, in *Le stoffe di Cangrande*, 176–79. Elizabeth Monnas has found similar motifs on an unpublished dalmatic, reported to have belonged to Pierre de Luxembourg (1369–89), in the church of Saint-Pierre at Avignon and on a silk fragment (Museum of London no. 1747/6) excavated in 1972 from the site of Baynard's Castle and datable to the decades of 1370–80.

15. The technique occurs on the braid of Cangrande della Scala's sword scabbard, and Anne Wardwell has found this technique in several Italian silks of the early fourteenth century, including the stola belonging to the insignia of the Holy Roman Empire; see *Le stoffe di Cangrande* and Fillitz, *Katalog der weltlichen und der geistlichen Schatzkammer,* 60, no. 173; cf. also King, "A Chasuble of the Later Middle Ages," 34–35, and Tietzel, *Italienische Seidengewebe,* 73–75.

16. This way of decorating the parchment sides of the book block was not unknown in royal manuscripts during the reign of Louis IX; see *Le trésor de la Sainte-Chapelle,* 215, no. 59. An in-depth study of the history of this aspect of book decoration is unfortunately lacking; see, however, the brief survey by Albert Derolez, "La tranche dorée et ciselée d'après les collections de la Bibliothèque de l'Université de Gand."

17. I am grateful to Marie-Pierre Laffitte for this information.

18. For the late-fourteenth-century practice of sending out books to be rebound, covered in silks, gilded and engraved on the sides, see the accounts concerning the collection of Isabelle of Bavaria published by Vallet de Viriville, "La bibliothèque d'Isabeau de Bavière," esp. 681. North Italian silks were certainly available in Paris at this time, for some are catalogued in the treasury of Notre-Dame; see Wardwell, "Stylistic Development," 186.

19. Labarte, *Inventaire,* nos. 1218, 3050, 3052, 3290, and passim; the full entries for the Psalter of Saint Louis are given in notes 13 and 14 to the Introduction.

20. A textile binding suggests there was also a slipcase, though the inventory does not mention one.

21. It is uncertain whether she donated the Psalter to Poissy during her lifetime or bequeathed it at her death.

22. Une bande de bois a été remplacée le long du dos et n'est que localement recouverte par la soierie.

23. La largeur a été obtenue en ajoutant 60 mm—correspondant à l'étoffe manquant entre les deux plats, c'est à dire au dos du manuscrit—aux largeurs d'étoffe originairement présentes sur chaque plat. Ces 60 mm ont été directement mesurés sur la reconstruction du décor de le diagramme 6 et sont donc approximatifs. La hauteur tient compte du fait que le tissu n'a pas été collé droit fil sur les ais.

Bibliography

Primary Sources

Albertus Magnus. *Opera Omnia*. Paris, 1890–95.

Ambrose. *Enarratio in Psalmum I.*

Anselm of Laon. *Glossa ordinaria*. In *PL*, vol. 113.

Aristotle. *On the Soul; Parva Naturalia; On Breath.* Translated by W. S. Hett. Loeb Classical Library, 33. Cambridge, Mass., 1975.

Augustine. *Contra Faustum Manichaeum.*

——. *De coto quaestionibus ex veteri testamento.*

——. *De civitate Dei.*

——. *Locutionum in Heptateuchum libri VII.*

——. *Quaestionum in Heptateuchum libri VII.*

——. *Super Psalmos.*

Bacon, Roger. *Opera Hactenus Inedita Rogeri Baconi.* Edited by Robert Steele. 16 vols. Oxford, 1905–.

——. *The Opus Majus of Roger Bacon.* Translated by Robert Belle Burke. 2 vols. Philadelphia, 1928.

Bartholomaeus, Anglicus. *Le livre des propriétés des choses: Une encyclopédie au XIVe siècle.* Translated by Bernard Ribémont. Paris, 1999.

Benoît de Sainte-Maure. *La roman de Troie.*

Bible, Old Testament, Greek, Septuagint. Edited by Alfred Rahlfs. Stuttgart, 1935.

Bonaventure, Saint. *Opera Omnia.* Edited by P. David Fleming. Ad Claras Aquas, 1901.

——. *Opera Omnia.* Edited by A. C. Peltier. Paris, 1866.

Cassiodorus. *Historia tripartita.*

Deux versions inédites de la Légende de l'Antéchrist en vers français du XIIIe siècle. Lund, 1928.

Duchesne, François, ed. *Historiae Francorum Scriptores.* Vol. 5. Paris, 1649.

Étienne de Bourbon. *Anecdotes historiques, légendes et apologues.* Paris, 1877.

Eusebius. *Chronographia.*

Gaufrido de Belloloco [Geoffroy de Beaulieu]. *Vita Sancti Ludovici.*

——. *Vita Ludovici noni.* In *RHF*, 20:3–27.

Geufroi de Paris. "Bible des sept états du monde." Edited by L. Kastner. In "Some Old French Poems on the Antichrist," *Modern Language Review* 2 (1906–7): 26–31.

Gregory of Tours. *Historia Francorum.*

Grosseteste, Robert. *On Light.* Translated by Clare Riedl. Milwaukee, Wis., 1978.

Guibert de Tournai. *Eruditio regum et principum.*

Guillaume d'Auvergne. *De Legibus.* In *Opera Omnia.* Paris, 1674.

Guillaume de Chartres. *Vita et actibus regis Francorum Ludovici. . . .* In *RHF*, 20:27–44.

Guillaume de Lancia. *Diaeta Salutis.* In *Opera Omnia S. Bonaventura,* 8:247–358. Ad Claras Aquas, 1882–1902.

Guillaume de Lorris and Jean de Meun. *Le roman de la rose.* Edited by Ernest Langlois. Société des anciens textes Français. Paris, 1914.

——. *Romance of the Rose.* Translated by Charles Dahlberg. Princeton, 1971.

Guillaume de Nangis. *Gesta sanctae memoriae Ludovici Franciae.*

Guillaume de Saint-Pathus. *Vie de Saint Louis.* Edited by H.-François Delaborde. Paris, 1899.

Guillaume de Tyr. *Histoire de la guerre sainte.*

Guillaume Perrault. *De eruditio principum.*

Henri d'Arci. "Si d'Antéchrist volez oir la memorie." Edited by L. Kastner. In "Some Old French Poems on the Antichrist," *Modern Language Review* 1 (1906): 269–81.

Hieronymi, Sancti [Saint Jerome]. *Excerpta de Psalterio.* In *Commentarioli in Psalmos,* in *CCSL,* 72:177–210.

Hincmarius, archbishop of Reims. *Opuscula Varia.*

Histoire de Joseph (12th cent.).

Honorius Augustodunsensis. *Speculum ecclesiae.* In *PL,* 172:813–1104.

Hudeczek, Methodius. "De lumine et coloribus." *Angelicum* 21 (1944): 112–38.

Hugh of St. Victor. *Adnotationes elucidatoriae in Pentateuchon.*

——. *Adnotationes elucidatoriae in librum Iudicum.*

——. *Adnotationes elucidatoriae in libros Regum.*

——. *Didascalicon.*

Hugonis, monachi Floriancensis [Hugh of Fleury]. *Tractatus de regia potestate et sacerdotali dignitate.* In Monumenta Germaniae Historica, 2:465–94. Hannover, 1892.

Isidore of Seville. *Questiones in Vetus Testamentum.* In *PL,* vol. 83.

Jacobus de Voragine. *The Golden Legend: Readings on the Saints.* Translated by William Granger Ryan. Princeton, 1993.

Jacques de Vitry. *Historia orientalis*. (Cf. Claude Buridant, ed., *La traduction de l'Historia orientalis* [Paris, 1986].)

——. *Sermones communes et feriales*. (Cf. Joseph Greven, ed., *Die Exempla aus den Sermones feriales et communes des Jakob von Vitry* [Heidelberg, 1914].)

——. *Sermones de sanctis*.

——. *Sermones dominicales (de tempore)*. Edited by T. Lyngam. 1575.

——. *Sermones vulgares* or *Sermones ad status*. (Cf. Thomas Frederick Crane, ed., *The Exempla, or Illustrative Stories from the Sermones Vulgares of Jacques de Vitry* [London, 1890; repr., Nendeln, 1967].)

Jean de Joinville. *Histoire de Saint Louis*.

——. *Vie de Saint Louis*. Edited by Jacques Monfrin. Paris, 1995.

John of Garland. *The Parisiana Poetria of John of Garland*. Edited, with introduction, translation, and notes, by Traugott Lawler. Yale Studies in English, 182. New Haven, 1974.

John of Limoges. *Opera omnia*. Edited by Constantine Horvath. 3 vols. Veszprem, 1932.

Liber quintus receptarum sententiarum.

Le Livre des Juges (12th cent., translated for the Templars).

Lombard, Peter. *Commentarium in Psalmos*.

——. *Sententiae in IV Libris Distinctae*. Rome, 1981.

Ludus de Antichristo. Edited by Karl Young. In *The Drama of the Medieval Church*, 2:371–87. Oxford, 1933.

Maurice of Sully, bishop of Paris, ca. 1120–96. *Maurice of Sully and the Medieval Vernacular Homily, with the Text of Maurice's French Homilies*. Translated by C. Robson. Oxford, 1952.

Orosius, Paulus. *Historiarum adversum paganos*.

Otto of Freising. *Chronica; sive, Historia de duabus civitatibus*. Edited by Adolf Hofmeister. Hannover, 1912. Reprint, 1982.

Petrus Riga. *Aurora*.

——. *Versus de Sancta Susanna*. In *PL*, 171:1287–92 (misattributed to Hildebert of Lavardin).

Petrus Comestor. *Historia Libri Genesis*.

——. *Historia scholastica*. In *PL*, vol. 198.

——. *Sermones*. In *PL*, vol. 198, cols. 1721–370.

The Play of Antichrist. Translated by John Wright. Toronto, 1967.

Les quatre livres des rois, traduits en français du XIIe siècle. Edited by Antoine-Jean-Victor Le Roux de Lincy. Collection des documents in édits sur l'histoire de France, 2nd ser. Paris, 1841.

Rigaud, Eude. *Journal des visites pastorales d'Eude Rigaud, archevêque de Rouen, 1248–1269*. Edited by Théodose Bonnin. Rouen, 1852.

Robert de Flamborough. *Liber poenitentialis*. Edited by J. J. Francis Firth. Toronto, 1971.

Salimbene di Adam. *Cronica*.

Sedulius Scotus. *De rectoribus Christianis*.

Summa musice: A Thirteenth-Century Manual for Singers. Edited by and translated by Christopher Page. Cambridge and New York, 1991.

Thibault de Champagne. *The Lyrics of Thibault de Champagne*. Edited by and translated Kathleen J. Brahney. Garland Library of Medieval Literature, 41. New York, 1989.

Thomas de Chobham. *Summa Confessorum*. Edited by F. Broomfield. Analecta Mediaevalia Namurcensia, 25. Paris, 1963.

Thomas Aquinas. *Opera Omnia*. Parma, 1852–73. Reprint, 1948–50.

Vincent of Beauvais. *De eruditione filiorum nobilium*. Edited by Arpad Steiner. Mediaeval Academy of America Publications, 32. Cambridge, 1938.

——. *Speculum historiale*.

——. *Vincentii Beluacensis: De morali principis institutione*. Edited by Robert J. Schneider. Corpus Christianorum, Continuatio Mediaevalis, 137. Turnholt, 1995.

Wilhelm von Rubruk. "Itinerarium." In *Itinera et relationes Fratrum minorum saeculi XIII et XIV*, edited by Anastasius van den Wyngaert, vol. 1 of *Sinica Franciscana*. Ad Claras Aquas, 1929.

Witelo. *Opticae*. Basil, 1572.

General Bibliography

L'abbaye de Maubuisson (Notre-Dame-la-Royale): Histoire et cartulaire. Edited by Adolphe Dutilleux and Joseph Depoin. Pontoise, 1882–85.

Abou-El-Haj, Barbara. *The Medieval Cult of the Saints: Formations and Transformations*. Cambridge, 1994.

Abulafia, Anna Sapir. *Christians and Jews in the Twelfth-Century Renaissance*. London and New York, 1995.

Acta Sanctorum. Edited by Joannes Bollandus and Godefridus Henschenius. Vol. 6. Paris and Rome, 1863.

Ad Litteram: Authoritative Texts and Their Medieval Readers. Edited by Mark Jordan and Kent Emery Jr. Notre Dame, Ind., and London, 1992.

Adam-Even, Paul, and Léon Jéquier. "Un armorial français du XIIIe siècle: L'armorial Wijnbergen." *Archives héraldiques suisses* 65–68 (1951–54).

Adams, Ann Jensen, ed. *Rembrandt's Bathsheba Reading King David's Letter*. Masterpieces of Western Painting. Cambridge, 1998.

Adhémar, Jean. *Influences antiques dans l'art du Moyen Âge français.* London, 1939.

———. "Le trésor d'argenterie donné par Saint Didier aux églises d'Auxerre (VIIe siècle)." *Revue archéologique,* 6th ser., 4 (July–September 1934): 44–54.

Akdogan, Cemil. "Albertus Magnus, Saint, 1193?–1280." Ph.D. diss., UCLA, 1978.

Albertus Magnus and the Sciences: Commemorative Essays, 1980. Edited by James A. Weisheipl. Pontifical Institute of Mediaeval Studies: Studies and Texts, 49. Toronto, 1980.

Albon, André d'. *Le livre des Juges.* Lyons, 1913.

Alexander, Jonathan J. G. *Medieval Illuminators and Their Methods of Work.* New Haven and London, 1992.

Alexander of Hales. *Quaestiones Disputatae "Antequam Esset Frater."* Bibliotheca Franciscana Scholastica Medii Aevi cura Collegii S. Bonaventurae. Quaracchi, 1960.

Alfillé, Tanya. *The Psalms in the Thirteenth-Century Bible Moralisée: A Study of Text and Image.* Ph.D. diss., University of London, 1991.

Al-Hamdani, B. "The Iconographical Sources of the Genesis Frescoes Once Found in S. Paolo, Filim." In *Atti del IX Congresso internazionale de archeologia cristiana: Roma, 21–27 settembre 1975,* vol. 2, *Comunicazioni su scoperte inedite,* 11–35. Vatican City, 1978.

Alter, Robert. *The World of Biblical Literature.* New York, 1992.

Althoff, Gerd, Johannes Fried, and Patrick J. Geary, eds. *Medieval Concepts of the Past: Ritual, Memory, Historiography.* Washington, D.C., and New York, 2002.

Andrieu, Michel. *The Symbolism of Churches and Church Ornaments.* Translated by John Neale and Benjamin Webb. 3rd ed. London, 1906.

Angles, Higino. "Eine Sequenzensammlung mit Mensuralnotation und volkstümlichen Melodien (Paris. B.N. lat.1343)." In *Speculum Musicae Artis: Festgabe für Heinrich Husmann zum 60. Geburtstag am 16. Dezember 1968,* edited by Heinz Becker and Reinhard Gerlach, 9–17. Munich, 1970.

Antiquity and the Middle Ages: From Ancient Greece to the Fifteenth Century. Edited by James McKinnon. London, 1990.

Anton, H. H. *Fürstenspiegel und Herrscherethos in der Karolingerzeit.* Bonner historische Forschungen, 32. Bonn, 1968.

Arbois de Jubainville, Henry d'. "Les armoires des comtes de Champagne d'après leurs sceaux." *Revue archéologique* 9 (1852): 178–83.

———. "Catalogue d'actes des comtes de Brienne, 950–1356," *Bibliotheque de l'École de Chartres* 33 (1872): 141–86.

———. *Histoire des ducs et des comtes de Champagne.* Vol. 4, *1181–1285.* Paris, 1865.

Archambault, Paul. "Joinville: History as Chivalric Code." In *Seven French Chroniclers: Witnesses to History.* Syracuse, N.Y., 1974.

Arensberg, Susan MacMillan. "The Padua Bible and the Late Medieval Biblical Picture Book." Ph.D. diss., Johns Hopkins University, 1986.

Armstrong, Carol. *Odd Man Out.* Chicago, 1991.

Arnulf, Arwed. *Versus ad Picturas: Studien zur Titulusdichtung als Quellengattung der Kunstgeschichte von der Antike bis zum Hochmittelalter.* Kunstwissenschaftliche Studien, 72. Munich and Berlin, 1997.

Art and the Courts: France and England from 1259 to 1328. Exh. cat. 2 vols. National Gallery of Canada. Ottowa, 1972.

L'art au temps des rois maudits: Philippe le Bel et ses fils, 1285–1328: Paris, Galeries nationales du Grand Palias, 17 mars–19 juin 1998. Exh. cat. Paris, 1998.

Artistes, artisans et production artistique au Moyen Âge. Edited by Xavier Barral i Altet. 3 vols. Paris, 1986–90.

Artistic Integration in Gothic Buildings. Edited by Virginia Raguin, Kathryn Brush, and Peter Draper. Toronto, London, and Buffalo, 1995.

Aubert, Marcel. *Notre-Dame de Paris.* 2nd ed. Paris, 1929.

Auerbach, Erich. "Figura." In *Scenes from the Drama of European Literature,* translated by Ralph Mannheim and C. Garvin, 11–76. New York, 1959.

Avery, Charles. *Giambologna: The Complete Sculpture.* Oxford, 1987.

Avner, Tamar. *A Comparison of the Illustration of the Homily on the Nativity in the Manuscripts Mount Athos, Esphigmenu Monastery, Cod. 14 and Jerusalem, Greek Partiarchate Library, Taphou Cod. 14.* 2 vols. Ph.D. thesis, Hebrew University, 1978.

———. "Septuagint Illustrations of the Book of Judges in Manuscripts of the Court School of Saint Louis." In *Byzantium and the West, c. 850–c. 1200: Proceedings of the XVIII Spring Symposium of Byzantine Studies,* edited by J. D. Howard-Johnston, 297–317. Amsterdam, 1988.

Avril, François. "À quand remontent les premiers ateliers d'enlumineurs laïcs à Paris?" *Les dossiers de l'archéologie* 16 (1976): 36–44.

———. "L'atelier du Psautier d'Ingeburge? Problèmes de localisation et de datation." In *Art, objets d'art, collections: Études sur l'art du Moyen Âge et de la Renaissance, sur l'histoire du goût et des collections,* 16–21. Paris, 1987.

———. "Autour du bréviaire de Poissy (Chantilly, Musée Condé MS. 804): Quelques oeuvres nouvellement découvertes de l'enlumineur Jacquet Maci." *Musée Condé* 7 (1964): 1–6.

———. "Un chef d'oeuvre de l'enluminure sous le règne de Jean le Bon: La Bible moralisée manuscrit français 167 de la Bibliothèque nationale." *Monuments et mémoires, Fondation Eugène Piot* 58 (1972): 91–125.

———. "L'enluminure à l'époque gothique (1200–1420)." In *Histoire universelle de la peinture*, edited by Jean Baudry, 4:217–328. Geneva, 1979. Reprinted in Avril, *L'enluminure a l'époque gothique: 1200–1420*. Paris, 1995.

———. "Un enlumineur ornemaniste parisien de la première moitié du xive siècle: Jacobus Mathey (Jaquet Maci?)." *Bulletin monumental* 129, no. 4 (1971): 249–64.

———. *Manuscript Painting at the Court of France: The Fourteenth Century*. Translated by Ursule Molinaro. New York, 1978.

Avril, François, and Jean Lafaurie. *La librairie de Charles V.* Exh. cat. Bibliothèque nationale. Paris, 1968.

Avril, François, et al. *The Year 1200: A Symposium*. Introduction by Jeffrey Hoffeld. New York, 1975.

Babelon, Ernest. *Catalogue des camées antiques et modernes de la Bibliothèque nationale*. 2 vols. Paris, 1897.

Babelon, Jean. "Une nouvelle image de Saint Louis sur un bas-relief du Musée Carnavalet." *Monuments historiques de la France* 16, no. 4 (1970): 31–40.

Babilas, Wolfgang. *Untersuchungen zu den sermoni subalpini*. Münchner Romanistische Arbeiten, 24. Munich, 1968.

Bagliani, Agostino Paravicini. "La scienza araba nella Roma del duecento: Prospettive di ricerca." In *La diffusione delle scienze islamiche nel Medio Evo Europeo: Convegno internazionale promosso dall'Accademia nazionale dei Lincei, Fondazione Leone Caetani e dall'Università di Roma "La Sapienza,"* 103–66. Rome, 1987.

Baker, Malcolm. "Medieval Illustrations of Bede's Life of Cuthbert." *JWCI* 41 (1978): 16–49.

Bal, Mieke. *Reading Rembrandt: Beyond the Word-Image Opposition*. Cambridge, 1991.

Balard, Michel. "La croisade de Thibaud IV de Champagne (1239–1240)." In *Les champenois et la croisade: Actes des quatrième journées rémoises 27–28 novembre 1987*, edited by Yvonne Bellenger and Danielle Quéruel, 85–95. Paris, 1989.

Balayé, Simone. *La Bibliothèque nationale, des origines à 1880*. Geneva, 1988.

Baldwin, John W. *Aristocratic Life in Medieval France: The Romances of Jean Renart and Gerbert de Montreuil, 1190–1230*, Baltimore, 2000.

———. *The Government of Philip Augustus: Foundations of French Royal Power in the Middle Ages*. Berkeley and Los Angeles, 1986.

———. *The Language of Sex: Five Voices from Northern France Around 1200*. Chicago, 1994.

———. *Masters, Princes, and Merchants: The Social Views of*

Peter the Chanter and His Circle. Princeton, 1970.

Baltzer, Rebecca A. "Performance Practice, the Notre-Dame Calendar, and the Earliest Latin Liturgical Motets." In *Das Ereignis "Notre-Dame,"* edited by Wulf Arlt and Fritz Reckow. Wolfenbüttel, forthcoming.

———. "A Royal French Breviary from the Reign of Saint Louis." *Mediaeval Studies* (forthcoming).

———. "Thirteenth-Century Illuminated Miniatures and the Date of the Florence Manuscript," *Journal of the American Musicological Society* 25, no. 1 (1972): 1–18.

Bapst, Germain. "La châsse de Saint-Geneviève." *Revue archéologique*, 3rd ser., 8 (1886): 18–84.

Baratier, Edouard. *Enquêtes sur les droits et revenus de Charles Ier d'Anjou en Provence, 1252 et 1278*. Paris, 1969.

———. "Saint Louis, roi de France, et la Provence." *Provincia: Revue mensuelle d'histoire et d'archéologie provençales* 6, no. 5 (1971): 36–37.

Barber, Malcolm. *The New Knighthood: A History of the Order of the Temple*. New York and Cambridge, 1994.

Barbet de Jouy, Henri. *Notice des antiquités, objets du Moyen-Âge, de la Renaissance et des temps moderne composant le Musée des souverains*. Paris, 1866.

Barlow, Frank. "The King's Evil." *English Historical Review* 95 (1980): 3–27.

Barnes, Carl F. "Le problème Villard de Honnecourt." In *Les bâtisseurs des cathédrales gothiques*, 209–23.

Baron, Françoise. "Enlumineurs, peintres et sculpteurs parisiens des xiiie et xive siècles d'après les rôles de la taille." *Bulletin archéologique du Comité des travaux historiques et scientifiques*, n.s., 4 (1969): 37–121.

———. "Enlumineurs, peintres et sculpteurs parisiens des xive et xve siècles d'après les archives de l'hôpital Saint-Jacques-aux-Pèlerins." *Bulletin archéologique du Comité des travaux historiques et scientifiques*, n.s., 6 (1970–71): 77–115.

———. "Mort et résurrection du jubé de la cathédrale d'Amiens." *Revue de l'art*, no. 87 (1990): 29–41.

———. "La partie orientale détruite de la tour du choeur de Notre-Dame de Paris. *Revue de l'art*, no. 128 (2000): 11–29.

———. "Remarques sur le décor sculpté de Saint-Denis—À propos d'une exposition." *Revue du Louvre et des Musées de France* 35, nos. 5–6 (1985): 348–56.

Baron, Françoise, with the collaboration of Corinne Jankowiak and Christine Vivet. *Sculpture française*. Paris, 1996.

Bataillon, Louis-Jacques. "Intermédiaires entre les traités de morale pratique et les sermons: Les *distinctions* bibliques alphabétiques." In *Les genres littéraires dans les sources théologiques et philosophiques médiévales: Définition, critique et exploitation*, Université Catholique de Louvain, Publications de l'Institut d'études médiévales, 2nd ser., 5:213–26. Louvain-la-Neuve, 1982.

Les bâtisseurs des cathédrales gothiques. Exh. cat. Edited by Roland Recht. Strasbourg, 1989.

Beaune, Colette. *The Birth of an Ideology: Myths and Symbols of a Nation in Late Medieval France.* Translated by Susan Ross Huston, edited by Frederick L. Cheyette. Berkeley and Los Angeles, 1991.

———. "La légende de Jean Tristan fils de Saint Louis." *Mélanges de l'École française de Rome: Moyen Âge—temps modernes* 98, no. 1 (1986): 143–60.

———. *Naissance de la nation France.* Paris, 1985.

Beazley, C. Raymond, ed. *The Texts and Versions of John de Plano Carpini and William de Rubruquis.* London, 1903.

Beer, Ellen J. *Beiträge zur oberrheinischen Buchmalerei in der ersten Hälfte des 14. Jahrhunderts, unter besonderer Berücksichtigung der Initialornamentik.* Basel, 1959.

———. "Marginalien zum Thema Goldgrund." *ZKg* 46 (1983): 271–86.

———. "Pariser Buchmalerei in der Zeit Ludwigs des Heiligen und im letzten Viertel des 13. Jahrhunderts." *ZKg* 44 (1981): 62–91.

Beichner, Paul E., ed. *Aurora: Petri Rigae Biblia Versificata.* Notre Dame, Ind., 1965.

Belting, Hans, and Guglielmo Cavallo. *Die Bibel des Niketas.* Wiesbaden, 1979.

Benjamin, Jessica. "Master and Slave: The Fantasy of Erotic Domination." In *Powers of Desire: The Politics of Sexuality,* edited by Ann Snitow, Christine Stansell, and Sharon Thompson, 280–99. New York, 1983.

Bennert, Uwe. "Art et propagande politique sous Philippe IV le Bel: Le cycle des rois de France dans la Grand'salle du palais de la Cité." *Revue de l'art,* no. 97 (1992): 46–59.

Benoit, Fernand. *Sarcophages paléochrétiens d'Arles et de Marseille.* Fouilles et monuments archéologiques en France métropolitaine: Supplément a *Gallia,* 5. Paris, 1954.

Benveniste, Henriette. "Joinville et les 'autres': Les procédés de représentation dans l'Histoire de Saint Louis." *Le Moyen Âge: Revue d'histoire et de philologie* 102, no. 1 (1996): 27–55.

Benz, Ernst. *Die Vision: Erfahrungsformen und Bilderwelt.* Stuttgart, 1969.

Berger, Élie. *Histoire de Blanche de Castille, reine de France.* Bibliothèque des Écoles françaises d'Athènes et de Rome, 70. Paris, 1895.

———, comp. *Layettes du Trésor des chartes.* Vol. 4. Archives nationale, inventaires et documents. Paris, 1902.

Berger, Samuel. *La Bible française au Moyen Âge: Étude sur les plus anciennes versions de la Bible écrites en prose de langue d'oil.* Paris, 1884.

Berger, Samuel, and Durrieu, Paul. "Les notes pour l'enlumineur." *Mémoires de la Société des antiquaires de France,* 6th ser., 3 (1893): 1–29.

Berges, Wilhelm. *Die Fürstenspiegel des hohen und späten Mittelalters.* Schriften der Monumenta Germanae Historica, 2. Leipzig, 1938. Reprint, Stuttgart, 1952.

Bergman, Robert P. *The Salerno Ivories: Ars Sacra from Medieval Amalfi.* Cambridge, Mass., 1980.

Bériou, Nicole. *L'avènement des maîtres de la parole: La prédiction a Paris au XIIIe siècle.* Paris, 1998.

———. "La confession dans les écrits théologiques et pastoraux du XIIIe siècle: Médication de l'âme ou démarche judiciaire?" In *L'aveu: Antiquité et Moyen Âge: Actes de la table ronde organisée par l'École française de Rome avec le concours du CNRS et de l'Université de Trieste, Rome 28–30 mars 1984,* 261–82. Rome, 1986.

———. "De la lecture aux épousailles: Le rôle des images dans la communication de la Parole de Dieu au XIIIe siècle." *Cristianesimo nella storia* 14 (1993): 535–68.

———. "Robert de Sorbon, le prud'homme et le béguin." In *Comptes rendus de l'Académie des inscriptions et belles lettres,* 469–510. Paris, 1994.

Bériou, Nicole, and David D'Avray. *Modern Questions About Medieval Sermons: Essays on Marriage, Death, History, and Sanctity.* Spoleto, 1994.

Bertin, G., and A. Foulet. "The Book of Judges in Old French Prose: The Gardener A. Sage Library Fragment." *Roumania* 90 (1969): 121–29.

Białostocki, Jan. *The Message of Images: Studies in the History of Art.* Vienna, 1988.

The Bible and Medieval Culture. Edited by W. Lourdaux and D. Verhelst. Mediaevalia Lovaniensia, ser. 1, studia 7. Louvain, 1979.

The Bible in the Middle Ages: Its Influence on Literature and Art. Edited by Bernard S. Levy. Medieval and Renaissance Texts and Studies, 89. Binghampton, 1992.

Bibliothèque nationale de France. *Les manuscrits à peinture en France du XIIIe au XVIe siècle.* Exh. cat. Paris, 1955.

Bideault, Maryse. "Le tombeau de Dagobert dans l'abbaye royale de Saint-Denis." *Revue de l'art,* no. 18 (1972): 26–32.

Bieber, Margarete. *The Sculpture of the Hellenistic Age.* Rev. ed. New York, 1961.

Billson, Marcus. "Joinville's *Histoire de Saint Louis:* Hagiography, History, and Memoir." *American Benedictine Review* 31, no. 4 (1980): 418–42.

Binski, Paul. *The Painted Chamber at Westminster.* Society of Antiquaries of London, Occasional Papers, n.s., 9. London, 1986.

———. "Reflections on *La Estoire de Seint Aedward le Rei:* Hagiography and Kingship in Thirteenth-Century England." *Journal of Medieval History* 16 (1990): 333–50.

———. *Westminster Abbey and the Plantagenets: Kingship and*

the Representation of Power, 1200–1400. New Haven and London, 1995.

Birkmeyer, Karl M. "The Architectural Motif in Netherlandish Painting in the Fifteenth Century." *Art Bulletin* 43, no. 1 (1961).

Bischoff, B. "La nomenclature des écritures livresque du IXe au XIIIe siècle." In *Nomenclature des écritures livresques du IXe au XVIe siècle,* Colloques internationaux du CNRS, sciences humaines, 4:7–14. Paris, 1954.

Bjerken, Mildred. *Medieval Paris, the Town of Books.* Metuchen, N.J., 1973.

Black, Nancy. "The Language of the Illustrations of Chrétien de Troyes's *Le Chevalier au Lion (Yvain). Studies in Iconography* 15 (1993): 45–75.

Blanc, Michel. "Time and Tense in Old French Narrative." *Archivum Linguisticum* 16, no. 2 (1964): 96–124.

Bloch, Denise. "La formation de la Bibliothèque du Roi." In *Histoire des bibliothèques françaises,* vol. 1, *Les bibliothèques médiévales du VIe siècle à 1530,* 328–29. Paris, 1989.

Bloch, Marc. *Les rois thaumaturges: Étude sur le caractère surnaturel attribué à la puissance royale particulièrement en France et en Angleterre.* 2nd ed. Paris, 1983.

Bloch, P. "Typologie." In *LCI,* vol. 4, cols. 395–404.

Bloch, R. Howard. "Geneology as a Medieval Mental Structure and Textual Form." In *GRLMA,* XI/1:135–56.

———. *Medieval Misogyny and the Invention of Western Romantic Love.* Chicago, 1991.

Blum, Pamela Z. "Fingerprinting the Stone at Saint-Denis: A Pilot Study." *Gesta* 33, no. 1 (1994): 19–28.

Blumenfeld-Kosinski, Renate. "Moralization and History: Verse and Prose in the 'Histoire Ancienne Jusqu'à César' (in B.N. fr.20125)." *Zeitschrift für romanischen Philologie* 97 (1981): 41–46.

Blumenkranz, Bernhard. "La représentation de *Synagoga* dans les Bibles moralisées françaises du XIIIe au XVe siècle." In *Proceedings of the Israel Academy of Sciences and Humanities* 5 (1971–1976): 70–91.

Boehm, Barbara Drake. *The Hours of Jeanne d'Évreux.* Lucerne, 2000.

Boerner, Bruno. "Interprétation du programme iconographique de la châsse de Sainte Gertrude à Nivelles." In *Un trésor gothique,* 225–33.

Boespflug, François. "Un étrange spectacle: Le Buisson ardent comme théophanie dans l'art occidental." *Revue de l'art,* no. 97 (1992): 11–31.

Bogaert, Pierre-Maurice. "Adaptations et versions de la Bible en prose (langue d'oïl)." In *Les genres littéraires dans les sources théologiques et philosophiques médiévales: Définition, critique et exploitation,* Université Catholique de Louvain, Publications de l'Institut d'études médiévales,

2nd ser., 5:259–77. Louvain-la-Neuve, 1982.

Böhm, Ludwig. *Johann von Brienne, König von Jerusalem.* Heidelberg, 1938.

Bonnard, Jean. *Les traductions de la Bible en vers français du Moyen Âge.* Paris, 1884. Reprint, Geneva, 1907.

Bonne, Jean-Claude. "The Manuscript of the Ordo of 1250 and Its Illuminations." In *Coronations: Medieval and Early Modern Monarchic Ritual,* edited by Janos M. Bak. Berkeley, Los Angeles, and Oxford, 1990.

Bony, Jean. *French Gothic Architecture of the 12th and 13th Centuries.* Berkeley, Los Angeles, London, 1983.

Born, Lester Kruger. "The Perfect Prince: A Study in Thirteenth- and Fourteenth-Century Ideals." *Speculum* 3 (1928): 470–504.

Borsook, Eve. *Messages in Mosaic: The Royal Programmes of Norman Sicily (1130–1187).* Oxford, 1990.

Boucheron, Patrick. "Saint Louis, comédien et martyr: L'écriture d'une vie." *Médiévales* 34 (1998): 69–77.

Bouchot, Henri. *Les primitifs français, 1292–1500.* Paris, 1904.

Bougenot, Etienne-Symphorien. "Comptes de dépenses de Blanche de Castille (1241)." *Bulletin historique et philologique du Comité des travaux historiques et scientifiques,* nos. 3–4 (1889).

Bouman, Cornelius Adrianus. *Sacring and Crowning: The Development of the Latin Ritual for the Anointing of Kings and the Coronation of an Emperor Before the Eleventh Century.* Groningen, 1857.

Boureau, Alain. "Les cérémonies royales françaises entre performance juridique et compétence liturgique." *Annales ESC* 46, no. 6 (1991): 1253–64.

———. "Les enseignements absolutistes de Saint Louis." In *La monarchie absolutiste et l'histoire en France: Théories du pouvoir, propagandes monarchiques et mythologies nationales: Colloque tenu en Sorbonne, Paris, 26–27 mai 1986,* 79–97. Paris, 1987.

———. "Pierre de Jean Olivi et l'émergence d'une théorie contractuelle de la royauté au XIIIe siècle." In *Représentation, pouvoir et royauté a la fin du Moyen Âge: Actes du colloque organisé par l'Université du Maine les 25–26 mars 1994,* 165–75. Paris, 1995.

Bourgeois, M. *Histoire des comtes de Brienne.* Troyes, 1848.

Bourilly, Victor-Louis, and Raoul Busquet. *La Provence au Moyen Âge: Histoire politique, l'Église, les institutions, 1112–1481.* Paris, 1924.

Boyle, Leonard. "The Fourth Lateran Council and Manuals of Popular Theology." In *The Popular Literature of Medieval England,* edited by Thomas Heffernan, 30–43. Knoxville, Tenn., 1985.

Bozzolo, Carla, Dominique Coq, Denis Muzerelle, and Enzo Ornato. "L'artisan médiéval et la page: Peut-on

déceler des procédés géométriques de mise en page?" In *Artistes, artisans et production artistique,* 3:295–305.

Braig, R. H. *Der Schrein des Heilgen Taurinus in Evreux.* Ph.D. diss., Frei Universität, Berlin, 1978.

Bräm, Andreas. "Buchmalerei des 13. und 14. Jahrhunderts in Frankreich, Flandern, Hennegau, Maasland und Lothringen: Literaturbericht 1970–92." *Kunstchronik* 47, no. 1 (1994): 35–46, and no. 2 (1994): 73–96.

Branner, Robert. "Books: Gothic Architecture." *Journal of the Society of Architectural Historians* 32 (1973): 327–33.

——. "Un bréviaire parisien enlumine du XIIIe siècle a l'université Harvard." *Bulletin de la Société de l'histoire de l'art français* (1973): 11–18.

——. "The Copenhagen *Corpus.*" *Konsthistorisk Tidskrift* 38 (1969): 97–119.

——. "The Grande Châsse of the Sainte-Chapelle." *Gazette des beaux-arts* 77 (1971): 5–18.

——. "Manuscript-Makers in Mid-Thirteenth Century Paris." *Art Bulletin* 48, no. 1 (1966): 65–67.

——. *Manuscript Painting in Paris During the Reign of Saint Louis.* California Studies in the History of Art, 18. Berkeley and Los Angeles, 1977.

——. "The Painted Medallions in the Sainte-Chapelle in Paris." *Transactions of the American Philosophical Society,* n.s., 58, no. 2 (1968).

——. "Le premier évangéliaire de la Sainte-Chapelle." *Revue de l'art,* no. 3 (1969): 37–48.

——. "Rediscovering a Parisian Paintshop of the Thirteenth Century." *Boston Museum Bulletin* 69 (1971): 165–72.

——. *St. Louis and the Court Style in Gothic Architecture.* Studies in Architecture, edited by Anthony Blunt and Rudolf Wittkower, no. 7. London, 1965.

——. "St Louis et l'enluminure parisienne au XIIIe siècle." in *Septième centenaire de la mort de Saint Louis,* 69–84.

——. "Two Parisian *Capella* Books in Bari." *Gesta* 8, no. 2 (1969): 14–19.

Brault, Gerard J. "The Cross in Medieval Heraldry." *Antiquaries Journal* 47, no. 2 (1967): 214–23.

——. *Early Blazon.* Oxford, 1972.

——, ed. *Eight Thirteenth-Century Rolls of Arms in French and Anglo-Norman Blazon.* University Park, Pa., and London, 1973.

Braun, Joseph. *Die Reliquiare des christlichen Kultes und ihre Entwicklung.* Freiburg, 1940.

Brayer, E., and A.-M. Bouly de Lesdain. "Les prières usuelles annexées aux anciennes traductions françaises du psautier." *Bulletin de l'Institut de recherche et d'histoire des textes* 15 (1967–68): 69–120.

Brehier, M. Louis. *La cathédrale de Reims: Une oeuvre française.* Paris, 1916.

Brenk, Beat. "Bildprogrammatik und Geschichtsverständnis der Kapetinger im Querhaus der Kathedrale von Chartres." *Arte medievale,* 2nd ser., 5, no. 2 (1991), 71–95.

——. "Der Concepteur und sein Adressat, oder: Von der Verhüllung der Botschaft." In *Modernes Mittelalter: Neue Bilder einer populären Epoche,* edited by Joachim Heinzle, 431–50. Frankfurt am Main, 1994.

——. *Die frühchristlichen Mosaiken in S. Maria Maggiore zu Rom.* Wiesbaden, 1975.

——. "The Sainte-Chapelle as a Capetian Political Program." In *Artistic Integration in Gothic Buildings,* edited by Virginia Chieffo Raguin, Kathryn Brush, and Peter Draper, 195–213. Toronto, 1995.

——. "Le texte et l'image dans la 'vie des saints' au Moyen Âge: Rôle du concepteur et rôle du peintre." In *Texte et image: Actes du colloque international de Chantilly,* 31–39. Paris, 1984.

Brett, Edward Tracy. *Humbert of Romans: His Life and Views of Thirteenth-Century Society.* Pontifical Institute of Mediaeval Studies: Studies and Texts, 67. Toronto, 1984.

Brial, Michel, et al. "Discours sur l'état des lettres en France au XIIIe siècle." *Histoire littéraire de la France* 16 (1824).

Briggs, Charles. *Giles of Rome's "De Regimine Principum": Reading and Writing Politics at Court and University, c. 1275–c. 1525.* Cambridge and New York, 1999.

Brincken, Anna-Dorothee von den. "Geschichtsbetrachtung bei Vincenz von Beauvais: Die 'Apologia Actoris' zum 'Speculum Maius.'" *Deutsches Archiv* 34, no. 2 (1978): 410–89.

——. "Die lateinische Weltchronistik." In *Mensch und Weltgeschichte: Zur Geschichte der Universalgeschichtsschreibung,* edited by Alexander Randa, 47–57. Salzburg and Munich, 1969.

——. *Die Nationes Christianorum Orientalium im Verständnis der lateinischen Historiographie von der Mitte des 12. bis in die zweite Hälfte des 14. Jahrhunderts.* Cologne and Vienna, 1973.

——. *Studien zur lateinischen Weltchronistik bis in das Zeitalter Ottos von Freising.* Düsseldorf, 1957.

Broderick, Herbert. "The Iconographic and Compositional Sources of the Drawings in Oxford, Bodleian Library, MS Junius 11." Ph.D. diss., Columbia University, 1978.

Brown, Elizabeth A. R. "Burying and Unburying the Kings of France." In *Persons in Groups: Social Behavior as Identity Formation in Medieval and Renaissance Europe,* edited by Richard C. Trexler, Medieval and Renaissance Texts and Studies, 36:241–66. Binghamton, N.Y., 1985.

——. "The Chapels and Cult of Saint Louis at Saint-Denis," *Mediaevalia* 10 (1984): 280–331.

——. "La généalogie capétienne dans l'historiographie du

Moyen Âge: Philippe le Bel, le reniement du *reditus* et la création d'une ascendance carolingienne pour Hugues Capet." In *Religion et culture autour de l'an mil: Royaume capétien et Lotharingie: Actes du colloque Hugues Capet 987–1987,* edited by Dominique Iogna-Prat and Jean-Charles Picard, 199–214. Paris, 1990.

——. "La notion de la légitimité et la prophétie à la cour de Philippe Auguste." In *La France de Philippe Auguste: Le temps des mutations: Actes du colloque international organisé par le C.N.R.S.,* edited by Robert-Henri Bautier, Colloques internationaux du Centre national de la recherche scientifique, no. 602:77–110. Paris, 1982.

——. "Philippe le Bel and the Remains of Saint Louis." *Gazette des beaux-arts* 95 (1980): 175–82.

——. "The Prince Is the Father of the King: The Character and Childhood of Philip the Fair of France." *Mediaeval Studies* 49 (1987): 282–334.

——. "Taxation and Morality in the Thirteenth and Fourteenth Centuries: Conscience and Political Power and the Kings of France." *French Historical Studies* 8, no. 1 (1973): 1–28.

——. "Vincent de Beauvais and the *Reditus Regni Francorum ad Stirpem Caroli Imperatoris*." in *Vincent de Beauvais: Intentions et réception,* 167–96.

Brown, Michelle P. *The British Library Guide to Writing and Scripts: History and Techniques.* London, 1998.

——. *A Guide to Western Historical Scripts from Antiquity to 1600.* London, 1990.

Brownlee, Kevin. "Discourse as *Proueces* in *Aucassin et Nicolette*." *Yale French Studies* 70 (1986): 167–82.

——. "Machaut's Motet 15 and the *Roman de la Rose*: The Literary Context of *Amours Qui a le Pouoir / Faux Samblant m'a Deceu / Vidi Dominum*." *Early Music History* 10 (1991): 1–14.

Bruckner, Mathilda Tomaryn. *Shaping Romance: Interpretation, Truth, and Closure in Twelfth-Century French Fictions.* Philadelphia, 1993.

Le brûlement du Talmud à Paris: 1242–1244. Edited by Gilbert Dahan and Elie Nicolas. Paris, 1999.

Bruyne, Edgar de. *Études d'esthétique médiévale.* 3 vols. Bruges, 1946.

Bruzelius, Caroline Astrid. "L'achèvement de la basilique au XIIIe siècle." *Dossiers d'archéologie,* no. 261 (2001): 38–49.

——. "The Construction of Notre-Dame in Paris." *Art Bulletin* 69, no. 4 (1987): 540–69.

——. Review of *Art and Crusade,* by Daniel H. Weiss. *Speculum* 76, no. 3 (2001): 813–15.

——. "Seated Judge or King." In *The Brummer Collection of Medieval Art,* 192–95. Durham, N.C., and London, 1991.

——. *The 13th-Century Church at St-Denis.* Yale Publications in the History of Art, 33. New Haven and London, 1985.

Buc, Philippe. *L'ambiguïté du livre: Prince, pouvoir, et peuple dans les commentaires de la Bible au Moyen Âge.* Théologie historique, 95. Paris, 1994.

——. *The Dangers of Ritual: Between Early Medieval Texts and Social Scientific Theory.* Princeton, 2001.

——. "David's Adultery with Bathsheba and the Healing Power of the Capetian Kings." *Viator* 24 (1993): 101–20.

——. "Exégèse et pensée politique: Radulphus Niger (vers 1190) et Nicolas de Lyre (vers 1330)." In *Représentation, pouvoir et royauté à la fin du Moyen Âge: Actes du colloque organise par l'Université du Maine les 25–26 mars 1994,* edited by Joël Blanchard, 145–64. Paris, 1995.

——. *Potestas: Prince, pouvoir, et peuple dans les commentaires de la Bible (Paris et France du Nord, 1100–1330).* Ph.D. thesis, École des hautes études en sciences sociales, 1989.

——. "Pouvoir royal et commentaires de la Bible (1150–1350)." *Annales ESC* 44, no. 3 (1989): 691–713.

——. "*Principes genetium dominatur eorum*: Princely Power Between Legitimacy and Illegitimacy in Twelfth-Century Exegesis." In *Cultures of Power: Lordship, Status, and Process in Twelfth-Century Europe,* edited by Thomas Bisson, 310–28. Philadelphia, 1995.

Bucher, François. "Micro-Architecture as the 'Idea' of Gothic Theory and Style." *Gesta* 15 (1976): 71–89.

——. *The Pamplona Bibles.* New Haven, 1970.

Büchler, Alfred. "Zu den Psalmillustrationen der Haseloff-Schule II.: Psalter mit eklektischen Programmen." *ZKg* 54 (1991): 145–80.

Buchthal, Hugo. *Miniature Painting in the Latin Kingdom of Jerusalem.* Oxford, 1957.

Buckley, James M. "The Problematical Octogenarianism of John of Brienne." *Speculum* 32 (1957): 315–22.

Building Accounts of King Henry III. Edited by Howard Colvin. Oxford, 1971.

Buisson, Ludwig. "Saint Louis: Justice et amour de Dieu." *Francia* 6 (1978): 127–49.

Bumke, Joachim. *Courtly Culture: Literature and Society in the High Middle Ages.* Translated by Thomas Dunlap. Berkeley and Los Angeles, 1991.

Bunim, Miriam Schild. *Space in Medieval Painting and the Forerunners of Perspective.* New York, 1940.

Bunjes, Hermann. *Die steinernen Altaraufsätze der hohen Gotik und der Stand der gotischen Plastik in der Île-de-France um 1300.* Marburg, 1937.

Burns, E. J. *Bodytalk: When Women Speak in Old French Literature.* Philadelphia, 1993.

Buschmann, Erna. "Ministerium Dei—idoneitas: Um ihre Deutung aus den mittelalterlichen Fürstenspiegeln." *Historisches Jahrbuch* 82 (1963): 70–101.

Busse Berger, Anna Maria. "Mnemotechnics and Notre Dame Polyphony." Ph.D. diss., Boston University, 1986.

Büttner, Brigitte. "Dressing and Undressing Bodies in Late Medieval Images." In *Künstlerische Austausch—Artistic Exchange: Akten des XXVIII. Internationalen Kongresses für Kunstgeschichte, Berlin, 15.–20. Juli 1992,* 2:383–92. Berlin, 1993.

Büttner, Frank O. *Imitatio Pietatis: Motive der christlichen Ikonographie als Modelle zur Verähnlichung.* Berlin, 1983.

Büttner, Philippe. "Bilderzyklen in englischen und französischen Psalterhandschriften des 12. und 13. Jahrhunderts: Visuelle Realisationen persönlich gefärbter Heilsgeschichte?" In *Für irdischen Ruhm,* 131–54.

Bynum, Caroline. "Did the Twelfth Century Discover the Individual?" *Journal of Ecclesiastical History* 31 (1980): 1–17.

———. *Jesus as Mother. Studies in the Spirituality of the High Middle Ages.* Berkeley and Los Angeles, 1982.

Bynum, Caroline, and Paul Freedman, eds. *Last Things: Death and the Apocalypse in the Middle Ages.* Philadelphia, 1999.

Byvanck, Alexander Willem. *Les principaux manuscrits à peintures de la Bibliothèque royale des Pays-Bas et du Musée Meermanno-Westreenianum à La Haye.* Paris, 1924.

Cadden, Joan. *Meanings of Sex Difference in the Middle Ages: Medicine, Science, and Culture.* Cambridge, 1993.

Cahen, Claude. "Saint Louis et l'Islam." In *Turcobyzantina et Oriens Christianus,* Variorum Reprints, Collected Studies Series, 34:3–12. London, 1974.

Cahier, Charles, and Arthur Martin. *Monographie de la cathédrale de Bourges: Vitraux de XIIIe siècle.* Paris, 1841–44.

Cahn, Walter. "Moses ben Abraham's *Chroniques de la Bible.*" *Artibus et historiae* 16 (1987): 55–66.

———. *Romanesque Bible Illumination.* Ithaca, N.Y., 1982.

———. *Romanesque Manuscripts: The Twelfth Century.* 2 vols. Pt. 1 of *A Survey of Manuscripts Illuminated in France,* edited by François Avril and Jonathan J. G. Alexander. London, 1996.

Calkins, Robert. "Additional Lacunae in the Lambeth Bible." *Gesta* 28, no. 2 (1981): 127–29.

———. *Distribution of Labor: The Illuminators of the Hours of Catherine of Cleves and Their Workshop.* Transactions of the American Philosophical Society, vol. 69, pt. 5. Philadelphia, 1979.

———. *Illuminated Books of the Middle Ages.* Ithaca, N.Y., 1983.

———. "Stages of Execution: Procedures of Illumination as Revealed in an Unfinished Book of Hours." *Gesta* 17 (1978): 61–70.

Camille, Michael. "The Eye in the Text: Vision in the Illuminated Manuscripts of the Latin Aristotle." *Macrologus* 6 (1998): 129–45.

———. *The Gothic Idol: Ideology and Image-Making in Medieval Art.* Cambridge, 1989.

———. Introduction to *Künstlerische Austausch—Artistic Exchange: Akten des XXVIII. Internationalen Kongresses für Kunstgeschichte, Berlin, 15.–20. Juli 1992.* Berlin, 1993.

———. *Master of Death: The Lifeless Art of Pierre Remiet.* New Haven and London, 1996.

———. "An Oxford University Textbook Illuminated by William de Brailes." *Burlington Magazine* 137, no. 1106 (1995): 292–99.

———. "Visual Signs of the Sacred Page: Books in the *Bible Moralisée.*" *Word & Image* 5, no. 1 (1989): 111–30.

Campbell, Gerard G. "The Attitude of the Monarchy Toward the Use of Ecclesiastical Censures in the Reign of Saint Louis." *Speculum* 35, no. 4 (1960): 535–55.

———. "The Protest of Saint Louis." *Traditio* 15 (1959): 405–19.

———. "Temporal and Spiriual Regalia During the Reigns of St. Louis and Philip III." *Traditio* 20 (1964): 351–83.

Carette, Martine, and Didier Deroeux. *Carreaux de pavement médiévaux de Flandre et d'Artois (XIIIe–XVe siècles).* Mémoires de la Commission départementale d'histoire et d'archéologie du Pas-de-Calais, 22. Arras, 1985.

Carolus-Barré, Louis. "Les enquêtes pour la canonisation de Saint Louis—de Grégoire X a Boniface VIII—et la bulle *Gloria laus,* du 11 août." *Revue de l'histoire de l'Église de France* 57 (1971): 26–29.

———. "Les Franciscains et le procès de canonisation de Saint Louis." *Les Amis de Saint François* 12, no. 1 (1971): 3–6.

———. "Guillaume de Saint-Pathus, confesseur de la reine Marguerite et biographe de Saint Louis." *Archivum Franciscanum Historicum* 79, nos. 1–2 (1986): 142–52.

———. "Les loges du palais." *Bulletin de la Société nationale des antiquaires de France* (1980–81): 355–61.

———. "Le prince héritier Louis (1244–1260) et l'intérim du pouvoir royal de la mort de Blanche de Castille (Novembre 1252) au retour de Saint Louis en France (Juillet 1254)." *Académie des inscriptions et belles-lettres: Comptes-rendus des séances* 4 (1970–71): 588–96.

———. *Le procès de canonisation de Saint Louis (1272–1297): Essai de reconstitution.* Collection de l'École française de Rome, 195. Rome, 1994

———. "Saint Louis dans l'histoire et la légende." *Annuaire-bulletin de la Société de l'histoire de France* (1970–71): 37–49.

———. "Saint Louis et la translation des corps saints." In *Études d'histoire du droit canonique, dédiées à Gabriel Le Bras,* 2:1087–112. Paris, 1965.

Carozzi, Claude. "Le roi et la liturgie chez Helgaud de Fleury." In *Hagiographie, cultures et sociétés, IVe–XIIe siècles: Actes du colloque organisé à Nanterre et à Paris (2–5 mai 1979),* 417–32. Paris, 1981.

Carrasco, Magdalena. "The Early Illustrated Manuscript of the Passion of St. Agatha (Paris, Bibl. Nat., MS lat 5594)." *Gesta* 24, no. 1 (1985): 19–32.

———. "Note on the Iconography of the Romanesque Illustrated Manuscript of the Life of St. Albinus of Angers." *ZKg* 47, no. 3 (1984): 333–48.

Carré, Yannick. *Le baiser sur la bouche en Moyen Âge.* Paris, 1992.

Les carreaux de pavage dans la Bourgogne médiévale. Exh. cat. Edited by M. Pinette. Musée Rolin. Autun, 1981.

Carruthers, Mary. "The Poet as Master Builder: Composition and Locational Memory in the Middle Ages." *New Literary History* 24 (1993), 881–904.

Castellazzo, Moses dal. *Bilder-Pentateuch.* Venice, 1521. Facsimile ed. Edited by Kurt Schubert. Vienna, 1983.

Catalogue des livres de la bibliothèque du Cte A . . . G . . . Moscow, 1811.

Catalogue des livres de la bibliothèque du Cte. Alexis de Golowkin. Leipzig, 1798.

Caviness, Madeline Harrison. "Biblical Stories in Windows: Were They Bibles for the Poor?" In *The Bible in the Middle Ages: Its Influence on Literature and Art,* edited by Bernard S. Levy, Medieval and Renaissance Texts and Studies, 89:103–47. Binghamton, N.Y., 1992.

———. "The Simple Perception of Matter and the Representation of Narrative, ca. 1180–1280." *Gesta* 30, no. 1 (1991): 48–64.

———. *Sumptuous Arts at the Royal Abbeys in Reims and Braine: Ornatus elegantiae, varietate stupendes.* Princeton, 1990.

Cazanave, Caroline. "Joinville et La vie de Saint Louis: Un historien et une oeuvre multiformes." *Le Moyen Âge: Revue d'histoire et de philologie* 105, no. 1 (1999): 129–36.

Cazelles, Brigitte, ed. *The Lady as Saint: A Collection of French Hagiographic Romances of the Thirteenth Century.* Philadelphia, 1991.

La chanson de geste e il ciclo di Guglielmo d'Orange: Atti del Convegno di Bologna (7–9 ottobre 1996). Edited by Andrea Fassò. Rome, 1997.

Les chansons de croisade. Edited by Joseph Bédier and Pierre Aubry. Paris, 1909.

Chartier, Roger. *Cultural History: Between Practices and Representation.* Translated by Lydia Cochrane. Ithaca, N.Y., 1998.

Chartularium Universitatis Parisiensis. Edited by Heinrich Denifle and Emile Chatelain. 4 vols. Paris, 1889–97.

Chazan, Robert. *Medieval Stereotypes and Modern Antisemitism.* Berkeley and Los Angeles, 1997.

Chenu, Marie-Dominique. *Nature, Man, and Society in the Twelfth Century.* Edited and translated by Jerome Taylor and Lester K. Little. Chicago and London, 1968.

———. *La théologie au douzième siècle.* Paris, 1976.

Chiffoleau, Jacques. "Saint Louis, Frederic II et les constructions institutionnelles du XIIIe siècle." *Médiévales* 34 (spring 1998): 13–23.

Christe, Yves. "Les Bibles moralisées et les vitraux de la Sainte-Chapelle: Le vitrail de l'Exode." *Bulletin monumental* 157, no. 4 (1999): 329–46.

Chronique du religieux de Saint-Denys. Edited by Louis Bellaguet. Collection de documents inédits sur l'histoire de France. Vols. 2 and 4. Paris, 1839–52.

Les Chroniques de Hainaut; ou, Les ambitions d'un prince bourguignon. Edited by Christiane van den Bergen-Pantens. Turnhout, 2000.

Ciggaar, Krijnie. "Manuscripts as Intermediaries: The Crusader States and Literary Cross-Fertilization." In *East and West in the Crusader States: Context, Contacts, Confrontations: Acta of the Congress Held at the Hernen Castle in May 1993,* edited by Krijnie Ciggaar, Adelbert Davids, and Herman Teule. Louvain, 1996.

Clark, Timothy J. *The Painting of Modern Life: Paris in the Art of Manet and His Followers.* Princeton, 1984.

Clarke, Mark. *The Art of All Colours: Mediaeval Recipe Books for Painters and Illuminators.* London, 2001.

Classen, Peter. "*Res Gestae,* Universal History, Apocalypse: Visions of Past and Future." In *Renaissance and Renewal in the Twelfth Century,* edited by Robert Benson and Giles Constable, 387–417. Cambridge, Mass., 1982.

Clunas, Craig. *Superfluous Things: Material Culture and Social Status in Early Modern China.* Urbana, Ill., and Cambridge, 1991.

Cockerell, Sydney Carlyle. *A Psalter and Hours Executed Before 1270 for a Lady Connected with St. Louis, Probably His Sister Isabelle of France, Founder of the Abbey of Longchamp, Now in the Collection of Henry Yates Thompson.* London, 1905.

———. *The Work of W. de Brailes, an English Illuminator of the Thirteenth Century.* Cambridge, 1930.

Cockerell, Sydney Carlyle, Montague Rhodes James, and Charles J. Ffoulkes. *A Book of Old Testament Illustrations of the Middle of the Thirteenth Century Sent by Cardinal Bernard Maciejowski to Shah Abbas the Great, King of Persia, Now in the Pierpont Morgan Library at New York.* Cambridge, 1927.

Cockshaw, Pierre. "Le Bréviaire de Belleville (Paris, Bibliothèque nationale, MSS latins 10483–10484): Problèmes textuels et iconographiques." In *Medieval Codicology, Iconography, Literature, and Translation: Studies for Keith Val Sinclair,* edited by Peter Rolfe Monks and D. D. R. Owen, 94–109. Leiden and New York, 1994.

Cohen, Jeremy. *The Friars and the Jews: The Evolution of Medieval Anti-Judaism.* Ithaca, N.Y., and London, 1982.

Cole, Penny J. *The Preaching of the Crusades to the Holy Land, 1095–1270.* Cambridge, Mass., 1991.

Cole, Penny, D. L. D'Avray, and J. Riley-Smith. "Application of Theology to Current Affairs: Memorial Sermons on the Dead of Mansurah and on Innocent IV." *Historical Research* 63 (1990): 227–47.

Colish, Marcia L. *Medieval Foundations of the Western Intellectual Tradition, 400–1400.* New Haven, 1997.

———. *Peter Lombard.* Leiden and New York, 1994.

———. "*Psalterium Scholasticorum:* Peter Lombard and the Emergence of Scholastic Psalm Exegesis." *Speculum* 67 (1992): 531–48.

Collette, Carolyn. "Some Aesthetic Implications of Multiplication of Species." *Avista* 9, no. 1 (1995): 3–5.

Colman, Janet. *Ancient and Medieval Memories: Studies in the Reconstruction of the Past.* Cambridge, 1992.

Comfort, William Wistar. "The Literary Role of the Saracens in the French Epic." *Publications of the MLA* 4 (1940): 628–59.

Congar, Yves. "Ecclesia ab Abel." In *Abhandlungen über Theologie und Kirche: Festschrift für Karl Adams,* edited by Heinrich Elfers and F. Hofmann, 79–108. Düsseldorf, 1952.

Conklin, George. "Ingeborg of Denmark, Queen of France, 1193–1223." in *Queens and Queenship in Medieval Europe,* edited by Anne Duggan, 39–52. Woodbridge, Suffolk, 1997.

Coornaert, Emile. "Notes sur les corporations parisiennes au temps de Saint Louis d'après le 'livre de métier' d'Etienne Boileau." *Revue historique* 177 (1936): 343–52.

Copeland, Rita. *Rhetoric, Hermeneutics, and Translation in the Middle Ages: Academic Traditions and Vernacular Texts.* Cambridge, 1991.

Cornell, Henrik. *Biblia Pauperum.* Stockholm, 1925.

Corrigan, Kathleen Anne. "The Ninth Century Byzantine Marginal Psalters: Moscow, Historical Museum cod. 129; Mount Athos, Pantocrator 61; Paris, Bibliothèque Nationale gr. 20." Ph.D. diss., University of California, Los Angeles, 1984.

Cothren, Michael W. "The Iconography of Theophilus Windows in the First Half of the Thirteenth Century." *Speculum* 59, no. 2 (1984): 308–41.

Couderic, Camille, ed. *Les enlumineurs des manuscrits du Moyen Âge (du VIe au XVe siècle) de la Bibliothèque nationale.* Paris, 1927.

Les Couleurs au Moyen Âge. Sénéfiance, no. 24. Aix-en-Provence, 1988.

Coulter, Cornelia C. "The Library of the Angevin Kings at Naples." *Transactions and Proceedings of the American Philological Association* 75 (1944): 141–55.

Courtenay, William. "The King and the Leaden Coin: The Economic Background of 'Sine Qua Non' Causality." *Traditio* 28 (1972): 185–200.

Crane, Susan. *Insular Romance: Politics, Faith, and Culture in Anglo-Norman and Middle English Literature.* Berkeley, Los Angeles, and London, 1986.

Craven, Wayne. "The Iconography of the David and Bathsheba Cycle at the Cathedral of Auxerre." *Journal of the Society of Architectural Historians* 34 (1975): 226–37.

Crist, L. S. "The Breviary of Saint Louis: The Development of a Legendary Miracle." *JWCI* 28 (1965): 319–23.

Crocker, Richard. "*Musica Rhythmica* and *Musica Metrica* in Antique and Medieval Theory." *Journal of Music Theory* 2, no. 1 (1958): 2–23.

Croisy-Naquet, Catherine. "Le fastueux banquet de Saumur dans la *Vie de Saint Louis de Joinville*." *Revue de littérature française et comparée* (Pau), November 9, 1997, 21–30.

Crosby, Sumner McKnight. *L'abbaye royal de Saint-Denis.* Paris, 1953.

Cross-Cultural Convergences in the Crusader Period: Essays Presented to Aryeh Grabois on His Sixty-Fifth Birthday. Edited by Michael Goodich, Sophia Menache, and Sylvia Schein. New York, 1995.

The Crusades and Their Sources: Essays Presented to Bernard Hamilton. Edited by John France and William Zajac. Aldershot, Hampshire, and Brookfield, Vt., 1998.

The Crusades from the Perspective of Byzantium and the Muslim World. Edited by Angeliki Laiou and Roy Parviz Mottahedeh. Washington, D.C., 2001.

Cutler, Anthony. "The Aristocratic Psalters in Byzantium." *Bibliothèque des cahiers archéologiques* 13 (Paris 1984): 116–18.

———. "The Psalter of Basil II." *Arte Veneta* 30 (1976): 9–19.

Curtius, Ernst Robert. *Li quatre livre des reis.* Halle, 1911.

Cwi, Joan S. "A Study of Carolingian Biblical Theology: The David Cycle at St. John, Müstair." In *Riforma religiosa e arti nell'epoca carolingia,* edited by Alfred A. Schmid, Atti del XXIV Congresso internazionale di storia dell'arte, 1:117–28. Bologna, 1983.

Dbrowska, MaBgorzata. "L'attitude pro-byzantine de Saint Louis: Les opinions des sources françaises concernant cette question." *Byzantinoslavica* 50 (1990): 11–23.

Dahan, Gilbert. "La connaissance de l'hébreu dans les correctoires de la Bible du XIIIe siècle: Notes préliminaires." In *Rashi, 1040–1990: Hommage à Ephraïm E. Urbach: Congres européen des études juives,* edited by Gabrielle Sed-Rajna, 567–78. Paris, 1993.

———. "L'exégèse de l'histoire de Cain et Abel du XII^e-XIV siècle." *Recherches de théologie ancienne et médiévale* 49 (1982): 21–89, and 50 (1983): 5–68.

———. "Exégèse et polémique dans les commentaires de la *Genèse* d'Etienne Langton." In *Les Juifs au regard de l'histoire: Mélanges en l'honneur de Bernhard Blumenkranz,* edited by Gilbert Dahan, 129–48. Paris, 1985.

———. "L'interprétation de l'Ancien Testament dans les drames religieux (XIe–XIIIe siècles)." *Romania* 100 (1979): 71–103.

———. "Saint Bonaventure et les Juifs." *Archivum Franciscanum Historicum* 77 (1984): 369–405.

D'Alverny, Marie Therese. "La connaissance de l'Islam au temps de Saint Louis." In *Septième centenaire de la mort de Saint Louis,* 235–46.

Daly, Saralyn R. "Peter Comestor: Master of Histories." *Speculum* 32, no. 1 (1957): 62–73.

Daniélou, Jean. *The Bible and the Liturgy.* Notre Dame, Ind., 1956.

———. *Sacramentum futuri: Études sur les origines de la typologie biblique.* Paris, 1950.

Daumet, Georges. *Mémoire sur les relations de la France et de la Castille de 1255 à 1320.* Paris, 1913.

David, Marcel. "Le serment du sacre du IXe au XVe siècle: Contribution à l'étude des limites juridiques de la souveraineté." *Revue du Moyen Âge latin* 6, nos. 1–3 (1950): 5–180, 183–272.

David-Roy, M. "Saint Louis bâtisseur—des monuments disparus." *Archéologia* 31 (November–December 1969): 14–20.

Davidsohn, Robert. *Philipp II. August von Frankreich und Ingeborg.* Stuttgart, 1888.

Davidson, Clifford. "Space and Time in Medieval Drama: Meditations on Orientation in the Early Theatre." In *Word, Picture, and Spectacle,* edited by Clifford Davidson. Kalamazoo, Mich., 1984.

Davis, Steven, ed. *Color Perception: Philosophical, Psychological, Artistic, and Computational Perspectives.* New York and Oxford, 2000.

Davis-Weyer, Caecilia. "Komposition und Szenenwahl im *Dittochaeum* des Prudentius." In *Studien zur spätantiken und byzantinischen Kunst: Friedrich Wilhelm Deichmann gewidmet,* edited by Otto Feld and Urs Peschlow, 3:19–29. Bonn, 1980.

D'Avray, D. L. *Death and the Prince: Memorial Preaching Before 1350.* Oxford, 1994.

———. *The Preaching of the Friars: Sermons Diffused from Paris Before 1300.* Oxford, 1985.

Davril, Anselmus. *La vie des moines au temps des grandes abbayes: Xe–XIIIe siècles.* Paris, 2000.

Deckers, Johannes. *Der alttestamentliche Zyklus von S. Maria Maggiore in Rom.* Bonn, 1976.

DeCoo, Wilfried. "La Bible française du XIIIe siècle et l'Evangile selon Marc." *Romanica Gaudensia* 12 (1969): 53–65.

"De David li prophecie." Edited by G. E. Fuhrken. *Zeitschrift für romanische Philologie* 19 (1895): 189–234.

De Floriani, Anna. *Miniature parigine del Duecento: Il Salterio di Albenga e altri manoscritti.* Genoa, 1990.

De Hamel, Christopher. *Glossed Books of the Bible and the Origins of the Paris Booktrade.* Woodbridge, Suffolk, 1984.

Dei gesta per Francos: Études sur les croisades dédiées à Jean Richard. Edited by Michael Balard, Benjamin Z. Kedar, Jonathan Riley-Smith. Aldershot, Hampshire, 2001.

Delaborde, Henri-François. "Fragments de l'enquête faite à Saint-Denis in 1282 en vue de la canonisation de Saint-Louis." *Mémoires de la Société de l'histoire de Paris et l'Ile de France* 23 (1896): 1–71.

Delaporte, Yves, and Étienne Houvet. *Les vitraux de la cathédrale de Chartres.* Chartres, 1926.

Delaissé, L. M. J. "Towards a History of the Medieval Book." *Divinitas* 11 (1967): 423–35.

De la Selle, Xavier. "La confession et l'aumône: Confesseurs et aumôniers des rois de France du XIIIe au XVe siècles." *Journal des savants* 7–12 (1993): 255–86.

Delisle, Léopold. *Le cabinet des manuscrits de la Bibliothèque impériale.* 3 vols. Paris, 1868–81.

———. "Exposition des primitives français." In *RHF,* vol. 20.

———. "Livres d'images destinés à l'instruction religieuse et aux exercices de piété des laïques." *Histoire littéraire de la France* 31 (1893): 213–85.

———. Notes in *Journal des savants* (1899): 438; (1903): 304; (1909): 86.

———. *Notice de douze livres royaux du XIIIe et du XIVe siècle.* Paris, 1902.

———. *Recherches sur la librairie de Charles V.* 2 vols. Paris, 1907.

Demus, Otto. "Die Farbe in der byzantinischen Buchmalerei." In *Studies in Byzantium, Venice, and the West.* London, 1998.

———. *The Mosaics of Norman Sicily.* London, 1949.

———. *The Mosaics of San Marco in Venice.* Chicago and London, 1984.

Denny, Don. "Some Narrative Subjects in the Portal Sculpture of Auxerre Cathedral." *Speculum* 51, no. 1 (1976): 23–34.

Derolez, Albert. "La tranche dorée et ciselée d'après les collections de la Bibliothèque de l'Université de Gand." In *De libris compactis miscellanea,* Studia Bibliothecae Wittockianae 1:251–72. Brussels, 1984.

Derpmann, Manfred. *Die Josephgeschichte: Auffassung und Darstellung im Mittelalter.* Beihefte zum *Mittellateinischen Jahrbuch,* 13. Ratingen, 1974.

Deschamps, Paul. "Combats de cavalerie et épisodes de Croisades dans les peintures murales du XIIe et du XIIIe siècle." *Orientalia Christiana Periodica* 13, nos. 1–2 (1947): 454–74.

———. *Saint Louis et le rayonnement de l'art français, . . . lecture du 15 novembre 1946.* Institut de France, Académie des inscriptions et belles-lettres, 28. Paris, 1946.

Deschamps, Paul, and Thibout, Marc. *La peinture murale en France au début de l'époque gothique, de Philippe-Auguste à la fin du règne de Charles V (1180–1380).* Paris, 1963.

Deshman, Robert. "Anglo-Saxon Art After Alfred." *Art Bulletin* 56, no. 2 (1974): 176–200.

———. "The Exalted Servant: The Ruler Theology in the Prayerbook of Charles the Bald." *Viator* 11 (1980): 385–417.

D'Esneval, Amaury. "La division de la Vulgate latine en chapitres dans l'édition parisienne du XIIIe siècle." *Revue des science philosophiques et théologiques* 62 (October 1978): 559–68.

Deuchler, Florens, ed. *Der Ingeborgpsalter.* Berlin, 1967. Reprint, Graz, 1985.

Devauchelle, Roger. *La reliure en France, de ses origines à nos jours.* Vol. 2, *De 1700 à 1850.* Paris, 1960.

Dewan, Lawrence. "St. Albert, the Sensibles, and Spiritual Being." In *Albertus Magnus and the Sciences,* 291–320.

Devisse, Jean. *Hincmar, archevêque de Reims, 845–882.* Geneva, 1975–76.

De Winter, Patrick. *La bibliothèque de Philippe le Hardi, Duc de Bourgogne (1364–1404): Étude sur les manuscrits à peintures d'une collection princière à l'époque du "Style Gothique International."* Paris, 1985.

———. "The *Grandes Heures* of Philip the Bold, Duke of Burgundy: The Copyist Jean L'Avenant and His Patrons at the French Court." *Speculum* 57, no. 4 (1982): 786–842.

Diamond, Joan. "Manufacture and Market in Parisian Illumination Around 1300." In *Europäische Kunst um 1300,* edited by Elisabeth Liskar, Akten des XXV. Internationalen Kongresses für Kunstgeschichte, 6:101–10. Vienna, 1986.

Dibdin, Thomas Frognall. *A Bibliographical, Antiquarian, and Picturesque Tour in France and Germany.* 3 vols. London, 1821.

Diebold, William. "The Ruler Portrait of Charles the Bald in the S. Paolo Bible." *Art Bulletin* 76, no. 1 (1994): 6–18.

La diffusione delle scienze islamiche nel Medio Evo europeo: Roma, 2–4 ottobre 1984: Convegno internazionale promosso dall'Accademia nazionale dei Lincei, Fondazione Leone Caetani e dall'Università di Roma. Rome, 1987.

Dimier, Anselme. "Un grand évêque cistercien, ami de Saint Louis: Gautier de Chartres." *Cîteaux, commentarii cistercienses: Revue d'histoire cistercienne/A Journal of Historical Studies* 22, no. 1 (1971): 5–14.

———. "Saint Louis et les Prémontrés." *Analecta Praemonstratensia* 46, nos. 1–2 (1970): 139–43.

Dodwell, Charles Reginald, and Peter Clemoes, eds. *The Old English Illustrated Hexateuch: British Museum Cotton Claudius B. IV.* Early English Manuscripts in Facsimile, 18. Copenhagen, 1974.

Dogaer, Georges. *Flemish Miniature Painting in the Fifteenth and Sixteenth Centuries.* Amsterdam, 1987.

Donovan, Claire. *The de Brailes Hours: Shaping the Book of Hours in Thirteenth-Century Oxford.* London, 1991.

———. "The Mise-en-page of Early Books of Hours in England." In *Medieval Book Production: Assessing the Evidence: Proceedings of the Second Conference of the Seminar in the History of the Book to 1500, Oxford, July 1988,* edited by Linda Brownrigg, 147–61. Los Altos Hills, Calif., 1990.

Dosher, Harry Randall. "The Concept of the Ideal Prince in French Political Thought, 800–1760." Ph.D. diss., University of North Carolina, Chapel Hill, 1969.

Douais, Célestin. *Essai sur l'organisation des études dans l'ordre des frères prêcheurs au treizième et au quatorzième siècle (1216–1342): Première province de Provence—province de Toulouse avec de nombreux textes inédits et un état du personnel enseignant dans cinquante-cinq couvents du midi de la France.* Paris, 1884.

Douët d'Arcq, Louis. *Collection de sceaux.* 3 vols. Paris, 1863–68.

Dronke, Peter. *The Medieval Poet and His World.* Edizioni di storia e letteratura. Rome, 1984.

———. "Tradition and Innovation in Medieval Western Colour-Imagery." *Eranos* 41 (1971): 51–107.

Druon, Maurice. "Saint Louis et la notion de justice." *La revue des deux mondes* 12 (1970): 524–32.

Duchesne, André. *Historiae Francorum Scriptores.* Vol. 5. Paris, 1649.

Duggan, Anne. *Kings and Kingship in Medieval Europe.* 5th ed. London, 1993.

Dunbabin, Jean. "The Maccabees as Exemplars in the Tenth and Eleventh Centuries." In *The Bible in the Medieval World: Essays in Memory of Beryl Smalley,* edited by Katherine Walsh and Diana Wood. Oxford, 1985.

Dupont, Jacques, and Cesare Gnudi. *La peinture gothique.* Geneva, 1954.

Durrieu, Paul. "Le Psautier de Saint Louis." *Gazette des beaux-arts* 34 (1905): 507–10.

———. "Un siècle de l'histoire de miniature parisienne à partir du règne de Saint Louis." *Journal des savants* (January 1909): 5–19.

The Eadwine Psalter: Text, Image, and Monastic Culture in Twelfth-Century Canterbury. Edited by Margaret T. Gibson, T. A. Heslop, and Richard W. Pfaff. London and University Park, Pa., 1992.

The Early Middle Ages to 1300. Edited by Richard Crocker and David Hiley. Oxford and New York, 1990.

Earp, Lawrence. "Scribal Practice, Manuscript Production, and the Transmission of Music in Late Medieval France: The Manuscripts of Guillame de Machaut." Ph.D. diss., Princeton University, 1983.

Ebenbauer, Alfred. "Historiographie zwischen der Spätantike und Beginn volkssprachlicher Geschichtsschreibung im Mittelalter." In *GRLMA*, XI/1:57–113.

Eberhardt, Otto. *Via Regia: Der Fürstenspiegel Smaragds von St. Mihiel und seine literarische Gattung.* Munich, 1977.

Eberle, Patricia. "The Lovers' Glass: Nature's Discourse on Optics and the Optical Design of the *Romance of the Rose*." *University of Toronto Quarterly* 46, no. 3 (1977): 241–62.

Echt, Rodulf. *Emile Boeswillwald als Denkmalpfleger: Untersuchungen zu Problemen und Methoden der französischen Denkmalpflege im 19. Jahrhundert.* Saarbrücker Beiträge zur Altertumskunde, 39. Bonn, 1984.

Edbury, Peter. "The Lyon *Eracles* and the Old French Continuations of William of Tyre." In *Montjoie: Studies in Crusade History in Honour of Hans Eberhard Mayer,* edited by Benjamin Kedar, Jonathan Riley-Smith, and Rudolf Hiestand, 139–53. Aldershot, Hampshire, 1997.

Edgerton, Mills F., Jr. "A Mediaeval 'Tractatus de Coloribus': Together with a Contribution to the Study of the Color-Vocabulary of Latin." *Mediaeval Studies* 25 (1963): 173–208.

Edmondson, Christine Ann. "The Psalter of Henry of Blois: A Study in Romanesque Manuscript Illumination." Ph.D. diss., New York University, 1978.

Egbert, Donald Drew. *The Tickhill Psalter and Related Manuscripts.* Princeton, 1940.

Eggenberger, Christoph. *Psalterium aureum Sancti Galli: Mittelalterliche Psalterillustration im Kloster St. Gallen.* Sigmaringen, 1987.

Ehlers, Joachim. "Kontinuität und Tradition als Grundlage mittelalterlicher Nationsbildung in Frankreich." In *Beiträge zur Bildung der französischen Nation im Früh- und Hochmittelalter,* edited by Helmut Beumann, 15–47. Sigmaringen, 1983.

Eleen, Luba. "The Frescoes from the Life of Saint Paul in San Paolo fuori le mure in Rome: Early Christian or Medieval?" *Revue d'art canadienne/Canadian Art Review* 12, no. 1 (1985): 251–59.

Elias, Norbert. *The Civilizing Process.* Vol. 1, *The History of Manners;* vol. 2, *State Formation and Civilization.* Translated by Edmund Jephcott. Oxford, 1978–82.

Ellenius, Allan. *Iconography, Propaganda, and Legitimation.* Oxford and New York, 1998.

Elm, Kaspar. "Nec minori celebritate a catholicis cultoribus observatur et colitur: Zwei Berichte über die 1119/20 erfolgte Auffindung und Erhebung der Gebeine der Patriarchen Abraham, Isaak, und Jakob." *Zeitschrift für Religions- und Geistesgeschichte* 49 (1997): 320–44.

Emery, Richard. *The Friars of Medieval France.* New York and London, 1962.

Epstein, Marcy J. "*Ludovicus decus regnantium:* Perspectives on the Rhymed Office." *Speculum* 53, no. 2 (1978): 283–334.

Erdmann, Carl. *The Origins of the Idea of Crusade.* Translated by Marshall Baldwin and Walter Goffart. Princeton, 1977.

Erffa, Hans Martin von. *Ikonologie der Genesis,* Munich, 1989.

Erlande-Brandenburg, Alain. "L'Adam du musée de Cluny." *La revue du Louvre et des Musées de France* 25 (1975): 81–90.

———. *L'art gothique.* Paris, 1983.

———. *Notre-Dame de Paris.* Paris, 1991.

———. "Nouvelles remarques sur le portail central de Notre-Dame de Paris." *Bulletin monumental* 132 (1974): 287–96.

———. "La priorale Saint-Louis de Poissy." *Bulletin monumental* 129, no. 2 (1971): 85–112.

———. "Les remaniements du portail central à Notre-Dame de Paris." *Bulletin monumental* 129 (1971): 241–48.

———. *Le roi est mort: Étude sur les funérailles, les sépultures, et les tombeaux des rois de France jusqu'à la fin du XIIIe siècle.* Bibliothèque de la Société française d'archéologie, 7. Geneva, 1975.

———. "La sculpture à Paris au milieu du XIIIe siècle." *Bulletin de la Société de l'histoire de Paris et de l'Ile de France* 97 (1970): 31–42.

———. "Le tombeau de Saint Louis." *Bulletin monumental* 126, no. 1 (1968): 7–28.

Erlande-Brandenburg, Alain, Jean Grosjean, and Marcel Thomas, eds. *La Bible de Prague.* Paris, 1989.

Erlande-Brandenburg, Alain, and Dominique Thibaudat. *Les sculptures de Notre-Dame de Paris au musée de Cluny.* Paris, 1982.

L'érotisme au Moyen Âge: Études présentées au troisième colloque de l'Institut d'études médiévales. Edited by Bruno Roy. Montreal, 1977.

Esmeijer, Anna C. *Divina Quaternitas: A Preliminary Study in the Method and Application of Visual Exegesis.* Amsterdam, 1978.

Études franciscaines 11 (1904): 101.

Europäische Kunst um 1300. Edited by Elisabeth Liskar. Akten des XXV. Internationalen Kongresses für Kunstgeschichte, 6. Vienna, 1986.

European Monarchy: Its Evolution and Practice from Roman Antiquity to Modern Times. Edited by Heinz Duchhardt, Richard A. Jackson, and David Sturdy. Stuttgart, 1992.

Evergates, Theodore. *Feudal Society in the Bailliage of Troyes Under the Counts of Champagne, 1152–1284.* Baltimore and London, 1975.

Everist, Mark. *Polyphonic Music in Thirteenth-Century France: Aspects of Sources and Distributions.* New York and London, 1989.

——. "The Rondeau Motet: Paris and Artois in the Thirteenth Century." *Notes* 69 (1988): 1–22.

Ewig, Egon. "Zum christlichen Königsgedanken im Frühmittelalter." In *Das Königtum, Seine geistigen und rechtlichen Grundlagen,* edited by Theodor Mayer, Konstanzer Arbeitskreis für mittelalterliche Geschichte: Vorträge und Forschungen, 3:7–73. Lindau, 1956.

Fagniez, Gustave. *Documents relatifs à l'histoire de l'industrie et du commerce en France.* Vol. 1. Paris, 1898.

Falke, Otto von. *Kunstgeschichte der Seidenweberei.* 2 vols. Berlin, 1913.

Farmer, Sharon. "Softening the Hearts of Men: Women, Embodiment, and Persuasion in the Thirteenth Century." In *Embodied Love: Sensuality and Relationship as Feminist Values,* edited by Paula Cooey, Sharon Farmer, and Mary Ellen Ross, 115–33. San Francisco, 1987.

Fassler, Margot. "The Role of the Parisian Sequence in the Evolution of Notre-Dame Polyphony." *Speculum* 62, no. 2 (1987): 345–74.

Les fastes du gothique: Le siècle de Charles V: Galeries nationales du Grand Palais, 9 octobre–1er février 1982. Exh. cat. Edited by F. Baron et al. Paris, 1981.

Fauvel Studies: Allegory, Chronicle, Music, and Image in Paris, Bibliothèque Nationale de France, MS Français 146. Edited by Margaret Bent and Andrew Wathey, Oxford and New York, 1998.

Fawtier, Robert. *La Bible historiée toute figurée de la John Rylands Library.* Paris, 1924. (Originally publ. in *SFRMP* [1923].)

Fayet, Sylvie. "Le regard scientifique sur les couleurs à travers quelques encyclopédistes Latins du XIIe siècle." *Bibliothèque de l'École des Chartes* 150 (1992): 51–70.

Ferber, Stanley. "Jean Pucelle and Giovanni Pisano." *Art Bulletin* 116, no. 1 (1984): 65–72.

Ferrante, Joan M. "Artist Figures in the Tristan Stories." *Tristania* 4, no. 2 (1979): 25–35.

——. "The Court in Medieval Literature—the Center of the Problem." In *The Medieval Court in Europe,* edited by Edward Haymes, 1–25. Munich, 1986.

Ferster, Judith. *Fictions of Advice: The Literature and Politics of Counsel in Late Medieval England.* Philadelphia, 1996.

Feuilloy, Clotilde, Jannie Long, and Catherine Maupeou. "Représentations de Saint-Louis sous l'aspect des rois de France." *Monuments historiques de la France* 16, no. 4 (1970): 47–52.

Fianu, Kouky. "Les professionnels du livre à la fin du XIIIe siècle: L'enseignement des registres fiscaux parisiens." *BÉC* 150 (1992): 185–222.

Fillitz, Hermann. *Katalog der weltlichen und der geistlichen Schatzkammer.* 5th ed. Vienna, 1971.

Fizelière, Albert de la. *Rymaille sur les plus célèbres bibliotières de Paris en 1649: Avec des notes et un essai sur les autres bibliothèques particulières du temps.* Paris, 1868.

Fleischman, Suzanne. "Discourse as Space/Discourse as Time: Reflections on the Metalanguage of Spoken and Written Discourse." *Journal of Pragmatics* 16 (1991): 291–306.

——. "Discourse Functions of Tense-Aspect Oppositions in Narrative: Toward a Theory of Grounding." *Linguistics* 23 (1985): 851–82.

——. *Tense and Narrativity: From Medieval Performance to Modern Fiction.* Austin, 1990.

Focillon, Henri. *Art d'Occident.* 1938. 2nd ed., Paris, 1983.

Folda, Jaroslav. *Crusader Manuscript Illumination at Saint Jean d'Acre, 1275–1291.* Princeton, 1976.

——. "The Hospitaller Master in Paris and Acre: Some Reconsiderations in Light of New Evidence." *Journal of the Walters Art Gallery* 54 (1996): 51–59, 269–72.

——. "Paris, Bibliothèque Nationale, MS Lat. 5334, and the Origins of the Hospitaller Master." In *Montjoie: Studies in Crusade History in Honour of Hans Eberhard Mayer,* edited by Benjamin Kedar, Jonathan Riley-Smith and Rudolf Hiestand. Aldershot, Hampshire, 1997.

Folena, Gianfranco, and Gian Lorenzo Mellini. *Bibbia istoriata padovana della fine del Trecento: Pentateuco, Giosuè, Ruth.* Saggi e studi di storia dell'arte, 5. Venice, 1962.

Foly, Edward. *The First Ordinary of the Royal Abbey of Saint-Denis in France.* Fribourg, 1990.

Folz, Robert. "La sainteté de Louis IX d'après les textes liturgiques de sa fête." *Revue d'histoire de l'Église de France* 57, no. 158 (1971): 31–45.

——. *Les saints rois du Moyen Âge en Occident (VIe–XIIIe siècles).* Subsidia Hagiographica, 68. Brussels, 1984.

Forsyth, William H. "A Gothic Doorway from Moutiers-Saint-Jean." *Metropolitan Museum Journal* 13 (1979): 33–74.

Four English Political Tracts of the Later Middle Ages. Edited by Jean-Philippe Genet. London, 1977.

Fox, John Howard. *Robert de Blois: Son oeuvre didactique et narrative.* Paris, n.d.

La France de Saint Louis: Septième centenaire de la mort de Saint Louis: Exposition nationale organisée par le Ministère

des affaires culturelles avec la collaboration du Ministère de l'éducation nationale, Salle des gens d'armes du Palais, Paris, octobre 1970–janvier 1971. Exh. cat. Edited by Jean Pierre Babelon. Paris, 1971.

Franklin, Alfred. Les anciennes bibliothèques de Paris; églises, monastères, collèges, etc. 3 vols. Histoire général de Paris. Paris, 1867–73.

Friedman, Lionel J. Text and Iconography for Joinville's "Credo." Cambridge, Mass., 1958.

Frodl-Kraft, Eva. "Zu den Kirchenschaubildern in den Hochchorfenstern von Reims—Abbildung und Abstraktion." Wiener Jahrbuch für Kunstgeschichte 25 (1972): 53–86.

Frugoni, Chiara. "Saint Louis et Saint François." Médiévales 34 (spring 1998): 35–38.

Funkenstein, Amos. Perceptions of Jewish History. Berkeley and Los Angeles, 1995.

——. Theology and the Scientific Imagination from the Middle Ages to the Seventeenth Century. Princeton, 1986.

Funkenstein, Josef. "Malkizedek in der Staatslehre." Archiv für Rechts- und Sozial-Philosophie (Berlin) 41 (1954–55): 32–36.

——. "Samuel und Saul in der Staatslehre des Mittelalters." Archiv für Rechts- und Sozial-Philosophie (Berlin) 40 (1952–53): 129–41.

Für irdischen Ruhm und himmlischen Lohn: Stifter und Auftraggeber in der mittelalterlichen Kunst. Edited by Hans-Rudolf Meier, Carola Jäggi, and Philippe Büttner. Berlin, 1995.

Gaborit-Chopin, Danielle. "Nicodème travesti: La Descente de Croix d'ivoire du Louvre." Revue de l'art, no. 81 (1988): 31–46.

——. "Une Vierge d'ivoire du XIIIe siècle." La revue du Louvre et des Musées de France 33 (1983): 270–79.

Gaehde, Joachim E. "Carolingian Interpretations of an Early Christian Picture Cycle to the Octateuch in the Bible of San Paolo Fuori le Mura in Rome." FSt 8 (1974): 351–84.

Gage, John. "Color in Western Art." Art Bulletin 72, no. 4 (1990): 518–41.

——. Colour and Culture: Practice and Meaning from Antiquity to Abstraction. Boston, Toronto, and London, 1993.

——. "Colour Words in the High Middle Ages." Leids kunsthistorisch jaarboek 11 (1998): 35–48.

——. "Gothic Glass: Two Aspects of a Dionysian Aesthetic." Art History 5, no. 1 (1982): 36–58.

——. "A Locus Classicus of Colour Theory: The Fortunes of Apelles." JWCI 44 (1981): 1–26.

Gaillard, Georges. Les fresques de Saint-Savin. Paris, 1944.

Galindo, P. "La 'Biblia de Leon' del 960." Gesammelte Aufsätze zur Kulturgeschichte Spaniens 16 (1960): 37–76.

Ganneron, Edmond. La cassette de Saint Louis. Paris, 1858.

Gaposchkin, Marianne Cecelia. "The King of France and the Queen of Heaven: The Iconography of the Porte Rouge of Notre Dame of Paris." Gesta 39, no. 1 (2000): 58–72.

——. "The Sanctification and Memorialization of Louis IX of France, 1270–1350." Ph.D. diss., University of California, Berkeley, 2001.

Gassman, David Louis. "Translatio Studii: A Study of Intellectual History in the Thirteenth Century." Ph.D. diss., Cornell University, 1973.

Gaston, Jean. Les images des confréries parisiennes avant la Révolution. Paris, 1910.

Gaston, Robert William. "Studies in the Early Christian 'Tituli' of Wall Decoration in the Latin West." Ph.D. diss., University of London, 1969.

Gatouillet, Françoise. "À Saint-Sulpice-de-Favrières, des vitraux témoins de l'art parisien au temps de Saint Louis." Les dossiers de l'archéologie 26 (1978): 56–62.

Gauthier, Marie-Madeleine. "Le tableau de la crucifixion sur les évangiles ottoniens donnes par Charles V à la Sainte-Chapelle et l'orfèvrerie parisienne du temps de Saint Louis." Monuments et Mémoires (Paris) 59 (1974): 171–208.

Gauthier-Walter, Marie-Dominique. "Joseph, figure idéale du roi?" Cahiers archéologiques 38 (1990): 25–36.

Gebhardt, Oscar von, ed. The Miniatures of the Ashburham Pentateuch. London, 1883.

Gellrich, Jesse. The Idea of the Book in the Middle Ages: Language Theory, Mythology, and Fiction. Ithaca, N.Y., 1985.

Genet, Jean-Philippe. Four English Political Tracts of the Later Middle Ages. London, 1977.

——. "Saint Louis: Le roi politique." Médiévales 34 (spring 1998): 25–34.

Les genres littéraires dans les sources théologiques et philosophiques médiévales: Définition, critique et exploitation. Université Catholique de Louvain, Publications de l'Institut d'études médiévales, 2nd ser., 5. Louvain-la-Neuve, 1982.

Gerhke, Pamela. Saints and Scribes: Medieval Hagiography in Its Manuscript Context. Berkeley and Los Angeles, 1993.

Germanier, Veronique. "L'Ecclesia comme Sponsa Christi dans les Bibles moralisées de la première moitié du XIIIème siècle." Arte Christiana (Milan) 84 (1996): 243–52.

Gerstinger, Hans. Die Wiener Genesis. Vienna, 1931.

Gilissen, Léon. Prolégomènes à la codicologie. Ghent, 1977.

——. La reliure occidentale antérieure à 1400. Turnhout, 1983.

Gilson, E. La philosophie au Moyen Âge des origines patristiques a la fin du XIVe siècle. 2nd ed. Paris, 1947.

Ginzberg, Louis. The Legends of the Jews. Translated from the German by Henrietta Szold. 7 vols. Philadelphia, 1909–38.

Gnudi, Cesare. "Le jubé de Bourges et l'apogée du 'classicisme' dans la sculpture de l'Ile-de-France au milieu du XIIIe siècle." *Revue de l'art*, no. 3 (1969): 18–36.

Göbl, Robert. *Antike Numismatik*. Vol. 2. Munich, 1978.

Goez, Werner. *Translatio imperii: Ein Beitrag zur Geschichte des Geschichtsdenkens und der politischen Theorien in Mittelalter und in der frühen Neuzeit*. Tübingen, 1958.

Gold, Penny Schine. *The Lady and the Virgin: Image, Attitude, and Experience in Twelfth-Century France*. Chicago and London, 1985.

Göller, Gottfried. *Vinzenz von Beauvais O.P. (um 1194–1264) und sein Musiktraktat im Speculum doctrinale*. Regensburg, 1959.

Gollner, Marie Louise. "Rhythm and Pattern: The Two-Voice Motets of Codex Montpellier." *Viator* 30 (1999): 145–63.

Gombrich, Ernst H. "Light, Form, and Texture in Fifteenth-Century Painting North and South of the Alps." In *The Heritage of Apelles*, 19–35. Oxford, 1976.

Goodich, Michael. *Vita Perfecta: The Ideal of Sainthood in the Thirteenth Century*. Stuttgart, 1982.

Gottlieb, Theodor. *Über mittelalterliche Bibliotheken*. Leipzig, 1890. Reprint, Graz, 1955.

Gould, Karen. "The Sequences *De Sanctis Reliquiis* as Sainte-Chapelle Inventories." *Mediaeval Studies* 43 (1981): 315–41.

Gousset, Marie-Thérèse, François Avril, and Jean Richard, eds. *Saint Louis, roi de France: Livre des faits de Monseigneur Saint Louis*. Paris, 1990.

Gouttebroze, Jean-Guy. "Deux modèles de sainteté royale: Edouard le Confesseur et Saint Louis." *Cahiers de civilisation médiévale* 42 (1999): 243–58.

Grabmann, Martin. *I divieti ecclesiastici di Aristotele sotto Innocenzo III e Gregorio IX*. Miscellania Historiae Pontificiae, 5. Rome, 1941.

———. *Die Geschichte der scholastischen Methode*. 2 vols. Freiburg im Breisgau, 1909.

Grabois, Aryeh. "Anselme, l'Ancien Testament et l'idée de croisade." In *Les mutations socio-culturelles au tournant des XIe–XIIe siècles: Études anselmiennes (IVe session)*, 161–73. Paris, 1984.

———. "La bibliothèque du noble d'*Outremer* à Acre dans la seconde moitié du XIIIe siècle." *Le Moyen Âge: Revue d'histoire et de philologie* 103, no. 1 (1997): 53–66.

———. "Un centre intellectuel juif à Paris sur la rive gauche aux XIIe–XIIIe siècles?" *Revue des études juives* (Paris) 131 (1972): 222–24.

———. "Un mythe fondamental de l'histoire de France au Moyen Âge: Le 'roi David,' précurseur du 'roi très chrétien.'" *Revue historique* (Paris) 287, no. 1 (1992): 11–31.

———. "La royauté sacrée au XIIe siècle: Manifestation de propagande royale." In *Idéologie et propagande en France: Colloque organisé par l'Institut d'histoire et de civilisation française de l'Université de Haifa*, 31–41. Paris, 1987.

Graham, Henry Brown. "Old Testament Cycles of Illustration in the English Psalter in Munich (Bayerische Staatsbibliothek, clm. 835)." Ph.D. diss., Princeton University, 1975.

Grandeau, Yann. "Les enfants de Charles VI." *Bulletin philologique et historique du Comité des travaux historiques et scientifiques* 2 (1967): 809–49.

Graus, František. "Littérature et mentalité médiévales: Le roi et le peuple." *Historica* 16 (1969): 5–79.

Gravdal, Kathryn. *Vilain and Courtois: Transgressive Parody in French Literature of the Twelfth and Thirteenth Centuries*. Lincoln, Nebr., 1989.

Green, Dennis Howard. *The Millstätter Exodus: A Crusading Epic*. Cambridge, 1966.

Greenia, George. "University Book Production and Courtly Patronage in Thirteenth-Century France and Spain." In *Medieval Iberia: Essays on the History and Literature of Medieval Spain*, edited by Donald Kagay and Joseph Snow, 103–28. New York, 1997.

Griffiths, Quentin. "The Counselors of Louis IX." Ph.D. diss., University of California, Berkeley, 1964.

———. "New Men Among the Lay Counselors of Saint Louis' Parlement." *Mediaeval Studies* 32 (1970): 234–72.

Grigsby, John. "Miroir des bonnes femmes: A New Fragment of the *Somme le Roi* and a *Miroir des Bonnes Femmes*, a Hitherto Unnoticed Text." *Romania* 82 (1962): 458–81.

———. "Miroir des bonnes femmes (suite)." *Romania* 83 (1962): 30–51.

Grillo, P. R. "Chronicles and the Continuations of the Old French Crusade Cycle." *Studi medievali*, 3rd ser., 2 (1996): 905–16.

Grimm, Reinhold R. "Den Grenzfall des Bibelepos." In *GRLMA*, IV/1:488–501.

Grodecki, Louis. "Les origines de la peinture gothique et le 'Maître de Saint Cheron' de la cathédrale de Chartres." *Revue de l'art*, nos. 40–41 (1978): 43–64.

———. "Les problèmes de la peinture gothique." *Critique* 11, no. 98 (1955): 610–24.

———. *Sainte-Chapelle*. Paris, 1963.

———. "Sainte Chapelle de Paris." In *Les vitraux de Notre-Dame et de la Sainte-Chapelle de Paris*, by Marcel Aubert, Louis Grodecki, and Jean Lafond, Corpus Vitrearum Medii Aevi, France, 1. Paris, 1957.

———. "Saint Louis et le vitrail." *Monuments historiques de la France* 16 (1970): 5–21.

———. "Les vitraux allégoriques de Saint-Denis." *Art de France* 1 (1961): 19–41.

———. "Les vitraux de la cathédrale de Poitiers." *Congrès archéologiques* 109 (1952): 138–63.

Grodecki, Louis, and Catherine Brissac. *Le vitrail gothique au XIIIe siècle.* Fribourg, 1984.

Grundmann, Herbert. *Geschichtsschreibung im Mittelalter.* Göttingen, 1965.

———. "Sacerdotium—Regnum—Studium: Zur Wertung der Wissenschaft im 13. Jahrhundert." *Archiv für Kulturgeschichte* 34 (1951): 5–21.

Guenée, Bernard. "La culture historique des nobles: Le succès des faits des Romains, (XIIIe siècle–XV siècle)." In *La noblesse au Moyen Âge: XIe–XVe siècles: Essais à la mémoire de Robert Boutreche,* edited by Philippe Contamine, 261–88. Paris, 1976.

———. *Histoire et culture historique dans l'Occident médiéval.* Paris, 1980.

Guérout, Jean. "Le Palais de la Cité, des origines à 1417: Essai topographique et archéologique." *Fédération des Sociétés historiques et archéologues de Paris et de l'Ile-de-France: Mémoires* 1 (1949): 57–183; 2 (1950): 23–204; 3 (1951): 7–101.

Guest, Gerald B., ed. *Bible Moralisée: Codex Vindobonensis 2554, Vienna, Österreichische Nationalbibliothek.* Manuscripts in Miniature, 2. London, 1995.

———. "Queens, Kings, and Clergy: Figures of Authority in the Thirteenth-Century Moralized Bibles." Ph.D. diss., New York University, 1998.

Gumbrecht, Hans-Ulrich. "Die kaum artikulierte Prämisse: Volkssprachliche Universalhistorie unter heilsgeschichtlicher Perspektive." In *GRLMA,* XI/1:799–817.

Gundossi-Villain, Christiane. *Le navire médiéval a travers les miniatures.* Paris, 1985.

Gunsbourg, Charles, ed. *Catalogue des livres de la bibliothèque du Prince Michel Galitzin.* Moscow, 1866.

Gutmann, Joseph. "Josephus' Jewish Antiquities in Twelfth-Century Art." *ZKg* 4 (1985): 434–41.

Haeberlein, Fritz. "Grundzüge einer nachantiken Farbenikonographie." *Römisches Jahrbuch für Kunstgeschichte* 3 (1939): 75–126.

Haenens, Albert d'. "*Liber scriptus intus et foris:* Une signature d'Hugo d'Oignies (vers 1230–1240)." In *Calames et cahiers: Mélanges de codicologie et de paléographie offerts à Léon Gilissen,* ed. Jacques Lemaire and Émile van Balberghe, 33–40. Brussels, 1985.

Hahn, Cynthia. "The Creation of the Cosmos: Genesis Illustration in the Octateuchs." *Cahiers archéologiques* 29 (1979): 29–40.

———. "Picturing the Past: Narrative in the life of the Saints." *Art History* 13, no. 1 (1990): 1–33.

Hahnloser, Hans R. *Villard de Honnecourt: Kritische Gesam-*

tausgabe des Bauhüttenbuches ms. fr. 19093 der Pariser Nationalbibliothek. 2nd and rev. ed. Graz, 1972.

Hallam, Elizabeth M. "Philip the Fair and the Cult of Saint Louis." *Studies in Church History* 18 (1982): 201–14.

Hamann-MacLean, Richard. *Die Kathedrale von Reims.* Stuttgart, 1993.

Hamburger, Jeffrey. "A 'Liber Precum' in Selestat and the Development of the Illustrated Prayerbook in Germany." *Art Bulletin* 73 (1991): 209–36.

Handschriftenbeschreibung in Österreich: Referate, Beratungen und Ergebnisse der Arbeitstagungen in Kermsmünster (1973) und Zwettl (1974). Edited by Otto Mazal. Vienna, 1975.

Haney, Kristine Edmondson. "Some Old Testament Pictures in the Psalter of Henry of Blois." *Gesta* 24, no. 1 (1985): 33–45.

———. *The Winchester Psalter: An Iconographic Study.* Leicester, Leicestershire, 1986.

Harrison, Evelyn B. "Apollo's Cloak." *Studies in Classical Art and Archaeology: A Tribute to Peter Heinrich von Blanckenhagen,* ed. Günter Kopcke and Mary B. Moore. Locust Valley, N.Y., 1979.

Harrsen, Meta. *Cursus Sanctae Mariae: A Thirteenth-Century Manuscript, Now M. 739 in the Pierpont Morgan Library.* New York, 1937.

Haseloff, Arthur. "La miniature des XIIIe et XIVe siècles." In *Histoire de l'art,* edited by André Michel, vol. 3, pt. 1, 329–43. Paris, 1906.

———. "Les psautiers de Saint-Louis." *Bulletin et mémoires de la Société nationale des antiquaires de France,* 59 (6th ser., no. 9, mémoires) (1899): 17–42.

Haseloff, Günther. *Die Psalterillustration im 13. Jahrhundert: Studien zur Geschichte der Buchmalerei in England, Frankreich und den Niederlanden.* Kiel, 1938.

Haskins, Charles Homer. *The Renaissance of the Twelfth Century.* Cambridge, 1927.

Hassal, William Owen, ed. *The Holkham Bible Picture Book.* London, 1954.

Hathaway, Neil. "Compilatio: From Plagiarism to Compiling." *Viator* 20 (1989): 19–44.

Haupt, Johannes Gottfried. *Die Farbensymbolik in der sakralen Kunst des abendländischen Mittelalters.* Dresden, 1941.

Haussherr, Reiner. "Beobachtungen an den Illustrationen zum Buche Genesis in der Bible Moralisée." *Kunstchronik* 19 (1966): 313–14.

———, ed. *Bible Moralisée: Codex Vindobonensis 2554 der Österreichischen Nationalbibliothek.* Codices selecti, 40. Graz, 1973.

———. "Christus-Johannes-Gruppen in der Bible Moralisée." *ZKg* 27, no. 2 (1964): 133–52.

———. "Der Ingeborgpsalter: Bemerkungen zu Datierungs-

und Stilfragen." In Avril et al., *The Year 1200*, 231–50.

——. "Ein Pariser martyrologischer Kalender aus der ersten Hälfte des 13. Jahrhunderts." In *Festschrift Matthias Zender: Studien zur Volkssulptur, Sprache und Landesgeschichte*, edited by Edith Ennen and Günter Wiegelmann, 2:1076–103. Bonn, 1972.

——. "Petrus Cantor, Stephen Langton, Hugo von St. Cher und der Isaias-Prolog der Bible Moralisée." In *Verbum et Signum: Festschrift Friedrich Ohly*, edited by Hans Fromm, Wolfgang Harms, and Uwe Ruberg, 2:347–64. Munich, 1975.

——. Review of *Der Ingeborgpsalter*, edited by Florens Deuchler. *ZKg* 32 (1969): 51–58.

——. "Sensus litteralis und sensu spiritualis in der Bible Moralisée." *FSt* 6 (1972): 356–80.

——. "Templum Salomonis und Ecclesia Christi: Zu einem Bildvergleich der Bible Moralisée." *ZKg* 31 (1968): 101–21.

——. "Über die Auswahl des Bibeltextes in der Bible Moralisée." *ZKg* 51 (1988): 126–46.

——. "Eine Warnung vor dem Studium von zivilem und kanonischem Recht in der Bible Moralisée." *FSt* 9 (1975): 390–404.

——. "Zum Psalter cod. S. n. 2611 der Österreichischen Nationalbibliothek." *Wiener Jahrbuch für Kunstgeschichte* 26 (1973): 46–56.

Havet, J. "Comte du Trésor du Louvre (Tousaint, 1296)." *BÉC* 45 (1884).

Hearing the Motet: Essays on the Motet of the Middle Ages and Renaissance. Edited by Dolores Pesce. New York, 1997.

Heck, Christian. *L'échelle céleste dans l'art du Moyen Âge: Une image de la quête du ciel*. Paris, 1997.

Hedeman, Anne Dawson. *The Royal Image: Illustrations of the Grandes Chroniques de France, 1274–1422*. Berkeley and Los Angeles, 1991.

Heffernan, Thomas. *Sacred Biography: Saints and Their Biographers in the Middle Ages*. Oxford, 1988.

Heimann, Adelheid. "Three Illustrations from the Bury St. Edmunds Psalter and Their Prototypes: Notes on the Iconography of Some Anglo-Saxon Drawings." *JWCI* 29 (1966): 39–59.

Heinlein, James Michael. "The Ideology of Reform in the French Moralized Bible." Ph.D. diss., Northwestern University, 1991.

Helsinger, Howard. "Images on the Beatus Page of some Medieval Psalters." *Art Bulletin* 53, no. 2 (1971): 161–76.

Henderson, George. "'Abraham Genuit Isaac': Transitions from the Old Testament to the New Testament in the Prefatory Illustrations of Some Twelfth-Century English Psalters." *Gesta* 26, no. 2 (1987): 127–39.

——. "The Joshua Cycle in the Bible Moralisée." *Journal of the British Archeological Association*, 3rd ser., 31 (1968): 38–59.

——. "Late Antique Influences in Some English Medieval Illustrations of Genesis." *JWCI* 25 (1962): 172–98.

——. "A Programme of Illusrations in Bodleian MS Junius XI." In *Studies in Memory of David Talbot Rice*, edited by Giles Robertson and George Henderson, 113–45. Edinburgh, 1975. Reprinted in Henderson, *Studies*, 138–83.

——. "The Sources of the Genesis Cycle at Saint-Savin-sur-Gartempe." *Journal of the British Archaeological Association* 26 (1963): 11–26. Reprinted in Henderson, *Studies*, 111–37.

——. *Studies in English Bible Illustration*. 2 vols. London, 1985.

Henderson, George, and Frances Crawford Burkitt. "Jewish and Christian Apocalypse." In *Jewish and Christian Apocalypses*, Schweich Lectures of the British Academy, 1913, 17–33. London, 1914.

Hermann, Julius. *Die westeuropäische Handschriften und Inkunabeln der Gotik und der Renaissance: Englische und französische Handschriften des XIII. Jahrhunderts*. Beschreibendes Verzeichnis der illuminierten Handschriften in Österreich, n.s., VII, 1. Leipzig, 1935.

Hermann-Mascard, Nicole. *Les reliques des saintes: Formation coutumière d'un droit*. Paris, 1975.

Herzog, Reinhart. *Die Bibelepik der lateinischen Spätantike*. Theorie und Geschichte der Literatur und der schönen Künste, 37. Munich, 1975.

Hesseling, Dirk Christian, ed. *Miniatures de l'Octateuque grec de Smyrne*. Codices graeci et latini photographice depicti, suppl., 6. Leiden, 1909.

Heuser, Hans-Jorgen. *Oberrheinische Goldschmiedekunst im Hochmittelalter*. Berlin, 1974.

Higgitt, John. *The Murthly Hours: Devotion, Literacy, and Luxury in Paris, England, and the Gaelic West*. British Library Studies in Medieval Culture. London, 2000.

Hills, Paul. *The Light of Early Italian Painting*. New Haven and London, 1987.

——. *Venetian Colour: Marble, Mosaic, Painting, and Glass, 1250–1550*. New Haven, 1999.

Hindman, Sandra L. *Christine de Pizan's "Epistre Othéa": Painting and Politics at the Court of Charles VI*. Pontifical Institute of Mediaeval Studies: Studies and Texts, 77. Toronto, 1986.

——. *Medieval and Renaissance Miniature Painting*. London, 1988.

——. "The Roles of Author and Artist in the Procedure of Illustrating Late Medieval Texts." *Text and Image, Acta*, 10 (1983): 27–62.

Hinkle, William M. "The King and the Pope on the Virgin Portal at Notre Dame." *Art Bulletin* 48 (1966): 1–13.

Hinnebusch, John Frederick. "Extant Manuscripts of the Writings of Jacques de Vitry." *Scriptorium* 51 (1997): 156–64.

Histoire de l'édition française. Edited by Henri Jean Martin et al. Vol. 1. Paris, 1982.

Histoire littéraire de la France. Vol. 18. Paris, 1835 and 1838.

Histoire universelle de la peinture. Vol. 4. Edited by Jean Baudry. Geneva, 1979.

Hoekstra, Gerald. "The French Motet as Trope: Multiple Levels of Meaning in *Quant Florist la Violete / El Mois de Mai / Et Gaudebit.*" *Speculum* 73, no. 1 (1998): 32–57.

Hoffmann, Hartmut. *Buchkunst und Königtum im ottonischen und frühsalischen Reich.* Monumenta Germaniae Historica, Schriften, 30. Vol. 1. Stuttgart, 1986.

Hoffmann, Konrad. "Sugers 'Anagogisches Fenster' in Saint-Denis." *Wallraff-Richartz-Jahrbuch* 30 (1968): 57–88.

Hohenzollern, Johann Georg Prinz von. *Die Königsgalerie der französischen Kathedrale: Herkunft, Bedeutung, Nachfolge.* Munich, 1965.

Holladay, Joan A. "The Education of Jeanne d'Evreux: Personal Piety and Dynastic Salvation in Her Book of Hours at the Cloisters." *Art History* 17, no. 4 (1994): 585–611.

Hollander, Anne. *Seeing Through Clothes.* New York, 1978.

Hollengreen, Laura Holden. "Exemplary Old Testament Narratives on the North Transept Façade of Chartres Cathedral." Ph.D. diss., University of California, Berkeley, 1998.

Holum, Kenneth, and Vikan Gary. "The Trier Ivory, *Adventus* Ceremonial, and the Relics of Saint Stephen." *DOP* 33 (1979): 115–33.

Hopper, Paul J. "Aspect and Foregrounding in Discourse." *Syntax and Semantics* 12 (1979): 213–41.

Horste, Kathryn. "'A Child Is Born': The Iconography of the Portail Ste.-Anne at Paris." *Art Bulletin* 69, no. 2 (1967): 188–210.

——. *Cloister Design and Monastic Reform in Toulouse: The Romanesque Sculpture of La Daurade.* Oxford, 1992.

Huber, Paul. *Bild und Botschaft: Byzantinische Miniaturen zum Alten und Neuen Testament.* Zurich, 1973.

Hubert, Emmanuelle. "Pierre et Eudes de Montreuil, architectes de Saint Louis." *Archéologia* 37 (1970): 32–37.

Hueck, Irene. *Das Programm der Kuppelmosaiken im Florentiner Baptisterium.* Ph.D. diss., Ludwig-Maximilians Universität, Munich, 1962.

Hughes, Andrew. *Medieval Manuscripts for Mass and Office.* Toronto and Buffalo, 1982.

Hughes, Christopher G. "Visual Typology in Early Gothic Art, 1140–1240." Ph.D. diss., University of California, Berkeley, 2000.

Huglo, Michel. "The Dispersal of the Manuscripts of Royaumont in Europe and in North America." *Vincent of Beauvais Newsletter* 25 (2000): 5–12.

Hull, Caroline S. "Rylands MS French 5: The Form and Function of a Medieval Bible Picture Book." *Bulletin of the John Rylands University Library of Manchester* 77, no. 2 (1995): 3–24.

Humphreys, Kenneth William. *The Book Provisions of the Mediaeval Friars, 1215–1400.* Amsterdam, 1964.

Huot, Sylvia. "A Book Made for a Queen: The Shaping of a Late Medieval Anthology Manuscript (B.N. fr. 24429)." In *The Whole Book: Cultural Perspectives on the Medieval Miscellany,* edited by Stephen Nichols and Siegfried Wenzel, 123–43. Ann Arbor, Mich., 1996.

——. "Languages of Love: Vernacular Motets on the Tenor FLOS FILIUS EJUS." In *Conjunctures: Medieval Studies in Honor of Douglas Kelly,* edited by Keith Busby and Norris Lacy, 169–80. Amsterdam, 1994.

——. "Medieval Readers of the *Roman de la Rose:* The Evidence of Marginal Notations." *Romance Philology* 43, no. 3 (1990): 400–420.

——. "Polyphonic Poetry: The Old French Motet and Its Literary Context." *French Forum* 14, no. 3 (1989): 261–78.

——. "The Scribe as Editor: Rubrication as Critical Apparatus in Two Manuscripts of the *Roman de la Rose.*" *L'esprit créateur* 27, no. 1 (1987): 67–78.

——. "Visualization and Memory: The Illustration of Troubadour Lyric in a Thirteenth-Century Manuscript." *Gesta* 31, no. 1 (1992): 3–14.

——. "Voices and Instruments in Medieval French Secular Music: On the Use of Literary Texts as Evidence for Performance Practice." *Musica Disciplina* 43 (1989): 63–113.

——. Review of Tibaut, *Le roman de la poire,* edited by Christiane Marchello-Nizia. *Speculum* 64 (1989): 223–24.

Huschen, Heinrich. "Albertus Magnus und seine Musikanschauung." In *Speculum Musicae Artis: Festgabe für Heinrich Husmann zum 60. Geburtstag am 16. Dezember 1968,* edited by Heinz Becker and Reinhard Gerlach, 205–18. Munich, 1970.

Images in Ivory: Precious Objects of the Gothic Age. Exh. cat. Detroit Institute of Art. Detroit, 1997.

Imaging the Early Medieval Bible. Edited by John Williams. University Park, Pa., 1999.

Istoriia rodov russkogo dvorianstva. Vol. 1. Moscow, 1860.

Jackson, Peter. "The Crusades of 1239–41 and Their Aftermath." *Bulletin of the School of Oriental and African Studies* 50 (1987): 32–60.

Jackson, Richard A. "Manuscripts, Texts, and Enigmas of Medieval French Coronation Ordines." *Viator* 23 (1992): 35–72.

——, ed. *Ordines Coronationis Franciae: Texts and Ordines for the Coronation of Frankish and French Kings and Queens in the Middle Ages.* 2 vols. Philadelphia, 1995–2000.

——. "Les *ordines* des coronation royaux au Moyen Âge." In *Le sacre des rois: Actes du colloque international d'histoire sur les sacres et couronnements royaux (Reims, 1975)*, 63–74. Paris, 1985.

Jacoby, David. "The Kingdom of Jerusalem and the Collapse of Hohenstaufen Power in the Levant." *DOP* 40 (1986): 83–101.

Jacquart, Danielle, and Claude Thomasset. *Sexuality and Medicine in the Middle Ages.* Translated by Mathew Adamson. Princeton, 1988.

Jaeger, C. Stephen. *The Origins of Courtliness: Civilizing Trends and the Formation of Courtly Ideals, 939–1210.* Philadelphia, 1985.

James, Montague Rhodes, ed. *The Apocalypse in Latin and French (Bodleian MS Douce 180)*. Roxburghe Club Publications, 33. Oxford, 1922.

——, ed. *The Bohun Manuscripts.* Roxburghe Club Publications, 200. Oxford, 1936.

——. *A Descriptive Catalogue of the Latin Manuscripts in the John Rylands University Library.* Manchester and London, 1921. Reprint, with an introduction and notes by Frank Taylor, Manchester, 1980.

——. *A Descriptive Catalogue of the Manuscripts in the Library of Pembroke College, Cambridge.* Cambridge, 1905.

Jayr, Arnaud. "Saint Louis, le croise et le roi." In *La croix et le croissant: Actes de la IVe Université d'été de Renaissance catholique, Quarré les Tombes, août 1995*, 133–62. Issy-les-Moulineaux, 1996.

"Jean Cholet." *Mémoires de la société académique d'archéologie, science et arts* 11 (1882): 790–855.

Jeremias, Gisela. *Die Holztür der Basilika S. Sabina in Rom.* Tübingen, 1980.

Johanek, Peter. "König Arthur und die Plantagenets: Über den Zusammenhang von Historiographie und höfischer Epik in mittelalterlicher Propaganda." *FSt* 21 (1987): 346–89.

Johnson, Phyllis, and Brigitte Cazelles. *Le vain siècle guerpir: A Literary Approach to Sainthood Through Old French Hagiography of the Twelfth Century.* Chapel Hill, N.C., 1979.

Jones, C. Meredith. "The Conventional Saracens in the Songs of Geste." *Speculum* 17 (1942): 201.

Jongkees, A. G. "Translatio Studii: Les avatars d'un thème médiéval." In *Miscellanea mediaevalia in memoriam Jan Frederick Niermeyer*, 41–51. Groningen, 1967.

Jordan, Alyce A. "Narrative Design in the Stained Glass Windows of the Ste.-Chapelle in Paris." 2 vols. Ph.D. diss., Bryn Mawr College, 1994.

——. *Visualizing Kingship in the Windows of the Sainte-Chapelle.* Publications of the International Center of Medieval Art, 5. Turnhout, 2002.

Jordan, William Chester. "'Amen!' Cinq fois 'Amen!': Les chansons de la croisade égyptienne de Saint Louis, une source négligée d'opinion royaliste." *Médiévales* 34 (spring 1998): 79–91.

——. "The Case of Saint Louis." *Viator* 19 (1980): 209–17.

——. "Cloth of Many Colors, the Franciscans, and the Benedictine Abbey of Saint-Denis: A Problem in Joinville's *Histoire de Saint Louis.*" *American Benedictine Review* 31, no. 4 (1980): 443–46.

——. "Cutting the Budget: The Impact of the Crusades on Appropriations for Public Works in France." *Revue belge de philologie et d'histoire* 76 (1998): 307–18.

——. *Ideology and Royal Power in Medieval France: Kingship, Crusades, and the Jews.* Burlington, Vt., 2001.

——. *Louis IX and the Challenge of the Crusade: A Study in Rulership.* Princeton, 1979.

——. "The Psalter of Saint-Louis (B.N. MS. Lat. 10525): The Program of the Seventy-Eight Full-Page Illustrations." *High Middle Ages, Acta* 7 (1988): 65–91.

——. "*Quando fuit natus:* Interpreting the Birth of Philip Augustus." In *The Work of Jacques Le Goff and the Challenges of Medieval History*, edited by Miri Rubin, 171–87. Woodbridge, Suffolk, and Rochester, N.Y., 1997.

——. "Saint Louis in French Epic and Drama." In *Medievalism in Europe II*, edited by Leslie J. Workman and Kathleen Verduin, Studies in Medievalism, 8:174–94. Holland, Mich., 1996.

Josipovici, Gabriel. *The Book of God: A Response to the Bible.* New Haven, 1988.

Joubert, Fabienne. *Le jubé de Bourges.* Esposition-dossier du département des sculptures, 44. Paris, 1994.

——. "Les retables du milieu du XIIIe siècle à l'abbatiale de Saint-Denis." *Bulletin monumental* 131, no. 1 (1973): 17–27.

Justice, Steven. "The Authority of Ritual in the *Jeu d'Adam.*" *Speculum* 62, no. 4 (1987): 851–64.

Kahsnitz, Rainer. "Der christologische Zyklus im Odbert-Psalter." *ZKg* 51 (1988): 33–125.

——. "Staufische Kameen." In *Die Zeit der Staufer*, vol. 5, *Supplement: Vorträge und Forschungen*, edited by Reiner Haussherr and Christian Väterlein, 477–520.

——. *Der Werdener Psalter in Berlin MS. theol. lat. fol. 358: Eine Untersuchung zu Problemen mittelalterlicher Psalterillustration.* Düsseldorf, 1979.

Kantorowicz, Ernst H. *The King's Two Bodies: A Study in Medieval Political Theology.* Princeton, 1957.

——. *Laudes Regiae: A Study in Liturgical Acclamations and*

Medieval Ruler Worship. University of California Publications in History, 33. Berkeley and Los Angeles, 1946.

Kaplan, E. Ann. "Is the Gaze Male?" In *Powers of Desire: The Politics of Sexuality,* edited by Ann Snitow, Christine Stansell, and Sharon Thompson, 309–27. New York, 1983.

Kartschoke, Dieter. *Bibeldichtung: Studien zur Geschichte der epischen Bibelparaphrase von Juvencus bis Otfrid von Weissenburg.* Munich, 1975.

Katz, David. *The World of Colour.* London, 1935.

Katzenellenbogen, Adolf. *Allegories of the Virtues and Vices in Mediaeval Art from Early Christian Times to the Thirteenth Century.* London, 1939. Reprint, New York, 1964.

——. *The Sculptural Programs of Chartres Cathedral.* Baltimore, 1959.

Kauffmann, Claus Michael. "Art and Popular Culture: New Themes in the Holkham Bible Picture Book." In *Studies in Medieval Art and Architecture Presented to Peter Lasko,* edited by David Buckton and T. A. Heslop, 46–69. London, 1994.

——. *Romanesque Manuscripts, 1066–1190.* A Survey of Manuscripts Illuminated in the British Isles, 3. London, 1975.

Kauffmann, Martin. "The Image of St. Louis." In *Kings and Kingship in Medieval Europe,* edited by Anna Duggan, 265–86. London, 1993.

Kedar, Benjamin. *Crusade and Mission: European Approaches Toward the Muslims.* Princeton, 1984.

Keller, Hans-Erich. "La structure du *Roman de la Poire.*" In *Conjunctures: Medieval Studies in Honor of Douglas Kelly,* edited by Keith Busby and Norris Lacy, 205–17. Amsterdam, 1994.

Kelly, Douglas. "Theory of Composition in Medieval Narrative Poetry and Geoffrey of Vinsant's *Poetria Nova.*" *Mediaeval Studies* 31 (1969): 117–48.

Kemp, Martin. *The Science of Art: Optical Themes in Western Art from Brunelleschi to Seurat.* New Haven, 1990.

Kemp, Wolfgang. *The Narratives of Gothic Stained Glass.* Translated by Caroline Dobson Saltzwedel. Cambridge, 1997.

——. *Sermo Corporeus: Die Erzählung der mittelalterlichen Glasfenster.* Munich, 1987.

Kennedy, Elspeth. "Social and Political Ideas in the French Prose *Lancelot.*" *Medium Aevum* 26 (1957): 90–106.

Kermode, Frank. "The Plain Sense of Things." In *Midrash and Literature,* edited by Geoffrey H. Hartman and Sanford Budick, 179–94. New Haven and London, 1986.

Kessler, Herbert L. "An Apostle in Armor and the Mission of Carolingian Art." *Arte medievale,* 2nd ser., 4, no. 1 (1990): 17–39.

——. "'Caput et Speculum Omnium Ecclesiarum': Old St. Peter's and Church Decoration in Medieval Latium." In *Italian Church Decoration of the Middle Ages and Early Renaissance: Functions, Forms, and Regional Traditions,* edited by William Tronzo, 119–46. Bologna, 1989.

——. "Diction in the 'Bibles of the Illiterate.'" In *World Art: Themes of Unity in Diversity: Acts of the XXVIth International Congress of the History of Art,* edited by Irving Lavin, 2:297–304. University Park, Pa., and London, 1989.

——. *The Illustrated Bibles from Tours.* Studies in Manuscript Illumination, 7. Princeton, 1977.

——. "Pictorial Narrative and Church Mission in Sixth-Century Gaul." In *Pictorial Narrative in Antiquity and the Middle Ages,* edited by Herbert L. Kessler and Marianna Shreve Simpson, Studies in the History of Art, 16: Symposium Series, 4:75–91. Washington, D.C., 1986.

——. *Spiritual Seeing: Picturing God's Invisibility in Medieval Art.* Philadelphia, 2000.

——. "Through the Temple Veil: The Holy Image in Judaism and Christianity." *Kairos,* n.s., 32/33 (1990/91): 53–71.

Kessler, Herbert L., and Paul Edward Dutton. *The Poetry and Paintings of the First Bible of Charles the Bald.* Ann Arbor, Mich., 1997.

Kidson, Peter. *Sculpture at Chartres.* London, 1958.

Kimpel, Dieter. "Le développement de la taille en série dans l'architecture médiévale et son rôle dans l'histoire économique." *Bulletin monumental* 135 (1977): 195–222.

——. "Ökonomie, Technik und Form in der hochgotischen Architektur." In *Bauwerk und Bildwerk im Hochmittelalter,* edited by Karl Clausberg et al., 103–25. Giessen, 1981.

——. *Die Querhausarme von Notre-Dame zu Paris und ihre Skulpturen.* Ph.D. diss., University of Bonn, 1971.

Kimpel, Dieter, and Robert Suckale. *Die gotische Architektur in Frankreich 1130–1270.* Munich, 1985.

King, D. "A Chasuble of the Later Middle Ages." *CIETA Bulletin,* no. 27 (1968).

Kirn, Paul. "Saul in der Staatslehre." In *Staat und Persönlichkeit: Erich Brandenburg zum 60. Geburtstag,* 28–47. Leipzig, 1928.

Klapisch-Zuber, Christiane. "La genèse de l'arbre généalogique." In *L'arbre: Histoire naturelle et symbolique de l'arbre, du bois et du fruit au Moyen Âge,* Cahiers du Léopard d'Or, 2:41–81. Paris, 1993.

Klein, Peter K. Commentary volume to the facsimile *Apokalypse, MS. Douce 180.* Codices selecti, 72. Graz, 1983. Reprinted separately as *Endzeiterwartung und Ritterideologie: Die englischen Bilderapokalypsen der Frühgotik und MS Douce 180.* Graz, 1983.

Klemm, Elisabeth. *Ein romanischer Miniaturzyklus aus dem Maasgebiet.* Wiener kunstgeschichtliche Forschungen, 2. Vienna, 1973.

Klesse, Brigitte. *Seidenstoffe in der italienischen Malerei des 14. Jahrhunderts.* Bern, 1967.

Koch, Guntram. *Die mythologischen Sarkophage.* Die antiken Sarkophagreliefs, 12. Vol. 6, *Meleager.* Edited by F. Matz and B. Andraea. Berlin, 1975.

Kohler, Charles Alfred. *Catalogue des manuscrits de la Bibliothèque Sainte-Geneviève.* Vol. 1. Paris, 1893.

Köhler, Wilhelm, and Florentine Mütherich. *Die karolingischen Miniaturen.* Vol. 5, *Die Hofschule Karls des Kahlen.* Berlin, 1982.

Kosmer, Ellen. "Master Honoré: A Reconsideration of the Documents." *Gesta* 14, no. 1 (1975): 63–68.

Das kostbare Evangeliar des heiligen Bernward. Exh. cat. Edited by Michael Brandt. Munich, 1993.

Kottje, Raymond. "Karl der Große und der Alte Bund." *Trierer theologische Zeitschrift* 76 (1967): 15–31.

——. *Studien zum Einfluß des Alten Testamentes auf Recht und Liturgie des frühen Mittelalters (6.–8. Jahrhunderts).* Bonner historische Forschungen, 23. Bonn, 1964.

Kouwer, Benjamin. *Colors and Their Character: A Psychological Study.* Translated by H. C. Bos-van Kasteel. The Hague, 1949.

Krautheimer, Richard. Review of *Space in Medieval Painting and the Forerunners of Perspective,* by Miriam Schild Bunim. *Art Bulletin* 23, no. 2 (1941): 178–80.

Krieger, Michaela. *Gotische Bilderbibel, Paris 13. Jahrhundert: Faksimile der Handschrift Cod. Ser. N. 2611, fol. 1–22 der Österreichischen Nationalbibliothek, Wien.* Suttgart, 1988.

——. *Grisaille als Metapher: Zum Entstehen der Peinture en Camaieu im frühen 14. Jahrhundert.* Vienna, 1995.

——. "Die niederländische Grisaillemalerei des 15. Jahrhunderts: Bemerkungen zu neuerer Literatur." *Kunstchronik* 49 (1996): 575–88.

Kroos, Renate. "Grabbräuche—Grabbilder." In *Memoria: Der geschichtliche Zeugniswert des liturgischen Gedenkens im Mittelalter,* edited by Karl Schmid and Joachim Wollasch, 285–353. Munich, 1984.

Krüger, Karl Heinrich. *Die Universalchroniken.* Typologie des sources du Moyen Âge occidental, 16. Turnhout, 1976.

Kruger, Steven F. *Dreaming in the Middle Ages.* Cambridge Studies in Medieval Literature, 14. Cambridge, 1992.

Kruse, Christiane, and Felix Thürlemann, eds. *Porträt, Landschaft, Interieur: Jan van Eycks Rolin-Madonna im ästhetischen Kontext.* Tübingen, 1999.

Krynen, Jacques. *L'empire du roi: Idées et croyances politiques en France XIIIe–XVe siècle.* Paris, 1993.

Kubler, George. "Toward a Reductive Theory of Visual Style." In *Ars auro prior: Studia Ioanni Białostocki sexagenario dicata,* 21–26. Warsaw, 1981.

Kuczynski, Michael. *Prophetic Song: The Psalms as Moral Discourse in Late Medieval England.* Philadelphia, 1995.

Kunoth-Leifels, Elisabeth. "Bathseba." In *LCI,* vol. 1, cols. 253–57.

——. *Über die Darstellung der "Bathsheba im Bade": Studien zur Geschichte des Bildthemas 4. bis 17. Jahrhundert.* Essen, 1962.

Künstlerischer Austausch/Artistic Exchange: Akten des XXVIII. Internationalen Kongresses für Kunstgeschichte, Berlin, 15.–20. Juli 1992. Edited by Thomas W. Gaehtgens. 3 vols. Berlin, 1993.

Kuntz, Marion Leathers, and Paul Grimley Kuntz, eds. *Jacob's Ladder and the Tree of Life: Concepts of Hierarchy and the Great Chain of Being.* New York, 1987.

Kurmann, Peter. "Cathédrale miniature ou reliquaire monumental? L'architecture de la châsse de Sainte Gertrude." In *Un trésor gothique,* 135–53.

——. "Un colosse aux pieds d'argile: La chronologie de la sculpture française du XIIIe siècle repose-t-elle sur des dates assurées?" In *Épigraphie et iconographie: Actes du colloque tenu à Poitiers les 5–8 octobre 1995,* edited by Robert Favreau, Civilisation médiévale, 2:143–52. Poitiers, 1996.

——. *La façade de la Cathédrale de Reims.* 2 vols. Paris and Lausanne, 1987.

——. "Mobilité des artistes ou mobilité des modelés? À propos de l'atelier des sculpteurs Rémois au XIII siècle." *Revue de l'art,* no. 120 (1998): 23–34.

Kurmann-Schwarz, Brigitte. "La châsse de Sainte Gertrude et l'art de la court en France au XIIIe siècle: État de la question et problèmes." In *Un trésor gothique,* 237–49.

Kurz, O. "Ein insulares Musterbuchblatt und die byzantinische Psalterillustration." *Byzantinisch-neugriechische Jahrbuch* 4 (1937–38): 84–93.

Labande, E. R. "Quelques traits de caractère du roi Saint Louis." *Revue d'histoire de la spiritualité* 1 (1974): 135–46.

——. "Saint Louis pèlerin." *Revue d'histoire de l'Église de France* 57, no. 158 (1971): 5–18.

Labarte, Jules. *Histoire des arts industriel au Moyen Âge et à l'époque de la Renaissance.* Vol. 3. Paris, 1865.

——, ed. *Inventaire du mobilier de Charles V, roi de France.* Collection de documents inédits sur l'histoire de France, 3rd ser., Archéologie. Paris, 1879.

La Bigne, Marguerin de. *Maxima bibliotheca veterum patrum.* Vol. 25. Lyons, 1677.

Laborde, Alexandre de, ed. *La Bible moralisée illustrée conservée à Oxford, Paris et Londres.* 5 Vols. Paris, 1911–27.

Lacombe, George. *Aristoteles Latinus: Codices.* Vol. 1. Rome, 1939.

Laffitte, Marie-Pierre, and Ursula Baurmeister. *Des livres et des rois.* Paris, 1992.

Laffitte, Marie-Pierre, Odile Valansot, Dominique de Reyer, and Witold Novik. "Trois reliures médiévales à éléments de tissu." *Bulletin du Centre international d'études des textiles anciens,* no. 74 (1997): 50–63.

Lafond, Jean. "Notre Dame de Paris." In *Les vitraux de Notre-Dame et de la Sainte-Chapelle de Paris,* by Marcel Aubert, Louis Grodecki, and Jean Lafond, Corpus Vitrearum Medii Aevi, France, 1:52–56. Paris, 1957.

Lagarde, George. *La naissance de l'esprit laïque en déclin du Moyen Âge.* Paris, 1956.

Laiou, Angeliki E. *Gender, Society, and Economic Life in Byzantium.* Aldershot, Hampshire, and Brookfield, Vt., 1992.

Lammers, Walther. "Ein karolingisches Bildprogramm in der Aula Regia von Ingelheim." In *Festschrift für Hermann Heimpel,* Veröffentlichungen des Max-Planck-Instituts für Geschichte, 36, 3:226–89. Göttingen, 1972.

Lancaster, R. Kent. "Artists, Suppliers, and Clerks: The Human Factor in the Patronage of King Henry III." *JWCI* 35 (1972): 81–107.

Langlois, Charles Victor. *Le règne de Philippe III le Hardi.* Paris, 1887.

Langmuir, Gavin I. "'Judei Nostri' and the Beginning of Capetian Legislation." *Traditio* 16 (1960): 203–39.

——. "*Tanquam Servi:* The Change in Jewish Status in French Law About 1200." In *Les Juifs dans l'histoire de France,* edited by Myriam Yardeni, 24–54. Leiden, 1980.

Larmat, Jean. "Les bains dans la littérature française du Moyen Âge." In *Les soins de beauté: Moyen Âge—début des temps moderne: Actes du IIIe colloque internationale, Grasse (26–28 avril 1985),* 195–210. Nice, 1987.

Lasalle, M. "Les fenêtres des chapelles de la nef de Notre-Dame de Paris." *Information d'histoire de l'art* 17 (1972): 28–32.

Lassus, Jean. *L'illustration byzantine du Livre des Rois, Vaticanus Graecus 333.* Bibliothèque des cahiers archéologiques, 9. Paris, 1973

Lautier, Claudine, and Maryse Bideault. "Saint-Nicaise de Reims: Chronique et nouvelles remarques sur l'architecture." *Bulletin monumental* 135, no. 4 (1977): 295–330.

Lazarev, Viktor. *Storia della pittura bizantina.* Biblioteca di storia dell'arte, 7. Turin, 1967.

Leaf, William. "Saracen and Crusader Heraldry in Joinville's History of Saint Louis." *Journal of the Royal Asiatic Society of Great Britain and Ireland* 2 (1983): 208–14.

Leber, Constant. *Collection des meilleurs dissertations: Notices et traites particuliers relatifs à l'histoire de France.* Vol. 2. Collection de pièces relatives a l'histoire de France, 19. Paris, 1838.

Lebeuf, Jean. *Histoire de la ville et de tout le diocèse de Paris.* 5 vols. Paris, 1883.

Lecoy de la Marche, Albert. *La chaire française au Moyen Âge, spécialement au XIIIe siècle.* 2nd ed. Paris, 1886.

——. *Les manuscrits et la miniature.* Paris, 1884.

——. "Saint Louis, sa famille et sa cour d'après les anecdotes contemporaines." *Revue des questions historiques* 22 (1877): 465–84.

Lefébure, Amélie. "Chronique: Iconographie de Saint-Louis." *Bulletin monumental* 128, no. 2 (1970): 156–57.

Le Goff, Jacques. "A Coronation Program for the Age of Saint Louis: The Ordo of 1250." In *Coronations: Medieval and Early Modern Monarchic Ritual,* edited by Janos M. Bak, 46–57. Berkeley, Los Angeles, and Oxford, 1990.

——. "Les gestes de Saint Louis: Approches d'un modèle et d'une personnalité." In *Clio et son regard: Mélanges d'histoire, d'histoire de l'art et d'archéologie offerts à Jacques Stiennon,* edited by Rita Lejeune and Joseph Deckers, 445–59. Liège, 1982.

——. "Une métaphore urbaine de Guillaume d'Auvergne." In *L'imaginaire médiévale,* 242–47. Paris, 1985.

——. "Philippe Auguste dans les 'exempla.'" In *La France de Philippe Auguste: Le temps des mutations: Actes du colloque international organisé par le C.N.R.S.,* edited by Robert-Henri Bautier, Colloques internationaux du Centre national de la recherche scientifique, no. 602:145–55. Paris, 1982.

——. "Portrait du roi idéal." *L'histoire* 81 (September 1985): 73–76.

——. "Royauté biblique et idéal monarchique médiéval: Saint Louis et Josias." In *Les Juifs au regard de l'histoire: Mélanges en l'honneur de Bernhard Blumenkranz,* edited by Gilbert Dahan, 157–62. Paris, 1985.

——. "Saint de l'Église et saint du peuple: Les miracles officiels de Saint Louis entre sa mort et sa canonisation (1270–1297)." In *Histoire sociale, sensibilités collectives et mentalites,* 172–79. Paris, 1985.

——. *Saint Louis.* Paris, 1996.

——. "Saint Louis and the Mediterranean." *Mediterranean Historical Review* 5, no. 1 (1990): 21–43.

——. "Saint Louis et le parole royale." In *Le prince et son historien,* 7–21.

——. "Saint Louis et la pratique sacramentelle." *La Maison-Dieu: Revue trimestrielle du Centre nationale de la pastorale liturgique* 197 (1994): 99–124.

——. "The Whys and Ways of Writing a Biography: The Case of Saint Louis." *Exemplaria* 1.1 (1989): 207–25.

Le Goff, Jacques, Eric Palazzo, Jean-Claude Bonne, and Marie-Noël Colette. *Le sacre royal à l'époque de Saint*

Louis: D'après le manuscrit latin 1246 de la B.N.F. Paris, 2001.

Le Nain de Tillemont, Louis Sebastien. *Vie de Saint Louis, roi de France.* 6 vols. Edited by Julien Philippe de Gaulle. Paris, 1847–51.

Leniaud, Jean-Michel, and Françoise Perrot. *La Sainte Chapelle.* Paris, 1991.

Leroquais, Victor. *Les psautiers: Manuscrits latins des bibliothèques publiques de France.* 3 vols. Mâcon, 1940–41.

———. *Les sacramentaires et les missel manuscrits des bibliothèques publiques de France.* 3 vols. Paris, 1924.

Le Roux de Lincy, Antoine-Jean-Victor. "Comptes des dépenses faites par Charles V dans le Château du Louvre, des années 1364 à 1368." *Revue archéologique* 8, no. 2 (1852): 670–91, 760–72.

Leroy, Jules. *Les manuscrits syriaques à peintures conservés dans les bibliothèques d'Europe et d'Orient.* Institut français d'archéologie de Beyrouth: Bibliothèque archéologique et historique, 77. Paris, 1964.

Lesne, Émile. *Histoire de la propriété ecclésiastique en France.* Vol. 4, *Les livres: "Scriptoria" et bibliothèques du commencement du VIIIe siècle à la fin du XIe siècle.* Lille, 1938.

Levin, Inabelle. *The Quedlinburg Itala: The Oldest Illustrated Biblical Manuscript.* Leiden, 1985.

Lewis, Andrew W. *Royal Succession in Capetian France: Studies on Familial Order and the State.* Cambridge and London, 1981.

Lewis, Suzanne. *The Art of Matthew Paris in the Chronica Majora.* Berkeley and Los Angeles, 1987.

———. *Reading Images: Narrative Discourse and Reception in the Thirteenth-Century Illuminated Apocalypse.* Cambridge, 1995.

Leyser, Karl. *Rule and Conflict in Early Medieval Society: Ottonian Saxony.* London, 1979.

L'Hermite-LeClerq, Paulette. "L'image de la femme dans le *De eruditione filiorum nobelium* de Vincent de Beauvais." In *Mariage et sexualité au Moyen Âge: Accord ou crise?* edited by Michel Rouche, Cultures et civilisations médiévales, 21:243–61. Paris, 2000.

La libraire de Charles V. Exh. cat. Paris, 1968.

Liebman, Charles J. *The Old French Psalter Commentary: Contribution to a Critical Study of the Text Attributed to Simon of Tournai.* W. F. Humphry Press, 1982.

Light, Laura. "The New Thirteenth-Century Bible and the Challenge of Heresy." *Viator* 18 (1987): 275–88.

———. "Versions et révisions du texte biblique." In *Le Moyen Âge et la Bible,* 75–93.

Lillich, Meredith Parsons. *The Armor of Light: Stained Glass in Western France, 1250–1325.* California Studies in the History of Art, 23. Berkeley and Los Angeles, 1994.

———. "Early Heraldry: How to Crack the Code." *Gesta* 30, no. 1 (1991).

———. "An Early Image of Saint Louis." *Gazette des beaux-arts* 75 (1970): 251–56.

———. *Rainbow like an Emerald: Stained Glass in Lorraine in the Thirteenth and Early Fourteenth Centuries.* College Art Association, Monographs on the Fine Arts, 47. University Park, Pa., 1991.

Lindbaum, David C. *The Beginnings of Western Science.* Chicago, 1992.

Lindberg, David C. *Theories of Vision from al-Kindi to Kepler.* Chicago, 1976.

Lipton, Sara. *Images of Intolerance: The Representation of Jews and Judaism in the Bible Moralisée.* Berkeley and Los Angeles, 1999.

———. "Jews, Heretics, and the Sign of the Cat in the Bible Moralisée." *Word and Image* 8, no. 4 (1992): 362–77.

———. "Jews in the Commentary Text and Illustrations of the Early Thirteenth-Century Bibles Moralisées." Ph.D. diss., Yale University, 1991.

La littérature historiographique des origines à 1500. Grundriß der romanischen Literaturen des Mittelalters, 11. Heidelberg, 1987.

Little, Charles T. "Ivoires et art gothique." *Revue de l'art,* no. 46 (1979): 58–67.

Little, Lester. "Frater Ludovicus: A Study of Saint Louis' Involvement in Evangelical Christianity." Ph.D. diss., Princeton University, 1962.

———. "Saint Louis' Involvement with the Friars." *Church History* 33 (1964): 125–48.

Liversidge, Michael, and Paul Binski. "Two Ceiling Paintings from Westminster Palace." *Burlington Magazine* 137, no. 1109 (1995): 491–501.

Lobanov-Rostovskii, Aleksei Borisovich. *Russkaia rodoslovnaia kniga.* 2nd ed. Vol. 1. St. Petersburg, 1895.

Lobrichon, Guy. "Les éditions de la Bible latine dans les universités du XIIIe siècle." In *La Bibbia del XIII secolo: Storia del testo, storia dell'esegesi: Convegno della Società internazionale per lo studio del Medioevo latino (SISMEL), Firenze, 1–2 giugno 2001,* edited by Giuseppe Cremascoli and Francesco Santi. Florence, 2004.

Lombard-Jourdan, Anne. *Fleur de lis et oriflamme: Signes célestes du royaume de France.* Paris, 1991.

London, Hugh Stanford. "Glover's and Walford's Roll." In *Aspilogia, Being Materials of Heraldry,* vol. 2. Oxford, 1967.

Longnon, Jean. "Les vues de Charles d'Anjou pour la deuxième croisade de Saint Louis: Tunis ou Constantinople?" In *Septième centenaire de la mort de Saint Louis,* 183–95.

Lowden, John. *Illuminated Prophet Books: A Study of Byzantine Manuscripts of the Major and Minor Prophets.* University Park, Pa., 1988.

———. *The Making of the "Bibles Moralisées."* 2 vols. University Park, Pa., 2000.

———. *The Octateuchs: A Study in Byzantine Manuscript Illumination.* University Park, Pa., 1992.

———. "The Production of the Vatopedi Octateuch." *DOP* 36 (1982): 115–26.

Lower, Michael. *Papal Authority and the Barons' Crusade of 1239.* Ph.D. diss., Cambridge University, 1999.

Lozinski, G. "Recherches sur les sources du Credo de Joinville." *Neuphilologische Mitteilungen* 31 (1930): 170–231.

Lubac, Henri de. *Exégèse médiévale: Les quatre sens de l'écriture.* Paris, 1959–64.

Luchaire, Achille. *Philippe Auguste et son temps (1137–1226).* 1902. Reprint, Paris, 1982.

Luscombe, David Edward. "Peter Comestor." In *The Bible in the Medieval World: Essays in Memory of Beryl Smalley,* edited by Katherine Walsh and Diana Wood, 109–29. Oxford, 1985.

Lusignan, Serge. *Parler vulgairement: Les intellectuels et la langue française aux XIIIe et XIVe siècles.* Paris and Montreal, 1986.

———. "L'Université de Paris comme composante de l'identité du royaume de France: Étude sur le thème de *translatio studii.*" In *Identité régionale et conscience nationale en France et en Allemagne du Moyen Âge a l'époque moderne,* edited by Rainer Babel and Jean-Marie Moeglin, Beihefte zu Francia, 39:59–72. Sigmaringen, 1997.

Lynn, Jo. "Appendix: Preliminary Technical Report on the Westminster Panels." *Burlington Magazine* 137, no. 1109 (1995).

Maekawa, Kumiko. *Narrative and Experience: Innovations in Thirteenth-Century Picture Books.* Frankfurt am Main, 2000.

Maichel, Daniel. *Introductio ad historiam literariam de præcipuis bibliothecis parisiensibus, locupletata annotationibus atque methodo, qua rectus bibliothecarum usus & vera studiorum ratio ostenditur.* Leipzig, 1721.

Maier, Christoph Thomas. "Crisis, Liturgy, and the Crusade in the Twelfth and Thirteenth Centuries." *Journal of Ecclesiastical History* 48 (1997): 628–57.

———. *Crusade, Propaganda, and Ideology: Model Sermons for the Preaching of the Cross.* Cambridge, 2000.

———. *The Friars and the Preaching of the Cross in the Thirteenth Century.* Ph.D. diss., University of London, 1990.

———. *Preaching the Crusades: Mendicant Friars and the Cross in the Thirteenth Century.* Cambridge, 1994.

Makedonskaia, Elena. "Ob odnoi biblioteke v dome na Volkhonke." In *Al'manakh bibliofilia,* 82–92. Moscow, 1979.

Malet, Christian. "L'oeuvre hospitalière de Saint Louis et ses fondations en faveur des lépreux." In *Saint Louis pèlerin et le pèlerinage de Rocamadour au XIIIe siècle: 1er colloque de Rocamadour, 1er–3 mai 1970,* 67–95. Boissor, 1973.

Malo-Renault, Jean. "Un 'chansonnier' manuscrit de l'école de Jean Pucelle a Montpellier." *Les trésors des bibliothèques de France* 4 (1933): 145–56.

Manhes-Deremble, Colette. *Les vitraux narratifs de la cathédrale de Chartres: Étude iconographique.* Corpus Vitrearum Medii Aevi, France, Séries Études, 2. Paris, 1993.

Manieri-Ricci, Camillo. *Saggi di codice diplomatico.* Suppl. 2. Naples, 1883.

The Man of Many Devices, Who Wandered Full Many Ways—: Festschrift in Honour of János M. Bak. Edited by Balázs Nagy and Marcell Sebök. Budapest and Plymouth, 1999.

Mansel, Philip. *Louis XVIII.* London, 1981.

Marin, Louis. *Portrait of the King.* Translated by Martha Houle. Minneapolis, 1988.

Markowsky, Barbara. *Europäische Seidengewebe des 13.–18. Jahrhunderts.* Cologne, 1976.

Marrow, James H. *The Golden Age of Dutch Manuscript Painting.* New York, 1990.

———. "Symbol and Meaning in Northern European Art of the Late Middle Ages and Early Renaissance." *Simiolus: Netherlands Quarterly for the History of Art* 16 (1986): 150–69.

Marsch, Edgar. *Biblische Prophetie und chronographische Dichtung: Stoff- und Wirkungsgeschichte der Vision des Propheten Daniel nach Dan. VII.* Berlin, 1972.

Marti, Kevin. "Traditional Characteristics of the Resurrected Body in *Pearl.*" *Viator* 24 (1993): 311–36.

Martin, Henry Marie Radegonde. *Catalogue des manuscrits de la Bibliothèque de l'Arsenal.* Vol. 2. Paris, 1886.

———. "Les esquisses des miniatures." *Revue archéologique* 2 (1904): 17–45.

———. *Les joyaux de l'enluminure à la Bibliothèque nationale.* Paris and Brussels, 1928.

———. *La miniature française du XIIIe au XVe siècle.* Paris and Brussels, 1923.

———. *Les peintures de manuscrits et la miniature en France: Étude critique.* Paris, 1909.

———. *Psautier de Saint Louis et de Blanche de Castille.* Vol. 1 of *Les joyaux de l'Arsenal.* Paris, 1909.

Martindale, Andrew. *The Rise of the Artist in the Middle Ages and Early Renaissance.* London, 1972.

Mathews, Thomas F., and Avedis K. Sanjian. *Armenian Gospel Iconography. The Tradition of the Glajor Gospel.* Dumbarton Oaks Studies, 29. Washington, D.C., 1991.

Mathiassen, Finn. *The Style of the Early Motet (c. 1200–1250): An Investigation of the Old Corpus of the Montpellier Manuscript.* Copenhagen, 1966.

McCannon, Afrodesia Egyptia. "Reading Subversion in the Vie de Saint Louis." Ph.D. diss., University of California, Berkeley, 1998.

McCarthy, Joseph. *Humanistic Emphasis in the Educational Thought of Vincent of Beauvais.* Leiden, 1976.

McCormick, Michael. *Eternal Victory: Triumphal Rulership in Late Antiquity, Byzantium, and the Early Medieval West.* Cambridge, 1986.

McGovern, John. "The Rise of New Economic Attitudes—Economic Humanism, Economic Nationalism—During the Later Middle Ages and the Renaissance, A.D. 1200–1550." *Viator* 1 (1970): 217–53.

McGrath, Robert Leon. "The Romances of the Maccabees in Medieval Art and Literature." Ph.D. diss., Princeton University, 1963.

McGuire, Henry. "The Depiction of Sorrow in Middle Byzantine Art." *DOP* 31 (1977): 123–74.

McKitterick, Rosamond. "Perceptions of Justice in Western Europe in the Ninth and Tenth Centuries." In *La giustizia nell'alto Medioevo, secoli IX–XI.* Settimane di studio del Centro italiano di studi sull'alto Medioevo, 44, 2:1075–104. Spoleto, 1997.

Means, Laurel. "'Ffor as moche as yche man may not haue pe astrolabe': Popular Middle English Variations on the Computus." *Speculum* 67 (1992): 595–623.

Medieval and Renaissance Stained Glass from New England Collections. Exh. cat. Edited by Madeline Harrison Caviness. Busch Reisinger Museum, Harvard University. Medford, Mass., 1978.

Medieval Literary Theory and Criticism, c. 1100–c. 1375. Edited by Alastair J. Minnis and A. Brian Scott. Oxford, 1988.

Meier-Staubach, Cristel. "La matérialité et l'immatérialité des couleurs: À propos du traite *De coloribus* d'Avranches 235." In *Science antique, science médiévale (autour d'Avranches 235): Actes du colloque international (Mont-Saint-Michel, 4–7 septembre 1998),* edited by Louis Callebat and Olivier Desbordes, 451–69. Zurich, Hildesheim, and New York, 2000.

———. "Vom Homo Coelestus zum Homo Faber: Die Reorganisation der mittelalterlicher Enzyklopädie für neue Gebrauchsfunctionen bei Vinzenz von Beauvais und Bruno Latini." In *Pragmatische Schriftlichkeit im Mittelalter: Erscheinungsformen und Entwicklungsstufen,* edited by Hagen Keller, Klaus Grubmüller, and Nikolaus Staubach, 159–75. Munich, 1992.

Meiss, Millard. *French Painting in the Time of Jean de Berry.* Vol. 1, *The Late Fourteenth Century and the Patronage of the Duke.* 2nd ed. London, 1969.

Mellinkoff, Ruth. *Outcasts: Signs of Otherness in Northern European Art of the Late Middle Ages.* Berkeley and Los Angeles, 1993.

———. *The Horned Moses in Medieval Art and Thought.* Berkeley and Los Angeles, 1970.

———. *The Mark of Cain.* Berkeley and Los Angeles, 1981.

Meltzer, Françoise. *Salome and the Dance of Writing: Portraits of Mimesis in Literature.* Chicago, 1987.

Mély, Fernand de. "Nos vieilles cathédrales et leurs maîtres d'oeuvre." *Revue archéologique,* 5th ser., 11 (1920): 347.

Melville, Gert. "Spätmittelalterliche Geschichtskompendium—eine Aufgabenstellung." *Römische historische Jahrbuch* 22 (1980): 51–104.

———. "System und Diachronie: Untersuchungen zur theoretischen Grundlegung geschichtsschreiberischer Praxis im Mittelalter." *Historisches Jahrbuch* 95 (1975): 32–67, 308–41.

Menache, Sophia. *The Vox Dei: Communication in the Middle Ages.* New York and Oxford, 1990.

Il Menologio di Basil II (Cod. Vaticano Greco 1613). Codices e Vaticani selecti, 8. Turin, 1907.

Mercuri, Chiara. "San Luigi a la crociata." *Mélanges de l'École française de Rome: Moyen Âge* 108, no. 1 (1996): 221–41.

Merlini, Elena. "Il trittico eburneo della certosa di Pavia." *Arte Cristiana* 73 (1985): 374–84.

Merrifield, Mary. *Original Treatises on the Arts of Painting.* London, 1849. Reprint, New York, 1967.

Merrill, Allison. "A Psalter of the Ingebord Psalter Atelier." Ph.D. diss., Columbia University, 1994.

Messier, Ronald A. "The Christian Community of Tunis at the Time of St. Louis' Crusade, A.D. 1270." In *The Meeting of Two Worlds: Cultural Exchange Between East and West During the Period of the Crusades,* edited by Vladimir P. Goss, 241–55. Kalamazoo, Mich., 1986.

Mesuret, Robert. *Les peintures murales du Sud-Ouest de la France du XIe au XVIe siècle.* Paris, 1967.

Meyer, Heinz. *Die Enzyklopädie des Bartholomäus Anglicus: Untersuchungen zur Überlieferungs- und Rezeptionsgeschichte von "De proprietatibus rerum."* Munich, 2000.

———. "Der Psalter als Gattung in der Sicht der mittelalterlichen Bibelexegese." *FSt* 20 (1986): 1–24.

Meyer, Paul. "Notice sur la *Bible des sept états du monde* de Geufroi de Paris." In *Notices et extraits des manuscrits de la Bibliothèque nationale et autres bibliothèques publies par l'académie des inscriptions et belles-lettres,* vol. 39, pt. 1. Paris, 1909.

———. "Les premières compilations françaises d'histoire ancienne." *Romania* 14 (1885): 1–81.

Mezquita Mesa, Teresa. "La Biblia Moralizada de la Catedral de Toledo." *Goya* 181–82 (1984): 17–20.

Michaëlsson, Karl. *Le livre de la taille de Paris l'an 1296*. Acta Universitatis Gothoburgensis; Göteborgs Högskolas Årsskrift, 64. Göteborg, 1958.

———. *Le livre de la taille de Paris l'an 1297*. Acta Universitatis Gothoburgensis; Göteborgs Högskolas Årsskrift, 67. Göteborg, 1962.

———. *Le livre de la taille de Paris l'an de grace 1313*. Acta Universitatis Gothoburgensis; Göteborgs Högskolas Årsskrift, 57. Göteborg, 1951.

Michaux, Theodor. *Die Hauptentscheidungen des 1. Krenzzugs Ludwig IX. im ihrer politischen Bedingtheit*. Ph.D. diss., Cologne, 1953.

Michler, Jürgen. "Die Dominikanerkirche in Konstanz und die Farbe in der Bettelordensarchitektur um 1300." *ZKg* 53, no. 3 (1990): 252–76.

———. *Gotische Wandmalerei am Bodensee*. Friedrichshafen, 1992.

———. "Grundlagen zur gotischen Wandmalerei." *Jahrbuch der Berliner Museen* 32 (1990): 85–136.

Minnis, Alastair J. *Medieval Theory of Authorship*. 2nd ed. Philadelphia, 1988.

Mise en page et mise en texte du livre manuscrit. Edited by Henri-Jean Martin and Jean Vezin. Paris, 1990.

MBynarczyk, Gertrud. *Ein Franziskanerinnenkloster im 15. Jahrhundert: Edition und Analyse von Besitzinventaren aus der Abtei Longchamp*. Pariser historische Studien, 23. Bonn, 1987.

Modality in Grammar and Discourse. Edited by Joan Bykel and Suzanne Fleischman. Amsterdam and Philadelphia, 1995.

Mohr, W. "Christlich-alttestamentliches Gedankengut in der Entwicklung des karolingischen Kaisertums." In *Judentum im Mittelalter: Beiträge zum christlich-jüdischen Gespräch*, edited by Paul Wilpert, 382–409. Berlin, 1966.

Mokretsova, I. P., and V. L. Romanova. *Les manuscrits enluminés français du XIIIe siècle dans les collections soviétiques, 1200–1270* (in Russian and French). Moscow, 1983.

Molsdorf, Wilhelm. *Christliche Symbolik der mittelalterlichen Kunst*. Leipzig, 1926.

Monfrin, Jacques. "Joinville et la prise de Damiette (1249)." *Académie des inscriptions et belles-lettres: Comptes-rendus des séances* 2 (1976): 268–85.

La monnaie, miroir des rois: Hôtel de la monnaie, Paris, février–avril 1978. Exh cat. Paris, 1978.

Montfaucon, Bernard de. *Bibliotheca bibliothecarum manuscriptorum nova*. Hildesheim and New York, 1982.

———. *Les monuments de la monarchie françoise, qui comprennant l'histoire de France, avec les figures de chaque règne que l'injure des temps à épargnées*. Paris, 1729–33.

———. *The Supplement to Antiquity Explained, and Represented in Sculptures*. Translated by David Humphreys. London, 1725.

Montesquiou-Fezensac, Blaise de, with the collaboration of Danielle Gaborit-Chopin. *Le trésor de Saint-Denis*. 3 vols. Paris, 1973–77.

Montias, J. Michael. "Cost and Value in Seventeenth-Century Dutch Art." *Art History* 10, no. 4 (1987): 455–66.

Moore, Philip. *The Works of Peter of Poitiers, Master of Theology and Chancellor of Paris (1193–1205)*. Notre Dame, Ind., 1936.

Morand, Sauveur-Jérôme. *Histoire de la Sainte-Chapelle royale de Paris*. Paris, 1790.

Moreau-Rendu, Suzanne. *Le prieuré royal de Saint-Louis de Poissy*. Colmar, 1968.

Morgan, Nigel J. "Aspects of Colour in English and French Manuscript Painting of the Late Thirteenth Century." In *Europäische Kunst um 1300*, edited by Elisabeth Liskar, Akten des XXV. Internationalen Kongresses für Kunstgeschichte, 6:111–16. Vienna, 1986.

———. *Early Gothic Manuscripts*. Vol. 1, *1190–1250*; vol. 2, *1250–1285*. A Survey of Manuscripts Illuminated in the British Isles, 4. London, 1982 and 1988.

———. "The Iconography of Twelfth-Century Mosan Enamels." In *Rhein und Maas: Kunst und Kultur, 800–1400: 2, Berichte, Beiträge und Forschungen zum Themenkreis der Ausstellung und des Katalogs*, edited by Anton Legner, 265–75. Cologne, 1973.

———. "Old Testament Illustration in Thirteenth-Century England." In *The Bible in the Middle Ages: Its Influence on Literature and Art*, edited by Bernard S. Levy, Medieval and Renaissance Texts and Studies, 89:149–98. Binghamton, N.Y., 1992.

Morrison, Stanley. *"Black Letter" Text*. Cambridge, 1942.

Le Moyen Âge et la Bible. Edited by Pierre Riché and Guy Lobrichon. Bible de tous les temps, 4. Paris, 1984.

Muir, Lynette. *Liturgy and Drama of the Anglo-Norman Adam*. Oxford, 1973.

Munby, Alan Noel Latimer. *The Formation of the Phillipps Library*. Vol. 1, *Up to the Year 1840*. Phillipps Studies, no. 3. Cambridge, 1954.

Murray, Alan V. "'Mighty Against the Enemies of Christ': The Relic of the True Cross in the Armies of the Kingdom of Jerusalem." In *The Crusades and Their Sources: Essays Presented to Bernard Hamilton*, edited by John France and William G. Zajac, 217–38. Aldershot, Hampshire, and Brookfield, Vt., 1998.

Murray, Stephen. *Notre Dame, Cathedral of Amiens: The Power of Change in Gothic*. Cambridge, 1996.

Musée Marmottan. *La Collection Wildenstein*. Paris, n.d.

Musset, Lucien. "Saint Louis et la Normandie." *L'art de Basse-Normandie* 61 (1972): 8–12.

Mütherich, Florentine. "Die verschiedenen Bedeutungs-schichten in der frühmittelalterlichen Psalterillustration." *FSt* 6 (1972): 232–44.

Napier, Arthur Sampson. *History of the Holy Rood-Tree*. London, 1894.

Narkiss, Bezalel. "Towards a Further Study of the Ashburn-ham Pentateuch (Pentateuque de Tours)." *Cahiers archéologiques* 19 (1969): 45–59.

Nathan, Hans. "The Function of Text in French 13th-Century Motets." *Musical Quarterly* 28, no. 3 (1942): 445–62.

Naughton, Joan. "Friars and Their Books at Saint-Louis de Poissy, a Dominican Foundation for Nuns." *Scriptorium* 52, no. 1 (1998): 83–102.

Nead, Lynda. *The Female Nude: Art, Obscenity, and Sexuality*. London and New York, 1992.

Nebbiai-Dalla Guarda, Donatella. *La Bibliothèque de l'Abbaye de Saint-Denis en France du IXe au XVIIIe siècle*. Paris, 1985.

Nees, Lawrence. *A Tainted Mantel: Hercules and the Classical Tradition at the Carolingian Court*. Philadelphia, 1991.

Nelson, Janet L. "Inauguration Rituals." In *Early Medieval Kingship*, edited by P. H. Sawyer and I. N. Wood, 50–71. Leeds, 1977.

——. "Ritual and Reality in the Early Medieval Ordines." *Studies in Church History* 11 (1975): 41–51.

——. "Royal Saints and Early Medieval Kingship." In *Sanctity and Secularity: The Church and the World*, edited by Derek Baker, 39–44. Oxford, 1973.

——. "Symbols in Context: Rulers' Inauguration Rituals in Byzantium and the West in the Early Middle Ages." In *The Orthodox Church and the West (Studies in Church History* 13), edited by Derek Baker, 97–119. Oxford, 1976.

Nemeitz, Joachim Christoph. *Le séjour de Paris*. Leiden, 1727.

Neuss, Wilhelm. *Die katalanische Bibelillustration um die Wende des ersten Jahrtausend und die altspanische Buch-malerei*. Bonn and Leipzig, 1922.

Nichols, Stephen. "'Art' and 'Nature': Looking for (Medieval) Principles of Order in Occitan *Chansonnier* N (Morgan 819)." In *The Whole Book: Cultural Perspectives on the Medieval Miscellany*, edited by Stephen Nichols and Siegfried Wenzel, 83–121. Ann Arbor, Mich., 1996.

——. "Empowering New Discourse: Response to Eugene Vance and Hope Weissman." *Exemplaria* 2.1 (1990): 127–48.

Nicot, René. *Histoire et évolution d'un fief royal, Chilly-Mazarin-Longjumeau*. Etampes, 1986.

Nieuwerkerke, Alfred-Emilien O'Hara, comte de. *Rapport de M. le comte de Nieuwerkerke, . . . sur la situation des musées impériaux pendant le règne de S. M. Napoléon III (1853–1869)*. Paris, 1869.

Nilgen, Ursula. "Königs- und Bischofsreihen in der Kunst-propaganda des Hochmittelalter." In *Studien zur mittel-alterlichen Kunst 800–1250: Festschrift für Florentine Mütherich zum 70. Geburtstag*, edited by Katharina Bierbrauer, Peter K. Klein, and Willibald Sauerländer, 217–34. Munich, 1985.

Nordenfalk, Carl. "Les cinq sens dans l'art du Moyen Âge." *Revue de l'art*, no. 34 (1976): 17–28.

Nordström, Carl-Otto. "Rabbinica in frühchristlichen und byzantinischen Illustrationen zum 4. Buch Mose." *Figura*, n.s., 1 (1959): 24–47.

Nordström, Folke. *The Auxerre Reliefs: A Harbinger of the Renaissance in France During the Reign of Philip le Bel*. Uppsala, 1974.

Norton, Christopher. *Carreaux de pavement du Moyen Âge et de la Renaissance: Collections du Musée Carnavalet*. Catalogues d'art et d'histoire du Musée Carnavalet, 7. Paris, 1992.

Norton, E. C., and M. C. Horton. "A Parisian Workshop at Canterbury: A Late Thirteenth-Century Tile Pavement in the Corona Chapel and the Origins of Tyler Hill." *Journal of the British Archaeological Association* 134 (1981): 58–80.

Notice de manuscrits, livres rares, et ouvrages sur les sciences, beaux-arts, etc.; tirée du cabinet de Son Excellence le prince M. Galitzin. Moscow, 1816.

Notice des antiquités, objet du Moyen-Âge, de la Renaissance et des temps modernes composant le Musée des souverains. Paris, 1866.

Oakeshott, Walter. *The Two Winchester Bibles*. Oxford, 1981.

O'Connell, David. *The Teachings of Saint Louis*. Chapel Hill, N.C., 1972.

——. *The Instructions of Saint Louis*. Chapel Hill, N.C., 1979.

O'Donnell, J. Reginald. "Tractatus Magistri Guillelmi Alvernensis *De Bono et Malo*." *Mediaeval Studies* 8 (1946): 245–99.

The Old English Hexateuch: Aspects and Approaches. Edited by Rebecca Barnhouse and Benjamin Withers. Kalamazoo, Mich., 2000.

Old Testament Miniatures: A Medieval Picture Book with 283 Paintings from the Creation to the Story of David. Introduction and legends by Sydney Carlyle Cockerell, preface by John Plummer. New York, 1969.

Oliver, Judith. *Gothic Manuscript Illumination in the Diocese of Liege (c. 1250–c. 1330)*. Louvain, 1988.

——. "Worship and the Word: Some Gothic Nonnen-bücher in Their Devotional Context." In *Women and the Book: Assessing the Visual Evidence*, edited by Jane H. M.

Taylor and Lesley Smith, 106–22. Toronto and Buffalo, 1996.

Oltrogge, Doris. *Die Illustrationzyklen zur "Histoire ancienne jusqu'à César" (1250–1400)*. Europäische Hochschulen-schriften, ser. 28, vol. 94. Frankfurt, 1987.

Omont, Henri, ed. *Psautier de Saint Louis*. Macon, 1902.

——, ed. *Psautier illustré (XIIIe siècle)*. Paris, n.d.

Openshaw, Kathleen M. J. "The Battle Between Christ and Satan in the Tiberius Psalter." *JWCI* 52 (1989): 14–33.

——. "Images, Texts, and Contexts: The Iconography of the Tiberius Psalter, London, British Library, MS Cotton Tiberius C.VI." Ph.D. diss., University of Toronto, 1990. (To be published as *Images, Texts, and Contexts: The Anglo-Saxon Tiberius Psalter.* Cambridge, forthcoming.)

——. "The Symbolic Illustration of the Psalter: An Insular Tradition." *Arte medievale* 6, no. 1 (1992): 41–60.

——. "Weapons in the Daily Battle: Images of the Conquest of Evil in the Early Medieval Psalter." *Art Bulletin* 75, no. 1 (1993): 17–38.

The Optics of Ibn al-Haytham: Books I–III: On Direct Vision. Translated, with an introduction and commentary, by A. I. Sabra. 2 vols. London, 1989.

L'or au Moyen Âge: Monnaie, métal, objets, symbole. Sénéfiance, 12. Aix-en-Provence, 1983.

Other Middle Ages: Witnesses at the Margins of Medieval Society. Edited by Michael Goodich. Philadelphia, 1998.

Ouspensky, Fedor Ivanovich. *L'Octateuque de la Bibliothèque du Sérail à Constantinople.* Sophia, 1907.

Ouy, Gilbert. *Les manuscrits de l'Abbaye de Saint-Victor: Catalogue établi sur la base du répertoire de Claude de Grandrue (1514).* [Turnhout], 1999.

Ouy, Gilbert, and Danièle Calvot. *L'oeuvre de Gerson à Saint-Victor de Paris: Catalogue des manuscrits.* Paris, 1990.

Owens, Joseph. "Judgment and Truth in Aquinas." *Mediaeval Studies* 32 (1970): 138–50.

Pächt, Otto. *Book Illumination of the Middle Ages.* Translated by Kay Davenport. London and Oxford, 1986.

——. *The Rise of Pictorial Narrative in Twelfth-Century England.* Oxford, 1962.

Pächt, Otto, Charles Reginald Dodwell, and Francis Wormald. *The Saint Albans Psalter (Albani Psalter).* Studies of the Warburg Institute, 25. London, 1960.

Pächt, Otto, and Dagmar Thoss. *Französische Schule I.* Die illuminierten Handschriften und Inkunabeln der Öster-reichischen Nationalbibliothek, 1. Edited by Otto Pächt. Veröffentlichungen der Kommission für Schrift- und Buchwesen des Mittelalters, edited by H. Hunger, ser. 1 (Österreichische Akademie der Wissenschaften, Denkschriften, 118), vol. 1. Vienna, 1974.

Page, Christopher. *Discarding Images: Reflections on Music and Culture in Medieval France.* Oxford, 1993.

——. "Johannes de Grocheio on Secular Music: A Corrected Text and a New Translation." *Plainsong and Medieval Music* 2, no. 1 (1993): 17–41.

——. *The Owl and the Nightingale: Musical Life and Ideas in France, 1100–1300.* Berkeley and Los Angeles, 1990.

——. "The Performance of Ars Antiqua Motets." *Early Music* 16, no. 2 (1988): 147–64.

——. "Polyphony Before 1400." In *Performance Practice,* edited by Howard Mayer Brown and Stanley Sadie, 1:79–104. London, 1989.

——. *The Summa Musicae: A Thirteenth-Century Manual for Singers.* Cambridge, 1991.

——. *Voices and Instruments of the Middle Ages: Instrumental Practice and Songs in France, 1100–1300.* Berkeley and Los Angeles, 1986.

Painter, Sydney. "The Crusade of Theobald of Champagne and Richard of Cornwall, 1239–1241." In *A History of the Crusades,* edited by Kenneth Meyer Setton, vol. 2, *The Later Crusades, 1189–1311,* edited by R. L. Wolff and Harry W. Hazard, 463–87. Madison, Wis., and London, 1969.

Pange, Jean de. *Le roi très chrétien.* Paris, 1949.

Panofsky, Erwin. *Early Netherlandish Painting: Its Origin and Character.* 2 vols. Cambridge, Mass., 1971.

——. *The Life and Art of Albrecht Dürer.* 4th ed. Princeton, 1955.

——. *Renaissance and Renascences in Western Art.* Uppsala, 1960.

Papanicolaou, Linda May. "Stained Glass from the Cathedral of Tours: The Impact of the Sainte-Chapelle in the 1240s." *Metropolitan Museum Journal* 15 (1981): 53–65.

Parkes, Malcolm Beckwith. "The Influence of the Concepts of *Ordinatio* and *Compilatio* on the Development of the Book." In *Medieval Learning and Literature: Essays Presented to Richard William Hunt,* edited by Jonathan J. G. Alexander and Margaret T. Gibson, 115–38. Oxford, 1976.

Parkhurst, Charles. "A Viewpoint for Giotto's Life of Mary in the Arena Chapel." In *Shop Talk: Studies in Honor of Seymour Slive, Presented on His Seventy-Fifth Birthday.* Cambridge, Mass., 1995.

Parsons, John Carmi. *The Court and Household of Eleanor of Castile in 1290.* Pontifical Institute of Mediaeval Studies: Studies and Texts, 37. Toronto, 1977.

Pastoureau, Michel. *Armorial des chevaliers de la Table Ronde.* Paris, 1983.

——. "La couleur et l'historien." In *Pigments et colorants de l'antiquité et du Moyen Âge,* 21–40. Paris, 1990.

——. *Figures et couleurs: Études sure la symbolique et la sensibilité médiévales.* Paris, 1986.

——. "Figures et couleurs péjoratives en héraldique médiévale." In *Comunicaciones del XV Congreso de las ciencias genealógica y heráldica*, 3:321–38. Madrid, 1983. Reprinted in *Figures et couleurs*, 193–207.

——. *L'hermine et le sinople: Études d'héraldique médiévale.* Paris, 1982.

——. "L'origine suisse des armoiries du royaume d'Aragon." *Archives héraldiques suisses* (1980): 3–10.

——. *Traité d'héraldique.* Paris, 1979.

——. "Quel est le roi des animaux?" In *Figures et couleurs*, 159–75.

Paulmier-Fouquart, Monique. "Histoire ecclésiastique et histoire universelle: Le Memoriale temporum." In *Vincent de Beauvais: Intentions et réception*, 87–110. Paris, 1990.

——. "Historiographie et hagiographie dans le *Speculum historiale* de Vincent de Beauvais: Le modèle de Saint Edmond Rich." *Archivum Fratrum Praedicatorum* 68 (1998): 165–75.

Paulmier-Fouquart, Monique, and M.-C. Duchenne. "La matière de l'histoire selon Vincent de Beauvais: Les titres du chapitres du *Speculum historiale*." In *Saint-Denis et la royauté: Études offertes à Bernard Guenée*, 405–20.

Paulmier-Fouquart, Monique, and Serge Lusignan. "Vincent de Beauvais et l'histoire du *Speculum maius*." *Journal des savants* (1990): 97–124.

Pelckmans, Paul. "Deux visages de la mort dans la vie de Saint Louis de Jean de Joinville." *Periodico di cultura francese*, 3rd ser., 17 (1975): 12–24.

Perdrizet, Paul. *Le calendrier parisien à la fin du Moyen Âge.* Paris, 1933.

Pérez Llamazares, Julio. *Catálogo de los códices y documentos de la Real Colegiata de San Isidoro de León.* León, 1923.

Pernoud, Regine. "Un chef-d'oeuvre de l'enluminure: Le Psautier de Saint Louis." *Jardin des arts* 85 (1970): 10–15.

Perrot, Françoise. "Le vitrail, la croisade et la champagne: Réflexion sur les fenêtres hautes du choeur a la cathédrale de Chartres." In *Les Champenois et la croisade: Actes des quatrièmes journées rémoises 27–28 novembre 1987*, 109–30. Paris, 1989.

Pesce, Dolores. "A Revised View of the Thirteenth-Century Latin Double Motet." *Journal of the American Musicological Society* 40, no. 3 (1987): 405–42.

——. "The Significance of Text in Thirteenth-Century Latin Motets." *Acta Musicologica* 58, no. 1 (1986): 91–116.

Peters, Edward. *The Shadow King: Rex Inutilis in Medieval Law and Literature, 751–1327.* New Haven and London, 1970.

Petersohn, Jürgen. "Saint Denis—Westminster—Aachen: Die Karls-Translatio von 1165 und ihre Vorbilder." *Deutsches Archiv für Erforschung des Mittelalters* 31 (1975): 420–54.

Peterson, Elizabeth Anne. "Accidents and Adaptations in Transmission Among Fully Illustrated French Psalters in the Thirteenth Century." *ZKg* 50, no. 3 (1987): 375–84.

——. "Iconography of the Historiated Psalm Initials in the Thirteenth-Century French Fully-Illustrated Psalter Group." Ph.D. diss., University of Pittsburg, 1991.

Petit-Dutaillis, Charles. *Étude sur la vie et le règne de Louis VII (1187–1226).* Paris, 1894.

Petitmengin, Pierre. "La Bible de Saint Louis." In *Mise en page et mise en texte du livre manuscrit.*

P. G. G. "Documents divers relatifs à la croisade de Saint Louis contre Tunis (1270)." *Cahiers de Tunisie* 25, nos. 99–100 (1977): 245–82.

Pickens, Rupert. "Historical Consciousness in Old French Narrative." *French Forum* 4, no. 2 (1979): 168–84.

Pierre, lumière, couleur: Études d'histoire de l'art du Moyen Âge en l'honneur d'Anne Prache. Edited by Fabienne Joubert and Dany Sandron. Paris, 1999.

Pijoán, José. "Les miniatures de l'Octateuch à les Bibles romàniques catalanes." *Anuari de l'Institut d'estudis catalans* 4 (1911–12): 475–507.

Pillinger, Renata. *Die Tituli Historiarum, oder das sogenannte Dittochaeon des Prudentius: Versuch eines philologisch-archäologischen Kommentars.* Vienna, 1980.

Pinard, Théodule. "Le prière de Longjumeau." *Revue archéologique* 7 (1850): 385–86.

Pinoteau, Hervé. "Autour de la Bulle 'Dei Filius.'" *Itinéraires* 11, no. 147 (1970): 99–123.

——. "La date de la cassette de Saint Louis: Été 1236?" *Cahiers d'héraldique* 4 (1983): 97–126.

——. *Héraldique capétienne.* Paris, 1979.

——. "Les origines de l'héraldique capétienne." In *Comunicaciones y conclusiones del III Congreso internacional de genealogía y heráldica*, 485–511. Madrid, 1955. Reprinted, with additions, in *Vingt-cinq ans d'études dynastiques.*

——. *Vingt-cinq ans d'études dynastiques.* Paris, 1982.

Pinoteau, Hervé, and Claude Le Gallo. *L'héraldique de Saint Louis et de ses compagnons.* Les cahiers nobles, 27. Paris, 1966.

Piper, Paul. "Zwei deutsche Altarflügel des 13. Jahrhunderts im Britischen Museum." *Niederdeutsche Beiträge zur Kunstgeschichte* 3 (1964): 215–27.

Piponnier, Françoise. *Dress in the Middle Ages.* Translated by Caroline Beamish. New Haven, 1997.

Pitts, Brent. "Versions of the Apocalypse in Medieval French Verse." *Speculum* 58, no. 1 (1983): 31–59.

Plotzek, Joachim M. *Das Perikopenbuch Heinrichs III. in Bremen und seine Stellung innerhalb der Echternacher Buchmalerei*. Ph.D. diss., Cologne, 1970.

Plotzek, Joachim M., and Anton von Euw. *Die Handschriften der Sammlung Ludwig*. Vol. 1. Cologne, 1979.

Les plus beaux manuscrits français du VIIIe au XVIe siècle conservés dans la bibliothèque nationales de Paris. Exh. cat. Paris, 1937.

Poèmes d'amour des XIIe au XIIIe siècles, textes suivis d'exemples musicaux. Edited and translated by Emmanuèle Baumgartner and Françoise Ferrand. Paris, 1983.

Poerck, Guy de, and Rika van Deyck. "La Bible et l'activité traductrice dans les pays romans avant 1300." In *GRLMA*, VI/1:21–48 and 2:56–65.

Poetae Latini aevi Carolini (II). Edited by Ernst Dümmler. Monumenta Germaniae Historica, Poetae Latini medii aevi, 2. Berlin, 1884. Reprint, 1999.

Poirion, Daniel. "Merveille architecturale et section narrative en France au Moyen Âge." *Venezia arti* (1987): 14–21.

Pollard, Graham. "The Company of Stationers Before 1557." *Library*, 4th ser., 18, no. 1 (1937): 1–38.

——. "The Construction of English Twelfth-Century Bindings." *Library*, 5th ser., 13, no. 3 (1962): 1–22.

——. "Describing Medieval Bookbindings." In *Medieval Learning and Literature: Essays Presented to Richard William Hunt*, edited by Jonathan J. G. Alexander and Margaret T. Gibson, 50–65. Oxford, 1976.

——. "The *Pecia* System in the Medieval Universities." In *Medieval Scribes, Manuscripts, and Libraries: Essays Presented to N. R. Ker*, edited by Malcolm Beckwith Parkes and Andrew Watson, 145–61. London, 1978.

——. "The University and the Book Trade in Mediaeval Oxford." In *Beiträge zum Berufsbewußtsein des mittelalterlichen Menschen*, edited by Paul Wilpert, Miscellanea mediaevalia, 3:336–44. Berlin, 1964.

Polzin, Robert. *Samuel and the Deuteronomist: A Literary Study of the Deuteronomic History*. San Francisco, 1989.

Le pontifical romain au Moyen-Âge. Edited by Michel Andrieu. Vol. 3, *Le pontifical de Guillaume Durand*. Studi e testi, 88. Vatican City, 1940.

Poorter, Alphonse de. *Le traité Eruditio regum et principum de Guibert de Tournai*. Les philosophes belges: Textes et études, 9. Louvain, 1914.

Pope, Arthur Upham, and Phyllis Ackerman, eds. *A Survey of Persian Art, from Prehistoric Times to the Present*. London and New York, 1967–.

Porcher, Jean. *L'enluminure française*. Paris, 1959.

——. "Séance du 8 juillet." *Bulletin de la Société nationale des antiquaires de France* 64 (1964).

Pouillon, Henri. "La beauté, propriété transcendantale,

chez les Scolastiques (1220–1270)." *Archives d'histoire doctrinale et littéraire du Moyen Âge* 15 (1946): 263–329.

Prache, Anne. *Cathedrals of Europe*. Ithaca, N.Y., 2000.

——. "Un architecte du XIIIe siècle et son oeuvre: Pierre de Montreuil." *Histoire et archéologie*, no. 47 (1980): 26–39.

Prawer, Joshua. *Histoire du royaume latin de Jérusalem*. Translated by G. Nahon. Vol. 2, *Les croisades et le second royaume latin*. Paris, 1970.

Le prince et son historien: La vie de Saint Louis de Joinville. Edited by Jean Dufournet and Laurence Harf. Paris, 1997.

Prost, Bernard. "Recherches sur les 'peintures du roi' antérieurs au règne de Charles VI." In *Études d'histoire du Moyen Âge dédiées à Gabriel Monod*, edited by E. Lavisse, 389–403. Paris, 1896.

Le Psautier de Saint Louis. Faksimile-Ausgabe der ganzseitigen Miniaturen, des Kalendariums und der Seiten mit Bildinitialen des Manuscrit Latin 10525 der Bibliothèque nationale, Paris. Introduction by Marcel Thomas. Codices selecti, 37. Graz, 1970.

Quednau, Ursula. *Die Westportale der Kathedrale von Auxerre*. Forschungen zur Kunstgeschichte und christlichen Archäologie, 10. Wiesbaden, 1979.

Raft, Adam. "Beobachtungen über Theophilus 'De diversis artibus.'" *Restauratorenblätter* 13 (1992): 25–32.

Raguin, Virginia Chieffo. "The Isaiah Master of the Sainte-Chapelle in Burgundy." *Art Bulletin* 59, no. 4 (1977): 483–92.

——. "Mid-Thirteenth-Century Patronage at Auxerre and the Sculptural Program of the Cathedral." *Studies in Iconography* 14 (1995): 131–51.

——. *Stained Glass in Thirteenth-Century Burgundy*. Princeton, 1982.

Ragusa, Isa. "An Illustrated Psalter from Lyre Abbey." *Speculum* 46, no. 2 (1971): 267–81.

Randall, Lillian, et al. *Medieval and Renaissance Manuscripts in the Walters Art Gallery*. Vol. 1, *France, 875–1420*. Baltimore and London, 1989.

Randall, Richard, Jr. *The Golden Age of Ivory: Gothic Ivories in North American Collections*. New York, 1993.

Randall, Richard, Jr., et al. *Masterpieces of Ivory from the Walters Art Gallery*. New York, 1985.

La rationalisation du temps au XIIIe siècle: Musique et mentalités: Actes du colloque de Royaumont, 1991. Edited by Catherine Homo-Lechner. Grâne, 1998.

Ratzinger, Joseph. *The Theology of History in St. Bonaventura*. Chicago, 1971.

Rau, Bernd. *Die ornamentalen Hintergründe in der französischen gotischen Buchmalerei*. Ph.D. diss., Tübingen, 1975.

Ravaux, Jean-Pierre. "Les vitraux de l'abside de la cathédrale de Châlons-sur-Marne donnes par Saint Louis." *Mémoires de la Société d'agriculture, commerce, sciences et arts du Département de la Marne* 104 (1989): 73–89.

Raw, Barbara. "The Probable Derivation of Most of the Illustrations in Junius 11 from an Illustrated Old Saxon *Genesis*." *Anglo-Saxon England* 5 (1976): 133–48.

Recensement des vitraux anciens de la France. Corpus Vitrearum Medii Aevi, France, série complémentaire. Vol. 2, *Les vitraux du Centre et des Pays de la Loire;* vol. 3, *Les vitraux de Bourgogne, Franche-Comté, et Rhône-Alpes.* Paris, 1981 and 1986.

Regalado, Nancy. *Poetic Patterns in Rutebeuf: A Study in Noncourtly Poetic Modes of the Thirteenth Century.* New Haven and London, 1970.

Das Reich der Salier, 1024–1125. Exh. cat. Mainz, Zentral Museum. Sigmaringen, 1992.

Reichardt, Paul. "'Several Illuminations, Coarsely Executed': The Illustrations of the *Pearl* Manuscript." *Studies in Iconography* 18 (1997): 119–42.

Remensnyder, Amy G. *Remembering Kings Past: Monastic Foundation Legends in Medieval Southern France.* Ithaca, N.Y., 1995.

Reudenbach, Bruno. "Die Londoner Psalterkarte und ihre Rückseite: Ökumenekarten als Psalterillustration." *FSt* 32 (1998): 164–81.

Revel-Neher, Elisabeth. "La double page du Codex Amiantinus et ses rapports avec les plans du Tabernacle dans l'art juif et dans l'art byzantin." *Journal of Jewish Art* 9 (1982): 6–17.

Riant, Paul Edouard Didier, comte. "Des dépouilles religieuses enlevées à Constantinople au XIIIe siècle et des documents historiques nés de leur transport en Occident." *Mémoires de la Société nationale des antiquaires de France,* 4th ser., 6 (1875): 182–83.

———. *Exuviae sacrae constantinoplitanae.* Vol. 1. Geneva, 1877.

Richard, Jean. "La croisade de 1270, premier 'passage général'?" In *Académie des inscriptions et belles-lettres: Comptes-rendus des séances de l'année 1989,* 510–23. Paris, 1989.

———. *The Crusades, c. 1071–c. 1291.* Cambridge, 1964.

———. "La fondation d'une église latine en Orient par Saint Louis: Damiette." In *Orient et Occident au Moyen Âge: Contacts et relations (XVIIe–XVe s.),* Variorum Preprint, CS49, 39–54. London, 1976.

———. "Joinville a la croisade." In *Le prince et son historien,* 23–31.

———. "La politique orientale de Saint Louis: La croisade de 1248." In *Septième centenaire de la mort de Saint Louis,* 197–207.

———. *Saint Louis: Crusader King of France.* Edited and abridged by Simon Lloyd, translated by Jean Birrell. Cambridge and Paris, 1992.

———. "Sur les pas de Plancarpin et de Rubrouck: La lettre de Saint Louis à Sartaq." *Journal des savants* 1 (1977): 48–61.

Richard, Jules-Marie. *Une petite-nièce de Saint Louis: Mahaut, comtesse d'Artois et de Bourgogne (1302–1329).* Paris, 1887.

Riché, Pierre. "La Bible et la vie politique dans le haut Moyen Âge." In *Le Moyen Âge et la Bible,* 385–99.

———. "Danses profanes et religieuses dans le haut Moyen Âge." In *Histoire sociale, sensibilités collectives et mentalités: Mélanges Robert Mandrou,* 159–67. Paris, 1985.

———. *Les écoles et l'enseignement dans l'Occident chrétien de la fin du Ve siècle au milieu du XIe siècle.* Paris, 1979.

Rickert, Franz. *Studien zum Ashburnham Pentateuch (Paris, Bibl. Nat. NAL 2334).* Ph.D. diss., Rheinische Friedrich-Wilhelms-Universtität, Bonn, 1986.

Ridyard, Susan. *The Royal Saints of Anglo-Saxon England: A Study of West Saxon and East Anglian Cults.* Cambridge, 1988.

Riley-Smith, Jonathan. *The First Crusade and the Idea of Crusading.* Philadelphia, 1986.

Ritter, Georges, ed. *Les vitraux de la cathédrale de Rouen, XIIIe, XIVe, XVe et XVIe siècles.* Cognac, 1926.

Roberts, Michael. *Biblical Epic and Rhetorical Paraphrase in Late Antiquity.* ARCA, Classical and Medieval Texts, Papers, and Monographs, 16. Liverpool, 1985.

Robinson, Pamela R. *Catalogue of Dated and Datable Manuscripts (c. 737–1600) in Cambridge Libraries.* Vol. 1, no. 202. Cambridge, 1988.

Robson, C. A. "Vernacular Scriptures in France." In *Cambridge History of the Bible,* edited by G. W. H. Lampe, vol. 2, *The West from the Fathers to the Reformation,* 436–52. Cambridge, 1969.

Roeder, Josef. *Das Fürstenbild in den mittelalterlichen Fürstenspiegeln auf französischen Boden.* Emsdetten, 1933.

Roehricht, Reinhold. "Die Kreuzzüge des Grafen Theobald von Navarra und Richard von Cornwallis nach dem Heiligen Lande." In *Forschungen zur deutschen Geschichte,* 67–102. Osnabrück, 1968.

Roesner, Edward H. "The Emergence of *Musica Mensurabilis*." In *Studies in Musical Sources and Style: Essays in Honor of Jan LaRue,* edited by Eugene Wolf and Edward Roesner, 41–74. Madison, Wis., 1990.

Roesner, Edward H., François Avril, and Nancy Freeman Regalado. Introduction to *Le Roman de Fauvel: In the Edition of Mesire Chaillou de Pesstain: A Reproduction in Facsimile of the Complete Manuscript, Paris, Bibliothèque Nationale, Fonds Français 146.* New York, 1990.

Röhrig, Floridus. "Rota in medio rotae." *Jahrbuch des Stiftes Klosterneuburg*, n.s., 5 (1965): 1–113.

Romanini, Angiola Maria. "Arnolfo pittore: Pittura e spazio virtuale nel cantiere gotico." *Arte medievale* 11, nos. 1–2 (1999): 3–33.

Roosen-Runge, Heinz. *Farbgebung und Technik frühmittelalterlicher Buchmalerei. Studien zu den Traktaten "Mappae Clavicula" und "Heraclius."* Kunstwissenschaftliche Studien, 38. Berlin, 1967.

Rosenthal, Jane E. "The Unique Architectural Settings of the Arenberg Evangelists." In *Studien zur mittelalterlichen Kunst 800–1250: Festschrift für Florentine Mütherich zum 70. Geburtstag*, edited by Katharina Bierbrauer, Peter K. Klein, and Willibald Sauerländer, 145–56. Munich, 1985.

Rosenwein, Barbara, and Lester Little. "Social Meaning and Mendicant Spirituality." *Past & Present* 63, no. 5 (1974): 4–32.

Rotili, Mario. *L'Arco di Traiano a Benevento.* Rome, 1972.

Rouche, Michel. "Miroirs des prince ou miroirs du clergé?" In *Committenti e produzione artistico-letteraria nell'alto Medioevo occidentale, 4–10 aprile 1991*, Settimane di studio del Centro italiano di studi sull'alto Medioevo, 39, 1:341–64. Spoleto, 1992.

Rouse, Richard H. "La diffusion en Occident au XIIIe siècle des outils de travail facilitant l'accès aux textes autoritatifs." *Revue des études islamiques* 44 (1976): 115–47.

——. "The Goldsmith and the Peacocks: Jean de le Mote in the Household of Simon de Lille, 1340." *Viator* 28 (1997): 281–303.

——. "Manuscripts Belonging to Richard de Fournival." *Revue d'histoire des textes* 3 (1973): 253–69.

——. *Preachers, Florilegia, and Sermons: Studies on the Manipulus Florum of Thomas of Ireland.* Toronto, 1979.

Rouse, Richard H., and Mary A. Rouse. "La bibliothèque du collège de Sorbonne." In *Histoire des bibliothèques françaises: Les bibliothèques médiévales du VIe siècle à 1530.* Paris, 1989.

——. "The Book Trade at the University of Paris, ca. 1250–1350." In *La production du livre universitaire au Moyen Âge: Exemplar et pecia: Actes du symposium tenu au Collegio San Bonaventura de Grottaferrata en mai 1983*, edited by Louis J. Bataillon, Bertrand G. Guyot, and Richard H. Rouse, 41–114. Paris, 1988. Reprinted in Mary A. Rouse and Richard H. Rouse, *Authentic Witnesses: Approaches to Medieval Texts and Manuscripts*, 259–338. Notre Dame, 1991.

——. "The Commercial Production of Manuscript Books in Late-Thirteenth-Century and Early-Fourteenth-Century Paris." In *Medieval Book Production: Assessing the Evidence*, edited by Linda I. Brownrigg, 103–15. Los Altos Hills, Calif., 1990.

——. *Manuscripts and Their Makers: Commercial Book Producers in Medieval Paris, 1200–1500.* 2 vols. London, 2000.

——. "Thomas of Wymondswold." *Journal of the Walters Art Gallery* 54 (*Essays in Honor of Lilian M. C. Randall*) (1996): 61–68.

Roy, Bruno, and Paul Zumthor. *Jeux de mémoire: Aspects de la mnémotechnie médiévale.* Montreal and Paris, 1985.

Ruiz, Teófilo F. "Une royauté sans sacré: La monarchie castillane du Bas Moyen Âge." *Annales ESC* 39, no. 3 (1984): 429–53.

Rump, Andreas. *Die Meerwesen auf den antiken Sarkophagreliefs.* Berlin, 1939.

Rüth, Uwe Max. *Die Farbgebung in der byzantinischen Wandmalerei der spätpaläologischen Epoche, 1341–1453.* Ph.D. diss., Bonn, 1977.

Sadler, Donna. "The King as Subject, the King as Author: Art and Politics of Louis IX." In *European Monarchy*, 53–68.

——. "Lessons Fit for a King: The Sculptural Program of the Verso of the West Façade of Reims Cathedral." *Arte medievale*, 2nd ser., 9 (1995): 49–69.

Sadler-Davis, Donna. "The Sculptural Program of the Verso of the West Façade of Reims Cathedral." Ph.D. diss., Indiana University, 1984.

Saint Denis et la royauté: Études offertes a Bernard Guenée. Edited by Françoise Autrand, Claude Gauvard, and Jean-Marie Moeglin. Paris, 1999.

Saint Louis: Exposition organisée par la direction générale des archives de France, Sainte-Chapelle, mai–août 1960. Exh. cat. Paris, 1960.

Salet, Francis. "Chronique: Une image de Saint Louis au Musée Carnavalet." *Bulletin monumental* 129, no. 3 (1971): 206–7.

Samaran, Charles, and Robert Marichal, eds. *Catalogue des manuscrits en écriture latine portant des indications de date, de lieu ou de copiste.* Vol. 3, *Bibliothèque nationale, Fonds latin (nos 8001 à 18613).* Paris, 1974.

Sanders, Ernest H. "Consonance and Rhythm in the Organum of the Twelfth and Thirteenth Centuries." *Journal of the American Musicological Society* 33 (1980) 264–86.

——. "The Medieval Motet." In *Gattungen der Musik in Einzeldarstellungen*, edited by Wulf Arlt et al., 497–573. Bern and Munich, 1973.

Sandler, Lucy Freeman. *Gothic Manuscripts, 1285–1385.* A Survey of Manuscripts Illuminated in the British Isles, 5. 2 vols. London and New York, 1986.

——. "Notes for the Illuminator: The Case of the *Omne Bonum*." *Art Bulletin* 71, no. 4 (1989): 551–64.

——. "The Word in the Text and the Image in the Margin: The Case of the Luttrell Psalter." *Journal of the Walters Art Gallery* 54 (1996): 87–99.

Santamaria, Ulderico, and Paola Santopadre. "Il maestro Oltremontano: Studio della tecnica pittorica mediante indagini chimiche." In *Il cantiere pittorico della Basilica superiore di San Francesco in Assisi,* edited by Giuseppe Basile and P. Pasquale Magro, Il miracolo di Assisi, Collana storico-artistico della Basilica e del Sacro Convento di San Francisco in Assisi, 13:37–42. Assisi, 2001.

Sargent-Baur, Barbara N. *Brothers of Dragons: Job Dolens and François Villon.* Garland Monographs in Medieval literature, 3. New York and London, 1990.

——. *Journeys Toward God: Pilgrimage and Crusade.* Kalamazoo, Mich., 1992.

Sass, Ernst, ed. *L'estoire Joseph.* Gesellschaft für romanische Literatur, 12. Dresden, 1906.

Sauerländer, Willibald. *Gotische Skulptur in Frankreich, 1140–1270.* Munich, 1970.

——. *Das Königsportal in Chartres: Heilsgeschichte und Lebenswirklichkeit.* Frankfurt am Main, 1984.

——. "Die Marienkrönungsportale von Senlis und Mantes." *Wallraff-Richartz-Jahrbuch* 20 (1958): 115–62.

——. *Le siècle des cathédrales, 1140–1260.* Paris, 1989.

Scaglione, Aldo. *Knights at Court: Courtliness, Chivalry, and Courtesy from Ottonian Germany to Renaissance Italy.* Berkeley and Los Angeles, 1991.

Schapiro, Meyer. Review of *Der Ingeborgpsalter,* edited by Florens Deuchler. *Cahiers de civilisation médiévale* 15, no. 2 (1972): 151–53.

Scheller, Robert. *Exemplum: Model-Book Drawings and the Practice of Artistic Transmission in the Middle Ages (ca. 900–1470).* Amsterdam, 1995.

Schenkuhn, Wolfgang. *Ordines Studentes: Aspekte zur Kirchenarchitektur der Dominikaner und Franziskaner im 13. Jahrhundert.* Berlin, 1985.

Schiffrin, Deborah. "Tense Variation in Narrative." *Language* 57, no. 1 (1981): 45–62.

Schiller, Getrud. *Ikonographie der christlichen Kunst.* Vol. 4. Gütersloh, 1976.

Schleusener-Eichholz, Gudrun. *Das Auge im Mittelalter.* Munich, 1985.

Schlicht, Markus. "La clôture du choeur de Notre-Dame de Paris." *Bulletin monumental* 159, no. 3 (2001): 264–365.

Schlosser, Julius von. *Quellenbuch zur Kunstgeschichte des abendländischen Mittelalters.* Vienna, 1896.

Schmidt, Gerhard. "Materialien zur französischen Buchmalerei der Hochgotik I: Kanonistische Handschriften." *Wiener Jahrbuch für Kunstgeschichte* 28 (1975): 159–70.

Schmidt, Roderich. "Aetatis Mundi: Die Weltalter als Gliederungsprinzip der Geschichte." *Zeitschrift für Kirchengeschichte,* 4th ser., 67, no. 3 (1955–56): 288–317.

Schmidt-Chazan, Mireille. "L'idée d'empire dans le *Speculum Historiale* de Vincent de Beauvais." In *Vincent de Beauvais: Intentions et réception,* 253–83.

Schmitt, Jean-Claude. "Bildhaftes Denken: Die Darstellung biblischer Träume in mittelalterlichen Handschriften." In *Träume im Mittelalter: Ikonologische Studien,* 9–24.

Schneider, Christian. *Prophetisches Sacerdotium und heilsgeschichtliches Regnum im Dialog, 1073–1077: Zur Geschichte Gregors VII. und Heinrichs IV.* Munich, 1972.

Schneider, Robert. "A 'Mirror for Princes' by Vincent of Beauvais." In *Studium Generale: Studies Offered to Astrik L. Gabriel,* edited by Leslie S. Domonkos and Robert Schneider, 207–23. Notre-Dame, Ind., 1967.

Schneider, Robert, and Richard Rouse. "The Medieval Circulation of the *De Morali Principis Institutione* of Vincent of Beauvais." *Viator* 22 (1991): 189–213.

Scholtka, Annette. "Theophilus Presbyter: Die maltechnischen Anweisungen und ihr Gegenüberstellung mit naturwissenschaftlichen Untersuchungsbefunden." *Zeitschrift für Kunsttechnologie und Konservierung* 6, no. 1 (1992): 1–53.

Schramm, Percy Ernst. "Das Alte und das Neue Testament in der Staatslehre und Staatssymbolik des Mittelalters." In *La Bibbia nell'alto Medioevo,* Settimane di studio del Centro italiano di studi sull'alto Medioevo, 10:229–55. Spoleto, 1963. Reprinted in Schramm, *Kaiser, Könige, und Päpste,* vol. 4, pt. 1, 123–40.

——. *Die deutschen Kaiser und Könige in Bildern ihrer Zeit, 751–1190.* 2nd ed. Edited by Florentine Mütherich. Munich, 1983.

——. *Kaiser, Könige, und Päpste: Gesammelte Aufsätze zur Geschichte des Mittelalters.* Vol. 4, *Beiträge zur allgemeinen Geschichte,* pt. 1, *Rom und Kaiser: Geistliche und weltliche Gewalt das Reformpapsttum zur Geschichte von Nord- und Westeuropa.* Stuttgart, 1970.

——. *Der König von Frankreich.* 2nd ed. Weimar, 1960.

——. "Ordines Studien II: Die Krönung bei den Westfranken und den Franzosen." *Archiv für Urkundenforschung* 15 (1938): 3–55.

Schutzner, Svato. *Medieval and Renaissance Manuscript Books in the Library of Congress: A Descriptive Catalogue.* Vol. 1, *Bibles, Liturgy, Books of Hours.* Washington, D.C., 1989.

Scott, Darwin Floyd. "The Latin Clausula Motets from the Fourth Fascicle of the Codex Montpellier: A Study of the Texts and Their Relationship to the Music." Masters thesis, University of California, Los Angeles, 1977.

Scriptoria Medii Aevi Helvetica: Denkmäler schweizerischer

Schreibkunst des Mittelalters. Edited by Albert Bruckner. Vol. 5. Genf, 1949.

Sculpture française du XIVe siècle. Cahiers, Musée d'art et d'essai, no. 19. Paris, 1985.

Sears, Elizabeth. "Sensory Perception and Its Metaphors in the Time of Richard of Fournival." In *Medicine and the Five Senses,* edited by William F. Bynum and Roy Porter, 17–39, 276–83. Cambridge, 1993.

Seckler, Max. *Le salut et l'histoire: La pensée de Saint Thomas d'Aquin sur la théologie de l'histoire*. Paris, 1967.

The Second Sense: Studies in Hearing and Musical Judgement from Antiquity to the Seventeenth Century. Edited by Charles Burnett, Michael Fend, and Penelope Gouk. London, 1991.

Sed-Rajna, Gabrielle. "Résumé de la conférence." *École pratique des hautes études: Section des sciences religieuses: Annuaire, résumé des conférences et travaux* 96 (1987–88): 234–36.

———. "Further Thoughts on an Early Illustrated Pentateuch." *Journal of Jewish Art* 10 (1984): 29–31.

Selig, Karl-Ludwig, and Elizabeth Sears, eds. *The Verbal and the Visual: Essays in Honor of William Sebastian Heckscher*. New York, 1990.

Septième centenaire de la mort de Saint Louis: Actes des colloques de Royaumont et de Paris, 21–27 mai 1970. Paris, 1976.

Serper, Arie. "Le roi Saint Louis et le poète Rutebeuf." *Romance Notes* 9 (1967): 134–40.

Seymour, Michael C. et al. *Bartholomaeus Anglicus and His Encyclopedia*. Aldershot, Hampshire, 1992.

Sherman, Claire Richter. *Imaging Aristotle: Verbal and Visual Representation in Fourteenth-Century France*. Berkeley and Los Angeles, 1995.

Sherman, Randi E. "Observations on the Genesis Iconography of the Ripoll Bible." *Rutgers Art Review* 2 (1981): 1–12.

Shonk, Timothy A. "A Study of the Auchinleck Manuscript: Bookmen and Bookmaking in the Early Fourteenth Century." *Speculum* 60, no. 1 (1985): 71–91.

Siberry, Elizabeth. *Criticism of Crusading, 1095–1274*. Oxford, 1985.

Le siècle d'or de la miniature flamande: Le mécénat de Philippe le Bon: Exposition organisée à l'occasion du 400e anniversaire de la fondation de la Bibliothèque royale de Philippe II à Bruxelles, le 12 avril 1559, Palais des beaux-arts, Bruxelles, Rijksmuseum, Amsterdam, 26 juin–13 septembre 1959. Brussels, 1959.

Silverman, Kaja. *Male Subjectivity at the Margins*. London and New York, 1992.

Simon, M. "Melchisédech dans la polémique entre juifs et chrétiens et dans la légende." *Revue d'histoire et de philosophie religieuses* 17, no. 1 (1937): 58–93.

Sirat, Jacques. "Documents inédits pour servir a l'histoire du Vexin: Deux chartes de Saint Louis et de Blanche de Castille." *Société historique et archéologique de l'arrondissement de Pontoise et du Vexin: Bulletin semestriel*, n.s., 22 (1976): 15–17.

Sivéry, Gérard. *Blanche de Castille*. Paris, 1990.

———. *Saint Louis et son siècle*. Paris 1985.

Skubiszewski, Piotr. "The Iconography of a Romanesque Chalice from Trzemeszno." *JWCI* 34 (1971): 40–64.

———. *Czara WBocBawska: Studia nad spu[cizn wschodu w sztuce wczesnego [redniowiecza*. PoznaD, 1965.

Slattery, Maureen. *Myth, Man, and Sovereign Saint: King Louis IX in Jean de Joinville's Sources*. New York, Bern, and Frankfurt am Main, 1985.

Small, Graeme. *George Chastelain and the Shaping of Valois Burgundy: Political and Historical Culture at Court in the Fifteenth Century*. Woodbridge, Suffolk, and Rochester, N.Y., 1997.

Smalley, Beryl. *Historians in the Middle Ages*. New York, 1974.

———. *Studies in Medieval Thought and Learning from Abelard to Wyclif*. London, 1981.

———. *The Study of the Bible in the Middle Ages*. Notre-Dame, Ind., 1964.

———. "Use of the 'Spiritual' Senses of Scripture in Persuasion and Argument by Scholars in the Middle Ages." *Recherches de théologie ancienne et médiévale* 52 (1985): 44–63.

———. "William of Auvergne, John of La Rochelle, and St. Thomas Aquinas on the Old Law." In *St. Thomas Aquinas, 1274–1974*, 1:10–71. Toronto, 1974. Reprinted in *Studies in Medieval Thought and Learning from Abelard to Wyclif*, 121–81.

Smeets, Jean Robert. *La Bible de Jehan Malkaraume*. Assen, 1978.

———. "Les traductions, adaptations et paraphrases de la Bible en vers." In *GRLMA*, VI/1:48–57.

———. "Les traductions-adaptations versifiées de la Bible en ancien français." In *Les genres littéraires dans les sources théologiques et philosophiques médiévales: Définition, critique et exploitation*, Publications de l'Institut d'études médiévale: Textes, études, congrès, 2nd ser., 5:244–77. Louvain-la-Neuve, 1982.

Smith, A. Mark. "Getting the Big Picture in Perspectivist Optics." *Isis* 72, no. 264 (1981): 568–89.

Smith, Cyril Stanley, and John G. Hawthorne, eds. *Mappae Clavicula: A Little Key to the World of Medieval Techniques*. Transactions of the American Philosophical Society, n.s., vol. 64, pt. 4. Philadelphia, 1974.

Smith, Norman. "An Early Thirteenth-Century Motet." In *Models of Musical Analysis: Music Before 1600*, edited by

Mark Everist, 20–37. Oxford and Cambridge, Mass., 1992.

Smith, Susan. *The Power of Women: A Topos in Medieval Art and Literature.* Philadelphia, 1995.

Sneddon, C. R. "The 'Bible du XIIIe Siècle': Its Medieval Public in the Light of Its Manuscript Tradition." In *The Bible and Medieval Culture*, 127–40.

———. *A Critical Edition of the Four Gospels in the Thirteenth-Century Old French Translation of the Bible.* Ph.D. diss., Oxford University, 1978.

Société de l'École des Chartres. *Album paléographique; ou, Recueil de documents importants relatifs à l'histoire et à la littérature nationales.* Paris, 1887.

Söhring, Otto. "Werke bildender Kunst in altfranzösischen Epen." *Romanische Forschungen* 12 (1900): 491–640.

Solterer, Helen. "Letter Writing and Picture Reading: Medieval Textuality and the *Bestiaire d'Amour.*" *Word & Image* 5, no. 1 (1989): 131–47.

Spatharakis, Iohannis. *The Portrait in Byzantine Illuminated Manuscripts.* Leiden, 1976.

Spearing, A. C. *The Medieval Poet as Voyeur: Looking and Listening in Medieval Love-Narratives.* Cambridge, 1993.

Spicq, P. Ceslas. *Esquisse d'une histoire de l'exégèse latine au Moyen Âge.* Paris, 1944.

Spiegel, Gabrielle M. *The Chronicle Tradition at Saint-Denis: A Survey.* Brookline, Mass., and Leiden, 1978.

———. "Genealogy: Form and Function in Medieval Historical Narrative." *History and Theory* 22, no. 1 (1983): 43–53.

———. "Political Unity in Medieval Historiography: A Sketch." *History and Theory* 14, no. 3 (1975): 314–25.

———. "The *Reditus Regni ad Stirpem Karoli Magni*: A New Look." *French Historical Studies* 7, no. 2 (1971–72): 145–74.

———. *Romancing the Past: The Rise of Vernacular Prose Historiography in Thirteenth-Century France.* The New Historicism, 23. Berkeley and Los Angeles, 1993.

Spörl, Johannes. *Grundformen hochmittelalterlicher Geschichtsanschauung: Studien zum Weltbild der Geschichtsschreiber des 12. Jahrhunderts.* Munich, 1935.

Stacey, Robert. "The Conversion of Jews to Christianity in Thirteenth-Century England." *Speculum* 67, no. 2 (1992): 263–83.

Stahl, Harvey. "Bestiaire de Douai." *Revue de l'art* 8 (1970): 6–15.

———. "Eve's Reach: A Note on Dramatic Elements in the Hildesheim Doors." In *Reading Medieval Images: The Art Historian and the Object*, edited by Elizabeth Sears and Thelma Thomas, 163–76. Michigan, 2002.

———. "Les frontispices enluminés d'un livre d'heures a Cambrai." In *1300—l'art au temps de Philippe le Bel*, edited by Danielle Gaborit-Chopin and François Avril, XVIes Rencontres de l'École du Louvre, 89–101. Paris, 2001.

———. "Heaven in View: The Place of the Elect in an Illuminated Book of Hours." In *Last Things: Death and Apocalypse in the Middle Ages*, edited by Caroline Bynum and Paul Freedman, 205–32, 344–50. Philadelphia, 1999.

———. "The Iconographic Sources of the Old Testament Miniatures, Pierpont Morgan Library, M. 638." Ph.D. diss., New York University, 1974.

———. "Old Testament Illustration During the Reign of St. Louis: The Morgan Picture Book and the New Biblical Cycles." In *Atti del XXIV Congresso internazionale di storia dell'arte*, 2:79–93. Bologna, 1982.

———. Review of *Le livre d'images de Madame Marie*, by Alison Stones. *Speculum* 77, no. 2 (2002): 640–43.

Stamm, Lieselotte Esther. *Die Rüdiger Schopf-Handschriften: Die Meister einer Freiburger Werkstatt des späten 14. Jahrhunderts und ihre Arbeitsweise.* Aarau, 1981.

Stanbury, Sarah. "The Gaze on the Body of *Pearl's* Dead Girl." In *Feminist Approaches to the Body in Medieval Literature*, edited by Linda Lomperis and Sarah Stanbury, 96–115. Philadelphia, 1993.

———. *Seeing the Gawain Poet: Descriptions and the Act of Perception.* Philadelphia, 1991.

Stanton, Anne Rudloff. "*La Genealogye Comence*: Kinship and Difference in the Queen Mary Psalter." *Studies in Iconography* 17 (1996): 177–214.

Steger, Hugo. *David Rex et Propheta: König David als vorbildliche Verkörperung des Herrschers und Dichters im Mittelalter.* Erlanger Beiträge zur Sprach- und Kunstwissenschaft, 6. Nuremberg, 1961.

Stein, Henri. *Le Palais de justice et la Sainte-Chapelle de Paris.* Paris, 1912.

Steneck, Nicholas H. "Albert on the Psychology of Sense Perception." In *Albertus Magnus and the Sciences*, 263–90.

Sterling, Charles. *La peinture médiévale à Paris, 1300–1500.* Vol. 1. Paris, 1987.

Stettiner, Richard. *Die illustrierten Prudentiushandschriften.* Berlin, 1895.

Stevens, John. *Words and Music in the Middle Ages: Song, Narratives, Dance, and Drama, 1050–1350.* Cambridge, 1986.

Stewart, Susan. *On Longing: Narratives of the Miniature, the Gigantic, the Souvenir, the Collector.* Durham, N.C., 1993.

Stirnemann, Patricia. "Les bibliothèques princières et privées aux XIIe et XIIIe siècles." In *Histoire des bibliothèques françaises*, edited by André Vernet, vol. 1, *Les bibliothèques médiévales du VIe siècle jusqu'à 1530*, 173–91. Paris, 1989.

———. "Current Research in France Concerning Colour

and Technique in Manuscripts and Wall Paintings of the 13th and 14th Centuries." In *Norwegian Medieval Altar Frontals and Related Material: Papers from the Conference in Oslo, 16–19 December 1989,* 137–43. Rome, 1995.

——. "Note sur la Bible moralisée en trois volumes conservée à Oxford, Paris et Londres, et sur ses copies." *Scriptorium* 53, no. 1 (1999): 120–24.

——. "Quelques bibliothèques princières et la production hors scriptorium au XIIe siècle." *Bulletin archéologique du Comité des travaux historiques et scientifiques,* n.s., 17–18, fasc. A (1984): 7–38.

Le stoffe di Cangrande: Ritrovamenti e ricerche sul 300 veronese. Edited by Licisco Magagnato. Florence, 1983.

Stones, Alison. "Indications écrites et modèles picturaux, guides aux peintres de manuscrits enluminés aux environs de 1300." In *Artistes, artisans et production artistique,* 3:321–49.

——. *Le livre d'images de Madame Marie: Reproduction intégral du manuscrit nouvelles acquisitions françaises 16251 de la Bibliothèque nationale de France.* Paris, 1997.

——. "Sacred and Profane Art: Secular and Liturgical Book-Illumination in the Thirteenth Century." In *The Epic in Medieval Society: Aesthetic and Moral Values,* edited by Harald Scholler, 100–112. Tübingen, 1977.

——. "Secular Manuscript Illumination in France." In *Medieval Manuscripts and Textual Criticism,* edited by Christopher Kleinhenz. Chapel Hill, N.C., 1976.

Stork, Hans-Walter. *Bible Moralisée: Codex Vindobonensis 2554 der Österreichischen Nationalbibliothek, Transkription und Übersetzung.* St. Ingbert, 1988.

——. *The Bible of St. Louis.* Codices selecti, Commentarium, CII. Graz, 1996.

——. *Die Wiener französische Bible Moralisée: Codex 2554 der Österreichischen Nationalbibliothek.* St. Ingbert, 1992.

Stratford, N. "Three English Romanesque Enamelled Ciboria." *Burlington Magazine* 126, no. 973 (1984): 204–16.

Strayer, Joseph. *Administration of Normandy Under Saint Louis.* Cambridge, Mass., 1932. Reprint, 1970.

——. "The Crusades of Louis IX." In *Medieval Statecraft,* 129–92.

——. "France: The Holy Land, the Chosen People, and the Most Christian King." In *Action and Conviction in Early Modern Europe,* edited by Theodore K. Rabb and Jerrold E. Seigel, 3–16. Princeton, 1969. Reprinted in *Medieval Statecraft and the Perspectives of History,* 300–314.

——. *Medieval Statecraft and the Perspectives of History.* Edited by John F. Benton and Thomas N. Bisson. Princeton, 1971.

Strohm, Paul. "Guillaume as Narrator and Lover in the *Roman de la Rose.*" *Romance Review* 59, no. 1 (1968): 3–9.

Strosetzki, Norbert. "Kain und Romulus als Stadtgründer." *Forschungen und Fortschritte* 6 (1930): 184–88.

Studien zur Geschichte der europäischen Skulptur im 12./13. Jahrhundert. Edited by Georg Kamp. Frankfurt, 1994.

Studies in the Illustration of the Psalter. Edited by Brendan Cassidy and Rosemary Muir Wright. Stamford, Lincolnshire, 2000.

Studies in Perception: Interrelations in the History of Philosophy and Science. Edited by Peter K. Machamer and Robert G. Turnbull. Columbus, Ohio, 1978.

Stuener, Wolfgang. *Peccatum und Potestas: Der Sündenfall und die Entstehung der herrscherlichen Gewalt im mittelalterlichen Staatsdenken.* Sigmaringen, 1987.

Styger, P. "La decorazione a fresco del sec. XII della chiesa di S. Giovanni a Porta Latina." *Studi romani* 2 (1914): 261–322.

Subes-Picot, Marie-Pasquine. "Peinture sur pierre: Note sur la technique des peintures du XIIIe siècle découverte a la cathédrale d'Angers." *Revue de l'art,* no. 97 (1992): 85–93.

Suckale, Robert. *Studien zu Stilbildung und Stilwandel der Madonnenstatuen der Ile-de-France zwischen 1230 und 1300.* Ph.D. diss., Munich, 1971.

Suckale-Redlefsen, Gude. *Die Bilderzyklen zum Davidleben von den Anfängen bis zum Ende des 11. Jahrhunderts.* Munich, 1970.

——. "Psalmen, Psalterillustration." In *LCI,* vol. 3, 466–81.

Suleiman, Susan Rubin. *The Female Body in Western Culture: Contemporary Perspectives.* Cambridge, Mass., and London, 1985–86.

Summers, David. *The Judgment of Sense: Renaissance Naturalism and the Rise of Aesthetics.* Cambridge, 1987.

Swarzenski, Georg. *Die Salzburger Malerei: Von den ersten Anfängen bis zur Blütezeit des romanischen Stils.* Leipzig, 1913.

Swarzenski, Hanns, ed. *Mosaner Psalter-Fragment.* 2 vols. Graz, 1974–75.

——. "Unknown Bible Pictures by W. de Brailes and Some Notes on Early English Bible Illustration." *Journal of the Walters Art Gallery* 1 (1938): 54–69

Swoboda, Karl M. *Die Gotik von 1150 bis 1300.* Geschichte der Bildenden Kunst, 2. Vienna and Munich 1977.

Szirmai, Julia C. *La Bible anonyme du Ms. Paris B.N., F. Fr. 763: Édition critique.* Amsterdam, 1985.

Szkilnik, Michelle. "Le Livre des saintes paroles de Joinville." *Revue de littératures françaises et comparée* 9 (November 1997): 31–40.

Taburet-Delahaye, Elisabeth. *L'orfèvrerie gothique au Musée du Cluny, XIIe–début XVe siècle.* Paris, 1989.

Tachau, Katherine H. "God's Compass and *Vana Curiositas:*

Scientific Study in the Old French Bible Moralisée." *Art Bulletin* 80, no. 1 (1988): 7–33.

———. *Vision and Certitude in the Age of Ockham: Optics, Epistemology, and the Foundations of Semantics, 1250–1345.* Leiden, 1988.

Taittinger, Claude. *Thibaud le Chansonnier, comte de Champagne.* Paris, 1987.

Tammen, Silke. "Bilder der Sodomie in der Bible moralisée." *Frauen Kunst Wissenschaft* 21 (July 1996): 30–48.

Taralon, Jean. "La chasse de Saint-Taurin d'Évreux." *Bulletin monumental* 140, no. 1 (1982): 41–56.

———. "Observations sur le portail central et sur la façade occidentale de Notre-Dame de Paris." *Bulletin monumental* 149, no. 4 (1991): 341–432.

Temple, El|bieta. *Anglo-Saxon Manuscripts, 900–1066.* A Survey of Manuscripts Illuminated in the British Isles, 2. London, 1976.

Tense-Aspect: Between Semantics and Pragmatics: Containing the Contributions to a Symposium on Tense and Aspect Held at UCLA, May 1979. Edited by Paul Hopper. Amsterdam and Philadelphia, 1982.

Terline, Joseph de. "La tête de Saint Louis à Saint-Germain-en-Laye." *Monuments Piot* 45 (1951): 123–40.

Tesnière, Marie-Hélène. "Medieval Collections of the Bibliothèque Nationale de France: From the Eighth to the Fifteenth Century." In Tesnière and Gifford, *Creating French Culture.*

Tesnière, Marie-Hélène, and Prosser Gifford, eds. *Creating French Culture: Treasures from the Bibliothèque Nationale de France.* New Haven and London, 1995.

Teulet, Alexandre, comp. *Layettes du Trésor des chartes.* Vol. 2. Archives nationale, inventaires et documents. Paris, 1863.

Theiss, Peter, and Otto-Joachim Grüsser. "Vision and Cognition in the Natural Philosophy of Albert the Great (Albertus Magnus)." *Documenta Opthlamologica* 86 (1994): 123–51.

Thesauri Hymnologici Hymnarium. 2 vols. Edited by Clemens Blume. Analecta Hymnica Medii Aevi, 51. Leipzig, 1908–9.

Thomas, Marcel. "L'iconographie de Saint Louis, dans *Les Heures de Jeanne de Navarre.*" In *Septième centenaire de la mort de Saint Louis,* 209–31.

Throop, Palmer Allan. *Criticism of the Crusade: A Study of Public Opinion and Crusade Propaganda.* Amsterdam, 1940.

Tietzel, Brigitte. *Italienische Seidengewebe des 13., 14. und 15. Jahrhunderts.* Cologne, 1984.

Tischler, Hans. "Intellectual Trends in Thirteenth-Century Paris as Reflected in the Texts of Motets." *Music Review* 29 (1968): 1–11.

Toma, Kathy. "La tête de feuilles gothique." *L'information de l'histoire de l'art* 20 (1975): 180–91.

Tormo, Elías. "La Biblia de San Luis de la Catedral de Toledo." *Boletín de la Real academia de la historia* 82 (1923): 11–17, 121–32, 198–201, 289–96.

Toubert, Helene. *Un art dirigé: Reforme grégorienne et iconographie.* Paris, 1990.

Transformations of the Court Style: Gothic Art in Europe, 1270 to 1320. Exh. cat. Providence, 1977.

"Translatio S. Honorinae virginis et martyris et ejusdem miracula." *Analecta Bollandiana* 9 (1890): 141–43.

Träume im Mittelalter: Ikonologische Studien. Edited by Agostino Paravicini Bagliani and Giorgio Stabile. Stuttgart and Zurich, 1989.

Tremlett, Thomas Daniel, ed. "The Matthew Paris Shields." In *Aspilogia, Being Materials of Heraldry,* vol. 2. Oxford, 1967.

Le trésor de la Sainte-Chapelle. Exh. cat. Edited by Jannic Durand and Marie-Pierre Laffitte. Musée du Louvre. Paris, 2001.

Le trésor de Saint-Denis. Exh. cat. Edited by Danielle Gaborit-Chopin et al. Musée du Louvre. Paris, 1991.

Un trésor gothique: La châsse de Nivelles. Exh. cat. Cologne, Schnütgen-Museum, November 24, 1995–February 11, 1996; Paris, Musée national du Moyen Âge, Thermes de Cluny, March 12–June 10, 1996. Paris, 1996.

Tristram, Ernest William. *English Medieval Wall Painting: The Thirteenth Century.* 2 vols. Oxford, 1944–50.

Tronzo, William. *The Via Latina Catacomb: Imitation and Discontinuity in Fourth-Century Roman Painting.* University Park, Pa., and London, 1986.

Trotter, David Andrew. *Medieval French Literature and the Crusades (1100–1300).* Geneva, 1988.

Tuety, M. "Inventaire des biens de Charlotte de Savoie." *Bibliothèque de l'École de Chartres,* 6th ser., 1 (18??): 357.

The Turin-Milan Hours. Fascsimile with commentary by James H. Marrow, Anne Hagopian van Buren, and Silvana Pettenati. 2 vols. Lucerne, 1994–96.

Tyson, Diana. "Patronage of French Vernacular History Written in the Twelfth and Thirteenth Centuries." *Romania* 100 (1979): 180–222.

Udovitch, Joan Diamond. "The Papeleu Master: A Parisian Manuscript Illuminator of the Early Fourteenth Century." Ph.D. diss., New York University, 1979.

———. "Three Astronomers in a Thirteenth Century Psalter." *Marsyas* 17 (1991): 79–83.

Ullmann, Walter. *The Carolingian Renaissance and the Idea of Kingship.* London, 1969.

Ulrich, Anna. *Kain und Abel in der Kunst: Untersuchungen zur Ikonographie und Auslegungsgeschichte.* Bamberg, 1981.

The Union of Words and Music in Medieval Poetry. Edited by Rebecca A. Baltzer, Thomas Cable, and James I. Wimsatt. Austin, Tex., 1991.

Vaivre, Jean-Bernard de. "Le décor héraldique de la cassette d'Aix-la-Chapelle." *Aachen Kunstblätter* 45 (1974): 97–124.

Vallet de Viriville, Auguste. "La bibliothèque d'Isabeau de Bavière." *Bulletin du bibliophile et du bibliothécaire*, 13th ser., January 1858, 676–86.

Valois, Noël. *Guillaume d'Auvergne, évêque de Paris (1228–1249) sa vie et ses ouvrages.* Paris, 1880.

van Buren, Anne Hagopian. "Les Chroniques de Hainaut: Texte, histoire, et illustrations: The Artists of Volume I." In *Les Chroniques de Hainaut*, 65–74.

———. "The Date of the Miniatures." In *Les Chroniques de Hainaut*, 61–64.

———. "Dress and Costume." In *Les Chroniques de Hainaut*, 111–17.

———. "Jean Wauquelin de Mons et la production du livre aux Pays-Bas." *Publication du Centre européen d'études burgondo-médianes*, no. 23 (1983): 53–66.

———. "William Vrelant: Questions and Issues." *Revue belge d'archéologie de l'art* 68 (1999): 3–30.

Van Dijk, Stephen Joseph Peter. *Sources of the Modern Roman Liturgy: The Ordinals by Haymo of Faversham and Related Documents (1243–1307).* Leiden, 1963.

Van Moé, Émile. "Sur la date du petit psautier de Saint Louis de la Bibliothèque nationale." *Bibliothèque de l'École des Chartres* 98 (1937): 423.

———. "Le Psautier de Saint-Louis." *Arts et métier graphiques* 6 (1937): 25–31, 71–74.

van Os, Henk. *The Power of Memory.* Baarn, 1999.

van Uytfanghe, Marc. "Modèles bibliques dans l'hagiographie." In *Le Moyen Âge et la Bible*, 449–87.

The Varieties of Musicology: Essays in Honor of Murray Lefkowitz. Edited by John Daverio and John Ogasapian. Warren, Mich., 2000.

Velislai Biblia Picta. Edited by Karel Stejskal. Editio cimelia bohemica, 12. Prague, 1970.

Verkerk, Dorothy Hoogland. "Biblical Manuscripts in Rome 400–700 and the Ashburnham Pentateuch." In *Imaging the Early Medieval Bible*, 97–120.

———. "Exodus and Easter Vigil in the Ashburnham Pentatuch." *Art Bulletin* 77 (1995): 94–105.

———. *Liturgy and Narrative in the Exodus Cycle of the Ashburnham Pentateuch.* Ph.D. diss., Rutgers University, 1992.

Vescovini, Graziella Federici. "La fortune de l'optique d'Ibn Al-Haitham: Le livre *De aspectibus (Kitâb Al-Manâzir)* dans le Moyen-Âge latin." *Archives internationales d'histoire des science* 40 (1990): 220–38.

The Vespasian Psalter: British Musuem, Cotton Vespasian A.I. Edited by David H. Wright. Early English Manuscripts in Facsmile, 14. Copenhagen, 1967.

Vezin, Jean. *Évolution des techniques de la reliure médiévale.* Paris, 1973.

———. "La fabrication du manuscrit." In *Histoire de l'édition française*, edited by Henri-Jean Martin, Roger Chartier, and Jean-Pierre Vivet, vol. 1, *Le livre conquérant: Du Moyen Âge au milieu du XVIIe siècle*, 25–47. Paris, 1982.

Viard, Jules, ed. *Les grandes chroniques de France.* 10 vols. Paris, 1920–53.

———. *Les journaux du trésor de Charles IV le Bel.* Paris, 1917.

Vidier, M. A. "Notes et documents sur le personnel, les biens et l'administration de la Sainte-Chapelle, du XIIIe au XVe siècle." *Mémoires de la Société de l'histoire de Paris et de Ile-de-France* 28 (1901): 213–15.

Vincent de Beauvais: Intentions et réception d'une oeuvre encyclopédique au Moyen Âge: Actes du XIVe colloque de l'Institut d'études médiévales, 27–30 avril 1988. Edited by Monique Paulmier-Foucart, Serge Lusignan, and Alain Nadeau. Saint-Laurent, 1990.

La visione e lo sguardo nel Medio Evo/View and Vision in the Middle Ages. 2 vols. Micrologus, 5–6. Florence, 1997.

Les vitraux de Paris, de la région parisienne, de la Picardie et du Nord-Pas-de-Calais, Corpus Vitrearum Medii Aevi, France, série complementaire: Recensement des vitraux anciens de la France, I. Paris, 1978.

Vitry, Paul. *La cathédrale de Reims: Architecture et sculptures.* 2 vols. Paris, 1919.

Vitti, Karl. "Nouvelle et structure hagiographique: Le récit historiographique de Jean de Joinville." In *Mittelalter-bilder aus neuen Perspektive*, edited by Ernstpeter Ruhe and Rudolf Belhrens, 380–91. Munich, 1985.

Vitzthum, Georg Graf. *Die Pariser Miniaturmalerei von der Zeit des hl. Ludwig bis zu Philip von Valois und ihr Verhältnis zur Malerei in Nordwesteuropa.* Leipzig, 1907.

Vöge, Wilhelm. *Bildhauer des Mittelalters.* Edited by Erwin Panofsky. Berlin, 1958.

von Euw, Anton. "L'enluminure." In *Un trésor gothique*, 261–74.

von Moos, Peter. "Die Trostschrift des Vincenz von Beauvais für Ludwig IX.: Vorstudie zur Motiv- und Gattungs-geschichte der 'Consolatio.'" *Mittellateinisches Jahrbuch* 4 (1967): 173–218.

von Schlosser, Julius. *Quellenbuch zur Kunstgeschichte des abendländischen Mittelalters.* Vienna, 1896.

von Simson, Otto Georg. *Das Mittelalter II: Das hohe Mittel-alter.* Propylaen Kunstgeschichte, vol. 6. Berlin, 1972.

———. "Opere superante materiam: Zur Bedeutung der Sainte-Chapelle zu Paris." In *Clio et son regard: Mélanges d'histoire, d'histoire de l'art et d'archéologie offerts à Jacques Stiennon*, edited by Rita Lejeune and Joseph Deckers, 597–613. Liège, 1982.

Voorbij, Johannes Benedictus. "The Speculum Historiale: Some Aspects of Its Genesis and Manuscript Tradition." In *Vincent of Beauvais and Alexander the Great*, edited by W. J. Aerts, E. R. Smits, and J. B. Voorbij, 11–55. Groningen, 1986.

Waite, William. "Johannes de Garlandia, Poet and Musician." *Speculum* 35, no. 2 (1960): 179–95.

Wakefield, Walter, and Austin Evans. *Heresies of the High Middle Ages*. New York, 1991.

Waquet, Françoise. *Les fêtes royales sous la Restauration; ou, L'Ancien Régime retrouvé*. Bibliothèque de la Société française d'archéologie, 14. Paris, 1981.

Wardwell, Anne E. "The Stylistic Development of 14th and 15th Century Italian Silk Design." *Aachen Kunstblätter* 47 (1976–77): 177–226.

Warner, George Frederic, ed. *The Guthlac Roll*. Oxford, 1928.

——, ed. *Queen Mary's Psalter*. London, 1912.

Warnke, Martin. *The Court Artist: On the Ancestry of the Modern Artist*. Cambridge, 1993.

Watson, Arthur. *The Early Iconography of the Tree of Jesse*. London, 1934.

Weber, Richard. "Vincent of Beauvais: A Study in Medieval Historiography." Ph.D., diss., University of Michigan, 1965.

Weber, Robert. *Le psautier romain et les autres anciens psautiers latin*. Rome, 1953.

Weisheipl, James A. "The Life and Work of St. Albert the Great." In *Albertus Magnus and the Sciences*.

Weiss, Daniel H. "Architectural Symbolism and the Decoration of the Ste.-Chapelle." *Art Bulletin* 77, no. 2 (1995): 308–20.

——. *Art and Crusade in the Age of Saint Louis*. Cambridge and New York, 1998.

——. "Biblical History and Medieval Historiography: Rationalizing Strategies in Crusader Art." *Modern Language Notes* 108 (1993): 710–37.

——. "Envisioning a Christian Palestine: Ideology in the Crusader Images of the Arsenal Old Testament." Ph.D. diss., Johns Hopkins University, 1995.

——. "The Three Solomon Portraits in the Arsenal Old Testament and the Construction of Meaning in Crusader Painting." *Arte medievale*, 2nd ser., 6, no. 2 (1992): 15–38.

Weiss, Daniel H., with Sussan Babaie, Sydney C. Cockerell, Vera Basch Moreen, and William C. Voelkle. *Der Kreuzritterbibel = The Morgan Crusader Bible = Le Bible des Croisades*. 2 vols. Lucerne, 1998–99.

Weitzmann, Kurt. "The Genesis Mosaics of San Marco and the Cotton Genesis Miniatures." In Otto Demus, *The Mosaics of San Marco in Venice*, vol. 2, pt. 1, 108–42 (text), and pt. 2 (plates).

——. *The Joshua Roll*. Studies in Manuscript Illumination, 3. Princeton, 1948.

——. *The Miniatures of the Sacra Parallela*. Studies in Manuscript Illumination, 8. Princeton, 1979.

Weitzmann, Kurt, and Massimo Bernabò, with the collaboration of Rita Tarasconi. *The Byzantine Octateuchs*. The Illustrations in the Manuscripts of the Septuagint, 2. 2 vols. Princeton, 1999.

Weitzmann, Kurt, and Herbert L. Kessler. *The Cotton Genesis, British Library Codex Cotton Otho B. VI*. The Illustrations of Manuscripts of the Septuagint, 1. Princeton, 1986.

——. *The Frescoes of the Dura Synagogue and Christian Art*. Washington, D.C., 1990.

Wentzel, Hans. "Mittelalter und Antike im Spiegel kleiner Kunstwerke des 13. Jahrhunderts." In *Studier tillägnade Henrik Cornell*, 67–93. Stockholm, 1950.

——. "Eine Pariser Kamee des 13. Jahrhunderts in byzantinischen Stil." In *Études d'art français offerts à Charles Sterling*, edited by Albert Chatelet and Nicole Reynaud, 31–39. Paris, 1975.

——. "Portraits 'à l'Antique' on French Mediaeval Gems and Seals." *JWCI* 16 (1953): 342–50.

——. "Die vier Kameen im Aachener Domschatz und die französische Gemmen-Schneidekunst des 13. Jahrhunderts." *Zeitschrift für Kunstwissenschaft* 8 (1954): 1–18.

Wenzel, Horst. *Partizipation und Mimesis: Die Lesbarkeit der Körper am Hof und in der höfischen Literatur*. Frankfurt am Main, 1988.

Werner, Karl-Ferdinand. "Il y a mille ans, les Carolingiens: Fin d'une dynastie, début d'un mythe." In *Annuaire-Bulletin de la Société de l'histoire de France, années 1991–1992*, 71–89. Paris, 1993.

White, John. *Art and Architecture in Italy, 1250 to 1400*. 2nd ed. Harmondsworth, Middlesex, 1987.

Whitley, Kathleen P. *The Gilded Page: The History and Technique of Manuscript Gilding*. New Castle, Del., and London, 2000.

Williams, John. "The Bible in Spain." In *Imaging the Early Medieval Bible*, 179–218.

——. "A Castilian Tradition of Bible Illumination: The Romanesque Bible from San Millán." *JWCI* 28 (1965): 66–85.

——. "A Model for the Léon Bibles." *Madrider Mitteilungen* 8 (1967): 281–86.

Williamson, Paul. *Gothic Sculpture, 1140–1300*. New Haven, 1995.

Willmes, Peter. *Der Herrscher 'Adventus' im Kloster des Frühmittelalters*. Münstersche Mittelalter-Schriften, 22. Munich, 1976.

Wilmart, André. "L'admonition de Jonas au roi Pepin et le

florilège canonique d'Orléans." *Revue bénédictine* 45 (1933): 214–33.

Wilpert, Josef. *Die römischen Mosaiken und Malereien der kirchlichen Bauten vom IV. bis XIII. Jahrhundert.* 4 vols. Freiburg im Breisgau, 1916. Reprinted as *Die römischen Mosaiken der kirchlichen Bauten vom IV.–XIII. Jahrhundert.* Freiburg im Breisgau, Basel, and Vienna, 1976.

Wirth, Jean. "Peinture et perception visuelle au XIIIe siècle." In *La visione e lo sguardo nel Medio Evo,* 1:113–28.

Wirth, Karl-August. *Pictor in Carmine: Ein Handbuch der Typologie aus dem 12. Jahrhundert.* Berlin, 1989.

Wittekind, Susanne. *Kommentar mit Bildern: Zur Ausstattung mittelalterlicher Psalmenkommentare und Verwendung der Davidgeschichte in Texten und Bildern am Beispiel des Psalmenkommentars des Petrus Lombardus (Bamberg, Staatsbibliothek, Msc. Bibl. 59).* Frankfurt am Main, 1994.

Witzling, Mara R. "The Winchester Psalter: A Re-Ordering of Its Prefatory Miniatures According to Scriptural Sequence." *Gesta* 23, no. 1 (1984): 17–25.

Wolfthal, Diane. "'A Hue and a Cry': Medieval Rape Imagery and Its Transformation." *Art Bulletin* 75, no. 1 (1993): 39–64.

Wolinski, Mary Elizabeth. "The Montpellier Codex: Its Compilation, Notation, and Implications for the Chronology of the Thirteenth-Century Motet." Ph.D. diss., Brandeis University, 1988.

Wood, Christopher. "'Curious Pictures' and the Art of Description." *Word & Image* 11, no. 4 (1995): 332–52.

Woolf, Rosemary. "The Effect of Typology on the English Medieval Plays of Abraham and Isaac." *Speculum* 32 (1957): 805–25.

Wormald, Francis. "An English Eleventh Century Psalter with Pictures, British Museum Cotton MS. Tiberius C.iv." *Walpole Society* 38 (1960–62): 1–14.

———. "Some Illustrated Manuscripts of the Lives of Saints." *Bulletin of the John Rylands Library* 35, no. 1 (1952): 248–66. Reprinted in *Collected Writings,* edited by Jonathan J. G. Alexander, T. J. Brown, and Joan Gibbs, 2:43–56. London, 1984.

———. *The Winchester Psalter.* London, 1973.

Wormald, Francis, and Phyllis M. Giles. *A Descriptive Catalogue of the Additional Illuminated Manuscripts in the Fitzwilliam Museum Acquired Between 1895 and 1979.* Cambridge, 1982.

Wright, Craig. "Leoninus, Poet and Musician." *Journal of the American Musicological Society* 39 (1986): 1–35.

———. *Music and Ceremony at Notre-Dame of Paris, 500–1500.* Cambridge and New York, 1989.

Wright, David. "Canon Tables of the Codex Beneventanus." *DOP* 33 (1979): 137–55.

Wright, Georgia Sommers. "A Royal Tomb Program in the Reign of Saint Louis." *Art Bulletin* 56, no. 2 (1974): 224–43.

Wright, Rosemary Muir. *Art and Anti-Christ in Medieval Europe.* Manchester and New York, 1995.

———. "An Image Fit for a King: The Glazier Psalter Reconsidered." *Journal of Medieval History* 19 (1993): 70–124.

Wunsche, Raimund. "Der Jüngling vom Magdalensberg: Studie zur römischen Ideal Plastik." In *Festschrift Luitpold Dussler: 28 Studien zur Archäologie und Kunstgeschichte,* edited by J. A. Schmoll gen. Eisenwerth, Marcell Restle, and Herbert Weiermann, 45–80. Munich, 1972.

Young, Karl. *The Drama of the Medieval Church.* Oxford, 1933. Reprint, 1962.

Yudkin, Jeremy. *Music in Medieval Europe.* Englewood Cliffs, N.J., 1989.

Zanardi, Bruno. "Relazione di restauro della decorazione della cappella del Sancta Sanctorum con due appendici sulle tecniche d'esecuzione dei dipinti murali duecenteschi." In *Sancta Sanctorum,* 230–69. Milan, 1995.

Die Zeit der Staufer: Geschichte, Kunst, Kultur. Exh. cat. Edited by Reiner Haussherr. 5 vols. Stuttgart, 1977.

Zerner, Henri. "Observations on the Use of the Concept of Mannerism." In *The Meaning of Mannerism,* edited by Franklin Robinson and Stephen Nichols, 105–19. Hanover, N.H., 1972.

Zink, Michel. *La prédication en langue romane: Avant 1300.* Nouvelle bibliothèque du Moyen Âge, 4. Paris, 1976.

———. *La subjectivité littéraire: Autour du siècle de Saint Louis.* Paris, 1985.

———. "Time and Representation of the Self in Thirteenth-Century French Poetry." *Poetics Today* 5, no. 3 (1984): 611–27.

Index

frames in, 272 n. 97
gold in, 37
motifs in, 272 n. 97
painting of, 37, 69–70, 72–73, 74–75
prickings in, 33
production of, 40
space in, 72–73

gathering X
architecture in, 39, 272 n. 103
artist of, 69–71, 272 n. 103
color in, 39, 70–71, 272 n. 103
decoration in, 272 n. 103
design conception for, 272 n. 103
frames in, 272 n. 97
gold in, 37, 271 n. 85
motifs in, 272 n. 97
painting of, 39, 69–71, 272 n. 103
production of, 40
space in, 71

gathering XI
architecture in, 39, 74, 75–76, 77–78
artist of, 74–77, 77–78
bole in, 74, 75
color in, 37–39, 40, 74, 75–77, 77–78
decoration in, 75
design conception for, 75–76
drawings for, 75
frames in, 40, 74, 75, 272 n. 97
gold in, 37, 74, 75
motifs in, 74, 272 n. 97
painting of, 37–39, 40, 74–77, 77–78
prickings in, 74
production of, 40, 74, 75
structure of, 74

gathering XII
architecture in, 39, 74, 75–76, 77–78
artist of, 74–77, 77–78, 177
bole in, 74, 75
color in, 36, 37–39, 74, 75–77, 77–78, 177
decoration in, 75
design conception for, 75–76
drawings for, 75
frames in, 74, 75, 272 n. 97
gold in, 37, 74, 75
modeling in, 36, 37, 37–39, 74–77, 117–18, 177
motifs in, 74, 272 n. 97
painting of, 36, 37, 37–39, 74–77, 77–78, 177
prickings in, 74
production of, 40, 74, 75
structure of, 74

gathering XIII
architecture in, 74, 75–76, 77–78
artist of, 74–78, 177
bole in, 74, 75
color in, 36, 37–39, 74, 75–77, 77–78, 177
decoration in, 75, 77–78
design conception for, 75–76, 77–78
drawings for, 75

frames in, 66, 74, 75, 77–78, 272 n. 97
gold in, 37, 74, 75
modeling in, 36, 37, 37–39, 74–77, 117–18, 177
motifs in, 74, 78, 272 n. 97
painting of, 36, 37, 37–39, 74–78, 177
prickings in, 74
production of, 40, 74, 75
space in, 75, 77
structure of, 74

gathering XV, 46–49
gathering XVII, 306 n. 8
gathering XVIII, 46–49
gathering XX, 235
gathering XXIX, 50
Gauthier of Joigny, 263 n. 133
Gauthier the Silent, 60
gems, 123, 125, 285 n. 207
gender, 269 n. 50
genealogy, 17, 159–60, 161–62, 169–71, 173–75
Geoffrey de Paris, 158
Geoffroy de Beaulieu, 15
Germain, Saint, 14
Gertrude, Saint, 87
Gesta Philippi Augusti (Rigord), 162
gesture, 123–26, 175, 177, 289 n. 31, 300 n. 36.
 See also expression
Giambologna, 272 n. 89
Gideon, 72, 110, 152, 206, 271 n. 85, 279 n. 85
Gilgal. *See* folio 78r
Giotto, 275 n. 2, 305 n. 12, search for other
Girart des Moulin, 158
Glossed Psalter, 307 n. 5
God
 Creator, 255 n. 140
 in folio 1v, 3, 89
 in folio 30r, 176
 in folio 35v, 112–13
 in folio 36r, 173
 in folio 38r, 176
 in Ingeborg Psalter, 139
 kingship and, 163, 181–84
 in Psalter of Blanche of Castile, 148
 in Saint-Germain-en-Laye psalter, 148
Godograndi, Saint, 262 n. 106
gold
 architecture and, 39, 84
 bole and, 35, 37
 color and, 37
 in folio 1v–4r, 260 n. 75
 in folio 7v, 260 n. 75
 in folio 10r, 260 n. 75
 in folio 13v–14r, 260 n. 75
 in folio 20r, 271 n. 85
 in folio 35v, 35, 259 n. 49
 in folio 36r, 259 n. 49
 in folio 43v–45v, 259 n. 49
 in folio 48r, 259 n. 49
 in folio 50r, 259 n. 49, 271 n. 85
 in folio 52r, 271 n. 85

in folio 64r, 259 n. 49
in folio 66r–67v, 259 n. 49
in folio 69v–70r, 259 n. 49
in folio 78r, 259 n. 49
in gathering III, 70
in gathering V, 70, 271 n. 85
in gatherings VI–VII, 271 n. 85
in gathering X, 271 n. 85
in gatherings XI–XIII, 74, 75
in illuminated manuscripts generally, 32
painting and, 37
in prefatory miniatures generally, 4, 26, 32, 35, 37, 39, 78, 210
rulings for, 28
golden calf. *See* folio 35v
Goliath, 171
Golitsyn, Mikhail Aleksandrovich, 249 n. 29
Golitzyn, Mikhail Petrovich, 6–7
Golovkin, Aleksandr Aleksandrovich, 248 n. 24
Golovkin, Alexis, 6
Grand Cameo, 123, 285 n. 207
Grandes chroniques de France, 162
Great Canterbury Psalter, 150, 292 n. 75
Gregory, 45, 306 n. 4
Gregory VI, 181
Gregory IX, 161, 279 n. 96
Gregory of Tours, 294 n. 120
grisaille, 38–39, 130–31, 287 n. 246
Grodecki, Louis, 164
Grosseteste, Robert, 128
Guillaume de Braye, 264 n. 139
Guillaume de Poitiers, 267 n. 4
Guillaume de Saint-Pathus, 15
Guillaume le Breton, 162
Gulbenkian Apocalypse, 260 n. 68
Guy de Mello, 285 n. 205

hagiography, 152–54, 206
hairstyle, 177
Ham, 126
Haseloff, Arthur, 8–9, 66
Haseloff, Günther, 251 n. 52
healing touch, 163, 304 n. 138
Hebrews. *See also* Israelites; Jews
 in folio 45v, 111
 in folio 59v, 114
 in folio 71v, 43–44, 94
 in folio 72r, 118, 156, 177
 in folio 75v, 77
 in Morgan Picture Book, 99, *100*
Heffernan, Thomas, 292 n. 82
Henry III, 60
Henry IV, 7, 181
Heraclius, 297 n. 174
heraldry
 in Bibliothèque nationale de France MS
 lat. 10434, 14
 Castile, castles of, 2, 14, 45–50, 209–10
 cinquefoils and, 46, 48–49

for folio 56r, 281 n. 124
for folio 57v, 126, 279 n. 99, 280 n. 103, 281 n. 124
for folio 58r, 279 n. 99
for folio 59v, 126
for folio 62r, 281 n. 124
for folio 63v, 277 n. 51
for folio 64r, 277 n. 51
for folio 66r, 279 n. 99
for folio 71v, 93–95
for folio 72r, 118–21
for folio 73v, 122–23, 280 n. 108, 283 nn. 177, 179
for folio 74r, 283 n. 177, 284 n. 183
for folio 75v, 126, 280 n. 103, 283 n. 179
for folio 76r, 121, 283 nn. 177, 179
for folio 78r, 158–59, 283 nn. 177, 179
for frames, 107–9
illuminated manuscripts as generally, 126–31
for Ingeborg Psalter, 90, 204
for modeling, 116–26, 129–31
Morgan Picture Book as, 96, 98–101, 278 n. 62
Parisian art as, 116–31
for prefatory miniatures generally, 83–109, 116–31, 158–59, 204
for Psalter of Blanche of Castile, 90, 204–5
Sainte-Chapelle as, 89, 91, 95–98, 101
sculpture as, 116–26
for space, 100, 102–4, 107–9
space. *See also* frames; page design
architecture and, 83–89, 102–3
in folio 7v, 88
in folio 13v, 88
in folio 30r, 107–9
in folio 33v, 107–9
in folio 38r–39v, 77
in folio 40r, 107–9
in folio 75v, 77, 78
in folio 76r, 78
in folio 77v–78r, 77, 78
in folio 110v, 78
in folio 126v, 78
in gathering I, 65
in gathering III, 78
in gathering IV, 67–68
in gatherings VI–VII, 71
in gathering IX, 72–73
in gathering X, 71
in gathering XIII, 75, 77
interpretation and, 83–89
modeling and, 287 n. 246
in prefatory miniatures generally, 83–89
in psalms, 78
sources for, 100, 102–4, 107–9

Speculum historiale (Vincent of Beauvais)
history in, 159–60, 162, 163, 166–67, 169–70, 297 n. 165
on Jacob, 174
on Saul, 182
Speculum maius (Vincent of Beauvais), 159, 169
Spiegel, Gabrielle, 160, 161
Sponsa, 186
Sponsus, 186
Stahl, Harvey, xiii–xiv, 12
stained glass
at Chartres cathedral, 152–54, 153, 156, 158, 165, 206, 298 n. 180
kingship and, 162
Old Testament in, 156, 161, 162, 164–66, 206, 297 n. 165, 298 n. 174
in Paris, 127–28
at Reims, 87, 162
at Sainte-Chapelle, 89, 91, 95–98, 97, 101, 161, 162, 164–66, 182, 208, 297 n. 165, 298 n. 174
at Saint-Rémi, 162, 165
Steinheil, Louis, 7–8
Stephen, Saint, 118, 120, 126
Sterling, Charles, 10
St. Johns College MS K.26, 90, 90
St. Louis and the Court Style in Gothic Architecture (Branner), 9–10
stream, 195–96
Susanna, 302 n. 93
Susanna at the Bath (Rembrandt), 199

tabernacle
in folio 71v, 112
in folio 78r, 173, 179, 183
interpretation of, 165, 173, 175
at Sainte-Chapelle, 96, 166
Teachings (Louis IX), 164, 211
tense, grammatical, 112–15
text pages. *See* prayers; psalms; script
Theophilus, 116, 118, 143, 204
Thibaut IV of Champagne, 196, 209
Thibaut V of Champagne-Navarre, 3, 47, 263 n. 127
Thomas, Saint, 152, 153
Thompson, Henry Yates, 8
Tiberius Psalter, 134–39, 136, 137, 146, 148, 205, 206
Toledo, cathedral of, 16, 17, 254 nn. 127, 130
translatio studii, 105
Tree of Jesse, 138–39, 289 n. 41, 300 n. 30
trees
David and Bathsheba and, 195–96, 200
in folio 7v, 88, 112, 170, 173–74
in Saint Albans Psalter, 138
in Saint-Germain-en-Laye psalter, 148
Tree of Jesse, 138–39, 289 n. 41, 300 n. 30

Trinity College psalter, 150
Trojan dynasty, 162
True Cross, 44, 161, 297 n. 174. *See also* Holy Cross
typology, 154–58, 185–92

Urban IV, 287 n. 247
Uriah the Hittite, 186, 187
Utrecht Psalter, 304 n. 127

Vallière, duke of, 249 n. 25
Val Saint-Éloi at Longjumeau, 60
van der Weyden, Roger, 305 n. 12
Vaudetaur, Jean, 60
Vendôme, Mathieu, 287 n. 249
Vial, Gabriel, 238, 243–45
Victor, Saint, 253 n. 110
Villard de Honnecourt, 60, 285 n. 206
Vincent of Beauvais
on color, 129
on Crusades, 182
De morali principis institutione, 170, 181–84, 208
on history, 159–60, 162, 163, 166–67, 169–70, 171, 207, 297 n. 165
on kingship, 170, 181–84, 208
Liber consolatorius, 164, 182
Louis IX and, 170, 182
Speculum historiale, 159–60, 162, 163, 166–67, 169–70, 174, 182, 297 n. 165
Speculum maius, 159, 169
Virgin and Child, 116–17, 117, 119, 122, 187. *See also* Mary, Virgin
vision, 185–86, 189–92, 196, 198–201, 304 n. 138. *See also* optics; senses
Vitzthum, Georg, 9

walls, 102–4
Walter, Master, 60
Wardwell, Anne, 308 n. 15
Washington breviary, 228
Wijnbergen Armorial, 48
William de Brailes, 195, 277 n. 43
William of Auvergne, 156–58
William X of Auvergne, 295 n. 138
William of Beaulieu, 164
William of Rubruck, 15
William of Saint-Pathus, 13
Williams, John, 281 n. 141
Winchester Psalter, 90, 150
Wirth, Jean, 275 n. 2
Witelo, 129
women, 143, 185–201, 204
Wright, Georgia Sommers, 284 n. 191